DICTIONARY OF 20TH-CENTURY DESIGN

DICTIONARY OF 20TH-CENTURY DESIGN

JOHN PILE

A Roundtable Press Book

DA CAPO PRESS
NEW YORK

Library of Congress Cataloging in Publication Data

Pile, John F.
 Dictionary of 20th-century design / John Pile.—1st Da Capo Press ed.
 p. cm.
 Originally published: New York: Facts on File, 1990.
 Includes bibliographical references and index.
 ISBN 0-306-80569-3
 1. Design—History—20th century—Dictionaries. I. Title.
NK1390.P53 1994 93-39780
745.4′442′03—dc20 CIP

First Da Capo Press edition 1994

This Da Capo Press paperback edition of the *Dictionary of 20th-Century Design*
is an unabridged republication of the edition first published in New York in 1990.
It is hereby reprinted by arrangement with Facts On File.

Published by Da Capo Press, Inc.
A Subsidiary of Plenum Publishing Corporation
233 Spring Street, New York, N.Y. 10013

Manufactured in the United States of America

CONTENTS

INTRODUCTION

Within the portion of the 20th century that is now history, design has emerged as a field of human activity with its own identity. The fine arts, including architecture, have a long history, stretching back to the beginnings of civilization. Although the making of useful artifacts has gone on for an equally long time, such work has in the past been viewed as craft—work done according to custom or practical necessity—certainly not as the work of specialized professionals. The 19th century turned the scientific discoveries of the Renaissance to practical, technological use, bringing about the Industrial Revolution and probably the greatest change in human circumstances since the Stone Age. But how to give the resulting objects appropriate form remained, in the 19th century, an unsolved puzzle. The revivals of past styles, such as Greek or Gothic, as well as the riotous variety of the Victorian age, evaded the issue, and the term "applied art" is all too accurate in describing the results. Only around the turn of the century did the question of what design should be in a technologically advanced world begin to be addressed.

This book attempts to collect into one volume, of manageable size, a cross section of information about the emergence of design as an important expression of modern realities. Questions at once arise about how "design" is defined, as the word is used in such varied contexts. There is design in engineering, design in fashion, design in architecture, stage design, graphic design, and design in the fine arts. To make a book of less than encyclopedic dimensions, it is necessary to narrow the definition of the word and decide what to include or exclude. For the purposes of this book, design is understood as the making of decisions that determine the *form*—the shape, size, color, texture, and pattern—of any object whose primary reason for existence is functional. Form as an aspect of the fine arts, in particular of painting and sculpture, is not the subject here. Although architecture, usually classified as a fine art, is primarily concerned with the design of buildings for some specific use, this book is not a dictionary of architecture. The field has its own extensive literature, and its inclusion would overwhelm the space available here. Nevertheless, architects have been a major force in developing modern design ideas and have often designed nonarchitectural objects. To that extent, people and topics from the field of architecture appear here.

Similarly engineering, inventions, and the crafts (pottery, weaving, wood and metal working, among others) are represented here only to the extent that they affect fields of product, industrial, graphic, interior, exhibition, typographic, and advertising design. Fashion design, also a field with its own considerable literature, styles, and terminology, is limited here to the impact of fashion designers on the wider range of design activities. Because of their influence on design, the fine arts and photography have been given some attention also. Although they certainly encompass design issues, the fields of town, urban, and regional planning and landscape architecture have been viewed as too specialized for inclusion.

Decisions about specific entries and the depth of coverage have been made on the basis of the importance, relevance, and influence of topics and personalities. Although the focus is 20th-century design, a few developments and personalities from the 19th century are included because of their impact on this century's design. William Morris and the Arts and Crafts movement and Art Nouveau, for example, are so much a part of the Modern movement that exclusion on the basis of dates seems wrong. Topics have been chosen from such categories as:

- Styles, periods, and movements
- Designers and design firms
- Critics, writers, and educators
- Museums, design schools, and organizations
- Designed objects of special design interest ("classics")
- Manufacturers, dealers, and shops with special design orientation
- Technical terms particular to design

- Materials and manufacturing techniques of special importance in 20th-century design
- Magazines and journals with a design focus

Decisions about what to include are at times somewhat arbitrary, and each reader will probably question the value of some entries and wish for others that are absent.

The sources for the information included are widely various, and an effort has been made to cross-check references to verify dates, spellings, and facts. Any reference book of this kind depends on secondary sources of information with only occasional data collection from primary sources through conversation or correspondence. Much information comes from design histories, museum publications, periodical articles, and such general references as biographical indexes and encyclopedias. The bibliography lists the most used sources, but many hundreds of other references have contributed bits of data. Some information, however, was difficult to obtain or check and can only be described as "best available." Who actually designed an object credited to a large design firm? Is the date of an object the time when it was conceived, first manufactured, or first sold? Who should be credited with being first with certain ideas that have surfaced in several different contexts? Although every effort has been made to be accurate, corrections and additional data will be welcomed in an effort to make future editions more complete.

In addition to serving as a source for specific information that may be otherwise difficult to locate, like all dictionaries, this one can provide something closer to entertainment. The user who has located a wanted fact may choose to read onward or, opening the book at random, may enjoy noting the sequence of information arranged according to the orderly but arbitrary rules of alphabetical sequence. To learn about Anchor blocks, Arabia china, Samuel Bing's shop, the buildings of Paul Cret, the great DO-X airplane, and so forward through the alphabet may seem a pursuit of trivia, but it can also be a way of meeting new and interesting events, objects, and people. It is the goal of this dictionary to be in equal degrees both useful and enjoyable.

A&E DESIGN

Swedish firm that has concentrated on design, often experimental in character, of products for use by disabled and handicapped people. Brushes and sanitary equipment are among the products developed having innovative forms. The firm was founded in 1968 by Tom Ahlstrom and Hans Erlich, both graduates of the Swedish Konstfackskolan.

AALTO, ALVAR (1898–1976)

Finnish architect and designer now widely regarded as one of the most important figures of the Modern movement. Born in Kuortane, Finland, Aalto graduated from the Helsinki Polytechnic in 1921. He studied there with Armas Lindgren, a leading figure of the romantic Scandinavian revival of the early part of the century. He established his own practice in 1923 and married Aino Marsio in 1925, working with her as a design partner from time to time thereafter. His early work mixed romantic revival and classical elements as in his Workers' Club (and theater) of 1924 in Jyvaskyla where the ground floor is surrounded externally by a portico of Neo-Greek doric columns.

His building of 1928 in Turku for the Turun Sanomat newspaper is a clear example of IN-TERNATIONAL STYLE modernism. The Paimio Sanatorium of 1930–33 and the Viipuri City Library of 1935 commissions won in architec-

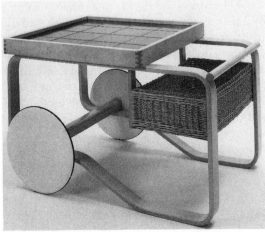

Tea cart using molded plywood for the side frames. An Alvar Aalto design of 1936. Photo courtesy of International Contract Furnishings, Inc.

tural competitions are the major masterpieces that established Aalto's international reputation. As part of the Paimio project, Aalto developed a range of modern furniture similar in concept to such BAUHAUS designs as those of Marcel BREUER. However, Aalto's designs were produced in laminated birch MOLDED PLYWOOD rather than in the metal tubing typical of Bauhaus design. Through a relationship with Otto Korhonen, a Finnish furniture manufacturer, Aalto's designs were put into quantity production. Aalto established the firm of ARTEK in 1935 to distribute his furniture and other, related designs with financial help from Maire Gullichsen, wife of a successful Finnish industrialist for whom he also designed a famous modern house, Villa Mairea of 1938. Artek continues to offer most of Aalto's designs at the present time.

Awareness of Aalto's work in America was furthered by his design for the Finnish Pavilion at the New York WORLD'S FAIR of 1938–39. The small exhibit, actually only an interior within a larger structure, became a major critical success in the design professions in the United States at the time. From 1946–48 Aalto held a professorship at MIT in Cambridge. During this period he designed Baker Hall, an MIT dormitory building, his only major architectural work in the United States. Many major works in Finland and in other European countries include the House of Culture in Helsinki (1955–58), the Vuoksenniska Church at Imatra of 1956–58, buildings at Seinajoki (1953–67), and a Cultural Center at Wolfsburg, Germany (1958–63). His designs for the campus and many of the buildings of the Finnish Technical Institute at Otaniemi (1949–64) where he was a teacher are among his most distinguished works.

The design-oriented public knows Aalto best for the products that remain in current production: the furniture of Artek and the glass vases and tray produced by IITTALA and offered for sale at the MUSEUM OF MODERN ART in New York, as is his elegant wheeled tea cart. Most of his buildings included light fixtures, hardware, and other detail elements of comparable quality, unfortunately not visible or available to the general public.

Among what is often called the "first generation" of modern architects and designers in Europe (Walter GROPIUS, LE CORBUSIER, Ludwig MIES VAN DER ROHE, and others of their era), Aalto is distinguished by his ability to balance the austerity and mechanistic quality typical of

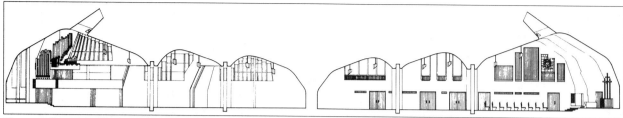

Cross-section of the Vuoksenniska Church (1956-58) at Imatra, Finland, designed by Alvar Aalto.

International Style work with a more poetic and humane sensibility that makes his work at the same time admirable *and* likable. The often-heard accusation that modern design is "cold" does not apply to the designs of Aalto.

AARNIO, EERO (b. 1932)

Finnish interior and industrial designer trained in Helsinki at the Institute of Industrial Arts. Aarnio's best known designs are for chairs using plastics as the primary material. His Ball or Globe chair of 1960 is a sphere, open on one side to permit the occupant to move into its upholstered interior. The Gyro chair of 1968 is a round, hollowed-out form of FIBERGLASS in which the seating space is a simple hollow in what appears to be a solid, flattened spherical mass.

ABBOTT, BERENICE (b. 1898)

American photographer known for a design-oriented, documentary approach. Abbott went to Paris in 1921 as an art student and, while there, became an assistant to the avant-garde photographer Man RAY. In 1925 she set up practice as a professional portrait photographer. Also during that year, she met French photographer Eugène Atget (1857–1927), then an elderly and little-known commercial photographer who had, over a lifetime, documented Paris with a huge collection of photos. Abbott acquired his negatives, eventually arranging to have them sold to the MUSEUM OF MODERN ART in New York. After returning to New York in 1929, Abbott turned to documentary photography, taking on the 1935 WPA photo project known as "Changing New York." Later she worked in scientific photography and on a documentary project "U.S. Route 1." The direct and unsentimental character of her images gave them a design-oriented quality of a kind that came to typify "modern photography." She taught at the New School in New York beginning in 1934 and continuing until 1958. She was the author of several technical photography books. Her *A Portrait of Maine* of 1968 is a photo documentation of the Maine region where she has lived since 1964, continuing active work. *Berenice Abbott: American Photographer* by Hank O'Neal (1982) is a fine survey of her work.

ABSTRACTA

System for constructing demountable metal cage structures suitable for display and exhibition constructions and other uses, including some furniture types and storage units. The system was designed by Danish designer Poul CADOVIUS in 1960. Linear elements are sections of tubing cut to module length dimensions. The connectors are starlike castings made up of a ball with two to six projecting cones placed at right angles that fit into the ends of the tubes. Abstracta structures are easy to assemble, take apart, and reuse and are very simple and elegant in appearance. The system is widely used in a great variety of display and other commercial applications.

ACTION OFFICE

Office furniture system developed by Robert PROPST for the American furniture firm HERMAN MILLER. Propst was employed by Herman Miller in 1958 as a researcher. His studies of office work practices and habits led to proposals for a new approach to office furniture that would use modular work surfaces and storage units to replace conventional desks and credenzas. He proposed a stand-up work top (for use by a standing person), display shelves, and file units that could be wall-hung or built on stands. The Action Office I group was introduced in 1964, with appearance details credited to the office of George NELSON and Company. By coincidence, this was at the time when OFFICE LANDSCAPE concepts developed in West Germany by the QUICKBORNER TEAM were being taken up by American office planners. Propst grasped the possible relationship of these two ideas and redesigned the Action Office system to make use of movable panels as primary supports for work surfaces and storage units. This produced Action Office II (1968). At a time when no other furniture suitable for "open plan" (landscape) offices was available

in the United States, Action Office II became an immense success. It was widely imitated by other manufacturers, so that the concept has become a standard alternative to conventional desks in modern office planning. Revised and expanded over the years, the system remains in production and in wide use.

ADAMS, ANSEL (1902–1984)

American photographer known for his documentation of the nature and scenic beauty of the American Far West. Adams was born in San Francisco and took up photography in the Yosemite area in 1916. His super-sharp, superbly detailed photographs of western landscapes

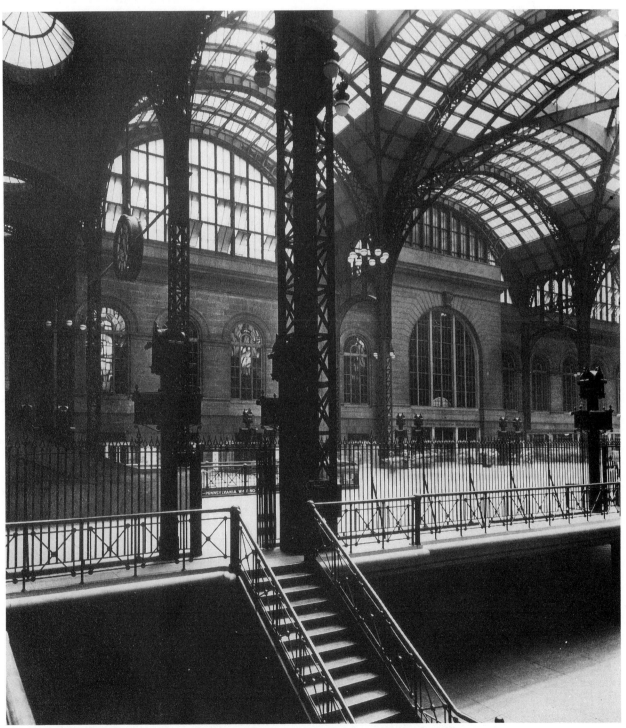

Berenice Abbott photograph of the interior of New York's Pennsylvania Railroad Station (now demolished).
Photo courtesy of the Museum of the City of New York.

made with a large camera with a lens stopped down to a minimum diaphragm opening led to his becoming known as a key figure in the "*f*/64" school of photography. In 1928 he became the official photographer of the Sierra Club, an organization that he continued to support in its efforts for wilderness conservation. He was the recipient of a Guggenheim Fellowship in 1948. His work has been frequently exhibited and widely published. His technical books advocating his "zone system" of exposure and print control have made his methodology accessible and much studied.

ADAPTIVE REUSE
Popular term for architectural and interior design projects relating to historic PRESERVATION and RESTORATION. Since the 1960s, architects, designers and developers have become concerned with finding new uses for buildings of historic and/or aesthetic merit that have become functionally obsolete (abandoned railroad stations, for example). They make conversions to preserve whatever may be of value in the building while making it useful and, in many situations, also economically productive. The reconstruction of New York's Jefferson Market Courthouse as a library, of Boston's Faneuil Hall/Quincy Market as a shopping area, and loft buildings in many cities as residential properties are prime examples of adaptive reuse.

AD HOC
In interior design and architecture, designs that use "found" materials or materials at hand or near the construction site. The term *ad hoc* has the general meaning of "for a particular place or purpose," which has come to mean "picked up casually." A wave of ad hoc design has been part of the experimental efforts that seek directions outside of or beyond the aesthetic of MODERNISM. Houses built of driftwood, recycled cans or bottles, or combinations of such materials and interiors furnished with used cable reels, barrels and kegs, hammocks, and similar items are typical examples of the ad hoc direction in design.

ADIRONDACK STYLE
Rustic furniture style that takes its name from the Adirondack region of New York State. Lodges and camps there were often furnished with the simple, rough-hewn style furniture, which was even sometimes made from tree branches with the bark left on. The style retained some popularity from c. 1900 to World War II. Because it was admired by Gustav STICKLEY, the style has a rela-

tionship to the ARTS AND CRAFTS movement in the first half of the 20th century. There has been a recent revival of interest in restoring, preserving, and using surviving Adirondack-style pieces.

AEG (ALLGEMEINE ELEKTRIZITÄTS-GESELLSCHAFT)
Giant German manufacturer of electrical products, founded in 1883 by Emil Rathenau. It became a significant force in the design world through its patronage of the designer and architect Peter BEHRENS in the early 20th century. Behrens designed the AEG trademark, such products as electric fans and lighting fixtures, and many brochures and other graphic materials. The AEG turbine factory he designed in Berlin is an important, pioneering work of modern architecture. AEG has continued to show a concern for design excellence and manufactures many electrical products of fine design quality.

AERODYNAMIC STYLING
Design using forms derived from the science of aerodynamics, which developed in connection with aviation and is concerned with the study of the movement of solid bodies through the air. In the 1920s and 1930s it became known that certain shapes, such as the bullet-shaped front and tapering rear typical of large dirigibles, were maximally efficient for aircraft. Such forms came to be called streamlined and were associated with concepts of MODERNISM, speed, and progress. Aerodynamic forms were adopted by industrial designers for locomotives, automobiles and eventually for such illogical applications as pencil sharpeners and toasters. In recent years, a more serious interest in aerodynamics has developed in automotive design in an effort to improve fuel efficiency. Minimizing air resistance has led to many recent designs characterized by flowing shapes and smooth surfaces.

AESTHETIC MOVEMENT
Loosely related group of developments in British art, architecture, design, and taste in the second half of the 19th century. The aesthetic movement had no formal organization or leadership, but involved many ideas and many people who wished to move away from the rigidities of early Victorianism toward a freer view of art and design that, in retrospect, was destined to lead into the MODERNISM of the 20th century. The aesthetic movement included the ARTS AND CRAFTS movement, led by William MORRIS and his followers; the architectural style of Norman Shaw and E.W. Godwin, which

came to be called "Queen Anne"; the work of the Prè-Raphaelite painters, including Holman Hunt and Edward Burne-Jones; and the influence of nature forms and of Japanese art as in the work of James Abbott McNeill Whistler and Aubrey Beardsley, with Oscar Wilde representing the movement in literature and poetry. The LIBERTY shop in London grew and prospered as a prime marketplace for textiles and objects in the fashion of the movement's leaders. While based in England, the aesthetic movement exerted influence on contemporary and later developments in the art and design of continental Europe, leading into ART NOUVEAU and Vienna SECESSION, and in America it inspired the work of Louis Comfort TIFFANY, Gustav STICKLEY, and the Craftsman movement. The ever-popular Gilbert and Sullivan operetta *Patience* draws its humor from a satiric treatment of the extremes affected by some of the movement's exponents.

AESTHETICS

Branch of philosophy dealing with theories of beauty and artistic issues of merit and taste; in design fields, term used to describe the aspects of design that are not primarily utilitarian. Design theory commonly views design as dealing with three only loosely related issues: function, meaning utilitarian purpose; structure and materials; and aesthetics—concern with the aspects of a design that appeal to the senses, making an object attractive or beautiful. Since there is, in practice, little agreement as to what is beautiful, with standards subject to change with the passage of time, in differing cultures, and with changes in taste, discussion of aesthetic values involves constant debate. In MODERN design, some theorists, known as FUNCTIONALISTS, have advanced the view that aesthetic success is automatic whenever functional success is achieved. Other views seek absolute values based on the study of scale, proportion, balance, harmony, and similar basic concepts. Mathematical studies of proportion and harmony refer to such relationships as the GOLDEN SECTION, known and used in much historic and primitive art and design and discovered in many forms of nature. The MODULOR system developed and used by LE CORBUSIER is a modern approach to design aesthetics based on Golden Section proportions.

AFFRIME, MARVIN B. (b. 1925)

Founder and president of SPACE DESIGN GROUP, a leading New York interior design and office

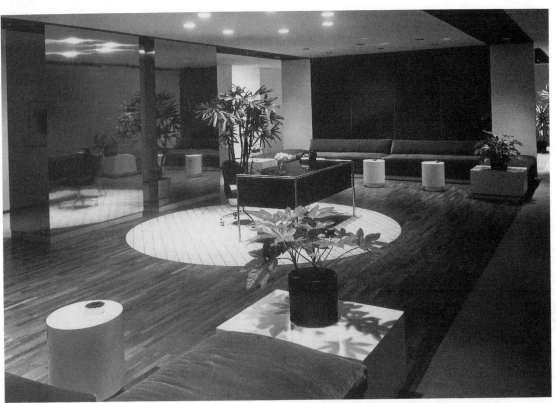

Reception area in the offices of the Benton & Bowles advertising agency in New York designed by Marvin Affrime's firm, Space Design Group. Photo courtesy of Space Design Group.

planning firm. Marvin Affrime was trained as an architect at the University of Illinois. In 1958 the firm was founded with Frank Failla as vice-president and chief designer. The firm has been responsible for many large planning projects such as the office facilities for Benton & Bowles in New York, the corporate headquarters of Johns-Manville Corporation, Denver, Colorado, and the New York office of International Paper Corporation. The firm's work is typically colorful, opulent, and active while adhering to the functional goals of MODERNISM.

AHLSTROM, TOM
See A&E DESIGN.

AHRÉN, UNO (1897–1977)
A Swedish architect and designer who was a pioneer in introducing the concepts of MODERNISM into Sweden in the 1920s. Ahrén collaborated with Sven MARKELIUS and E. Gunnar ASPLUND in buildings for the Stockholm exhibition of 1930 and was the designer of a Ford factory of 1929 and a 1930 cinema in Stockholm that were among the first major MODERN works in Sweden. Ahrén exerted a significant influence on the development of the style known as Swedish Modern.

AIRFLOW CHRYSLER
Chrysler and De Soto 1934 automobiles developed by Carl BREER with curving, streamlined forms derived from aerodynamics. Their appearance was so startlingly unlike that of other, more boxlike automotive products that public acceptance was very poor. The Airflow Chrysler has come to be considered a classic case of a consumer design ahead of its time, although later admired for being inventive and advanced.

AIRSTREAM
Brand name of the travel trailers manufactured by the firm of the same name founded by Wally Byam, an advertising executive and publisher. Byam built a trailer for his own use as a hobby in 1934. He used ALUMINUM for a streamlined unit based on aircraft technology. Its light weight and lowered air resistance were highly functional, but its striking shape and gleaming exterior finish made the Airstream trailer handsome in contrast with most competitors. Over the years since its mid-1930s introduction, various improvements and varied designs have been introduced by Airstream, but all Airstreams retain an elegantly streamlined, functional form and aluminum exterior finish,

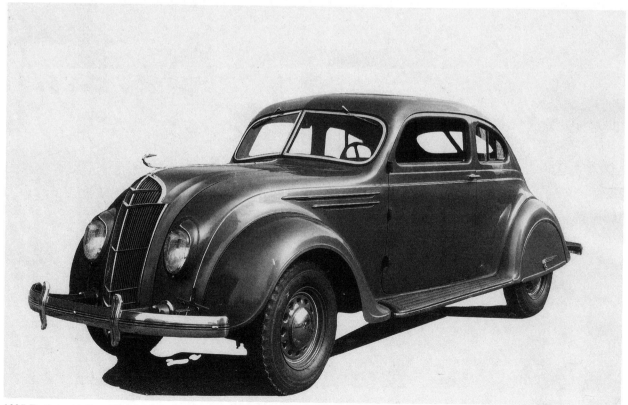

1935 De Soto Airflow Model SG. Photo courtesy of Chrysler Corporation.

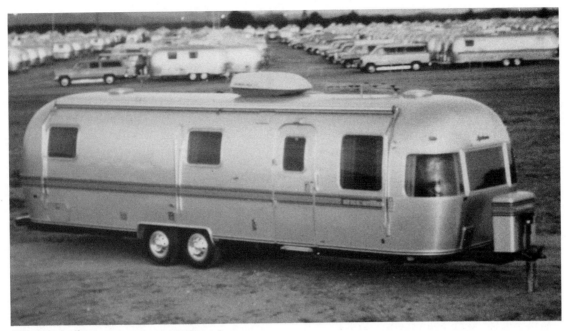

Airstream trailer. Photo courtesy of Airstream, Inc.

making them readily recognizable. Of top quality and price, Airstream trailers are greatly admired by trailer-travel enthusiasts. Airstream owners take great pride in their rolling homes and form a kind of cult represented by the Wally Byam Caravan Club, which holds regular gatherings to which members bring their Airstreams in huge numbers. The popularity of this excellent, functional design, retained consistently over many years, is a striking example of the possibilities for commercial success of a product largely untouched by superficial STYLING.

AKARI LAMP

Simple lanternlike lamp designed by sculptor Isamu NOGUCHI in 1952. The design is a sphere of mulberry bark paper held by a frame of wire rings. The unit folds flat and opens up into a globe when pulled from top and bottom. An ordinary light bulb is the source of illumination. The Akari lamp strongly suggests traditional Japanese lanterns, but is also highly suitable to austere, modern interiors.

ALBERS, ANNI (b. 1899)

German designer whose special interests were weaving and textile design, fields in which she was a leader in the development of a MODERN, fully abstract approach. Born in Berlin, in 1922 Albers became a student at the BAUHAUS, where she met and married Josef ALBERS. She taught with her husband at Black Mountain College in North Carolina until 1949 when she moved to New Haven. Her work as a weaver is widely respected, and she has taught and lectured in many universities in the U.S., Europe, and Japan. Her books, *On Designing* (1959) and *On Weaving* (1965), are definitive works in their area.

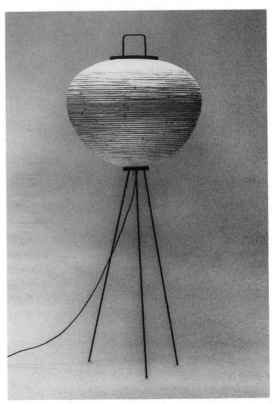

Akari lamp designed by Isamu Noguchi. Photo courtesy of the Isamu Noguchi Garden Museum.

ALBERS, JOSEF (1888–1976)

Widely known as a teacher and an artist. From 1913–20 he studied at art schools in Berlin, Essen, and Munich. He entered the BAUHAUS as a student in 1920, becoming a teacher there in 1923 and a master in 1925. He married weaver and textile designer Anni ALBERS. He was particularly concerned with the preliminary course (on which the current foundation courses in many design schools are based) and with the furniture workshop. With the closing of the Bauhaus in 1933, Albers was appointed to a teaching post at Black Mountain College in North Carolina where he remained until 1949. In 1950 he became a professor and chairman of the design department at Yale where his teaching of COLOR theory was closely related to his work as an artist. His paintings and prints collectively entitled *Homage to the Square* are closely related to his color theory as set forth in the text and set of color plates titled *Interaction of Color*, produced in a small (and costly) edition. A compact book version of this work with a small selection of color illustrations is regarded as an outstanding text in the field. His paintings are owned by many major museums and commissioned works appear in a number of architectural settings.

ALBINI, FRANCO (1905–1977)

Italian designer and architect, best known for innovative furniture design that was part of the widely admired MODERN work of post–World War II Italy. Albini was born near Como and graduated from Milan Polytechnic in 1929, where he also taught from 1963–75. He designed LA RINASCENTE department store in Rome in 1957. His chairs with sculptural wood legs, his glass-topped desk and related armchair with slim steel frames (distributed in the U.S. by KNOLL in the early 1940s), and his tension-wire suspended shelving are among the projects for which he was best known.

ALBINSON, DON (b. 1915)

Furniture designer trained in Sweden and at CRANBROOK ACADEMY and Yale. Albinson was associated with Charles EAMES for a number of years and played an important part in the development of several of Eames's furniture designs. He was design director of KNOLL INTERNATIONAL from 1964–71. His stacking chair of 1964, a FIBERGLASS shell supported on a leg base of cast aluminum, was his most significant work there. Since leaving Knoll, he has worked as an independent designer of office seating and systems furniture for Westinghouse.

ALCHYMIA

See STUDIO ALCHYMIA.

ALDEN, JOHN G. (1884–1962)

American designer of yachts and other craft, particularly known for his schooners based on traditional New England fishing boats. John Alden was a largely self-taught naval architect, although he worked for eight years for the firm of B.B. Crowninshield, a Boston specialist in Gloucester fishing schooners. After World War I he established himself as a designer of yachts as well as a dealer and marine insurance broker. By the time of his retirement in 1955, Alden had designed some 900 yachts, many of them ocean-racing schooners, ketches, or yawls. Beginning in 1921, he built himself a sequence of 13 yachts, all named *Malabar. Malabar XIII*, the last of the series, was built in 1945. All were used for cruising as well as sailing, and all were outstanding for their seaworthiness as well as speed. Alden was also the designer of many successful motor yachts, motor sailers, and small racing craft, such as the popular Q-class "one-design" racer. Alden designs are still widely admired as representing an ideal balance between speed and practicality in small sailing vessels.

ALEXANDER, CHRISTOPHER (b. 1936)

British architect best known as a teacher, writer, and theorist. He studied mathematics at Cambridge University and architecture at Harvard. His brief but difficult book *Notes on the Synthesis of Form* (1964) outlines a systematic approach to design, making the design process subject to methods with some of the precision associated with mathematical and scientific thinking. Alexander's approach uses diagrams and charts developed from graph theory in modern mathematics. All design problems are broken down into simple elements through a process of decomposition so that they can then be solved through an orderly synthesis. The approach has strong appeal to those interested in DESIGN METHOD and in the application of computer techniques to design.

Alexander has since had several opportunities to apply his approach to actual problems, including town planning studies for a new town in India. On the basis of experience, he has

backed away from his theories to some extent and now regards them as preliminary explorations rather than as realized techniques for immediate application. Since 1963 he has been a faculty member at the University of California in Berkeley. In 1967 he established his own design firm, the Center for Environmental Structure. Since 1983 his design work has turned toward a simple VERNACULAR vocabulary. His designs for the New Eishin University near Tokyo suggest a village of small gabled houses. He has also developed office furniture designs with the traditional feeling of simple kitchen furniture.

ALLEN, DAVIS (b. 1916)
American interior designer of major influential projects in the 1950s and 1960s. A graduate of Yale's architectural school, Allen worked with Florence KNOLL and with several other firms before joining SKIDMORE, OWINGS & MERRILL in 1950. There he became head of the interior design department where he was responsible for the interiors of many major projects including the Pepsi-Cola Corporate Headquarters building in New York (1960), the Crown Zellerbach building in San Francisco (1957–59), and the Upjohn Company building in Kalamazoo, Michigan (1959–61). The interiors follow the generally geometric character of the architecture, with a strong recall of the work of Ludwig MIES VAN DER ROHE. He was responsible for many furniture projects designed at SOM and is identified with an office furniture group, the Davis Allen Collection, produced by GF Business Equipment.

ALLGEMEINE ELEKTRIZITÄTS-GESELLSCHAFT
See AEG.

ALUMINUM
Lightweight, silvery metal refined from bauxite ore, a naturally occurring mineral. Because aluminum is lighter than STEEL of comparable strength, it came to be used in the construction of aircraft. It is also nonrusting (although it develops a surface oxide) and so is widely used for kitchen cookwear, household utensils, and decorative objects. Because of its recent availability and its association with aviation, it came to be associated with MODERNISM in the 1920s and 1930s. A favorite material for furniture, it is used in sheet, tube, and structural shapes (such as Is, Ts, and angles), in castings, and EXTRUDED in many specialized shapes.

The natural silvery surface of polished aluminum develops a gray coating of corrosion unless treated by *anodizing*, a process similar to electroplating, which protects the surface while leaving its natural metallic color. Anodizing can also be done with color. Various paints and coatings are also suitable for finishing aluminum. The cast aluminum bases of many Charles EAMES tables and chairs and the extruded aluminum parts of furniture by Gae AULENTI, Andrew MORRISON, and Bruce HANNAH are typical modern applications of this metal.

AMBASZ, EMILIO (b. 1943)
Argentinian designer. Trained as an architect at Princeton, Ambasz was curator of architecture and design at the MUSEUM OF MODERN ART in New York from 1970 to 1976, where he directed the exhibition *Italy: The New Domestic Landscape* in 1973. Since 1976 Ambasz has been in independent practice as an architect, and an interior and industrial designer. His best-known work is the Vertabra chair of 1979 manufactured in Italy by Castelli, an ERGONOMIC design that received a COMPASSO D'ORO award in 1981.

AMERICAN INSTITUTE OF ARCHITECTS (AIA)
Primary American professional organization of architects, devoted to establishing professional ethical and practice standards and representing architecture to legislative bodies and to the general public. The organization was founded in 1857 by the New York architect Richard Upjohn and a number of his peers. There are now chapters of the American Institute of Architects (AIA) in many American states and cities, a major headquarters in the institute's own building in Washington, D.C., and a membership of over 50,000. The AIA publishes standard documents (forms of contract), informational books and other publications, and a monthly magazine, the *AIA Journal*, renamed *Architecture* in 1983. The organization holds an annual convention, sponsors various honors and awards, and maintains a relationship with the colleges and universities offering architectural education and with the governmental agencies that register architects as licensed professionals.

AMERICAN INSTITUTE OF GRAPHIC ARTS (AIGA)
American organization of graphic designers founded in 1914 to encourage excellence in

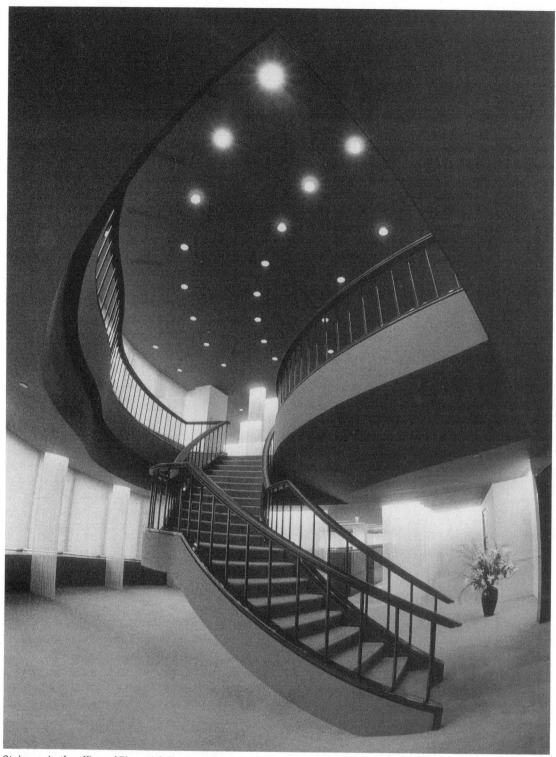

Stairway in the offices of Financial Guaranty Insurance Company designed by Emilio Ambasz & Associates, Inc.
Photo courtesy of Emilio Ambasz & Associates, Inc.

graphic design through public relations efforts such as exhibitions, publications, and competitions. Membership includes designers in independent and in corporate roles working in advertising, in book and magazine design, and in film, television, and exhibit design in which graphics play a major role. Local chapters of the American Institute of Graphic Arts (AIGA) encourage communication among designers in a particular geographical area, while the national

organization represents the profession in governmental relationships and encourages superior education for graphic designers. An annual book show was begun in 1920, and the Institute's Gold Medal for outstanding achievement has been awarded annually for 65 years. *Graphic Design USA* is an annual publication documenting the superior work included in annual AIGA exhibits, and the *AIGA Journal* is a quarterly publication dealing with graphic design issues.

AMERICAN SOCIETY OF INTERIOR DESIGNERS (ASID)

American professional organization representing interior designers' interests and maintaining standards of ethics and professional practice. The American Society of Interior Designers (ASID) was founded in 1975 with the merger of the American Institute of Interior Designers (AID) and the National Society of Interior Designers (NSID). The AID was founded in 1931 as the American Institute of Decorators with 342 members. The NSID was founded in 1957 as a result of the then-developing conflict between the concept of the decorator and the designer, a conflict now largely resolved. The present organization has more than 28,000 members in 48 local chapters. Activities include encouragement of superior education for the field, establishment of business and professional standards, publicity, and concern with such legal issues as continuing efforts to gain licensed status for qualified interior designers. The ASID was influential in launching the Foundation for Interior Design Education Research (FIDER), the Interior Design Educators Council (IDEC), and the National Council for Interior Design Qualification (NCIDQ), which certifies individuals who successfully pass a qualifying examination demonstrating competence in the field. The ASID also represents American interior designers in relation to the International Federation of Interior Designers/Interior Architects (IFI), the primary international organization representing the profession.

AMMANN, OTHMAR H. (1875–1965)

Distinguished Swiss-born American structural engineer and designer of many major bridges. Othmar Ammann received his training in engineering at the Swiss Federal Polytechnical Institute before moving to the United States in 1904. Ammann designed the steel arch Bay-onne Bridge over the Kill van Kull, connecting New Jersey and Staten Island with a span of 1,675 feet, with partner Allston Dana in 1927. As chief engineer for the Port of New York Authority, Ammann was in charge of the design of the George Washington Bridge (1931), the Goethals Bridge and Outerbridge Crossing (1928), the Triborough (1936), and the Bronx-Whitestone Bridge (1939). He was a consultant for the design of the Golden Gate Bridge in San Francisco (1937). As a partner in the firm of Ammann and Whitney, he was responsible for the design of the Throgs Neck (1961) and Verrazano-Narrows (1964) suspension bridges as well as many other structures, including several very wide-span airplane hangars.

AN AMERICAN PLACE

See STIEGLITZ, ALFRED.

ANCHOR BLOCKS

German system of building blocks, a construction toy for children popular in the 19th and early 20th century, particularly in Europe. The system was developed and produced beginning in 1879 by Dr. F. Ad. Richter in Rudolstadt, Germany. The concept was based on the FROEBEL block system, which Frank Lloyd WRIGHT regarded as an important influence on his design thinking. However, anchor blocks were made of an artificial "stone" so that they were heavy and precise in form, permitting large, complicated structures. All blocks were based on a modular cube, about one inch on a side, so they could be divided into smaller units (down to quarter-inch dimensions) and multiplied into larger dimensions up to about five inches. Cylindrical, triangular, pyramidal, and arch-shaped blocks were included in three colors: brick red, cream, and slate blue. The blocks were sold in sets packed in neat wooden boxes. The smallest set for beginners came with a book of simple designs for "buildings" suitable for young children. Larger and more complex sets could be added as supplements, each with a book of plans for more elaborate structures, progressing to very complex constructions demanding adult-level abilities in plan reading and muscular coordination. Many imitations were produced in wood and "stone," and such building sets were very popular toys for many years. Just after World War I, when anything German was shunned in the United States, Richter established a New York branch and produced his system under the name Union

Design from the plan book provided with a set of Anchor blocks, c. 1910.

Blocks. It is interesting to note that Anchor blocks were used by Charles and Ray EAMES as props for some of their films and as backgrounds for some advertising designs. Sets of Anchor blocks in good condition are now rare and have become collectors' items.

ANDERSEN, GUNNAR AAGAARD (1919–1982)

Danish designer of an extraordinary chair now in the design collection of the MUSEUM OF MODERN ART in New York. The armchair of roughly cubical form is executed in urethane plastic foam loosely shaped in what seems to be an oozing mass of dripping material coated with a brown, leatherlike plastic surface. The design is highly controversial, striking some viewers as disgusting, while others find it fascinating, humorous, or both. It was executed by Andersen at Dansk Polyether Industri in Denmark.

ANTHROPOMETRICS

The systematic study of the dimensions of the human body, including body size and body parts, and the range of normal body movements such as arm and leg reach. Since the study is based on measurements of large numbers of people, it is possible to arrive at averages and, through statistical techniques, at percentile values indicating the proportion of a population that will depart from average to a specific degree. Statistics can be broken down by sex, age, and nationality. Designers make use of anthropometric data in arriving at suitable dimensions for such products as chairs and tools and for elements of control levers and panels. The field of ERGONOMICS is strongly based on anthropometric data.

Industrial designer Henry DREYFUSS took an unusual interest in anthropometrics in his work and wrote *The Measure of Man* (1967), a portfolio of anthropometric data. Since his death, several of his associates have continued his studies in booklets and charts entitled *Humanscale 1/2/3, 4/5/6,* and *7/8/9,* which are the most complete references in the field.

APPLE COMPUTER

Computer manufacturing firm based in Cupertino, California, founded by Steven Jobs, a computer expert who successfully challenged such major manufacturers as IBM with a product line not compatible with other manufacturers' systems. Apple computers have been of distinguished design, developed by the German-American industrial design firm FROGDESIGN. The very successful Apple IIC, the Macintosh, and Apple IIGS units are examples of the compactness and neat detailing typical of Apple products. The Apple IIC of 1984 was one of the products included in the WHITNEY MUSEUM OF AMERICAN ART *High Styles* exhibition in 1985 in New York.

ARABIA

Finnish manufacturer of pottery and ceramics founded in 1874 that developed a reputation in

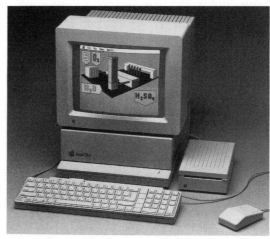

Apple IIGS™ personal computer. Photo courtesy of Apple Computer, Inc.

the 1930s as a producer of simple designs of modern character. In 1946, Kaj FRANCK was placed in charge of design. Under his direction, may fine table service patterns were developed such as simple Kilta ware, Teema, and Ruska, the last commissioned from Ulla PROCOPÉ. Franck retired in 1978, but the firm continues to produce ceramics of fine design quality.

ARCHER, COLIN (1832–1921)

Norwegian (born of British parents) designer of sailing craft whose work has had a major impact on the design of modern yachts. With no formal training in naval architecture, Archer relied on first-hand experience observing boat building and sailing near his birthplace and home at Tolderodden, Norway. He concentrated on the design of fishing and pilot boats that offered improved safety and performance as compared with traditional types then in use. The reputation of Archer designs eventually spread, and he received commissions to design sailing yachts, most often of the double-ended hull type for which he was particularly known. The work of American designers John ALDEN and William Atkin included many designs based on Archer precedents. There has been a modern revival of interest in Archer designs in Norway and Sweden, and a Colin Archer Club has been organized to encourage the building of modern yachts in designs based on his practices. The designs of Paul Johnson, a Bermuda-based designer and sailor, are related to the concepts of Archer's double-enders.

ARCHIGRAM

Architectural group formed in England in 1961, including Warren Chalk (b. 1927) and Peter Cook (b. 1936), that developed futuristic projects with an exaggerated technological focus suggestive of science fiction. Archigram's best-known project was Plug-in-City of 1965, a proposal for a fantastic megastructure in which prefabricated HIGH-TECH elements would be assembled to form a complete community.

ARCHITECTS COLLABORATIVE, THE

See THOMPSON, BENJAMIN.

ARCHIZOOM ASSOCIATI

Architectural design studio formed in Florence in 1966, the firm's designs and projects were characterized by an experimental, avant-garde, and often mischievous nature. The firm was founded by architects Andrea Branzi (b. 1938),

Gilberto Corretti (b. 1940), and Massimo Morozzi (b. 1941), and industrial designers Dario and Lucia Bartolini (b. 1943 and 1944). The group dissolved in 1974, but its influence can be traced in such subsequent developments as the work of the MEMPHIS design group.

ARENS, EGMONT (1888–1966)

American industrial and packaging designer whose work of the 1930s followed the streamlined direction typical of the most advanced work of the time. His book, *Consumer Engineering*, of 1932 (written with Roy Sheldon) was influential during the depression in promoting the idea that improved design could be a tool to increase product sales. Many of his package designs, such as the coffee bags for A&P food stores were once universally familiar. His Kitchen Aid mixer of *c.* 1946 is a typical example of his approach to product design.

ARMANI, GIORGIO (b. 1935)

Italian fashion designer, known for work that is characterized by a quality of casual elegance, a quality that has even been described as "over-serious." Armani's educational background included two years of medical school followed by military service. In the 1950s he took a job designing windows for LA RINASCENTE, moving there into buying, and then turning to fashion design. He was associated with La Rinascente until he established his own design studio in 1970, producing designs for various manufacturers. In 1975 he founded his own label. He now operates a chain of shops, designs leather wares for Mario Valentino, and has even designed uniforms for the Italian Air Force. His style depends heavily on the traditional detailing of men's clothing, adapting that vocabulary to jackets and skirts for women with a reserved, tailored dignity. He was the winner of a 1979 Neiman-Marcus Award.

ARNHEIM, RUDOLF (b. 1904)

Theorist, teacher, and writer in the field of Gestalt perception often called "experimental aesthetics." His 1954 book, *Art and Visual Perception*, deals with such concepts as BALANCE, FORM, light, COLOR, tension, and expression and their significance in architecture and design as well as in the fine arts of painting and sculpture.

ARP, JEAN (HANS) (1887–1966)

German-born artist whose abstract work in paintings, collage, and sculpture has exerted a strong influence on MODERN graphic, pattern, and product design. Arp studied art in Weimar and Paris and was then in touch with Paul KLEE, Wassily KANDINSKY, Pablo Picasso and Amedeo Modigliani, before striking out in his own direction in 1915. His work included collage arrangements of torn paper in strictly abstract patterns and relief sculptures in which flat wood cut-outs were superimposed in layers. The shapes were usually organically curved, sometimes suggesting human forms, sometimes the irregularity of microscopic amoebae. Arp has been sometimes classified as a member of the Zurich DADA movement, although his work is usually more strongly abstract than that might imply. Titles such as *Objects Arranged According to the Laws of Chance* (1930) suggest his acceptance of some degree of randomness in his arrangement of carefully crafted forms. His fully three-dimensional sculpture includes abstract, organically curving masses with polished surfaces, often similar to the work of Constantin BRANCUSI. Because of its abstract but elegant play with form, Arp's work seems close to graphic, architectural, and industrial design. Many of the favorite abstract forms of 20th-century design suggest Arp's influence.

ARSTROM, FOLKE (b. 1907)

Swedish designer of flatware and hollowware. After studying at the Royal Academy of Fine Arts in Stockholm, Arstrom opened his own design office in 1934 and took charge of design for the metal tableware firm of Gense in 1940. He is best known for simple stainless steel flatware patterns, Thebe and the very popular Focus of 1956.

ART CENTER COLLEGE OF DESIGN

Major American school of art and design located in Pasadena, California. Art Center College of Design was founded in 1930 by Edward A. ("Tink") Adams to offer training in graphic and industrial design in the Los Angeles area where no such programs were available at that time. The school has grown to an enrollment of some 1,200 students and has established a reputation as the leading school of automotive design in America, although that program serves only a small part of its total student body. The college now offers undergraduate and graduate degrees in advertising, film, fine arts, graphic and package design, illustration, industrial design, and photography. The school occupies a striking glass and steel building designed by the distinguished California architect Craig Ellwood in 1976.

The Art Center's influence on automobile design has been very strong, with many of its students moving into the industry in Detroit. While criticism has been leveled at Art Center graduates' emphasis on STYLING, it is probable that industry pressure is primarily to blame for that tendency. Art Center has trained many designers whose work for foreign manufacturers including CITROËN, Honda, Nissan, and Toyota, leads to a conclusion that many of the "rational" directions in foreign automobile design actually have an American origin. There is now a European-affiliated campus in a renovated and enlarged chateau near Vevey, Switzerland.

ART DECO

Popular decorative design style of the 1920s and 1930s. The name is taken from the Paris exhibitions of *Les Arts Décoratifs*, where such work was first exhibited.

The development of Art Deco was influenced by cubist painting, African and Native American art, and, most important, an appreciation of the polished, dynamic forms of modern machinery and streamlined aircraft. The style is characterized by stepped forms, rounded corners, triple-striped decorative elements, and the use of CHROMIUM and black trim. Important practitioners of the style have included Emile-Jacques RUHLMANN and Louis SÜE in France, and Donald DESKEY and Gilbert ROHDE in the United States.

From the beginning, Art Deco was fashion- and commercially oriented, in contrast to the more theoretical basis of the BAUHAUS and "serious" MODERNISM. Thus, it became a popular style for theaters, restaurants, hotels, ocean liners, and WORLD'S FAIR exhibits. The interior of RADIO CITY MUSIC HALL and the architecture and interiors of New York's CHRYSLER BUILDING are striking examples of Art Deco design.

In its time, Art Deco was dismissed by modernists as foolish. They denigrated the style as MODERNISTIC, putting a modern surface on things without any of modernism's depths. The terms MODERNE and Jazz Modern were also used to describe this work. In recent years,

however, Art Deco has become increasingly appreciated, and it is now seriously studied and collected.

ARTEK
Finnish firm founded in 1935 to distribute (and later produce) the furniture designs of Alvar AALTO. In the United States, an affiliated firm, Artek-Pascoe, maintained a shop in New York and offered Aalto designs for American distribution. (Pascoe eventually dropped the association with Artek.) The Finnish company maintains Aalto designs in current production for worldwide distribution.

ARTELUCE
Italian producer of MODERN lamps and lighting fixtures. Founded in Milan in the 1940s, Arteluce had Gino Sarfatti as its first designer. It has subsequently produced designs by Cini BOERI, Livio CASTIGLIONI, Gianfranco FRATTINI, and Vittorio Vigano, among other distinguished Italian designers.

ARTEMIDE
Milan manufacturer of MODERN Italian furniture and lighting fixtures. The firm was founded in 1951 by Ernesto Gismondi and is known for such products as the Selene chairs and lighting designs of Vico MAGISTRETTI; lighting by Gae AULENTI, Sergio Mazza, and Angelo MANGIAROTTI; and furniture by Emma Gismondi. The popular Tizio lamp of 1978 by Richard SAPPER is an Artemide product. The firm has also provided support to the recent MEMPHIS movement. It maintains a retail store in Milan.

ART NOUVEAU
Style developed in continental Europe during the last decades of the 19th century that forms a link with the MODERNISM of the early 20th century. The term (which means simply "new art") was the name of a Paris shop opened in 1895 by Samuel BING to market the innovative design work of such French designers as Eugène GAILLARD, Émile GALLÉ, Hector GUIMARD, and René LALIQUE. Victor HORTA and Henri VAN DE VELDE were leading exponents of the style in Belgium, while in Germany and the Scandinavian countries it became known as JUGENDSTIL (the "young style") and is represented by the work of August ENDELL in Germany and Lars Sonck (1870–1956), the architect of the Tampere cathedral, in Finland. As the

Shogun floor lamp designed by Mario Botta, an Artemide product. Photo by Aldo Ballo, courtesy of Artemide, Inc.

name implies, the style was an important development in the fine arts, but it found particularly strong expression in architecture, in interior design and the design of furniture and decorative objects, and in the graphic arts. Art Nouveau work is characterized by the abandonment of historicism, the close linkage of design and fine art, and the free use of orna-

mentation, generally based on forms of nature. The decorative ornament developed on this basis generally makes use of florid, flowing curves suggestive of plant forms, often using a whiplash S-curve, which is viewed as a uniquely Art Nouveau theme.

The stylistic designation "Art Nouveau" was at one time used to apply only to such designs in France and Belgium, but it has been extended in modern critical and historical discussion to include the work of Jugendstil designers and architects and such isolated practitioners as Charles Rennie MACKINTOSH in Scotland, Antonio GAUDÍ in Spain, and Louis Comfort TIFFANY in the United States. Even the work of Louis SULLIVAN, the American pioneer Modernist, can be related to Art Nouveau through the nature of his personal style of ornamentation. The work of the Vienna SECESSION is also often viewed as an aspect of Art Nouveau, although it is generally more reserved in its use of ornament and more inclined to rectilinear (as distinguished from curvilinear) forms. The Secessionist work of Josef OLBRICH and Josef HOFFMANN often seems to have a close affinity with contemporary Art Nouveau work in France and Belgium. Because the LIBERTY shop in London offered Art Nouveau imports and commissioned the design of objects and textiles from British designers, the designation "Liberty Style" is often used to describe Art Nouveau in England.

Art Nouveau design did not achieve wide popular acceptance but remained a style appealing to a limited elite audience of tasteful, aesthetically concerned, generally affluent consumers who viewed it as a fashionable, avant-garde expression of its time. The demands the style made on skillful craftsmanship, its use of costly materials, and its limited volume of production made its products expensive in a way that favored its role as status symbol and ensured limited distribution. For these reasons and probably also because of the extreme forms that Art Nouveau design often took, it faded almost as rapidly as it had developed and, by the time of World War I, virtually disappeared. Some of its leaders, including Horta and Guimard, abandoned the style and carried on in more conventional (and less interesting) stylistic vocabularies. Many older histories of Modernism mention Art Nouveau only briefly and dismiss it as a "style that failed." Beginning in the 1940s, interest in Art Nouveau work was revived, and it has been the subject of many exhibits and is now studied and collected as one of the primary developments leading to 20th-century modernism. A number of excellent books offer surveys of the style; among them Robert Schmutzler's *Art Nouveau* (1964), S. Tschudi Madsen's *Art Nouveau* (1967), and Maurice Rheims's *The Flowering of Art Nouveau* (undated) are outstanding.

ARTS AND CRAFTS

Name of an English movement in design that originated with a 1888 London exhibition organized by the Art Workers' Guild. That organization was a club formed by employees of the architect Norman Shaw to encourage interest in the kind of design favored by William MORRIS and his followers. Members of the guild wore ceremonial robes and met to discuss their opposition to the tradition-oriented Royal Institute of British Architects and to organize the Arts and Crafts Exhibition Society under the presidency of Walter CRANE. The ideas of John Ruskin (1819–1900), the writer, critic, and propagandist, and Augustus Welby Pugin (1812–1852), a Gothic revivalist architect, were behind Arts and Crafts ideals. Both men favored a return to the traditions of the Middle Ages with its close unity of design and craft. Morris took up these ideas but placed less emphasis on the

Fall front desk in the Arts and Crafts tradition, a Gustav Stickley design. Photo courtesy of Beth Cathers American Arts and Crafts.

revival of medievalism and more on the concepts of honesty of expression in workmanship and materials. Architects, designers, and craftsmen associated with the Arts and Crafts movement included Charles R. ASHBEE, H.M. BAILLIE SCOTT, Ernest GIMSON, C.F.A. VOYSEY, and Philip WEBB, while Morris is generally conceded to be its primary inspirational leader. The Arts and Crafts movement is a key aspect of the AESTHETIC MOVEMENT in England, which included parallel ideas in fine art, literature, and every aspect of 19th-century culture.

In spite of its somewhat romantic idealism and backward-looking nostalgia for pre-industrial, medieval, and rural simplicity, the Arts and Crafts movement embodied hints of the directions that MODERNISM was to take in its emphasis on functional design and honest use of materials and production techniques. These ideas were taken up and incorporated into CRAFTSMAN designs in the United States, into the development of ART NOUVEAU in Europe, and, through the efforts of Hermann MUTHESIUS, into the DEUTSCHER WERKBUND movement in Germany, and so, through Walter GROPIUS, into the modernism of the 1920s and 30s. Any historical survey of the development of modern design must begin with consideration of the Arts and Crafts movement. An excellent historical survey of the topic is Gillian Naylor's 1971 book, *The Arts and Crafts Movement*.

ARUP, (SIR) OVE (b. 1895)

English engineer, educated in Germany and Denmark. Arup was a consultant to Berthold Lubetkin and the Tecton group, architects, when they were designing the Highgate flats and the penguin pool at the London Zoo. Arup helped design the Sydney Opera House by Jørn Utzon. His bridge in Durham, England, is a fine example of the elegance of his work.

ARZBERG

China and procelain made by the Porzellanfabrik Arzberg, a German manufacturer established in 1888 and known since the 1930s for products that include simple, MODERN lines. Among Arzberg's most famous products are those designed by Hermann GRETSCH, whose 1382 line of 1931, available in plain white or with the subtle decoration of a single thin red line, quickly became a modern design CLASSIC. Gretsch's 2050 and 2200 lines and the 2000 line of 1954 by Heinrich Löffelhardt continue the same tradition.

ASHBEE, CHARLES ROBERT (1863–1942)

British designer-craftsman whose work linked 19th-century design reforms with 20th-century movement toward MODERNISM. Ashbee was a student of history at Cambridge, but went to work for architect G.F. Bodley in 1883 in London. He became associated with the Guild of Handicraft and through it with the design thinking of the ARTS AND CRAFTS movement. His work included typographical design and designs for furniture, jewelry, silver, pottery, carpets, and wallpapers. He became a member of the Art Workers' Guild in 1989 and was its best-known designer and spokesman until its end in 1907. Thereafter he was known as a theorist and critic, but was also active as a town planner. Both in his work and in his writing, Ashbee can be viewed as a transitional figure with roots in the Arts and Crafts movement, but with stylistic inclinations more closely linked to ART NOUVEAU.

ASHLEY, LAURA (1926–1985)

English designer and distributor of interior design products having a particularly cozy stylistic character. Born in Wales, Laura Ashley grew up aware of modest British interior design thought of as "cottagey." In 1968 she established Laura Ashley, Ltd. with her husband. The London shop sold textiles, wallpapers, and other materials for interiors, all having the unique Ashley style, which typically consisted of dense floral patterns in pleasant and tasteful colors. The Ashley approach has been very successful, leading to a chain of shops worldwide and associated production of Ashley style materials, including women's clothing. A number of books have been devoted to presentation and promotion of the Ashley style.

ASPEN DESIGN CONFERENCE

See INTERNATIONAL DESIGN CONFERENCE IN ASPEN.

ASPLUND, GUNNAR (1885–1940)

Swedish architect, also known for his interior and furniture design. Asplund designed furniture for the Stockholm City Hall in 1921 and the furniture and other detail elements for his own Stockholm City Library of 1928. Although all of his work is clearly part of the modern movement in Sweden, it uses carving, decorative detail, and color that suggest the influence of neo-classic and romantic Scandinavian revival. Some of his furniture designs are in current production by CASSINA in Italy. Asplund was the architect for the 1928–30 Stockholm Exhibition, bringing worldwide attention to Swedish

Group of Laura Ashley textiles from the Venetian Collection. Photo courtesy of Laura Ashley, Inc.

MODERNISM. His later work included chapels and cemeteries of great simplicity and dignity. The Woodland Crematorium at Stockholm (1940) has been particularly admired.

ASSOCIATED SPACE DESIGN
Interior design and office planning firm based in Atlanta, Georgia, known for successfully incorporating the ideas of BÜROLANDSCHAFT planning into more conventional office design practice. ASD's work includes offices for various government agencies and for major corporations such as the McDonald's headquarters building in Chicago. The firm was founded by architect William Pulgram, who is currently its president, with Richard Stonis as executive vice-president. Pulgram and Stonis are the authors of *Designing the Automated Office* (1984), an authoritative book in its field.

AUBOCK, CARL (b. 1924)
Austrian MODERN architect and designer trained in Vienna and at MIT. Aubock's work includes designs for furniture, metalware, ceramics, and glass as well as industrial products

and sports equipment. A metal cocktail shaker of Aubock's design is in the design collection of the MUSEUM OF MODERN ART in New York. A number of his designs are produced and distributed by the Vienna firm operated by his family of the same name.

AULENTI, GAE (GAETANA) (b. 1927)
Italian designer best known for her furniture and exhibition design. Trained and later a teacher at the Milan Politecnico, Aulenti has designed displays and showrooms for OLIVETTI and showrooms for KNOLL INTERNATIONAL. Her most recent major project has been to design the new exhibition areas of the 1988 Musée d' Orsay in Paris. She has also designed lamps for a number of Italian manufacturers and a group of furniture for KNOLL using frames of bent ALUMINUM EXTRUSIONs.

AVEDON, RICHARD (b. 1923)
American photographer known for his creative approach to fashion and portrait photography. Avedon studied with Alexey BRODOVITCH at the New School in New York before establishing

Armchair and side chair designed by Gae Aulenti. Photo courtesy of Knoll International, Inc.

his own studio in 1946. He was a regular contributor to *Harper's Bazaar* from 1945 to 1965, where Brodovitch was art director, and also was frequently published in *Life* and *Theater Arts* magazines. Although at first primarily a fashion photographer, his portraits, often of famous people, became equally well known, while his work became constantly more varied and more creative. His series of full-length portraits of average people in varied work costumes (published in *Harper's Bazaar*) typifies his movement away from fashion formulas. His work is often exhibited, and he has published a number of books, including *Observations* of 1959 (with a text by Truman Capote), a collection of his celebrity portraits up to that time.

AXONOMETRIC DRAWING

Type of architectural drawing in which the three-dimensionality of solid or hollow objects is revealed through a projection onto a flat plane so that width, length, and height each run in a particular direction. For example, height is normally shown as vertical, while width and length may be drawn at 30°, 45°, 60°, or any other angle to the horizontal. Dimensions are measured along the three-dimensional axes at scales that may be the same, or they may be adjusted to allow for foreshortening of width and depth. ISOMETRIC drawing is a special case of axonometric projection in which all three axial dimensions are drawn at the same scale, most often with height on the vertical axis and width and length drawn at a 30° angle to the horizontal.

Isometric and other axonometric drawings are widely used in architecture and interior design to show three-dimensional relationships while retaining accurate scale dimensions.

BACHE, DAVID (b. 1926)

British automobile designer whose best-known works include the Land-Rover of 1959, the Rover 2000 of 1963, and the Range Rover of 1970. His influence was present in many products of the automotive firm British Leyland until his departure from that firm in 1981.

BAHNSEN, UWE (b. 1930)

German automobile designer who has been vice-president in charge of design for FORD of Europe since 1976. The British Ford Sierra of 1982 is the best-known and most widely admired example of design produced under his direction.

BAILLIE-SCOTT, MACKAY HUGH (1865–1945)

English architect and designer involved with the ARTS AND CRAFTS movement. Baillie-Scott received his training while working in the office of the Bath city architect from 1886–89. His architectural work was strongly influenced by C.F.A. VOYSEY and his furniture, metalwork, and wallpaper design by A.H. MACKMURDO. His commission to decorate rooms in a palace at the art colony at Darmstadt in 1898 led to his developing a reputation in Germany where his work was recognized by the influential critic Hermann MUTHESIUS. He continued architectural practice and produced furniture designs for production and publication in Germany and Switzerland until his retirement from active practice in 1939. Baillie-Scott's architectural planning around the turn of the century introduced a new sense of openness to British domestic design, although his later work was more conventional. His furniture and interior design was often heavily rustic, but still original, mixing the craft tradition with hints of ART NOUVEAU experimentalism.

BAKELITE

Trade name of one of the first PLASTICS to come into wide use. A phenolic invented in 1907 by chemist Leo Baekeland, the material is a good insulator against heat and electric current, can easily be molded in varied shapes, and is relatively inexpensive. It has a wide application in electrical hardware, for example, for handles and enclosure elements on kitchen wares, irons, and similar products. The material is brittle, making it easily damaged by impact; its color is normally limited to browns and black. The term has become a generic name for any phenolic plastic, regardless of manufacturer.

BALANCE

Concept that has a role in design AESTHETICS, with its suggestion that elements should be placed so as to bring about a sense of visual repose. It can be viewed as analogous to the physical balance achieved when objects of equal weight are placed on either side of a central fulcrum, or when objects of different weight are brought into balance by being placed at different distances from a fulcrum (as in the familiar weighing scale with a sliding weight). SYMMETRY is the most obvious means of achieving balance, with its placement of identical elements on opposite sides of one or more axes. Bilateral symmetry, balancing elements on two sides of a central axis, is common in many natural forms (including the human body) and is, perhaps for that reason, a much favored way of achieving balance. Many classical, Renaissance, and modern objects (including works of art and architecture) are bilaterally symmetrical. Asymmetry is also capable of providing visual balance, but only through a more subtle adjustment of elements. Visual "weight" or mass is brought into balance through placement at varied distances from an imagined axis or through different colors or shapes that generate an impression of stability even when the forms in question do not actually match. Asymmetry has been favored in modern design as a means of escape from the routine of symmetry so common in most historic work. Symmetry of function often imposes symmetrical balance on such familiar objects as tools, cooking utensils, chairs, boats, automobiles, and other vehicles where efforts to avoid symmetry tend to seem forced. Radial symmetry in which elements are placed in balance on the sides of more than one axis, quite common in nature (in the form of starfish or many flowers, for example) is the basis for some architectural and object design. The circle and its three-dimensional extension, the sphere, are symmetrical about an infinite number of axes and so may be viewed as the most totally balanced of all forms.

BALDWIN, BENJAMIN (b. 1913)

Leading American interior designer of the modernist school. Baldwin was trained as an architect at Princeton, studied with Eliel SAARINEN at CRANBROOK ACADEMY, and then worked with Eliel and Eero Saarinen from 1939–40. With the Chicago architect Harry Weese, he was a winner in the 1940–41 furniture design contest conducted by the MUSEUM OF MODERN ART in New York. Baldwin was in charge of interior design of the Terrace Plaza Hotel in Cincinnati for architects SKIDMORE, OWINGS & MERRILL (1947) before establishing his own interior design practice in 1948. Since then he has worked largely in residential interior design in Chicago, New York, and Sara-

sota, Florida. His work is sometimes described as minimalist because of its simplicity and close affinity with modern architecture—a quality that has made it possible for him to work with such noted modern architects as Edward Larrabee Barnes, Louis KAHN, and I.M. Pei. His own house in East Hampton, Long Island, is a fine example of his work.

BALDWIN, WILLIAM ("BILLY") (1903–1984)

Well-known American interior decorator. William Baldwin first became known as a chief assistant to Ruby Ross Wood in 1935. Following her death in 1950, he entered into a partnership with Edward Martin that was devoted to residential interiors with a florid and colorful character. His clients were often celebrities from the theatrical world (Cole Porter was one), and his work combined antiques with more modern elements in a way suggestive of stage sets. He retired from active practice in 1972.

BALENCIAGA, CRISTOBAL (1895–1972)

Fashion designer whose work suggested the influence of his Spanish Basque origins. Balenciaga is viewed as a "dean" of fashion design, sometimes called "the greatest of the century." At the age of eighteen he established Elsa, a retail shop in San Sebastián and shortly thereafter in Madrid and Barcelona. He made regular buying trips to Paris to augment his own design productions. In 1937, in response to the Spanish Civil War, he relocated to Paris opening a shop there that remained in business for thirty years. His first offerings were quiet and simple, but he soon developed design directions generally independent of the trends of any particular moment. His work was characterized by a bold sense of color, use of much black, strong and stiff fabrics, and rich ornament suggestive of traditional Spanish origins. Hats, scarfs, and rich jewelry were frequent additions to his productions. His work had a quality of timeless elegance. In 1968 Balenciaga retired, surprising the fashion world with his sudden rejection of the couture field.

BALMAIN, PIERRE (1904–1982)

French fashion designer known for his rich, somewhat conservative clothes and for his stage and film costumes. Balmain studied at the University of Grenoble and then went to Paris to study architecture at the École des BEAUX-ARTS, but he dropped that direction to take a position with couturier Edward MOLYNEUX in 1934. In 1939 he joined the firm of Lucien Lelong, where he, along with Christian DIOR, was placed in charge of design. In 1946 Balmain opened his own firm. The somewhat "architectural" splendor of his designs had an appeal to wealthy (often older) women, including many celebrities. In 1947 he opened a boutique, Jolie Madame, in Paris, followed by others in South America and in New York. Ready-to-wear and sportswear lines followed, the latter named Elbalmain. Perfumes include Ivoire, Vent-Vert, and Miss Balmain. He received a Neiman-Marcus Award in 1955, and his 1964 autobiography, *My Years and Seasons*, gives a history of the Balmain era. Since Balmain's death, the firm has been carried on by a Danish designer, Erik Mortensen, who has extended its scope with many lines and licenses.

BANG & OLUFSEN

Danish manufacturer of high-quality audio and video equipment. The firm has maintained an extraordinary commitment to fine MODERN design in the appearance of its products together with innovative technical development. Peter Bang and Svend Olufsen began building wireless sets in the attic of the Olufsen family home in Struer, Denmark, in 1925. By 1929 they were operating a small factory that produced such innovative equipment as an early push-button tuning radio. A pick-up arm of 1965 designed by B&O staff designer E. Rørbaek Madsen was one of the first products to attract design attention to the firm. A refined version of this arm is part of the Beogram 3000 turntable, the first of several B&O products to be included in the design collection of the MUSEUM OF MODERN ART in New York. In 1966 Acton BJØRN designed the neat and simple Beolit 500 radio, a box faced with natural wood, with controls in the form of black buttons arranged in a solid band. Jacob JENSEN designed many subsequent B&O products including the Beosystem 1200 component hi-fi group of 1969, the Beocenter 7002 unit of 1979, the Beogram 8000 phonograph unit of 1980, and a variety of more recent products such as the Beovision MX5000 television and VX5000 VCR. B&O products are of consistently high quality (and high price); their external designs are unique in emphasizing simplicity, unobtrusive controls, genuine wood panels, and black-finished metal, in contrast to the

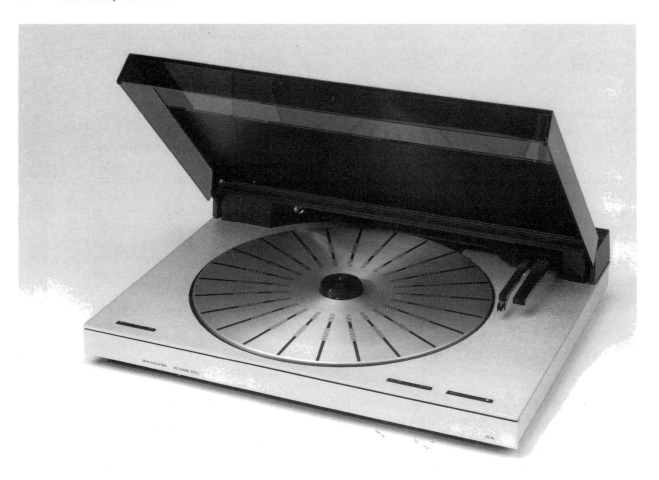

Bang & Olufsen Beogram 5500 phonograph turntable. Photo courtesy of DYM/SR & A, Inc. Public Relations, in association with Sumner & Rider Associates, Inc.

complex display of controls and high-tech look of most comparable equipment.

BANHAM, REYNER (1920–1988)

British writer and critic, who was an influential theorist in 20th-century design. Banham's enthusiasm for mass culture, POP ART, and related developments of the 1950s and 1960s was basic to his views of design. He was a staff writer for the *Architectural Review* in the 1950s. His books, *Theory and Design in the First Machine Age* (1960) and *Design by Choice* (1981), and his involvement with the INTERNATIONAL DESIGN CONFERENCE IN ASPEN have made him a significant figure in the interpretation of recent design history.

BARCELONA CHAIR

Chair, together with an ottoman, designed by Ludwig MIES VAN DER ROHE in 1929 for the BARCELONA PAVILION. Its design consists of a simple X frame of steel bars supporting leather straps that carry seat and back cushions covered in leather. The Barcelona chair

has become known as a modern design CLASSIC, maintained in production by KNOLL INTERNATIONAL.

Barcelona chair of 1929 by Ludwig Mies van der Rohe.
Photo courtesy of Knoll International, Inc.

BARCELONA PAVILION

German Pavilion at the Barcelona Exhibition of 1929 that became one of the best-known and most admired works of INTERNATIONAL STYLE modern architecture by Ludwig MIES VAN DER ROHE. The building, demolished after the close of the exhibition, was reconstructed in 1986 in its original location.

BARNACK, OSCAR (1879–1936)

Inventor/designer of the LEICA, the first successful 35mm camera. Barnack grasped the possibility of using 35mm motion picture film for still photographs and developed a light, portable instrument and the optics to make this practical. The Leica camera has become a greatly admired icon of modern technological design, sternly functional in the tradition of Leitz optical instruments, but beautiful in a way that has made it a key example of industrial design in the 20th century.

BARNSLEY BROTHERS

English cabinet makers and designers of furniture in the ARTS AND CRAFTS tradition. In 1895 Ernest (1863–1926) and Sidney (1865–1926) established a workshop in partnership with Ernest GIMSON to produce furniture at the small Cotswold town of Pinbury, moving in 1902 to Sapperton in Gloucestershire. Ernest Barnsley had worked for the church architect Snedding, Sidney for Norman Shaw. With Gimson they established a "Cotswold School" of craft-made furniture of simple design based on VERNACULAR country craft traditions. After 1926 the Barnsley/Gimson production was carried on by Dutch craftsman Peter Waals, who had joined the shop in 1901, at his shop at Chalford, Gloucestershire, until his death in 1937.

Original Leica model UR of 1913 designed by Oscar Barnack. Photo courtesy of Leica USA, Inc.

BARRAGÁN, LUIS (1902–1988)

Mexican engineer and architect whose work combines the austerity of the INTERNATIONAL STYLE, or MINIMALIST modernism, with a strong use of chromatic color. Barragán was a self-taught architect, although he had some training in engineering and experience in his family's building business in Guadalajara. He traveled in Spain and was influenced by the VERNACULAR architecture of that country as well as that of his native Mexico. His work also shows influences of LE CORBUSIER and of many artists, historic and contemporary. His work in architecture and interior design takes on the qualities of abstract painting with its use of simple forms and strong areas of color. His own house in Mexico City (1947) and the 1954 chapel at Tlalpán, Mexico, are well-known examples of his work. His work was exhibited at the MUSEUM OF MODERN ART in New York in a 1976 retrospective, and he was the recipient of the PRITZKER PRIZE in 1980 in recognition of his work's international reputation.

BARTOLINI, DAVIO, AND LUCIA

See ARCHIZOOM ASSOCIATI.

BASS, SAUL (b. 1921)

Distinguished American graphic designer. Bass studied at the Art Students League in New York and at Brooklyn College under Gyorgy KEPES before working for several major advertising agencies beginning in 1946. In 1952, he opened his own office and has produced work for many American corporate clients including the Bell System and United Air Lines. Bass has received a large number of awards for his work, which include graphics for a number of motion pictures. His titles for *West Side Story* are an outstanding example of his work in this field.

BAUHAUS

German school of design that, in the 1920s and 1930s, became the leading intellectual and creative center in the development of MODERNISM. The Bauhaus was founded at Weimar in 1919 when Walter GROPIUS directed a merger of two preexisting art schools. The institution was originally named *Staatliches Bauhaus Weimar* and announced its dedication to the unity of the arts with the crafts. Space was obtained in several existing buildings including one designed by Henri VAN DE VELDE. Early in its history, Gropius recruited a remarkable roster of teachers including Johannes ITTEN, Wassily

KANDINSKY, Paul KLEE, László MOHOLY-NAGY, and George Mucha. The teaching program was highly innovative, replacing traditional representational introduction to drawing with a six-month preliminary course (Vorlehre or Vorkurs) in which materials, form, and color were explored in abstract exercises. In the next step (Werklehre), students worked simultaneously under two masters, one an artist, the other a craftsman specializing in a particular discipline. The final years were devoted to actual design in architecture and building or related fields.

Although the Bauhaus approach was, in its day, highly original, its ideas were strongly rooted in the earlier directions encouraged by the DEUTSCHER WERKBUND, which were in turn drawn from aspects of the ideology of the ARTS AND CRAFTS movement. Conservative opponents of Bauhaus directions regarded the institution as dangerously radical and organized political opposition to its continuation in Weimar. In 1925, the Weimar Bauhaus was closed in order to relocate in the industrial city of Dessau where Josef ALBERS, Herbert BAYER, and Marcel BREUER took up teaching and where the school was able to build its own famous building, an INTERNATIONAL STYLE masterpiece designed by Gropius, with all interiors, furniture, and details designed by Bauhaus staff and students.

In 1927 Hannes MEYER became head of a newly formed department of architecture. His political views and personality caused a rift in the Bauhaus faculty, leading to the resignation of Gropius and a number of his colleagues in 1928 when Meyer became the new director. Under his leadership, Bauhaus designs were licensed to manufacturers, making Bauhaus

design available to a larger public. Continuing conflict led to Meyer's resignation in 1930 when Ludwig MIES VAN DER ROHE became director. The rise of Nazism brought the Bauhaus under increasing political attack, leading to a decision to relocate in Berlin in 1932. By 1933 the school was closed by the Nazis and then dissolved by its faculty. Many of the leading Bauhaus faculty members relocated outside of Germany, in England and, then, in the United States and elsewhere around the world. Gropius, Mies van der Rohe, and Moholy-Nagy each became leaders in design education in America, bringing about a remarkable transfer of the school's ideas into all modern design.

In view of the brief lifespan of the Bauhaus as an institution and the small number of students it actually trained (no more than 1,250), its impact on design practice, design education, and design theory has been remarkable. Bauhaus publications were widely read, and its ideas were taken up and disseminated by such distinguished historians and critics as Sigfried GIEDION and Nikolas PEVSNER. A 1938 exhibition at the MUSEUM OF MODERN ART in New York presented Bauhaus work to an American audience. The generally abstract, MINIMALIST, unornamented character of most Bauhaus architecture and design came to be the characteristic form of modernism in the 1940–1960 period, and the term "Bauhaus" is still used to describe design of a generally simple and mechanistic character, while Bauhaus curriculum has served as a model for the programs of innumerable art, design, and architectural schools. Designs by Marianne BRANDT, Marcel Breuer, Mies van der Rohe, and Wilhelm WAGENFELD have become CLASSICS, still in pro-

Bauhaus building at Dessau designed by Walter Gropius in 1925–26.

duction and widely used. Bauhaus influence is strongly evident in modern typography, graphic, and exhibition design, while the publications of Bauhaus-related figures form a sizable library of major design theory and literature.

Efforts to recreate the Bauhaus in new contexts such as the brief-lived school called the New Bauhaus in Chicago and the HOCHSCHULE FÜR GESTALTUNG at Ulm have had only limited success, although the INSTITUTE OF DESIGN in Chicago is an indirect descendant of such efforts. In the 1980s, Bauhaus concepts have come under occasional attack as alternatives to International Style modernism have proliferated. The 1982 book by Tom Wolfe, *From Bauhaus to Our House*, makes a case for the idea that Bauhaus concepts have dominated and damaged American design in recent years. Wolfe's amusing presentation of this idea attracted some popular interest, but outraged the professional design community where Bauhaus ideas are still widely respected, even as design practice moves into newer modes. The massive 1969 book by Hans Maria Wingler, *Bauhaus*, is a definitive documentation of Bauhaus history and achievement.

BAYER, HERBERT (b. 1900)
Austrian-born American graphic designer and art director who played a major role in bringing BAUHAUS design concepts to the United States. Bayer was a student at the Bauhaus from 1921 to 1923 and a master there from 1925 to 1928. His 1925 typeface, Universal, was an interesting effort to develop a single SANS SERIF face to replace the conventional capital and lowercase alphabets. From 1923–30 he worked in Berlin as art director for the European *Vogue* magazine, a post he held until 1938 when he emigrated to America. He was active in graphic and advertising design for various firms until he joined the CONTAINER CORPORATION OF AMERICA in 1946, where he was the director of its design department. He continues in practice in Aspen, Colorado.

BAYLEY, STEPHEN (b. 1952)
British critic, writer, and museum director. A native of Liverpool, Bayley studied art history at Manchester University. He became known as a lecturer and writer for various English and American magazines and for his BBC broadcasts dealing with art and design subjects. From 1982 to 1986 he was the director of the BOILERHOUSE PROJECT, the modern design center at the VICTO-RIA AND ALBERT MUSEUM in London. Since 1986 he has been in charge of the development of the London Design Museum sponsored by Sir Terence CONRAN, which opened in 1989. His 1979 book, *In Good Shape*, is an excellent study of industrial design work of the 1900–1960 era.

BBPR
Milan architectural and design office that became a major factor in the post–World War II renaissance of functional, modern Italian design. BBPR was established in 1932 by four partners, Gianluigi Banfi (1910–1945), Ludovico Belgiojoso (b. 1909), Enrico Peressutti (1908–1976), and Ernesto Rogers (1909–1969). Rogers was the first editor of *DOMUS* magazine and established its central role in documenting Italian architecture and design. The firm's *The Form of the Useful* exhibition was a significant part of the 1951 TRIENNALE in Milan. In architecture, their Torre Velasca of 1958, a major skyscraper in Milan with a silhouette oddly suggestive of a medieval campanile, is a striking example of BBPR style that combines MODERNISM with references to traditional Italian architecture.

BEALL, LESTER (1903–1969)
American graphic designer who introduced DADA and surrealist elements in his earlier works. In Chicago, Beall studied art history at the Lane Technical School and at the University of Chicago. He established his own practice in New York in 1935. His posters for the U.S. Rural Electrification Agency were outstanding in their simple, abstract impact. In 1951 he relocated his office to his home in Connecticut. His work in graphic design, packaging, and trademark design includes many familiar forms associated with major American corporations, including Rohn & Haas, Caterpillar Tractor, and International Paper Corporation. His work was the subject of a 1937 exhibition at the MUSEUM OF MODERN ART in New York.

BEAUX-ARTS STYLE
Style characteristic of architecture, interior design, and related objects (such as textiles and furniture) designed under the influence of the French École des BEAUX-ARTS during the second half of the 19th century. Beaux-Arts design combines a concern for rational, functional planning with a florid decorative style based generally on the classic architecture of ancient Rome and the Renaissance. Many prominent American architects, including Raymond HOOD, George HOWE, Charles Follen McKim,

The 3 points of the equilateral triangle are ¼ unit from the inside diameter of the "ring"

ring is 1 unit

Distance from center to tip of triangle is 4¼ units

1 unit

1 unit

1 unit

1 unit

¼ unit

¼ unit

6 units

11 units

Lester Beall's 1960 logotype for the International Paper Company.

and John Russell Pope, studied at the Beaux-Arts in Paris in the late 19th and early 20th century. They introduced Beaux-Arts thinking into American architectural education and into their own and their students' work. Outstanding examples of Beaux-Arts design in the United States include the New York Public Library by Carrère and Hastings (1897–1911) and Grand Central Station in New York by Warren and Wetmore (1907–1913).

BEAUX-ARTS, ÉCOLE DES
Officially sponsored school of art and design in Paris, established in 1819 as a successor to various royal academies that had previously been the authorized teaching institutions for the arts in France. In the second half of the 19th century, the Beaux-Arts became internationally famous as the outstanding school of architecture. Students came to study there from all parts of the world, particularly from the United States. Teaching was based on students' developing designs to satisfy the requirements of imaginary "programs" that spelled out what a client might want in an actual building project. Students worked in the "ateliers" under the direction of an established architect, and their finished drawings were then judged in competition by a jury of professionals at the École. Famous teachers included Charles Garnier, ar-

chitect of the Paris Opera; Henri Labrouste, an early user of iron and glass in his Paris libraries; and Victor Laloux. American architects who studied at the Beaux-Arts included Charles Follen McKim of the firm of McKim, Mead & WHITE, H.H. Richardson, and Louis SULLIVAN. The work and teaching of such men were influential in spreading the BEAUX-ARTS STYLE in America.

BEENE, GEOFFREY (b. 1927)

American fashion designer known for his youthful, almost playful approach, combined with respect for traditional craftsmanship and detail. Beene was a medical student at Tulane University in New Orleans before dropping out to relocate in Los Angeles and take a job with I. Magnin in store display. His fashion sketches led to his enrolling at the Traphagen School in New York and then to study in Paris, where he worked briefly for Edward MOLYNEUX. For seven years he worked in design for the New York dress firm of Harmay and then for Traina, where his name began to appear on the label. In 1962 Beene opened his own firm. His work often crosses the lines between sportswear and more formal costume, using the best of materials and fine details along with generally bright and lively color. An element of humor appears in his designs, which sometimes verge on the shocking. He has used as many as four fabrics in one costume. His lines now include lower-priced Beene Boutique and Bazaar lines and Beene Bag Sportswear. He has also set up licensing for eyeglasses, furs, men's wear, perfumes, and shoes. He has shown in Milan and even set up an office there. Beene has won many awards, including a 1964 Neiman-Marcus Award and a series of Coty Awards, his fifth in 1982.

BEHRENS, PETER (1868–1940)

Distinguished German architect and industrial designer who played an important role in the development of 20th-century MODERNISM. Behrens was born in Hamburg and studied painting at Karlsruhe and Dusseldorf. His early career as a painter and graphic artist reveals him as an exponent of JUGENDSTIL artwork. He was invited to join the art colony at Darmstadt in 1901. His major career as a self-taught architect began with his design for his own house at Darmstadt (the only building there *not* designed by Josef OLBRICH)—complete with furniture and decorative details of his own design. It incorporates both ARTS AND CRAFTS and Jugendstil influences in an individualistic way that points toward his later work.

In 1906 Behrens was asked to design graphic materials for AEG, the vast German electrical corporation. His involvement there led to his appointment as architect and product designer for that firm. In addition to graphic materials and a trademark for AEG, Behrens designed light fixtures, fans, kettles, and other products. His most important architectural work was the turbine factory for the AEG in Berlin (1908–1909). He was a founding member of the DEUTSCHER WERKBUND in 1908.

His rejection of historical imitation and the simplicity and functional logic of his design make him a major figure in the development of modernism. His influence can also be traced through the fact that Walter GROPIUS, LE CORBUSIER, and Ludwig MIES VAN DER ROHE were all employed in his office around 1910 and were strongly influenced by his ideas. He became director of architecture at the Vienna Academy in 1932 and headed the department of architecture at the Prussian Academy in Berlin from 1936 until his death.

The wide range of his work for AEG has led to the realization that he was a practitioner in the field of CORPORATE IDENTITY long before that term had come into general use. Recent publications and exhibitions have stimulated new interest in Behrens' work.

BEL GEDDES, NORMAN (1893–1958)

American industrial and stage designer with a prominent role in the use of STREAMLINING in the design style of the 1930s. Bel Geddes was born in Michigan and studied briefly at the Art Institute of Chicago before establishing his own office as an industrial designer. His work included Toledo scales, Philco radio cabinets, and a Graham Page automobile, but his influence was greatest through the publication of unrealized, generally futuristic projects. His 1932 book, *Horizons*, described and illustrated such projects as a fully streamlined ocean liner and a huge passenger airplane with public lounges, promenade decks (in the wings), and a gymnasium. His best known and most influential work was the FUTURAMA exhibit for General Motors at the 1939 New York WORLD'S FAIR in which visitors traveled above a model landscape complete with cities and highways as Bel Geddes anticipated they might be in the future. The exhibit is often credited as a major force in the development of modern superhighway systems.

BELL, ALEXANDER GRAHAM (1847–1922)

Inventor of the telephone, who also designed early telephone instruments and made a contribution to the development of aircraft. Born in Scotland, Bell moved to Canada in 1870 and then to the United States in 1872. The first telephone was demonstrated in 1876, and the first commercial model, a simple wood box of Bell's own design, was introduced in 1877. The so-called Butterstamp model of 1878 took its name from the form of the receiver unit, a form that survived until the French phone, with combined mouthpiece and receiver, was introduced in 1937.

In 1907 Bell organized the Aerial Experiment Association (AEA) to promote work on aircraft design and was the designer of a spectacular man-lifting kite. In spite of their striking appearance, Bell's aircraft designs were not particularly successful and never equaled the earlier (1903) efforts of the WRIGHT BROTHERS.

BELLINI, MARIO (b. 1935)

Leading Italian industrial designer, best known for his product design for OLIVETTI. Bellini was trained in architecture at Milan Polytechnic, graduating in 1959. He opened his own office there in 1962. He first attracted attention with his rubbery Divisumma 18 printing calculator of 1972 and the Lexikon 82 typewriter of 1972–73, both for Olivetti. He continues to design for that company but has also worked for BRIONVEGA, designed furniture for CASSINA, Oppioni, and Vitra, and lighting for ARTEMIDE and Flos. Several of his designs have won COMPASSO D'ORO awards, and several are in the design collection of the MUSEUM OF MODERN ART in New York, where he was given a one-man exhibit in 1987, accompanied by a Museum publication. Since 1986 he has been editor-in-chief of *DOMUS* magazine.

BENNETTON, GIULIANA (b. 1938)

Founder of an Italian company in 1965, a manufacturer and retailer of knitwear. With her three brothers, Benetton has built up a firm with over 2,500 shops all over the world offering clothing of simple design in attractive colors. The design of the shops and the merchandise offered are of high quality and support each other in conveying an image of bright modernity. The firm has adopted advanced computer and automation techniques in manufacturing and business management.

Yamaha YHD-1 headphones designed by Mario Bellini. Photo courtesy of Roher Public Relations.

BENNETT, WARD (b. 1917)

Distinguished American furniture and interior designer. Bennett studied art with Hans Hofmann in New York and with the sculptor Constantin BRANCUSI in Paris before working briefly for LE CORBUSIER beginning in 1938. As an interior designer, he has been a consultant to SKIDMORE, OWINGS & MERRILL, for example, designing the interiors of the executive offices of the Chase Manhattan Bank in New York. He has also designed office and residential projects for a number of private clients. His style is generally quiet, reserved, and elegant, with an implication of luxury conveyed through simplicity. His own New York apartment and house at Springs on Long Island are fine examples of his work. His furniture designs, distributed by Brickel Associates, include a wide variety of simple pieces retaining a somewhat traditional feeling along with their strictly modern forms. Bennett has also been active as a sculptor, jewelry designer, and designer of china and silver tableware.

BENTWOOD

Type of wood created by a manufacturing process in which solid wood, cut into long, thin strips, is placed in a pressure steam chamber until it is softened sufficiently to permit bending around molds or forms; on cooling, after removal from the forms, the bent shapes are retained. The process was developed by Michael THONET (1796–1871) in Vienna and was the basis for the great variety of designs produced by his firm and various imitators in the late 19th and early 20th centuries. Designs ranged from simple restaurant and café chairs to the much admired ornate rocking chair valued by collectors. The bentwood process is still in use in a number of European countries and has had some limited acceptance in the United States, although the lack of availability of an ideal wood (a European beech is particularly suitable) has limited American production.

BENZ, KARL (1844–1929)

German engineer and inventor, a key figure in the development of the modern automobile. Benz was a primary inventor of the internal combustion engine. His 1879 two-stroke engine led to the light-weight four-stroke engine that powered his first automobile of 1885. He worked later with Panhard, Lavassor, and Daimler in the development of the Daimler-Benz automobile. The modern firm of MERCEDES-BENZ continues to carry the Benz name.

BERLAGE, HENDRIKUS PETRUS (1856–1934)

Dutch architect whose work strongly influenced the development of early MODERNISM. Berlage was trained at the Zurich Polytechnic and worked for the well-known Amsterdam architect P.J.H. Cuypers. His best known and most influential work is the Amsterdam Bourse (stock exchange) begun in 1897. Although this building retains a somewhat conservative character, it is not a study in historicism. The dignity of its handsome and simple brickwork and the glass and iron roof of its vast interior space had a strong effect on the next generation of architects in Holland.

BERNADOTTE, SIGVARD (b. 1907)

Leading Swedish craft and industrial designer. Bernadotte, son of the Swedish king Gustave V, began his design career in the firm of Georg JENSEN, working in silver, furniture, textiles and helping to build that firm's international reputation. In 1949 he opened an industrial design office in Copenhagen, with the Danish designer Acton BJØRN, where he made a wide variety of industrially produced products. The dignified audio equipment of BANG & OLUFSEN is an example of distinguished work of the firm. Since 1964 he has been the head of his own design firm in Stockholm serving a number of major clients.

BERNHARD, LUCIAN (1883–1972)

German-born artist and designer best-known for his design of widely used typefaces. Bernhard was educated in Switzerland and, when

Armchair designed by Ward Bennett. Photo courtesy of Brickel Associates, Inc.

Silver flatware designed by Sigvard Bernadotte. Photo courtesy of Royal Copenhagen.

only 15, won a poster design contest in Berlin. In 1903 he took up interior and furniture design in Munich in the MODERN idiom of the time. In 1913 he produced his first type design, Bernhard Antiqua. By 1923 when he came to the United States, he had designed some 25 faces for German type founders. In America he designed 10 more faces for American Type Founders and Bauer Type, including Bernhard Roman (1923), Bernhard Gothic, a series of simple SANS SERIF faces (1928–29), and Fashion (1929), a rather mannered type style reflecting an ART DECO orientation. Bernhard represents an important link between German and American development of typefaces with a strongly modern character.

BERTOIA, HARRY (1915–1978)

American sculptor who also made a major contribution to modern furniture design. Bertoia was born in Italy and came to the United States in 1930. He took up studies in design at CRANBROOK ACADEMY in 1937 and eventually became a teacher there. He was a contemporary of Charles EAMES at Cranbrook and in 1949 accepted a position with Eames in his California office. Bertoia had a significant role in the development of Eames's furniture designs, particularly the wire chairs of 1951. The exact magnitude of Bertoia's contribution to the Eames designs remains a matter of uncertainty, but Bertoia became dissatisfied and left Eames to undertake independent design work for KNOLL in 1952. His classic steel rod chair introduced in 1952 has a striking visual character: a contoured wire cage shell supports thin cushions.

After his work for Knoll, Bertoia turned his attention almost exclusively to sculpture. His open metal-cage works became popular as accent elements in such architectural interiors as the main banking room of SKIDMORE, OWINGS & MERRILL's Manufacturers Hanover Trust Building of 1953–54 in New York.

BERTONE, FLAMINIO (b. 1903)

Italian automobile body designer. His most visible work was for CITROËN and included the

design of the Traction Avant, the 2CV, and, most striking of all post-war Citroën cars, the DS models.

BERTONE, NUCCIO (GIUSEPPE) (b. 1914)

Italian automobile body designer. Bertone has been responsible for a number of distinguished automobile designs including the Alfa Romeo Giulietta Sprint of 1954, the Lamborghini of 1966, and the CITROËN BX of 1982. His work has been central in the development of typically Italian automotive design.

BILL, MAX (b. 1908)

Swiss architect and designer whose work is identified with the austere MODERNISM thought of as characteristically Swiss. Bill studied at the BAUHAUS and was director of the HOCHSCHULE FÜR GESTALTUNG at Ulm from 1951 to 1956. His influence, through his teaching, writing, and the Güte Form exhibitions that he organized, has been a continuing force in favor of the functionalist ideas that stem from Bauhaus origins. His work as a painter and sculptor equals his design production in importance and quality.

BINDESBØLL, THORWALD (1846–1908)

Danish architect and designer associated with the Danish expression of the ART NOUVEAU style. Trained as an architect, Bindesbøll began practice in 1876. He designed earthenware ceramics for the Valby factory in Copenhagen and was also a designer of book bindings, jewelry, furniture, and metalware. Silver of his design was shown at the Paris Exhibition of 1900. Bindesbøll's work is characterized by strong undulating and curvilinear forms typical of Art Nouveau. The Carlsberg beer label is a Bindesbøll design still in regular use.

BING, SAMUEL (1838–1919)

German promoter and dealer who played a major role in the development and marketing of the ART NOUVEAU style. Bing had traveled in

the Far East in the 1870s and then set up a shop in Paris, La Porte Chinoise, to market Chinese, Japanese, and other imported objects. On a visit to the United States, he went to the 1893 Columbian Exhibition in Chicago and became familiar with the work of H.H. Richardson and Louis SULLIVAN. In 1895 he opened a Paris shop with the name, Maison de L'Art Nouveau (House of the New Art), thus giving the generally accepted name to the style the shop featured. The furniture designs of Edward Colonna, George de Feure, and Eugene GAILLARD were among those that Bing favored, along with artwork, glassware, jewelry, and other objects. He commissioned designs by Pierre Bonnard, Henri de Toulouse-Lautrec and Édouard Vuillard, among others, for execution in stained glass by Louis Comfort TIFFANY in New York. Work by Émile GALLÉ, René LALIQUE, William MORRIS, Henri VAN DE VELDE, and C.F.A. VOYSEY was exhibited and sold at the Bing shop. His pavilion at the 1900 Paris Exhibition included a group of rooms in Art Nouveau style, designed by his three featured designers and filled with furniture and details in the florid, colorful, often extreme character typical of the movement. Bing was the author of several books and many magazine articles promoting work in the style that he sponsored. His son, Marcel (1875–1920), took over management of the shop in 1905, but soon changed its emphasis to the sale of antiques.

BJØRN, ACTON (b. 1910)

Danish architect and town planner who has become active as an industrial designer. He entered into a partnership with Sigvard BERNADOTTE in 1949. The firm produced a variety of products including household wares, bathroom fixtures, and products for the business machinery firm Facit. His minimalist but elegant Beolit 500 radio for BANG & OLUFSEN won a 1966 award in Denmark and is an outstanding example of his work.

BLACK, MISHA (1910–1977)

British designer and design teacher. Born in Russia, Black was trained as an architect and became a prominent figure in English design when he founded the Design Research Unit with Milner Gray in 1944. His best-known work was in exhibition design, as in the *Britain Can Make It* exhibit of 1946 and in portions of the 1951 *Festival of Britain*. He was an influential teacher of industrial design at the Royal College of Art.

BLASS, BILL (b. 1922)

Leading American fashion designer. Blass was self-taught as a fashion artist, drawing inspiration from the films he watched as a boy in his hometown in the American Midwest. He studied for a time at the PARSONS SCHOOL OF DESIGN and then began his professional career as a sketch artist in New York in 1940, where he also worked for Anne Klein and Anna Miller, Ltd. Blass established his own design house in 1970. Since then his name and work have become well-known, placing him among the leaders of current apparel designers. He is known for women's suits with details borrowed from men's clothing, often trimmed with fur. He frequently uses lace, pure natural fabrics, and bright, strong colors. He has developed a less expensive Blassport line, a line of menswear, and has licensed the use of his name to some thirty-five other firms. He has even designed interiors for the LINCOLN CONTINENTAL automobile. Blass won Coty Awards in 1961, 1963, 1968, and 1970.

Bill Blass 1985 design: wool jacket and leather pants.
Photo courtesy of Bill Blass, Ltd.

BLÉRIOT, LOUIS (1872–1936)

French pioneer aviator and airplane designer. Blériot began his career as a manufacturer of automobile accessories, but became interested in flying in 1901. His early efforts at airplane building had very limited success, but by 1907 he arrived at the general plan of a tractor (engine-in-front) monoplane, the Blériot VI, which managed a number of successful (although brief) flights. In several further steps, he progressed to the Blériot XI, the design that turned out to be his masterpiece. (The design must be credited, in part, to collaboration with Raymond Saulnier.) In 1909 Blériot made the first successful flight across the English Channel in this airplane, earning fame for himself and his airplane as well. The structure was made of STEEL tubing, ash, and bamboo with fabric covering. Power was supplied by a 25-horsepower, three-cylinder engine. The wings were without ailerons, and banking was controlled by warping the entire wing. Bicycle-type wire landing wheels and the open frame of the rear fuselage construction gave the Blériot XI a fragile, insectlike appearance of great elegance. Its form was a first step toward the development of modern aircraft types. Shortly after his triumphant Channel flight, Blériot quit flying to devote himself to commercial production of his design. By 1914 over 800 Blériot aircraft had been produced. A surviving example was restored in 1979 and is displayed in the Smithsonian National Air and Space Museum in Washington, D.C.

BLOW MOLDING

Manufacturing technique for forming hollow objects such as bottles from THERMOPLASTICS. A heat-softened plastic tube is passed into a mold that is then closed, sealing one end of the tube. Air is blown into the tube at high pressure from the opposite end, forcing the plastic to balloon out to fit the mold. The mold is then opened to release the molded object, which becomes somewhat hardened as it cools. Inexpensive bottles are made in this way in a range of sizes. Molded in a corrugated, bellowslike form, "squeeze bottles" can dispense contents in a spray or powder when squeezed. Modern packaging makes extensive use of this production technique.

BMW (BAYERISCHE MOTOREN WERKE)

German firm noted for its automobile designs. Founded in 1916 by Karl Rapp and Gustav Otto as a manufacturer of aircraft engines, BMW began manufacturing motorcycles in 1923 and finally automobiles in 1929. Many of its products have been of outstanding design quality. The 2002 sedan of 1968–76, designed by BMW staff under the direction of Andreas Glas, was particularly admired for its logical and consistent design, free of meaningless ornament and with a unity of theme rare in automobile design. The 2002 and more recent BMW designs have become popular imports in the United States.

BOCCIONI, UMBERTO
See FUTURISM.

BMW 2002 sedan. Photo courtesy BMW of North America, Inc.

BOERI, CINI (b. 1924)

Italian architect and industrial designer. A graduate of the Milan Polytechnic in 1951, Boeri worked with Marco ZANUSO before establishing an independent practice in 1963. Her work includes lighting for ARTELUCE and Stilnovo and furniture for KNOLL. Her Lunario table of 1972, with its startlingly cantilevered glass top, is probably her best-known work, together with a modular sofa system of the same year. She also designed a showroom for Knoll in 1976. Boeri was the winner of a 1979 COMPASSO D'ORO award with another seating system titled Strips.

BOILERHOUSE PROJECT

Department of the VICTORIA AND ALBERT MUSEUM in London established in 1981 to concentrate on exhibitions, publications, and other educational activities relating to modern design. It was directed by Stephen BAYLEY from 1982 to 1986.

BOJESEN, KAI (1886–1938)

Danish craft designer of silver and woodenware products. Born in Copenhagen, Bojesen became an apprentice with Georg JENSEN in 1907. He established his own shop as a silversmith in Copenhagen in 1913 where his silver flatware and related stainless steel products moved toward a restrained, modern style. He also developed plain wooden objects and wooden toys of a simple but playful character. He was a strong influence in the establishment of the Copenhagen design center, DEN PERMANENTE, in 1931. Bojesen has won a number of design awards, including a gold medal at the 1954 TRIENNALE in Milan.

BOLEX

Brand name of the motion picture cameras produced by the Swiss firm of E. PAILLARD. In 1930 Paillard developed a camera using 16mm film instead of the standard 35mm film then universally used for motion pictures. The resulting smaller, lighter weight camera of high precision and quality was introduced in 1932. In various improved models it became a favorite camera for the serious amateur and documentary film producer and an admired design CLASSIC as well. Later, even smaller, 8mm Bolexes were introduced, also of high quality and excellent design.

BONET, ANTONIO (b. 1913)

Argentine architect best known in America for his role in the development of the HARDOY chair, a modern version of an earlier vernacular, folding, military campaign chair that was made into a steel-framed, canvas sling unit by Bonet, Juan Kurchan, and Jorge Ferrari-Hardoy

Bolex B-8L Compumatic, an 8mm movie camera.

around 1938. Bonet was born in Barcelona, worked in an architectural office there, and then spent two years in Paris working for LE CORBUSIER before moving to Argentina in 1938. His practice has included work in Uruguay and in Spain as well as projects in Argentina.

BONSIEPE, GUI (b. 1934)

Italian designer, teacher, and critic who was trained at the HOCHSCHULE FÜR GESTALTUNG at Ulm, Germany, and became influential through his role as a teacher of design there from 1960 to 1968. After the school closed, Bonsiepe relocated in South America where he published his 1975 book, *Teoria e Practica del Disegno Industriale*.

BOTTA, MARIO (b. 1943)

Swiss architect and designer who has attracted notice as a POST-MODERNIST though the simple rectilinear quality of his designs, which turn oddly disturbing through their eccentric departures from SYMMETRY and their strongly graphic use of color. Botta was trained at the Art College in Milan and at the architectural school in Venice. He opened his office in Lugano, Switzerland, in 1969. His reputation was established with a house at Liggornetto in the Ticino in Switzerland (1975–76), a convent library at Lugano (1976–79), and a cylindrical

house of striking appearance at Stabio, Switzerland (1980–81). His work (including unbuilt projects) has been widely exhibited and published, and he is a well-known lecturer. His arm and armless chairs of 1983 have made his work in furniture visible worldwide.

BOUÉ, MICHEL (1936–1971)

French automobile designer. Boué's brief career with the French manufacturer Renault centered on the development of the Renault 5, or R5 (known in the United States as Le Car) in 1972, an economical front-wheel-drive compact car of simple and logical form. The design is notable for its consistency and unity, a reflection of its development by a single person of exceptional talent.

BOULANGER, PIERRE (1886–1950)

French engineer who became chief of the CITROËN automobile firm in 1935. He was the person responsible for the development of the Traction Avant, 2CV, ID, and DS models that made Citroën the leader in innovative automobile design from the 1930s until recent years. It is said that Boulanger's insistence that the driver's seat of the DS accommodate him wearing a hat (and he was tall) led to the exceptionally spacious design of the car's interior.

Prima and Seconda chairs designed by Mario Botta. Photo courtesy of International Contract Furnishings, Inc.

BOYER, WILLIAM F.
American automobile designer. Boyer is one of several designers with the Ford Motor Company STYLING studios who has been credited with a major role in the development of the body design of the Ford THUNDERBIRD (known to auto enthusiasts as the "T-Bird"). This product showed it could be commercially successful to mass produce a car with sports car attributes.

BRADLEY, WILL H. (1868–1962)
American graphic artist and designer known for work closely allied to the ARTS AND CRAFTS movement. Bradley was born in Boston and became a professional wood engraver with a studio in Chicago established in 1883. He became known as a designer of magazine covers and posters and in 1901 and 1902 published interior and furniture designs in the *Ladies' Home Journal* illustrated by his own drawings. His work suggests the traditions of Charles Rennie MACKINTOSH and C.F.A. VOYSEY in Britain and was influential in making their styles known in America as an aspect of the CRAFTSMAN movement. In the later years of his career he worked as a typographer and became art director for the Hearst publishing empire in 1915. He retired in 1930 from active creative work.

BRANCUSI, CONSTANTIN (1876–1957)
Romanian sculptor whose work with simple, abstract form has become a major presence in the art of the 20th century and a significant influence in the forms of MODERN design. Brancusi studied at the Bucharest Academy of Fine Arts before relocating in Paris in 1904, where he studied for a time at the École des BEAUX-ARTS. His work rapidly moved toward simplification and abstraction, with a reclining human head changing from an abstracted but still recognizable form in *Sleeping Muse* of 1909–10 to the egglike simplification of *The Newborn* by 1915. The famous *Mlle. Pogany* (1931) is an ovoidal version of a head in polished marble, while the 1919 *Bird in Space* is a bladelike form in gleaming bronze. Brancusi's sculpture often suggests the geometric perfection of mechanical parts and so has offered a link between the expressive aesthetic of fine art and the forms typical of industrially produced products. His three-dimensional forms and perfectly polished surfaces have made him a "designers' sculptor."

BRANDT, MARIANNE (b. 1893)
German designer and teacher whose career began at, and is closely associated with, the BAUHAUS. Brandt studied painting at Weimar before becoming a Bauhaus student in 1923 and instructor in the metalworking shop in 1924, which was run by László MOHOLY-NAGY. Her metal teapot of 1924 and various lamp and light fixture designs have become well-known examples of Bauhaus design ideals. From 1949 until 1951 she was a teacher of industrial design at Dresden and from 1951 to 1954 in Berlin. Her teapot is in the collection of the MUSEUM OF MODERN ART in New York and can also be purchased there in reproduction.

BRANZI, ANDREA (b. 1928)
Italian architect and designer who was a member of the Florentine group ARCHIZOOM ASSOCIATI in the late 1960s. Relocating in Milan, he worked with STUDIO ALCHYMIA in 1979 and developed designs introduced by MEMPHIS. He is a teacher at the Domus Academy and edits the magazine *Modo*.

BRASS
Alloy of copper and ZINC. Its hardness makes it suitable for many mechanical parts that require precise form, while it is soft enough to make machining relatively easy. Brass does not rust, but corrodes unless kept polished or protected by a coating of lacquer. Brass hardware is widely used in marine and architectural applications, for piping, and for instrument and mechanical parts. The bright appearance of polished brass has also made it popular as decorative trim on furniture and other products.

BRAUN
German manufacturer of electrical and electronic products known for its support of outstanding modern design. The firm was founded in 1921 in Frankfurt to produce small electrical appliances, radios, and phonographs. After founder Max Braun's death in 1951, his sons took over the business and, with the particular interest of Artur Braun (b. 1925), introduced a design program supporting the puristic and minimalist style that had its origins in BAUHAUS theory and was typical of the work from the HOCHSCHULE FÜR GESTALTUNG at Ulm. The designs and ideas of Dr. Fritz EICHLER and Hans GUGELOT, recruited from the Hochschule, made the Braun product line a

Braun automatic coffee maker and coffee grinder. Photo courtesy of Braun, Inc.

showcase of advanced German product design. Reorganized as Braun AG, the firm introduced electronic flash units, Nizo moving picture cameras, electric shavers, and a variety of kitchen appliances, all of outstanding design quality. In addition to Eichler and Gugelot, Otl Aicher, Dieter RAMS, and other distinguished German designers were employed on various products. In 1964, the MUSEUM OF MODERN ART in New York devoted a special show to Braun products and the Audio 1 hi-fi unit received a Milan TRIENNALE gold medal. Braun advertising, graphic, packaging, and exhibition design

have been at a generally high level, matching the quality of the product design program.

In 1967, controlling interest in Braun was acquired by the Boston-based American Gillette Company. Braun products continue to set a high standard that engages the admiration of design professionals, teachers, and critics worldwide. Public acceptance has been excellent internationally, undermining the myth that public taste resists design excellence. Many Braun products are available in the United States, but some, notably radio and hi-fi equipment, are not, because Braun has not estab-

lished adequate distribution and service arrangements. Among manufacturing companies, Braun remains one of a very short list (no more than eight or ten) that maintains a consistently high level of design in every aspect of their activities.

BRAY, ROBERT (b. 1942)

American interior designer practicing in the partnership of BRAY-SCHAIBLE in New York. Bray was born in Oklahoma and studied engineering at Oklahoma State University. He met Michael SCHAIBLE at the PARSONS SCHOOL OF DESIGN where he studied interior design. After working in several large design offices, Bray entered into practice with Schaible in 1969.

BRAY-SCHAIBLE

American interior design partnership formed in 1969 by Robert BRAY and Michael SCHAIBLE in New York. The firm's work includes both residential and business interiors. Their First National Bank of Hialeah, Florida, of 1974 is a good example of their style, with smooth, simple surfaces, and strong accent colors. The work of the firm tends toward MINIMALISM, but its formal austerity is relieved by the use of rich materials, textures, and colors.

BRAZING

Process for joining nonferrous metal parts by soldering with an alloy that melts at a temperature lower than that which melts the metals being joined. Brazing is commonly used to join parts of ALUMINUM, BRASS, and copper, all important materials in 20th-century designs, although the joint produced is generally less strong than will result from WELDING (where the metals being joined are melted so that they fuse together).

BREER, CARL (1883–1970)

American automotive engineer best known for his role in the development of the AIRFLOW CHRYSLER of 1934. Breer was trained as an engineer at Throop Polytechnic Institute and at Stanford University in California graduating in 1909. In the 1930s Breer was chief engineer for Chrysler when a decision was made to produce an advanced model that would incorporate knowledge of STREAMLINING gained from aeronautical engineering. The Airflow Chrysler (and the smaller, similar De Soto) incorporated various other technical innovations, but it was the unconventional appearance of the car that attracted the most attention. The attention was often not favorable, however, and the Airflow models failed to gain wide popularity. Breer's work is remembered as bold and pioneering, but possibly ahead of its time in terms of public acceptance. He remained active in engineering aspects of Chrysler design until his retirement in 1951.

BREUER, MARCEL (1902–1981)

Hungarian-born designer and architect associated with the BAUHAUS and the spread of its design concepts. Breuer was born in Pecs, Hungary, and studied at the Vienna Academy of Art before taking up study at the Bauhaus in 1920. In 1926 he became the master of interior design, working on actual interior projects and on related furniture designs. His early wood furniture is strongly reminiscent of DE STIJL designs, but his discovery of the possibilities of steel tubing initiated his production of such famous design CLASSICS as the tubular WASSILY CHAIR of 1925 and the various tubular side chairs of 1925–28, including the CANTILEVER-seat CESCA CHAIR still in production by KNOLL and a number of imitators.

After the closing of the Bauhaus in 1933, Breuer moved to England where he developed furniture designs in plywood for Isokon, but turned increasingly to architectural practice. In 1937 he came to the United States, invited by Walter GROPIUS to join him at Harvard as a professor of design. Breuer and Gropius also established a partnership as architects and produced a number of distinguished examples of modern work, among the first in America. In 1946, Breuer established his own architectural office in New York with Herbert Beckhard, Robert Gatje, and Hamilton Smith as partners. In 1949 Breuer was asked to build a demonstration modern house in the garden of the MUSEUM OF MODERN ART in New York. A handsome example of MODERNISM in residential design, it was seen by a large public.

Breuer's own house in New Canaan, Connecticut, of 1947 was one of a large number of residential projects combining INTERNATIONAL STYLE modernism with the use of varied, often natural materials (especially stone and wood) in a strongly expressive and personal way. Breuer's office received an increasing flow of larger building commissions from the 1950s onward, including the UNESCO headquarters in Paris (1953), with Zehrfuss and NERVI; an IBM research center at La Gaude, France (1960–61); the HUD headquarters in Washington, D.C.

Interior of the living room of the Neumann house in Croton-on-Hudson, New York, a 1953 design by Marcel Breuer.
Photo courtesy of Marcel Breuer & Associates, Architects.

(1963–68); the Priory of the Annunciation and Mary College at Bismarck, North Dakota (1954–68); and the WHITNEY MUSEUM OF AMERICAN ART in New York (1963–68), which, with its massive forms in concrete, hints at the direction called "brutalism" and is probably his best-known work. Since his death, Breuer's associates have carried on his firm under the name MBA, Architects and Planners.

Of all his works, it is probably the chairs that he designed in his Bauhaus days which make Breuer's work widely familiar. Once considered excessively mechanistic and avant-garde, they are now accepted as comfortable, useful, and economical classics suitable for use in the widest possible variety of home and public interiors.

BREWER, CECIL (1894–1972)

British architect who was an influential member of the DESIGN AND INDUSTRIES ASSOCIATION (DIA), an English organization founded in 1915 after the example of the DEUTSCHER WERKBUND. Brewer was the architect of the store in Tottenham Court Road operated by Ambrose Heal, an early backer of MODERNISM in home furnishings. The building was, for its time (1916), quite modern in concept. Brewer was described in a 1951 DIA *Year Book* as a man

of "austere intellectual skepticism." It was his role in making British industry aware of the effectiveness of the German Werkbund that made the DIA an effective force in promoting design excellence in England.

BRIONVEGA

Italian manufacturer of radio, television, and high-fidelity products. Founded in the 1940s in Milan, the firm has become known for its sponsorship of advanced product design by a number of Italy's best-known designers. Well-known BrionVega products include the 126 phonograph of 1966 by Achille CASTIGLIONI, the Black 201 television set of 1969, and the hinged portable radios of 1964 and 1965. The last products, designs of Richard SAPPER and Marco ZANUSO, are in the design collection of the MUSEUM OF MODERN ART in New York.

BRODOVITCH, ALEXEY (1898–1971)

Russian-born art director, graphic designer, and teacher with major influence in the United States. Born in Ogolitchi, Russia, Brodovitch came to the United States in 1930 to take up a design career. From 1934 to 1956 he was art director of *Harper's Bazaar* magazine, a post in which his own design and his influence on other designers and photog-

raphers was extensive. His use of strong photographic images, emphatic typography, simple layout with generous white space characterized his innovative style.

He continued in practice as a consultant after leaving *Harper's Bazaar* until his retirement in 1967. Classes he conducted in design and photography were attended by many younger designers and photographers, who looked toward him as their mentor. The character of the American fashion magazine and of modern fashion photography was largely molded by Brodovitch.

BRONZE

Alloy of copper and ZINC or tin, developed in ancient times, that is, during the Bronze Age (c. 2500 B.C.–500 B.C.). Bronze is most often used for CASTING and is a favored material for sculpture. Its normal brown color is stable against rust or corrosion, making it useful for such details of architectural trim as door and window frames. Design of the ART DECO era made frequent use of decorative details in bronze. An unusual and striking use in MODERN architecture is the exterior metal of the curtain walls of the Seagram Building in New York by Ludwig MIES VAN DER ROHE.

BRUTALISM (OR NEW BRUTALISM)

Term first used in the 1950s by British architectural critics to describe an aspect of MODERN architectural design that emphasizes massive forms, usually constructed of REINFORCED CONCRETE with its rough surfaces left exposed. Much of the later work of LE CORBUSIER is often referred to as brutalist. The term is applied to the work of such architects as Paul Rudolph in the United States or Kenzo Tange in Japan that display similar characteristics.

BRUYÈRE, ANDRÉ (b. 1912)

French architect and designer of furniture and other objects of a highly individualistic character. Bruyère's designs for furniture, lamps, and small objects have an almost surrealistic quality of personal expression within the vocabulary of MODERNISM, but contain a sculptural quality unique to his work. A stand holding a large magnifying lens placed for viewing a rock and a washbasin of marble with negligible depth for holding water are typical examples of his often eccentric works.

BUEHRIG, GORDON M. (1904–1990)

American automotive designer of the 1930s. He studied at Bradley Polytechnic in Peoria, Illinois before becoming an apprentice in the auto body shop of Gotfredson Body Company in Detroit in 1924. Buehrig was the designer ("stylist") for the Auburn Automobile Company when that company's president, E.L. Cord, decided to introduce a new, luxury car bearing his name. The CORD 810 of 1936 and the 812 that followed are outstanding examples of Buehrig's work and remain greatly admired CLASSICS, still valued by collectors of antique automobiles.

BUGATTI, CARLO (1856–1940)

Italian designer of furniture in both wood and metal. Bugatti was born in Milan and began work in furniture design there in 1880. In 1888 he established a workshop in Milan, producing work that won a medal in the Paris Exhibition of 1900. By 1904 he had moved to Paris to devote his career to painting. He continued to produce silverware for the table as well as furniture of a highly original and often eccentric character based to a degree on ART NOUVEAU combined with a hint of FUTURISM. Bugatti's son Ettore and grandson Jean kept the Bugatti name important in Italian design for three generations.

BUGATTI, ETTORE (1881–1947)

Italian designer, the son of Carlo BUGATTI, primarily known as a designer of automobiles. Ettore Bugatti, at one time or another, built cars in Italy, Germany, and France. His products included both racing and sports cars and luxury sedans, such as the legendary Type 41 Royale, a massive vehicle of great elegance. Bugatti's greatest contribution was in the technical and engineering design of engines, but the appearance of many of his cars—even the appearance of their mechanical components—was remarkably sophisticated. A picture of a Bugatti motor appears in LE CORBUSIER's *Vers une architecture* of 1923.

BUGATTI, JEAN (1909–1939)

Italian-born designer and son of Ettore BUGATTI, who joined in his father's career as a designer of sport and luxury automobiles. The Type 57 Bugatti of 1934, built in both sedan and open touring versions, is largely his work. His streamlined railcars for the French state railways (also of 1934) are among the earliest examples of modern railroad equipment produced in Europe. Bugatti died in an accident while testing a streamlined version of the Type 57.

BUNSHAFT, GORDON (b. 1909)

American architect who was the partner in the large firm of SKIDMORE, OWINGS & MERRILL (SOM) credited with the design of a number of that firm's most distinguished glass wall and steel buildings. Trained at MIT, Bunshaft worked briefly for Edward Durrell STONE before joining Skidmore, Owings & Merrill where he became a partner in 1949. He was the partner in charge of design for such major SOM projects as Lever House (1951–52), the Pepsi-Cola Building (1959) and the Chase Manhattan Bank headquarters (1961), all in New York; the U.S. Air Force Academy (1956–62) at Colorado Springs; and the Beinecke Rare Book Library (1964) on the Yale campus in New Haven, Connecticut. The Bunshaft aesthetic has generally been austere and mechanistic; seemingly he drew on Ludwig MIES VAN DER ROHE as a major inspiration. His role in raising SOM's work to a high level of design quality was much praised in the 1950s and 1960s, although more recently in the 1980s, this work has also been criticized for a certain coldness and monotony.

BURDICK, BRUCE (b. 1933)

American industrial designer best-known for an innovative system of office furniture and for work in exhibit design. Burdick studied architecture at the University of Southern California and received his degree in industrial design from the ART CENTER COLLEGE OF DESIGN in 1961. While still a student, he worked for a time in the office of Charles EAMES and then for John Follis and Herb Rosenthal before opening his own office in 1970 in Los Angeles and moving in 1977 to San Francisco. As an exhibition designer, Burdick has produced permanent exhibits for the Chicago Museum of Science and Industry, a number of traveling exhibits, and work for the San Francisco Zoo, including a Primate Educational Center. As a furniture designer, his major work has been the development of the Burdick Group for HERMAN MILLER (1980), a system using many separate work surface and storage components that can be assembled in varied configurations on a "backbone" support armature. The system has received several awards, including a Time magazine "Best of 1981" industrial design award. In 1986 Burdick received an INDUSTRIAL DESIGN magazine award for new directions in the design of zoos.

BURGEE, JOHN (b. 1933)

American architect known for his partnership with Philip JOHNSON. Burgee received his architectural education at Notre Dame University in Indiana and worked for the Chicago firms of Holabird and Root and Naess-Murphy before collaborating with Johnson on a 1965 project. The relationship led to a Johnson/Burgee partnership in 1967. Many major projects often viewed as Johnson designs are in fact the work of this partnership—for example, Pennzoil Plaza in Houston, Texas (1972–76), the AT&T Building in New York (1985), and the elliptical office tower at 53rd Street and Third Avenue in New York often called the Lipstick Building in reaction to its shape. Since 1987, the firm has been called John Burgee Architects to reflect Johnson's current role as design consultant while Burgee, with two partners, has primary responsibility for the firm's operation.

BURGESS, W. STARLING (1878–1947)

American naval architect and designer of sailing yachts known for his successful designs for racing craft, including several winners of America's Cup races. His father, Edward Burgess, was a self-taught naval architect with a Boston practice. Starling Burgess was educated at Harvard and served in the Spanish-American War before setting up a ship-building yard at Marblehead, Massachusetts, in 1905. He was, in 1910, the designer of the first successful airplane built in New England and, shortly after, of the first successful flying boat. His design for the 59-foot schooner Nina of 1928 was a great success in racing in both American and British waters and established his reputation as a master designer of fast sailing craft. His most famous designs were Enterprise (1930), Rainbow (1934), and Ranger (1937); the last designed in collaboration with Olin STEPHENS. All three were America's Cup winners. Burgess was largely responsible for establishing the characteristic design of the modern racing sailboat, with its extraordinary aesthetic qualities, both as seen under sail and in the "lines" of the hull, which are normally hidden below the water surface.

BURNETT, WILLIAM ("BILL")

American automobile designer who was one of several staff members at the FORD Motor Company credited with a major role in the development of the 1956 Ford THUNDERBIRD. The T-Bird, as it came to be called, was successfully marketed in 1955 in an effort to produce an American sports car competitive with European designs.

BURNS, AARON (b. 1922)

American graphic designer and typographer. Burns worked as an assistant to Herb LUBALIN and was a leading typographic designer for The Composing Room, a New York type house, from 1952 to 1960. His book *Typography* (1961) is a recognized, authoritative text in the field. He was, in 1970, a co-founder with Lubalin and Ed Rondthaler, of the INTERNATIONAL TYPEFACE CORPORATION (ITC), and an important influence in modern TYPOGRAPHY, commissioning the redrawing of many traditional TYPEFACES and new designs by leading modern typographers such as Matthew CARTER and Herman ZAPF. From 1971 to 1977 Burns and Lubalin edited and produced *U&lc*, a respected tabloid magazine (still in circulation) dealing with typography and its role in modern graphic design.

BÜROLANDSCHAFT

German term, often translated as "office landscape," for office planning and design according to theories developed in the 1960s by Eberhardt and Wolfgang SCHNELLE of the QUICKBORNER TEAM in Hamburg. All partitioning is avoided with limited privacy provided by movable screens. Workstations are organized and placed on the basis of a careful analysis of communication processes, and layout is designed in a free nongeometric scatter. The extensive use of plants in large, open spaces led to the term "landscape." The concept has come into extensive use in the United States, generally in a somewhat modified form described by the term "open office planning."

BURTIN, WILL (1908–1972)

German-born graphic designer and exhibition designer with a distinguished practice in the United States. Born in Cologne, Burtin trained and practiced in Germany until 1938 when he came to New York. He produced wartime exhibition and graphic design for the U.S. Army Air Corps before becoming art director of *Fortune* magazine in 1945. His work in advertising and graphic design drew special notice when he became a consultant designer to the Upjohn pharmaceutical company in 1948. His packaging and graphics for Upjohn set the style of austere modern graphics widely emulated by other pharmaceutical companies. Other clients included Eastman Kodak, Union Carbide, and the Smithsonian Institution. He also produced exhibition design for Upjohn, including a gigantic walk-in model of a single cell (1958) that drew much favorable attention from the design community.

Typical Bürolandschaft, office "landscape" or plan, developed by the Quickborner Team. Drawing courtesy of Quickborner Team.

BURTON, SCOTT (1939–1989)

American artist-furniture designer whose work is conceived of as abstract sculpture, possibly as theatrical or outdoor seating as well. Burton's pieces are generally massive, solid stone blocks, often simple to the point of MINIMALIST, but sometimes with faces of rough-hewn rock. A table of 1978–81 is of translucent onyx, illuminated from within by fluorescent light. Burton chairs were included in the WHITNEY MUSEUM *High Styles* exhibition of 1985, and a pair of chairs, each of massive blocks of gneiss, were acquired by the MUSEUM OF MODERN ART in New York for its collection.

BUTTERFIELD, LINDSAY PHILIP (1869–1948)

English designer of textiles and wallpapers suggesting a late manifestation of the ARTS AND CRAFTS movement. The work of Butterfield (and of C.F.A. VOYSEY) was a major design influence for a number of manufacturers including LIBERTY's. Butterfield's book *Floral Forms in Historical Design* (1922) is an important reference largely based on designs in the collections of the VICTORIA AND ALBERT MUSEUM.

CAD

Popular acronym for "computer-aided drawing" and "computer-aided design." The development of compact and inexpensive computer equipment in the 1960s and the availability of programs for computer design and drafting have made CAD techniques increasingly popular. Designs and drawings are developed on a computer CRT screen, where revision is easy and the creation of various perspective views virtually automatic and instantaneous. Hard copy is printed on paper by a printer or plotter as needed. CAD techniques are now in general use in engineering and architectural offices, and their use is increasing in interior and industrial design firms. While CAD has demonstrated its ability to augment and even replace conventional drafting in many applications,

Scott Burton, Rock Chairs (A Pair), *1980–81, gneiss, 49⅜" x 36" x 47" (first), 44" x 46" x 74" (second).* Collection, The Museum of Modern Art, New York, acquired through the Philip Johnson, Mrs. Joseph Pulitzer, Jr., and Robert Rosenblum Funds.

Interior perspective drawing produced by a CAD (Computer-Aided Design) program. Photo courtesy of Skidmore, Owings & Merrill.

skill in drawing will remain an important element in architects' and designers' professional practice for the foreseeable future.

CADOVIUS, POUL (b. 1911)

Danish designer and manufacturer of furniture and furniture systems. Cadovius heads Cado Design A/N, a large manufacturing organization that produces many of his own designs and those of other Danish designers as well. His best-known and most successful group is the Royal System of 1945 and the related System Cado, versatile groups of "wall systems" that combine shelving and storage units in any desired arrangement with vertical supports making up a storage wall or room divider. Cadovius's designs for these products use wood and attractive details to create a soft or "warm" character that has proven appealing to residential users in many parts of the world who value the DANISH MODERN style. His ABSTRACTA system, in contrast, uses metal tubular supports and metal connectors to generate assemblies better suited to display and other commercial applications with an INTERNATIONAL STYLE character. Cadovius's firm is based at Svendborg, while he lives and maintains a display in an old farmhouse estate called "Christianhus" near Horsholm, Denmark.

Cadovius designs have won many awards, including a medal at the Milan TRIENNALE in 1957 and a gold medal at the Brussels WORLD'S FAIR in 1961.

CALDER, ALEXANDER (1898–1976)

American sculptor known for the MODERN "mobiles" and "stabiles" that he invented. Calder was the son and grandson of American sculptors who worked in the academic tradition of their times. He was trained as a mechanical engineer at Stevens Institute in Hoboken, New Jersey, and studied painting at the Art Students League of New York. He began to make wire figures and toys in 1925 and, during a 1926–31 stay in Paris, became known for his tiny circus of animated wire figures. Many leaders of the avant-garde Paris art scene, including Jean ARP, Fernand Leger, Joan Miró, Piet MONDRIAN, and Theo VAN DOESBURG, visited Calder to see his circus, thus establishing his connections to the DADA and Surrealist movements of the day. Around 1930 he began to make more abstract sculptures using wire or metal rod links to hold metal vanelike forms in clusters that were balanced so as to permit movement when suspended from the ceiling. These were the mobiles that became his special

contribution to the development of modern art. By the mid-1930s he was also making stabiles— large sculptures using abstract forms of metal similar to those of the mobiles, but fixed in place. Calder also produced drawings, watercolors, illustrated books, and jewelry that usually included articulated parts suggestive of his mobiles. A major retrospective exhibit of his work at the MUSEUM OF MODERN ART in New York (1943) led to the highly successful late phase of his career in which he received many commissions, often for giant mobiles or stabiles to be used in architectural spaces, both indoors and out.

Calder's work had a playful quality in its forms, in its use of color, and in the mobiles' incorporation of movement, which made it acceptable to a wide, popular audience, while it remained valued as a major contribution to the development of artistic modernism. His sculpture was particularly popular among modern architects who appreciated the way in which a Calder could set off and enliven the often austere forms of much modern architecture. Calder forms and the concept of the mobile were taken up in the fields of industrial and advertising design and continue to appear, sometimes in sadly cheapened form, but often as a lively stimulus for design directions of genuine validity.

CALLAHAN, HARRY (b. 1912)

American photographer known for his design-oriented abstract images. Callahan was self-taught as an amateur photographer, and eventually began working as a lab technician and professional photographer for Chrysler and GENERAL MOTORS in Detroit. As an independent photographer, his work has been widely exhibited and published. His subjects are usually commonplace, but are treated with a carefully planned dignity that gives them a quality of abstract timelessness. From 1961 to 1973 he was chairman of the photography department at the RHODE ISLAND SCHOOL OF DESIGN. He continued as a teacher there until his retirement in 1977.

CAMBER

Term borrowed from naval architecture and shipbuilding which refers to a slight upward curvature of arching that is commonly used on the decks of a ship to aid in draining off water. The term is now used in the design professions to describe the slight upward arching of a beam to cancel out downward deflection; the curve of the upper surface of an airplane wing or other airfoil; and the inward tilt given to the front wheels of an automobile.

CAMBRIDGE SEVEN ASSOCIATES

Architectural and design firm based in Cambridge, Massachusetts, with a New York office as well, which was founded in 1962 by seven partners including Louis Bakanowsky, Peter Chermayeff, Paul Dietrich, and Terry Rankine, professionals with varied interests who extended the work of the firm to include interior, industrial, graphic, and exhibit design as well as work in urban planning. The special interest of Cambridge Seven Associates in graphic and exhibition design has brought it projects relating to museum and display installations and to transport systems and facilities. Major projects have included an overall design program for the Massachusetts Transit Authority; aquariums in Baltimore, Boston and Denver; a number of museum exhibit projects; and such major exhibit assignments as the U.S. Pavilion at Expo 67 in Montreal, which was housed in one of Buckminster FULLER's GEODESIC domes. Other work has included hotels, shops, and banks. The Baltimore Aquarium, with its strongly geometric exterior forms, its complex internal escalator circulation, and its lively graphic elements, is an outstanding example of the firm's blend of architectural, exhibition, and graphic design skills.

CANDLEPOWER

Basic unit of light intensity used in the systematic design of lighting. Candlepower is defined as light output equal to that of a standard candle of specified dimension and composition. Light from early electric lamps was commonly rated in candlepower (Edison's early bulbs, for example, delivered 16 candlepower) before rating by wattage became usual. The footcandle, now used as the unit of measurement for illumination, is the light level that a one candlepower light source delivers to a surface at a distance of one foot.

CANTILEVER

Projecting or overhanging beam or other element supported only at one end. The use of STEEL and REINFORCED CONCRETE in architecture has made cantilevers relatively easy to construct, so that they have become a common feature of modern buildings. LE CORBUSIER's Unité apartments at Marseilles and the Citibank

headquarters in New York by Hugh Stubbins are buildings that make striking use of cantilever construction. Cantilever construction is also used in smaller products such as the familiar CESCA CHAIR (often referred to as a cantilever chair), designed by Marcel BREUER in 1928.

CARDIN, PIERRE (b. 1922)

French fashion designer (born in Venice) who has expanded his activities into a wide variety of design fields with licensing to some 500 firms in 93 countries. He was apprenticed to a tailor before World War II and after the war worked for several Paris fashion houses before spending three years with the House of DIOR. He opened his own firm in 1953. His early work focused on traditional suits and coats, but by the 1960s he had become an innovator, using big patterns with references to the OP art of the day. He has been a key figure in turning the concept of haute couture into a commodity for the mass-market, applying a name and monogram to a range of goods, often with only tenuous connections to fashion design. Perfumes, luggage, men's fashions, and wigs, among other items, all bear his label. His work has included interior design for restaurants and aircraft along with a continuing flow of fashion apparel products.

CARNEGIE-MELLON UNIVERSITY

American institution offering design training through its College of Fine Arts. The school was founded in 1900 with the support of the millionaire industrialist and philanthropist Andrew Carnegie as a school of technology related to the heavy industries of the Pittsburgh, Pennsylvania, area where it is located. In 1911 its College of Fine Arts was created, offering courses in architecture and music. The present structure includes a division of environmental arts, with programs divided into architecture and design (graphic and industrial design). The divisions of performing arts and visual arts offer majors in those fields. The first degree-granting program in industrial design in America was established in 1935 at Carnegie Institute of Technology, as it was then known, under the direction of Donald Dohner. The program became a prototype for similar offerings at PRATT INSTITUTE and thereafter at other American design schools.

CARTER, MATTHEW (b. 1938)

American designer of TYPEFACES whose most visible work is the Bell Centennial used in most American telephone books. Carter was born in England, but works in Cambridge, Massachusetts, as a vice-president of Bitstream, Inc., a computer-based type house.

CARTIER-BRESSON, HENRI (b. 1908)

French photographer known for his realistic images that capture fleeting relationships in a way that is both documentary and expressive. Cartier-Bresson studied painting before becoming involved in photography and film making in the 1930s. His first published work appeared in *Vu* magazine and his career was, for a time, that of a photojournalist. A LEICA user throughout his career, he has exploited the ability of the miniature camera to catch people in life situations, in movement or action within settings so as to suggest complexity and meaning through a single image. The title of his book, *The Decisive Moment* (1952), is a particularly apt summation of his unique point of view. Although he is often considered to be primarily devoted to realities that are architypically French, he has also worked in India, China, and the USSR with equal success. Throughout a very long career, Cartier-Bresson has been able to produce work that maintains an equal level of excellence whether as photojournalism, as documentary photography, or as an aspect of MODERN art that combines realism with a touch of the surreal.

CASHIN, BONNIE (b. 1915)

American fashion designer whose sweaters and related designs tend to have an informal "California" flavor. Cashin studied painting at the Art Student's League in New York and then in Paris before returning to her native California to design costumes for films at Twentieth-Century Fox. Her 1944 costume for Gene Tierney in *Laura* established her fame. In 1949 Cashin returned to New York to found her own firm, with her designs following an independent and informal direction using sturdy materials in natural and bright colors, often with leather and brass trimmings. In 1953 she undertook a collaboration with manufacturers Phillip Sills and Ballantyne, producing sportswear in classic, simple forms. Cashin was the winner of a 1950 Neiman-Marcus Award and a 1961 Coty Award. She also heads a foundation, the Innovative Design Fund, dedicated to encouraging younger designers of fresh, utilitarian work in fashion fields.

CASSANDRE, A.M. (1901–1968)

Pseudonym taken by Adolphe Jean Marie Mouron, an outstanding French graphic artist

and designer. Cassandre was born in Russia and moved to Paris in 1915 to study at the École des BEAUX-ARTS. After 1922 he became well known for his advertising design, particularly a large number of posters in the ART DECO style. Many of his works advertise steamships, trains, and electrical appliances and symbolize the excitement of these modern developments through semi-abstract imagery. Cassandre was also active in stage design and as a typographer. His work, with its semi-abstract, simplified forms, has a continuing influence on contemporary graphic design.

CASSINA, CESARE (b. 1909)

Head of a prominent Italian furniture company known for its production of outstanding MODERN designs. Cassina comes from a family with a long tradition in craft furniture production. In 1927 he established the firm in Milan in partnership with his brother. After World War II, the Cassina firm produced the designs of such Italian modernists as Franco ALBINI, Mario BELLINI, and Gio PONTI. More recently the firm has added many CLASSIC designs including those of LE CORBUSIER, Charles Rennie MACKINTOSH, and Gerrit RIETVELD to its line. The firm remains a leader among design-oriented Italian manufacturers.

Drawing (partial section) of the Boalum table lamp designed by Livio Castiglioni and Gianfranco Frattini.
Drawing courtesy of Artemide Inc.

CASTIGLIONI, ACHILLE (b. 1918)

Leading Italian industrial and exhibition designer and architect whose work is typical of post–World War II Italian MODERNISM. Castiglioni was trained in architecture at the Milan Politecnico and began practice in partnership with his brother Piergiacomo in 1945. He has been a significant figure in the Milan TRIENNALE exhibitions and, with Piergiacomo, the winner of a number of COMPASSO D'ORO awards. His best-known work is in varied lighting devices for the Italian manufacturer Flos, but he has also designed glass, silver, furniture, and electronic devices for a number of Italian companies, including Alessi, BRIONVEGA, and Gavina.

CASTIGLIONI, LIVIO (1911–1979)

Italian designer best known for his work in lighting. After graduation from the Milan Politecnico in architecture, Castiglioni established a design firm in 1938 with his brother Piergiacomo, developing, among other projects, the Phonpla Model 547 of 1940, an all-plastic radio with an unusual sculptured form conceptually ahead of its time. His best-known work, developed with Gianfranco FRATTINI, is the Boalum table lamp of 1969, a flexible plastic hose of translucent material with many small light bulbs inside it, produced by ARTEMIDE. It may be coiled in any desired configuration at the user's whim.

CASTIGLIONI, PIERGIACOMO (1913–1968)

Italian industrial designer, a regular collaborator with his brother Achille. The middle of the three Castiglioni brothers was trained at the Milan Politecnico and then worked in partnership with his brother Livio from 1938–1940 and then with Achille after 1945. His work in modern lighting, furniture, appliances, and in architectural and exhibition design was largely produced in the latter collaboration.

CASTING

Manufacturing process in which a metal or PLASTIC material in liquid form is shaped by pouring into a hollow mold where it hardens into a solid. Metals are made liquid for casting by melting, while plastic resins are made to harden through the chemical action of a catalyst additive. Cast iron was one of the first commonly used metals in the Industrial Revolution of the 19th century. BRASS, BRONZE, and ALUMINUM are often used for casting small

hardware items and decorative trim, and special alloys (usually made largely of zinc) are in general use for DIE CASTING of small metal parts in automatic machines. Solid parts of plastic (often of clear acrylic) are also produced by casting in a mold.

CASTLE, WENDELL (b. 1932)
American craftsman-designer of furniture, often of unique, sculptural form. Trained in both industrial design and sculpture at the University of Kansas, Castle has combined these fields in his work. He carves tables and chairs from masssive blocks of wood made by gluing together smaller pieces, often of contrasting color and grain. Forms are generally smooth, organic, and curvilinear. In his most recent work, he has introduced decorative color and pattern in ways that hint at historic prototypes. Castle is a leading figure in the American Crafts Movement and also has been influential through the teaching workshop he has run since 1970.

CBS
(COLUMBIA BROADCASTING SYSTEM)
Broadcasting corporation that has exercised a strong influence on American graphic design through its consistent use and promotion of the work of a number of outstanding designers. William Paley as chairman and Frank Stanton as president of the broadcasting company were strong backers of visual graphics of outstanding merit both on the TV screen and in corporate printed materials. William GOLDEN, as art director, was responsible for the well-known "eye" TRADEMARK of c. 1955 still in use. He and Lou DORFSMAN (who took over as art director after Golden's death in 1959) produced a remarkable outpouring of printed materials, mostly for in-house use or with broadcasting sponsors and so rarely seen by the general public. Although not significantly involved in production of manufactured products, CBS is generally viewed as one of the most design-oriented of major American corporations.

CENTENNIAL EXHIBITION
WORLD'S FAIR of 1876 held in Philadelphia's Fairmount Park to celebrate the one-hundredth anniversary of the signing of the United States Declaration of Independence. Following the CRYSTAL PALACE exhibition by 25 years, the Centennial played a role in the United States similar to that of the 1851 exhibition in London. It celebrated the growth and success of the nation and did so with many exhibits that also hailed the coming of mechanization in industry. Many of the objects displayed typified the extremes of overornamentation characteristic of Victorian taste, but others, such as the giant Corliss steam engine that dominated Machinery Hall, pointed to the functional direction that was, eventually, to lead to MODERNISM. The Centennial lacked any architectural monument to equal the Crystal Palace, and its many buildings included examples of ornate classicism, such as the surviving Memorial Hall, and of iron and glass functionalism (albeit with touches of Moorish decoration) in Horticultural Hall. The many small pavilions and display buildings in widely varied style pointed the way to more recent World's Fairs.

CENTER FOR ENVIRONMENTAL STRUCTURE
See ALEXANDER, CHRISTOPHER.

CENTURY OF PROGRESS EXHIBITION
Chicago WORLD'S FAIR of 1933–34, a major showcase of both ART DECO and MODERN designs in architecture and industrial design. Its role as the first publicly accessible showcase for modernist directions was of major significance. Although it occurred at a low point in the Great Depression, the Century of Progress Exhibition included many elements pointing toward future optimism. Architecturally, the fair leaned on established figures, including Paul CRET and Raymond HOOD, who tended toward Art Deco motifs, often using bright colors, stimulated by the involvement of Joseph URBAN. Also present were many more adventurous, smaller projects such as the *House of Tomorrow* designed by George Fred Keck, a steel and glass octagon complete with airplane hangar for the predicted family plane. Buckminster FULLER's DYMAXION automobile and the Burlington Zephyr railroad train were first seen at this fair. Critics from the historicist Ralph Adams CRAM to the still-controversial modernist Frank Lloyd WRIGHT tended to offer negative comments, finding the fair either too advanced or not advanced enough.

CESCA CHAIR
Design CLASSIC of the BAUHAUS era (1928) by Marcel BREUER. This metal tube CANTILEVER design was derived from various prototypes of a year or two before. Mart STAM developed a similar design as early as 1926, which resulted in bitter debate over credit for origination of the

Cesca chair, designed by Marcel Breuer. Photo courtesy of Knoll International, Inc.

design concept. As it is now produced, the Cesca chair, with or without arms, is clearly Breuer's design. Its popularity and broad acceptance in modern contexts are a tribute to the long life of a design that was originally ahead of its time.

CHADWICK, DON (b. 1936)

American industrial designer best known for his work in furniture design. Chadwick earned a degree in industrial design at UCLA and worked for Victor Gruen, an architect, before he established his own practice in Los Angeles in 1964. His C- Forms office desk system of 1979 for HERMAN MILLER brought him into prominence, while his modular, curvable seating system, introduced in 1974 for the same manufacturer, is his best-known work. More recently, he has been a collaborator with Bill STUMPF in the Winona, Minnesota, firm of Chadwick, Stumpf and Associates working on the ERGONOMIC seating known as the Equa system.

CHALK, WARREN
See ARCHIGRAM.

CHANEL, GABRIELLE ("COCO") (1883–1971)

Leading French fashion designer. A British admirer encouraged her to set up a Paris shop in 1910. Chanel's social reputation as a favorite of the Paris avant-garde added to her fame as she designed costumes for Cocteau's *Antigone* (which also had sets by Picasso) and for

Stravinsky's ballet *Le Train Bleu*. Chanel's characteristic style was established during the 1920s, a style based on simplicity and neatness of a timeless sort. Two- and three-piece suits and the "little black dress" were favorite themes, with an emphasis on practicality and style. She was a designer of jewelry, both real and costume, often of massive and flamboyant form. Her Paris shop was closed during World War II, but reopened in 1954 and has continued to emphasize the same themes of style without undue pretension. Chanel was the winner of a Neiman Marcus Award in 1957. The famous perfume *Chanel No. 5*, with its simple and elegant packaging (and high price), remains one of the best-known products bearing her name. Karl LAGERFELD carries on the firm's design direction.

CHAREAU, PIERRE (1883–1950)

French designer and architect whose work of the 1920s and 1930s forms a link between ART DECO and the more purist architectural MODERNISM of the INTERNATIONAL STYLE. His best-known work is a Paris house of 1929–31 called *Maison de Verre* (House of Glass) designed in collaboration with Dutch architect Bernard Bijvoet. It uses steel framing and glass block in a way that seems to anticipate HIGH-TECH of recent years. Furniture Chareau designed is used along with tapestries by Jean LURÇAT.

As editor of the 1929 publication *Meubles*, he played a significant role in publicizing the work of many of the leading modernists of the time. Chareau came to the United States in 1939 and continued work in a generally Art Deco style that never received wide recognition.

CHEMEX
See SCHLUMBOHM, PETER.

CHERMAYEFF & GEISMAR

American graphic design firm in which Ivan CHERMAYEFF and Thomas GEISMAR are partners. The firm was founded in 1956 with Robert Brownjohn as a third partner and took its present name after Brownjohn left it in 1960.

CHERMAYEFF, IVAN (b. 1932)

Leading American graphic designer. Chermayeff came to the United States with his father, Serge CHERMAYEFF, in 1939. He studied at Harvard, the INSTITUTE OF DESIGN in Chicago, and Yale before becoming an assistant to Alvin LUSTIG in 1955. In 1956 he joined Thomas GEISMAR and Robert Brownjohn in a firm that

became, after Brownjohn's departure in 1959 CHERMAYEFF & GEISMAR. The firm's work has included trademarks, identity programs, and graphic design for such clients as the Chase Manhattan Bank, Mobil Oil Company, and Xerox. Chermayeff is also a partner in the related firm CAMBRIDGE SEVEN.

CHERMAYEFF, SERGE (SERGIUS IVAN) (b. 1900)

Pioneer modernist architect, designer, and educator. Chermayeff was born in Russia but lived in England from 1910 until 1940 when he relocated to the United States. In 1931 he established an architectural practice in England designing interiors for the BBC, stacking tubular chairs, and an EKCO radio case in plastic (1935), an early example of the creative use of a new material. His work followed the norms of INTERNATIONAL STYLE modernism with its functional logic and simplicity of form. From 1933 to 1936 he was a partner of Eric MENDELSOHN. The best-known work of the firm was the De La Ware pavilion at Bexhill, England. After coming to America in 1940, he has been influential as a teacher of design at Brooklyn College, The INSTITUTE OF DESIGN in Chicago (where he was president from 1946 to 1951), Harvard, and Yale. His writing and work are well documented in *Design and the Public Good*, a 1982 book edited by Richard Plunz.

CHROMA

Technical term in COLOR theory for the intensity, purity, or saturation of a color. In the MUNSELL color system, chroma is rated on a scale from 1 to 14, with the highest numbers indicating maximum saturation. Different hues reach maximum saturation at different number levels and at differing levels of value (from light to dark).

CHROMIUM

Metallic element used in making various alloys and a material for electroplating. Chromium (or "chrome") plating is a favorite way of surfacing STEEL since it protects against rust and creates a coating that can be polished to a mirrorlike reflective shine. Chromium is a very hard metal, making chromium plate a more durable alternative to paint as a surface treatment for steel and other metals such as the alloys used for DIE CASTING. Although the practical value of chrome plating is often quite important, its gleaming appearance is an equally important factor in its use on metal trim elements where the bright glitter of chrome provides bright, silvery accents. The excessive use of chrome-plated trim is an aspect of the STYLING of American automobiles that has been subject to much criticism by designers and design critics, though it remains a design device with strong popular appeal.

CHRYSLER BUILDING

New York Skyscraper, a key monument of the ART DECO phase of American architectural design. A 1930 design of architect William Van Alen, the Chrysler Building was, until the EMPIRE STATE BUILDING was constructed in 1931, the tallest building in the world, with a height of 1,048 feet. Its ornamentation with "gargoyles" fashioned after automobile radiator caps, its spectacular Deco lobby spaces with rich materials, geometric ornamentation, and decorative lighting, its setback forms, and stainless steel spike top makes it a striking example of the Art Deco architectural design of its time as well as one of New York's most famous landmarks.

CHWAST, SEYMOUR (b. 1931)

American illustrator and graphic designer. Chwast was a founding partner in 1954 in the New York PUSH PIN STUDIOS (now the Pushpin Group) with Milton GLASER and Edward Sorel. He remained with that firm until 1982. Moving away from the abstract modernism typical of graphic design of the 1940s, Chwast's work in posters, greeting cards, children's books, record covers, films, and packages introduced whimsical illustrative elements in a way that has had a strong influence on graphic designers of the 1970s and 1980s. In 1985 he received the Gold Medal of the AMERICAN INSTITUTE OF GRAPHIC ARTS, and his works are in the collections of many museums including the MUSEUM OF MODERN ART, the Smithsonian Institution, and the Library of Congress. In partnership with Steven Heller he formed Push Pin Editions, makers of various books on art and design including *The Left-Handed Designer* (1985), a survey of Chwast's work, and *Graphic Style: From Victorian to Post-Modern* (1988), a richly illustrated reference.

CIAM (THE INTERNATIONAL CONGRESS OF MODERN ARCHITECTS)

Organization founded in 1928 at Château de la Sarraz by a group of first-generation modern-

Seymour Chwast poster design for a Chwast retrospective exhibit at the Cooper Union Gallery in New York, 1986.
Courtesy of The Pushpin Group.

ists to advance the cause of MODERNISM within the architectural profession. Twenty-four leading architects, including LE CORBUSIER and Walter GROPIUS, were CIAM's founders, while Swiss historian Sigfried GIEDION acted as a spokesman for the organization in building up the now widely accepted history of the MODERN movement. From time to time organizational conferences served to maintain some degree of unity among the members from different countries despite many debates and conflicts. Urban planning was a subject of particular interest, but one that produced theoretical differences that were impossible to resolve. The organization dissolved after the 1956 meeting in Dubrovnik, Yugoslavia. Attempts by a group designated Team X to take over and carry on the work of CIAM have had only limited success.

CITROËN

French automobile manufacturer noted for its innovative technology and design. The firm was founded before World War I as an arms manufacturer, but after the war it turned to production of cars, introducing the Type A in 1919, the first popular, mass-produced automobile in Europe, designed by Jules Saloman. In 1934, Citroën introduced the first front-wheel-drive car, the Traction Avant model 7A, ahead of its competition in both engineering and design by many years. Pierre BOULANGER is credited with the design of the 2CV of 1939, a highly economical and practical four-seat car offering basic transportation in a functional and unusual boxy design. This design, with various improvements, remains in production and has en-

joyed enormous popularity in Europe where it has been the only major competition for the popular VOLKSWAGEN. In 1957 the extraordinary DS19 appeared, combining front wheel drive with a hydropneumatic suspension that eliminated springs and shock absorbers while offering superior comfort and handling characteristics. The fully AERODYNAMIC body form, with its "duckbill" hood and FASTBACK rear, was developed by Flaminio BERTONE, the Italian designer who aided in the development of the 2CV. Later models including the ID19 and the DS21 included minor variations and improvements, but the basic design was retained through 1975. More recent models including the SM, BX, and CX retain many innovative features, but have never attained the remarkably advanced status of earlier Citroën products.

CLASSIC

Term that has come into wide usage to describe design that has taken on a timeless quality transcending changes in taste and fashion. Automobiles, chairs, and various other products have come to be known as classics through a kind of consensus among critics, historians, and the public as to what objects, through both design excellence and timeliness, deserve a special status as representative of their time. The LINCOLN CONTINENTAL automobile and BARCELONA and CESCA CHAIRS are generally recognized as classics. More recent designs, such as the EAMES plywood chair, the VOLKSWAGEN Beetle, and the IBM Selectric typewriter, stand in an uncertain ground, potential classics not yet universally recognized as worthy of that status.

Citroën DS21 sedan of 1969. Photo by John Pile.

CLASSICISM

Design direction based on certain abstract principles of order and organization found in the AESTHETICS of the classical antiquity of Greece and Rome. Classicism may draw directly on the design of antiquity through the use of specific elements such as the ORDERS of architecture, or it may have a less specific basis in the use of concepts of SYMMETRY, BALANCE, and organization that were also characteristic of the most admired antique works. The term "neo-classicism" is often used to describe the revival of classical concepts in design as in the architecture of late 18th-century France when classical principles found new life in the work of architects such as Ange-Jacques Gabriel (1698–1782) whose Petit Trianon is a prime example of this direction.

COATES, WELLS (1895–1958)

English architect and industrial designer, one of the first practitioners of MODERNISM in Great Britain. Coates was born in Japan and studied engineering at McGill University in Montreal, Canada. In 1929 he moved to London where he took up architectural practice. His Lawn Road Flats of 1934 in London is his best-known building in the typically INTERNATIONAL STYLE idiom. In 1931 he founded Isokon with Jack Pritchard to manufacture furniture and other products of modern design in plywood. In 1933 he was among the founders of the MARS group, the English chapter of CIAM. As an industrial designer, he became known for furniture design using tubular steel and plywood in a BAUHAUS-related style. His best-known work is an EKCO radio (Model AD65) of 1934, a cylindrical table model of ART DECO character with a case of BAKELITE plastic. He was also the designer of a variety of other Ekco electrical products, of BBC radio studio interiors, and of aircraft interiors for British Overseas Airways Corporation.

COLANI, LUIGI (b. 1928)

German industrial designer known for his aggressively futuristic approach to design. Colani was educated in Berlin and Paris in painting, sculpture, and, later, AERODYNAMICS. His drawings of futuristically streamlined cars led to his development of a variety of racing and sports cars built as PROTOTYPES but never actually produced. Only the Colani GT Spider, a two-seat sports body for a VOLKSWAGEN chassis, was produced as a do-it-yourself FIBERGLASS kit. About 500 were sold from 1950 to 1960. More recent projects have included furniture designs, a design for a small TV set, and various designs for cars, trucks, and boats, all with typically Colani sweeping, curvilinear forms, often suggesting fantastic exaggeration of any possible reality. Other Colani projects have included shoe designs for Paris fashion houses and the "Drop" porcelain tableware line for the ROSENTHAL Studio-Linie, the winner of a 1972 Hanover Güte Industrieform award. Colani's concern for organic and ergonomic forms characterizes each of these projects.

COLLAGE

Technique of creating art or graphic works by assembling various material fragments and pasting them on a flat surface. Collage became a widely used technique for the production of abstract works of MODERN art during the 1920s and has continued as a significant alternative to painting used by many artists. Typical collage materials are colored papers, fragments of cloth, wood, or other materials, and bits of printed material or actual objects, often cut or torn before being combined in a finished work. Collage was developed, to an exceptional degree, by the German artist Kurt SCHWITTERS (1887–1948), an important figure in the DADA movement. The technique was taken up and used by many leading modern artists including Henri Matisse, Georges Braque, and Pablo Picasso.

COLOMBO, JOE (1930–1971)

Italian designer noted for adventurous, avant garde approaches to a variety of everyday products, chiefly lighting and furniture. Trained as an architect at the Milan Politecnico, Colombo was a painter and sculptor for a time until he set up his own design firm in 1961. His work included the one-piece, all-plastic chair of 1965 for Kartell; the O-Luce Lamp of the same year, which has a single curved slab of acrylic conveying light from a tube in the base; and the all-in-one cart kitchen of 1963 for Boffi. He won several COMPASSO D'ORO and Milan TRIENNALE awards, and a number of his designs were included in the exhibition *Italy: The New Domestic Landscape* at the MUSEUM OF MODERN ART in New York in 1972. His designs had a radical, perhaps experimental or futuristic quality that made them of great interest in the design professions but that met with limited public acceptance. In spite of his brief creative career, he has become a significant figure in the history of design.

COLONNA, EDOUARD (1862–1948)

Belgian-born architect and designer who worked both in France and in the United States in a style closely related to ART NOUVEAU. Colonna came to New York in 1882 where he worked for Louis Comfort TIFFANY before moving to the Midwest to design railroad car interiors. He relocated to Paris in 1898 where his Tiffany punch bowl was exhibited in 1900. He worked in Paris for the firm of Samuel BING designing jewelry, furniture, and decorative items. Colonna returned to New York in 1905 to become an antique dealer and decorator. He retired to France in 1923.

COLOR

Visual effect that results from the ability of the eye and associated functions of the brain to experience differences in the wavelengths of radiant energy of light. These differences result in the familiar awareness that light itself can differ in color and that surfaces and objects appear to be colored according to the light wavelengths that they reflect or absorb. Daylight and artificial light that appears similar to daylight contains a mixture of all visible wavelengths and is described as "white" light. When some (or most) wavelengths are filtered out, white light appears to be colored, as happens, for instance, when haze filters daylight late in the day, making the light seem orange or reddish, or when gelatine filters are used to color stage lighting. Objects are seen as the result of light falling on them and being reflected back to a viewer. If the object seen absorbs some wavelengths and reflects back others, it appears in the color of the reflected light so that it is described as "colored."

There are differences in the behavior of the color of light and the colors of objects that result from pigments, dyes, and other colorants that produce color effects by absorbing some wavelengths. The color effects of light are described as additive color effects because they result from the addition of varied wavelengths. Color effects of pigments and dyes are called SUBTRACTIVE COLOR since they result from the absorption (subtraction) of some light wavelengths. When colored light is mixed, the result is an increase in brightness, while the mixture of subtractive colors reduces the level of reflected light.

When white light is passed through a prism, the various colors present are separated in order of their wavelengths, producing the familiar rainbow order of red, orange, yellow, green, blue, violet. Subtractive color can be arranged in a circle, or color wheel. Three "primary" rainbow colors—red, yellow, and blue—cannot be produced by the mixture of any other colors. Mixture of any two primaries produces "secondary" color: orange from red and yellow, green from yellow and blue, and violet from blue and red. The secondaries fall between the primaries that produce them when all six colors are arranged in the circular, or wheel, arrangement. When working with the additive color of light, the primaries are red, green, and blue, with yellow produced by the mixture of red and green.

Additional subtractive color effects result from the mixture of a pure color with white or black (producing "tints" and "shades") or from a mixture of all three primaries, which tends to neutralize whatever primary may be dominant. Colors are named in many different ways so that exact description is often difficult and confusing. Such terms as "dull green," "rose color," "warm gray," or "dusty rose," while descriptive, may have different meanings for different people. Many efforts have been made to organize the realities of color into a system, more or less scientific, and systematic study of color is part of the training of most artists and designers. The best-known systems are those of Wilhelm OSTWALD and Albert MUNSELL. Both systems are widely studied and used, and both have major similarities. In both systems, a given color sample is identified as having three characteristics. These are:

Hue: This quality gives a color its basic name and places it in a color wheel arrangement. Hues are given the names of primaries or combinations of primaries—such as red or red-orange—or using letters for the primaries—such intermediates as RRO, OOY, or YYG.

Value: This characteristic describes the "lightness" or "darkness" of a color, placing it on a scale that runs from pure white to pure black. Numbers are used for this scale with 10 equal to white and 0 equal to black. Any sample can be assigned its value number by noting the point on the "gray scale" from white to black that it matches in value.

Chroma (or saturation): The purity or intensity of a given sample is defined by this term. As a pure color is mixed with colors from the opposite side of the color wheel,

it becomes neutralized. The degree of purity is indicated by a high number (up to 14), while a lower number indicates a neutral.

Any color sample can thus be designated by letters and numbers. For example, in the Munsell system, RO8/5 indicates a red-orange with a value of 8 and a chroma of 5. Arrangement of all possible colors in a three-dimensional cluster creates a "color solid," with values arranged vertically, hues in a circle, and chromas in horizontal bands. Such a solid, and charts resulting from cutting sections through it in various planes, are useful tools in the study of color harmony. Other useful terms in the study of color include:

> *Neutral colors*: Those colors of low chroma that are generally perceived as grays, browns, tans, or given such names as beige or taupe.
> *Monochromatic colors*: Colors belonging to one hue or very closely related hues, even if varied in value and chroma.
> *Analagous colors*: Adjacent hues in the color wheel.
> *Complementary colors*: Colors placed in opposite positions in the color wheel, so that green is the complementary of red, violet the complementary of yellow, and orange the complementary of blue. Mixture of a color with its complementary tends to produce a neutral.

Colors are generally perceived as "warm" (red, orange, and yellow) or "cool" (green, blue, and violet), and these terms are also applied to neutrals to indicate what hues may be present in them. Thus a "warm brown" may be a tint or shade of a warm color, and a "cool gray" may be a tint or shade of blue, green, or violet, or some mix of those hues. Perception of color is modified by the size of a sample in relation to its background, by its relationship with adjacent colors, and by other complex effects demonstrated in the massive book by Josef ALBERS, *Interaction of Color*.

COLOR TEMPERATURE

Number expressing the color of light in a scale from warm to cool. The unit of color temperature is the degree Kelvin (°K) or, in recent terminology, the kelvin (k). Higher numbers indicate cold (bluish) light, lower numbers warm (reddish) light. For example, normal daylight has a color temperature of about 6500k; incandescent light is in a range of 2700k to 3000k. Color temperature is an important matter in lighting design for modern interiors.

COLOR WHEEL

Chart used in the study of color theory in which the various hues are arranged in a circle in order of the spectrum (or rainbow): red, orange, yellow, green, blue, violet, with violet next to red in order to close the circle. When so arranged, each secondary color falls between the two primaries that can be mixed to make it up, and each color falls directly opposite its complementary color across the circle.

COMPASSO D'ORO

Award for design excellence established in 1954 by the Italian department store chain LA RINASCENTE. Since 1956, the awards have been given annually to outstanding Italian product designs, usually in the area of home furnishings and related objects. The award has been a significant factor in increasing the recognition of many distinguished Italian designers and raising the level and status of Italian design generally. Winners of the award have included Franco ALBINI, Joe COLOMBO, and Ettore SOTTSASS among many others.

COMPRESSION MOLDING

Manufacturing technique used for making objects or parts of THERMOPLASTICS. The appropriate resin and catalyst mix is placed in a mold; after the mold is closed, heat and pressure bring about hardening of the plastic. When the mold is opened, the finished molding is removed. Melamine and the Phenolics are among the plastics most often formed by compression molding.

COMPUTER-AIDED DESIGN

See CAD.

CONCRETE

See REINFORCED CONCRETE.

CONGRÈS INTERNATIONAL D'ARCHITECTURE MODERNE

See CIAM.

CONRAN, TERENCE (b. 1931)

British designer best known as a popular merchandiser of home furnishings products of generally excellent design quality. Trained as a textile designer, Conran founded his own firm,

The Conran Design Group, in 1955. In 1957 he opened a London shop with Mary QUANT and, thereafter, his own London shop called HABITAT. Its success led to the opening of more stores, eventually leading to an international chain including shops in the United States that carry the name CONRAN'S. The stores offer a wide range of items including textiles, rugs, tableware, and lighting in both MODERN styles and simple traditional styles of the kind that may be called VERNACULAR design. Conran has also produced a number of consumer-oriented books with rich illustration and texts by a number of writers that give design and technical advice to householders. The first such book, *The House Book* (1974), has been joined by a number of others dealing with such specialized subjects as kitchen and bath design. Together, these books and the shops have created a "Conran style" that is both modern and comfortable. In a recent Conran project, the old (1911) Michelin House in London was converted into a Conran shop with a special orientation toward luxury and unusual style.

CONRAN'S

Chain of retail home furnishings shops offering furniture and related household products of generally fine design quality at moderate prices. Conran's is the American wing of the chain founded by Terence CONRAN in England under the name HABITAT. Through mail-order catalogs and a number of retail showrooms, Conran's offers the public reasonably priced alternatives to the products sold in conventional furniture and department stores or in the showrooms of manufacturers who deal only with design professionals.

CONSTRAINT

Term describing a restriction or limiting factor, used in studies of DESIGN METHOD or other efforts to make design processes logical and orderly. In the making of a design PROGRAM, it is necessary to list, along with functional purposes and needs, the constraints that the designer must consider as limitations on what may be possible. Typical constraints include maximum or minimum size, legal restrictions, and, perhaps most important of all, cost limitations.

CONSTRUCTIVISM

Term used to describe the stylistic character of the art and design that developed after the Russian Revolution of 1917. Constructivist art is largely abstract and uses visual elements as parts of works that are "constructed," that is, assembled rather than painted or carved as in most historic fine art. In Russia, the painters El LISSITSKY and Kasimir MALEVICH (of the famous 1918 painting *White on White*), the sculptor Naum Gabo, and the sculptor-designer Vladimir TATLIN are the best-known constructivists. Elsewhere in Europe, constructivist directions are apparent in the Dutch DE STIJL movement in the work of Piet MONDRIAN and Theo van DOESBURG. The movement's influence can be seen in much BAUHAUS design and in the mainstream of developing MODERNISM.

CONTAINER CORPORATION OF AMERICA

Major American industrial corporation with an exceptional history of support for MODERN design. As a maker of packaging materials, the Container Corporation offered design help to its clients. Under its Chairman, Walter Paepcke, the company developed a special interest in quality modern design, retaining Herbert BAYER as art director. The company's own advertising and graphic materials set a high standard as a model for its customers. The handsome *World Geo-Graphic Atlas* of 1953, ed-

1946 advertisement for the Container Corporation of America series "Great Ideas of Western Man." Design by Paul Rand. Courtesy of Paul Rand, Inc.

ited and designed by Bayer, is a remarkable example of a promotional publication of outstanding design.

CONTEMPORARY DESIGN
Term often used rather loosely to describe any current or recent design work. Most commonly, the term refers to design that is neither based on historical precedent nor MODERN in the stylistic sense of simple, austere, and unornamented. In the furniture and decorating trades, the term is used to give a stylistic name to design that might more accurately be called nondescript or characterless.

CONTINUOUS SPECTRUM LIGHT
All the wavelengths (colors) that make up white light. When passed through a prism, such light displays a continuous rainbow band of COLOR. Sunlight and incandescent electric light are characterized by a continuous spectrum as distinguished from the discontinuous spectra of such sources as mercury vapor, sodium, or neon lighting.

CONTRACT DESIGN
Term in general use in the design professions and trades to describe nonresidential interior design and the design of related furniture, textiles, carpet, lighting, and other products for commercial, office, and institutional use. The term is derived from the fact that work for such projects and the purchase of objects for use in them are usually dealt with through contracts with manufacturers rather than through retail channels. Periodicals addressing American contract markets include, among others, *Contract*, *INTERIORS*, and *INTERIOR DESIGN*.

COOK, PETER
See ARCHIGRAM.

COOPER, DAN (1901–1965)
New York interior designer who established a retail shop offering textiles and, occasionally, lamps and furniture of excellent MODERN design before such products were widely available. Most of the products offered were of Cooper's own design, but he was also one of the first to import Swedish modern furniture. He accepted commissions as an interior decorator, usually for residential projects.

COOPER-HEWITT MUSEUM (NATIONAL MUSEUM OF DESIGN)
New York museum founded in 1897 as part of the COOPER UNION School of Art. It became a branch of the national Smithsonian Institution in 1967, occupying the grandiose former Carnegie mansion at 91st Street and Fifth Avenue, built in 1901. The Cooper-Hewitt owns a vast collection of designed materials including textiles, documents, and archives relating to design, and conducts a program of regularly changing exhibits focusing on design-related subjects, such as ocean liners, buttons, Scandinavian Modernism, Indian textiles, Vienna Moderne, and the influence of Palladio.

COOPER UNION
School of engineering, art, architecture, and design founded in the 19th century by the American industrialist Peter Cooper as an all-scholarship institution to train young people of exceptional talent. It occupies an 1859 brownstone building on Cooper Square in New York, the earliest surviving building in America using steel frame construction. Its basement, Great Hall, is famous as the scene of a public address by Abraham Lincoln. The school now occupies space in various nearby buildings and continues to offer teaching programs of very high quality.

CORAY, HANS (b. 1907)
Swiss designer best known for his Spartana chair of 1938. Coray's all-ALUMINUM stacking chair with a perforated seat and back section has a distinctive appearance that accounts for its long-lived popularity in Europe. Coray's 1952 Landa chair, with a molded aluminum seat and back on a steel tube frame, did not reach the same level of popularity. The Italian firm of Zanotta is the manufacturer of both designs.

CORBUSIER
See LE CORBUSIER.

CORD AUTOMOBILE
Cord 810 model of 1936 is widely recognized as a CLASSIC of American automobile design. The car was named for E.L. Cord, the Auburn Company president who supported its development. The introduction of front-wheel drive made the car strikingly advanced in engineering terms, while the body and interior design by Gordon BUEHRIG made it equally striking in visual terms. Only about 3,000 Cords were

built, but surviving examples continue to be admired, collected, and valued.

CORPORATE IDENTITY

Term that describes efforts to bring consistency and unity to the visible aspects of a corporation's activities. Various industrial and graphic designers have become corporate identity experts, establishing a trademark or LOGO-TYPE for a company, standard theme colors, standardized graphic forms for printed materials, packaging, and, whenever possible, some control of product design. Well-known, successful corporate identity programs include Eliot NOYES's programs for IBM and Mobil, CHERMAYEFF & GEISMAR's program for Chase Manhattan, as well as those of CBS, Pan Am, and Eastern Airlines. Airlines and oil companies have often been leaders in developing corporate identity programs.

CORRETTI, GILBERTO

See ARCHIZOOM ASSOCIATI.

CORVETTE

GENERAL MOTORS (Chevrolet) automobile designed as an American rival to European sport cars. General Motors vice-president Harley J. EARL is viewed as the motive power behind the decision to produce a two-seater car with advanced body design, which first appeared in 1953. The FIBERGLASS body was a blend of functional STREAMLINING and somewhat gross styling elements suggestive of GM auto body design of the decade. In 1956 the design was changed and a V-8 engine substituted for the original 6. Debate about the merit of the Corvette centered on whether it was a "true" sport car or merely a typically American consumer product disguised to appeal to a special audience. The redesigned Stingray model of 1963 was a striking visual form that brought new popularity to the Corvette. Since that time, the Corvette has become something of a cult object, valued, collected, and displayed by ardent devotees.

COURRÈGES, ANDRÉ (b. 1923)

French fashion designer who has been described as *the* POP designer of the mid-1960s. Courrèges was trained in civil engineering and then studied textile and fashion design at Pau and Paris before becoming a cutter for BALENCIAGA from 1950 until 1961, when he set up his own house. His austerely simple architectural shapes eventually led to the sensational mini-skirt of Prototypes, his couture designs; Couture Future, luxury ready-to-wear products; and Hyperbole, inexpensive ready-to-wear. White, pale colors, grid patterns, and stripes were favorite themes. While his design was somewhat in eclipse in the 1970s, Courrèges boutiques continue to prosper, and new lines have appeared offering sports clothes (under the name Sport Futur), accessories, and perfumes.

COUSINS DESIGN

New York product and packaging design firm founded in 1963 by Morison Cousins (b. 1934) who was joined as a partner in 1964 by his brother, Michael Cousins (b. 1938). Morison Cousins is a 1955 graduate of PRATT INSTITUTE and Michael a 1960 graduate of the RHODE ISLAND SCHOOL OF DESIGN, both in industrial design. The firm has remained small (with a staff of only six), while the quality of its work has maintained a high standard, leading to a number of awards and inclusion in several museum collections. The Space-Tel telephone of innova-

1956 Chevrolet Corvette. Photo courtesy of Chevrolet.

Space-Tel telephone designed by Morison S. Cousins in 1983. Photo courtesy of Cousins Design.

tive form designed for the Atari-Tel Division of Warner Communications is in the permanent collection of the MUSEUM OF MODERN ART in New York, as are the Gillette Promax hair dryer and the Privecode answering machine designed for International Mobile Machines.

CPM
Designation for the "critical path method," a system for scheduling projects by visual charting. The name refers to the ability to identify the "critical path" of interrelated steps, thereby establishing the shortest time in which a project can be completed. Any delay in steps that are on the critical path will delay the entire project, while efforts to speed a project must involve shortening steps on the critical path. All other steps that make up alternate routes through the chart are noncritical in that their duration will not determine total project time. CPM has come into wide use in scheduling complex construction projects and the introduction of new products and systems in civilian and military industrial production. CPM schedules can be adapted to computer monitoring as an aid in controlling process scheduling of highly complex projects. CPM charts of a fairly simple nature are usually adequate to plan design project schedules. The process of making the chart is often helpful in understanding the re-

lationship of various steps and in organizing work in a way that will meet a preestablished schedule.

THE CRAFTSMAN
American magazine published from 1901 to 1916 under the direction of Gustav STICKLEY as a vehicle for his ideas, designs, and products. Early issues presented the work and ideas of John Ruskin and William MORRIS, introducing an American audience to the ideas of the English ARTS AND CRAFTS movement. Articles presented artwork, fiction, advanced social and political ideas, along with favoring the work of such architects as C.F.A. VOYSEY and examples of English VERNACULAR cottages and American houses in the "Bungalow" style. The magazine was produced at the Craftsman Building in New York where there were also showrooms featuring the work of Stickley and other makers of furniture and decorative objects in the related design vocabulary.

CRAFTSMAN (MOVEMENT)
American effort to import and Americanize the ideas of the ARTS AND CRAFTS movement in England. The ideas of Charles EASTLAKE, William MORRIS, and John Ruskin became known in the United States in the 1880s and influenced architectural and furniture design work to

some degree. The furniture of Gustav STICKLEY formed a central theme for the Craftsman movement, which he encouraged through his magazine *THE CRAFTSMAN*. The theme was taken up by others including Elbert HUBBARD and his ROYCROFT SHOPS. The terms "Golden Oak" and "Mission Style" were also often used to describe Craftsman design. The movement began to lose momentum around 1910 and was effectively ended by the time of World War I. Craftsman design influence can be traced in the work of the PRAIRIE SCHOOL architects and GREENE & GREENE and, to some degree, in the early work of Frank Lloyd WRIGHT.

CRAM, RALPH ADAMS (1863–1942)

American architect known for his achievement in ECLECTIC Gothic Revival work, primarily in religious and academic buildings. Cram studied art in Boston and was an art critic for a time before forming an architectural partnership with Charles Wentworth in 1889. In 1892 Bertram G. GOODHUE joined the firm, which became, in 1913, Cram, Goodhue, & Ferguson. Among the many Gothic buildings designed by the firm are the East Liberty Presbyterian Church in Pittsburgh, the Swedenborgian Cathedral at Bryn Athyn, Pennsylvania, and St. Thomas Church (1914) in New York. In 1911, Cram took over design of the then-partly-built Cathedral of St. John the Divine in New York, revising the design from Byzantine to Gothic style. The Gothic buildings of Princeton University are the result of his role as supervising architect for that institution. Cram was an energetic propagandist for the Gothic style and was the author of a number of books, such as his *Church Building* of 1901, which offers "good" and "bad" examples, including a number of Cram's early works in the former category.

CRANBROOK ACADEMY

American school of art and design founded by George G. Booth in 1932 on his former estate near Detroit as a more craft-oriented alternative to more conventional art school, college, and university art and design education. The Finnish architect Eliel SAARINEN was the primary creative leader in developing the school's direction as well as the architect and planner for the distinguished buildings that make up its campus. In spite of its modest size (normally there are about 150 students at any one time), Cranbrook has exerted a powerful influence on the development of 20th-century design in America. Its students who have become leaders in American design have included Benjamin BAL-

DWIN, Harry BERTOIA, Charles and Ray EAMES, Florence KNOLL, Jack Lenor LARSEN, David ROWLAND, Eero SAARINEN (son of Eliel), and Harry Weese. The history of the institution and the work of its students are thoroughly documented in *Design in America: The Cranbrook Vision*, a 1983 book honoring the school's fiftieth year.

CRANE, WALTER (1845–1915)

English illustrator and designer of textiles and wallpapers in the tradition of the ARTS AND CRAFTS movement. Crane's early reputation was based on his work as an artist and illustrator who was particularly successful with children's books. In the 1870s his acquaintance with William MORRIS and Philip WEBB drew him into the Arts and Crafts movement. He then began to design china, tiles, vases, textiles, and, with particular success, wallpapers. He was a founding member of the Art Worker's Guild and became something of a spokesman for Morris's ideas, through his own writing, lecturing, and teaching. After 1900, his reputation spread in Europe where he was involved in several design exhibitions that carried on the British encouragement of craft-oriented design.

CRET, PAUL PHILIPPE (1876–1945)

French-born architect who was active and influential in American architecture in the first half of the 20th century. Cret was a graduate of the Paris École des BEAUX-ARTS and was invited to America in 1903 to become the principal teacher and critic at the architectural school (School of Fine Arts) of the University of Pennsylvania in Philadelphia. Under his leadership, the school became preeminent in American architectural education. Particularly well known as a teacher, Cret numbered Louis KAHN among his many distinguished students.

Cret also had an active practice. He designed the Pan American Union Building of 1903, the Folger Shakespearean Library of 1930–32, and the Federal Reserve Office Building of 1935–37, all in Washington, D.C. The Federal Reserve commission was won through a competition. His work moved gradually from the florid ornamentalism typical of the Beaux-Arts style toward a more and more simplified type of design, often called "stripped classicism." Cret searched for his own modern direction and accepted such commissions as the design of the Hall of Science (which had strong ART DECO quali-

ties) at the Chicago CENTURY OF PROGRESS EXPOSITION of 1933 and the interiors of the Burlington Zephyr railroad train of 1934.

CRITICAL PATH METHOD
See CPM.

CROSBY, FLETCHER, FORBES
British industrial and graphic design firm organized in 1965, which was reorganized and renamed PENTAGRAM in 1972.

CROSBY, THEO (b. 1925)
English architect practicing as a partner in the firm PENTAGRAM. Crosby was born and educated in South Africa and joined the London architectural office of Fry, Drew, Drake & Lasdun in 1947. From 1953 until 1962 he was an editor of *Architectural Design* magazine and had a private practice. In 1965 he became a founding partner in the design firm of Crosby, Fletcher, Forbes, continuing as a partner when the firm reorganized in 1972 to become Pentagram.

CRYSTAL PALACE
Iron and glass structure built to contain the "Great Exhibition" of 1851 in London, often

Interior of the Crystal Palace as shown in a late 19th-century engraving.

viewed as the first truly MODERN building and so a precursor of 20th-century architecture. Queen Victoria's consort, Prince Albert, seeking a building in which to house the first WORLD'S FAIR, was led to Joseph Paxton, a landscape gardener who had developed a technique for building greenhouses for tropical plants with iron frames holding panes of glass. His proposal for what was essentially a giant (800,000 square feet) greenhouse was accepted and built with the aid of the engineering firm of Fox and Henderson. The structure, assembled from PREFABRICATED parts, was a great popular and aesthetic success and stood in startling contrast to the ornamental, generally tasteless Victorian wares exhibited within it. After the exhibition, the Crystal Palace was disassembled, reconstructed at Sydenham on the edge of London, and destroyed by fire in 1937. Paxton's design, free of historical references, with minimal ornamentation, and made of industrial materials viewed as typically modern, is widely regarded as a key monument in the early development of modern architecture.

CUYPERS, PIERRE JOSEPH HUBERT (1827–1921)
Dutch architect best known for his designs for the Rijksmuseum and the Central Station in Amsterdam as well as many Dutch neogothic churches. Trained at the Antwerp Academy, Cuypers founded a workshop in 1852 for the production of religious art. Although his work is largely of gothic revival character, his straightforward use of brick and his frequent application of metal and glass elements places him in the line of Dutch developments that lead to Hendrik BERLAGE and later Dutch modernists.

CZESCHKA, CARL OTTO (1878–1960)
Viennese artist and designer associated with the turn-of-the-century MODERNISM of the Vienna SECESSION. In 1904 he was one of a group including Josef HOFFMANN and Koloman MOSER producing designs for the WIENER WERKSTÄTTE. Czeschka was the designer of some stained glass for Hoffmann's Palais Stoclet of 1911 in Brussels. He became a teacher of design at the school of applied arts in Hamburg where he continued as a professor until his retirement in 1943.

DADA

Movement in the development of MODERN art in Europe that assailed art conventions through the use of absurdity. The beginnings of Dada are usually traced to Zurich around 1916 when habitués of the Cabaret Voltaire, including Jean ARP, the Janco brothers, Hans Richter, and Tristan Tzara, began to create an anti-art art movement that generated work intended as attacks on art as it was usually understood. The works of Marcel Duchamp are among the best-known Dadaist achievements. In addition to paintings, he made use of "found objects," everyday things displayed as works of art, sometimes somewhat modified, sometimes just as they were found. His *Fountain* of 1917 is simply a standard urinal signed and displayed as a sculpture. Kurt SCHWITTERS produced *Merzbild*, which were collages made up of various paper fragments that would ordinarily be viewed as trash, arranged and pasted down to form works of art.

Although conceived as a challenge to art, Dada had the effect of opening up new directions in art now widely accepted as legitimate. Through its acceptance of utilitarian, even banal objects as appropriate elements in art works, Dada aided in moving functional design into the world of fine art in a way that has had a major impact on the modern view of all design activities.

DADO

Rectangular groove cut into a board for ornamental effect or an element in joining wood parts. Also, a dado may be the lower part of an interior wall set off by a molding and usually paneled or decorated in some way that differentiates it from the upper part of the wall. The top molding of such a dado is often called a "chair rail."

DANISH MODERN

Term identifying the MODERNISM developed in post–World War II Denmark by such designers as Kai BOJESEN, Finn JUHL, and Hans WEGNER. Danish design of the 1930s had developed a cautious modernism based on craft traditions in the furniture of Kaare KLINT and the silver of

Georg JENSEN exhibited in the shop DEN PERMANENTE (opened in 1934) in Copenhagen, where only products meeting a high standard of design quality were shown. In the 1950s, Danish design developed in a strongly FUNCTIONALIST direction, but always with a certain sense of craft tradition that led to qualities of warmth and softness which aided the growth of worldwide popularity for Danish design. At a time when modernism was still somewhat new and frightening to American consumers, Danish modern became a popular compromise, often called "contemporary" or "transitional" to distinguish it from the more mechanistic qualities of BAUHAUS-inspired functionalism. Economic developments in recent years have made Danish products less economical than they were in the 1950s, a tendency that, combined with changing taste, has limited the importance of Danish design in current markets.

DANKO, PETER (b. 1949)

American furniture designer who developed a molded plywood chair in 1976. Danko formed a single sheet of plywood into a configuration providing seat, back, and support structure. Unable to locate a manufacturer willing to produce his design, Danko took up manufacturing on his own in order to make his design generally available.

DANSK

American importer and producer of tableware and other household accessories of modern de-

Lightwoods Collection designed by Thomas Hucker for Dansk. Photo courtesy of Dansk International Designs, Ltd.

sign that is suggestive of Danish design, although not necessarily the work of Danish designers. Dansk International Designs was founded by Danish designer Jens QUISTGAARD with Ted Nierenberg, an American businessman. Dansk products, including many of Quistgaard's designs in wood, ceramics, glass, and metal, tend to combine a typically Scandinavian modern flavor with a decorative quality that makes them acceptable to a large consumer audience.

DARRIN, HOWARD (b. 1897)

American industrial designer best known for designing the body of the Kaiser and Frazer automobiles produced briefly (beginning in 1947) by the firm founded by Henry J. KAISER.

DAY, ROBIN (b. 1915)

English furniture designer best known for a variety of furniture products developed for the British furniture manufacturer HILLE. Day studied at the Royal College of Art in London and opened his own design office in 1948. His name became well known that same year when he was a prize winner (with Clive Latimer) in a MUSEUM OF MODERN ART furniture competition with designs for a home storage furniture system using metal supports that simply lean against any wall. Modified versions of the winning designs were briefly in production in the United States. Beginning in 1950, Day produced designs of considerable variety for Hille. His most successful project was the Polyprop chair of 1962–63, a stacking chair with a seat and back component of polypropylene, a soft and flexible PLASTIC introduced in 1962. The chair has been produced and sold in vast numbers. Day has also designed flatware, carpets, appliances, exhibitions, and airplane interiors.

DC-3

Douglas DC-3 airplane of 1934, which proved to be one of the most successful aircraft designs ever developed. Its predecessors, the DC-1, DC-2, and DST, were steps toward the development of the DC-3, all twin-engined, low-wing monoplanes of clean, streamlined form with retractable landing gear and a 21-passenger seating capacity. The success of the DC-3 is usually credited with having made passenger air transportation reliable, practical, and widely available. The basic design of the DC-3 established the norm for passenger aircraft and became the basis for many similar designs by other manufacturers and for the gradually larger four-engined transport airplanes that succeeded it. Even modern jet aircraft owe much of their basic form to the DC-3. Including the military version (C-47), some 11,000 DC-3s were built. A surprising number remain in service, particularly in out-of-the-way locations where only short-runway airfields are available.

DE CARLI, CARLO (1910–1971)

Italian architect and designer who produced furniture designs after World War II of the typically active and sculptural character favored by the group of designers closely associated with Gio PONTI and extensively published in DOMUS magazine. His designs used steel rod and tubing with foam upholstery in sculptured shapes. His 683 chair of 1954 is a foldable unit with MOLDED PLYWOOD seat and back, solid frame members in sculptured forms, and metal legs and connecting pivots. CASSINA of Milan was the manufacturer of most of de Carli's designs.

DECONSTRUCTIVISM

Term coined in the late 1980s for an emerging direction in architectural design that uses broken and jagged forms, warped and overlapped planes, and shapes that can be disturbing, even hostile, in marked contrast to the logical and orderly objectives of MODERNISM. Although the word is a rather misleading variation on the term "deconstructionism" as used in the fields of philosophy and literary criticism, its meaning in architectural criticism is quite unrelated. Deconstructivism is not a "movement" in the sense of a coordinated effort, but rather a common direction that critics have identified in the work of a number of totally unrelated designers. A relationship to the constructivist directions of the 1910–1920s era is observable, although it is probably more fortuitous than deliberate. A 1988 exhibit at the MUSEUM OF MODERN ART in New York (organized by Philip JOHNSON) established the term and identified the deconstructivist style through the exhibition of the work of seven architects in which a common trend is discernible. Among the seven were Peter Eisenman (b. 1932), Frank GEHRY, Zaha Hadid (b. 1950), and Bernard Tschumi (b. 1944). Many of the works shown were in the form of models and drawings that suggested fantasy architecture of doubtful practicality aimed at challenging both the sedate conven-

tions of the MODERN movement and the retrogressive directions of POST-MODERNISM. Bernard Tschumi's "follies" in the Parc de la Villette in Paris are among the few deconstructivist works that have actually been executed. The 1988 book *Deconstructivist Architecture* illustrates the work shown in the exhibit and offers a critical essay by Mark Wigley, an architect and theorist now teaching at Princeton University.

DE HARAK, RUDOLPH (b. 1924)
Self-taught graphic designer known for imaginative posters, magazine illustrations, book and record jackets, and exhibition design. De Harak began his work on the West Coast but, since 1950, has been based in New York. He has produced illustrations for *Esquire* magazine, record covers for Columbia, and some 350 book jackets for McGraw-Hill. He has also been a successful teacher at COOPER UNION in New York where he is Frank Stanton Professor of Design (now Emeritus). His exhibit design work was used at Expo 67 in Montreal and at Osaka, Japan, in 1970. Following the main line of MODERNISM, De Harak often uses SANS SERIF types arranged in geometrically ordered ways with abstract or semi-abstract visual images.

DE LA RENTA, OSCAR (b. 1932)
New York–based fashion designer known for ornate and amusing design, often based on exotic themes and cultures. De la Renta was born in the Dominican Republic and studied art in Madrid. He began his professional career in Paris with a job with Cristobal BALENCIAGA and then at Jeanne LANVIN before moving to New York to take over couture design for Elizabeth Arden. In 1965 he began work for Jane Derby, taking over the firm in 1967 and giving it his name. De la Renta's reputation as a celebrity of the social world has supported the growing reputation of his work as a designer. He was the winner of a 1968 Coty Award for his Russian- and gypsy-inspired collection of that year, of a Neiman-Marcus Award in 1968, and of a Coty Hall of Fame Award in 1973. In 1977, perfumes were introduced under the de la Renta name, and various other products have been added to his lines, including bathing suits, bed linens, and jewelry.

DELAUNAY, SONIA (1885–1979)
Russian-born artist and textile designer, based in France for most of her career. In Paris in the 1920s Delaunay was associated with the DADA and surrealist movements, designing colorful bookbindings, shop interiors, and textiles in abstract patterns. She contributed decorative design elements for the Aeronautical Pavilion at the 1937 Paris Exhibition and later produced designs for glass, mosaics, and tapestries, all of a bright, modern, abstract character.

DE LUCCHI, MICHELE (b. 1952)
Italian architect and designer whose best-known MEMPHIS furniture designs are typically colorful and playful. De Lucchi received his architectural degree in Florence in 1975. In 1978 he relocated to Milan where he developed avant-garde furniture designs for STUDIO ALCHYMIA and, later, for Memphis. He has also worked for OLIVETTI (with Ettore SOTTSASS) on the Icarus and other office furniture systems and on the design of many FIORUCCI shops.

DEN PERMANENTE
Danish shop devoted to the sale of furniture and household products of high design quality. Den Permanente was founded in 1934 in Copenhagen by Kai BOJESEN and Georg JENSEN as a permanent exhibit of the best in DANISH MODERN design. It became, and remains, a significant factor in promoting the functional, but craft and tradition-related qualities of Danish design taste that have led to its great popularity, particularly in the period immediately after World War II.

DE PATTA, MARGARET (b. 1907)
American jeweler, trained at the INSTITUTE OF DESIGN in Chicago, who has become known for her hand-crafted jewelry of MODERNIST design. Its abstract character is seemingly based on the sculptural forms typical of constructivist work of the 1920s and 1930s.

DESIGN CENTRE
Permanent exhibition center in London devoted to the promotion of design excellence through public educational activities. The Design Centre was opened in 1956 in the Haymarket under the sponsorship of the British Council of Industrial Design. It exhibits selected objects of superior design quality, maintains an index of sources for materials and products of good design quality, and conducts a publishing program of booklets offering advice on design issues of interest to consumers.

DESIGN AND INDUSTRIES ASSOCIATION (DIA)

English organization formed somewhat on the model of the DEUTSCHER WERKBUND to encourage the recognition and adoption of quality design in business and commerce. The Design and Industries Association (DIA) was formed following a design exhibition held in London in 1915. With Cecil BREWER as founding secretary and W.R. LETHABY and Ernest GIMSON important influences, the DIA developed an orientation strongly linked to ARTS AND CRAFTS tradition in England. Involvement with MODERNISM was resisted for some time, but by the 1930s, the DIA had become an active promoter of MODERN design with leanings toward the INTERNATIONAL STYLE. Magazines were launched, *Design in Industry* in 1932 and *Design for To-day* in 1933, but each was short-lived, with the latter discontinued in 1936. Frank PICK and Gordon RUSSELL were active supporters of the DIA. After World War II, its functions were gradually taken over by other organizations, which were to a degree descended from it, including the Council for Art and Industry and the Council of Industrial Design (CoID).

DESIGN METHOD

Theoretical branch of study in the design fields that attempts to develop orderly and systematic approaches to design creativity. Method or methodology in design is a recent effort to replace traditional views that design depends solely on talent or intuition and must so remain mysterious and essentially unteachable with more explicitly analytical techniques that establish a rational structure for understanding design processes. Design method has been advanced by the increasing application of computer techniques to complex design problems. In order to put computers to work, it becomes necessary to define exactly the steps that must be taken in dealing with a problem. Computer design requires explicit method, which, once developed, allows explanation of conventional design techniques.

The California-based Design Methods Group, along with Christopher Jones in his 1970 book *Design Method*, and Christopher ALEXANDER, particularly in his book *Notes on the Synthesis of Form*, have all made contributions to a developing body of theory that attempts to break down the complexity of design problems into discrete elements that can be rationally understood. Methodological studies have been most useful in dealing with large and complex architectural and planning projects, such as airports, health-care facilities and whole town plans, where the number of interacting issues can become impossible for the human mind alone to grasp and deal with. Concepts drawn from mathematical theory of sets and from graph theory have been explored in design methodology with results that remain debatable.

DESIGN RESEARCH (DR)

Retail distributor of well-designed products selected from many sources, most of them imports suitable for home use. Design Research (DR) was started in 1953 at Cambridge, Massachusetts, by Benjamin THOMPSON, one of the partners in the architectural firm of the Architects Collaborative (TAC). It was in response to the difficulty of finding products of good design quality in American retail shops. The "Research" in the firm name was a reference to its dedication to searching out furniture, household objects, and textiles of every sort of fine design quality wherever they might be found and making these available in an attractive shop. The success of the Cambridge shop led to its expansion to New York, Philadelphia, and San Francisco. The shops were well designed, and their contents became a virtual museum of design excellence with everything available for purchase. Imports were chosen from Germany, Greece, Morocco (rugs), Sweden, Denmark, and, with particular emphasis, Finland. The textiles and dresses of MARIMEKKO were also featured in DR shops. The success of the firm led to a problem as Thompson found the organization's demands on his time excessive, and in the late 1960s, changing economic conditions forced the prices of imported products upward until many lost their appeal in American markets. Ultimately, the DR shops closed, but they are remembered as a striking demonstration of the popularity of products of fine design quality in consumer markets.

DESIGNS FOR BUSINESS

New York-based office planning and interior design firm active in the 1950s in many major office projects. The firm was founded by brothers Joseph and Maurice Mogulescu and, with Gerald Luss as chief designer, became known for corporate headquarters offices for such firms as Corning Glass, *The New York Times*, the Federal Aviation Administration, and Time, Inc. (for its Rockefeller Center building interiors). After the departure of Luss to found his

own firm and the retirement of the founders, the firm discontinued operations in the 1960s.

DESKEY, DONALD (1894–1989)

American industrial and interior designer associated with the ART DECO style of the 1930s. Deskey's early work of the 1920s and 1930s included interiors for private apartments and homes including the Mandel house by Edward Durrell STONE, an early work of modern architecture in the United States. His best-known project was the Art Deco interior design of the RADIO CITY MUSIC HALL in ROCKEFELLER CENTER, widely regarded as a masterpiece of American style. As an industrial designer, Deskey was responsible for the development of Weldtex, a patented form of fir plywood with a striated surface that disguised the strong (and ugly) grain pattern of the material. After World War II, Deskey enlarged his firm, adding architectural, product design, and packaging design departments. The firm designed a variety of offices and showrooms, interiors for the reconverted liner S.S. *Argentina* (the first modern interiors for an American ship), and worked in products, exhibition, and packaging design with Procter & Gamble as an important client. His design for the Crest toothpaste package of 1950 is still in current use.

DE SOTO

See AIRFLOW CHRYSLER.

DE STIJL

Dutch MODERNIST movement in design and the arts taking its name from the magazine that was its communication organ. The movement was founded by the Dutch sculptor and architect Theo van DOESBURG in 1917 in Leyden when the publication of *De Stijl* magazine also began. Publication continued until 1928. The movement favored a constructivist approach based on abstract geometric form and the use of neutral and pure primary colors. In addition to van Doesberg, the leading figures associated with De Stijl were the painter Piet MONDRIAN, the architect J.J.P. OUD, and Gerrit RIETVELD whose furniture designs and Schröder house at Utrecht are among the best-known De Stijl works. Although direct links with the BAUHAUS were limited, De Stijl thinking had considerable influence in the development of design theory at the Bauhaus in Germany.

DEUTSCHER WERKBUND

German association founded in 1907 to promote excellence in design and design-related craft and manufacturing. In its early years the Werkbund carried forward craft traditions somewhat in the manner of William MORRIS's ARTS AND CRAFTS movement. The orientation turned toward a more clearly modernist direction with the 1914 exhibition in Cologne housed in buildings designed by Walter GROPIUS. Among the personalities associated with the organization were Peter BEHRENS, Ludwig MIES VAN DER ROHE, Hermann MUTHESIUS, Richard RIEMERSCHMIDT, and Henry VAN DE VELDE. The organization grew to a membership of over 3,000 and had direct connections with its Austrian counterpart. A 1927 exhibition included the building of a model suburb, Die WEISSENHOF SIEDLUNG at Stuttgart, that included buildings by many of the major European modernists of the time. The organization was dissolved in 1934 in response to the growing pressure against MODERNISM generated by the rise of the Nazi regime. A revival of the Werkbund began in 1947.

DE WOLFE, ELSIE (1865–1950)

American interior decorator and designer, often viewed as the originator of modern professional interior design. After an early career as an actress, de Wolfe took on a total renovation (c. 1910) of the New York Irving Place townhouse she shared with Elisabeth Marbury, a successful literary agent. Her renovation changed the dark, cluttered Victorian interiors in the direction of simplicity, brightness, and cheer, albeit with the use of traditional objects and stylistic motifs. Notables who visited the house spread word of the de Wolfe style and brought professional commissions. Stanford WHITE, the noted architect, asked her to deal with the interiors of the Colony Club (1905–07), a project that further advanced her vocabulary of light color tones and simple forms. She became a spokesperson for the "good design" direction of its day, giving lectures and writing a popular and influential book of 1913, *The House in Good Taste*. She continued to conduct a successful practice in New York, in Paris (where she became Lady Mendl with her 1926 marriage to Sir Charles Mendl), and finally in Beverly Hills. Although never an advocate of MODERNISM as that term is now understood, Elsie de Wolfe moved the decorator's profession toward the modern world with her em-

Sketch by Norman Diekman of a residential living space of his design. Drawing courtesy of Norman Diekman.

phasis on professionalism and with her advocacy of simplicity and common sense in design.

DIA

See DESIGN AND INDUSTRIES ASSOCIATION.

DIAMOND, FREDA (b. 1905)

American designer and consultant to industry on matters of style and taste. A graduate of COOPER UNION, Diamond became a consultant in 1942 to Libbey glass in both design and marketing matters. Her Classic Crystal series of glassware for Libbey in 1950 was included in a GOOD DESIGN exhibition at the MUSEUM OF MODERN ART in New York in the same year.

DIE CASTING

Process for making objects or parts by forcing molten metal under pressure into a tool steel mold. When the mold is opened, the cooled and hardened metal casting is pushed out so the cycle can be repeated. Automatic die casting machines make the production of parts rapid and inexpensive. Metals most used for die casting are alloys developed for the purpose, usually with ZINC as a major component.

DIEKMAN, NORMAN (b. 1939)

American architectural and interior designer known for his furniture designs and for his exceptional drawings. Diekman was trained as an architect at PRATT INSTITUTE and worked for a time at SKIDMORE, OWINGS & MERRILL and then with Philip JOHNSON before working for a number of years as a draftsman and collaborator in furniture and interior design for Ward BENNETT. He has been in independent practice since 1982. His best-known work is a luxurious executive office furniture group, Canto, developed for the Stow/Davis firm (now a subsid-

iary of Steelcase) in 1985. The group uses elegant wood finishes, subtle curves, and special hardware details to enrich basically simple MODERN forms. Diekman is the author of two books (with co-author John Pile), *Drawing Interior Architecture* (1983) and *Sketching Interior Architecture* (1985), both featuring many examples of his designs and drawings.

DIESEL, RUDOLF (1858–1913)

German inventor, born in Paris, best known for the type of internal combustion engine that carries his name. Diesel published the theory of his engine in 1893 and began experimentation with a version of his design that would burn coal dust as a fuel. The diesel engine differs from the gasoline engine in using compression alone (without an electrical spark) to ignite the fuel in the cylinders to produce the forceful expansion that drives the piston. Diesel engines can burn heavy oil rather than gasoline and so are generally more economical to operate, although they are heavier and more expensive to build than comparable gasoline engines. Diesel engines have come into wide use as the power source for large vehicles, such as ships and locomotives where they have largely supplanted steam power. The diesel engine is often used to run an electric generator that supplies power to motors which move wheels or propellers in diesel-electric drive. This is their usual application in railroad locomotion and was universal in submarines until atomic power became an available alternative. Diesel engines are widely used for heavy trucks and for construction machinery, but their acceptance in passenger automobiles has been limited by noisy, rough-running qualities and difficult starting. Their promise of good fuel economy has not turned out to be as significant as had been anticipated in the small engines used in cars.

DIETRICH, RAYMOND HENRI (1894–1980)

American automobile designer known for the elegant custom bodies he designed for luxury cars of the 1920s and 1930s. Dietrich had worked as an engraver before joining Brewster and Company, New York coach builders in 1913. In partnership with Thomas Hibberd, he established Le Baron Carrossiers in New York in 1920, providing stately and elegant body designs to custom builders. In 1925, Dietrich, Inc. was established to produce designs for major manufacturers, including Lincoln, Packard, and Pierce Arrow. Dietrich joined the Chrysler design staff in Detroit in 1932, remaining until 1940. After 1949, his consulting firm, Ray Dietrich, Inc., was based in Grand Rapids, Michigan, where he worked for Checker, Lincoln, and Mercury, until his retirement in 1969. Dietrich-designed coachwork of great elegance is the basis for the CLASSIC quality of many one-of-a-kind examples of Chrysler, Lincoln, and Packard cars, now admired and collected as valued antiques.

DIFFRIENT, NIELS (b. 1928)

American industrial designer best known for his development of chairs based on ERGONOMICS. Diffrient studied at CRANBROOK ACADEMY

Helena swivel chair designed by Niels Diffrient. Photo by Rudolph Janu, courtesy of SunarHauserman, Inc.

in the 1940s and worked with the SAARINEN office from 1946 to 1951. From 1951 to 1952 he was with the office of Walter B. Ford and thereafter in New York in the office of Henry DREYFUSS where he became a partner in 1956. His work there included aircraft interiors, road and farm machinery, and studies in ANTHROPOMETRICS and ergonomics. In 1955 he was a partner with Marco ZANUSO in the design of a Borletti sewing machine. After leaving the Dreyfuss office in 1981, Diffrient became an independent designer concentrating on furniture. His chairs for KNOLL and his office systems furniture and chairs for SunarHauserman, including the complex, adjustable *Jefferson* chair for Sunar, are his best-known recent projects. He remains in practice in Ridgefield, Connecticut.

DIOR, CHRISTIAN (1905–1957)

French fashion designer best known for his 1947 line, with its long skirts and hint of a backward turn toward the austere style of the World War I era. Dior studied in Paris with the intention of becoming a career diplomat, but in 1927 opened a small Paris art gallery showing the works of avant-garde artists such as Salvador Dali and Jean Cocteau. The Depression closed the gallery, leading Dior to turn to fashion design in 1935 and work as a designer for the Parisian couturier Robert Piguet. After World War II, he became a designer for Lucien Lelong. In 1947 his firm launched with overwhelming success the style that became known as the New Look. His annual lines thereafter, each with a central theme, were popular and widely copied in the production of ready-to-wear manufacturers. The theme of 1951 was an Oval line; of 1952 an Open Tulip line. The H line of 1954 and the A line of 1955 took their names from the letterforms on which they were based. The 1957 Fuseau (spindle) line used skirts tapered in a true spindle shape. Practicality and a look that was both soft and architectural were typical themes of Dior's designs. His firm was taken over briefly by Yves SAINT LAURENT and then by Marc Bohan after Dior's death. Gianfranco Ferre is currently design director. As the House of Dior, the organization has continued to grow with divisions devoted to hats, furs, shoes, perfumes (Miss Dior), and jewelry. The New York branch alone employed a staff of about 1,200 by 1948. Dior was the recipient of a 1947 Neiman Marcus Award and a Parsons Medal in 1956. His autobiography, *Dior by Dior*, was published in 1957, the year of his death.

Jefferson armchair and ottoman designed by Niels Diffrient. Photo courtesy of SunarHauserman, Inc.

DITZEL, NANA (b. 1923)

Danish designer of furniture, fabrics, and table-wares. Ditzel was trained at the Copenhagen School of Arts and Crafts and began a design partnership in 1946 with her husband Jørgen Ditzel, who died in 1961. In 1954 she began designing for Georg JENSEN, and since 1970 she has worked in London continuing to design for Danish firms including Scandus and DEN PERMANENTE. Her furniture and other designs are usually of the simple, logical style that typifies DANISH MODERN. Her woven cane chairs have been particularly admired for their contemporary use of traditional craft material and technique.

DOBLIN, JAY (1920–1989)

American product designer and design educator. Doblin received his design education at PRATT INSTITUTE and worked for the office of Raymond LOEWY from 1942 to 1955. From 1955 to 1969 he was director of the INSTITUTE OF DESIGN, the design school of Illinois Institute of Technology in Chicago. In 1964 he was one of the founders of UNIMARK, a design consultancy with a particular interest in CORPORATE IDEN-

TITY programs. He continues in practice as a consultant designer. His book, *One Hundred Great Product Designs* (published in 1970), documents many designs that have come to be universally admired as CLASSICS.

DOESBURG, THEO VAN (1883–1931)

Dutch architect and designer, a major figure in the DE STIJL movement of the 1920s. Van Doesburg was a pen name for C.E.M. Küpper who began his career as a painter, but was drawn toward architecture through collaboration with J.J.P. OUD and Jan Wils beginning in 1916. In 1917 he founded the magazine *De Stijl*. He taught briefly at the BAUHAUS in 1922. His reputation rests on his paintings and in large measure on drawings and models for works never executed. His only completed projects were an entertainment group at The Aubette in Strasbourg, France, of 1928 (since demolished) and a house at Meudon of 1931. A kit for a paper model of the "Maison d'Artiste," reproducing the model van Doesburg and Cornelis van Eesteren designed in 1923 for an exhibition in Paris, is currently available.

DOHNER, DONALD R. (1907–1944)
American industrial designer and design educator best-known for his role in establishing two major INDUSTRIAL DESIGN training programs. Dohner assumed the title Director of Art for Heavy Industry with the Westinghouse Corporation in 1929 where he was responsible for the design of various products ranging from electric locomotives to vacuum cleaners and water coolers. He left Westinghouse to take a position at Carnegie Institute of Technology (now CARNEGIE-MELLON UNIVERSITY) in Pittsburgh, Pennsylvania, where, working with Peter MÜLLER-MUNK, he established the first American educational program in industrial design. In 1935 he left Carnegie to relocate in Brooklyn, New York, where he established a similar program at PRATT INSTITUTE. Dohner was responsible for inviting Alexander KOSTELLOW to teach at Pratt, which initiated a highly successful period in the history of that school.

DOMUS
Leading monthly Italian design and architectural magazine. *Domus* was founded in 1927 by Gio PONTI in Milan and has since been the primary vehicle for publishing the best of modern Italian work. The editorship was taken over for a time by Ernesto Rogers, with Ponti later returning to the magazine, until his death in 1979. Alessandro Mendini has been its editor since then.

DORFLES, GILLO (b. 1910)
Italian design theorist and writer. Dorfles teaches AESTHETICS at the University of Milan and has written and lectured on a variety of art and design topics. He has been influential in developing the Milan TRIENNALE exhibitions and the COMPASSO D'ORO award program and is the author of several books in Italian dealing with industrial design. His book on KITSCH—*Kitsch: The World of Bad Taste* (1967)—incorporates his own writing with a selection of essays by other designers, critics, and writers. With its varied perspectives it is the most complete book available on the subject.

DORFSMAN, LOU (b. 1918)
American graphic designer known for his distinguished work for CBS. Dorfsman studied design at COOPER UNION and was hired in 1946 by CBS's design director, William GOLDEN. He succeeded Golden after his death in 1959, becoming vice-president in charge of design for CBS. He has been responsible for the continuing high quality of CBS advertising, TV and corporate graphics. His development of lettering and graphics for CBS' New York headquarters (an Eero SAARINEN design) is an outstanding example of modern architectural graphic design. He has also played an active role in organizing the INTERNATIONAL DESIGN CONFERENCE IN ASPEN and as a spokesman for design issues.

DOUGLAS AIRCRAFT CO.
Leading American airplane builder whose 1930s products are credited with having made air transportation practical as a form of mass transport. The firm was founded in 1920 by Donald Wills Douglas (1892–1981) and developed the pioneer low-wing, twin-engined monoplanes, the DC-1 and DC-2, predecessors of the famous DC-3, one of the most successful airplanes ever produced. Later Douglas products, beginning with the DC-4, introduced tricycle landing gear and moved to four engines. The DC-8 was a highly successful four-engined jet transport. The successor company, McDonnell Douglas, continues production of the modern DC-9 and DC-10 jet transport aircraft.

DOVETAIL
Term for a wedge shape (with a fanciful similarity to the form of a dove's tail) used in making joints, particularly in woodwork. A dovetail joint uses a number of dovetail-shaped tabs that fit into corresponding cutouts in an adjoining part. Cabinet drawers and other box forms are often joined with dovetails at corners. These may be hand cut or machine made; the former are regarded as evidence of quality craftsmanship. A through, or slip, dovetail, often used in modern drawer construction, has a dovetail-shaped projecting element that slides into a continuous groove of matching shape.

DO-X
Giant flying-boat airplane built by the German firm of Dornier and first flown in 1929. The DO-X had been preceded with some success by the flying boats Dornier WAL and Super-WAL, the latter operating on a regular schedule between Europe and South America. Each carried eight to ten passengers and mail. The huge DO-X, however, carried up to 150 passengers and was intended to provide a regular trans-

Atlantic passenger service. It had three decks and provided spacious passenger accommodation somewhat in the manner of a ship. Twelve engines mounted above the single wing, six facing forward and six facing aft, were required to power it. A flight to New York was made, but because the DO-X was underpowered and unable to gain safe altitude, its use was discontinued. The elegant appearance of the DO-X attracted favorable design attention so that its forms had some influence on MODERNIST design thinking.

DRAPER, DOROTHY (1889–1969)

American interior decorator known for her designs for hotels, restaurants, clubs, and other public spaces. She founded her own firm in 1925 and produced early work in a version of the popular ART DECO idiom of the time. In the 1930s, her work took on more eclectic, traditional elements, often in overscaled, exaggerated form. Her book of 1939, *Decorating Is Fun!*, sums up the Draper approach with its energetic, somewhat flamboyant, commercial emphasis. The redecoration of the Pompeiian restaurant of New York's Metropolitan Museum of Art is a highly visible (although now somewhat altered) example of the florid Draper style.

DRESSER, CHRISTOPHER (1834–1904)

British designer in the tradition of "applied art," who produced a variety of works, ranging in style from florid Victorian to a simplicity presaging the MODERN movement. Dresser studied at the London School of Design beginning in 1847, but developed an interest in botany that earned him a doctoral degree at Jena in 1860. He turned again to design in the 1860s, becoming a successful and productive professional. He produced designs for TIFFANY in New York and for LIBERTY in London and was the author of a number of publications that articulated the design philosophy of the time. His designs for textiles and ironwork now seem dated to many, but many of his designs for glass and metal products have a simplicity, elegance, and geometric quality that has led to his being called the first industrial designer, as the term is understood in the modern profession.

DREXLER, ARTHUR (1925–1987)

American design critic and writer, highly influential through his 35 years as a curator and director of the Department of Architecture and Design of the MUSEUM OF MODERN ART in New York. Drexler was trained at COOPER UNION in New York, worked for several architectural firms and, briefly, for George NELSON and Company on furniture design. He was also, briefly, an editor of *INTERIORS* magazine and in that role met Philip JOHNSON, then head of the Museum of Modern Art's architecture department. Johnson hired Drexler for the museum and so began a series of Drexler exhibitions and publications that have had strong influence on American design thinking. Exhibitions such as *Eight Automobiles* in 1951 and *Twentieth-Century Engineering* in 1964 made the museum an active force in design fields largely ignored by most art museums. In architecture Drexler exhibited the work of such important modernists as LE CORBUSIER, Ludwig MIES VAN DER ROHE, Richard NEUTRA, and Louis I. KAHN, but his exhibits also included traditional Japanese design and 19th-century work from the École des BEAUX-ARTS. He received a medal from the AMERICAN INSTITUTE OF ARCHITECTS in 1977 honoring his contribution to the profession.

DREYFUSS, HENRY (1904–1972)

Pioneer American industrial designer regarded, in the later years of his career, as a widely respected dean of the design profession in the United States. Dreyfuss had no formal design training, but worked in theater design for Norman BEL GEDDES in the 1920s. In 1929 he established his own office for the practice of the newly established profession of INDUSTRIAL DESIGN. His work included Hoover vacuum cleaners, clocks, farm and construction machinery, and passenger railroad equipment for the New York Central Railroad. His streamlined Hudson locomotive for that railroad is an outstanding example of the 1930s ART DECO style direction. His standard telephones for the Bell system are probably the most generally familiar of his projects. His firm also worked on aircraft interiors, including those of the LOCKHEED Constellation and the Boeing 707 jet and various subsequent Boeing products.

Dreyfuss established a reputation as one of the most thoughtful and dedicated of all industrial designers, preferring to favor functional issues over styling of a more superficial kind. His books, *Designing for People* (1955) and *The Measure of Man* (1959), emphasize his concerns with human values, especially through the developing study of ERGONOMICS. The Dreyfuss office has continued in practice since his death.

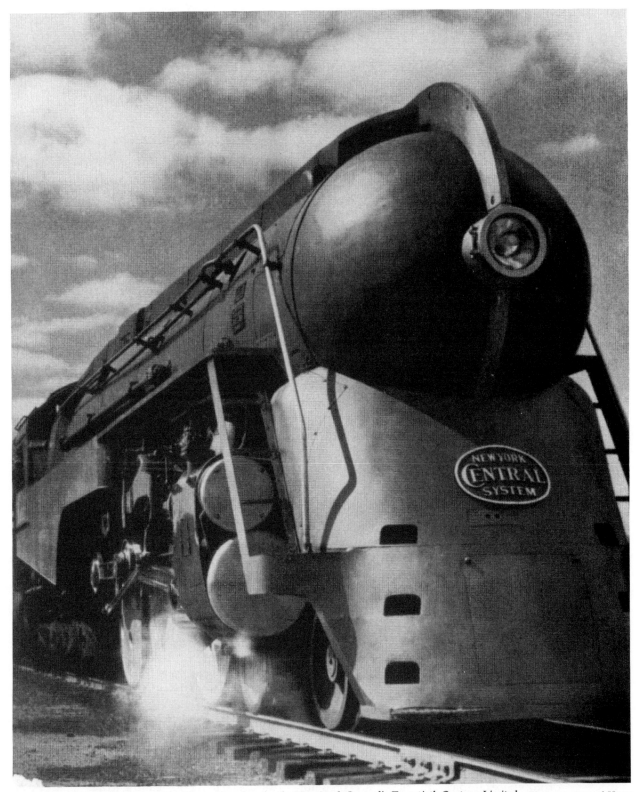

Streamlined locomotive designed by Henry Dreyfuss for the New York Central's Twentieth Century Limited. Photo courtesy of Henry Dreyfuss Associates.

DUDOK, WILLEM MARINUS (1884–1974)

Leading Dutch modernist architect who began practice in 1916 in the small city of Hilversum, near Amsterdam. His work usually uses rectangular, blocky forms constructed in brick with overhanging slab roof planes that suggest

an interest in CONSTRUCTIVISM, along with an awareness of the work of Frank Lloyd WRIGHT. His best-known works are the Dr. Bavink school of 1921 at Hilversum and the Hilversum town hall of 1928–30. The latter is regarded as his masterpiece, a striking and monumental work that became internationally famous. Its interiors and detailing match the strong character of its general design concept.

D'URSO, JOSEPH PAUL (b. 1943)

American interior designer whose work is usually associated with trends known as MINIMALISM and HIGH-TECH. D'Urso graduated from PRATT INSTITUTE in Brooklyn in interior design in 1965 and studied in London and Manchester, England, thereafter. After working briefly with Ward BENNETT, he opened his own office in New York in 1968, beginning with modest residential projects. His work is generally geometrically simple, with white walls and unbroken planes of various materials suggesting the minimalist direction in painting and sculpture. His fondness for using industrial materials and products in every kind of interior has led to his work being described as taking a high-tech direction, although he dislikes the use of the term. Recent larger projects have included a Calvin KLEIN showroom, shops for the Esprit clothing store chain, and a vast hotel-like club in Hong Kong. D'Urso has also designed a number of furniture products for KNOLL INTERNATIONAL, including tables and an upholstered sofa group of simple forms and luxurious proportions.

DYMAXION

Word coined by Buckminster FULLER to describe a number of his projects. The word is made up of *dynamic* and *maximum* and is intended to define Fuller's aims toward "maximizing" performance through recognition of "dynamic" forces. The first Dymaxion House of 1927, developed in a model but never constructed, was a hexagonal living space suspended one story above the ground by tension cables radiating from a central vertical mast. His Dymaxion automobile of 1933, a radical, truly streamlined design, was built in three prototype examples, but never accepted for production. The second Dymaxion House of 1946, a domed cylinder, was built as a prototype at Wichita, Kansas, and attracted wide notice, but once again, production was never undertaken because of technical and financial difficulties that made such a radical solution to housing problems seem to be too advanced for its day.

EAMES, CHARLES (1907–1978)

American architect and designer, greatly admired leader in many design activities, but most widely known as a designer of MODERN furniture. Eames was trained as an architect at Washington University in St. Louis when that school was still dominated by the ideas of BEAUX-ARTS architectural training and design. In 1929 he traveled in Europe, visited the WEISSENHOF SIEDLUNG at Stuttgart, and became acquainted with the work of the pioneer modernists of the 1920s. On his return to St. Louis in 1930 he began practice as a partner in the office of Gray & Eames. After a visit to Mexico in 1934, he entered into a new partnership in St. Louis in the firm of Eames & Walsh. In 1937 Eames accepted a post as head of the department of experimental design at CRANBROOK ACADEMY in Michigan. He met a number of architects and designers at Cranbrook who were to become leaders in their fields, among them Eero SAARINEN with whom he worked on various architectural projects.

Eames and Saarinen in collaboration were winners of two first prizes in the New York MUSEUM OF MODERN ART Organic Furniture competition of 1940. Although their winning designs were never put into production, they formed the basis for later work in furniture by both men. After his 1941 marriage to Ray Kaiser (see Ray Kaiser EAMES), Eames moved to California where he began experimental work with MOLDED PLYWOOD, leading to a U.S. Navy contract for wartime work on plywood traction splints and stretchers. As a by-product, he began experimenting with the design of molded plywood furniture. A group of this furniture was completed for exhibition in a one-man show at the Museum of Modern Art

BODY FLUSH = in 1946. The furniture attracted the attention of George NELSON, who had recently taken charge of design for the furniture maker HERMAN MILLER. At his suggestion, Herman Miller became the producer and distributor of the 1946 Eames designs and all subsequent Eames furniture products. Chairs with FIBERGLASS shells were introduced in 1949 and in steel wire in 1952. In 1949 Charles and Ray Eames moved into their house in Santa Monica, a building constructed of standard industrial building components that became the best known of Eames's architectural works. *The Toy* of 1951 and *House of Cards* of 1952 exploited the playful character of much of the Eames's work. Of simple paper and wood, the toys were colorful and decorative, while offering varied possibilities for creative play.

In the 1950s, the Eames began work on films that were a mix of entertainment and education as in *A Communications Primer*, *Toccata for Toy Trains*, and *Two Baroque Churches*. The first of these led to assignments in film and exhibit design for IBM, the U.S. government, and the government of India. As Eames's reputation grew, he became the recipient of many awards and honors and came to be regarded as the greatest as well as the most versatile of American designers of the 20th century. Work for Herman Miller continued to be an important part of Eames's work, including showroom and exhibit design, the design of furniture and graphics, as well as a constantly expanding list of furniture products and systems. In the last category, several systems were developed for use in such public spaces as airport terminal buildings. Plastic chair shells could be used on a continuous basis, creating arrangements that were also adaptable as lecture room or stadium seating. Another group of public seating known as Tandem Seating used cast ALUMINUM frames to support padded seat and back units. Probably the best known of Eames's designs are the 1956 lounge chair and ottoman, molded plywood units supported on cast aluminum bases supporting leather cushions. In spite of its unconventional appearance, the comfort of the chair and its visual suggestion of comfort have made it a CLASSIC, and something of a status symbol as well. The design has been much imitated, but remains in production and much in demand.

Eames's designs generally made use of organically curving, sculptural forms in combination with mechanistic structural details that are now thought of as pointing toward the design direction called HIGH-TECH. While there was never any ornamental detail as such, Eames's furniture is generally inherently decorative, projecting an aesthetic that is strongly modern in character without being austere or forbidding. It has been said that Eames's work, in the end, amounted to only "one house and a few chairs." While his total production was, in fact, vastly more than that, it is true that those were the most memorable and influential parts of Eames's career. It remains remarkable that the quality of Eames's work, combined with a sincerity and an element of playfulness, makes it symbolic of the best aspects of American design.

EAMES, RAY KAISER (1915–1988)

American artist and designer known for her work in cooperation with her husband, Charles EAMES. Ray Kaiser studied painting with Hans Hofmann in New York and Provincetown, Massachusetts, in the 1930s. Her work was shown at the Riverside Museum in New York

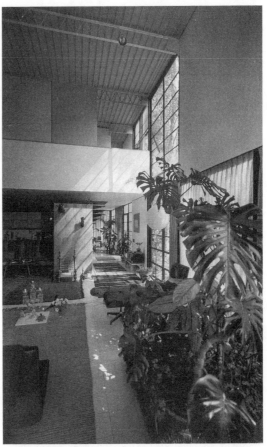

Living area in the Venice, California, house designed by Charles and Ray Eames for their own use. Photo courtesy of Charles Eames.

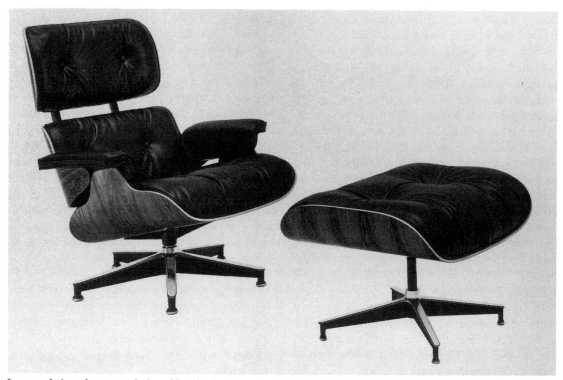

Lounge chair and ottoman designed by Charles Eames for Herman Miller. Photo courtesy of Herman Miller, Inc., Archives.

in 1936. In 1940 and 1941 she studied at CRANBROOK ACADEMY, where she met, and in 1941 married, Charles Eames. Eames had already won several prizes for his furniture design. The couple moved to California where Ray Eames designed some covers for *Arts and Architecture* and participated in many Charles Eames projects. Ray Eames's influence was particularly strong in developing the style of detail that was typical of the Eames's own home, of the displays of the Eames's furniture in HERMAN MILLER showrooms, and of the settings used in both still and moving picture photography produced by the Eames office. An acceptance of what might be called "orderly clutter," made up of accessories, kites, toys, and small charming objects, became typical of Eames interiors and graphics under Ray Eames's influence. Although her contribution is not easily separated from the work of her husband, Ray Eames was the sole designer of a number of turned wood stools of playful character that were added to the Herman Miller product line in 1960.

EARL, HARLEY J. (1893–1954)
American design executive responsible for the STYLING of GENERAL MOTORS cars from 1927 until his retirement in 1959. Earl was born in California, the son of a builder of custom auto

bodies. Earl attended Stanford University while also working in the family business. After joining General Motors in 1927, he exerted a constantly increasing influence in favor of design as a major ingredient in sales success. His 1927 LaSalle, dignified and elegant with its narrow hood and simple radiator grille, is viewed as his first major success. Over the years, particularly after World War II, the styling of General Motors cars became gradually more exaggerated, introducing excess CHROMIUM trim, oversized bodies, wraparound windshields, and, ultimately, tailfins. The concept of forced obsolescence is often associated with the constantly changing body designs developed under Earl's direction and imitated by other American automobile manufacturers.

EASTLAKE, CHARLES LOCKE (1836–1900)
English architect, designer, and theorist whose writings had a considerable influence on the design of the late 19th and early 20th centuries. Eastlake exhibited a few architectural designs early in his career, but by 1865 had turned to writing as his primary activity. Articles that he had written for various magazines were reworked to form the 1872 book *Hints on Household Taste*, a popular and persuasive tract urging a style that drew on the ARTS AND CRAFTS ideas of William MORRIS and was also

Illustration from Charles Locke Eastlake's book Hints on Household Taste *showing his own design for a mantel.*

based on the style called "Queen Anne." Eastlake's teachings and his own illustrations that appear in his book had a particularly strong effect in America where the "Eastlake Style") (which often had little connection with his own design) became quite popular. Eastlake's rejection of imitative HISTORICISM and his urging of logic and simplicity influenced the development of the CRAFTSMAN movement and so can be viewed as a remote predecessor of MODERNISM. Eastlake drawings and the work produced in his name are often quite floridly decorated and so tend to seem typically Victorian in character.

EASTMAN, GEORGE (1854–1932)
American inventor and industrialist who made photography an available and popular activity. Eastman began to manufacture sensitized glass plates in 1880, but experimented with ways to replace the clumsy and fragile glass soon after that time. By 1884 he had developed the flexible cellulose film that was destined to replace the plate and the invention of roll film followed immediately. In 1892 he founded the Eastman KODAK Company. With the convenient Kodak

folding camera and the slogan, "You push the button, we do the rest," Eastman popularized photography. Film was returned to Kodak for processing, so the amateur did not need to learn darkroom techniques. Other innovations followed: In 1900 Eastman introduced "daylight" roll film using a paper backing and leader to make it possible to load and unload the film in normal light. That same year, the inexpensive Kodak Brownie camera came out, with a design that was simple to the point of MINIMALISM. Later Kodak cameras include designs by the industrial designer Walter Dorwin TEAGUE, as well as "in-house" designs of varying merit.

EASTMAN KODAK COMPANY
See KODAK.

ÉCART INTERNATIONAL
Paris-based firm founded by Andrée Putman in 1978 to reproduce and market furniture and other design works by such historic figures of MODERNISM as Antonio GAUDÍ, Eileen GRAY, and Robert MALLET-STEVENS. The firm has also become the vehicle for Putman's work in interior design, including projects for various fashion designers and for hotels such as Morgans (1984) in New York.

ECLECTICISM
Term used in design and architecture to refer to the practice of borrowing from various historic styles, sometimes in combination. From about 1900 until World War II, most architecture and interior design was eclectic, using the styles of ancient Greece and Rome, the Middle Ages, and the Renaissance as the taste of architects and clients might suggest. Such buildings as New York's old Pennsylvania Railroad terminal built in imitation of Roman baths, the Woolworth Building constructed in the style of a Gothic cathedral tower, and many lesser buildings are typical of the eclectic phase of American architecture. Interiors were similarly designed in imitative styles. Manufacturers of furniture, lighting devices, and similar items produced designs to match the popular periods and styles. Although eclecticism was largely displaced by MODERNISM, it survives in the continuing manufacture of antique reproductions and is currently being revived in a modified form as an aspect of POST-MODERNISM.

ÉCOLE DES BEAUX-ARTS
See BEAUX-ARTS.

Viaduct of Garabit, designed by Gustave Alexandre Eiffel. Photo by John Pile.

EDISON, THOMAS ALVA (1847–1931)

One of the most productive of American inventors of the late 19th and early 20th centuries. His invention of the phonograph ("talking machine") in 1877 and of the electric light bulb in 1878 established his reputation as a key figure in the development of modern technology. As with many inventors, Edison combined invention with design through the necessity of giving form to his original prototypes. Although many Edison designs seem crude, others, such as the incandescent bulb, were so well conceived as to become the norm, surviving with little change to the present. Edison was a prolific inventor of many electrical devices and systems and played an important role in the development of modern, near-universally available electrical power distribution systems.

EDSEL

Brand name of an automobile introduced by the Ford Motor Company in 1958. The Edsel has become a legend of the failure of a giant company in developing, designing, and marketing of a product so badly suited to consumer preferences that it faced almost total public rejection. The Edsel (named for Henry FORD's son) was developed with the aid of consumer preference studies of the time and was designed with heavily exaggerated STYLING elements of the kind that had become popular in the early 1950s. By the time the Edsel appeared, however, public taste had changed, turning away from such styling toward a slightly more conservative direction. The Edsel therefore seemed a caricature of over-design, the subject of derision rather than admiration. The model was discontinued after a very brief production run. Surviving examples have, ironically, become collectors' items, because of their rarity and because they are examples of styling excess in American automotive design.

EICHENBERGER, HANS (b. 1926)

Swiss architect and furniture designer whose work is in a restrained, geometric MODERN vocabulary based on INTERNATIONAL STYLE concepts. Trained as a cabinetmaker in Bern and Paris, Eichenberger's architectural work has included a cultural center at Belmont, a church at Flamatt (both in Switzerland), and student housing at Stuttgart in West Germany. He established his own firm to produce a number of his designs, including a delicate armchair using an A-frame of steel tubing to support a round seat and a slim, cane-wrapped back. A lounge chair of 1957 uses a frame of steel tube to support a seat and back of flowing contour webbed with rubber. His Omega office system (1953–56) uses rolling drawer units and simple tables with legs of tubular steel in an inverted T configuration. The manufacturer is Theo Jacob in Bern; Stendig, Inc. has been the New York importer.

EICHLER, FRITZ (b. 1911)

German designer and design executive, a key figure in the development of the BRAUN design program. Eichler began his career in theater design. In 1954 he met Artur Braun and became design director for the new and advanced design direction that the company was about to take. As product and advertising director for Braun, he has been responsible for bringing Otl Aicher, Hans GUGELOT, and other designers connected with the HOCHSCHULE FÜR GESTALTUNG at Ulm into the Braun design program.

EIFFEL, ALEXANDRE GUSTAVE (1832–1923)

French engineer best known for the Paris tower that carries his name. Eiffel was trained in engineering and worked for various firms before establishing his own office in 1866. He worked on a number of railway projects and became known for his handsome steel bridges over the Douro in Portugal (1877–78) and the Viaduct of Garabit in central France (1880–84). He was the engineer for the Bon Marché store in Paris (1876) and developed the iron support structure for the Statue of Liberty in New York (1885). When he worked on the Paris tower in 1889, it was by far the tallest structure in the world (985 feet) and held that rank until the CHRYSLER BUILDING was built in New York in 1930. The Eiffel Tower combined hints of BEAUX- ARTS and ART NOUVEAU design thinking with the engineering concepts of its steel lattice structure.

EKCO PRODUCTS COMPANY

American manufacturer of kitchen utensils of superior, straightforward design. The firm was founded in 1888 by Edward Katzinger (hence the Ekco product name) and manufactured kitchen tools of an industrial VERNACULAR sort. Ekco can openers of anonymous design were included in an Albright Art Gallery design exhibit in Buffalo, New York in 1947. In 1955 a line of utensils known as Flint 2000 was designed for Ekco by the Chicago industrial design firm of LATHAM TYLER JENSEN using stainless steel utility parts with riveted black plastic handles. Ekco products have established a quality norm for household utensils.

ELEVATION

Term given to an ORTHOGRAPHIC projection drawing showing an object in front, side, or rear view, with all parts presented in full size or to scale in true size relationship. An elevation results from projection of an object's form onto a vertical plane. Elevations are, with PLANS and SECTIONS, the basic drawings of architecture and design showing objects in accurate form and scale. Representing a three-dimensional object accurately on flat paper normally requires a minimum of three views: a plan or top view, a cross-sectional view, and at least one elevation. Additional elevations are often required to show front, sides, and rear, if these aspects of the object differ in ways not revealed by the other drawings. While the terms "front view" or "side view" have the same meaning as "front elevation" or "side elevation," the latter terms are usually preferred. They make it clear that the view is strictly orthographic, that is, not a PERSPECTIVE in which foreshortening might make it impossible to measure, or scale off, dimensions accurately.

ELLIPSE

Geometric figure, a section of a cone cut at an angle to the cone's central axis. An ellipse is also the trace of a moving point whose location is always the sum of its distances from two fixed points. This makes it possible to draw an ellipse by placing pins at the two points (called "foci"), tying a slack thread to the pins, and moving a pencil in such a way as to hold the thread taut. The longest dimension of an ellipse (called its "major axis") and the shortest dimension (called the "minor axis") are always at right angles and divide the ellipse into four matching quarters. The projection of a circle placed at an angle to a plane onto that plane will always be an ellipse. Because the angle of this circle to the plane determines the proportions of the ellipse, the shape of a particular ellipse is often described by giving that angle in degrees. Template guides are widely used by designers and architects to draw ellipses of many angles and dimensions; ingenious instruments have been developed for the same purpose.

ELLIS, HARVEY (1852–1904)

Architect and designer associated with the CRAFTSMAN movement in America. Ellis had studied art and traveled to Venice before meeting H.H. Richardson. In 1879 he established practice as an architect in partnership with his brother Charles. He continued to paint and design posters until 1902 when he joined Gustav STICKLEY's venture in Syracuse, New York.

Until his death, Ellis designed furniture, textiles, and interiors in the Craftsman style.

ELLIS, PERRY (1940–1986)

American fashion designer known for an "anti-fashion" approach to fashion design. Perry Ellis's training was in business and retailing (with degrees from William and Mary and New York University), and he began his career with a post as a department store buyer in Richmond, Virginia. In 1968 he moved to New York to work for the firm of John Meyer of Norwich, where he began to design status-oriented sportswear. In 1975 he started work with the Vera companies, launching his label, Perry Ellis for Portfolio, for that firm. In 1978 he established his own firm, which concentrates on sportswear with natural textures and simple forms. Ellis gradually added bed linens, furs, men's clothing, scarves, and shoes. Simplicity, often based on traditional themes with an emphasis on active movement, is characteristic of Ellis's design. He was the winner of 1979 Neiman-Marcus and Coty Awards. The Portfolio label was revived in 1984. Since his death, the Perry Ellis name has been retained by his company.

ELMSLIE, GEORGE GRANT (1871–1952)

Scottish-born American architect whose work is associated with the PRAIRIE SCHOOL of design. Elmslie came to the United States in 1885 and was working for the Chicago architect J.L. Silsbee when Frank Lloyd WRIGHT was also employed by that office. In 1889 he went to work for Adler and SULLIVAN, becoming chief designer there in 1895. Elmslie developed much of Sullivan's florid, ART NOUVEAU ornament and had a significant role in all his work. In 1909 he left Sullivan to form a partnership with William Purcell and George Feick, continuing from 1913 to 1922 with Purcell only. The 1911 bank in Winona, Minnesota, is a good example of their work. Elmslie was also a designer of furniture, textiles, and metal work in the Prairie School style.

EMPIRE STATE BUILDING

New York City skyscraper of ART DECO design, for many years the tallest building in the world. This structure of 1929–31 was designed by the firm of Shreve, Lamb & Harmon as an 85-floor office tower, but a pylon was added to the top, supposedly as a mooring mast for dirigibles, increasing the height to 102 stories (1,239 feet)

and establishing a height record that lasted until 1972. The building has the setback form typical of tall buildings constructed in the 1920-to-1950 era of zoning regulations and so regarded as the "skyscraper style." Details are in the Art Deco mode as are the interiors of public spaces. The design was generally regarded as banal and commercial in quality, but recent boredom with the INTERNATIONAL STYLE buildings of the post–World War II era has created a cult of reaction that now admires the 1930s skyscrapers, of which this is the largest and most spectacular. Its status as a tourist attraction remains undiminished.

ENDELL, ERNST M. AUGUST (1871–1925)

German architect and designer generally identified with JUGENDSTIL design. Endell was born in Berlin and relocated in Munich in 1892 where he set up in architectural and design practice. His best-known work is the Elvira photo studio of 1897–98 with a facade combining original and imaginative architectural forms with a fantastic bas-relief sculpture. It has come to be regarded as a quintessential example of ART NOUVEAU as it developed in Germany. Endell's work included furniture, textiles, and jewelry. From 1904 to 1914 he ran his own design school in Berlin; in 1918 he became director of the Breslau Academy.

ENVALL, BJORN (b. 1942)

Swedish automobile designer responsible for designing the SAAB 900 series of 1979–80. Envall worked for Sixten SASON on the Saab 99 before becoming chief designer for Saab after Sason's retirement in 1977. He has shown a particular concern for ergonomic, safety, and environmental considerations and appears wiling to produce designs that do not follow current STYLING trends, thus giving Saab automobiles a unique character in relation to their competition.

ENVIRONMENTAL PSYCHOLOGY

Term for a growing field of study that attempts to develop a systematic relationship between the design of the humanly created environment and the nature of human behavior as affected by the environment. It is widely believed, at least by designers, that the designed environment has a strong effect on human behavior and satisfaction with life experience, but little experimental data exists to support such belief. Environmental psychology seeks to define and

Empire State Building. Photo courtesy of New York Convention and Visitors Bureau.

clarify this relationship and to aid designers in producing work that will have optimum human impact. Consultants in the field are now often asked to participate in the design of projects (most often architectural and interior design) where the effect of the newly created environment on human users is expected to be significant. The term "architectural psychology" is sometimes used to refer to the same or related fields of study and practice.

ERECTOR
Construction toy developed by A.C. Gilbert, an American inventor and designer, in 1913. The toy consists of a set of steel girder strips, perforated plates, and various wheels, pulleys, and other elements that can be assembled by a child with nuts and bolts to make a variety of working models of bridges, cranes, machines, and other objects following plan books or through improvisation. Sets were produced in a graduated series beginning with a few simple parts and progressing to considerable complexity.

Frank Hornby's MECCANO, an English construction toy of 1901 predates and closely parallels Erector but Gilbert's system seems to have been a totally independent development. Both toys have, over many years, been truly educational in introducing mechanical and engineering concepts into creative play.

ERGONOMI DESIGN GRUPPEN
Swedish design organization founded in 1979 by Maria Benktzon and Sven-Eric Jahlin, with a special interest in development of products and equipment for use by disabled people. Ergonomi Design is a cooperative of equal partners with a particular dedication toward ergonomic design for *all* users, including those with physical handicaps. Its work has included table flatware and other tools usable both by the physically handicapped and by others without special problems. The unusual, often sculptural, forms of resulting products are of considerable interest.

ERGONOMICS
Systematic study of relationship between products and human users. The closely associated study of ANTHROPOMETRICS makes it possible to develop designs in which elements that make direct contact with users are formed for the best possible interrelation. The forms and layout of controls and instruments, the design of finger and hand grips, and the arrangement

Windmill Pump

Windmill pump model, a design from the plan book supplied with an Erector construction toy set.

of seating surfaces and other furniture elements to promote efficiency, comfort, and physiologically optimum forms are special concerns of ergonomic study. The term has come into wide use in the promotion of chairs, such as the HERMAN MILLER Ergon chair designed by Bill STUMPF, and other products that are claimed to be designed to maximize human convenience and comfort in use.

ERICOFON 700
Trade name for a telephone of strikingly modern design by Swedish industrial designer Gosta Thames. It was brought to market by the Swedish firm of Thorn Ericsson (L.M. Ericsson Company, established in Stockholm in 1876). The Ericofon of 1954 is a one piece, upright plastic form in which the microphone and receiver are combined in one unit with the dial placed on the bottom plane. Picking up the unit opens the line and makes the dial accessible; placing the phone back on its base hangs up the connection. During the many years when telephones were generally confined to a few standard designs, the Ericofon with its smooth

sculptural form offered an interesting alternative that suggested the possible range of variation in the design of this ubiquitous instrument.

ERLICH, HANS
See A&E DESIGN.

ESCHMANN, JEAN (1896–1961)
American designer specializing in bookbindings. Eschmann was born in Switzerland and studied bookbinding there as an apprentice. He came to the United States in 1919 and in 1929 became the head of the bookbinding workshop at CRANBROOK ACADEMY. His work there included the design and handcrafting of fine bindings with a character that balanced a trace of ARTS AND CRAFTS aesthetic with a recognition of the MODERNISM of the 1920s and early 1930s. After 1933, Eschmann taught and worked in Detroit until he became head of the National Library Bindery in Cleveland in 1935.

ESHERICK, WHARTON (1887–1970)
American furniture designer and craftsman known for his creative, often sculptural designs in wood. Esherick began his career in the fine arts, but in 1913 turned to making furniture of his own design in a studio workshop near Philadelphia. His designs, while nontraditional, were usually curvilinear, suggesting an awareness of ART NOUVEAU precedents.

L'ESPRIT NOUVEAU
Design magazine published in Paris from 1920 to 1926 devoted to the promotion of the then developing ideas of MODERNISM in art, architecture and all other aspects of design. The architect LE CORBUSIER and the painter Amedée OZENFANT were principal contributors to the magazine, which promoted their views of modernism. Adolf LOOS's famous article "Ornement et Crime," appeared in a 1920 issue. In the Paris Exhibition of 1925, *L'Esprit Nouveau* had a pavilion designed by Le Corbusier that was a striking showcase for his ideas of architectural and interior design. A replica of the pavilion was built at Bologna, Italy, in 1977.

ESSLINGER, HARTMUT (b. 1945)
German industrial designer, founder and president of FROGDESIGN, an international firm known for its advanced design approaches. Esslinger studied electrical engineering at Stuttgart and design at the College of Design of Schwabisch Gmund in Germany. His first

major client was the German electronics firm of Wega (later absorbed by SONY), for whom he designed the series of color TV sets that included the 3020 model, now regarded as a CLASSIC of its day (1971). Other clients included KaVo for dental equipment and Hansgrohe bathroom fittings. As his firm grew, it was reorganized in 1982 under the frogdesign name, with offices in California and Tokyo in addition to the original office in Altensteig, West Germany. Esslinger continues to serve as president and design leader for frogdesign.

EVANS, WALKER (1903–1975)

American photographer known for the striking documentary character of his work. Evans was born in St. Louis and educated at Phillips Academy and Williams College. After working briefly in the New York Public Library, he moved to Paris, where he took up photography, using a small pocket camera. He returned to New York in 1927. The first major exhibition of his photography was at the MUSEUM OF MODERN ART in New York in 1933. Typical subjects were Victorian houses shown in clear images free of any romantic softening. In 1935 he became an official photographer for the Farm Security Administration, documenting the often grim farm conditions in the South during the Depression. Many of the photographs were published in his 1941 book with James Agee, *Let Us Now Praise Famous Men*. In 1945 Evans became a staff photographer for *Fortune* magazine, producing a number of photo essays including a study of common hand tools shown with total objectivity. From 1965 until his death he was a professor of photography at Yale University. Evans was the winner of a Guggenheim fellowship in 1940 and has been the subject of many exhibitions; his photographs are in the collections of many museums.

EXNER, VIRGIL (1909–1973)

American automobile designer usually credited with having a major role in the design of the 1947 STUDEBAKER. Exner worked on automotive STYLING in the 1930s under Harley EARL at General Motors. In 1939 he went to work for Raymond LOEWY, eventually developing the Studebaker body that has come to be regarded as a CLASSIC of post–war American design. In 1949 he returned to Detroit to work for Chrysler, introducing longer and lower body designs whose "forward look" was produced by exaggeratedly slanted front and rear forms. The rather garish lines of the Chrysler designs are in marked contrast with the generally neat and logical forms of the Loewy Studebakers.

EXTRUSION

Manufacturing process in which a continuous ribbon of material is produced by squeezing the softened material through a nozzle-like die whose opening is the desired shape of the final product. The shape is retained after cooling and hardening. ALUMINUM and various PLASTICS are the materials most often extruded. Since the die controls the form of the extrusion, complex shapes can be made cheaply and easily once the required die has been produced. Structural shapes and tubing are commonly extruded in aluminum as are more complex shapes used for window and door frames and other architectural details. Plastic extrusions are widely used for gaskets, window glass retaining moldings, hose, and pipe. The modest cost of creating an extrusion die makes this process popular as a means of producing special forms unique to a particular design. KNOLL INTERNATIONAL furniture products designed by Charles POLLOCK and Gae AULENTI make significant use of special aluminum extrusions.

EYRE, WILSON (1858–1944)

American architect known for his Shingle style houses of the late 19th century. Born in Florence, Italy (of American parents), Eyre studied architecture at MIT and began practice in Philadelphia in 1883. His work is associated with the ARTS AND CRAFTS movement and Queen Anne style of the time, although it has a unique personal character, with strong three-dimensional forms, that hints at the future developments of MODERNISM. Most of Eyre's work is residential, located in Philadelphia and the surrounding affluent suburbs. The Ashurst house (1885) in Overbrook, Pennsylvania, is one of his most distinguished early works. From 1901 until 1906, Eyre was the editor of *House and Garden* magazine, a pioneer consumer-oriented shelter publication. Other residential projects include the Horatio Gates Lloyd house (1914) in Haverford, Pennsylvania, and Hunting Hill Farm (1924) in Media, Pennsylvania, all in a simple but sophisticated style suggesting a British country vernacular. Eyre was not active after 1924.

FALLINGWATER

Famous house by Frank Lloyd WRIGHT at Bear Run, Pennsylvania, designed in 1936 for the KAUFMANN family of Pittsburgh. Wright placed dramatic concrete CANTILEVERS over a rocky waterfall in a wooded, rural site. The house is generally regarded as one of Wright's most striking masterpieces. Its dramatic form and the charm of its interiors are universally admired. It is now opened to the public for visits.

FARINA, BATTISTA (1893–1966)

Noted Italian designer and builder of custom automobile bodies. Farina studied automobile production in the United States in 1920 and established his own shop in Turin in 1930. In 1961 the firm was renamed PININFARINA; it is under this name that most of its recent work is identified.

FARNSWORTH HOUSE

Famous project of Ludwig MIES VAN DER ROHE, weekend house beside the Fox River near Plano, Illinois, built from 1945 to 1951 for Dr. Edith Farnsworth. The house is an ultimate example of the architect's effort to reduce building to minimal and universal terms. It consists of floor and roof planes supported by eight steel columns placed along their outer edges, with an all-glass rectangular enclosure that extends about two-thirds of the building's length. The interior is totally open except for a small rectangular block enclosing baths, utilities, and storage. Generally regarded as one of Mies' finest works, the house was unfortunately the cause of a bitter and notorious conflict between architect and client. The design seems to have been the inspiration for the equally famous Glass House of Philip JOHNSON at New Canaan, Connecticut.

FASTBACK

Term used in the automobile body design to describe a rear treatment in which a smooth, continuous line flows downward from the roof to the rear bumper. This form is related to STREAMLINING and is used to suggest a car that will go fast. It was the common form of auto-mobiles between 1932 and 1946. The alternative rear treatment ends the passenger compartment with a rear window and extends the lower rear of the body to provide a trunk. This is referred to as a NOTCHBACK because of the shape so created.

FATH, JACQUES (1912–1954)

French fashion designer known for flattering and feminine design sometimes verging on the mischievous. Fath was trained in a business school and worked for a time as an actor before opening his fashion house in 1937. After military service in World War II, Fath recognized the potential of American markets and entered into a contract to provide ready-to-wear design for the New York firm of Joseph Halpert. Thereafter he transferred his knowledge of American production methods to the ready-to-wear business in France. His products came to include hats, perfumes, and other lines, leading to increasing success up to the time of his death. His widow continued the firm briefly, but elected to close it in 1957. Fath was the winner of a 1949 Neiman-Marcus Award.

FAUX

French word meaning "false" that has come into use in design fields as a more attractive alternative to "imitation" or "false." Painted imitations of wood grain or marble veining, for example, when used in an elegant or fashionable context, are referred to as "faux marbre" or "faux ebony." This suggests a stylish or aesthetically worthy use of a simulated finish, rather than a tasteless imitation.

FEDERICO, GENE (b. 1918)

American graphic designer and art director, a leader in MODERN advertising design. Federico studied design at PRATT INSTITUTE in New York. After service in World War II, he became an associate art director of *Fortune* magazine in 1946. In 1947 he began work as an art director at Grey Advertising, a major New York agency, which was the first of several agency posts he held before founding his own agency in 1956 with three partners, Lord, Geller, Federico, Einstein. His work has made creative use of type, often in strongly contrasting large and small scale, often interwoven with photographic and abstract visual imagery. Federico's design is in the mainstream of graphic design modernism as it has developed in advertising of the mid-20th century.

FEEDBACK

Term for a technique of mechanical control, which has been taken up in computer technology and programming as well as in DESIGN METHOD. The basic concept of feedback is the use of some aspect of an action or process to establish automatic control of the continuing action. The classic example is the mechanical centrifugal governor, which opens and closes the steam valve of an engine in accordance with its speed so as to maintain a constant rate of rotation. Engine speed is established by setting the governor, which then controls speed automatically. A "feedback loop" describes the linkage or circuitry that exerts a similar control by monitoring the output of the device. Modern automation uses feedback to make "robots" and other automatic production systems self-governing. Feedback in design refers to evaluation of design proposals, which are used to modify and improve further proposals until a satisfactory level of functional workability is reached. In architecture the evaluation of completed projects can provide a form of feedback that leads to improved design in subsequent projects of a similar nature.

FERRAGAMO, SALVATORE (1898–1960)

Italian fashion designer who devoted his career to the design of shoes of great elegance and fine craftsmanship. Ferragamo was apprentice-trained as a shoemaker beginning at thirteen. In 1923 he came to the United States to study its factory shoemaking methods. He opened a shop in Hollywood and established a reputation there before returning to Italy in 1936 to set up a shop in Florence. His design was sometimes daring, but his later work became quite conservative, focusing on subtle design of great simplicity along with fine quality workmanship and concern for comfort. Ferragamo was the recipient of a 1947 Neiman-Marcus Award and, in 1957, published an autobiography, *Shoemaker of Dreams*. Since his death, his firm has continued to produce shoes in the Ferragamo tradition, which are now sold in many fashionable shops worldwide.

FIALLA, FRANK R.

See SPACE DESIGN GROUP.

FIAT

Largest Italian automobile manufacturer, with original factories near Turin. Founded in 1899 by Giovanni Agnelli, Fiat has often supported de-

sign excellence, employing such independent designers as GHIA, GIUGIARO, and PININFARINA. The 1935 500 Topolino, the 1978 Ritmo, and the 1979 Strada—each small, functional and unpretentious—are good examples of Fiat's dedication to producing basic cars for a mass market. The 124 Spider sports car is an example of quality design, in the tradition of Italian coach building, aimed at a special luxury market.

FIBERGLASS

Generic version of the trade name Fiberglas used by the Owens-Corning Glass Company for the hybrid material made from polyester PLASTIC reinforced with glass fibers. Fiberglass makes it possible to give high strength to glass parts that may be molded, or "hand laid-up," that is, built up on a mold with layers of glass cloth soaked in plastic resin. Fiberglass is increasingly used for automobile body parts and the hulls of small boats. It is also used for various household products and is the material of the first successful plastic chairs designed by Charles EAMES and Eero SAARINEN.

FIBONACCI (SERIES)

Sequence of numbers named for the Venetian mathematician, Leonardo Fibonacci (d. ca. 1250) who first noted their special qualities. Many theoretical concepts in historic and 20th-century design make reference to the GOLDEN SECTION and to the Fibonacci number sequence. A Fibonacci series begins with the numbers 1 and 1 and continues with each successive number the sum of the two preceding ones. The series is thus 1, 1, 2, 3, 5, 8, 13, 21, 34, 55, 89,..., etc. The ratio of each pair of successive numbers is found to approach more and more closely the ratio known as the Golden Ratio or Golden Section, in which the ratio of two successive numbers equals the ratio of the larger number to the sum of the two. The ratios 3:5, 5:8, 8:13, etc., grow successively closer to the golden ratio of 1:1.618..., an "irrational" number that can be approximated, but not expressed exactly in decimals. Many forms in nature—the spirals of shell growth, the arrangement of flower petals, circles of tree growth—follow patterns that can be expressed numerically in terms that parallel a Fibonacci series.

FILLET

Concave curved strip used to make a smooth transition between two meeting surfaces. Fil-

lets are used, for example, where airplane wings meet the fuselage and at meeting points on automobile bodies—such as where fenders meet a body surface. By adding to the smoothness of a form, fillets make air flow easier if the object moves at high speed and so are often used to aid in STREAMLINING. Modern industrial design practice may introduce fillets connecting forms in stationary objects to create a smooth or flowing appearance.

FIORUCCI, ELIO (b. 1935)
Italian clothing marketer whose shops typify an avant-garde or POP design direction. Fiorucci's first shop, opened in 1967 in the Milan Galleria, was designed by Ettore SOTTSASS. Fiorucci-printed fabrics usually project a zany comic-strip image in line with the chain's overall design approach.

FITCH RICHARDSONSMITH, INC.
See RICHARDSONSMITH.

FOLLOT, PAUL (1877–1941)
French designer whose career spanned the transition from ART NOUVEAU to ART DECO design. Follot's earliest work imitated medieval Gothic examples, but after 1901—in association with MEIER-GRAEFE's shop, La Maison Moderne—he turned to the florid, curvilinear forms of Art Nouveau, producing jewelry and textiles as well as decorative bronzes. After 1909, his work became simpler and more restrained in form. Follot became director of Pomone, the design studio of the Paris Bon Marché department store, after World War I, and his work took on the modernism of the Art Deco style. He designed the Fécamp suite of the liner *NORMANDIE*.

FORD, HENRY (1863–1947)
American inventor and industrialist known for his role in the development of MASS PRODUCTION and for his development of a practical, economical, and popular automobile. Ford was trained as a machinist's apprentice and, by 1893, had become the chief engineer of the electric company serving Detroit, Michigan. He was an early experimenter, arriving at an automobile design in 1903, which he put into production when he founded the Ford Motor Company in Dearborn (near Detroit). The Model T of 1908 remained in production until 1927 and became the first widely successful automobile, with production totaling more

than 16 million. The subsequent Model A reached a similar level of popularity, retaining the mechanical simplicity and highly functional design of the earlier model. Only with the introduction of the V8 models of 1932 and thereafter did Ford products begin to show the influence of consumer-oriented STYLING that dominated later automotive design. Ford's concept of the moving assembly line as the basis for efficient mass production has remained a key factor in Machine Age developments, only recently challenged by the growing role of automation. The Ford Motor Company continues to be a major producer of cars, trucks, and tractors.

FORM
Word used in design theory and criticism to describe all the qualities of an object that a designer may be concerned with. The form of a thing involves its shape, color, texture, ornamentation, and every other aspect of its physical reality. Form is clearly influenced by material and structure, but is understood as distinct from those aspects of an object. It is conceivable that two objects might be of different materials but have the same form and so look alike. The term "visual form" is also often used to help define the concept of form and limit it to the qualities of an object that can be seen. The term "function," signifying the uses to which an object can be put, is generally seen as distinct from form, leading to the theory that form is determined, or at least should be determined, by function. The much-quoted phrase, "form follows function," often wrongly attributed to Louis SULLIVAN—he used the phrase but was quoting the earlier artist and writer Horatio GREENOUGH (1805–1852)—defines the relation of form and function as understood by many MODERNISTS holding "FUNCTIONALIST" views. A MODERN conceptual view of form defines it as being the ways in which any given object or situation departs from randomness.

FORNASETTI, PIERO (1913–1988)
Italian decorative designer best known for his unconventional application of trompe l'oeil and other decorative patterns to the surfaces of modern furniture and other objects. Fornasetti's background was in theater design and fine art, with a strong leaning toward surrealism. In the 1950s, Fornasetti joined with Gio PONTI to develop furniture with smooth plywood surfaces covered with Fornasetti's pat-

terns and images (often reproductions of old engravings or realistic images from nature). Fornasetti's work has come into fresh recognition with the return to decorative design in much contemporary work.

FORTUNY, MARIANO (1871–1949)

Spanish-born, inventive fabric and fashion designer whose pleated silk and cotton classic dresses are collected as works of art. Mariano Fortuny was born in Granada, the son of a painter. His father died when he was three, and the family eventually settled in Venice. It was there that he invented a patented pleating process, the manufacture of which is still somewhat of a mystery. It is thought that the pleats were formed by hand with a damp cloth, stitched, and set with heat. The fabrics were dyed with natural materials, and velvets were treated with a succession of hand-applied dyes. Inspired by painting and ancient textiles, of which he had a large collection, Fortuny stenciled patterns with woodblocks. His first garment was a pleated scarf (1906). A year later, he produced his famous Delphos dress—a simple column of silk-satin. Manufacture of this dress continued until 1953. In 1912 Fortuny shops were opened in Paris, then in London, and by 1923, in New York. His stenciled cotton fabrics manufactured on the island of Guidecca can still be bought there. In 1980, an exhibit of Fortuny work was presented at Lyons, France, traveling thereafter to New York and Chicago.

FOSTER, NORMAN

See HIGH-TECH.

FOUQUET, GEORGES (1862–1957)

French designer and maker of jewelry in the ART NOUVEAU and ART DECO styles. Fouquet first came to note as the maker of jewelry designed by Alphonse MUCHA (who also designed the Fouquet shop) and with his own work in a typically florid Art Nouveau decorative style. In 1922 his work shifted toward an Art Deco vocabulary and was featured in the Paris exhibitions of 1925 and 1937. His son, Jean (b. 1899), followed his design directions and continued to produce Art Deco designs until his retirement.

FOX, UFFA (1898–1972)

British designer of sailing yachts, better known (at least in England) as a sailor and frequent member of the crew of Prince Philip when he sailed in races. Fox was the designer of exceptionally fast racing dinghies and keelboats such as *Avenger* of 1928 and the racing class known as Flying Fifteen. It was *Coweslip* of this class owned by Prince Philip that brought special fame to Fox, leading to his reputation as a writer, lecturer, and broadcaster and making him something of a celebrity.

FRANCK, KAJ (b. 1911)

Finnish designer of glass, ceramics, and other decorative products in a typically Scandinavian MODERN vocabulary. Franck was trained as an interior designer in Helsinki and worked on furniture, textiles, lighting fixtures, and designs of Wärtsilä glassware until 1945, when he became chief of design for ARABIA. His Kilta, Ruska, and Teema dinnerware services helped to establish the Arabia reputation for design quality. Kilta is a white service using functional forms of utmost simplicity; Ruska also uses simple forms but with a richly textured brown glaze. He was the winner of a gold medal at the Milan exhibition in 1951 and received a COMPASSO D'ORO award in 1957. He has continued in private practice since his retirement from Wärtsilä in 1978.

FRANK, JEAN-MICHEL (1895–1981)

French designer and interior decorator whose work bridges the ART DECO style of the 1920s and the MODERNIST style of the 1930s. Although educated as a lawyer, Frank began working with the interior decorator Adolphe Chanaux in 1929. The two set up a Paris shop in 1932, offering their furniture designs and Frank's services as an interior designer. His work became popular with many noted and wealthy clients, including Nelson Rockefeller for a New York apartment in 1937. Frank's work tended toward simplified geometric forms (regarded as remarkably austere in their day) along with rich materials and decorative details. The work of the Giacometti brothers often appeared in Frank's interiors, along with design by a number of other designers who together developed a kind of MODERNISM less doctrinaire and more decorative than the work of the modern architects of the time. Frank's work exerted considerable influence on the work of American decorators of the 1940s and 1950s.

FRANK, JOSEF (1885–1967)

Austrian designer of furniture and other household products who after 1932 transferred his base of operation to Sweden to become a dom-

inant figure there in the development of the style now called Swedish modern. Frank was educated at the Institute of Technology in Vienna, becoming professor at the Kunstgewerbeschule there in 1919. He designed interiors and furniture, including some bentwood designs for THONET that have become CLASSICS. He settled in Stockholm after his marriage in 1934, taught at the New School in New York from 1941 to 1946, but returned to Sweden where he remained active as a designer of textiles, wallpapers, lamps, and furniture for the rest of his career.

FRANKL, PAUL T. (1887–1958)

Austrian furniture and interior designer who came to the United States in 1914 to develop a career as an early modernist. In New York in the 1920s Frankl produced his so-called skyscraper furniture characterized by steplike setbacks. His interior design work was more typically ART DECO in style. He exerted considerable influence through the publication of his 1930 book, *Form and Re-Form*, in which he illustrates and discusses many examples of Art Deco and MODERNIST work, his own as well as that of others including Donald DESKY, Frederick KIESLER, Richard NEUTRA, and Frank Lloyd WRIGHT. After World War II, Frankl relocated in California where he became an active interior designer working in a simple, geometric style typical of what is called "California Modern."

FRATTINI, GIANFRANCO (b. 1926)

Italian architect and industrial and furniture designer. Trained at Milan Polytechnic, Frattini worked for the Italian architect Gio PONTI from 1952 to 1954. Since going into independent practice, he has worked on metal products, furniture, and lighting. His cabinets and shelving system of 1960 for Bernini, his Sesann upholstery of 1970 for Cassina, and his snaky Boalum light (designed in collaboration with Livio CASTIGLIONI) of 1971 for ARTEMIDE are among his best-known works.

FREYSSINET, EUGÈNE (1879–1962)

French structural engineer best known for his extraordinary constructions of REINFORCED CONCRETE. Freyssinet was the engineer who designed vast twin airship hangars, built in 1916–21 at Orly Airport near Paris, using a continuous parabolic concrete arch with a span of 295 feet. The hangars were destroyed in 1944.

Freyssinet was also the designer of various concrete bridges, including an arch bridge with a span of 430 feet over the Seine at Pierre du Vauvray, built in 1922 and reconstructed in 1946, and some buildings of the Gare d'Austerlitz in Paris of 1929.

FROEBEL, FRIEDRICH (1782–1852)

German educational theorist known for his system of education for very young children which encouraged conceptual design thinking. Froebel developed the idea of early childhood education in the *kindergarten*, which, in his demonstrations, was not merely a play school, but an opportunity to achieve essential, educational goals. The importance of Froebel's ideas in design fields results from his highly organized plan of introducing simple devices for teaching through visual and kinesthetic means so that conceptual learning can precede reading and writing. In the Froebel method, there are thirteen "gifts," each offering a child certain materials to be used in making various patterns and constructions in two and three dimensions. For example, the third gift provides cubical blocks and subsequent gifts add additional blocks that are multiples and submultiples of the basic cube, leading, eventually, to triangles based on the original cube dimensions. The large "nursery school blocks" in wide use are a large-scale version of the Froebel blocks—the originals were based on a 1-inch cube module. Many toy makers have produced block sets in wood or in a stonelike composition material in modular forms based on the Froebel block system, with the German ANCHOR BLOCKS a popular version in the early part of the 20th century.

Froebel's method and the Froebel blocks, in particular, have drawn special attention in architectural circles because of Frank Lloyd WRIGHT's detailed remembrance in his *Autobiography* of his delight in the Froebel materials and the role they seem to have played in developing his architectural thinking in terms of modular, geometric forms. In fact, block-building play with Froebel-based block systems tends to generate compositions that often resemble some of Wright's famous works.

FROGDESIGN

International design firm with a reputation for adventurous, even futuristic, product design. The firm resulted from the expansion of a consulting design practice founded in 1969 by

Hartmut ESSLINGER in the German town of Altensteig in the Black Forest. In 1982, the firm took its curious name from the Frog, a bright green, plastic-housed Wega TV set of unusual shape. Now frogdesign has offices in Campbell, California, and Tokyo, as well as its home base in Altensteig, West Germany. There are now more than forty staff members and a client roster including the German electrical firm AEG; APPLE COMPUTER, General Electric, and KODAK, in the United States; HOLZÄPFEL, König & Neurath, Marklin, and Louis Vuitton, in Europe; and Seiko and Yamaha in Japan as well as SONY (which absorbed Wega in 1975) in all three locations. The Apple IIC computer (1982–83) is probably the firm's best-known work (it was included in the WHITNEY MUSEUM 1985 *High Styles* exhibit), while the 1975–78 Wega Concept 51K is included in the design collection of the MUSEUM OF MODERN ART in New York. The King Zet office furniture for König & Neurath (1984) combines ERGONOMIC adjustability with simple and elegant form.

Esslinger continues to head the German office (and is the firm's president), Dieter Pfeifer is in charge of design in California, and Fritz Frenkler in Japan. The firm takes pride in its very international staff of generally young designers and tends to emphasize an avant-garde, imaginative, and sometimes irreverent point of view, while taking every advantage of the most advanced available technology in its own methods as well as in the products it develops. Such products as *frolerskate* roller skates for Indusco (1981) or an elaborate controller for Märklin HO model trains are as much part of frogdesign production as are the more serious efforts in plumbing fixtures and dental equipment. The firm's work has been widely published, exhibited, and honored with various awards. Some of its most advanced work is still in the form of prototypes or competition winners (such as the 1985 Yamaha motorcycle design that won a Motorrad competition). The work of frogdesign might be described as maintaining a balance between the austerity and MINIMALISM typical of the work of the HOCHSCHULE FÜR GESTALTUNG at Ulm and a more experimental, free, colorful, and even playful approach that seems in tune with the spirit of the latter half of the 20th century.

FRY, MAXWELL (b. 1899)

English modern architect and designer. Fry was trained at the Liverpool School of Architecture in traditional practice, but turned toward MODERNISM, becoming one of the founders of the MARS group in 1931. He was the designer of a number of projects of INTERNATIONAL STYLE character and was influential in encouraging Walter GROPIUS and Marcel BREUER to come to England, bringing direct BAUHAUS influence with them. Fry worked with his wife, Jane Drew, in the development of modern interior design in England, exhibiting a modern kitchen at the VICTORIA AND ALBERT MUSEUM in a 1946 exhibition. Fry and Drew have also had a major share in the design of the city of Chandigarh in India, although their work has been somewhat overshadowed by the involvement of LE CORBUSIER there.

FRY, ROGER ELIOT (1866–1934)

British artist and aesthetician identified with the OMEGA WORKSHOPS in London. A Cambridge graduate, Fry was a painter and art historian who served briefly (1905 to 1910) as the director of the Metropolitan Museum in New York. In 1912 Fry, together with the painter Wyndham Lewis, organized the Omega Workshops as a new effort at the union of art, design, and craft in the tradition of William MORRIS. After achieving limited success, the workshops closed in 1921.

Frolerskates designed by frogdesign for Indusco.
Photo courtesy of frogdesign, hartmut esslinger, inc.

FULLER, BUCKMINSTER (1895–1983)

Extraordinarily versatile American inventor, engineer, theorist, and teacher who advocated the possibilities of technology as a source of solutions to all human problems. Educated as a naval officer at the U.S. Naval Academy at Annapolis, Fuller turned, in the 1920s, to the development of unconventional engineering solutions to such basic design problems as the house and the automobile. His DYMAXION house of 1927 used tension cables to suspend its structure from a central mast. The Dymaxion car of 1932 was an aerodynamically streamlined, three-wheeled, rear-engine vehicle of highly unconventional form. These and a number of other projects such as a factory-made, one-piece bathroom failed to achieve commercial acceptance, probably because they were too far ahead of their time. In the 1960s, his concept of the GEODESIC dome, a technique for space enclosure using an arrangement of triangles to form part of a sphere, offered great efficiencies in weight and cost. Fuller domes have been used for industrial buildings, in military applications, and as exhibition structures. The large geodesic dome used as the U.S. pavilion at the Expo 67 WORLD'S FAIR at Montreal was a dramatic demonstration of the concept's possibilities. Many small geodesic domes have been built as homes by amateur experimenters and architects. The concepts of HIGH-TECH design owe their origins in large part to Fuller's ideas.

Fuller was the author of a number of books, including *Nine Chains to the Moon* (1938) and *Operating Manual for Spaceship Earth* (1969). He taught at a number of colleges and was well-known and popular for his nonstop lectures in which he mixed technical ideas and a philosophy that urged an intelligent exploitation of the possibilities of advanced technology to solve all human problems.

FULTON+PARTNERS

New York industrial design providing product, graphic, and package design to an extensive roster of major corporations. The firm was founded in 1966 by James Fulton (b. 1930), a 1951 graduate of PRATT INSTITUTE, who had worked with the office of Harley EARL in Detroit and LOEWY/Snaith in New York where he became a senior vice-president before establishing his own firm. The Fulton+Partners client list includes Citibank, Hess Oil, J.C. Penney, Proctor-Silex, Shell Oil, and Trans World Airlines, among many others. A recent typical project involved product and graphic design for excavators and other equipment produced by the Koehring Company. The straightfor-

Drawings of the Dymaxion car designed by Buckminster Fuller.

Bantam excavator designed by Fulton+Partners for the Bantam Division of Koehring company.
Photo courtesy of Fulton+Partners.

ward functional character of the firm's work is typical of current "mainline" American industrial design practice. The firm maintains a Paris affiliate, Endt Fulton Partners SA.

James Fulton is also Chairman of Design Publications, Inc., a publisher of design books and INDUSTRIAL DESIGN magazine, a major influence in the design professions in America.

FUNCTIONALISM

Term for a philosophy or doctrine in architecture and design that gives primary importance to the utilitarian values that a design is intended to serve. Architectural theorists have traditionally given equal emphasis to functional, constructional, and aesthetic values. MODERNISM tended to shift increasing emphasis toward function, viewing structure as a means to support function and aesthetics as a natural by-product of functional and constructive concerns. In its most extreme form, proponents of functionalism assert that *only* functional values matter and that aesthetic values will be served when functional issues are dealt with at an optimum level. While such an extreme view of functionalism has rarely been propounded by design leaders, this view has often been attributed to them on the basis of their accomplished works. BAUHAUS design placed a strong emphasis on function, as did the work of LE CORBUSIER, although aesthetic values were never neglected in either body of work. Recent criticism of MODERN work tends to attribute to it an overemphasis on functionalism, connecting that view with the frequently mechanistic character of modern work. It can

also be argued that it was the emphasis on a machine-oriented aesthetic rather than undue regard for functional considerations, which motivate the directions that modernism has taken.

FURNESS, FRANK (1839–1912)

American architect of the Victorian era, most of whose work is located in and around Philadelphia. Furness was trained through work in the offices of several architects, including Richard Morris Hunt in New York. He set up his own practice in Philadelphia in 1866 and became well known after building the Pennsylvania Academy of Fine Arts in 1871–76. Louis SULLI-VAN worked in his office briefly in 1873. Furness's work, while full of the ornamentalism characteristic of Victorian design, has a strength and originality that makes it of special interest. It ranges from the relative simplicity of Shingle Style houses to moorish and gothic-inspired fantasy. Many of his buildings include interior, furniture, and lighting elements of considerable individuality. In addition to the Academy of Fine Arts (recently carefully restored), his surviving works include the University of Pennsylvania library of 1888–91 (now the Furness Building) and a number of houses and several railroad stations in the suburban area around Philadelphia. Although with the coming of MODERNISM Furness's work was dismissed as typically Victorian excess, it is receiving new attention with the recent upsurge in interest in ornamentalism. The work of Robert VENTURI and various other POST-MOD-ERNIST architects can be viewed as a new exploration of some of Furness's design ideas.

FUTURA

Modern TYPEFACE designed in 1927 by Paul RENNER (1878–1956) and produced by the Bauer Type Foundry. Futura, an elegant SANS SERIF face, quickly became one of the most popular modern typefaces for display use and, occasionally also, for text use. Other sans serif faces such as HELVETICA have largely taken its place in the post–World War II era.

FUTURAMA

Name of the GENERAL MOTORS exhibit at the New York WORLD'S FAIR of 1939–40. Norman BEL GEDDES conceived and designed this famous exhibition pavilion to house a conveyer-belt ride above an imagined world of the future (1960) created in model form, in which dra-matic superhighways connected futuristic cities. The most popular exhibit at the fair, *Futurama* has often been credited as the key influence in the development of the superhigh-way network constructed after World War II.

FUTURISM

Movement in the fine arts based in Italy from about 1909 until the beginning of World War I. The term has come into general use to refer to any concepts that attempt to predict or suggest design directions for the future. The poet Filippo Tommaso Marinetti was a key leader in the development of the philosophical under-pinnings of futurism. Artists Giacomo Balla, Gino Severini, and particularly Umberto Boccioni carried forward its emphasis on cap-turing the velocity of motion, along with a fas-cination with mechanistic and violent elements. Futurism's impact on the design world was primarily through the architectural proposals of Antonio Sant'Elia (1888–1916) for city scenes of fantastic buildings, bridges, and roadways that suggested future directions, both admired and dreaded, that have, in fact, come into realization to some extent in recent times.

GAGE, ROBERT (b. 1921)

Leading American graphic designer and adver-tising art director known for his role in the development of a unique style of advertising. Robert Gage had studied with Alexey BRODOVITCH before becoming one of the found-ers of the New York advertising agency of Doyle, Dane, Bernbach in 1949. As a vice-pres-ident and chief art director, he worked closely with William Bernbach in the development of a recognizable style that made a close link be-tween text copy and visual image. Strong, real-istic visual images draw attention and lead directly into brief but memorable copy. Adver-tisements for Ohrbach's department store, for

Interior view of the Furness Building (originally the University Library) designed by Frank Furness in 1888 for the University of Pennsylvania, Philadelphia. Drawing (1985) by Venturi, Rauch and Scott Brown, courtesy of the University of Pennsylvania.

VOLKSWAGEN, and for Levy's Bread were both attention-getting and often entertaining classics. Levy's Bread poster series, for example, featured faces of obviously non-Jewish models happily eating rye bread with the copy line, "You don't have to be Jewish to love Levy's real Jewish Rye."

GAGGENAU

German manufacturer of kitchen appliances and equipment of unusually fine design quality, founded in 1665 as a foundry in a small town in the German Black Forest. The firm eventually grew to be a producer of bicycles, ranges, and ovens as well as woodworking machinery, expanding until it employed some 2,000 workers. After World War II the firm resurfaced as a manufacturer of built-in kitchen equipment. Its product design is the work of anonymous in-house designers, but it sets a high standard in its field with simple, functional forms and highly refined detailing. Gaggenau appliances are now manufactured in Germany and France, but are marketed worldwide, with significant distribution in the United States.

GAILLARD, EUGÈNE (1862–1933)

French designer of interiors, furniture, and textiles in the ART NOUVEAU tradition. Gaillard's work was exhibited at the 1900 Paris Exhibition in the pavilion of Samuel BING. Those rooms, a bedroom and a dining room, are now in the Museum für Kunst und Gewerbe in Hamburg.

In his 1906 book, *À Propos du Mobilier*, he expounds Art Nouveau philosophy, urging forms based on nature without direct imitation. His work, using flowing, curved lines, illustrates his point of view, with its simplicity suggesting the directions later MODERNISM was to take.

GALLÉ, ÉMILE (1846–1904)

French designer and manufacturer of glassware, furniture and other products of ART NOUVEAU style as developed by the School of Nancy. Gallé was the son of a Nancy dealer in glass and ceramics. He studied both design and nature subjects at Weimar and the techniques of glass making at a factory at Meisenthal before returning to Nancy in 1867. In 1874 he established his own workshop and took over an established pottery. In the 1878 and 1884 Paris Exhibitions, he showed the work of his firm and, in 1889, added furniture to the products he exhibited. By 1900, he had more than 300 workers in his factory. In 1904, shortly before his death, he opened his own shop in London. Gallé design won prizes at the 1900 Paris Exhibition and achieved wide popularity. The Gallé factory remained productive until 1931, producing a vast quantity of work.

In the course of his career, Gallé's work moved, from a somewhat heavy historicism to a free interpretation of natural motifs and then toward a more fully abstract direction. Gallé glass represents one of the primary contributions of Art Nouveau and remains a high point in the production of Nancy. Gallé furniture, with its heavy and elaborate decorative inlays and carving, now seems less appealing than Gallé glass. Gallé himself approached design from a strongly philosophical standpoint. Symbolic and metaphysical qualities were viewed as significant in a way that seems to have less meaning for modern viewers than the direct impressions conveyed by form and color in his work.

GATE, SIMON (1883–1945)

Swedish artist, illustrator, and designer best known for his role in design direction and design for the ORREFORS glass works. Simon Gate studied at the Stockholm Academy art school, traveled, and worked as a portrait painter and book illustrator before turning to the design of glass for Orrefors in 1916. There, he worked closely with Edward HALD and with craftsman glassblower Knut Bergquist. His designs use simple forms, geometric patterns, and, in some instances, figurative decoration. Gate was the winner of a grand prize at the 1925 Paris Exhibition. His work combines MODERNISM with a sense of traditional craft in a way that makes it typical of the direction known as Swedish Modern.

GAUDÍ I CORNET, ANTONIO (OR ANTONI) (1852–1926)

Spanish architect whose often fantastic forms are now associated with the ART NOUVEAU movement. Antonio Gaudí was trained as an architect at Barcelona University in a way that mixed a Victorian Gothic Revival direction with the increasingly dominant BEAUX-ARTS method. In 1879 he designed street lamps for Barcelona, and by 1885 he had designed a number of buildings in a mixture of styles that incorporated Moorish influences. By 1900, he was striking out in the original direction on which his fame is based. All Gaudí's major work is in Barcelona, including Casa Batlló (1904–06), which has a facade of striking originality with curiously curved, carved forms, wall surfaces covered with a mosaic of broken tiles and plates, and fantastic towerlike chimneys. Casa Milá (1906–10) is a large apartment house with a sculpturally formed exterior and rooms of unusual shape. In both buildings, Gaudí's highly personal carved and sculptured details appear along with room interiors and furniture of Art Nouveau character. Park Guell (1900–14) combines architectural, sculptural, and decorative detail in an outdoor setting of great variety, richness, and fantasy. Gaudí's intended masterwork, the Church of La Sagrada Familia, begun in 1883, occupied him throughout his working life, but it remains an incomplete fragment, although a vast construction, still only a roofless end of one transept and a portion of the choir rising to unique and curious towers with complex sculptural and surface detail. Gaudí's furniture and metalwork details repeat his curvilinear and fantastic architectural forms at small scale. Gaudí's work was generally regarded as eccentric and insignificant until after World War II when he was rediscovered, becoming a subject for study, exhibits, and much publication. Some of his furniture designs are available in reproduction form, produced with fine craftsmanship by B.D. Ediciones Diseno of Barcelona. The MUSEUM OF MODERN ART in New York devoted a 1957 exhibit and related publication to Gaudí's work.

GAVINA, DINO (b. 1932)

Italian furniture manufacturer, who manufactured a number of modern CLASSICS. The Gavina firm acquired the rights to the

Crypt of the Church of Santa Columa de Cervello, an 1898 design of Antonio Gaudí.

BAUHAUS-era designs of Marcel BREUER and set up manufacturing in Italy. It also commissioned designs by Cini BOERI and Tobia SCARPA. In 1968 the firm was bought by KNOLL INTERNATIONAL, bringing its design program into the Knoll product line.

GEHRY, FRANK O. (b. 1929)

Canadian-born American architect and designer whose unusual work has come to be associated with the design direction called DECONSTRUCTIVISM. Frank Gehry was trained at the University of Southern California and at

the Harvard Graduate School of Design. He worked for several large West-Coast architectural offices before establishing his own practice in 1962. Gehry's work has attracted attention for its experimental, often seemingly eccentric qualities, making use of elements, seemingly broken or torn, placed at odd and conflicting angles. His offices for Mid-Atlantic Toyota (1978) at Glen Burnie, Maryland, and the renovations of his own Santa Monica, California, house (1978–79) are examples of his AD HOC or "punk" design, usually classified as POST-MODERN by critics, although the highly individualistic character of the work is hardly implied by that term. The newly coined term "deconstructivism" is more descriptive of the fractured forms and clashing relationships in Gehry's recent work, such as the Fishdance Restaurant (1987) in Kobe, Japan, and various projects still under construction. Designs for further renovation of his own house and for an unbuilt house design of 1978 were included in the New York MUSEUM OF MODERN ART deconstructivist architecture exhibition and a New York WHITNEY MUSEUM exhibit devoted to his work, both in 1988.

In 1972 Gehry designed a group of seating units made from many layers of corrugated cardboard, designated Easy Edges Furniture— ad hoc designs that are light, surprisingly strong, and comfortable in spite of their seemingly improvised quality. A 1983 New York gallery installation was devoted to Gehry lamps, units made of torn fragments illuminated from within, which featured fish forms as a theme. A fish lamp was included in the Whitney *High Styles* exhibition of 1985.

GEISMAR, THOMAS (b. 1931)

American graphic designer. Trained at Yale University, Geismar is best-known for his role in the firm of CHERMAYEFF & GEISMAR, which serves such major clients as the Chase Manhattan Bank, Mobil Oil Corporation, and Xerox.

GENERAL MOTORS

American and international corporation (the largest manufacturing company in operation), primarily a builder of automobiles and related transport products. General Motors (GM) was founded in 1908 and gradually acquired various smaller automobile makers, including Chevrolet, Pontiac, Oldsmobile, Buick, and Cadillac. The diverse approaches to design by these firms were gradually brought together in

Tailfins of a Chevrolet sedan: General Motors' automotive design in its most exuberant years, the 1950s. Photo by John Pile.

an overall design program that was headed after 1925 by Harley EARL. Earl organized an intricate plan for sharing body components among the different brand names, with varied trim and detail giving each brand individuality. Changes in STYLING on an annual basis encouraged "forced obsolescence," leading consumers to buy new cars in greater numbers and at shorter intervals than might be required by actual wear. From 1959 to 1978, Bill MITCHELL took over Earl's role and directed GM styling. Although overwhelmingly successful commercially, the GM approach to design has been criticized for what is seen by some as its

neglect of functional and economic values in favor of size and glitter as sales features. The competition of European and Japanese imports has forced some adjustment in GM styling practice. Some GM products are now joint Japanese-American efforts.

General Motors is also a major manufacturer of household appliances under the Frigidaire brand name, of trucks and buses, and of diesel railroad locomotives through its electromotive division.

GENERAL PANEL CORPORATION
See WACHSMANN, KONRAD.

Geodesic dome designed by Buckminster Fuller and used for the United States pavilion at Expo 67 in Montreal. Photo by John Pile.

GENSE
See ARSTROM, FOLKE.

GEODESIC
Word coined by Buckminster FULLER to describe the geometry he developed (and eventually patented) making it possible to divide the surface of a sphere (or any part thereof) into triangles. A structure built according to this geometry has extraordinary strength, along with light weight and a resulting economy of materials. For large geodesic structure, the triangular units often form the base of tetrahedronal units, making the entire construction a special type of space frame or truss. The Fuller geodesic dome has been used for industrial, military, and exhibition structures where efficient enclosure of large space volumes is of importance. For example, the United States pavilion at the Expo 67 Fair in Montreal made striking use of a geodesic dome.

GERNREICH, RUDI (1922–1985)
Austrian-born American fashion designer known for dramatic sports clothes that encourage free bodily movement and display. Rudi Gernreich developed an interest in fashion while making sketches in the couture salon operated by his aunt in Vienna. In 1938 he moved (with his mother) to Los Angeles where he attended the ART CENTER COLLEGE OF DESIGN. In 1942 he became a dancer and costume designer with the Lester Horton Modern Dance Theater. In 1947 Gernreich gave up his career as a dancer to turn to dress design, opening his own firm in 1959. His sports clothes and bathing suits reflected his experience as a dancer and were often considered daring. Swimsuits with cutouts, the see-through blouse, and the topless bathing suit of 1964, for example, attracted sensational attention. After 1968, Gernreich withdrew from fashion design, although he continued to accept occasional free-lance assignments for ballet costume and professional dance and sport clothing. He was the winner of four Coty Awards from 1960 to 1967 and received a Special Tribute from the Council of Fashion Designers of America in 1985.

A&P store design by Robert P. Gersin Associates. Photo courtesy of Robert P. Gersin Associates Inc.

GERSIN, ROBERT P. (1929–1989)

American designer with a practice in product design, graphics, packaging, exhibition, and interior design. Gersin is a graduate of the Massachusetts College of Art and CRANBROOK ACADEMY and, while serving as an officer in the United States Navy, worked as an industrial design consultant for the Navy. He established a New York practice in 1959. The firm's projects have included a CORPORATE IDENTITY program for Sears Roebuck; packaging and point-of-sale materials for General Electric; interiors and equipment for an energy control center for the Houston Lighting and Power Company; a permanent exhibit at the headquarters of the Xerox Corporation; and a variety of projects for Head Ski. The firm has received many awards for its design achievements.

GESTETNER

Manufacturing firm that first commissioned product design by Raymond LOEWY. Sigmund Gestetner was a manufacturer of an office duplicating machine that in 1929 had the complex mechanical appearance of a piece of industrial machinery. Loewy redesigned the machine's external appearance, giving it a simplified, MODERN appearance less forbidding to a typical pur-

chaser. Its resulting commercial success established a pattern for industrial designers' efforts to aid product sales through improved and modernized design or STYLING. Gestetner remained a Loewy client for many years and produced many increasingly modernized designs with Loewy.

GG-1 LOCOMOTIVE

Electric locomotive with a striking streamlined shell designed by Raymond LOEWY. The GG-1 was developed in 1934 for use on the Pennsylvania Railroad's long-distance electrified passenger and freight routes. Loewy's design made the locomotive appear smooth, elegant, and fast even when standing still. A standardized type, it replaced a number of earlier smaller and slower electric locomotives. Some 139 were built between 1934 and 1943. The GG-1 was outstandingly successful, with many remaining in service into the 1970s.

GHIA, GIANCINTO (1887–1944)

Italian designer and builder of automobile bodies. Ghia learned his skills in a Turin body shop and became known for his custom designs for luxury and sports cars. Since Ghia's death, his firm has carried on under the direction of Mario

GG-1 streamlined electric locomotive designed by Raymond Loewy for the Pennsylvania Railroad.
Photo by A.F. Sozio, courtesy of Pennsylvania Railroad.

1971 Volkswagen Karmann Ghia hardtop, designed by Giancinto Ghia. Photo courtesy of Volkswagen of America, Inc.

Boana. Ghia bodies have been developed for exotic Italian cars including the Maserati, but the best-known and most widely visible Ghia design is the special sport body developed for the VOLKSWAGEN Beetle chassis and engine, known as the Karmann Ghia. The firm was absorbed by Ford in 1972 as a source of experimental body production.

GIBBS, WILLIAM FRANCIS (1886–1967)

American naval architect, the primary designer in the firm of Gibbs and Cox. Gibbs was responsible for a large number of naval and merchant ships including the liners *America* and, his last great achievement, the *United States*. Gibbs was known for his obsessive concern with excellence and with matters of safety in passenger ships. His concern for fire safety led to many innovations in ship interiors aimed at the elimination of inflammable wood and textiles. The *United States* was the largest and most successful American passenger ship. It established speed records for trans-Atlantic crossings that have never been exceeded. It was withdrawn from service and eventually scrapped when ship transportation declined as a result of the success of post-war airplanes, particularly jets, which made even the fastest ships seem unreasonably slow.

GIEDION, SIGFRIED (1894–1968)

Swiss-American architectural and design historian who played a significant role in the development and recognition of MODERN concepts in all aspects of design. Giedion studied art history in Zurich and Berlin and earned his doc-

torate under Heinrich Wölfflin at Munich. His 1938 lectures at Harvard formed the basis for his 1941 book, *Space, Time and Architecture*, one of the first works to place modern architecture in an historical context. It also created a new understanding and appreciation of the role of Baroque design in relation to MODERNISM. His *Mechanization Takes Command* of 1948 takes a similarly serious historical view of the development of utilitarian objects and is recognized as a basic work of design history. A number of other Giedion books deal with various aspects of art and architectural history. Giedion was among the founding members of the CIAM (International Congress of Modern Architecture).

GILBERT, A.C.

See ERECTOR.

GILBERT, CASS (1859-1934)

American architect of major importance in the era of ECLECTICISM. His best-known work is the Woolworth Building (1911–13) in New York, for many years the tallest building in the world (760 feet). It is a modern office building of steel-frame construction, but its exterior design is based on medieval Gothic forms typical of the great cathedrals. Its lobby, rich with pseudo-Byzantine mosaics, is ornamented with "gargoyle" portraits of Woolworth and Gilbert. It was designated "the cathedral of commerce" and represented an outstanding effort to make the Gothic style applicable to tall, modern buildings. In contrast, one of his last works, the Supreme Court Building in Washington, D.C. (1935), is a Roman Corinthian temple.

Gill Sans

abcdefghijklmnopqrstuvwxyz
ABCDEFGHIJKLMNOPQRSTUVWXYZ
1234567890 .,;:"&!?$

Gill Sans, the best-known typeface designed by Eric Gill.

GILL, ARTHUR ERIC ROWTON (1882–1940)

English artist, sculptor, and type designer best known for his design of several modern TYPEFACES. Gill studied at the Central School of Arts and Crafts in London and became known as an illustrator and book designer, working in a restrained and craftsmanly vocabulary within the developing idiom of MODERNISM. He was also a craftsman carver of architectural lettering on stone and so came to the design of typefaces for the Monotype Corporation. His Gill Sans, a modern SANS SERIF face of 1928, has become a widely used modern typeface. Gill was also a religious and sociological thinker who combined concern for art and design with interest in social theory.

GIMSON, ERNEST (1864–1919)

British craftsman-designer whose work is generally associated with the ARTS AND CRAFTS style. Gimson knew William MORRIS, Richard LETHABY, A.H. MACKMURDO, and Norman Shaw and became a designer of plasterwork and furniture in the general style of this group. He continued to produce furniture of craft-oriented, simple design throughout his life as well as occasional designs for plaster and metalwork and other architecturally related details.

GIRARD, ALEXANDER (b. 1907)

American architect and designer of interiors, exhibitions, and textiles, with a special skill in dealing with colors and textures. Girard was trained in London, Florence, and Rome but returned to New York in 1932 to open his own design office. In 1937 he relocated to Detroit, where he worked as both an architect and an interior designer, serving such clients as the Ford Motor Company (for car interiors) and the Detrola Corporation for both office interiors and product design (radio cabinets). In 1948 he designed and built his own house in Grosse Pointe, Michigan, which attracted attention for its lively MODERN interiors filled with a large collection of folk art objects and the somewhat daring use of bright colors. In 1952 he took over design direction of a textile program for HERMAN MILLER and developed new weaves, color

lines, and print patterns with a unique, personal design orientation. He designed GOOD DESIGN exhibitions at the MUSEUM OF MODERN ART in New York in 1953 and 1954. He also designed Herman Miller showrooms in San Francisco (1959) and New York (1961).

Other projects of interest include the large J. Irwin Miller house in 1952 in Columbus, Indiana (in collaboration with Eero SAARINEN), designs for two New York restaurants, and a successful CORPORATE IDENTITY program for Braniff International airlines begun in 1965. The program encompassed interior design of airplanes and terminals (with specially developed furniture), a logotype, graphics, and a color scheme for aircraft exteriors with colors so brilliant and varied that they suggested Easter eggs to some viewers.

Girard's home in Santa Fe, New Mexico, houses a vast collection of folk art and artifacts, materials that have been a theme and source of inspiration for all of his work.

GISMONDI, ERNESTO, AND EMMA

See ARTEMIDE.

GIUGIARO, GIORGIO (b. 1938)

Prominent Italian industrial designer, the key figure in the firm of ITALDESIGN. Giugiaro was trained at the Academy of Fine Arts in Turin before working on automotive projects for FIAT and the design firms of Nuccio BERTONE and Giancinto GHIA. His most visible work at Ital is probably the body design for the 1974 VOLKSWAGEN Rabbit (or Golf, as it is known in Europe), which established a new standard for the form of the modern small car. In addition to automobiles, Giugiaro has developed designs for NECCHI sewing machines (including the Logica model of 1982), Seiko watches, and even as unlikely a project as a new form of pasta, called *voiello*.

GIVENCHY, HUBERT TAFFIN DE (b. 1927)

French fashion designer known for quality design in a classic tradition stemming from Cristobal BALENCIAGA and emphasizing elegance over innovation. Hubert de Givenchy studied at the École des BEAUX-ARTS and worked for designers Jacques FATH, Lucien Lelong, Robert Piguet, and Elsa Schiaparelli before opening his own house in 1952. His design was invariably refined and understated but perfectly cut, relying in part on a staff taken over from Balenciaga when his house closed in 1968. The ready-to-

wear line designated Nouvelle Boutique has been added to Givenchy's couture production and is distributed throughout the world. The Givenchy name is now also attached to lines of eyeglasses, furs, home furnishings, men's shirts, perfumes, and sportswear under extensive licensing arrangements. A 1982 retrospective exhibition of Givenchy work at New York's Fashion Institute of Technology offered a comprehensive survey of his work.

GLASER, MILTON (b. 1929)

Highly successful American graphic designer. Glaser studied at COOPER UNION in New York and, on a Fulbright scholarship, with the Italian artist Giorgio Morandi in Bologna. His professional career began with the founding of PUSH PIN STUDIOS (with Seymour CHWAST and Edward Sorel) in New York in 1954. He established a reputation for the graphic redesign of magazine and newspaper formats, setting the standards for layout and typography at *New*

Logotype for the New York State Department of Commerce, designed in 1973 by Milton Glaser. Courtesy of Milton Glaser, Inc.

Poster designed by Milton Glaser for the 1983 San Diego Jazz Festival. Courtesy of Steelcase Design Partnership.

York magazine, *Paris-Match, the Village Voice, New West,* and *Esquire.* In addition, he has developed a wide variety of CORPORATE IDENTITY programs (for Grand Union supermarkets,

among others), packaging, and graphic materials. He is particularly known and highly visible through his design of posters for varied products, organizations, and events.

GLASGOW SCHOOL OF ART

Institution founded in the 1860s offering instruction in the fine arts, architecture, and design—particularly the design of patterns for textiles, wallpapers, and similar products. The school continues to be a respected institution in its fields, but its reputation internationally is somewhat overshadowed by the fame of the building it occupies. This building is the masterpiece of the architect Charles Rennie MACKINTOSH. Selected through a competition held in 1896, Mackintosh's design is a highly original and personal work strongly connected, in the view of most critics, with the ART NOUVEAU movement, although it is less ornamented and more austere than Continental work in that style. The building generated controversy and negative criticism when new, but has become a greatly admired example of the early developments of MODERNISM.

GLASS

Widely used, generally transparent sheet material made by melting silica (usually sand) with lime and soda. Although it has a long history since it was first made by the ancient Egyptians, glass has come to be thought of as a typically MODERN material, particularly when used in large sheets in architectural applications. The CRYSTAL PALACE, often viewed as the "first modern" building, was constructed almost en-

tirely of iron and glass. The 19th-century development of manufacturing techniques, whereby plate glass and ordinary ("window") glass could be produced in large sheets, made possible the large glass roofs of train sheds and factories and led to increasing use of glass walls and large windows in buildings by leading MODERNISTS. Indeed, large glass areas are viewed as typical of INTERNATIONAL STYLE design. In a parallel development, glass has come into increasing use in furniture for table and desk tops, for shop fronts and similar applications.

Since 1959, both "plate" and "ordinary" glass production has been changed to the more efficient process called "float glass," in which sheets are made by pouring molten glass onto a continuously moving metal sheet. The fragile nature of glass has been offset, to a degree, by the development of tempered ("unbreakable") glass, used for such special applications as frameless glass doors, and safety glass, used in windows of automobiles and other vehicles. Heat-resistant glass can be used for cooking pots and pans, while special glasses are made for windows to resist sun and heat penetration. Glass can be made in colors, translucent or opaque, mirrored or partly mirrored, textured or molded, in multilayered forms to create an insulating void between layers, and in bricks or hollow blocks to be used as masonry. Bulletproof glass is made for security applications.

Modern industrial techniques for blowing and molding glass have also made it a widely used material for bottles, drinking glasses, and other commonplace, utilitarian products. Many designers have developed unique forms for functional glassware, among them Josef HOFFMANN for Lobmeyr, Alvar AALTO for IITTALA, and designers of products for such glass works as ORREFORS, STEUBEN, and VENINI. Craft workers use glass blown, cast, laminated, or otherwise worked by hand as a material for both utilitarian and sculptural works.

Glass can also be spun into thin strands that become surprisingly flexible. Such glass fiber can be made into yarn, woven into cloth, or mixed with plastic resin to create FIBERGLASS, a hybrid material usually called a PLASTIC. It is used for car body parts, small boat hulls, and seat shells for chairs, such as those designed by Charles EAMES and Eero SAARINEN.

Although plastics such as acrylics (Plexiglas, Lucite) or Lexan are now used as alternatives to glass, their superior resistance to breakage is offset by higher cost and vulnerability to scratching and flame. Glass remains, therefore, a primary material with many modern applications.

GLOAG, JOHN (1896–1981)

Prolific British historian and author of books dealing with design and architecture (as well as a number of novels and short stories). Among the dozens of books Gloag produced are *Men and Buildings*, *English Furniture*, *The Englishman's Castle*, and *Industrial Art Explained*—the last a particularly useful early work on the development of modern industrial design. Gloag was a strong champion of MODERNISM and although some of his books may now seem somewhat dated, they are a rich source of historical information and contain many interesting illustrations.

GOLDEN, WILLIAM (1911–1959)

American graphic designer known for his early role in television graphics. Golden was trained in commercial design at a New York vocational high school and then worked for a time in California doing advertising layouts. He returned to New York in 1936 to take up graphic design work for Condé Nast. In 1937 he started work for CBS in radio-related graphics and became an art director for that firm. After World War II, Golden returned to his post as art director for CBS, producing advertising and other graphic materials. His best-known work is the CBS trademark logotype "eye" (1951), still in use and widely familiar. Golden was the recipient of many honors and awards, including a 1959 citation as Art Director of the Year by the New York Art Directors Club.

GOLDEN SECTION

Special mathematical relationship, also often called the "golden ratio," designated by the Greek letter *Phi*, which since ancient times has been believed to generate forms of high aesthetic quality. This concept was used in the design of the Egyptian pyramids at Giza, the Parthenon, and many medieval cathedrals. It was the basis for LE CORBUSIER's system of proportions that he called the MODULOR. It results from the discovery that there is only one ratio of A:B that satisfies the relationship $A/B = B/A+B$. Taking A = .618... and B = 1, it will be found that $.618/1... = 1/1.618....$ A rectangle drawn with sides measuring .618 and 1 will thus be a golden "rectangle."

Le Corbusier's design for the Ozenfant house (1922–23) in Paris. The porportions of the rectangle at right, on which the entire design is based, are a golden section.

GOLDFINGER, ERNÖ (b. 1902)

Architect and furniture designer whose primary career was based in England. Goldfinger was born in Budapest, studied at the École des BEAUX-ARTS in Paris, and worked under Auguste PERRET until establishing his own practice in Paris in 1924. He relocated to London in 1934 and became a modernist whose best-known work was in furniture using tubular steel and plywood. His book *British Furniture of Today* (1951) illustrates his own designs along with those of other modern designers of the time.

GOLDSHOLL, MORTON (b. 1911)

American graphic designer known for his work in packaging, CORPORATE IDENTITY programs, film and television, as well as more conventional graphic design. Goldsholl studied at the Chicago Institute of Art and at the INSTITUTE OF DESIGN before beginning work on book design for Paul Theobald, a Chicago publisher, and the Martin-Senour Paint Company, for whom he designed packaging and materials in a related program. His more recent work has included corporate identity programs for H.U.H. Hoffman and the Kimberly-Clark paper company. His work is generally lively and colorful with a certain playfulness within the MODERN graphic stylistic tradition. He is now a consultant designer with his own firm in Northfield, Illinois.

GOOD DESIGN

Series of exhibitions and consumer education program conducted by the MUSEUM OF MODERN ART in New York from 1949 to 1955. Recognition by the museum staff that the concept of design excellence had little meaning to the American public led to an effort, under the direction of Edgar Kaufmann, Jr., to identify and publicize specific examples of good design in consumer products. Each year the museum selected such objects as kitchen utensils, housewares, furniture, and lamps regarded as having outstanding designs. These objects were exhibited first at the museum and then again at the Merchandise Mart in Chicago, where, it was hoped, they would educate the taste of manufacturers as well as the general public. The first exhibit was designed by Charles and Ray EAMES; Finn JUHL, Paul RUDOLPH, and Alexander GIRARD designed later Good Design shows. Eventually, the museum authorized manufacturers and distributors to attach a tag to selected products as a museum "seal of approval." The Good Design program was dropped after 1955, perhaps because it was felt that its purpose had been accomplished, perhaps in part through a concern that the museum was becoming involved in an effort with an increasingly commercial tone.

GOODHUE, BERTRAM GROSVENOR (1869–1924)

American architect whose work developed from ECLECTICISM toward a creative proto-MODERNISM, who is also known as a graphic and type designer of some importance. Trained as a draftsman in the offices of James Renwick (1818–95) in New York and in the Boston office of Ralph Adams CRAM (1863–1942), Goodhue became a specialist in Gothic-style eclecticism. Promoted to a partner in Cram, Goodhue & Ferguson, he remained with that firm until 1913. His major work during that period was St. Thomas Church in New York (1914), a large, handsome neo-Gothic work. He was chief architect for the 1915 Panama-Pacific exhibition in San Diego, California, working there in an eclectic Spanish style. His St. Bartholomew's Church (1919) in New York is an outstanding work in eclectic Byzantine style.

As a graphic designer, Goodhue was influenced by the ARTS AND CRAFTS movement and the ideas of William MORRIS. In 1902, while working with the Cheltenham Press, he designed a TYPEFACE of that name, which, in 1906, was made a Linotype face available for machine typesetting. It is a classic ROMAN type, softened with an almost medieval quality suggesting handcrafted lettering. It was in very wide use until the 1920s, though it is still used today in display type.

Goodhue's last major work in architecture was the Nebraska State Capitol building (1922) in Lincoln, Nebraska. It has a tall tower topped with a dome designed in a style that is transitional between eclecticism (there is a Byzantine influence) and a more original form of modernism in which decorative detail is subordinate to overall massing.

GOUDY, FREDERIC W. (1865–1947)

American printer, typographer, and type designer known for a number of traditional ROMAN TYPEFACES. In 1903 Goudy set up the Village Press in a barn in Park Ridge, Illinois, where, with Will Ransom as a partner, he began to produce hand-printed books with bindings by his wife. His Goudy Old Style typeface of 1916 designed for American Type Founders is probably his best-known achievement, a classically elegant Roman face still frequently used. Garamont, Kennerly, and Goudy Trajan are other successful Goudy faces, the last based on the carved inscriptions on the Column of Trajan in Rome. Goudy was the author of a number of books on type and lettering and founded the magazine *Ars Typographica*. He won the Gold Medal of the AMERICAN INSTITUTE OF GRAPHIC ARTS (AIGA) in 1920.

GRANT, DUNCAN (1885–1978)

British artist and designer known for highly decorated work much at odds with the mainstream trend toward MODERNISM in the 1930s. Grant's work turned to textile and ceramic designs around 1912 (for the OMEGA WORKSHOPS until the collapse of that organization). In the 1920s and 1930s, he designed interiors, furniture, and such graphic materials as book jackets—always in an elaborately florid decorative vocabulary.

GRAVES, MICHAEL (b. 1934)

American architect and designer known for his leading role in the development of the design direction generally called POST-MODERNISM. Graves was trained as an architect at the University of Cincinnati and at Harvard, graduating in 1959. He worked for a time in the office of George NELSON in New York and then, in 1960, went to Rome for two years at the American Academy on a Prix de Rome fellowship. In 1962 he returned to Princeton, New Jersey, to take a teaching post at Princeton University and to establish a practice. In the 1970s he became known as one of the New York Five (also informally called "The Whites"), a group recognized for their abstract and puristic work in a Late Modern vocabulary. Toward the end of the 1970s, Graves pulled away from this group, introducing decorative elements, historic refer-

Drawing of the Portland Building, Portland, Oregon, by Michael Graves. Courtesy of Michael Graves, Architect.

Lounge chair and two settees designed by Michael Graves. Photo by Bill Kontzias, courtesy of SunarHauserman, Inc.

ences, and varied colors into his work in ways that justify the post-modernist designation. His best-known work is the Portland Building, a commission won through a 1980 competition, for a city office building in Portland, Oregon. The building is a simple, cubical block, but the

external surface treatment with decorative detail, color, and a sculptured figure make it both unusual and controversial. The Humana Building in Louisville, Kentucky, of 1985 is another large office building with comparable unusual decorative features. Graves has also completed a number of residential projects, shops, and showrooms and has been at work on designs for the expansion of the WHITNEY MUSEUM in New York, which involves a major addition to the existing structure by Marcel BREUER. Graves's first design that surrounded the Breuer building with a large and violently contrasting new work provoked something of a furor: Modified designs are still a cause of debate. Graves works out his designs in sketches and color drawings that have been exhibited as works of art in their own right. He is also the designer of many smaller objects, china, furniture, jewelry, lamps, and rugs. Probably his most popular small work is a metal teakettle with a bird-whistle spout produced by Alessi in Italy. He has received many honors and awards, including seven Honor Awards from the AMERICAN INSTITUTE OF ARCHITECTS and the Brunner Memorial Prize from the American Academy and Institute of Arts and Letters. Two volumes titled *Michael Graves: Buildings and Projects* published in 1983 and 1988 document his work.

GRAY, EILEEN (1878–1976)

Irish-born interior, furniture, and architectural designer whose Paris-based career spanned a stylistic range from ART DECO to the MODERNISM of the INTERNATIONAL STYLE. Gray studied at the Slade School of Art in London before moving to Paris in 1902, where she became an expert in the use of Japanese lacquer techniques, decorating furniture and screens with painting of her own design. After World War I, her work was extended to include the design of carpets in abstract patterns and interior design and decoration. She opened her own Paris gallery in 1922 to show her furniture, lamps, carpets, and lacquer work. Her work was admired by such leading modernists as J.J.P. OUD and LE CORBUSIER. A 1924 issue of the Dutch design magazine *WENDINGEN* was devoted to her work. Her architectural design included a house at Rocquebrune for Jean Badovici (1926–29) and her own house at Castellar (1932–34). Her furniture design used glass, mirror, ALUMINUM, and CHROMIUM-plated metal in geometric forms typical of the modernism of the 1930s. In spite of her outstanding work, Gray was largely forgotten after World War II; her name scarcely figures in most histories of the period. She was rediscovered in the 1960s and is now viewed as a significant figure in the development of modern design. The MUSEUM OF MODERN ART in New York devoted a 1980 exhibit to her work and produced a related book summarizing her career.

Gray was a lively figure, known as a great beauty as well as an adventurous personality—an aviation enthusiast who made an English Channel crossing in a balloon in 1909 with the Hon. C.S. Rolls of Rolls-Royce fame. A number of Gray designs are currently in production, including furniture by Stendig in New York, rugs, a mirror, and the sling chair Transat by ÉCART INTERNATIONAL in Paris. The adjustable height occasional table of 1927, with a steel frame and round glass top, is probably her best-known work presently available in reproduction.

GREENE & GREENE

American architects, the brothers Charles Sumner (1868–1957) and Henry Mather (1870–1954) Greene, known for a number of California houses designed in a personal form of the Stick style of early MODERNISM. The Greenes were born in Cincinnati, Ohio, and educated in a St. Louis, Missouri, manual training high school before receiving architectural training in the BEAUX-ARTS tradition at MIT in Cambridge, Massachusetts. They settled in Pasadena, California, and practiced there throughout their joint career. Their early works were in historically imitative styles, but by 1908 their Gamble House in Pasadena demonstrated their mastery of the style for which they are known. It can be regarded as an outgrowth of a VERNACULAR California "bungalow" style made lavish and disciplined through craftsmanship in wood detailing based on ARTS AND CRAFTS directions. Their other major works are the Blacker, Cordelia Culvertson, and Thorsen houses, all in Pasadena. In 1914 Charles Greene withdrew from the firm, relocated in Carmel, California, and ended his practice. Henry Greene retired in 1930.

The interiors of the four important Greene houses are remarkable for the superbly detailed woodwork and furniture using polished fine hardwoods with simple and delicate details. Their frequent use of pegged joints suggests both CRAFTSMAN and Chinese influences. Peter Hall, a master cabinetmaker, was responsible for much of the finely crafted furniture and woodwork executed in his shop. Windows, skylights, lamps, and light fixtures using glass and metal follow

related craft patterns. The Gamble house is now a museum, while objects designed by Greene & Greene are greatly valued by collectors. The two volumes of 1977 and 1979 *Greene & Greene* offer an excellent survey of the firm's work.

GREENHOUSE

Jargon term in the field of automobile body design for the upper part of a car body made up largely of windows. A body with a tapering FASTBACK rear form does not have a prominent greenhouse. Designs following the lead of Raymond LOEWY's 1947 STUDEBAKER, with its low trunk at the rear creating a NOTCHBACK, have a clearly defined upper section with front, back, and sides that are mostly windowed greenhouse.

GREENOUGH, HORATIO (1805–1852)

American sculptor of the Greek Revival era whose work was of less importance than his verbal theoretical output. His book *The Travels, Observations and Experiences of a Yankee Stonecutter* included the famous concept "form follows function" and offered, in support of this theory, such examples as the American clipper ship, an object of great beauty developed solely through pursuit of practical objectives. Louis SULLIVAN was strongly influenced by Greenough's doctrines and his views have come to be regarded as early indications of the functionalist basis for MODERNISM in all design.

GREGORIE, EUGENE (b. 1908)

American automobile designer best known for designing the body of the Ford THUNDERBIRD of 1954. Gregorie had been trained as a designer of yachts, but joined Ford in 1931. By 1935 he was placed in charge of STYLING at Ford. The Thunderbird was, it is believed, developed as an answer to the GENERAL MOTORS Chevrolet CORVETTE. While its claim to recognition as a true sports car may be questionable, its original and distinguished appearance has led to its acceptance as a design CLASSIC.

GREGOTTI, VITTORIO (b. 1927)

Italian designer and theorist speaking for recent Italian MODERNISM through his creative work, his writing, and as an editor of *Casabella*, *Edilizia Moderna*, and *Lotus*. As a teacher in Venice and in the work of his own firm in Milan, he has taken a major role in organizing and designing exhibitions and architectural projects. His hardware for Fusital, furniture for Casa Nova, and silver for Rossi and Arcandi are

typical of his work as a leading Italian industrial designer.

GRÈS, (MADAME) ALIX (b. 1910)

French fashion designer known for her independent and individual approach to design, favoring tradition over current style. Born Germaine Barton, she was educated in the arts before taking an apprenticeship with the Paris couture house of Premet. In the early 1930s she established her own firm under the name of Alix Barton, specializing in day dresses of jersey. In 1942 she made a fresh start taking her husband's pseudonym of Grès. Her work seems based on the concepts of the draped figure as it appears in ancient Greek sculpture, with simplicity and respect for the figure of the wearer. In 1985 she introduced a ready-to-wear line. She has licensed scarves and neckties and designs jewelry for Cartier.

GRESLEY, (SIR) HERBERT NIGEL (1876–1941)

British engineer known for the design of railroad locomotives, including streamlined types that achieved outstanding performance and speed. Gresley was in charge of locomotive design for the Great Northern Railway, and after World War I when British Railway systems were reorganized, he became chief mechanical engineer for the newly created London & North Eastern Railway. In 1923, his design for a Pacific locomotive (with 4-6-2 wheel arrangement) became a new standard for both freight and passenger service. Beginning in 1932, a drive for speed records developed in English railroading, and in 1934, a Gresley Pacific pulling the *Flying Scotsman* reached a peak speed of 100 mph. The first streamlined Gresley Pacifics were of the A4 class of 1935, with the *Mallard* setting a record speed of 126 mph in 1938. These locomotives were also notable for their reliability and performance in routine service in which they maintained high speeds over long runs in regularly scheduled service. The blue and silver exterior finish of these engines and their striking (if somewhat clumsy) streamlined form made them well-known examples of British design leadership. Gresley was knighted in recognition of his achievements.

GRETSCH, HERMANN (b. 1895)

German industrial designer known for his simple ARZBERG dinnerware of 1931 (designated model 1382). For many years this pattern was

almost the only unornamented, well-designed china available anywhere; it became a favorite with modern designers, and is still popular today. It is best known in undecorated white, although various decorative patterns were eventually developed and applied to it. One consists of nothing but a single thin red line running around the outer or top edge of each object.

GROPIUS, WALTER (1883–1969)

German architect who, through his work and through his leadership of the BAUHAUS, became one of the most significant figures in the development of MODERNISM. It is often said that modern design was formed by four leading "form givers": Frank Lloyd WRIGHT, LE CORBUSIER, Ludwig MIES VAN DER ROHE, and Walter Gropius. While Gropius's work in architecture and industrial design is of major importance, it was his role as a teacher and spokesman for modern design causes that brought about his vast influence.

Gropius, the son of a Berlin city architect, studied architecture at Munich and Berlin from 1903 to 1907. From 1908 until 1910, he worked for Peter BEHRENS in Berlin. His 1911 Fagus shoe-last factory at Alfeld (designed with Adolf Meyer) is regarded as one of the first examples of INTERNATIONAL STYLE architecture, with its large glass areas, flat roof, and clear external expression of internal structure. In 1913 he designed a diesel rail car in simple, functional

Walter Gropius' isometric drawing of the director's office in the Bauhaus at Dessau. Courtesy of Walter Gropius.

forms that were to become typical of modern industrial design. His exhibition buildings for the DEUTSCHER WERKBUND 1914 exhibition at Cologne are a major monument in the history of modern architecture.

In 1919, after serving in World War I, Gropius was appointed director of the fine arts and applied arts school in Weimar. He merged the two, creating the Bauhaus, which he formed according to his views about the importance of the relationship between art and design. The faculty he selected included a remarkable roster of important figures in art and design, many of whom eventually became independently famous. Gropius was the architect of the Bauhaus building of 1925 when the institution relocated in the German city of Dessau. The (surviving) building is a key structure in the development of modernism. It was included in the New York MUSEUM OF MODERN ART's *International Style* exhibit of 1932. Gropius resigned from the Bauhaus in 1928, setting up his own office in Berlin that year. His 1929 Siemensstadt housing in Berlin is a major work in the field of public housing. He was a founding member and became vice president of the Congrès International d'Architecture Moderne (CIAM) in 1929. His 1930 design for an Adler cabriolet automobile is a fine example of the application of FUNCTIONALISM in industrial design.

In 1934 Gropius relocated in England and worked on private houses and schools in collaboration with Maxwell FRY and on ISOKON furniture for production in England. His 1935 book, *The New Architecture and the Bauhaus*, was published before he left England for the United States in 1937 to become a professor at the Graduate School of Design at Harvard. He brought about a major change in that school in the direction of modernism, a change that eventually altered all architectural education in America. From 1938 until 1941 he also practiced in partnership with Marcel BREUER. His work with Konrad WACHSMANN on a Packaged House System for the General Panel Corporation would have made prefabricated housing of fine design widely available. However, it never achieved commercial distribution. In 1945 he founded The Architects Collaborative (TAC) with a group of Harvard associates in Cambridge, Massachusetts. The firm produced many houses, educational buildings, and other major works during Gropius's membership and has continued to be productive since his death. Gropius's own house (1939) at Lincoln,

Massachusetts, is a fine example of his international style work. It is now preserved as a museum and is open to the public.

Gropius was the author of many published articles and essays, a frequent speaker, and an effective spokesman for the cause of modern architecture and design of the highest quality. His influence continues to be significant through his surviving works, through the impact of Bauhaus teaching on design education, and through the work of his students and of their students, both in their own work and in their role as teachers in every aspect of architecture and design.

GRUBER, JACQUES (1870–1936)

French designer of glassware and furniture in the ART NOUVEAU style. Gruber worked on glassware for the Daum brothers in the town of Nancy and then studied in Paris at the École des BEAUX-ARTS. He was a teacher at the Beaux-Arts in Nancy. (Jean LURÇAT was one of his students.) He also designed ceramics, book bindings, and MAJORELLE furniture. After World War I, Gruber devoted most of his time to the design of stained glass.

GUCCI, GUCCIO (1881–1953)

Italian leather worker and designer, the founder of the present firm that carries his name. Gucci opened a shop in Florence in 1904 producing saddles and, eventually, luggage. His sons enlarged the business and opened a shop in Rome in 1939. Shops in Paris, London, and various American cities followed. Gucci products are of generally high quality and distinguished design. In recent years Gucci has taken a strong turn toward high fashion and status appeal. The use of a monogram logotype and a decorative motif of thin red and green stripes makes Gucci products easily recognizable.

GUGELOT, HANS (1920–1965)

Swiss designer and teacher strongly influential as head of industrial design at the HOCHSCHULE FÜR GESTALTUNG in Ulm from 1955 to 1965. Gugelot was trained at the technical college in Zurich and then worked for Max BILL from 1948 until 1950. In 1954 he began teaching in Ulm and also began work for the German firm of BRAUN. Dieter RAMS was his student and later was associated with him in the design of such products as the Braun record player of 1950 and the later model SK4 of 1956, striking examples of the puristic and minimalist style associated with the Ulm school and the products of Braun. The German version of the KODAK Carousel slide projector is another well-known example of his work, while his role as one of several designers of the Hamburger U-Bahn (transit system subway) was a factor in the restrained and elegant design of the trains of that system. The work of Gugelot and his students and associates at Ulm is thought by many to represent the highpoint of the minimalist direction in Swiss and German design from the 1950s to the 1970s.

SOLOMON R. GUGGENHEIM MUSEUM

Located in New York, one of the most important museums in the United States specializing in the collection and display of MODERN art. Founded in 1939 as the Museum of Non-objective Art, the importance and visibility of the institution were vastly enhanced when it moved into its present building, a major late work of Frank Lloyd WRIGHT. This building, completed in 1959, is a unique and striking design in reinforced concrete, having as its main exhibit space a spiral ramp wound around a skylit central space that runs the full height of the building. Wright died before the building was completed so that some details may not be quite as he intended. Although the architecture is often criticized as so strong as to overpower the works exhibited there, the museum is still one of Wright's masterpieces as well as one of the most exciting of New York's buildings. The museum now requires more space, and considerable controversy has developed over GWATHMEY, Siegel & Associates' addition.

GUILD, LURELLE (b. 1898)

American industrial designer, one of a group active in the 1930s who provided STYLING for manufacturers eager to boost sales in the difficult years of the Depression. A 1920 fine arts graduate of Syracuse University, Guild first worked in magazine illustration. He later claimed to have designed as many as a thousand products in a year. Such products as a Norge refrigerator and a May oil-burner, each styled in the manner known then as "modernistic," are typical of Guild's innumerable designs of the 1930s. His willingness to admit to "styling down" to a supposedly low level of public taste sets Guild apart from most of his competitors, who generally believed they were elevating public taste. His Electrolux vacuum cleaner of 1937 is probably his most famous design, with many thousands still in regular use.

Solomon R. Guggenheim Museum in New York; Frank Lloyd Wright, architect. Photo courtesy of the Solomon R. Guggenheim Museum.

GUILD OF HANDICRAFT
See ASHBEE, C.R.

GUIMARD, HECTOR (1867–1942)
French architect and designer, a leading figure in the ART NOUVEAU period in France. Trained at the École des Arts Décoratifs and at the École des BEAUX-ARTS in Paris, Guimard was strongly influenced by the ideas of Viollet-Le-Duc (1814–79), an influential architectural theorist. In 1888 he began his own practice, designing houses in a picturesque, highly personal style. In 1895, Guimard met Victor HORTA in Brussels and was strongly influenced by his work on such projects as the 1893 Tassel house. His own Castel Béranger, a Paris apartment house of 1894–98, is a major example of Guimard's own version of Art Nouveau design, with its elaborate and highly original decoration based on natural, mostly plant, growth forms. Guimard published and exhibited his designs for this building extensively, including those for furniture, wallpaper, and many small decorative details. A number of projects followed including private houses and apartment buildings. Guimard's own house in Paris (1909–12) is a fine example of his work, with rooms of unusual shape, rich interior detail, and furniture in Art Nouveau's typically florid style. His entrances to the stations of the Paris Metro system (1900) are probably the best-known and most visible (many survive) as well as some of the best of his works. They use a variety of standardized, prefabricated elements of iron and glass in various combinations that suit the differing sizes, locations, and needs of the many stations. All are richly ornamented in the Guimard style that has become a visual symbol of Paris ambiance.

Guimard continued to practice after World War I, although it is his earlier work that is best known and most admired. He left France for New York in 1938 and died there. The MUSEUM OF MODERN ART in New York staged an extensive exhibition of Guimard's work in 1970 that included examples of his furniture design, posters and other graphic materials, vases, and many small objects such as umbrella and cane handles and even a number of cologne bottles. After a period of neglect in the first half of the 20th century, Guimard has come to be recognized, with the emergence of new respect for Art Nouveau work, as a major figure in French design history.

GULLICHSEN, MAIRE
See AALTO, ALVAR.

GWATHMEY, CHARLES (b. 1938)
American architect, a partner with Robert Siegel in the New York firm of Gwathmey, Siegel & Associates known for its work in a

geometric MODERN style now often called LATE MODERNISM. Charles Gwathmey received his architectural education at the University of Pennsylvania and at Yale. He drew attention as one of the New York group called "The Five" (Peter Eisenman, Michael GRAVES, John Hejduk, Richard MEIER, and Gwathmey) or, informally, "The Whites" in recognition of the white box character of their work in the 1960s and early 1970s. Gwathmey's 1966 house and studio for his parents at Amagansett, New York, is an example of this work, seemingly based on the abstract forms of the 1920s–30s design of LE CORBUSIER. The firm's work has included many houses, larger buildings, and interiors. Most remain faithful to the cubistic geometry of earlier MODERNISM with frequent use of semicircular forms, white walls, and inserts of glass block. The Cogan house at East Hampton (1972), Whig Hall at Princeton University (1972), Pearl's Restaurant in New York (1972), and the KNOLL showroom in Boston (1978) are examples of the extensive work of the firm. The addition to the GUGGENHEIM MUSEUM (designed by Frank Lloyd WRIGHT) has been a focus of critical controversy. Gwathmey and Robert Siegel have also designed office furniture for Knoll in a reserved, simple modern vocabulary emphasizing fine woodworking craftsmanship. Gwathmey has taught and lectured at a number of American architectural schools and the work of the firm has been widely published.

HABITAT

International chain of stores owned by Terrence CONRAN that specializes in household goods (furniture, dishes, glassware, lamps, floor coverings, and so on) of reasonable price and excellent design. The majority of Habitat products have been

Gwathmey residence and studio, Amagansett, New York, 1966. Gwathmey Siegel & Associates, Architects. Photo by Norman McGrath, courtesy of Gwathmey Siegel & Associates, Architects.

specially designed for the firm, although a few CLASSICS are sometimes on display. It is easily possible to furnish an entire apartment or house using only objects from a Habitat shop; resulting interiors will be of a remarkably high design quality. Beginning with a single small shop in London in 1964, the Habitat chain reaches to France, Belgium, and Japan, and to the United States, where the stores are known as Conran's to avoid confusion with another firm.

HAERDTL, OSWALD (1889–1959)

Austrian architect best remembered for his glassware designs produced by the famous Austrian firm of J. & L. LOBMEYR. Many of Haerdtl's designs continue in production and remain greatly admired. Among the best known are a range of wine glasses and related pieces of totally simple, extremely elegant shape, characterized by stems of extreme thinness. A Lobmeyr champagne glass of Haerdtl's design is in the design collection of the MUSEUM OF MODERN ART in New York. At one time a partner with Josef HOFFMANN in Vienna, Haerdtl established an independent practice as an architect after 1939.

HAIGH, PAUL (b. 1949)

British-born American architect and designer known for innovative work in furniture and environmental design. Paul Haigh was trained at Leeds University and at the Royal College of Art in England. He worked on airport and hotel projects for the firm of Glynn-Smith Associates in London from 1975 to 1978 and then with Richard SAPPER for KNOLL-Milan in 1978 before coming to New York to work on Knoll projects, including the showroom and office interiors of Knoll's Wooster Street facility in New York. In 1981 he established his own firm, Haigh Space. The firm has worked on a variety of projects including showroom interiors (John Kaldor Fabricmaker), residential interiors (the Framingham house, 1985), and furniture (Conde House and Bernhardt). Chairs designed for Bernhardt have included Enigma, winner of an IBD (Institute of Business Designers) Silver Award in 1987, and Sinistra, winner of a 1988 IBD Gold Award.

HALD, EDWARD (1883–1980)

Swedish artist and designer of porcelains and glassware known for his work with the OR-REFORS factory. Hald studied painting under the Danish artist Johan ROHDE and for a year in Paris with Henri Matisse. He became a designer for the Rörstrand porcelain factory from 1917 until 1924 and for Karlskrona porcelain until 1933. Beginning in 1917, he also designed for Orrefors, working closely with artistic director Simon GATE. From 1924 until 1933 he was artistic director for Orrefors. His work exhibits the balance of restraint and tradition-oriented decorative qualities that are typical of Swedish MODERN design.

HALL, EDWARD T. (b. 1914)

Anthropologist whose studies and writing have had a direct influence on modern thinking about design and architecture. Hall's work became well-known with the publication of his books *The Silent Language* in 1959 and *The Hidden Dimension* in 1966. They report on his studies of the ways in which human interactions are influenced by such physical circumstances as the size and shape of spaces, placement of furniture, quality of light, color, and similar elements of the environment. When related to human life, the concept of territoriality, first studied as an aspect of animal behavior, has led to an awareness of the problems created by crowding in modern cities, buildings, and transport. The implications for designers are obvious, prompting the current interest in EN-VIRONMENTAL PSYCHOLOGY and such specialized studies as research in PROXEMICS, which deals with appropriate distances for various types of human interaction.

HALLER, FRITZ (b. 1924)

Swiss architect and furniture designer well known for the system of office furniture that bears his name. Haller has been in practice as architect and urban planner at Solothurn (near Basel), Switzerland, since 1949. He is the developer of several steel-frame building systems currently used in Europe. In 1960 he developed a related system of office furniture using interchangeable steel tubes and connectors to form frames that carry shelves, work-tops, files, and other storage elements. The system is light and open in appearance and can be (with painted panels) strongly colorful. The Haller system was distributed in America by HERMAN MILLER for a brief period under its Swiss name, Haller Programm, but has been independently distributed thereafter. Haller has taught at the University of Southern California and at the University of Karlsruhe, West Germany. He is the author of *Integralurban; a Model*, a study of

urban planning, and is the winner of several design awards.

HALLICRAFTERS

American manufacturer of radio equipment for amateur and utility communications whose post–World War II products became known for outstanding design quality. The firm produced radio equipment for the military during the war and, at its end, searched for new civilian markets. The office of Raymond LOEWY was retained to develop new designs and, with Richard LATHAM in charge, designed "ham" radio gear with a logical, neat, functional layout of dials and controls. The model I-20 of 1945 and the more elaborate SX-42 of 1946 were intended for hobbyist amateurs, but as a result of the appropriateness of their design, they became widely popular for general home entertainment use. The I-21 (1948) television set was similarly reasonable in design, but because of its tiny screen was quickly outclassed by other makers' products. Although now obsolete and long out of production, Hallicrafters designs of the 1940s remain an important object lesson in the acceptability of good design in consumer areas, where it is often claimed that only tasteless and overornamented products can have commercial success.

HALOGEN LIGHTING

Lighting provided by a special type of incandescent lamp (bulb or tube in nontechnical language) that uses a tungsten-halogen filament to produce high-intensity light in a very small (often miniature) lamp. A special quartz glass outer bulb or tube is used to resist the very high heat and internal pressure of halogen lamps, so that the fixtures must be designed to protect against contact with the tube and any possibility of breakage. Halogen light is often used for special purposes, such as stage lighting, projectors, and instrument, dental, and airport lighting applications.

HALSTON (ROY HALSTON FROWICK) (1932–1990)

American fashion designer known for an emphasis on simple elegance with a quality of minimalist FUNCTIONALISM. Halston studied at Indiana University and the Chicago Art Institute before moving to New York in 1957 to begin work on hats for Lilly Daché. In 1958 he became the milliner for Bergdorf Goodman, moving on to ready-to-wear design for that firm. In 1968 he opened his own house, developing his own ready-to-wear line, Halston International in 1970 and Halston Originals in 1972. In 1973 his firm was absorbed by Norton Simon, but retained its identity while adding men's wear and perfumes. Simple Halston designs in beige or white with strong color accents are shown in his austerely modern showroom by black-clad attendants. His extended lines include cosmetics for Max Factor, Hartmann luggage, loungewear, sportswear, and even a low-priced line for J.C. Penney. Halston was a winner of Coty Awards in 1962, 1969, 1971, and 1972 and was elected to the Coty Hall of Fame in 1974. He was one of five American designers included in a show at Versailles in 1978.

HAMADA, SHOJI (b. 1894)

Japanese potter, generally recognized as a leading master of his craft, who has succeeded in relating traditional technique to 20th-century design concepts. Shoji Hamada had comprehensive training in Japanese craft pottery techniques before relocating in England from 1919 to 1924 to work with Bernard LEACH, the outstanding British potter. At St. Ives in Cornwall, England, together they built a traditional Japanese kiln and began the production of fine pottery there. After an exhibition of his work in London, Hamada returned to Japan to establish a pottery with a traditional kiln at Mashiko, north of Tokyo. His fine work has made him internationally famous and led to his status as the leader of the contemporary Japanese craft movement and head of the Tokyo Folk Art Museum. Hamada's work is of great simplicity and subtlety, suggesting ancient or primitive work, while still maintaining a sense of its own time. Through his influence as a teacher and, indirectly, through the teaching, writing, and practice of Bernard Leach, Hamada has become a formative force in modern craft pottery throughout the world.

HAMBURGER U-BAHN

Name of the underground (subway) system in the city of Hamburg. Its special design interest arises from the fact that the passenger cars built by the firm of Linke-Hofmann Busch (founded in 1893) were designed by a team made up of Otl Aicher, Peter Cray, Hans GUGELOT, Herbert Lindinger, and Helmut Muller-Kuhn. Hans Gugelot, who headed the product design department of the HOCHSCHULE FÜR GESTALTUNG at Ulm from 1955 until his death in 1965, was a

consultant to the U-Bahn project from 1959 to 1962 and organized the Ulm-related group responsible for the design of the trains. As might be expected, the design with boxy, rounded corner forms is an outstanding example of the restrained, MINIMALIST direction of MODERNISM, with all elements of the cars, inside and out, organized according to the logical principles of FUNCTIONALISM.

HAMPTON, MARK (b. 1940)

American interior designer carrying on the practice of traditional design using objects, forms, and decorative detail of the 18th century. Hampton is a graduate of the New York University Institute of Fine Arts and worked with David HICKS, Mrs. Henry ("Sister") PARISH II, and McMillen, Inc. before establishing his own practice in 1976. His work is largely residential and includes restoration work on such historic buildings as Gracie Mansion in New York and Blair House in Washington, D.C. He is a frequent contributor of essays on interior design topics to *House and Garden* magazine.

HANKAR, PAUL (1859–1901)

Belgian architect and designer, an early figure in the development of the ART NOUVEAU movement. Hankar worked as a sculptor before studying at the Brussels Academy. Although an important figure in Art Nouveau history, his work has been overshadowed by the better-known work of such designers as Victor HORTA and Hector GUIMARD. He was the designer of

Interior design for Kips Bay show house, 1988, by Mark Hampton. Photo courtesy of Mark Hampton, Inc.

imaginative ironwork and original furniture, striking for their strong forms, but lacking the grace of most Art Nouveau work. His best-known works are a house in Brussels for the painter Ciamberlani (1897), which featured a richly decorated facade with curious circular forms and a villa at La Hulpe (1900), for the sculptor and jeweler Phillipe Wolfers. Both houses make use of unique circular and semicircular forms, but these appear harsh and awkward to most modern viewers.

HANNAH, BRUCE (b. 1941)

American industrial designer known for his furniture design for KNOLL INTERNATIONAL. Hannah was trained as an industrial designer at PRATT INSTITUTE in Brooklyn and won an Alcoa Corporation design award (with partner Andrew MORRISON) for a system of seating using a structural frame of ALUMINUM castings and EXTRUSIONS. Admired by Knoll representatives, the system was accepted for production in the Knoll line beginning in 1970. Hannah maintained an industrial design firm with Morrison for several years before launching his own practice. His best-known work is a comprehensive system of office furniture, also for Knoll, that makes extensive use of plastic components and provides for almost unlimited wiring for modern office computers and other electrical and electronic equipment. Hannah has taught at Pratt Institute and is now chairman of the industrial design department there.

HARASZTY, ESZTER (b. c. 1910)

Hungarian-American designer of textiles, colorist, and stylist. Beginning in the 1930s, Haraszty operated a textile production studio in Budapest. In 1947 she moved to the United States, and from 1949 until 1955, she was the design director for the KNOLL textile division, developing many classic fabrics for that firm and controlling selection of color for fabric lines for the division. Under her direction, Knoll commissioned textile designs from Stig Lindberg, Sven MARKELIUS, Marianne STRENGELL, and Angelo TESTA, among others. Haraszty also acted as the color stylist for many Knoll showrooms and interior design projects handled by the Knoll Planning Unit. Since 1958 she has operated her own design studio and consultancy in New York. Her use of simple, bright but subtle color relationships was the special characteristic of her work.

HARDOY CHAIR

MODERN chair with a canvas or leather seat supported by a frame of bent steel rod. The design is based on an Italian folding chair said to have been developed for camp use by military officers. The popular American version of 1938 is usually credited to Jorge Ferrari-Hardoy who, along with fellow Argentinean architects Juan Kurchan and Antonio Bonet, developed the design that was offered by the modern furniture firms of Artek-Pascoe and KNOLL. The chair was handsome, inexpensive, and easy to make and so was quickly put into production by many other manufacturers, often in cheapened and inferior versions. The wide availability and great popularity of the design (it was often called the Sling or Butterfly chair) eventually led to its overuse, reducing it to the status of a design cliché. It is currently in production by several different manufacturers.

HARDY HOLZMAN PFEIFFER ASSOCIATES

New York architectural firm known for its rather daring and futuristic design that is generally designated as HIGH-TECH. Mechanical elements, such as ducts and piping, and structural elements often become prominent visual forms emphasized with bright colors. Overall, the firm's design tends to be complex and active. Major projects include a Columbus, Indiana, Occupational Health Center (1973), the Minneapolis Orchestra Hall (1974), and the Brooklyn Children's Museum (1977). The firm was founded in 1967 by Hugh HARDY, Malcolm Holzman (b. 1940), and Norman Pfeiffer (b. 1940). The partners were recipients of a Medal of Honor awarded by the New York chapter of the AMERICAN INSTITUTE OF ARCHITECTS. Michael Sorkin's 1981 book, *Hardy Holzman Pfeiffer*, documents the work of the firm up to that date.

HARDY, HUGH (b. 1932)

American architect, the founder of the firm HARDY HOLZMAN PFEIFFER ASSOCIATES (HHPA). Hardy received his architectural training at Princeton University. In 1958 he began work as an architectural assistant to Jo Mielziner, a designer of theatrical scenery. In 1962 he opened his own architectural office with a practice particularly concerned with the design of performing arts spaces. Malcolm Holzman and Norman Pfeiffer became associates in 1964 and 1965, respectively. The present partnership was established in 1967.

HARPER, IRVING (b. 1916)

American industrial designer. Educated at Brooklyn College, PRATT INSTITUTE, and COOPER UNION, Harper was employed by Gilbert ROHDE and Raymond LOEWY before joining the firm of George NELSON. There he was responsible for the design of a number of products for Howard MILLER, including the famous Ball Clock of 1949 with twelve balls on stems in place of numerals, and a number of furniture designs for HERMAN MILLER, including the simple upholstery seating system of 1950 and the Marshmallow chair of 1956, which used many round cushions to form the seat and back. In 1963 he became a partner with Philip George in the firm of Harper & George, which did graphic and interior design projects for Braniff Airlines, Penn Central Railroad, and many other clients. He remains in active practice as an independent designer.

HARRISON, MARC (b. 1936)

American industrial designer whose practice has emphasized medical and industrial equipment. Trained at PRATT INSTITUTE in Brooklyn and at CRANBROOK ACADEMY in Michigan, Harrison has taught industrial design at the RHODE ISLAND SCHOOL OF DESIGN since 1959. He has worked on projects for the Red Cross and the Massachusetts Bay Transit Authority. In 1981 Harrison redesigned the Cuisinart food processor, taking special care to make it convenient for users with physical and visual handicaps.

HAUSSMANN, ROBERT (b. 1931)

Swiss industrial designer, recognized for his work on furniture, whose best-known design is

Ball Clock designed by Irving Harper. Photo courtesy of Howard Miller Clock Company.

a steel-framed side chair of 1956 often called the "Unesco" chair because of its use in the Paris UNESCO headquarters building designed by Marcel BREUER. Robert Haussmann studied in Amsterdam and Zurich before opening his own office (with Trix Hogl, now his wife) in 1967. His furniture design follows INTERNATIONAL STYLE traditions with a directness and logic that may be thought of as typical of the best modern Swiss work. His 1955 chair and ottoman use steel bar structure to support tufted leather cushions in a way suggestive of MIES VAN DER ROHE precedents. A full range of upholstery and tables has followed, with his designs distributed in the United States by Stendig, Inc. of New York. Haussmann was a teacher at the Zurich Art School from 1972 until 1978 and at the Technical University of Zurich from 1978 to 1981. With Alfred Hablutzel, Robert and Trix Haussmann are also active as textile designers, producing designs with three-dimensional geometric effects of great originality for production by the Swiss firm Mira-x.

HEAL'S
British furniture firm founded in 1910 and brought to prominence as a patron of design by Ambrose Heal (1872–1959). Heal encouraged, produced, and sold furniture of outstanding design in the firm's store on Tottenham Court Road in London. Heal was himself a designer in the ARTS AND CRAFTS tradition and brought his own and related craft design to public attention in the shop. In the 1930s and until recent years, Heal's made a point of exhibiting and selling the best of modern English and Scandinavian furniture, textiles, and related products. In 1983, Heal's was absorbed by the Mothercare division of Terence CONRAN'S firm of HABITAT.

HEARTFIELD, JOHN (1891–1968)
German artist and graphic designer (born Helmut Herzfeld) known for his early and successful use of PHOTOMONTAGE. Heartfield was a Berlin artist who, in the 1920s, became an active member of the DADA movement. His special contribution was the development of a montage technique in which photographs and other image materials are cut up and reassembled using a technique similar to COLLAGE. In the late 1920s and early 1930s, he used this technique to create propagandistic works attacking Hitler and the rising Nazi party. By 1933 he was

forced to leave Germany, staying briefly in Czechoslovakia before relocating in England where he changed his name (translating his German name into English) and continued his graphic work. Heartfield's role in 20th-century design is based on his development and exploitation of the montage technique, which has become a widely used part of the vocabulary of MODERN graphic design.

HEATH, EDITH (b. 1911)
American potter and ceramist known for modern production dinnerware that retains some of the visual qualities of hand-thrown pottery. Heath studied painting and sculpture at the Art Institute of Chicago and ceramics at the California School of Fine Arts in San Francisco. Until 1947 she produced handmade pottery, turning to factory production after that date. Her Coupe range of stoneware has received recognition for its handsome, simple, curvalinear forms and softly colored glazes. Since 1960, Heath's firm has also produced tiles for architectural uses.

HEIN, PIET (b. 1905)
Danish designer who is also a mathematician and poet-humorist well known for his small books of poems and cartoon sketches called "Grooks." Hein's design reputation is largely based on his remarkable invention of a new geometric shape, the super-ellipse, a form sharing some of the characteristics of the true ELLIPSE, the oval, and the rectangle—it might be called a somewhat squared ellipse. It has been used as the plan layout for a traffic "circle" in central Stockholm, as the form for the top of a table manufactured by Bruno MATHSSON, and, in three-dimensional form, to make the super-egg—a solid that has the peculiar property of being able to stand on end as readily as on its side.

HELLER, ORLO
American designer who, when working with Lester L. Wheeler and William H. Gref in the New York firm Bortic Studios, developed the design for the 1937 Aristocrat stapling machine for the E.H. Hotchkiss Company. The design makes use of a quite handsome simple form and represents an early use of PLASTIC to replace metal. It is, however, famous (or infamous) for its application of STREAMLINING to an object for which motion and therefore AERODYNAMICS are totally irrelevant.

HELLER, ROBERT (1899–1973)

American industrial designer whose work of the 1930s carried STREAMLINING and MODERNISM (as related to ART DECO) to an extreme. Heller's best-known work is a streamlined electric fan designed in 1938 for the A.C. Gilbert Company. Although his 1933 building for radio station WCAU in Philadelphia has, unfortunately, been destroyed, its interiors were a showcase of Art Deco interior design, while the street facade of blue cement with zig-zag trim in stainless steel symbolized the glamour of radio. However, conservative architects of that time and place found it offensive.

HELVETICA

Modern SANS SERIF typeface that has, since the 1960s, come to be a special favorite of graphic, exhibition, and industrial designers all around the world. Helvetica typifies the simplicity and elegance of the Swiss School of graphic design and TYPOGRAPHY. Helvetica had originally been known as Neue Haas Grotesk, an older, anonymous design. It was rediscovered in 1957 by Max Miedinger and reworked as a new face for the Swiss type foundry Haas. It quickly became a popular standard for a totally simple, strongly geometric sans serif face that would fit well with INTERNATIONAL STYLE–related graphic design. The wide acceptance of this face as a norm or standard for modern graphics has led to concern that it has become a modern cliché. This has led to an effort to find alternatives of equal quality that can offer some visual variety in modern print and lettered materials.

Helvetica®
abcdefghijklmnopqrstuvwxyz
ABCDEFGHIJKLMNOPQRSTUVWXYZ
1234567890 .,;:"&!?$

Helvetica, the typeface most closely associated with Swiss graphic design.

HENNINGSEN, POUL (1895–1967)

Danish industrial designer and architect best known for his lighting fixtures developed for the Poulsen firm. Trained as an architect in Copenhagen, Henningsen practiced architecture in Denmark while also becoming a spokesman for the cause of MODERNISM as editor of the magazine *Kritisk Revi* from 1926 to 1928. His first PH lighting fixture appeared in 1925; other

Drawing explaining the light distribution patterns of the Poul Henningsen PH lamp of 1925.

versions were developed over the years, with the admired PH-5 appearing in 1958. All are circular hanging fixtures with arrangements of louvers that provide excellent distribution of light.

HENRION, HENRI KAY FREDERICK (b. 1914)

Designer whose practice in England grew from posters and exhibit design into a comprehensive design office that offers clients a complete CORPORATE IDENTITY service. Henrion was trained in textile design in Paris, worked in the Middle East as an artist-designer of posters, and arrived in England during World War II where he produced posters for the British government. Since the war, his firm has served many major British and European firms, including Blue Circle Cement, KLM, and BEA (now British Airways). Henrion has been active in many design organizations and has become an effective spokesman for design interests.

HERLØW, ERIK (b. 1913)

Danish designer, influential as a teacher and exhibit designer as well as known for his own works that typify modern design in Denmark. Herløw was trained as an architect at the Royal Danish Academy of Fine Arts in Copenhagen and opened his office in 1945. His work in jewelry and metal products has included design for Georg JENSEN, flatware in silver and stainless steel, and designs for metalware for DANSK. His redesign of a simple vernacular coffee pot for Dansk Aluminium Industri replaced a nondescript product with an elegant, modern, sculptural form. Since 1955 he has been art director for the Royal Copenhagen porcelain firm. He has designed a number of exhibits of Danish design and was a co-founder of the Danish Industrial Design Society.

Herløw is the head of the industrial design department of the Royal Academy in Copenhagen.

HERMAN MILLER, INC.

American furniture manufacturer noted for its outstanding MODERN design. In 1923 D.J. DePree took over the Michigan Star Furniture Company of Zeeland, Michigan. DePree changed the name to Herman Miller, Inc., after his father-in-law, Herman Miller, a company board member. It made quality furniture in the popular traditional patterns of the day until, in the 1930s, it accepted the design leadership of Gilbert ROHDE, one of the pioneers of industrial design. Rohde persuaded the firm to produce furniture of modern (then ART DECO) design. After World War II (and after Rohde's death), George NELSON became the design director and, in 1946, introduced an entirely new line of furniture of typically MODERNIST design. Subsequently, Nelson introduced Charles EAMES and Alexander GIRARD to the Miller design team, with increasing critical and commercial success. More recently, the firm has produced the designs of Don CHADWICK, Robert PROPST, and Bill STUMPF, among others, maintaining its role as a leader in modern furniture production. Over the years, interest in residential furniture has declined, with an increasing concentration on CONTRACT products, including systems for healthcare facilities.

Herman Miller has over the years supported good design in its showrooms, advertising, and corporate identity graphics and shown devotion to design causes wherever they emerge. It is now an international corporation with production and distribution in Europe and other locations worldwide.

HERRESHOFF, NATHANAEL GREENE (CAPTAIN NAT) (1848–1938)

American naval architect and builder of yachts, both sail and power, of great variety and fine design. Herreshoff was a designer for the Corliss Steam Engine Company before he formed the Herreshoff Manufacturing Company with his brother John in 1878 as a shipyard and builder of marine engines. The firm built steam-powered launches that were popular with New York millionaires as a means of commuting to estates on Long Island Sound. *Stiletto* of 1883 was built to demonstrate the possibilities for high speed with steam power—she became the U.S. Navy Torpedo Boat No. 2 and remained in service until 1911. *Ballymena* of 1888 was Herreshoff's first steel-

Group of furniture manufactured by Herman Miller: plastic armchair designed by Charles Eames; other furniture by George Nelson and Company. Photo courtesy of Herman Miller, Inc.

hulled steam yacht. His first racing yacht was *Gloriana* of 1890—an innovative design to be followed by the series of winning America's Cup racers, *Vigilant* (1893), *Defender* (1895), *Columbia* (1899–90), *Reliance* (1903), and *Resolute* (1920), the last of the line. Each in turn was a successful Cup defender carrying the reputation of the designer forward. Herreshoff steam craft were generally of aggressive and functional appearance, while the sailing yachts displayed the elegant aesthetic that has made such craft greatly admired. Herreshoff's son, L. Francis Herreshoff (1890–1972), continued the practice of yacht design and was responsible for *Whirlwind* (1929), a particularly handsome J-class racing sloop.

HERSHEY, FRANKLIN QUICK (b. 1907)

American automobile designer best known for his work on the original (1955) Ford THUNDERBIRD, although a major portion of his career was spent with GENERAL MOTORS. Hershey studied at Occidental College in California before going to work for the California custom automobile design firm of Walter M. Murphy in 1927, where he remained, except for a brief period in 1928 at General Motors in Detroit, until the firm closed in 1931. He was briefly with Hudson before joining GM in 1932 to take charge of STYLING for Pontiac and later for Buick and overseas GM divisions. After World War II he returned to GM to work on Cadillac design and in the firm's experimental design studio. In 1953 he was placed in charge of styling at Ford. In 1956 he left automotive design to work for Kaiser Aluminum and then, until his retirement in 1978, for Wright Autotronics in California. Hershey's work spanned a wide range of automotive design concepts, extending from the peerless custom body of the early 1930s (designed at Walter Murphy) through GM models of the 1930s and early 1940s to the elegant and greatly admired 1955 Thunderbird, a sports car of simple form with minimal "styled" trim. Surprisingly, he also directed the design of other Ford cars, such as the 1957 Fairlane 500, which typified the trend toward oversized fenders and heavy CHROMIUM trim.

HERZFELD, HELMUT

See HEARTFIELD, JOHN.

HEURISTIC

Term for efforts to find solutions to problems through probing and experiment or trial and error, as distinguished from the application of strictly logical, deductive means. Applications of computer techniques, often involving FEEDBACK, are frequently described as heuristic. The word has become a popular design jargon term.

HICKS, DAVID (b. 1929)

English interior designer known for his carpet and textile designs as well as his interiors. Hicks began practice in London in 1955, establishing his own distinctive style using bright, often primary, colors and modern forms in combination with traditional furniture. His work has come to represent high fashion in interiors in England. His development of pattern design began in 1960, and the active, even busy designs to which his name is attached have become internationally stylish and popular. Clients have included Douglas Fairbanks, Viscount Lewisham, and President Nkrumah of Ghana for interiors of the presidential palace. His book *On Living* (1968) is one of seven he has published, aiding the popularization of his design approach.

HICKS, SHEILA (b. 1934)

American weaver and textile artist working in a unique, MODERN vocabulary. Hicks studied painting under Josef ALBERS at Yale, but developed an interest in textiles through extensive travel and study of traditional weaving in Mexico, South America, and India. Since 1967 she has maintained a studio in Paris, but has continued to travel and teach in many regions of the world. Her own work has turned to the design and production of large woven hangings that have the scale and presence of major works of art. The Ford Foundation Building in New York and an IBM tower in Paris are among the places where her works appear as soft and richly textural accents in modern architectural settings.

HIERARCHY

Term used in design theory to describe the ordering of requirements for a design in order of importance or in order from the general to the particular. The term comes from the ranking of clergy in religious orders but now refers to any ordering of items according to some scale of values from highest to lowest. The concept of hierarchical order has proven useful in design programming and in developing techniques for using computers to solve design problems.

HIGH-TECH
Popular term for a currently important stratum within the general stylistic territory of MODERNISM in which simple, MINIMALIST forms are used together with industrial materials and products of strongly technological character. The term was invented by writers and critics to describe a particular design direction that surfaced in the 1970s, but it is often disavowed by the practitioners of such work. The use of industrial carpet and rubber flooring materials, steel utility shelving and furniture from catalogs of hospital, factory, and office supplies along with industrial lighting devices is characteristic of this work. Such architectural projects as the Centre Pompidou in Paris designed by PIANO & ROGERS (1971–77) or the Sainsbury Centre at Norwich, England, designed by Norman Foster (1975–78) are buildings that may be regarded as examples of high-tech design. The interior designs of Peter Andes, Paul HAIGH, and Joseph Paul D'URSO may be similarly designated. The 1978 book *High-Tech* by Joan Kron and Suzanne Slesin defines and illustrates this design approach in considerable depth.

HILBERSHEIMER, LUDWIG KARL (1885–1967)
German architect and town planner known as a teacher and writer who was influential in advancing BAUHAUS theory as it applied to urban planning. Hilbersheimer was trained in architecture and planning at the Institute of Technology at Karlsruhe in Germany and established his own practice thereafter in Berlin. From 1928 until 1932 he was at the Bauhaus, teaching architecture, construction, housing, and town planning. In 1938 he emigrated to the United States to become a professor of city planning at ILLINOIS INSTITUTE OF TECHNOLOGY in Chicago and, after 1955, director of the department of city and regional planning there. He was the author of many articles and a number of books, including *Groszstadt Architektur* (1927) and *The New City* (1950) and *The Nature of Cities* (1955). Hilbersheimer's writing emphasizes historical study of urban forms, while his own approach to planning is highly theoretical, leading to abstract, geometric forms generated by studies of prevailing wind directions in relation to industrial pollution output and to the logical study of density, land use, and circulation patterns. Although his proposals now seem overly mechanistic, Hilbersheimer's basic concepts remain significant for all modern urban planning.

HILL, OLIVER F. (1887–1968)
English architect and designer whose work of the 1930s was an important part of the British contribution to the MODERNE or MODERNISTIC style. Beginning in 1910, Hill entered architectural practice, but his reputation is primarily based on his exhibit designs of the late 1920s and 1930s and his interior and furniture designs of daring, decorative character. His best-known interior project was the decoration of the Midland Hotel at Morecambe, England.

HILLE
Important English manufacturer and distributor of modern furniture. The firm was founded in 1906 by Salamon Hille, but its role in the promotion of MODERNISM began after World War II under the direction of Leslie and Rosamund Julius. Hille produced the furniture of Robin DAY and also, at one time or another was the producer of HERMAN MILLER and KNOLL products in England. In recent years, work of other designers including Fred Scott has been shown in the Hille product line.

HINE, LEWIS (1874–1940)
American documentary photographer particularly known for his dramatic interpretation of machine and other 20th-century industrial forms. Lewis Hine's earliest work documented the experience of immigrants arriving at Ellis Island. From 1908 to 1916 he worked for the National Child Labor Committee documenting working conditions in factories, workshops, and mines, with the goal of exposing little-known abuses. After World War I, his reputation for outstanding photography of industrial locations led to assignments from industry that accentuate the beauty of many mechanistic subjects. For example, from 1930 to 1931 he documented the men constructing the EMPIRE STATE BUILDING in New York in hundreds of striking photographs. Whether documenting the abuses of child labor or the drama of industry, Hine's work was always of fine technical and artistic quality, making him an important figure in the development of modern documentary photography.

HISTORICISM
Term used in art, architectural, and design history and criticism to describe design that is

based on or directly imitates the design of an earlier period. Much of the design of the 19th and early 20th centuries is of this kind. The development of MODERNISM can be regarded as a rebellion against such imitative design. Revivalism, in which an effort is made to revive a historic style in its totality, and ECLECTICISM, the borrowing of elements from many historic periods, are other terms that describe aspects of historicism. St. Patrick's Cathedral in New York City is an example of revivalism (Gothic) while the Woolworth Building, borrowing various Gothic and Byzantine details, is an example of eclecticism.

HISTORIC PRESERVATION
See PRESERVATION, HISTORIC.

HOCHSCHULE FÜR GESTALTUNG (ULM)
College of design founded at Ulm, Germany, in 1955 by Grete and Inge Scholl with Max BILL as director, whose program was an effort to recreate and carry forward the traditions of the BAUHAUS in industrial design and graphics. Tomas MALDONADO (its second director), Hans GUGELOT, and Dieter RAMS were among the distinguished designers and teachers associated with the school. The products, graphics, and packaging of the firm of BRAUN were closely connected with the work at Ulm and

The Ulm aesthetic: Braun E-4 radio-phonograph designed by Dieter Rams. Photo by G. Barrows, courtesy of George Nelson and Company, Inc.

have formed a showcase for the largely mini-malist or puristic aesthetic fostered at Ulm. The institution was closed in 1968 because of internal conflicts.

HOFFMANN, JOSEF (1870–1956)

Austrian architect and designer, a pioneer in the development of MODERNISM as expressed in the WERKSTÄTTE and SECESSION movements. Hoffmann was a pupil of Otto WAGNER. After traveling in Italy, he returned to Vienna to work for Wagner from 1895 until 1899. He became a professor of architecture at the Vienna School of Applied Arts in 1899 and held that position until 1941. A member of the Secession, he helped found the Werkstätte in 1903. Hoffmann visited England in 1902 and was strongly influenced by the work of Charles Rennie MACKINTOSH. His work moved away from the curvilinear forms typical of Wagner's work and became more rectilinear, with squares, cubes, and spheres appearing as favorite motifs. He was often humorously referred to as "Quadratl-Hoffmann" ("square" or "cubic" Hoffmann). The Puckersdorf Sanatorium outside Vienna (1903–06) was a major example of the geometrically abstract direction in Hoffmann's work, while the special furniture designed for it carried the same themes.

Hoffmann's major architectural masterpiece was the PALAIS STOCLET in Brussels of 1905–11. It is a large town mansion in a geometrically austere style, but with elaborate ornamentation inside and out, much of its artwork by Secessionist collaborators, including Gustav Klimt and Carl CZESCHKA. Rich materials are used and detailing is elaborate, including special furniture, lighting fixtures, hardware, and textiles. Hoffmann's designs included work for Werkstätte craftsmen and for factory production in great variety. He developed bentwood furniture for the firms of THONET and Fischl; glass for LOBMEYR, textiles, jewelry, metalware, and lighting for various manufacturers and for custom shops. Many of his designs used square motifs, as in objects made of sheet metal pierced with squares forming a grid pattern.

Hoffmann was the designer of Austrian pavilions at various exhibitions (at Cologne in 1914, Paris in 1925, and Stockholm in 1930, among others), but it is his work of 1902 to 1910 that has attracted most interest in his career, particularly in recent years when the modernism of Secession work, with its characteristic ornamentation, has drawn increasing attention

Josef Hoffmann drawing for a Vienna Secessionist interior.

because of POST-MODERN trends in both architecture and object design. Hoffmann remained active in both design and teaching, although few of his works were actually executed. Now much admired and collected, a number of his designs for furniture, metalwork, ceramics, and textiles are currently produced in reproduction.

HOLISTIC

Term describing theories or concepts that focus on complete entities or *wholes* and that view separate parts as elements of a whole rather than as isolated units. The term has entered into the current jargon of modern design.

HOLLEIN, HANS (b. 1934)

Austrian architect whose work is usually associated with POST-MODERNISM. Hollein was trained in Vienna, at the ILLINOIS INSTITUTE OF TECHNOLOGY in Chicago, and at the University of California, Berkeley, graduating in 1960. After working for several firms, he established his own office in Vienna in 1964. His work has included small shops in Vienna, the Olivetti Building in Amsterdam (1970), and the Austrian Travel Bureau in Vienna (1978). He has been associated with the

MEMPHIS group, which led him in the post-modernist direction. Since 1965, he has been editor of *Bau*, an architectural magazine, and since 1970, he has taught at the Academy of Art in Dusseldorf, West Germany.

HOLZÄPFEL, CHRISTIAN KG

German furniture manufacturing firm founded in 1899 in Wurttemberg that is known for its production of a wide variety of furniture products of simple but excellent design, including many by Herbert Hirche and Hartmut ESSLINGER. Hirche is the designer of the INTERWALL system, a range of modular storage and partition units of simple panel construction widely used in Europe, particularly for office applications. The system is available in the United States through the New York firm ICF (International Contract Furnishings, Inc.).

HOLZMAN, MALCOLM

See HARDY HOLZMAN PFEIFFER ASSOCIATES.

HOOD, RAYMOND M. (1881–1934)

American architect, one of many to work on the design of ROCKEFELLER CENTER, who moved toward MODERNISM at a time when ECLECTICISM was the dominant direction in architecture in the United States. A graduate of MIT, Hood was associated with J. André Fouilhoux and John Mead Howells. Together they won a competition for the design of the Chicago Tribune Building (1922) with a neo-Gothic skyscraper design complete with useless flying buttresses at its top. Under the influence of European modernism, Hood moved toward a noneclectic, modern style with details relating to ART DECO. His vertically striped Daily News and horizontally banded McGraw-Hill buildings (1930 and 1934), designed with Fouilhoux, exemplify this shift. Hood played a major role in the Art Deco design character of Rockefeller Center (begun 1932).

HORNBY, FRANK

See MECCANO.

HORTA, VICTOR (1861–1947)

Belgian architect and designer, a leader in the development of the ART NOUVEAU style between 1893 and 1903 when he produced many of the major works of that era. Horta studied interior decoration in Paris between 1878 and 1881 when he took up architectural training at the Academy in Brussels. In his first office job, he was put to work on the design of green-houses, leading to his awareness of the possibilities of iron and glass in architecture. His 1893 Tassel house in Brussels introduced the florid, curvilinear decoration of Art Nouveau, along with elements using exposed structural iron and glass. The Solvay house of 1894 in Brussels uses many of the same concepts in a larger, more elaborate city mansion. Horta's own house and studio of 1895 have survived with intact interiors and are now a museum open to the public. After 1903, Horta moved to a more conventional style, remaining active and successful in his architectural practice. His later works include the Palais des Beaux-Arts (1919–28) and the main railroad station (1937–52), both in Brussels, and both of a conservative and undistinguished style. Unfortunately, Horta's Art Nouveau public buildings have been destroyed: the L'Innovation department store (1901) by fire in 1966; the Maison du Peuple (1895) torn down in 1964.

For his 1890s interiors, Horta designed special furniture, light fixtures, details in wood, tile, and metal, even including such small details as door knobs and other hardware, all examples of Art Nouveau work at its best. The influence of his early work was, and is even now, strong. His early retreat from the work on which his reputation rests remains an unsolved mystery.

HORWITT, NATHAN GEORGE (1898–1990)

American industrial designer, a lesser-known member of the pioneer group that developed the profession in the United States in the 1930s. His Beta chair of 1930 for the Howell Company was included in the MACHINE ART exhibit at the MUSEUM OF MODERN ART in New York in 1934. Horwitt has come to more recent attention for his design of a wristwatch with a black face, no numerals, and a single tiny disk marking the 12-o'clock position. Designed in 1947, the watch was put into production by Movado watches without credit or compensation to Horwitt. The Horwitt watch is included in the Museum of Modern Art design collection and is known as the "Museum Watch." That name is also used by the pirated design, although the Museum of Modern Art disavows any relationship to it. Many imitators now produce similar watch designs.

HOWARD MILLER CLOCK COMPANY

Small manufacturer of clocks based in Zeeland, Michigan. Initially called the *Herman* Miller

Detail of interior of house Victor Horta designed for himself in Brussels with typical Art Nouveau decorative forms.
Photo by John Pile.

Clock Company (an outgrowth of HERMAN MILLER, INC.), it became the Howard Miller Clock Company in the 1930s, when Herman Miller's son Howard took it over. Though primarily a maker of traditional clock designs, the Howard Miller Clock Company was influenced somewhat by the MODERN designs of Herman Miller, Inc. At first the company produced clocks in the ART DECO style. After World War II, George NELSON offered modern clock designs to Howard Miller, including the noted Ball Clock (designed by Irving HARPER in the Nelson office), in which twelve balls act as the hour marks. It was a spectacular success and

cleared the way for many other modern clock designs and for the addition of lamps, lighting fixtures, and other household accessories, including fireplace tools and even, at one point, modern bird houses! Not all Howard Miller products are of uniform design exellence, but the company continues to offer some products of outstanding design quality.

HOWE, GEORGE (1886–1955)

American architect whose work moved from ECLECTICISM to MODERNISM and who exercised considerable influence as an educator and spokesman for modern architecture. Howe

was educated at Harvard and at the École des BEAUX-ARTS in Paris and joined the Philadelphia firm of Mellor, Meigs & Howe where he produced a variety of traditional houses and other buildings. After meeting William LESCAZE in 1929, Howe became converted to the ideas of modernism and designed, with Lescaze as a partner, the Philadelphia Savings Fund Society (PSFS) building in Philadelphia (1932), the first outstandingly excellent example of modern skyscraper design in America. Many details, including furniture, lighting, and small accessories, were designed by the architects in the modern FUNCTIONALIST style. Independently, Howe designed a handsome house with a strikingly cantilevered deck at Bar Harbor, Maine (1939), which was included in the MUSEUM OF MODERN ART exhibit and book *America Builds*. From 1950 to 1954 Howe was chairman of the architecture department at Yale University where he introduced Louis I. KAHN as a teacher and brought about reforms that made Yale a leading architectural school.

HUBBARD, ELBERT (1856–1915)

American publisher and manufacturer who promoted ARTS AND CRAFTS ideas through his ROYCROFT Press and shops in East Aurora, New York. Hubbard had been a soap salesman until 1894 when, on a visit to England, he met William MORRIS and became acquainted with his thinking and his Kelmscott Press. After returning to America, he established the Roycroft Press and began publication of an Arts and Crafts-oriented magazine, *The Philistine*. The press also produced many books of craft-oriented design modeled on Morris's production. Gradually, Roycroft activity was increased to include production of leatherwork, furniture, and metalwork closely paralleling the CRAFTSMAN designs of Gustav STICKLEY. In spite of their craft origins, Roycroft designs were manufactured in quantity in factory production and sold from regular catalogs. Hubbard and his wife were lost in the sinking of the *Lusitania*, but Roycroft shops operated until 1938 under the direction of their son Bert Hubbard.

HUMAN ENGINEERING

One of several terms that describe the relationship of human users to mechanical and other industrial products. The fields of ANTHROPOMETRICS and ERGONOMICS, which emerged after World War II, overlap the concerns of human engineering, with the latter term increasingly used to describe all such studies.

HUMAN FACTORS

Term for the ways in which human users relate to designed objects. Study of human factors includes ANTHROPOMETRICS and ERGONOMICS. The term is loosely used as a synonym for these terms and for HUMAN ENGINEERING, although each one describes, if used with precision, a slightly different phase. In a strict sense, human factors are the specific aspects of human use of a particular object, structure, or environment that should influence design. For example, the positioning of controls in aircraft and automobiles to favor easy recognition and access has improved convenience and safety.

HUNTER, DARD (1886–1966)

American craftsman-designer particularly known for his revival of the craft of making paper by hand. Hunter worked in various crafts as a member of the ROYCROFTERS group in East Aurora, New York, where he was a teacher of stained glass and jewelry crafts at the Dard Hunter School. After he made the first of two study trips to Vienna in 1908, he took up papermaking in Lime Rock, Connecticut, becoming an authority in the field, with the publication of his 1930 classic text, *Papermaking through Eighteen Centuries*.

HUXTABLE, L. GARTH (1911–1989)

American designer, a 1933 graduate of the Massachusetts School of Art who began his design career as an associate of Norman BEL GEDDES. He is best known for his single and elegant designs for special china, silver, and accessories for the Four Seasons restaurant in the Seagram Building in New York. The space was designed by Philip JOHNSON, with interior design collaboration by William PAHLMANN, while Huxtable's contribution was in carrying design consistency into the smallest details.

HVIDT, PETER (b. 1916)

Danish architect, designer, and cabinetmaker best known for a group of chairs designed for the firm of Fritz Hansen in 1950. Hvidt was trained in architecture and as a cabinetmaker at the School of Applied Art in Copenhagen where he later became a teacher. He entered into partnership with Orla Molgard-Nielsen (b. 1907), and the Hansen AX group was developed by the partners. They designed laminated plywood frames and seat and back surfaces to

permit knockdown construction for easy shipping. The chairs, typical examples of the DANISH MODERN style at its best, were distributed in the United States for a short time by the firm of HERMAN MILLER.

HYPERBOLIC PARABOLOID

Geometric form whose SECTIONS taken in one direction are hyperbolas, while sections taken in the other direction are parabolas. A saddle-shaped curved surface results that has the curious property of permitting straight lines to lie on its seemingly multiple-curved surface. This property makes it possible to construct hyperbolic paraboloid surfaces from straight materials such as wood strips. In architecture and engineering, structures of this form can be built by simple carpentry techniques. A house of 1954 at Raleigh, North Carolina, designed by Eduardo Catalano (b. 1917 in Argentina), is a striking demonstration of the possibilities of such structures. (See also ORTHOGRAPHIC PROJECTION.)

IBM (INTERNATIONAL BUSINESS MACHINES)

Leading American international corporation known for its support of excellence in every phase of design. The firm was founded in 1914 when Thomas J. Watson, Sr., a former executive of the National Cash Register Company, put together several smaller firms to create the Computing-Tabulating-Recording Company. The firm was a manufacturer of scales and time clocks that gradually expanded into production of other types of business equipment. In 1924, the present name, International Business Machines Corp. (IBM), was adopted. Under Watson, IBM grew on the strength of an aggressive sales and service orientation. IBM's involvement with design began when Thomas J. Watson, Jr. returned to the company in 1945 after service in World War II. He became president in 1952 and chief executive officer in 1956. Watson's acquaintance with architect and industrial designer Eliot NOYES led to his being given various design assignments and, eventually, general responsibility for all IBM design. Noyes was the designer of post-war IBM electric typewriters, including the 1961 Selectric model that became a virtual universal standard, while the punch card (now commonly known as an "IBM card") became a standard format for data storage and manipulation. As IBM entered into computer development (with the 1943 Harvard Mark I), the visual design of the enclosures and consoles gave IBM products an identity and air of quality that helped push the firm into a leadership role.

Noyes's advice and influence brought about an extraordinary level of design quality in all IBM products, graphic design (Paul RAND designed the firm's LOGOTYPE and many graphic materials), packaging, showrooms, and architectural projects including office buildings and

IBM logotype designed by Paul Rand. Courtesy of International Business Machines Corp.

factories in many locations worldwide. Marcel BREUER, Ludwig MIES VAN DER ROHE, Edward Larrabee Barnes, and Eero SAARINEN are among the architects who have designed for IBM. Charles EAMES was the designer of a number of IBM exhibits and produced a variety of educational films that aided understanding of the complex theories behind the function of IBM computer products. Since the retirement of Watson, IBM design has retreated somewhat from its preeminent rank, but still maintains high standards along with sponsorship of public-service exhibitions on art and design.

IITTALA

Finnish manufacturer of glassware (the full name is Karhula-iittala) that produces most of the well-designed glass made in Finland. The designs of Alvar AALTO, including vases, glasses, and trays, are among the best-known iittala products available in the U.S. through such shops as MARIMEKKO and the MUSEUM OF MODERN ART gift shop in New York. More recent designs of high quality are also in production, including the work of Valto Kokko, Timo SARPENEVA, and Tapio WIRKKALA.

IKEA

Swedish-based furniture manufacturer that has pioneered in direct retail sale of well-designed products to a wide consumer market. The firm was founded in 1943 by Ingmar Kamprad. IKEA shops are large, supermarketlike establishments in suburban areas outside of major cities where customers can make selections and load their purchases directly into their cars. In addition to furniture, IKEA now offers lamps, kitchenwares, china and glassware, blinds, linens, and floor coverings. Although designs are anonymous, the quality is generally excellent in the simple, Swedish modern tradition. There are stores in many European locations, in the Far East, and most recently (since 1987), in the United States.

ILLINOIS INSTITUTE OF TECHNOLOGY

American college that has had a significant impact on design through its architectural department and its INSTITUTE OF DESIGN. IIT (as it is most often known) was originally named Armour Institute in 1893 after its founder, Philip D. Armour. In 1938 Ludwig MIES VAN DER ROHE became head of its school of architecture and, shortly thereafter, began planning its new Chicago campus. The present campus is built according to Mies's plans, and many of the buildings are of his design. Crown Hall, a building typical of the Miesian concept of "universal space"—an almost totally open rectangle of steel frame and glass wall construction—houses the architectural and design schools. Mies's influence continues to shape IIT programs both through curriculum and philosophy and through the architectural character of the campus and its buildings.

INDUSTRIAL DESIGN

Most widely used term for the professional design of objects intended for quantity production. The term is not always used correctly since many industrial designers may work on products for craft manufacture and in related fields such as exhibition or interior design. The alternative term PRODUCT DESIGN is felt to be too limiting for the profession (although it is often used for that aspect of design work). "Designer" is too general since it includes architects, engineers, stage, and fashion designers, among others. Industrial design has thus become the usual designation for the profession, its professional societies, and courses offered in art and design schools in this field. The term "stylist," which implies design of a superficial, decorative nature, is still used by the Detroit automobile industry, ironically offering self-criticism of the attitudes toward design that have been typical in that field.

INDUSTRIAL DESIGN

Principal American journal dealing with professional design activities. *Industrial Design* was founded in 1954 by publisher Charles Whitney as an outgrowth of a department in his magazine *INTERIORS*. Although the magazine has changed ownership several times, under the editorship of Jane Fiske Mitarachi and Roger Guilfoyle it became the only serious American periodical in the field. It remains an important influence within the profession in the United States.

INDUSTRIAL DESIGNERS SOCIETY OF AMERICA (IDSA)

Leading professional organization of American industrial designers. IDSA was formed through the merger of the American Designers Institute (ADI), founded in 1938, which in 1951 became the Industrial Designers Institute (IDI), and the Society of Industrial Designers (SID),

founded in 1944 by Henry DREYFUSS, Raymond LOEWY, and Walter Dorwin TEAGUE, three leaders of the industrial design profession. In 1955 the SID became the American Society of Industrial Designers (ASID). The 1965 merger also incorporated the Industrial Designers Education Association (IDEA), which had been founded in 1957. The present organization has more than 2,000 members organized into eleven regional chapters. IDSA functions include establishing standards of professional practice and ethics, promoting quality design education, and encouraging awareness of professional design through public relations efforts, publications, and promoting exhibits of industrial designers' work. The organization maintains a national headquarters at Great Falls, Virginia, and has recently established a Prototype Design Center, with a permanent exhibit gallery to aid in developing design awareness on the part of the American public.

INJECTION MOLDING

Manufacturing technique in which PLASTIC in a semiliquid state is forced into a hollow mold where it hardens into the shape determined by the mold. The finished part is ejected from the mold ready for use or for whatever further finishing and assembly steps are required. While automatic machines can produce small injection moldings at high speed at relatively low cost, the high cost of the molds tends to limit use of the process to the production of objects and parts where demand can be expected to be high. THERMOPLASTICS such as styrene and polyethylene are the usual materials used for injection molding to produce such everyday objects as plastic knives and forks, containers, and toys.

INSTITUTE OF DESIGN

American design school located in Chicago that has both historical and philosophical links with the German BAUHAUS. In an effort to carry on Bauhaus education after the original institution was closed in 1933, a school called the "New Bauhaus" was founded in Chicago by László MOHOLY-NAGY with the sponsorship of the Chicago Association of Arts and Industries in 1937. Gyorgy KEPES was a faculty member and Walter GROPIUS a consultant. The school was closed in 1937, but in 1939 Moholy-Nagy founded the School of Design, a new institution with much of the same staff and educational program. In 1944, the name of the school was changed to Institute of Design and the status of a degree-granting college was attained. After Moholy-Nagy's death in 1946, Serge CHERMAYEFF became director, and in 1949 the school was absorbed into the ILLINOIS INSTITUTE OF TECHNOLOGY (formerly the Armour Institute). In 1951, directorship passed to Crombie Taylor and in 1955 to Jay Doblin, who was largely responsible for the present program.

Courses are offered in product design, visual design (largely graphics, and advertising and package design), photography, and art education. The school is housed in Crown Hall (1950–56), one of the buildings designed by Ludwig MIES VAN DER ROHE as part of his total campus plan. The institute continues to offer design education with strong connections to that of the original Bauhaus.

INTERIOR DECORATION

Most widely used term for the selection and placement of furniture, floor coverings, window treatments, textiles, and decorative objects as well as the choice of color for interiors. The term was almost universally used for both amateur and professional interior work until recent years when professional dissatisfaction with the implications of superficiality associated with the word "decoration" led to the use of the alternate term INTERIOR DESIGN. At present, the accepted distinction is that "decoration" is limited to product and color selection, usually in residential projects. Many schools and colleges have, since the 1920s, offered training in decoration, usually within programs in "home economics." Architects have, for many years, taken a dim view of decoration regarding it as a nonprofessional approach to interiors since it has been taken up by such commercial practitioners as retail furniture dealers and drapery and painting contractors and by amateurs with no particular training or experience. To avoid connotations of inferior status, many decorators since the 1940s have taken on the designation of "interior design" leading to wide confusion about the definition and significance of the two terms. Efforts to introduce legal restrictions on interior design practice through licensing may eventually help clarify the terminology in these fields.

INTERIOR DESIGN

Widely used term by designers of interior spaces who have extensive professional training and ethical standards and who include an

understanding of architectural planning and structure among their skills (as opposed to IN-TERIOR DECORATION). "Interior design" is now the term most often used for courses offered in design and art schools that go beyond surface decor and ornament, usually with a major emphasis on CONTRACT (commercial, institutional, and office) design and less attention to strictly residential interiors. Many architects accept interior design projects and often develop interior design departments within their firms. Concerns with issues of safety and larger environmental issues have led to efforts to obtain legal control of the use of the term "interior designer" and therefore limit practice in the field. Licensing laws may eventually require registration of interior designers in a way comparable to that now mandated for architects.

INTERIOR DESIGN

Major American magazine devoted to the professional interiors field. *Interior Design* deals with both CONTRACT and residential design work and is known for its full, often lavish, pictorial coverage of current work. For many years it was under the editorship of Sherman Emery, who should be credited with building it to a dominant position among design magazines. Since his retirement, the editorship has been taken over by Stanley Abercrombie, an architect and writer, who is responsible for moving the magazine toward increasingly serious criticism and comment on the profession and its relationship to the architectural profession.

INTERIORS

Influential American magazine dealing with interior design and related topics. A little-known magazine before World War II, it was purchased in 1940 by Charles Whitney, the founder of his own publishing firm, Whitney Publications. Under Whitney, the magazine improved and expanded until it became the primary journal in the field. A number of distinguished editors aided in improving the magazine, including Oga Gueft, editor from 1953 until her retirement in 1980. *Interiors* has been a major force in encouraging the development of modern INTERIOR DESIGN as distinguished from traditional INTERIOR DECORATION. Its support and publication of such writers as Sigfried GIEDION, George NELSON, and Bernard RUDOFSKY made it a serious critical journal as well as a source of more strictly commercial

data. Although several other competitive magazines have entered the field, *Interiors*, now under the editorial direction of Beverly Russell and with new ownership, continues as a significant publication for professional interior designers, emphasizing CONTRACT DESIGN to the total exclusion of residential work.

INTERNATIONAL CONGRESS OF MODERN ARCHITECTS
See CIAM.

INTERNATIONAL DESIGN CONFERENCE IN ASPEN (IDCA)
Annual week-long event held each summer at Aspen, Colorado, that brings together leaders in design fields from many countries to discuss issues of common concern. The IDCA was begun in 1951 by Walter Paepcke of the CONTAINER CORPORATION OF AMERICA. Participants in the conferences have included innumerable leaders in industrial and graphic design, architecture, and film as well as critics and writers involved in these and related fields. A number of corporations provide financial support. Each year a board chooses a topic and selects a director who plans the conference and invites speakers. Over the years theme topics have included *Design as a Function of Management, Man/Problem Solver, Paradox,* and *Shop Talk.* The conference takes place in an inflated tent structure and includes many subsidiary outdoor and indoor events in addition to numerous opportunities for informal and social contacts.

INTERNATIONAL STYLE
Term used to describe architectural design that is simple, functional, and unornamented, following the theoretical teachings of the BAUHAUS and the leading figures of MODERNISM of the 1920s and 1930s. While historic period design has generally been associated with national or regional traditions—as in French Gothic or Italian Renaissance styles—early modernism developed in France, Germany, the Scandinavian countries, and elsewhere in similar patterns, so that all such work can be considered truly international in character. The term was used as the title for an exhibition and related book at the MUSEUM OF MODERN ART in New York curated by Henry-Russell Hitchcock and Philip JOHNSON in 1932. Most of the work shown shared such characteristics as flat roofs, large glass areas, plain white walls, and an emphasis on the use of steel and concrete as

building materials. The term has come to be associated with and applied to such designs, while other types of modern work (that of Frank Lloyd WRIGHT, for example) are not described by this term.

INTERNATIONAL TYPEFACE CORPORATION (ITC)

American firm offering a wide range of TYPE-FACES for modern phototypesetting and digital system formats. ITC was founded in 1970 by Aaron BURNS, Herb LUBALIN, and Ed Rondthaler. The firm has arranged to have many popular traditional typefaces reworked into digital format and has also commissioned new typeface designs from a number of designers including Matthew CARTER and Hermann ZAPF.

INTERWALL

System of flat, usually white storage components and partitions particularly suited to office use developed and manufactured in Germany. Offering great versatility and simple modern design, the system was developed by designer Herbert Hirche for the firm of Holzäpfel in Ebhausen/Wurttemberg. It is known as INwand in Germany and in many other European countries where it is widely used. In the United States, the system is imported by the New York firm of ICF.

ISD, INC.

Major American INTERIOR DESIGN and office planning firm known for its many important CONTRACT design projects for large corporations and other institutions. The firm name stands for Interior Space Design. It was founded in 1960 as a branch of the architectural firm of Perkins & Will. In 1973 it became an independent firm with Kenneth E. Johnson as its president based in Chicago, and with Louis M.S. Beal as the head of its New York office. A Houston, Texas, office is now also maintained. Among the firm's many major clients and projects are AT&T, the Xerox Corporation, the Bos-

Main reception area in the Cleveland, Ohio, offices of Jones, Day, Reavis & Pogue, designed by ISD, Inc.
Photo by Nick Merrick, courtesy of ISD, Inc.

ton City Hall, and many banks, corporate offices, and institutional facilities. ISD, Inc. is known for its high professional and aesthetic standards of a MODERNIST character and its strongly architectural approach to interior design work. The firm has worked in collaboration with many major architectural offices on projects where a shared design point of view has helped achieve good cooperation in addition to a high quality of design.

ISOKON

English company founded in 1931 for the production of MODERN furniture with an emphasis on plywood (sometimes with metal facing) as a primary material. Jack Pritchard was the founder and primary leader of the venture, which produced various designs by Marcel BREUER, Wells COATES, and Walter GROPIUS and worked with various other leading modernists, including László MOHOLY-NAGY. Isokon products found only a limited market in England in the 1930s, but they include many designs that now have a significant place in the history of modern design.

ISOLA, MAIJA (b. 1927)

Finnish textile designer known for her use of bright colors and strong patterns. Isola studied at the Institute of Industrial Arts in Helsinki and became a designer for the firm of Printex in 1949. Her designs for silkscreen prints use large abstract forms and intense colors that suggest traditional designs from the Finnish

region of Karelia. The firm of MARIMEKKO took up distribution of Isola prints, tablecloths and sheets, and used them in apparel designs that attained wide popularity in the 1960s and 1970s and continue to have current acceptance.

ISOMETRIC

System of drawing a geometric projection in which horizontal lines are represented by lines drawn at equal angles (usually 30°) to the horizontal. Lines are drawn at the same scale in vertical and angled horizontal directions so that measurements can be taken directly along each of the three main axes. Isometric drawings can be regarded as a special type of AXONOMETRIC drawings. They offer a visual effect similar to that of PERSPECTIVE and are easier to draw, but lack the realistic effects of foreshortening and the convergence of lines toward distant vanishing points. Isometric projection is widely used in technical illustration and architectural drawings.

ISOZAKI, ARATA (b. 1931)

Japanese architect and designer who came to international prominence with his design for the Gunma Prefectural Museum of Fine Arts in Takasaki (1971–74), a complex design based on squares of various sizes interlocked in ways that create sometimes disturbing perspective illusions. Isozaki was trained at the University of Tokyo and worked with Kenzo Tange until he opened his own practice in 1963. His work has strongly geometric, abstract qualities, sug-

Mini sedan, the most famous design of Alec Issigonis. Photo by John Pile.

gesting a relationship to both LATE MODERNISM and POST-MODERNISM. His work, in America, includes various interior design projects and furniture design.

ISSIGONIS, ALEC (b. 1906)

British automotive engineer and automobile designer whose work includes some of the most important and innovative designs produced by the English motor industry. Issigonis was trained in London as an engineer and began work as a draftsman for Rootes Motors. He later joined Morris Motors and became that firm's chief engineer in 1961. His design (both engineering and appearance) for the Morris Minor of 1948 made it one of the most popular British cars of its era—it remained in production for twenty years. The Morris Mini of 1951 was an even more successful design introducing the modern transverse engine and front-wheel drive in a small car. The Mini offers surprising space and comfort, along with excellent economy and mechanical simplicity, in a way that has made it immensely popular in a number of variations, including the sporty Mini Cooper. The Mini sets a high standard for aesthetic design along with its technically advanced engineering. It remains in production in a somewhat updated form.

ITALDESIGN

Italian design firm whose work for Alfa Romeo, NECCHI, NIKON, Seiko, and VOLKSWAGEN has made it a leader in modern industrial design. Established in 1968 by Giorgio GIUGIARO, the firm has received international recognition.

ITTEN, JOHANNES (1888-1967)

Important Swiss-German design educator and theorist. Itten studied painting in Stuttgart and moved to Vienna in 1916 where he taught and worked as an artist. Beginning in 1919, he be-

Nikon F3 single-lens reflex camera with exterior design by ItalDesign. Photo courtesy of Nikon, Inc.

came a key personality in the development of the foundation course at the BAUHAUS. He left the Bauhaus in 1923 and set up his own school in Berlin in 1926; later he directed art schools in Switzerland. His artistic theory, largely concerned with COLOR in both scientific and expressive terms, was often intermingled with philosophy and mysticism derived from oriental religions. His book *The Art of Color* (1961) is a major work in the field.

J

JACKSON, DAKOTA (b. 1949)
American artist-designer of one-of-a-kind pieces that use geometric forms and varied materials to produce objects that can be viewed as sculpture while serving as furniture as well. Many of his earlier works, such as *Standing Bar* of 1979, incorporate hidden compartments, doors, and openings that transform it from a strictly sculptural form into an open, highly functional unit.

JACOBSEN, ARNE (1902–1971)
Leading Danish architect, who also made a major reputation in furniture and product de-

Ice bucket, coasters, ashtray, and other accessories designed for Stelton of Denmark by Arne Jacobsen. Photo courtesy of Stelton U.S.A.

sign. Jacobsen was trained at the Royal Danish Academy and came to notice with his designs for the town hall at Aarhus of 1938 (with Erik Møller) and that at Sollerod of 1940 (with Flemming Lassen) — both commissions were won in competitions. Jacobsen's design was in the strict modernist traditions of the INTERNATIONAL STYLE, with a certain elegance that seems particularly Scandinavian. His work included many fine houses and housing groups, schools, factories, and the tall SAS Hotel Royal, a prominent Copenhagen landmark. He was also the designer of flatware, china, glass, lamps, textiles, and furniture, including chairs for the firm of Fritz HANSEN.

JACQUARD
Weaving technique using a loom developed by Marie Jacquard (1752–1834) and, by extension, any textile woven by this method. The jacquard loom uses a system of punched cards to select individual warp threads, making it possible to weave complex patterns entirely automatically. Jacquard fabrics are often richly decorative, sometimes with pictorial motifs as patterns. Modern textile designers have taken advantage of the technique in developing complex, abstract patterns.

JARAY, PAUL (1889–1974)
Swiss engineer who pioneered in the development of automobile design using streamlined forms. As an engineer for the ZEPPELIN works, Jaray designed dirigible airships. In 1922 he patented an automobile design of streamlined form based on AERODYNAMICS. Although he never designed a production car, his ideas have had a major influence on all modern automotive design.

JAZZ MODERN
See ART DECO.

JEANNERET
Family name of the cousins Pierre and Charles-Édouard. The latter became famous under the pen name LE CORBUSIER. Pierre Jeanneret (1896–1967) was a less-known partner in the architectural work of Le Corbusier, playing a significant role behind the scenes.

JENSEN, GEORG ARTHUR (1866–1935)
Best known of all Danish craft-designers for his high-quality modern jewelry and silverware. Jensen was trained as a goldsmith and also

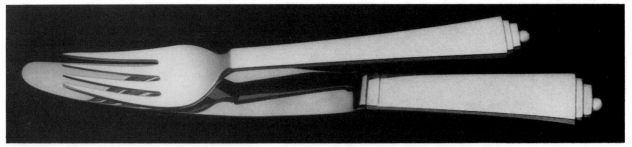

Pyramid, a silver flatware designed for Royal Copenhagen by Georg Jensen. Photo courtesy of Royal Copenhagen.

studied sculpture at the Copenhagen Academy. Beginning in 1895, he worked in ceramics with Joachim Petersen. Some of his work was exhibited at the Paris Exhibition of 1900. In 1904 he opened a small shop in Copenhagen, offering jewelry and silver of his own design. As the business grew, it produced and sold designs of other Danish designers and craftsmen, eventually distributing a wide variety of Scandinavian products of high design quality, which combine the aesthetics of MODERNISM with traces of Nordic traditionalism. The firm is now international, with the New York shop well known as a primary showcase for Danish design.

JENSEN, JACOB (b. 1926)

Danish industrial designer best known for his work for BANG & OLUFSEN (B&O). Jensen graduated from the Copenhagen School of Arts and Crafts and worked from 1952 until 1959 for Sigvard BERNADOTTE. From 1959 to 1961 he was a partner in the Chicago firm of LATHAM TYLER JENSEN. He returned to Copenhagen in 1961 to open his own office, with B&O becoming a major client. His Beosystem 1200 radio-phonograph for B&O won a Danish prize for industrial design in 1969. The later Beogram 4000 and 8000 have been widely admired as outstanding examples of recent Danish design.

JENSEN, SØREN GEORG (b. 1917)

Danish silversmith and sculptor, a son of the famous Georg JENSEN. Jensen was trained as an apprentice in his father's firm and studied at the Royal Danish Academy of Fine Arts in Copenhagen. He headed the design activities of the family firm from 1952 until 1974, when he retired to devote his time to sculpture. His designs for silver objects have a strongly sculptural quality and are in the best tradition of modern Danish design.

JOHNSON, CLARENCE L. ("KELLY") (b. 1910)

American aeronautical engineer whose work has had an extensive influence on the design of modern aircraft and, through influence, on all modern industrial design. Johnson was a graduate of the University of Michigan and began work for LOCKHEED in 1933. By 1938 he became chief engineer. The Lockheed P-38 fighter of 1941 was his first outstanding and original design. Later projects include the P-80 jet fighter, the U-2 spy plane and the C-130 Hercules military transport. His work is often credited with having had a strong influence on automotive design of 1952 when airplanelike "tail fins" appeared on American automobiles for purely STYLING reasons.

JOHNSON, PHILIP C. (b. 1906)

Leading American architect and vocal spokesman for modern architecture and design. A Harvard graduate, Johnson first became involved in the design fields as the director of the department of architecture at New York's MUSEUM OF MODERN ART (1930 to 1936 and later 1946 to 1964). With Henry-Russell Hitchcock, he organized the first major showing of MODERNISM in architecture in America with the 1932 exhibit, *The International Style.* He returned to Harvard as an architectural student, graduating there in 1943, and establishing his own practice in New York in 1954. He quickly became known for his own house in Cambridge, Massachusetts (1943), and his famous Glass House at New Canaan, Connecticut (1949). He joined with Ludwig MIES VAN DER ROHE in the design of the Seagram Building (1958), which is generally regarded as the best of the all-glass tower skyscrapers.

Johnson has worked with several partners, including Richard Foster and John BURGEE, producing many major works, such as the New York State Theater at New York's Lincoln Center (1964) and a number of museums, office buildings, and private houses.

Most of Johnson's work has been in the mainstream of modernism, however, beginning around 1980, his interest turned toward more

Promenade of the New York State Theater at Lincoln Center in New York City. Designed by Philip Johnson; sculptures by Elie Nadelman.
Photo by Bob Serating, courtesy of Lincoln Center for the Performing Arts, Inc.

eclectic directions in the manner of POST-MOD-ERNISM. His AT&T corporate headquarters building in New York (1984) shocked the architectural community with its historical references and sharp departure from modernist thinking. More recent works have become increasingly varied, adventurous, and controversial. Johnson has won many awards and honors and is often viewed as the "dean" of modern American architecture.

JOURDAIN, FRANÇOIS (1876–1958)

French architect and interior designer whose career extended from the ART NOUVEAU era through the MODERNISM of the 1930s. Jourdain was trained as a painter, but after 1909 worked only as an interior and furniture designer. He was interested in low cost, prefabricated furniture of simple design. His work and publications of the 1920s were well known and influential since he was a strong champion of the austere, undecorated design vocabulary of

the time. After 1945, he no longer produced design, but focused on historical writing about art and design.

JOURDAIN, FRITZ (1847–1937)

French architect of the ART NOUVEAU movement. Jourdain is best known for his design for the Samaritaine department store (1905) in Paris, an outstanding example of Art Nouveau's florid, curvilinear design with its ornamental facade and stained glass skylit central court.

JUDD, DONALD (b. 1928)

American artist-craftsman designer of simple, largely geometric furniture. Judd assembles his work out of wood planks in his own West Texas shop. The unpretentious nature of his designs makes them appear almost crude, but there are subtleties in form and detail that make a serious claim to the status of "works of art," particularly when groups of his designs are viewed together.

JUDSON, WILLIAM LEE (1842–1928)

American artist and craftsman whose stained glass work appears in some of the buildings of GREENE & GREENE and Frank Lloyd WRIGHT. Judson was born in England but set up as a portrait painter in Brooklyn. In 1893 he moved to Chicago and then to California, where he founded Judson Studios (1897) in Los Angeles. He continued to paint but also designed and produced stained glass and mosaics.

JUGENDSTIL

German term for the stylistic development usually called by its French term ART NOUVEAU. Jugendstil means, in literal translation, the "style of youth." The name came from the magazine *Jugend*, published from 1896 to 1914, which promoted this new style. Jugendstil designers centered in Munich included August ENDELL, Hermann OBRIST, and Bernhard PANKOK. Henri VAN DE VELDE, after his move to Berlin in 1899, formed a strong link between German and Belgian/French developments. His 1900 Havana Company cigar shop in Berlin, with its rich ornamentation and flowing, curved lines, is typical of Jugendstil work.

JUHL, FINN (b. 1912)

Danish furniture and interior designer and architect, a key figure in bringing about the international acceptance of DANISH MODERN in the 1950s. Juhl was trained as an architect at the Copenhagen Academy and became influential as a lecturer at the Fredericksberg Technical School from 1944 to 1954. His furniture design was acclaimed in the United States by Edgar KAUFMANN, Jr., in his 1950 and 1953 booklets for the MUSEUM OF MODERN ART in New York. In 1951 Juhl designed a major group of furniture for the Baker Furniture firm of Grand Rapids, Michigan. He also designed the interior of the Trusteeship Council chamber at the UN headquarters building in New York. He has continued to design furniture, glassware, and a variety of other products for a wide range of clients.

Juhl's designs are characterized by floating, biomorphic-shaped elements held in slim cages of elegantly shaped wood. They combine respect for the modernist drive for simplicity and geometric order with forms that are reminiscent of the Scandinavian tradition of a softer, handcrafted vocabulary of form.

KÄGE, WILHELM (1889–1960)

Swedish designer of porcelain, pottery, and other ceramics for the firm of Gustavsberg from 1917 to 1960. Käge studied painting at Gothenberg, Copenhagen, and Munich and was brought to the Gustavsberg firm as part of an effort to increase the artistic qualities of Swedish factory products. He was the designer of many dinnerware services, including Pyro (1930), Praktika I and II (1933 and 1945), and Farsta stoneware. His designs often express a folk or peasant quality. His work was widely exhibited and won many prizes, including a Paris 1925 Exhibition Grand Prix.

KAHN, ALBERT (1869–1942)

American architect best known for his work on industrial buildings, often of outstanding modernist design. Kahn was born in Germany but came to the United States as a child. He worked for a Detroit architectural firm for some years before establishing his own office in 1902. Much of his work was for automobile manufacturers in the Detroit area. While the work tended to be conservative in ornamental detail, it excelled in the functional parts of factories, where large glass areas and roof skylights generated forms related to those of more doctrinaire European modernists. The firm of Albert Kahn, Inc., was at its best with such works as the Chrysler Motor Company truck assembly plant building of 1936 near Detroit, with its dramatic structural trusses, or the Kellogg grain elevators in Battle Creek, Michigan. Kahn built projects around the world; there are many in the USSR and even a few in China and Japan.

KAHN, LOUIS I. (1901–1974)

American architect and architectural educator whose influence far outstrips the extent of his executed work. Kahn was born in Estonia and studied art and architecture, the latter at the University of Pennsylvania in Philadelphia from 1920–24, when the program there was oriented toward classical BEAUX-ARTS design. He worked for several Philadelphia firms and turned toward MODERNISM while working with George HOWE and Oscar Stonorov. Kahn was asked to teach at Yale by Howe in 1947. He

Salk Institute Laboratories at La Jolla, California. A 1965 design by Louis I. Kahn. Photo Courtesy of the Museum of Modern Art, New York.

stayed until 1957 and became known for his Yale University Art Gallery addition of 1953, with its triangular, trussed structure visible as gallery ceilings. His Richards Medical Research Laboratories at the University of Pennsylvania, with all the service elements grouped in external towers, followed in 1957–61. Although a controversial work disliked by many of its users, it established his international reputation. From 1957 until his death he taught at the University of Pennsylvania in Philadelphia, where he is credited with becoming a major influence in developing the "Philadelphia school" of MODERNISM, which includes the firms of Mitchell/Giurgola and VENTURI, Rauch and Scott Brown.

Kahn came to have an almost mystical power as an educator and architectural theorist in a way that went far beyond the seeming modesty of such works as his Unitarian Church (1963) in Rochester, New York, and his Salk Institute Laboratories (1965) in La Jolla, California. His last works included governmental buildings in Dacca, Pakistan (under construction at the time of his death), and the Kimbell Art Museum (1972) in Fort Worth, Texas. Kahn's design was generally simple in detail but powerful in form and full of complexities and subtleties that have made him one of the most admired and studied of all modern architects.

KAISER, HENRY J. (1882–1967)

American industrialist who had an impact on the design world through his firm's construction of the Boulder (Hoover) Dam (1936) in Colorado and a vast fleet of ships for the United States government for service in World War II. After the war, Kaiser turned toward consumer product production and developed the Kaiser, Frazer, and Henry J. automobiles, each with

innovative, simple, functional designs by Howard DARRIN of a quality ahead of their times. Although commercially successful for a time, Kaiser automobiles were eventually forced out of production by the resurgence of the older, well-established Detroit firms.

KAMALI, NORMA (b. 1945)

American fashion designer known for her "sweats," jump suits, and design influenced by the Mod London of the 1960s. Norma Kamali was trained as a fashion illustrator at the Fashion Institute of Technology in New York and, after many visits to London, opened a New York shop with her husband, Eddie, in 1968 to sell the latest in English and French clothing design. Her own designs were produced under the name Kamali Ltd. In 1978 she opened an independent shop with the name OMO. Her designs are youthful and imaginative but rarely eccentric. In 1982 she introduced a line of all-white clothes of a disposable material, Tyvec, naming the collection The Package. In 1983 the Council of Fashion Designers of America named her the outstanding designer of the year.

KANDINSKY, WASSILY (1866–1944)

Famous modern painter, born in Russia but later active in Germany and France. While Kandinsky was a founder (with Franz Marc) of the expressionist Blaue Reiter movement in painting, his impact on design fields stems from his role as a master at the BAUHAUS from 1922 to 1933 where he taught analytical drawing and conducted a COLOR seminar in addition to teaching mural painting. The work of his students was focused on confirmation of an aspect of Bauhaus theory that sought to relate color and FORM—the triangle to yellow, the square to red, and the circle to blue. After the Bauhaus was forced to close in 1933, Kandinsky relocated to Paris where he continued to paint.

KANE, BRIAN (b. 1948)

American furniture designer. His rubber chair of 1984 uses simple bent tubing to support a seat and form a back. Its minimalist or HIGH-TECH character is enhanced by the textural quality of black rubber tubing covering the structural elements. Manufactured by Metropolitan Furniture Corporation of South San Francisco, California, the chair was included in the WHITNEY MUSEUM OF AMERICAN ART 1985 *High Styles* exhibition.

KATAVOLOS, WILLIAM (b. 1924)

American designer, educator, and futurist best known for a furniture group designed with collaborators Douglas Kelley and Ross Littell in 1952 for the New York firm of Laverne Originals. The three-legged chair of steel tubing with a leather seat and back won an American Institute of Designers award in 1952 and was exhibited in 1953 at the MUSEUM OF MODERN ART in New York. The chair went out of production after a dispute between manufacturer and designers. Katavolos has since become a design theorist and developer of futuristic architectural proposals, including a floating city. He is a member of the architectural faculty at PRATT INSTITUTE, where he received his training in industrial design.

KAUFFER, EDWARD MCKNIGHT (1890–1954)

American artist and graphic designer best known for his posters, especially those designed while he was living in England from 1914 until 1940. Kauffer studied painting in Paris, but came to notice in the 1930s for his poster designs beginning with an assignment by Frank PICK for the London Underground (subway). His book *The Art of the Poster* appeared in 1924, and his work in the field using strong typography along with abstracted but recognizable illustrative imagery, was widely exhibited and received a variety of awards. He also designed books and book jackets. In 1940–1941 he produced several graphic designs for the New York MUSEUM OF MODERN ART. He became inactive after the early 1940s, having designed over 250 posters and 150 book jackets.

KAUFMANN, EDGAR, JR. (1910–1989)

American historian, writer, and museum curator who has had a major role in explicating MODERNISM in design and architecture to both professional and lay audiences. Edgar Kaufmann began his life work as an art student in New York and in several European cities before turning away from painting to become an apprentice architect at Frank Lloyd WRIGHT's Taliesin (1933-35). While working with Wright, he was instrumental in securing for Wright the commission to design the famous house FALLINGWATER for his parents. In 1940, after a short stint as a merchandise manager in his father's Pittsburgh department store, Kaufmann joined the MUSEUM OF MODERN ART in New York as head of its department

of industrial design. He was the author of several museum publications and directed exhibitions, including the 1950 to 1955 GOOD DESIGN shows aimed at educating the public to the merits of design excellence. After 1955, Kaufmann devoted his time to teaching at Columbia University and to independent scholarship and writing in the fields of architecture and design. His books include *The Rise of an American Architecture* (1970) with essays by various critics based on a Metropolitan Museum of Art exhibit, and *Fallingwater* (1986), the definitive book on the Wright house. He was a founding member of the Architectural History Foundation in 1978.

KD

KD is a construction trade abbreviation for the term "knock down." It is used to describe products that are designed to be shipped disassembled for later assembly at the point of delivery either by a dealer or by a purchaser. KD construction leads to economies in production by reducing steps that often require hard work, and more important, it saves on shipping costs of products that are bulky and often internally hollow. Furniture is particularly well suited to KD construction given both considerations. Even chairs can often be made so that they knock down into compact packages. Many other consumer products are now shipped KD—coat racks, storage bins, utility shelving, and such mechanical products as power lawnmowers are typical examples.

KECK, GEORGE FRED (1895–1980)

American modernist architect who built a significant reputation in the 1930s before MODERNISM became widely accepted. Keck first won recognition as the designer of the futuristic House of Tomorrow in a village of model homes at the CENTURY OF PROGRESS exhibition in Chicago in 1933. The house was a twelve-faceted, all-glass-walled circular pavilion placed on top of a base that included services, garage, and a hangar for the family airplane! At the 1934 fair, Keck provided his Crystal House, also with walls of glass and a strikingly modern interior. His work thereafter for private clients was largely residential, including many midwestern houses of simple modern design. Most of his designs emphasized the concept of the "solar house," which Keck developed by carefully studying patterns of the sun's path so that a maximum of winter sun aided heating and a

minimum of summer sun penetrated the house's windows. Orientation and placement of windows and overhangs for shading were planned to give maximal comfort and energy economy. It can be said that Keck is a precursor of the interest in solar heating that began in the 1970s.

KELLY, DOUGLAS
See LAVERNE, ERWINE.

KENZO (b. 1940)
Japanese fashion designer, one of the first to introduce Japanese influence into the Paris fashion field. Kenzo was an art student in Tokyo before attending the Bunka Gakuen School of Fashion there and winning a 1960 Japanese fashion design award. In 1965 he moved to Paris where he worked for various shops and textile firms before opening his own shop in 1970 using the name *Jungle JAP*. Since that name is unacceptable in the United States, the name Kenzo is substituted. His designs often have a hint of juvenile style with simple vests over shorts or miniskirts, often in combination with Japanese traditional forms such as kimono sleeves or with touches of European peasant or folk costume. He designs for the American firm The Limited as well as for his own Paris house.

KEPES, GYORGY (b. 1906)
Hungarian-born painter and designer best known as an educator and writer on design-related subjects. Kepes worked in stage and exhibit design in Berlin and London before coming to the United States in 1937. He taught at the INSTITUTE OF DESIGN in Chicago from 1937 until 1946 and, from 1946 until his retirement in 1974, was Professor of Visual Design at MIT. His book *Language of Vision* (1944) is a classic on MODERN design theory with its emphasis on abstract formal relationships closely related to modern art. He was general editor for the *Vision + Value* series published by MIT Press, which includes *The Man-Made Object* (1966), an anthology of essays on design subjects. He has remained active as a painter, and his abstract, modern works are in the collections of many major museums.

KIESLER, FREDERICK (1890–1965)
Austrian theatrical designer who became part of the DE STIJL movement in Holland in 1923. His *Cité dans l'Espace*, a De Stijl utopian city of

the future, was part of the Austrian exhibit at the 1925 Paris exhibition. From 1923 to 1960 he worked on the concept of a futuristic "Endless House" with curving, biomorphic forms. The house was never built, but often published and exhibited. After coming to the United States in 1926, he designed the Film Guild Cinema in New York in a style closely related to De Stijl thinking and established a reputation as both a sculptor and a designer of visionary and futuristic architectural projects. His *Art of This Century* gallery of 1942 was a strong expression of his personal aesthetic. From the 1940s until his death, Kiesler produced and regularly exhibited "Galaxies," sculptural works made by grouping flat, painted panels to form spatial environments. Lisa Phillip's 1989 book *Frederick Kiesler* is an inclusive survey of his achievements.

KING, JESSIE MARION (1876–1949)

Scotch artist and graphic designer whose work is related to the British version of ART NOUVEAU. King was trained at the GLASGOW SCHOOL OF ART and developed a style of watercolor painting (shown at the 1902 Turin Exhibition) and textile, wallpaper, jewelry, and tile design strongly influenced by Charles Rennie MACKINTOSH. She continued to work on book design, illustration, and binding throughout her career.

KING, PERRY (b. 1938)

English industrial designer. Trained at the Birmingham College of Art, King worked on various projects for OLIVETTI as an associate of Ettore SOTTSASS in Italy from 1965 to 1970. He developed, among other projects, the 1969 Olivetti Valentine portable typewriter. Working in Milan with Santiago Miranda, he has developed since 1977 office furniture for Olivetti, the Cable office system for Marcatré, and lighting designs for Flos and ARTELUCE.

KITSCH

Term used in design criticism to describe work of a deliberately tasteless, gross, and foolish sort. The Gillo DORFLES book of 1969, *Kitsch*, is the definitive study of the subject. It explains the obvious, popular attraction of objects and design elements that are silly, ugly, and insulting to both concepts of "high style" and serious theories of MODERNISM. Gift and novelty shops thrive on the commercial distribution of kitsch trinkets, while kitsch themes often appear in housing, furniture, and accessories intended for the mass market. Post-modern theory continues to struggle with POP or kitsch elements in an attempt to bring about an accommodation between popular taste and serious design theory.

KJAERHOLM, POUL (1929–1980)

Leading designer of DANISH MODERN furniture. Kjaerholm studied design in Copenhagen at the School of Arts and Crafts, where he was later a lecturer from 1952 until 1956. His elegant designs in metal, wood, marble, and plastic, combing geometric rigor with softer forms and materials suggestive of comfort, have been manufactured by the firms of E. Kold Christiensen, Ejnar Pedersen's P.P. Furniture, and Fritz Hansen. His simple steel-framed chair of 1956 won a grand prize at the Milan TRIENNALE of 1957, but his chaise of 1965, called the Hammond Chair, is probably his best-known work.

KLEE, PAUL (1879–1940)

Swiss painter of international fame who had an impact on design as a BAUHAUS teacher. Klee studied art at the Academy in Munich and exhibited as a member of the Blaue Reiter group there in 1911. From 1920 to 1931 he was a master at the Bauhaus, teaching weaving, stained glass, and painting as well as playing a major role in developing the theoretical preliminary course, which would now be called basic design. His 1925 book *Pedagogical Sketchbook* is a slim but basic work on art and design theory, available in a 1953 English translation. Klee's major reputation is based on his vast output of watercolors and oil paintings now viewed as among the most important examples of modern art. While his painting has tended to overshadow his role as a teacher of design, his contribution to Bauhaus philosophy, relating the psychological element in fine art to abstract art and design, is of major significance.

KLEIN, CALVIN (b. 1942)

American fashion designer, a graduate of the Fashion Institute of Technology in New York, who has built a major national and international "name" reputation. The Calvin Klein stylistic direction shows the influence of Yves SAINT LAURENT, but tends to have a more colorful, less subtle character. After five years as an apprentice designer with several large firms, Klein founded his own business in 1968 and has built a name for apparel design that is simple, functional, and classic, while at the same time

Evening wear, a "one-size-fits-all" design by Calvin Klein. Photo courtesy of Calvin Klein.

recognizable and stylish. His fame increased when, in 1980, Warren Hirsh joined the firm of Puritan and chose Klein as its star designer. Klein designer jeans quickly became an international fad, and his name continues to make anything associated with it, such as Obsession perfume, a commercial success. He won a Coty design award in each of five consecutive years beginning in 1973.

KLEPPER

German manufacturer of folding boats noted for their functional ingenuity, and elegant form. Klepper-Werke began as a tailoring shop in Bavaria headed by Johann Klepper who, in 1907, developed the first Klepper folding boat. Since 1919 the company has specialized in collapsible small boats for rowing, paddling, and

motor and sail propulsion, but it also produces clothing and tents for outdoor sporting uses.

KLINT, KAARE (1888–1954)

Danish furniture designer and architect who had, as both teacher and designer, a broad influence on the development of the type of modern furniture called "DANISH MODERN." Klint studied painting and architecture at the Copenhagen Academy. With his father P.V. Jensen Klint (1853–1930), Klint did extensive studies on human dimensions and developed storage furniture based on these studies. Beginning in 1924, he became a teacher of furniture design and craftsmanship at the Copenhagen Academy where he was also later a teacher of architecture. His teaching influenced a whole generation of Danish designers. His own work won many awards and appeared in a number of exhibitions. Klint's style was clearly modern, but retained a respect for traditional values in structure and craftsmanship. His folding deck chair and knock-down Safari chair, both of 1933 and both based on traditional models, are among his best-known works.

KNOLL, FLORENCE SCHUST (b. 1917)

American furniture and interior designer who was an important figure in the development of the firm of KNOLL INTERNATIONAL. She was trained at CRANBROOK ACADEMY with Eliel and Eero SAARINEN and studied architecture at the Architectural Association in London and at IL-LINOIS INSTITUTE OF TECHNOLOGY under Ludwig MIES VAN DER ROHE. She worked for both Marcel BREUER and Walter GROPIUS before joining Knoll in New York in 1943. There she became head of the Knoll Planning Unit, an interior design service offered as an aid to purchasers of Knoll furniture. The Planning Unit came to be an important design firm in its own right; it was often selected by many major architects because it offered interior design compatible with their work. Schust married Hans KNOLL, in 1946, and after his death in 1955, Florence Knoll became the chief designer and owner of the Knoll firm. Her relationship with former Cranbrook students and her ties with noted architects aided Knoll in becoming the manufacturer of many major furniture CLASSICs, including designs by Harry BERTOIA, Marcel Breuer, Ludwig Mies van der Rohe, and Eero Saarinen. Many of her own designs also became part of the Knoll product line. In 1959 Knoll came under new ownership, and in 1965, Florence Knoll retired, becoming known with a new marriage as Florence Knoll Basset.

KNOLL, HANS (1914–1955)

German-born founder of the American furniture company that became KNOLL INTERNATIONAL, a leader in production and distribution of modern furniture of high design quality. Knoll was born in Stuttgart, the son of a cabinetmaker. He was educated in Switzerland and in England, but relocated to the United States in 1937 where he established his own business, offering simple, modern furniture designed by, among others, Jens RISOM. After World War II, with the help of Florence Schust (who later became his wife), he built the business into a major institution in American design. Since his death, the firm has continued to grow with the introduction of many new product lines by a number of distinguished designers.

KNOLL INTERNATIONAL, INC.

Leading American and international manufacturer and distributor of MODERN furniture of top design quality. The firm was founded in 1937 by Hans KNOLL and, with the aid of Florence Schust KNOLL, grew to become one of the two or three best-known producers of quality modern furniture in the world. Knoll still manufactures the CLASSIC designs of Harry BERTOIA,

Knoll pedestal-base armchair, an Eero Saarinen design.
Photo courtesy of Knoll International, Inc.

Knoll Handkerchief stacking chairs designed by Massimo Vignelli. Photo courtesy of Knoll International, Inc.

Marcel BREUER, Ludwig MIES VAN DER ROHE, and Eero SAARINEN, but has added products by many others, including office systems by Bruce HANNAH, Andrew MORRISON, Bill STEPHENS, and Otto ZAPF, chairs by Charles POLLOCK and Lella and Massimo VIGNELLI; and various designs by Gae AULENTI. Recently, designs related to POST-MODERN and HIGH-TECH styles have been added, including some by Joseph Paul D'URSO, Richard MEIER, and Robert VENTURI. Knoll showroom design and the design of its catalogs, advertising, and graphics have always been of high quality since they are usually the work of distinguished designers such as Herbert MATTER. The firm provides an outstanding example of the application of the concept of CORPORATE IDENTITY established through a consistent design program.

KNORR, DONALD (b. 1922)

American architect and designer best known for designing a prize-winning chair in 1948. Knorr was trained as an architect at the University of Illinois and was a graduate student at CRANBROOK ACADEMY from 1947 to 1948, working briefly thereafter in the office of Eero and Eliel SAARINEN until he established his own practice in San Francisco in 1949. He won first prize in New York's MUSEUM OF MODERN ART International Competition for Low-Cost Furniture Design of 1948 with a design for a simple chair. Its seat and back were a springy loop of sheet metal supported on metal bar legs. The chair was put in production by KNOLL but was discontinued after a brief time. Knorr continues in practice as an architect.

KOCH, MOGENS (b. 1898)

Danish furniture designer who works in the DANISH MODERN tradition of simple craft-related wood forms. Koch studied architecture with Kaare KLINT at the Copenhagen Academy and later taught there. His foldable MK table and chair of 1933 are his best-known works, although he also developed a complete system of modular storage elements of simple and elegant design.

KODAK

Coined brand name for the cameras developed by George EASTMAN (1854-1932) that made photography a popular hobby activity through the use of his invention of roll film. With the slogan "You push the button, we do the rest," Eastman relieved the average camera user of the complexities of darkroom work and with the introduction of inexpensive box and folding cameras, "Kodak," quickly became a synonym for camera. On this basis the Eastman Kodak Company has become a major American and international corporation producing a vast variety of photographic and related and unrelated products. The design of Kodak products has varied from simple technology to the work of various industrial designers, including Walter Dorwin TEAGUE and, most recently,

No. 1A Pocket Kodak. Photo courtesy of Eastman Kodak Company.

Hans GUGELOT in Europe. Most Kodak design, however, is the work of anonymous in-house designers.

KOMAI, RAY (b. 1918)

American industrial and graphic designer whose best-known design is a simple chair with a seat and back formed with a single piece of molded plywood slit up the back. Trained at the ART CENTER COLLEGE in Los Angeles, Komai established his own office with Carter Winter in New York and developed a number of product and graphic designs for the J.G. Furniture Company in 1949. Komai has also designed textiles and wallpapers.

KOMENDA, ERWIN (1904–1966)

German automotive engineer responsible for the body design of a number of famous, CLASSIC cars. Komenda worked for Daimler-BENZ before joining Ferdinand PORSCHE in Stuttgart in the 1930s. He was the designer of the original VOLKSWAGEN Beetle, probably one of the most widely recognized automotive designs ever developed—however controversial. His design for the 1949 Porsche, a somewhat plump and bulging streamlined form, was developed through study of AERODYNAMICS rather than through aesthetic concerns. Komenda continued to develop Porsche body design through the model 911 of 1963. Many design critics would argue that Porsche design has not been of equal quality since that time.

KOPPEL, HENNING (1918-1981)

Danish designer of silver and glassware best known for his designs for Georg JENSEN. Koppel was trained as a sculptor in Copenhagen and Paris. His work included ORREFORS glass, jewelry, clocks, lighting and, for Georg Jensen, both hollowware and flatware in silver and stainless steel. He was the winner of three gold medals in Milan TRIENNALE exhibitions. His work was of strongly curvilinear, sculptural form in the best tradition of Scandinavian modern design.

KORHONEN, OTTO

See AALTO, ALVAR.

KOSTELLOW, ALEXANDER J. (1897–1954)

Iranian-born American design educator responsible for the development of two of the most successful programs in INDUSTRIAL DESIGN in American colleges. Kostellow was edu-

cated at the University of Berlin before coming to the United States to study art. He taught at the Kansas City Art Institute before moving to Pittsburgh, Pennsylvania, to become a design teacher at Carnegie Institute of Technology (now CARNEGIE-MELLON UNIVERSITY) in 1935 when a program in design was established there by Donald DOHNER and Peter MÜLLER-MUNK. In 1938, Dohner persuaded him to move to Brooklyn, New York, to head the "foundation program" at PRATT INSTITUTE. This was an introductory design year devoted to abstract concepts of form and color based on the teaching approach of the BAUHAUS. After Dohner's death in 1944, Kostellow became chairman of the entire industrial design program at Pratt and was highly successful in bringing the program there to a new level of success. The development of a Design Laboratory in cooperation with industry sponsors brought funding to the program and established links with industry that were favorable to the school and to the sponsors. GENERAL MOTORS, Monsanto Chemical, and Owens Corning were among the companies that maintained cooperative programs with Pratt under Kostellow. The teaching program at Pratt continues to carry forward many of the ideas and programs that Kostellow developed.

KOSTELLOW, ROWENA REED
See REED, ROWENA.

KRIZIA
Italian fashion design firm based in Milan whose designs often use printed cloth with a fruit theme suggesting a quality of fantasy. The firm was founded in 1954 by Mariucca Mandelli, its designer, with her husband, Aldo Pinto, as business manager. Mandelli began by making skirts with her friend Flora Dolci. As the firm began to grow, an exhibition was staged in 1957, with the Krizia name taken from a Plato dialogue. Karl LAGERFELD helped develop its varied style as a consultant to the firm for a time. The affiliated firm Kriziamaglia is a producer of knitwears using lively color and new techniques to produce designs having wide, international popularity that are often informal, witty, and even humorous.

KROLL, BORIS (b. 1913)
American textile designer and manufacturer known for a high level of design quality of decorative drapery and upholstery fabrics. Kroll established his own firm, Cromwell Designs, in 1938. It was succeeded by Boris Kroll in 1946, which is based in New York with showrooms in other major cities. Kroll has emphasized JACQUARD weaves and tapestries with a unique and subtle color sense.

KUKKAPURO, YRJO (b. 1933)
Finnish furniture designer who came to international notice with his Kasruselli 412 chair of 1965, a plastic armchair shell on a plastic base with steel connection that permits both rotation and rocking. Trained in industrial design at Helsinki, Kukkapuro established an independent design practice in 1959. His more recent Plaano office chair of 1978 is representative of the somewhat mechanistic aesthetic of recent Finnish furniture design.

KURAMATA, SHIRO (b. 1934)
Japanese designer of modern furniture, often with an eccentric twist, which relates his work to the MEMPHIS direction. Shiro Kuramata was trained in traditional craft woodworking and opened his own design firm in 1965. His best-known works are from the Fujiko group, Furniture in Irregular Forms (1970), which includes such oddities as tall chest of drawers bent into the shape of an S-curve.

KURT NAEF SPIELZEUG
Swiss manufacturer of unique playthings of outstanding quality and design. The typical Naef set is a box of geometric elements cut from hardwood with elegant precision. The forms of the blocks and their strong colors allow a great variety of construction. Each set contains special block forms, making its possibilities unique. Kurt Naef himself has been the designer for some sets, but other designers including Peer Clahsen and Jo Niemeyer have also designed for Naef. Niemeyer is the designer of the set named Modulon, a black cubical box containing 16 rectilinear blocks cut in the proportions of the GOLDEN SECTION and painted in black, white, and the three primary colors. Any arrangement or construction made with this set demonstrates the aesthetic properties of that system. Assembling a Naef set according to a particular plan and (often) repacking the blocks in their original arrangement can constitute something of a puzzle as well.

L

LA FARGE, JOHN (1835–1910)
American artist and designer of stained glass with strong stylistic connections to the Pre-Raphaelite direction of the ARTS AND CRAFTS and AESTHETIC MOVEMENTs in England. He studied and traveled in Europe before establishing his reputation as a mural painter and artist-designer of stained glass. His 1878 windows for H.H. Richardson's Trinity Church in Boston are a fine example of his work. He won a medal in the Paris Exhibition of 1889 for his stained glass designs, and continued to produce glass in a pictorial style, drawing on both Japanese and European artistic traditions.

LA GASSEY, HOMER C., JR. (b. 1924)
American automobile designer whose work at GENERAL MOTORS included the body design for the Buick Wildcat II of 1955. La Gassey was a 1947 graduate of PRATT INSTITUTE and also studied at Davidson College and Wayne State University. He served in the Air Force in World War II and developed an interest in military aircraft along with his fondness for racing cars and boats. In 1942 he began work at GM's STYLING section. Working under Harley EARL, the GM vice president for styling, he was part of the design group that moved post-war automotive design toward sculptural forms with exaggerated STREAMLINING, bulging curves, and sweeping lines of CHROMIUM. Leaving GM in 1955, La Gassey joined Chrysler and worked on 1957 Plymouth and Dodge designs under Vergil EXNER, introducing tail-fins to the designs of these otherwise basic, utilitarian cars. From 1960 until 1963 he maintained an independent design practice and then took up a post at Ford from 1963 until 1980. He is now a teacher of industrial design and chairman of the Transportation Section at the Center for Creative Studies in Detroit.

LAGERFELD, KARL (b. 1938)
German-born fashion designer who worked with several major Paris fashion houses before establishing his own firm with international distribution. Lagerfeld moved with his family from his native Hamburg to Paris, where while still a sixteen-year-old student he won a prize for a coat design in an International Wool Secretariat competition. The design was put in production by the house of Pierre BALMAIN who took on Lagerfeld as an employee. After three years, he became a free-lance designer working for Patou and KRIZIA before joining the firm of Chloë in the 1960s. He also designed furs for the Fendis, shoes for Valentino, and couture for CHANEL, where he became design director in 1983. In 1984 he finally launched a collection bearing his own label. Lagerfeld design is forceful, even extreme, and often incorporates elements of wit or fantasy as in the use of fabrics that may include printed or embroidered images of scissors, tools, or musical instruments. Lagerfeld was the winner of a 1980 Neiman-Marcus Award and a 1982 award of the Council of Fashion Designers of America. He maintains studios in Rome and New York in addition to his Paris base.

LALIQUE, RENÉ (1860–1945)
French craftsman-designer of jewelry and decorative glass whose long career extended through the eras of ART NOUVEAU and ART DECO with many honors and wide recognition in each phase of his work. He trained as a goldsmith and began independent work as a jeweler. His work before 1900 also included textiles, fans, and bookbindings. His work of Art Nouveau character was shown at the Paris Exhibition of 1900 and in many major exhibits thereafter. His practice broadened with designs for mirrors, decorative objects, lamps, and perfume bottles for the firm of Coty, and by 1908 he had moved toward more extensive production. In 1932 he was commissioned to design and make decorative panels and light fixtures for the French liner *NORMANDIE*. He continued to design and produce glass until the time of World War II.

LAMB, THOMAS B. (1897–1988)
American designer known for his specialization in the ERGONOMIC design of handles. Lamb studied at the Art Students League of New York and at New York University. For a time he was a cartoonist and writer of children's books before turning to textile and industrial design. In 1941 he began a study of the design of handles in relation to the physiology of the human hand, leading to a sculptured handle form that he patented and first exhibited in 1946. The MUSEUM OF MODERN ART in New York devoted an exhibit to Lamb handles in 1948.

The Wedge-Lock Handle, as Lamb's design is known, has been applied to a wide variety of tools and implements including cutlery, and surgical instruments. Lamb's handle clients have included Alcoa, Cutco (cutlery), Skil (tools), and Wearever (utensils). Lamb's special handle form is licensed to manufacturers on a royalty basis. Its effectiveness in improving grip and ease of manipulation make it an exceptional case of extensive success based on an extremely specialized design concentration.

LAMINATION
Any process in which many layers of a material are adhered together. Lamination is often used to make curved wooden parts that would be impractical to cut from a solid plank. Many sheets of veneer are spread with an adhesive, stacked together, and placed in a press where heat and pressure set the glue. The resulting sheets of laminated veneer are generally called PLYWOOD. If shaped molds are used in the press, lamination can be curved, resulting in MOLDED PLYWOOD (often misnamed "bent plywood"). Molded plywood has been used in many MODERN furniture designs, including those of Alvar AALTO and Charles EAMES.

Sheets of hard-surfacing material—paper with melamin PLASTIC resin used as a binder— are also made by lamination. Such "plastic laminate" (distributed under various trade names such as Formica and Micarta) has a very tough, impact, and stain-resistant surface and so is widely used for counter, table, and desk-top surfaces, for covering entire furniture pieces, and in other applications where a damage-resistant surface is required.

LANVIN, JEANNE (1867–1946)
French fashion designer, the founder of the oldest surviving Paris couture house, known for her youthful style for women of all ages. Jeanne Lanvin was apprentice-trained as a seamstress before she began her business career as a milliner in 1890 in Paris. She made some dresses for a sister and for her own daughter that were noticed by customers, who by 1909 were ordering her designs for themselves and their daughters. She usually worked with plain fabrics, adding stitching, quilting, and embroidery. Her work, always independent of changing styles, was consistent through the range from children's clothes to designs for adults. Wedding gowns and *robes de style* were her special achievement. With her nephew

Maurice Lanvin she opened a men's boutique in 1926 (the first couture men's shop) and added other lines—including perfumes—My Sin in 1925 and Arpège in 1927. She was a collector of modern art and drew on its influences in her design and use of color. She worked with a large staff of artists and designers directing their work through verbal instruction and criticism. After the death of Lanvin, design was taken over by a Spanish designer, Antonio del Castillo until 1963, and then by the Belgian Jules-François Crahay. The firm is now owned by Bernard Lanvin, the son of Jeanne's nephew, and his wife Maryll, who took charge of ready-to-wear design in 1980 and of all Lanvin design after the retirement of Crahay in 1984. Claude Montana is currently design director.

LAROCHE, GUY (b. 1923)
French fashion designer known for the development of a lively, informal style which led to a vast, successful, diversified line of products in every fashion field. Laroche became interested in fashion in Paris in the 1940s through a cousin who was working with designer Jean Patou. He then became an assistant to Jean Desses. From 1950 until 1955 he was a freelance designer in New York and then returned to Paris to introduce his own first collection in 1957. The Laroche label achieved a peak of fame in the 1960s. He has expanded into ready-to-wear lines and into licensing accessories, luggage, perfumes, rainwear, sportswear, and sunglasses. With his partner Giancarlo Giammetti, his empire has been built to a volume said to exceed $300 million annually.

LARSEN, JACK LENOR (b. 1927)
Leading American textile designer and weaver who is also an important figure in the contemporary craft movement, a trustee of the American Craft Council, and one of the founders (now a trustee) of the Haystack School of crafts on Deer Isle, Maine. Larsen was trained at the University of Washington in Seattle and at CRANBROOK ACADEMY. He opened his own studio in 1952. Larsen's firm is well known for the high quality of the textiles that it offers, many of Larsen's own design, and many by others whom he has selected and encouraged. The firm also offers a few other products related to interiors including furniture, floor coverings, and accessories. Larsen's work has been widely exhibited and has receive many awards, in-

Interplay, a Rovana knit casement fabric, designed by Jack Lenor Larsen. Photo courtesy of Jack Lenor Larsen.

cluding gold medals from the AMERICAN INSTI-TUTE OF ARCHITECTS and the 1964 Milan TRIENNALE. His books, *Beyond Craft: The Art Fabric* (with Mildred Constantine, 1973) and *Fabrics for Interiors* (with Jeanne Weeks, 1975), are standard works in their field.

LASZLO, PAUL (b. 1900)

Architect and interior designer best known for his work of the 1930s and 1940s in southern California. Laszlo was born in Budapest, Hungary, and studied in Vienna, Paris, and Berlin. He established an office in Vienna and then in 1927 moved to Stuttgart where he produced work that established a considerable reputation for him in Europe. In 1936 he relocated in Beverly Hills, California, and built up a practice there specializing in modern houses and interiors, often with Hollywood personalities as clients. Laszlo was a frequent designer of custom furniture, textiles, and lamps and designed a simple but luxurious upholstery and table group that was produced by HERMAN MILLER for a time in the late 1940s.

LATE MODERNISM

Term that has come into use in description and criticism of current architectural and design practice to designate work that continues to develop the ideas of MODERNISM, particularly the austere work of the INTERNATIONAL STYLE. While POST-MODERNISM tends to turn away from the ideas of the modern movement, introducing more decorative elements and often returning to HISTORICISM, the modernist direction survives and has also moved in the direction of greater complexity of form. The works of such architects as Charles GWATHMEY and Robert Siegel, Richard MEIER, and I. M. Pei with their strong loyalty to the modernist ethic, characterize the late-modernist direction.

LATHAM, RICHARD (b. 1920)

American industrial designer, a partner in the Chicago firm of LATHAM TYLER JENSEN, which has had many major corporations as clients. Latham worked for Raymond LOEWY from 1940 to 1955, becoming design chief in that firm's Chicago office. HALLICRAFTERS radios were among the products he developed for Loewy. He formed his own firm in 1955, and it has produced designs for BANG & OLUFSEN, ROSENTHAL, and Xerox, among many other corporate clients.

LATHAM TYLER JENSEN

American industrial design firm that formed in Chicago in 1955, and became a major American and international presence in the product design field. Richard LATHAM's background in the office of Raymond LOEWY, and Jacob JENSEN's experience in Denmark were combined with George Tyler's business skills. The firm was recognized for its design of housewares such as the kitchen utensils for the EKCO PRODUCTS COMPANY (1946) and glassware for the ROSENTHAL Studio-Linie. Latham now maintains an independent practice.

LATIMER, CLIVE (b. 1915)

English graphic and furniture designer. Trained at the Central School of Arts and Crafts

in London, where he later taught. Latimer began his design career in typography and graphic design. In the mid-1940s he turned to furniture design, working with the London firm of HEAL's. He came to notice in America when he won (jointly with Robin DAY) a first prize for storage furniture in New York's MUSEUM OF MODERN ART 1948 competition. The Festival of Britain in 1951 also brought examples of his chair design to public attention.

LAUREN, RALPH (b. 1939)

American fashion designer whose career has vastly expanded from the introduction of wide necktie designs to designing clothing for men, women, and children, as well as the environments they inhabit. Born in the Bronx, Lauren studied business at New York's City College at night while holding a wide variety of jobs in clothing stores, including Brooks Brothers, where he found an affinity for classic, sports-oriented clothing. There are overtones of belonging to upper-class circles in his relaxed styling and in his own life-style (he owns a 10,000-acre ranch in Colorado). In addition to clothing, his business now includes designs for fragrances, home furnishings, and luggage. The restored Rhinelander Mansion in New York serves as a flagship for his vast network of Polo/Ralph Lauren shops. He was the recipient of a 1970 Coty Men's Wear Award, the year before he began designing women's clothing.

LAVERNE, ERWINE (b. 1909)
AND ESTELLE (b. 1915)

American designers and distributors of products of modern design for interior use including textiles, wallpapers, and furniture. The Lavernes studied art with Hans Hofmann before forming their New York firm of Laverne Originals in 1938. A number of their designs were included in GOOD DESIGN exhibits at New York's MUSEUM OF MODERN ART in the 1950s. Their Marbalia wall coverings and their introduction of the furniture designs of William KATAVOLOS, Douglas Kelly, and Ross Littell attracted favorable attention. In 1957 they introduced a group of furniture molded in clear plastic that they designated "invisible" in recognition of its transparency.

LAX, MICHAEL (b. 1929)

American product, graphic, and exhibition designer best known for his design of a high-intensity miniature lamp. Lax was trained in

METAAL ™ Signature Bowl, a Michael Lax design produced by the Grainware Company of Chicago. Photo courtesy of Michael Lax Industrial Design.

ceramics design and technology at Alfred University before studying in Finland and Italy. Based in New York, his firm has worked on housewares and packaging for such companies as Copco, Corning Glass, Formica, and Salton. His miniature high-intensity lamp, designated Lytegem by its manufacturer, Lightolier, in 1965, is a simple spherical reflector placed above a cubic base. An extending arm permits the reflector to be swung in any desired position. Another design, the Modulon 10 air ionizer, is a simple black pyramid. Both were selected for inclusion in the design collection of the MUSEUM OF MODERN ART.

LEACH, BERNARD (1887–1979)

English master potter in the handcraft tradition, who reflected modernist directions in his works. Leach was born in Hong Kong and studied the traditional art and craftwork of China, Japan, and Korea, before moving to England in 1920. He established his own pottery at St. Ives in Cornwall where he produced individual works of high quality in terms of both craftsmanship and design. He eventually developed a range of basic designs that were handmade in considerable quantity and available for practical use. His shapes were generally simple and functional in a way that matched the developing taste of MODERNISM; his brush-painted decorations, where they occur, suggest a more self-conscious orientalism. His book, *A Potter's Book* (1940), is a standard text and manual in the field.

LE CORBUSIER (1887–1965)

Swiss-born French architect, designer, and painter, a leader in the development of MOD-

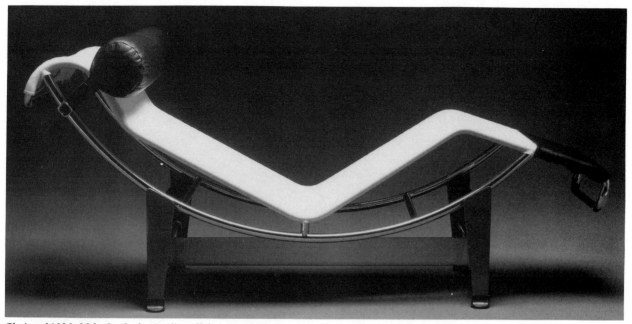

Chaise of 1928–29 by Le Corbusier (in collaboration with Charlotte Perriand). Photo courtesy of Atelier International, Ltd.

ERNISM and an important theorist and writer as well as practitioner. Le Corbusier is generally regarded as one of four leaders (the others are Walter GROPIUS, Ludwig MIES VAN DER ROHE, and Frank Lloyd WRIGHT) who, taken together, created the design and architectural direction now called MODERN. He was born in the Swiss town of La Chaux-de-Fonds and was named Charles-Édouard Jeanneret (he did not adopt his pseudonym until 1923 when he was settled in Paris). His earliest works as a self-taught architect are little-known houses (1906–12) near his birthplace built in a romantic, rural style with a hint of ART NOUVEAU influence. In 1908 he went to Paris to work for Auguste PERRET, the pioneer designer in REINFORCED CONCRETE. In 1910, he spent five months working in the office of the early German modernist Peter BEHRENS, meeting Walter Gropius and Mies Van der Rohe there and so establishing a link with these soon-to-be leaders in the development of the INTERNATIONAL STYLE. He returned to Switzerland in 1911 and, in 1916, designed his first major work, the Schwob house at La Chaux-de-Fonds. While retaining a somewhat classical flavor, this building, with its flat roofs and geometrically controlled aesthetic, hints at the directions his major work was to take. The house has recently been restored and widely published.

In 1917, Le Corbusier moved to Paris and, for a time, considered devoting himself to painting in a cubist-related style called Purism that he developed jointly with the painter Amédée OZENFANT. Together they founded the magazine *L'ESPRIT NOUVEAU*, which, in twenty-seven issues, served as a vehicle for publicizing their views on art and design. In 1922–23 he designed a Paris house and studio for Ozenfant, a striking example of the austere, abstract, mechanistically oriented direction that his work was to take. The house had smooth white walls and large window expanses and was topped by a saw-tooth skylight, a visually shocking element for residential design of the time. The design was based on a system of "regulating lines," geometric controls that relate proportions and forms to concepts that can be traced back to the ancient GOLDEN SECTION ratio. The house is still standing, and although somewhat altered, it remains an impressive early work.

In 1923, Le Corbusier published *Vers une architecture,* (the English translation appeared in 1927 as *Towards a New Architecture*), a collection of articles from *L'Esprit Nouveau* that turned out to be one of the most influential architectural books ever published. It sets forth the doctrine of modernism as a new design direction appropriate to the modern world of technology. Such phrases as "the house is a machine for living" have often been quoted as suggesting a "cult of the machine" as an aspect of modernism. In actuality, Le Corbusier makes a strong case for the merits of ancient, classical architecture and for a primary aesthetic orientation, at the same

1940 drawing of a living space interior by Le Corbusier.

time as he praises the engineering works of Gustave EIFFEL, Eugène FREYSSINET, and anonymous American engineers. He illustrates ocean liners, airplanes, and the engine of a BUGATTI automobile, along with details of the Parthenon and St. Peter's in Rome, finding parallels in their aesthetic merits.

Important architectural projects of the 1920s and 1930s include the Roche-Jeanneret house in Paris (1923), the Stein villa (Les Terrances) at Garches near Paris (1927), and the famous VILLA SAVOYE (Les Heures Claires) at Poissy (1929–31). The last is a white cubical box containing living spaces elevated to second floor level on tubular steel columns, with ramps for vertical circulation leading to living spaces on the roof, and a garage and services on the ground level.

Le Corbusier's competition entry for the Palace of the League of Nations (1927) was rejected, but the published drawings have become a major monument in the history of

dence, Cité de Refuge (1933), and a residence for Swiss students (1930–32), both in Paris, are larger buildings, indicating an approach to the design of high-rise structures. It was also in 1929 that Le Corbusier exhibited furniture, seating with steel frame structures supporting upholstered cushions, tables with simple standard restaurant pedestal bases and related storage, all designed in collaboration with his cousin Pierre Jeanneret (1896–1967) and Charlotte PERRIAND. In 1936 he went to Brazil to work with Oscar Niemeyer (b. 1907) on the Ministry of Education and Health building, which was completed in 1945 by a Brazilian group working with Niemeyer. All this work used the simple, cubistic architectonic forms, the smooth white walls, large glass areas, and somewhat mechanistic details that have come to be regarded as typical of International Style modernism.

After World War II, Le Corbusier's work changed in character: he abandoned the white

surfaces and more complex, sculptural forms. His theories of urban design led to the concepts of the UNITÉ D'HABITATION in Marseilles (1946–52) a high-rise surrounded by parklike open space, while the chapel at RONCHAMP (1950–55) extended the expressive, sculptural direction of his work. Other important projects included the Monastery of La TOURETTE near Lyons in France (1957–59) and, the only Le Corbusier building in the United States, the Carpenter Center for the Visual Arts at Harvard University in Cambridge, Massachusetts (1961–64). Le Corbusier was a leading figure among the thirteen architects selected to design the United Nations Headquarters in New York in 1946, but the project, although based on his design concepts, was badly distorted as finally built.

Beginning in 1950, Le Corbusier became involved in the planning of the new capital city of Chandigarh in Punjab, India. Much of the basic planning was his, as was the design of a number of major buildings, including the Secretariat, the Legislative Assembly, and High Court buildings. The work there was eventually taken over by Pierre Jeanneret and the English architects Maxwell FRY (b. 1899) and Jane Drew. As built, the city has been beset with problems, resulting from the mismatched realities of creating a modern metropolis and of the conditions in that region. Nevertheless, it remains a major demonstration of Le Corbusier's aesthetic.

The influence of Le Corbusier on all modern work in architecture and design can hardly be overstated. Controversial as his ideas have been and despite his frequent involvement in disputes with clients and various authorities (he was a difficult and irascible man), his work is widely admired, studied, and published. His theoretical writings, including the MODULOR system of proportion (published in two volumes in 1948–58), express his views, while his work as an artist would have made him a major figure. Many of his designs for furniture are manufactured in reproduction and widely used in modern interiors. He was a founding member of the Congrès International d'Architecture Moderne (CIAM) in 1928 and the recipient of many awards and honors, including the title of Chevalier of the Legion of Honor of France.

LEGO®
Plastic construction toy developed in Denmark that has outstanding design quality along with

LEGO® bricks, the basic unit of the LEGO® construction toy system. Photo courtesy of the LEGO® group. (LEGO® and the LEGO® logo are registered trademarks of INTERLEGO AG,© 1987 the LEGO® group).

very rich play possibilities. LEGO® is based on a modular plastic block studded on top with projecting disks that mate with a hollowed-out bottom so the blocks lock together. The system first appeared in 1947 and has gradually been expanded, with the addition of components in many shapes and sizes, all using the same connecting detail and all in modular sizes. In 1955 sets were introduced that make up particular toys (some very elaborate), but all using interchangeable components so that the toy can be used in a wide variety of ways as a child grows. The manufacturer, Lego System A/S of Billund, Denmark, does not give design credit to any individual, although the firm's founder, Godtfred Kirk Christiansen, appears to have developed the concept based on the children's wood blocks that the firm made previously. Many variations of LEGO® have appeared, including oversized DUPLO® blocks, and many imitations are now made. LEGO® is a truly educational toy in both technical and AESTHETIC terms.

LEGRAIN, PIERRE ÉMILE (1889–1929)

French designer of bookbindings and furniture whose work is associated with the ART DECO era, although it has an idiosyncratic character, often drawing on African primitive and modern cubist art as sources. Legrain studied drawing and applied art and then worked for the decorator Paul Iribe until 1914. Along with his designs for bookbindings, he worked on interiors and developed furniture, working in the 1920s for and with the fashion designer Jacques Doucet. His furniture used rich and exotic materials and forms that were often based on African tribal and Egyptian design themes. A grand piano made of glass drew wide attention. A display of his work in Paris in 1924 was designed by Pierre CHAREAU.

LEICA

Family of 35mm cameras considered design CLASSICs, which are produced by the German optical firm of Ernst LEITZ GmbH. of Wetzlar, West Germany. The concept of the miniature camera using standard motion picture film was developed around 1913 by Oskar BARNACK, a technician employed by Leitz. In 1924, a commercial version of the camera was put into production, and improved versions were introduced in quick succession, adding such refinements as range-finder focusing, interchangeable lenses, and a full range of fast

Leica M6 35mm camera, a recent model in the series of Leica miniature cameras. Photo courtesy of Leica, USA.

and slow shutter speeds. The design of the Leica, based on the technical vocabulary of quality optical instruments (such as the microscopes made by Leitz) and on close adherence to the functional demands of the camera, reached its high point with the models F and G of the 1930s. Acceptance by a number of famous photographers, such as Henri CARTIER-BRESSON and Walker EVANS, combined with awareness of the camera's technical excellence, made it extremely popular, and early models are now collected by a cult of admirers. Later models, including the post–World War II series M versions, have maintained Leica's high level of design excellence. Many similar cameras were developed to compete with the Leica (such as the Contax produced by ZEISS), but none reached the same level of popularity.

With the development of the miniature single-lens reflex camera, the popularity of the range-finder Leica type has been eclipsed. Although Leitz has introduced a series of reflex models under the Leica name, the design quality of the early Leicas and their high-level performance have kept many surviving examples in current use.

LEIGHTON, JOHN (1822–1912)

British graphic designer who published an important collection of ornamental designs in the book, *Suggestions in Design* (1880) and who also worked in stained glass. A co-founder and designer for the magazine *Graphic*, John Leighton was instrumental in drawing attention to Japanese design in the second half of the 19th century.

LEITZ, ERNST GMBH.

German optical and instrument-making firm internationally recognized for its production of

the LEICA camera, known for both its design and its performance quality. Founded in 1849 in Wetzlar, Germany, Leitz established a reputation in the 19th century for production of microscopes, lenses, and other optical instruments. Although the work of anonymous technical personnel, the design properties of Leitz instruments have always been very high. Leitz continues to make microscopes, laboratory instruments, and Leica and Leicaflex cameras that set high standards in their respective fields.

LESCAZE, WILLIAM (1896–1969)
American architect born in Switzerland, who is credited with introducing the INTERNATIONAL STYLE in America. Lescaze had studied with Karl MOSER before coming to the United States in 1920. His best-known work (in partnership with George HOWE) is the 1932 Philadelphia Savings Fund Society (PSFS) building, the first fully modern skyscraper anywhere, and one of the first examples of MODERNISM in American architecture. Lescaze seems to have been the leader in the design of the building (Howe's earlier work had been quite traditional), so a major share of the credit for its success is his. After the partnership with Howe ended in 1934, Lescaze continued to practice architecture in New York, designing a number of modern townhouses (including his own on 48th Street), the Williamsbridge housing project in New York, and various other works including radio stations, office buildings, and a pavilion for the 1939 New York WORLD'S FAIR. Lescaze also designed furniture, lighting, and many small accessory products—all by-products of his architectural work.

LETHABY, WILLIAM RICHARD (1857–1931)
English designer and architect who played an important role in the ARTS AND CRAFTS movement. Lethaby began his career working in several architectural offices, including that of Richard Norman Shaw. He was involved in founding the Art-Workers Guild in 1884 and the Arts and Crafts Exhibition Society in 1887. Lethaby worked with William MORRIS and Co. and from time to time with Ernest GIMSON and Philip WEBB, and he exhibited designs for furniture and other products in the Arts and Crafts tradition. He became a director and teacher at London Central School of Arts and Crafts, was a professor at the Royal College of Art until 1918, and participated in founding the DESIGN AND INDUSTRIES ASSOCIATION. He remained an active spokesman for excellence in design through writing and lectures up to the time of his death.

LEVI STRAUSS
American firm specializing in the production of utilitarian work pants, the famous "Levi's" that have become accepted as fashion items in modern times. The original Levi Strauss began his business in San Francisco during the 1850s' gold rush making tents for prospectors. Soon after, when the need for trousers outran the need for tents, the original Levi's, sturdy "jeans" intended for hard use, appeared to fill the demand. In 1873, metal rivets were introduced so the heavy cloth would resist tearing at points of maximum stress. In the 1960s, Levi's became a popular form of informal dress and acquired a status that made the brand name important in the world of fashionable apparel. The firm was honored with a 1971 Coty Special Award.

LIBERTY, (SIR) ARTHUR LASENBY (1843–1917)
English merchant whose support of ARTS AND CRAFTS, ART NOUVEAU, and other progressive design directions made his firm, Liberty's of London, a major force in the development of these design movements. Liberty opened his first shop in 1875, featuring silks and other Japanese imports. Many English designers associated with the AESTHETIC MOVEMENT designed for Liberty's, including Arthur Silver, the architect C. F. A. VOYSEY, and George Walton. The textiles known as "Liberty prints," generally colorful floral motifs in small scale, have carried the tradition of Liberty style into present times. The Liberty store remains a successful London establishment with a continuing reputation for supporting quality design.

LIEBES, DOROTHY (1899–1972)
Leading American designer of textiles, known for her typically modernist use of strong colors and unusual materials. Liebes's education was primarily academic, but in the 1930s she established a studio in San Francisco where she produced custom handweaves of simple design for designers and architects. In 1940 she became a designer for the production firm of Goodall Fabrics. As her reputation grew, she became a designer and consultant to a number of larger firms, including Sears Roebuck and DuPont.

For many years she was the only textile designer with national public recognition.

LINCOLN CONTINENTAL

Ford Motor Company luxury automobile of original and outstanding design, especially the models from 1939 to 1945. Henry FORD's son Edsel became interested in the design of expensive cars built in Europe and, after a 1938 trip abroad, asked Ford designers, including Eugene F. GREGORIE, to design a custom model for his own use. He labeled the resulting car *Continental*. It was characterized by simple, unornamented forms, restrained STREAMLINING, a long hood with simple radiator gille detailing, and a covered spare tire mounted at the back of the projecting trunk. The car was handsome and unique among American cars of the day. A decision was made to put the design into limited production. In 1941 a convertible version was added as an alternative to the closed original.

The design has come to be regarded as one of the most striking CLASSIC designs Detroit automobile firms have produced. It remains a "collectors' item," exerting a strong influence on later automotive design. The Continental name has been used for a number of later designs that have attempted to recapture the quality of the original design.

LINCOLN DIVISION
(OF FORD MOTOR COMPANY)

Division of Ford that produced cars using the Lincoln name. In this way Ford could launch a line of expensive luxury cars comparable to the Cadillacs and Chryslers of its competitors and at the same time minimize identification with the Ford reputation for economical, utilitarian vehicles. Lincolns were (and still are) big cars designed to appear costly and impressive. Lincoln design, however, was quite undistinguished except for the LINCOLN ZEPHYR and LINCOLN CONTINENTAL models, each in its own way interesting and outstanding in the history of automotive design. Although the Lincoln name survives, recent and current designs do not exhibit the design excellence of the earliest autos to carry that name.

LINCOLN ZEPHYR

Model designation given to the FORD Motor Company automobile intended as a luxury car, which was slightly less costly than the luxury Lincoln. The Lincoln Zephyr of 1936 with a V-12 engine, used lines somewhat related to those of the Ford V-8s of 1933 and thereafter, but the body was given strongly streamlined forms, suggestive of those of the earlier Chrysler AIRFLOW, but somewhat less radical and so less disturbing to the consumer public. The Zephyr is often viewed as the first American streamlined car to achieve even moderate public acceptance. Some of its forms and many of its mechanical elements were incorporated into the more elegant LINCOLN CONTINENTAL that appeared in 1939.

LINDGREN, ARMAS
See AALTO, ALVAR.

LIONNI, LEO (b. 1910)

American graphic designer and art director, born in Holland but educated in Italy. His early artistic interests related to the FUTURIST school of art, but in graphic design DE STIJL and BAUHAUS directions were more influential. His first graphic work was done in Milan for *DOMUS*

Lincoln Continental of 1948.

and *Casabella* magazines. In 1935 he relocated in the United States, becoming an art director for the N.W. Ayer advertising agency in Philadelphia. In 1947 he moved to New York to open his own office and to accept the simultaneous post of art director of *Fortune* magazine, an influential role that he played for fourteen years. At the same time he produced work for OLIVETTI, the CONTAINER CORPORATION OF AMERICA, and, occasionally, the MUSEUM OF MODERN ART in New York. He elected to retire in 1960 and since that time has worked in painting, designing, and producing children's books.

LIPPINCOTT & MARGULIES
Firm founded in New York in 1945 by J. Gordon Lippincott (b. 1909) and Walter Margulies (b. 1915) that became a leader in American INDUSTRIAL DESIGN and CORPORATE IDENTITY projects. The firm is known for its work for such major corporations as Chrysler, Eastern Airlines, Esso, Uniroyal, and Xerox.

The keystone of the communications strategy that Lippincott and Margulies devised for Eastern airlines, for example, was its use of Eastern's aircraft as moving billboards. The new look featured distinctive blue stripes running the length of the fuselage and bent upward to the tip of the tail. The same graphics were repeated at airport check-in counters, and ticket offices, and on aircraft interiors, ground support vehicles, hangars, ticket envelopes, stationery, and uniforms. The firm continues in active design practice.

LISSITZKY, EL (1890–1941)
Russian-born designer and artist associated with several MODERNIST movements including Supermatism and DE STIJL. Lissitzky studied at Darmstadt (with Josef OLBRICH) and was acquainted with Henri VAN DE VELDE before returning to Russia in 1915 where he was an active supporter of the Revolution. He became associated with the painter Kasimir MALEVICH and with Vladimir TATLIN in the modernism of the early Soviet regime. In 1924 he relocated in Switzerland but returned to Moscow in 1925 where he worked on various exhibition projects in a generally constructivist style. His influence in modern typography and graphic design is significant. After 1930, teaching became his primary activity. His 1930 chair of transparent PLASTIC is a striking early use of that material.

LITTELL, ROSS
See LAVERNE, ERWINE.

LITTLETON, HARVEY (b. 1922)
American designer-craftsman known as a potter, ceramics designer, and glassblower-artist. Littleton studied at CRANBROOK ACADEMY; in Brighton, England; and at the University of Michigan, where he received a degree in design. He taught ceramics at the Toledo Museum of Art (Toledo, Ohio) and at the University of Wisconsin and exhibited his own pottery and ceramic works widely. After 1962 Littleton turned to glassmaking, subsequently earning a major reputation for his work in that medium, which related concepts of modern design to a traditional craft. In 1977 he relocated his studio to Spruce Pine, North Carolina. His book *Glassblowing: A Search for Form* (1971) is a key work in its field.

LOBMEYR, LUDWIG (1829–1917)
Austrian designer and manufacturer of glassware of high quality and often outstandingly simple, MODERN design. Ludwig Lobmeyr was a son of Josef Lobmeyr (1792–1855), who founded the glassworks of that name in 1822. He was himself a designer and employed a number of other Viennese designers, including Adolf LOOS, in developing products of great elegance, many of which continue in production. Lobmeyr products by Oswald HAERDTL

Pentastar trademark and logo for the Chrysler Corporation, a Lippincott & Margulies design. Courtesy of Lippincott & Margulies, Inc.

and by his one-time employer Josèf HOFFMANN are included in the design collection of the MUSEUM OF MODERN ART in New York.

LOCKHEED AIRCRAFT CORPORATION

American firm founded in 1916 by Allan Lockheed (born Loughhead) in Burbank, California, to design and produce airplanes of advanced design. The single-engined, high-wing Lockheed Vega of 1927, designed by John K. Northrop, was one of the first truly streamlined airplanes, a monoplane without struts or wires. It was used by Amelia Earhart and Wiley Post in their pioneer flights and made Americans aware of the beauty possible in utilitarian forms. The Sirius of 1929 by the same designer was a low-winged design of similar styling, used by the Lindberghs in their early exploratory arctic flights. The Orion introduced retractable landing gear and may be considered one of the most elegant of pre–World War II aircraft designs. The first Electra, a twin-engined, all-metal transport of 1934, was also an outstanding design, but was overshadowed by the success of the larger Douglas DC-3. The postwar Lockheed Constellation and Super-Constellation carried forward the firm's reputation for outstanding design with the remarkably elegant forms of fuselage and the striking triple-rudder tail, destined, however to become obsolete with improving technology. Lockheed continues to produce military aircraft and the 1011 transport jet of distinguished design.

LOEWY, RAYMOND (1893–1986)

French-born American industrial designer, generally regarded as the originator and, for many years, the leading practitioner of that profession. Raymond Loewy studied electrical engineering in France before serving in World War I. In 1919 he relocated in New York where he worked briefly for Macy's department store as a window display designer. He then worked as a freelance fashion illustrator for *Harper's Bazaar* magazine and as a commercial artist, designing a trademark for Nieman-Marcus in 1923. In 1929, he was retained by the GESTETNER duplicating machine firm to rework the appearance of their product. The simplified MODERN shape he gave that previously complex, mechanistic object led to greatly increased sales and became a prototype for the typical industrial design assignment, the restyling (often STREAMLINING) of an object to increase its attractiveness to potential customers and users. In 1930 Loewy redesigned an automobile body for the Hupp Motor Company, leading to the streamlined 1934 Hupmobile. The Loewy firm grew rapidly as it acquired additional clients such as the Pennsylvania Railroad for the design of steam and electric locomotives (including the strikingly successful GG-1 electric) and passenger car exteriors and interiors, Sears Roebuck for a Coldspot electric refrigerator, buses for Greyhound, Coca-Cola for its well-known glass bottle, Lucky Strike for packaging, and many other products, packages, and CORPORATE IDENTITY programs. As the firm grew to have more than a hundred staff designers, partners William Snaith and A. Baker Barnhart took charge of design, while Loewy spent most of his time in semiretirement in France where he maintained a branch office. The Loewy name became well known to the American public (Loewy appeared on a *Time* magazine cover in 1947) and was often advertised to promote sales for products designed by the Loewry firm. Less-known work of the firm included interiors of department stores, ships, and even the Skylab spacecraft designed for the National Aeronautic and Space Administration (NASA).

Lockheed Constellation airplane. Photo courtesy of Lockheed-California Company, a division of Lockheed Corporation.

T-1 steam locomotive with exterior streamlined design by the office of Raymond Loewy. Photo courtesy of the Pennsylvania Railroad.

Work produced by the Loewy firm was of a generally high professional quality, frankly commercial in character, and so better liked by the consumer public than by critics and rival professionals. Loewy was a skillful salesman for his firm's services and made extensive use of publicity to further his fame. His book, *Never Leave Well Enough Alone* (1951), and Peter Mayer's *Industrial Design* (1978) together give a good account of the work of the firm, although they omit all mention of his partners and large staff and so give the impression that all Loewy office work was produced solely by the hand of Loewy himself.

LOGOTYPE

Term in typography and graphic design. Originally referring to a single block of type incorporating a whole word or name, logotype now designates a specially designed type which creates instant recognition for a particular product or company. A logotype was first used to ensure that a particular name, such as that of a firm, a product, or a brand, would always appear in the same style and typeface. In modern practice, a logotype is a unique form of a name or word such as a company name or TRADE-MARK. The "logo," as it is often called, plays an important role in CORPORATE IDENTITY programs, and in advertising and package design. Many famous logotypes, such as those of CBS,

Exxon, or IBM, are almost universally familiar. A logotype may be used as a trademark, but trademarks that are abstract or pictorial (not including any lettering or name) are not usually referred to as logotypes.

LOIS, GEORGE (b. 1931)

American graphic designer and art director known for the development of advertisements with an iconoclastic, mischievous, even shocking character. George Lois was educated at PRATT INSTITUTE in Brooklyn and worked as an art director for several agencies before becoming the first art director to form in 1960, with

Logotype designed by Pentagram for the New York radio and television station WNYC. Courtesy of Pentagram Design Services Inc.

two partners, his own agency, Papert Koenig Lois. His work uses the aesthetic of typically modern TYPOGRAPHY and graphic layout in combination with images and text that can be humorous or disturbing, but that have strong impact in both advertisement and magazine covers, such as those he designed for *Esquire*. Since 1967, Lois has been a partner in other agencies where he has continued to develop his personal style in both advertising design and concept.

LOOS, ADOLF (1870–1933)

Austrian designer and architect who played an important role in the development of MODERN-ISM as a result of both his own works and his published writings. Loos studied in Dresden and was in America from 1893 until 1896, returning to Vienna in 1896 to take up architectural practice. He worked for a time for Otto WAGNER, but although the SECESSION movement was at its peak, Loos was not a part of it, rather he took a more personal design direction that moved away from the decorative themes of the Secession, although his work was by no means free of decorative details. He designed a number of houses and shops in Vienna, including the tiny Kärntner Bar of 1908; the Goldman & Salatsch shop of 1910, which had strongly neo- classic elements; and the austere, geometric Steiner house of the same year. His fame is particularly based on his theoretical writings, such as his essay of 1908, "Ornament und Verbrechen" ("Ornament and Crime"), in which he attacks all decoration in a way that seems at odds with his own work. His entry in the Chicago Tribune Building competition of 1922, a Doric Greek column of skyscraper proportions, continues to excite interest, puzzlement, and amusement. Loos was the designer of some THONET furniture and of various products, including LOBMEYR glasses, which are still in production.

LUBALIN, HERB (1918–1982)

American graphic designer and typographer known for his distinctive use of TYPOGRAPHY in ways that are both disciplined and adventur-

Logotype designed by Herb Lubalin (with Alan Peckolick) in 1967 for **Mother and Child**, *a proposed magazine.*

ous. Lubalin was a 1939 graduate of COOPER UNION and then an art director for the advertising firm of Sudler & Hennessey until 1964 when he established his own firm (later to become Lubalin Peckolick Associates). As a magazine designer he established formats for *Avant Garde, Eros, Fact,* and an updated *Saturday Evening Post.* Beginning in 1973, he (along with Aaron BURNS) produced a tabloid magazine, *U&lc* (which stands for upper and lower case), an influential publication devoted to modern typography.

LUBETKIN, BERTHOLD

See MARS.

LÜBKE KG

German furniture manufacturer established in 1921 that currently produces MODERN furniture of high design quality in wood, aluminum, and steel. Among Lübke products that have attracted notice are the component seating units designed by Ernst Moeckl (1962) and the plastic chairs of Konrad Schafer (1969).

LUCE, JEAN (1895–1964)

French designer of ceramics and glass whose best-known work is of ART DECO style. Luce worked for his father's ceramics shop in Paris until he opened his own shop in 1923. His earlier work used decorative detail in transparent enamels on glass and, after 1924 sandblasted ornament. Form for both glass and ceramics was basically simple, with geometric and stylized floral decoration. Luce designed china and glass for the ocean liner *NORMANDIE* and was a juror for several Paris exhibitions of decorative art.

LURÇAT, ANDRÉ (1894–1970)

French architect known for his early MODERN-ISM of the 1920s. Lurçat studied at the École des BEAUX-ARTS in Paris, but turned to work of a simple, geometric sort associated with the ART DECO style. His best-known work is a school at Villejuif, Paris, of 1933, a thoughtfully planned building embracing the INTERNATIONAL STYLE vocabulary of its time. Lurçat was one of the founders of the Congrès International d'Architecture Moderne (CIAM) in 1928. His book *Architecture* (1929) summarizes his point of view. Lurçat was one of many architects who found it necessary to design furniture appropriate for his buildings, including tubular steel furniture manufactured by THONET.

LURÇAT, JEAN (1892–1966)

French artist and designer best known for designing tapestries as a medium for modern art. Lurçat began his career as a painter in Paris in the 1920s and in 1933 designed his first Aubusson tapestry for the Gobelin factory. In the 1940s he was close to the painters André Derain and Raoul Dufy; a 1942 exhibit in New York was a joint effort with Dufy. After World War II, he became a spokesman for the development of modern tapestry, and his 1950 book, *Designing Tapestry,* added to his reputation. His designs feature birds, animals, trees, stars, and related natural elements in colorful and decorative combinations. From time to time he also designed jewelry, ceramics, mosaics, and illustrated books.

LUSS, GERALD

See DESIGNS FOR BUSINESS.

LUSTIG, ALVIN (1915-1955)

American designer best-known for his innovative work in graphic design. Lustig was trained at the ART CENTER SCHOOL in Los Angeles. He studied for a short time with Frank Lloyd WRIGHT before giving up an interest in architecture in favor of industrial and graphic design. He opened his own office in 1936. In 1945–46 he became design director for *Look* magazine (designing their offices in addition to his graphic responsibilities). In 1951 he moved to New York to open an office there, concentrating on book and magazine design. His book jackets for New Directions Books, record jackets for the Haydn Society, and magazine design for *Art Digest* and INDUSTRIAL DESIGN using invented forms, hand lettering, type, and photographic images made a major contribution to the development of MODERN graphic practice.

LUTYENS, (SIR) EDWIN LANDSEER (1869–1944)

Leading English architect of the early 20th century. He gained professional training through work in the office of George & Peto in London from 1887 until 1889, when he set up his own practice. He soon began to produce designs for large country houses, usually in garden settings developed by the landscape architect Gertrude Jekyll. His work had a strongly traditional flavor, usually suggesting medieval precedents without being specifically imitative. As his success and fame increased, he turned increasingly to classical precedents and,

after 1912, became the key figure in the design of the new formal and monumental Indian capitol at New Delhi. Although he never established any connections with the growing direction of MODERNISM, his generally traditional work is recognized for its quality and frequent originality within its own limited vocabulary.

LUXO LAMP

Adjustable cantilevered arm lighting unit, using a double pantograph structure with springs arranged to provide tension so as to keep the lamp tilted as desired. The design has been traced to a 1937 patent issued to an English maker of springs, Herbert Terry & Sons of Reditch. The Terry lamp was manufactured in England under the trade name Anglepoise. Rights to the Anglepoise patent were bought by a Norwegian, Jac Jacobson, who began manufacture under the Luxo name. After World War II, production of an American Luxo began at Port Chester, New York. With the gradual introduction of varied arm lengths, types of shades, alternative bases, and various color finishes, the Luxo became a full line of lamps. The great convenience of the Luxo's easy adjustability, its FUNCTIONAL appearance, and its low price have made it tremendously popular. Many copies have been introduced, with production in many countries worldwide. The Luxo is a favorite drafting table or desk light among architects, engineers, designers, and artists and has taken on the status of a design CLASSIC. It is one of the products selected for

Recent table model of the Luxo lamp. Photo courtesy of Luxo Lamp Corporation.

inclusion in Jay DOBLIN's 1970 book, *One Hundred Great Product Designs*.

MacDonald, Frances (1874–1921)

Artist and designer, born in England, but trained at the GLASGOW SCHOOL OF ART where (with her sister Margaret MACDONALD) she met Charles Rennie MACKINTOSH. In 1894 she established a studio with her sister where their work included stained glass, metal work, embroidery, and illustration. Her work was shown at the ARTS AND CRAFTS exhibition of 1896, at Vienna in 1900, and Turin in 1902. After her marriage in 1899, she relocated to Liverpool where she was a teacher of arts and crafts at the university. Her work was strongly influenced by Mackintosh—her style closely similar to his. After 1907 she returned to Glasgow where she became a teacher of various crafts.

MacDonald, Margaret (1865–1933)

British-born artist-designer who worked closely with her sister Frances MACDONALD from 1894 until her marriage to Charles Rennie MACKINTOSH in 1900. MacDonald was educated at the GLASGOW SCHOOL OF ART, which is where she met Mackintosh. Her own work in watercolor painting and book illustration, as well as her work in textile design in collaboration with Mackintosh, is the primary basis of her reputation. After she and Mackintosh relocated to London in 1916, her work as a painter sustained them as his career tapered off in his later years.

Machine Art

Term used in art history and criticism to describe the relationship that developed in the 1920s and 1930s linking many MODERN artists with the increasing role of industrial machinery in production and its influence on products and environment. The concept of the house as a "machine for living" was expressed by LE CORBUSIER, while artists such as Marcel Duchamp incorporated machine-made elements into their work. With the inclination of MODERNISM to turn away from ornament, the actual forms of machines and mechanical parts came to be seen as having AESTHETIC value in their own right. In 1934, the MUSEUM OF MODERN ART in New York mounted an exhibit entitled *Machine Art* in which such objects as springs, ball bearings, and boat propellers were exhibited as art along with such designed objects with strongly mechanistic character as plumbing components, tools, instruments, and utensils and such designed items with machinelike qualities as clocks and furniture. The Modern movement has had a continuing relationship with the machine in its effort to find an expressive quality suited to the technological nature of modern life. The catalog of the *Machine Art* exhibit and the book, *The Machine Age in America 1918–1941*, published in connection with a Brooklyn Museum exhibit dealing with this subject, are excellent reviews of the impact of mechanics on design and art.

Mackintosh, Charles Rennie (1868–1928)

Scottish architect and designer whose unique style proved to be an important influence in the development of MODERNISM. After Mackintosh had some training at the GLASGOW SCHOOL OF ART, he became an apprentice in a Glasgow architectural firm in 1889. His early work involved a number of houses and apartments and, most visible in their day, several Glasgow tearooms for a Miss Cranston where his furniture, stained glass, and other decorative elements created an original unity with strong connections to the ART NOUVEAU work being produced in Belgium and France. In this work and the exhibition spaces designed for a Vienna SECESSION exhibit of 1900, Mackintosh worked in close collaboration with his wife, Margaret MACDONALD, her sister, Frances MACDONALD, and the less-known Herbert MacNair, making up a group that came to be known as "The Four."

Mackintosh won a competition to select an architect for a new building for the Glasgow School of Art. The building (completed 1909) is the major masterpiece on which his reputation is based. The work combines qualities of ARTS AND CRAFTS orientation with decorative elements that suggest a restrained awareness of Art Nouveau in a way that is unique and highly

Chair by Charles Rennie Mackintosh, designed for the director's office at the Glasgow School of Art.
Photo courtesy of Atelier International, Ltd.

personal. The building was not liked in Glasgow, where the public found it too unusual, and Mackintosh was unable to find architectural assignments after this triumph. After relocating to London in 1916, he executed a few small projects while continuing to design textiles and various smaller decorative objects.

After his death in comparative obscurity, his work was rediscovered in the 1930s as a significant precursor of modernism. It is now admired and studied, and many of his designs (including some furniture) are again in production. The 1953 biography and study of Mackintosh's work, *Charles Rennie Mackintosh and the Modern Movement*, by Thomas Howarth is the definitive study of his career.

MACKMURDO, ARTHUR HEYGATE (1851–1942)

English designer with close connections to the ARTS AND CRAFTS movement. Mackmurdo was born in London and began training as an architect there. He studied with John Ruskin at Oxford and traveled with him to Italy. He came into contact with William MORRIS in 1877 and in 1882 formed the Century Guild, an organization for the production of art-related craft design. His title page for his 1883 book, *Wren's City Churches*, is his most-often reproduced work, its strangely inappropriate curving floral patterns suggesting ART NOUVEAU awareness

rather than the classicism of Wren. As a transition figure bridging the shift from Arts and Crafts to Art Nouveau, Mackmurdo designed interiors, furniture, wallpapers, and metalwork while continuing some architectural practice. The Savoy Hotel in London of 1889 is his design in partnership with Herbert Horne. The magazine *Hobby Horse* was a vehicle for his ideas and designs beginning in 1884. After 1904 he withdrew from active design practice and devoted his energies to political and social causes.

MAGASIN DU NORD

Major department store in Copenhagen, Denmark, known for its excellent selection and display of well-designed products, particularly examples of the work of distinguished modern Danish designers.

MAGISTRETTI, VICO (b. 1920)

Italian architect, planner, and designer most widely known for his work in furniture design. Magistretti was born in Milan and trained as an architect at the Polytechnic there, graduating in 1945. His architectural work includes the Torre del Parco office building in Milan (1956), with its oddly overhanging top portion, and a training center for OLIVETTI in Barcelona (1970). In industrial and furniture design, he is known for the 1967 Eclisse lamp, a COMPASSO D'ORO winner; the Attollo lamp of 1977 for O-Luce, an elegant half-sphere seemingly balanced on a column with a pointed top; and the 1973 Maralunga chair, another Compasso d'Oro winner in 1979. The simple, wood-framed, rush-bottom chair Modello 115 designed for CASSINA in 1964 with its strongly traditional flavor, is probably his most popular work. The Sinbad chair of 1982 also for Cassina is said to have been derived from a horse blanket draped over a conventional chair. He continues to design for Cassina and ARTEMIDE and travels to London to teach at the Royal College of Art.

MAGNUSSEN, ERIK (b. 1940)

Danish designer of ceramics, glass, flatware, and furniture. Magnussen was trained in ceramics at the Copenhagen School of Arts and Crafts, graduating in 1960. Since 1962 he has worked on design of ceramics for Bing and Grøndahl and, after 1978, for Georg JENSEN as well. His designs are of near MINIMALIST simplicity and show great care for functional qualities. The 1967 Thermo coffee pitcher for A/S

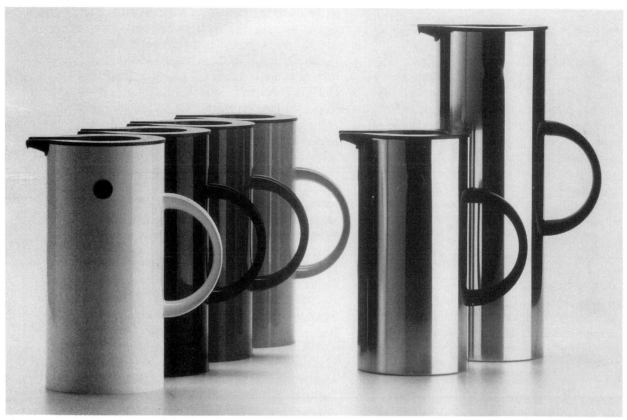

Thermo pitchers designed by Erik Magnussen for Stelton of Denmark. Photo courtesy of Stelton U.S.A.

Stelton with its self-closing top is a fine example of his design approach.

MAILLART, ROBERT (1872–1940)

Swiss structural engineer whose work in reinforced concrete structures, particularly bridges, has made him one of the very few engineers to become internationally famous for the AESTHETIC qualities of his work. Robert Maillart was trained at the Zurich Technical College and worked for several established engineering firms before setting up his own practice in 1902. He became a specialist in the design of concrete bridges, designing more than forty of increasingly elegant MODERNIST form. The most famous of his works, all in Switzerland, are the Val Tschiel Bridge near Donath of 1952; the spectacularly beautiful Salginatobel Bridge with a 295-foot-span, three-hinged arch near Schiers of 1929–1930; the curving Schwandbach Bridge of 1933; the bridge over the Thur near Felsegg of the same year; and the Arve Bridge at Vessy (Geneva) of 1936. Many of Maillart's bridges are in obscure places where local authorities were willing to accept his dramatically simple designs. Maillart also designed various other structures, including a 1910 warehouse in Zurich where a flat slab is supported by elegantly formed mushroom-top columns, and a 1939 exhibition pavilion also in Zurich which has a simple parabolic concrete arch 40 feet high but only 2¼ inches thick. Maillart's work has been exhibited at the MUSEUM OF MODERN ART in New York and is documented in a 1949 book, *Robert Maillart*, by Max Bill.

MAJORELLE, LOUIS (1859–1926)

French furniture manufacturer and designer whose factory at Nancy was a major producer of ART NOUVEAU and ART DECO furniture. His work until 1936 made him a major figure in the Art Nouveau-oriented School of Nancy. His designs reproduced the flowing curved lines typical of the Art Nouveau style in finely crafted wood, often with inlays and metal trim. Later Majorelle took up production of the Art Deco style, though with less success, since his interpretation of forms tended to be heavy and clumsy.

MALDONADO, TOMAS (b. 1922)

Argentine designer, design theorist, and teacher closely identified with the HOCHSCHULE

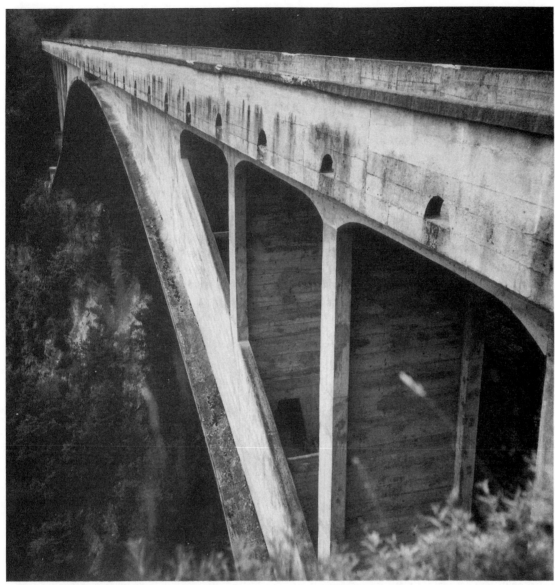

Salginatobel Bridge near Schiers, Switzerland, a design of Robert Maillart. Photo by John Pile.

FÜR GESTALTUNG at Ulm. Maldonado was educated at the Beaux-Arts in Buenos Aires and in 1951 became the editor of a design magazine *Nueva Vision*. He was invited to the school at Ulm by Max BILL in 1954 and, until 1966, was a key figure in developing the program of rigidly logical thinking that dominated the teaching at Ulm. His own work includes medical and technical instruments in the puristic, simple style typical of the school at Ulm, as well as some interior design projects. He now teaches design at the University of Bologna while living in Milan.

MALEVICH, KASIMIR (1878–1935)
Russian painter whose later work, often abstract studies in three-dimensional form, di-

rectly influenced the development of CONSTRUCTIVISM and the DE STIJL movement which became basic to the teaching of the BAUHAUS and the INTERNATIONAL STYLE in architecture. Malevich studied art in Moscow, and his early work paralleled that of the Cubists of 1910–13. His work quickly moved modern art into the realm of total abstraction with the development of his concept of Suprematism. Malevich used purely abstract forms, a black square on a simple white square background, for example, in *Basic Suprematist Element* of 1913 or the famous *White on White* of c. 1918 now owned by the MUSEUM OF MODERN ART in New York. Malevich's importance to design arises from his understanding of the ways in which the

geometric forms of architecture and industrial products relate to art. MINIMALIST concepts in design owe a continuing debt to Malevich's art.

MALLET-STEVENS, ROBERT (1886–1945)

French designer of furniture and architectural interiors, an important figure in the development of MODERNISM of the 1920s and 1930s. Mallet-Stevens was a student of the École Speciale d'Architecture from 1905 to 1910 and an admirer of the work of such pioneers as Charles Rennie MACKINTOSH and Josef HOFFMANN. Beginning in 1912, he produced furniture and interiors in an early modern style, his work gradually moving toward the modernism of the DE STIJL movement with similarities to the early work of LE CORBUSIER. He designed pavilions for the Paris exhibitions of 1929 and 1937. Mallet-Stevens was a frequent contributor to journals dealing with modern design and authored a book on modern stained glass. Although he opposed ornament in his writings, his own design tends toward a somewhat decorative version of the more mechanistic style of his time. A simple, metal-framed dining chair of his design has been returned to production by ÉCART INTERNATIONAL and has had considerable popular acceptance.

MALMSTEN, CARL (1888–1972)

Swedish furniture designer who favored craft-based design with a strongly traditional Nordic flavor. He may be considered a "father of Swedish Modern," although his work now seems somewhat dated. His reputation is largely based on the furniture he designed for the 1916–23 Stockholm City Hall, a famous work of Ragnar Östberg in a romantic, highly ornamented version of Scandinavian modernism. Malmsten was an influential teacher and critic of craft design who strongly opposed mechanistic modern directions. Malmsten operated his own production shops and for a time a retail store in Stockholm. He was the founder of three schools of hand craft in Sweden and encouraged a national network of such schools. The conservative simplicity of his design made his work popular.

MALOOF, SAM (b. 1916)

American woodworker and craftsman-designer who was a significant figure in the crafts revival of the 1950s and 1960s. Sam Maloof began his career as a graphic designer, but in 1949 turned to handmade furniture produced in his California shop. His work uses forms that have simple traditional and functional origins, but the elegantly refined carved forms that he develops give each object a strongly artistic quality. His rocking chairs are particularly admired; one (c. 1960) was included in the WHITNEY MUSEUM *High Styles* exhibition of 1986.

MANGIAROTTI, ANGELO (b. 1921)

Italian industrial designer. Born in Milan, Mangiarotti was educated at the Polytechnic Institute there, graduating in 1948. He taught at the INSTITUTE OF DESIGN in Chicago from 1953 to 1954 and briefly ran his own office in Ohio before returning to Italy in 1955, where he became an active figure in the highly experimental direction of Italian work developing at the time. His furniture designs (often with Bruno Morassutti as collaborator) for CASSINA, Fratelli Frigerio, and KNOLL include a number of storage and shelving systems, chairs, and a dining table supported on movable corner storage units. An ingenious storage system using plastic connectors to assemble standard panels designed for Poltronova was included in New York's MUSEUM OF MODERN ART exhibit *The New Italian Landscape*. Other distinguished designs by Mangiarotti include ceramics for Danese, silver for Cleto Munari, and simple but sculptural modern clocks for the Swiss firm Secticon (1962).

MANNERISM

Art historical term usually applied to the transitional period when the classicism of the High Renaissance began to move toward the freer

Lesbo table lamp designed by Angelo Mangiarotti.
Photo by Aldo Ballo, courtesy of Artemide Inc.

vocabulary of the Baroque era. Mannerism implies freedom, flexibility, and modification of an academic norm according to individualistic and personal inclinations. The term has taken on contemporary significance as applied to the effort to bend, modify, and escape from the austerities of MODERNIST design into the developing territory of POST-MODERNISM. It is fashionable, and perhaps appropriate, to call Post-Modernism a mannerist development.

MARGULIES, WALTER
See LIPPINCOTT & MARGULIES.

MARIMEKKO
Finnish firm whose name is identified with a range of apparel, accessories, and household items offered in a chain of stores that moved from a textile shop in Helsinki to international prominence. Before Armi RATIA founded Marimekko, she was employed as a designer for the Finnish firm of Printex. For Marimekko, she developed her own designs and those of other Finnish textile designers into a line of printed fabric full of strong forms and brilliant colors suggesting the traditional peasant design of the Finnish region of Karalia but interpreted in a way that was distinctively modern. The American DESIGN RESEARCH shops were strong supporters of Marimekko design, along with Finnish furniture and other products. Since the demise of that firm, Marimekko design has continued to be available in the United States through the firm's own shops.

MARKELIUS, SVEN (1889–1972)
Swedish architect who pioneered in introducing the vocabulary of MODERNISM through the INTERNATIONAL STYLE into Sweden. Markelius was trained at the Stockholm Technical College and Academy of Fine Arts. The concert hall at Halsingborg of 1932 was his first major work. His simple and elegantly modern Swedish Pavilion at the New York WORLD'S FAIR in 1939 brought him international notice. He was Stockholm's city architect and planner from 1944 to 1954 and was the primary planner of the satellite town of Vallingby near Stockholm, a much-admired example of advanced concepts in town planning. Markelius also often combined work in architecture with interior design. He was a member of the team that developed the design for the United Nations Headquarters building in New York; the interior of one of the council chambers there is a fine example

of his work. Markelius's work combines the ideas of International Style modernism with a certain humane quality that is characteristic of the best of Scandinavian design.

MARS
Modern Architectural Research Group founded as the English branch of CIAM (Congrès International d'Architecture Moderne) in 1932 under the leadership of Wells COATES. Members included such pioneer British modernists as Maxwell FRY, Amyas Connell, Basil Ward, Colin Lucas, and Berthold Lubetkin, the design leader of the firm Tecton. MARS served for a time as a useful focus for the modernist cause in English architecture, organizing a major exhibition of modern work in London in 1938 and exerting a positive influence in post–World War II rebuilding efforts. MARS disbanded in the 1950s.

MASS PRODUCTION
Widely used term that describes the modern method of industrial production in which a large number of identical items are manufactured through mechanized techniques. "Serial production" is a similar term, also referring to manufacturing based on the concept of the assembly line, where the object is moved (often by mechanized conveyors) past the work stations of individuals who perform particular repetitive tasks. The concept is based on the RATIONALIZATION OF PRODUCTION in which the steps of the manufacturing process are carefully analyzed and equipment is provided (often specially designed) so that each step can be accomplished with a minimum of handwork. Avoidance of the delays and constant changes of task typical of craftwork increases efficiency and permits a maximum of mechanization that makes the manufacturing process as near automatic as possible.

Modern designers and architects in the quest for a style suitable to the modern, technological world have been strongly influenced by the concept of mass production and have often endeavored to design in ways that are maximally suitable to the assembly line—sometimes designing objects (and most commonly buildings) that, while actually made by traditional craft techniques, have visual qualities that suggest mass production.

The early enthusiasm for assembly-line production has been somewhat dimmed in recent years by recognition of the unfortunate conse-

quences of monotonous, repetitive work for the individual worker which also often leads to a decline in quality as worker pride in skill is replaced by the demand for speed as the only significant work criterion. Recent efforts to organize work teams with greater responsibility for a total product and its quality have been introduced in some factories, including the classic assembly-line plant, the automobile factory. At the same time, automation in which human workers are entirely replaced by automatic machinery ("robots") make possible mass production free of human costs. Computer control of automated production also makes possible the efficient manufacture of varied products on a single assembly line reducing the emphasis on monotonous uniformity of product, ironically one of the consequences of mass production efficiency.

MATHSSON, KARL BRUNO (1907–1988)

Swedish furniture designer, a leading figure in the development of Scandinavian MODERN design. Karl Mathsson was trained by his father as a cabinetmaker but came to notice in the 1930s with the elegant chair and ottoman of laminated wood, originally named Pernilla, whose seating surfaces are straps of canvas webbing or leather. Since then Mathsson has designed various tables (including one whose top is shaped in the super-ellipse developed by Piet HEIN), a storage system, and chairs with metal frames such as the Jetson and Karin designs of the 1960s. Since 1966, Mathsson's 1930s chair designs have been in production by Dux Mobel, CLASSICS of Swedish modernism.

MATRIX (CHART)

Means of displaying the relationship between each item in a list and every other item in the same list, which can be developed as an aid in displaying data and evaluating proposals in almost any design area. A familiar type of matrix chart is the mileage chart often used on road maps to give distances between cities. In design, lists of PARAMETERS may be drawn up and the relationship of each item assigned a value indicating the level of its interrelationship with each other item in the list. For example, a scale may be developed giving levels of interrelationship:

5 very closely related
4 closely related
3 some relationship

2 very little relationship
1 no relationship

If there are five items or parameters under study designated with letters from, for example, A to E, a resulting matrix chart might display relationships as follows:

	A	B	C	D	E
E	4	2	0	3	
D	0	2	5		
C	3	1			
B	2				
A					

The triangular shape results from the fact that there is no need to duplicate values displayed.

While such a chart is hardly necessary to organize such a small number of values, where many (even hundreds) of items are involved, the matrix chart can be a useful design tool. For example, the matrix chart has come into use in office planning to show the level of interaction between individuals (or groups) in a complex organization and thus to aid planners in placing work stations. This technique has been an important step in open office (BÜROLAND-SCHAFT) planning and finds similar uses in architectural and urban planning. Along with a chart displaying levels of interaction between units, another set of numbers can be developed

Matrix chart displaying relationships between various units in an office complex as used in office landscape (Bürolandschaft) planning. Courtesy of Quickborner Team.

to indicate the actual level of proximity in a proposed layout. For example:

5 adjacent
4 very close
3 close
2 distant
1 very distant

By multiplying the value for the level of interaction with the figure for the level of proximity for each intersection of the matrix, a series of coefficients is developed, which, when added together, gives a figure of merit for a particular plan layout. The method is useful when comparing different plan proposals. This technique can aid planning of such complex projects as airports or hospital facilities.

MATTA, ROBERTO SEBASTIAN (b. 1911)

Chilean-born French artist, a surrealist and abstract expressionist, who also had architectural training and moved to Paris to work for LE CORBUSIER in the 1930s. Matta's importance in the design world is based on a single project, the Malitte seating system of 1966. It consists of five blocks of polyurethane foam covered with fabric that fit together to form a square; separated, they become a seating group that can be rearranged in a variety of ways. The system is produced in Italy by Gavina and distributed in the United States by KNOLL.

MATTER, HERBERT (1907–1984)

Swiss graphic designer and photographer. After studying at the École des BEAUX-ARTS in Paris and with Amédée OZENFANT and Fernand Léger, Matter designed travel posters and other graphic materials in Switzerland, often incorporating photography, before relocating in the United States in 1936. In 1939 he became a teacher of photography at Yale and also established his own photo and design studio. He became the graphic designer for KNOLL in 1946, producing many brochures, advertisements, and the classic Knoll logotype. His Herald logotype for the now-defunct New Haven Railroad was part of a CORPORATE IDENTITY program developed by Matter in the mid-1950s in cooperation with Florence KNOLL.

MAUGHAM, SYRIE (1879–1955)

Noted British interior designer and decorator (for a time the wife of the writer Somerset Maugham) who developed an individual style in the 1930s using pale, monochromatic colors, eventually moving toward all (or nearly all) white schemes. Her firm, Syrie, Ltd., established in the 1920s, began by producing work of the traditional ECLECTIC character typical of decorators' work of the time. As her style developed, Maugham often chose glass, mirror, and silvered frames with otherwise largely white finishes. While her white rooms often included furniture and details of traditional design character, these elements were often finished in white to reflect her particularly personal way of working.

MAXWELL, VERA (b. 1903)

American fashion designer whose work of the 1930s and 1940s was a significant part of the simple, practical direction in fashion that gave American design its special character. Maxwell was self-educated through reading, travel, study of ballet and, briefly in London, of tailoring. After working for several clothing manufacturers, she established the firm of Vera Maxwell Originals in 1947. Her designs were typically practical separates in tweeds, loden cloth, wool jersey, and raw silk. The "speed dress" with a top of stretch nylon and knit skirt, without fastenings, was her innovation. Her colors are generally subtle, neutrals with soft oranges, olive, and dull blues. The use of a coat lining matching the dress worn beneath is a special feature of her work. Maxwell was the winner of a 1951 Coty American Fashion Critics' Special Award and a 1955 Neiman-Marcus Award. In 1970, the Smithsonian in Washington, D.C., devoted a retrospective show to her work. She closed her business in 1985 but has since worked on a commissioned line for Peter Lynne.

MAYBECK, BERNARD (1862–1957)

American architect whose work in California is a significant factor in the development of a distinctive West Coast style. Born in New York, Maybeck was apprenticed to a cabinetmaker and worked briefly in his father's furniture-making shop before going to Paris to study at the École des BEAUX-ARTS. He returned to New York in 1886 and worked for the firm of Carrère & Hastings. After working briefly in Kansas City, Maybeck moved to Berkeley, California, in 1889. He worked in several firms there and taught drawing and architecture at the University of California at Berkeley before establishing his own practice in 1903. He designed

several buildings on the university campus as well as many houses, demonstrating his special use of wood as a building material. His 1910 Christian Science Church in Berkeley is a fine example of his unique style: wood and reinforced concrete are used together in a way that contains some hint of Japanese and other vernacular historic styles. His Palace of the Fine Arts for the Panama-Pacific exposition of 1912 (in part still standing) is a more ECLECTIC, romantic design, but still demonstrates Maybeck's individualistic and personal approach to architecture.

MAZZA, SERGIO
See ARTEMIDE.

MCCARDELL, CLAIRE (1905–1958)
American fashion designer whose simple and straight-forward approach made her work admired throughout the many design fields that normally view fashion as a world apart. McCardell studied fashion illustration at PARSONS SCHOOL OF DESIGN in New York and in Paris. She took a job with Robert Turk in 1929 and then, with him, joined Townley Frocks in 1931, taking over his role as designer after his death in 1932. Her first major success came in 1938 with her design of a simple, flowing robe dress named The Monastic. From 1938 to 1940 she worked with Hattie Carnegie to produce the Workshop Originals line, simple and practical designs that made her a functionalist of the fashion world. Returning to Townley in 1940, she developed the practical direction given the name "American Look." Her materials were calicos, denim, jersey, and ticking in simple forms, often with rivets and hooks, lacing, and similar practical details. Her Popover dress, a simple wrap-around, became a lasting CLASSIC. McCardell received many honors and awards, including the Coty Award in 1944, a Neiman-Marcus Award in 1948, and a Parsons Medal in 1956, the year her book, *What Shall I Wear?*, was published. Her ability to combine unpretentious practicality with a sense of style made her contribution to fashion design unique.

MCCOBB, PAUL (1917–1969)
American furniture designer whose low-priced department store furniture line probably brought MODERNISM in interior design to a larger segment of the American public than any other individual in the 1950s. McCobb had studied painting and worked as a display designer before establishing his own design practice in 1945. He worked closely with B.G. Mesberg (who had extensive experience in furniture sales) to develop a line of household furniture suitable for production in the New England factories which had previously produced Colonial Maple reproductions. The resulting Planner Group furniture of 1950 used traditional birch and maple and simple construction in an undecorated, modular fashion in a way that was ideally suited to the medium-to-low-priced department store market of the time. Other lines followed, including upholstered seating and room-divider storage.

MCFADDEN, MARY (b. 1936)
American fashion designer known for elegant designs that combine a simplicity of cut with the use of silks and other luxurious and colorful materials, often worn with large-scale, forceful jewelry. McFadden studied at the Sorbonne in Paris and at the Traphagen School in New York before turning to the field of sociology. After her marriage, she moved to South Africa, where she began work on the local edition of *Vogue* magazine. Subsequent residence in Rhodesia brought her into contact with African art and craft. In 1970 McFadden returned to New York and an editorial post at *Vogue*. She designed tunics to show off rare silks in that magazine that attracted the interest of Bendel's New York store buyers. This eventually led her to launch her own firm in 1976. Her design is thoughtful and methodical with a strong connection to the world of art. Her floating forms use rich materials along with modern technology and historic and artistic references. Her work now includes designs for eyeglasses, scarves, upholstery fabrics, and wallpapers. McFadden has won such awards as a 1976 Coty American Fashion Critics' Winnie, a 1979 Neiman-Marcus Award, and an election to the Coty Hall of Fame in 1979.

MCLUHAN, MARSHALL (1911–1981)
Canadian professor of English at McGill University who developed theories about the role of electronic media in mass popular culture. His books, including *The Mechanical Bride* (1951), *Understanding Media* (1964), and *The Medium Is the Message* (1967), argue the thesis that print is an outmoded medium, too "linear" in its approach to reality, while television and other visual media override time and distance instantaneously, making the world a "global

Paul McCobb's most successful furniture designs, the Planner Group of 1950. Photo courtesy of Paul McCobb.

village." The advertising and broadcasting industries took up McLuhan's ideas with great enthusiasm since they provided recognition and respect in a way not previously offered to these fields. McLuhan's name and his ideas were widely discussed in the 1960s and 1970s and exerted considerable influence in design fields where understanding present and future developments is always important. McLuhan's work is now little read and discussed, although its basic message still has validity.

MECCANO

British construction toy developed by Frank Hornby and patented by him in 1901. Like its American counterpart, ERECTOR, developed by A.C. Gilbert, Meccano contains perforated metal strips, nuts and bolts for assembly, and a variety of wheels, pulleys, and other accessory parts that make it possible to assemble any one of a great variety of mechanical toys and models. Sets of parts can be added to a basic batch to make more and more complex projects. Hornby also produced toy trains under his own

name and used the Meccano name for the line of Dinky Toy models of automobiles and other vehicles. Meccano has been elaborated on and developed over the years, including electric motors and other complex mechanical parts. It remains one of the finest of construction toys, encouraging creativity and imaginative design as part of play.

MEIER, RICHARD (b. 1934)

American architect and furniture designer who is a leading figure in the Late Modern design. Meier graduated from Cornell University in 1957 and worked for SKIDMORE, OWINGS & MERRILL and Marcel BREUER before opening his own office in 1963. He has designed many private houses, the Bronx Development Center in New York (1970–1976), the Atheneum and a group of other buildings at New Harmony, Indiana (1975–1979), the Getty Museum in Los Angeles (not yet completed), and a variety of other projects of varied types. He has taught at COOPER UNION, Yale, and Harvard, has lectured widely, has been included in various exhibitions, and

has been written about nationally and abroad. His work has a strongly geometric, abstract quality that often recalls the early work of LE CORBUSIER in a way that is sometimes called a "1920s revival." His furniture design for KNOLL consists of an armchair originally developed for the GUGGENHEIM MUSEUM library, related tables, and a chaise longue of wood construction and strongly geometric form, possibly suggesting the influence of the Vienna SECESSION designer Josef HOFFMANN.

MEIER-GRAEFE, JULIUS (1867–1935)

Hungarian-born writer and critic who was influential in encouraging and publicizing the ART NOUVEAU movement in the late 19th and early 20th centuries. Meier-Graefe was trained in engineering at Munich and Zurich and, in 1890, settled in Berlin. In 1893 he traveled in England and there met William MORRIS and other leaders of the ARTS AND CRAFTS movement. In 1895 Meier-Graefe moved to Paris and met Samuel BING. The two worked together founding the Art Nouveau movement. In 1897 he founded the magazine *Dekorative Kunst* (published from 1897 until 1929 in Munich), which publicized Art Nouveau work in Germany. In 1899 he opened a shop, La Maison Moderne, in Paris featuring the best modern design of the time. The shop exhibited at the 1902 Turin Exhibition, but closed in 1903. After 1905, Meier-Graefe became somewhat disillusioned with the ideas of Art Nouveau and turned his attention to art criticism and history. In 1934 he left Germany to escape Nazism and, in the last year of his life, applied for French citizenship.

MELLOR, DAVID (b. 1930)

British industrial designer, known for his designs of cutlery and for his kitchen shops offering household equipment of high design quality. Mellor started his career with a studio shop in Sheffield in 1954. He won a Design Council award for his 1957 Pride table service. His 1973 Provençal service, of simple but hearty form, uses handles of wood or plastic riveted to metal in a way that strongly suggests the tradition vernacular. His shops in London and Manchester have become showcases for housewares of good design for everyday use. Mellor's role in the Design Council and as a trustee of the VICTORIA AND ALBERT MUSEUM has made him an important spokesman for design issues.

MEMPHIS

Group of designers of furniture and household accessories who formed a loose relationship in 1981 in Milan under the leadership of Ettore SOTTSASS. Memphis was an outgrowth of the earlier STUDIO ALCHYMIA and shared its radical intention to break away from the formalism of the INTERNATIONAL STYLE as it had developed in Italy in the 1950–70 period. Sottsass encouraged the rebelliousness of younger designers and provided his own rebellious designs to create a display of furniture and other objects that were generally odd, erratic, illogical, avant garde and antiestablishment in their references to POP ART and popular culture. Bright colors and harsh, fantastic forms with a touch of KITSCH "bad taste" characterize Memphis designs produced by Andrea BRANZI, Aldo Cibic, Marco ZANUSO, and Sottsass himself. The Milan firm of ARTEMIDE showed an interest in Memphis design and provided a Milan showroom to give Memphis a highly visible focal point. Perhaps by coincidence, the introduction of Memphis seemed related to the upsurge of interest in POST-MODERNISM in architecture and in the related fields of interior and furniture design. While dismissed by many designers and critics as a fad, Memphis style has caught some aspect of public taste with its playful and mischievous departures from the order and logic of earlier MODERNISM. Barbara Radice's 1984 book, *Memphis*, is a useful survey of the group's work.

MENDELSOHN, ERICH (1887–1953)

German-born architect associated with the development of MODERNISM through the unique "expressionist" character of some of his earlier work. Mendelsohn was trained at the Technical High School in Munich and was then active in theater design while coming in contact with artists of the expressionist Blaue Reiter group. After service in World War I, he opened an office in Berlin in 1919 and began work on a research laboratory for studies relating to Einstein's theory of relativity. This led to his most famous work, the Einstein Tower at Potsdam, completed in 1924. It is an astronomical tower and observatory built in a flowing, sculptural form (intended for concrete construction but actually executed in brick and steel) which is viewed by critics as expressionistic. Commissions that followed, for houses and industrial and commercial buildings, led to designs that were generally more reserved and related to an

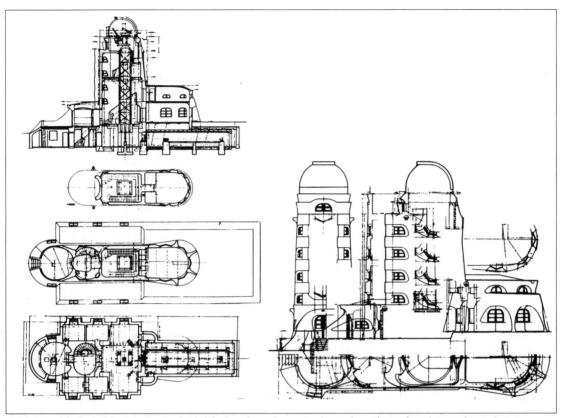

Erich Mendelsohn's Einstein Tower (1921) in Potsdam, Germany, in section, plans, elevations and top view.

INTERNATIONAL STYLE vocabulary, but often with semi- or quarter-circular elements with curved glass as corner accents. Mendelsohn's department store buildings for the firm of Schoken in Stuttgart and Chemnitz, Germany, are the best-known works of this period (1926–29), while his own house at Rupenhorn (Berlin) of 1930 is a fine example of his residential work in typically international style terms. Mendelsohn visited the United States in 1924, studied the skyscraper architecture of the day, and had a meeting with Frank Lloyd WRIGHT, which led to a continuing relationship. The atonal music of Arnold Schoenberg was also an ongoing source of stimulation.

In 1933 Mendelsohn left Germany for England where he established a partnership with Serge CHERMAYEFF. Together they designed the De La Ware Pavilion at Bexhill (1934–35). In 1939 Mendelsohn left for Palestine where he had a number of commissions, but in 1941 he relocated in the United States, becoming a citizen in 1946. He was active as a lecturer and teacher and then designed the Maimonides Hospital (1946–50) in San Francisco, a building of straightforward MODERN character. A number of residential and institutional projects followed, with his last major work the Mount Zion Community Center in St. Paul, Minnesota, of 1950–54.

In spite of his extensive achievements, Erich Mendelsohn has usually been viewed as a secondary figure, somewhat outside the main life of modernist development. A recent resurgence of interest in his work has led to exhibition of his striking sketches, with their strongly expressionist qualities, and fresh interest in his unique style. Bruno Zevi's 1985 book, *Erich Mendelsohn*, is an excellent, compact summary of Mendelsohn's achievements.

MENDL, LADY
See DE WOLFE, ELSIE.

MERCEDES-BENZ
Major German automobile brand produced by Daimler-Benz AG, which is also a truck, locomotive, and heavy machinery manufacturer known for its support of conservative design and high quality standards. Karl BENZ, one of the developers of the internal combustion engine, completed an early automobile in 1885. The rival firm, founded by Gottfried Daimler (1834–1900), named its 1902 model after the

daughter of a dealer-backer, Mercedes Jellinek. In 1927 the two firms combined to produce the Mercedes-Benz model S, an elegant open car with a design based on racing car precedents. Mercedes-Benz designs moved toward conservative, luxury models better known for engineering merit than for body STYLING until, in the post–World War II era, such adventurous designs as the 1954 300SL appeared, a design of Karl Wilfert known as "Gullwing" for its top-hinged, upward-opening side doors. Beginning in 1958, Bruno SACCO became a director of design for Daimler-Benz, and he was responsible for the reserved but elegant forms of the 1961 model 220SE and the 1963 230SL roadster. More recent Mercedes design has returned to a conservative image that emphasizes the role of the car as an affluent status symbol.

MERCER, HENRY CHAPMAN (1856–1930)
American ceramicist known for his popular tiles and for the remarkable home and museum he built in Bucks County, Pennsylvania. Mercer began his career as an archeologist at the University Museum in Philadelphia where he developed an interest in traditional Pennsylvania Dutch pottery. He founded the Moravian Tile Works in Doylestown, Pennsylvania, in 1898 to produce his own designs, both original and based on various historical examples. Beginning in 1910, he undertook the building of his estate using reinforced concrete to create structures of highly original, often eccentric character. Mercer tiles were used as decorative elements in many buildings of the early 20th century in the United States, including Grauman's Chinese Theater in Hollywood, California; the State Capitol in Harrisburg, Pennsylvania; and the library of Bryn Mawr College near Philadelphia. Mercer's estate is maintained as a museum, and his tile works is still operated as a museum activity.

MEYER, HANNES (1889–1954)
Swiss-born German architect known for his role at the BAUHAUS where he followed Walter GROPIUS as director from 1928 to 1930. Meyer was trained at the technical college at Basle and in Berlin. He began teaching at the Bauhaus in 1927 and also submitted an admired but unsuccessful entry to the Palace of the League of Nations competition held that year. After resigning from the Bauhaus, he worked in the USSR from 1930–36 and in Mexico from 1939–49 where he was director of an institute for town planning. While at the Bauhaus, Meyer was the editor of eight issues of *Bauhaus* magazine published in 1928–29. The 1965 book by Claude Schnaidt, *Hannes Meyer: Buildings, Projects and Writings*, is a comprehensive survey of his work.

MIES VAN DER ROHE, LUDWIG (1886–1969)
German MODERN architect and designer regarded as one of the great masters of INTERNATIONAL STYLE design. Mies van der Rohe (often referred to in the design professions simply as "Mies") is usually grouped with LE CORBUSIER, Walter GROPIUS, and Frank Lloyd WRIGHT as one of four great "form givers" who reshaped architecture in the 20th century. His training began with his father, a master stone mason, and continued in a trade school in his birthplace, Aachen, where he worked as an apprentice on building projects. He then worked for a time as a draftsman before moving to Berlin, in 1905, where he went to work for the furniture designer Bruno PAUL. In 1907, he undertook his first architectural project, a house whose design attracted the attention of Peter BEHRENS, then the leading modern architect of Germany. Mies worked for Behrens from 1909 to 1912, meeting there fellow employees Gropius and Charles Jeanneret (Le Corbusier, as he was later

Brno chair, a 1930 design of Ludwig Mies van der Rohe. Photo courtesy of Knoll International, Inc.

Crown Hall, the design and architecture department building of Illinois Institute of Technology, designed by Ludwig Mies van der Rohe. Photo by John Pile.

known). In 1912 he established his own office and began to design projects in a simplified classical style. Among them was a large house for the Kroller family intended to be built at The Hague, Holland. A full-size model in wood and canvas was built on the proposed site, but the building was never actually constructed.

After World War I, Mies began to make studies for skyscraper buildings with steel framing and glass exterior walls. Famous in the form of drawings and models, these projects were never built, but predicted post–World War II high-rise building design. His executed work included housing and private houses and, most important, the WEISSENHOF exhibition at Stuttgart where his model apartment house was built along with examples of the work of a number of other leading European MODERNIST architects in a demonstration cluster planned by Mies. In 1929, he was the designer of the German Pavilion at an International Exhibition in Barcelona, Spain. This very famous BARCELONA PAVILION used a simple slab roof supported on eight slim steel columns to define a space which was then divided by freely positioned slab screen walls of glass and marble that had no supporting function and thus avoided the creation of closed rooms. Although destroyed after the fair, this building became

world famous and vastly influential in the development of modernism. It has now been accurately reconstructed on its original site.

In the 1930 large private home Mies built for the Tugendhat family at Brno, Czechoslovakia, he applied the concepts of the Barcelona Pavilion to a house with glass walls that were retractable to make the living areas entirely open when desired. Special furniture designed for the Pavilion and for the TUGENDHAT HOUSE has become CLASSIC, establishing Mies's role as one of the major furniture designers of the era. His BARCELONA CHAIR has taken on the status of a thematic symbol of modernism in a way that the designer probably never anticipated. It remains currently in production and in wide use.

From 1930 to 1933, Mies taught at and was director of the BAUHAUS at Dessau and then in Berlin until its closing under Nazi governmental pressure. In 1937 Mies visited the United States and in 1938 relocated in Chicago, becoming director of the architectural department at Armour Institute, which was renamed ILLINOIS INSTITUTE OF TECHNOLOGY (IIT) in 1940. While holding his post there, Mies developed designs for a new campus and designed most of the major buildings there (1938–58). For example, Crown Hall is an exercise in the concept of "universal space," a totally open interior en-

closed by glass walls with a roof supported by steel girders that are visible from outside as they rise above the roof. Other buildings at IIT use brick for solid wall areas along with glass window walls—all with exposed steel structures painted black. Mies's often-quoted phrase "less is more" sums up his MINIMALIST intentions in the IIT buildings and all of his later work.

The Lakeshore Drive Apartments in Chicago (1948–51) finally demonstrate Mies's intention for skyscraper buildings with glass walls held by ribbons of black-painted steel. The simple, boxlike forms of these towers gain their AESTHETIC qualities from the careful study of proportion and detail that sets them apart from the often banal work of lesser architects who attempted to follow Mies's seemingly easy formulas. The small FARNSWORTH HOUSE at Plano, Illinois (1945–50), applies a similarly minimal approach to a house—it is a glass-walled box with floor and ceiling supported by eight external, white-painted steel H-columns. The interior space is one open area modulated by a small enclosure for baths and utilities.

In the 1950s and 1960s, Mies received many major commissions, including housing and office buildings in a number of cities, among them Chicago, Detroit, Montreal, Mexico City, Newark, New York, and Toronto. The Seagram Building in New York (1954–58, designed in collaboration with Philip JOHNSON) departs from Mies's usual practice in its use of dark bronze for the exposed metal grid holding bronze-tinted glass. It is regarded as a major masterpiece of Mies's style and of modern skyscraper architecture.

A number of projects for museums and exhibition halls remain unbuilt, but the 1962–68 New National Gallery in West Berlin, with its massive steel roof structure supported on eight slim columns, is another fine example of Mies's "universal space" created through minimal means of great elegance.

Since his death, the architecture of Mies van der Rohe, having reached a high point of influence, has been the subject of considerable controversy in architectural circles, both creative and critical. The construction of innumerable buildings more or less imitative of his style has led to rising complaint that such minimalist buildings are monotonous and inhuman. Recent directions such as that of POST-MODERNISM are distinctly hostile to the ideas and work of Mies van der Rohe, while admiration continues strong among others, particularly those who carry forward International Style ideas in recent work that is called LATE MODERN.

The work of Mies van der Rohe has been extensively exhibited and widely published, producing a virtual library of books about his work. He was the recipient of many awards and honors, including the Gold Medal of the AMERICAN INSTITUTE OF ARCHITECTS in 1960. Franz Schulze's 1985 book, *Mies van der Rohe: A Critical Biography*, is an excellent summary of Mies's career.

MILAN TRIENNALE
See TRIENNALE.

MILLER, HERMAN
See HERMAN MILLER, INC.

MILLER, HOWARD
See HOWARD MILLER CLOCK COMPANY.

MINIMALISM
Art historical and critical term used to describe the movements in art and design that strive for simplification and reduction of complexity. Ideally, minimal design uses only the simple forms of cubes and spheres, plain, unornamented surfaces, and solid colors. The famous statements of Adolf LOOS ("ornament is a crime") and Ludwig MIES VAN DER ROHE ("less is more") have become slogans for the minimalist direction in design. This is closely paralleled by minimalism in the fine arts where paintings of undifferentiated solid color and sculpture of simple geometric shape have had major acceptance. In architecture and in INDUSTRIAL DESIGN the minimalist direction has led to designs of austere simplicity, often of great elegance and dignity. The work associated with the HOCHSCHULE FÜR GESTALTUNG at Ulm, including the products of the German firm of BRAUN, is closely tied to the concepts of minimalism.

MINOX
Trade name for the sub-miniature camera developed by the firm of the same name founded in 1945 to produce the design of Walter Zapp. The Minox camera pushes the ideas of the miniature LEICA a step further by using 16mm film in a miniature cartridge. The resulting camera, no larger than the proverbial pack of chewing gum, is capable of photographs of high quality, although its tiny format has never had general acceptance in professional photography. The

Minox sub-miniature camera.

Minox has, inevitably, been characterized as a "spy camera" because of its easy concealment and has, no doubt, seen service in that role. The simple and elegant design of the Minox makes it a CLASSIC example of modern, technological, and instrument design.

MISSION STYLE

Popular term for furniture of the late 19th and early 20th centuries that drew its inspiration from the ARTS AND CRAFTS movement in England. In America, Gustav STICKLEY became the leader of the CRAFTSMAN movement and produced a full range of furniture of simple design with strongly emphasized craft details. Because of its resemblance, actual or fancied, to the furniture of the California missions, the term "mission" became a common descriptive designation for the work of Stickley and his followers and imitators. Because of the frequent use of oak as a primary material and the typical light brown finish applied to this wood, the furniture is also often called "golden oak." That term refers to the style as well as describes the actual finish.

MITCHELL, WILLIAM (BILL) (1912–1988)

American industrial designer, who was the member of the STYLING staff at GENERAL MOTORS (GM) identified with the extremes of 1960s design. Mitchell was the chief of GM styling from 1958 to 1978, the period when tailfins became a dominant motif. He supervised the design, among other cars, of the Corvette Sting Ray, the Buick Riviera, and the Cadillac Eldorado. While Harley EARL had been key in establishing the consumer-oriented direction of GM automotive style, Mitchell carried this direction forward into such products as the Cadillac 60 special of 1956, in its own way a CLASSIC of American automotive excess.

MOBILIA

Danish design magazine devoted to furniture and related household products. Founded in 1955, *Mobilia* has become an important forum for the presentation of MODERN design, most often Danish but also, from time to time, international. The magazine is partly bilingual.

MOCK-UP

Term for a rough model, usually full-size, built to check sizes, dimensional clearances, and basic layout of a design during development. A mock-up of a production product is usually built of plywood or other inexpensive materials in the exact forms and dimensions under consideration. It aids in evaluation of proposed forms with a minimum of investment and is usually produced before a PROTOTYPE, a more expensive preliminary made with actual materials and fully operational mechanics.

MODERN

Twentieth-century style characterized by simplicity of form, absence of decorative ornament, and emphasis on functional concerns. The word "modern" has the literal meanings of "recent" or "current" and therefore came into use in discussion and criticism of art and design

to describe developments of the early 20th century in which HISTORICISM and dependence on traditions were rejected in favor of directions that would relate to the social, economic, and technological realities of the "Machine Age." Movements in art and design such as ART NOUVEAU and Vienna SECESSION are often described as "pre-modern," since they turned away from tradition, but retained ornament, albeit of a newly invented sort. The ART DECO design of the 1920s and early 1930s attempted a modern style, but its superficial ornamentation and commercial orientation earned it the designation "MODERNISTIC," that is, "in the style of modernism." The work of such pioneering designers as LE CORBUSIER, Walter GROPIUS, Ludwig MIES VAN DER ROHE, and Frank Lloyd WRIGHT is generally viewed as defining modern architecture and design, with its close relationship to modern art of the same periods. In architecture, INTERNATIONAL STYLE modernism is usually characterized by the use of modern materials such as steel and concrete, large glass areas, smooth white wall surfaces, flat roofs, and details using tubular metal columns and glass block. Some work that uses more traditional and natural materials (such as brick, stone, and wood), sloping roofs, and, in some examples, ornament of an original sort can also be viewed as modern. Work relating to the BAUHAUS is generally of the first kind, while Frank Lloyd Wright's work is an outstanding example of the latter direction.

In other fields of design (such as interior, industrial, and graphic design), the stylistic significance of the term "modern" parallels its use in art and architecture. Rejection of historicism and most traditional decoration, emphasis on modern, machine-oriented technology, and functionalist concerns characterize modern appliances, furniture, packaging, printed materials, and vehicles. Beginning in the mid-1960s, various critics and designers began to voice the opinion that modernism had run its course and to herald the appearance of a new style that would replace modernism. The term POST-MODERNISM has come into use to describe such developments, with the paradoxical result that much recent work is not called "modern," while much modern work is now viewed as belonging to a bygone period. In an effort to identify recent work that follows the modern style of the 1920s to 1960s, the term LATE MODERNISM has come into use, adding further confusion to terminology already puzzling to the general public.

MODERNE

Historical and stylistic term for the advanced design efforts of the 1920s and 1930s. A French word, it refers to developments in France that were moving toward a truly MODERN style, but it implies a fashion-oriented emphasis, with a somewhat commercial bent lacking any serious theoretical basis. The term has become somewhat interchangeable with the English-language term "MODERNISTIC," which has similar suggestions of a modern style viewed as an alternative to other, more traditional styles. It has become a vocabulary for surface treatment rather than a design direction having more basic intentions.

MODERNISM

Stylistic directions adopted by the movements in art, architecture, and design that have turned away from historical and traditional styles in an effort to find a MODERN vocabulary suited to the realities of the 20th century.

MODERNISTIC

Stylistic term used to describe efforts in the 1920s and 1930s to find a design vocabulary suitable to the modern era. Modernistic design tends toward a fashion- or style-oriented view of the ideas of MODERNISM, posing the resulting style as an alternative to the historic styles that were the norms of ECLECTICISM. Modernistic implies a superficial use of ornament regarded as modern, as distinguished from the basic concepts of modernism in which form is derived from functional considerations without regard for other issues of surface appearance. In the 1930s and early 1940s the term "modernistic" or the French "MODERNE" was the popular designation for all design that attempted modern alternatives to the forms of HISTORICISM.

MODJESKI, RALPH (1861–1940)

American engineer, the primary designer for a number of major bridges whose best-known work is the Delaware River suspension bridge between Philadelphia and Camden, New Jersey, now known as the Benjamin Franklin Bridge. Modjeski worked as a partner in several firms over the years, including Modjeski & Cartlidge, designers of a steel railroad bridge over the Ohio River at Metropolis, Illinois (1914–17); Modjeski & Masters; and Modjeski, Masters & Chase. The Philadelphia-Camden bridge (1922–26) is sometimes referred to as the first truly modern suspension bridge, with its

two cables and simple, X-braced towers. Paul CRET worked with the engineers as a consulting architect. The nearby Walt Whitman Bridge of 1957 is a similar, but conceptually more modern structure by Modjeski & Masters, working together with the firm of AMMANN & Whitney.

MODULOR

System developed by the modern French architect LE CORBUSIER to aid in controlling dimensions and proportions in any design in a way intended to enhance aesthetic quality. The basis of the Modulor is a chart in which average dimensions of the human body are subdivided in a way related to the proportions of the GOLDEN SECTION. A standing human figure is divided at the waistline in the "golden" ratio of 1:1.618 (see chart).

Le Corbusier used the Modulor system in his own work, which may be a factor in the aesthetic power of his design. The system is summarized on a single chart, but is expounded in detail in a two-volume publication by Le Corbusier titled *Modulor I* and *Modulor II* (1948, English edition 1954).

MOGENSEN, BØRGE (1914–1972)

Danish designer of furniture using wood as a primary material in a modern vocabulary strongly based in traditional craft techniques. Mogensen studied at the Royal Academy in Copenhagen under Kaare KLINT and took up

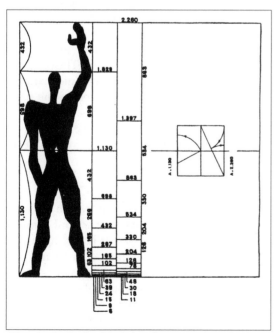

Chart by Le Corbusier giving the proportions developed by his Modulor system.

much of his design approach. His storage pieces are based on careful study of the actual dimensions of typical objects of daily use, and his seating is similarly related to human dimensions and proportions. His work represents the best aspects of the style that became widely popular in the 1950s as DANISH MODERN. Many Mogensen designs remain in production.

MOGULESCU, JOSEPH, AND MAURICE
See DESIGNS FOR BUSINESS.

MOHOLY-NAGY, LÁSZLÓ (1895–1946)

Hungarian artist, designer, and educator known both for his role at the BAUHAUS, where he developed introductory courses involving abstract work with materials and form, and for his work in abstract photography and film. Moholy-Nagy studied law in Budapest, but after military service in World War I he settled in Berlin and took up a career as an artist and writer on art-related topics. In 1923 he was appointed as a Bauhaus master and directed the introductory course (*Vorkurs*) and metal shop. He was also concerned with work in typography, photography, and stage design. In 1928 he left the Bauhaus and took up a practice as a typographer in Berlin, where he also worked in stage design for the Piscator Theater and the State Opera. From 1935–37 he was in London, and then, in 1937, he became director of The New Bauhaus in Chicago. In 1939 he opened his own design school there named simply The School of Design. In 1944 it became the INSTITUTE OF DESIGN, now part of Illinois Institute of Technology. The Chicago school followed Bauhaus teaching ideas quite closely, adding the sciences, history, and other liberal arts topics. Moholy-Nagy's best-known work involved experimentation with abstract form, light, and motion. He was active as an experimental photographer, using the techniques of the PHOTOGRAM and MONTAGE; as a maker of experimental films; and as a sculptor, producing works with a strongly constructivist character using abstract forms and effects of light and motion. His books, *The New Vision* (1946) and *Vision in Motion* (1947), present a fine survey of his ideas, teaching approach, and work.

MOLDED PLYWOOD

PLYWOOD produced in curved forms by a special manufacturing technique. It is sometimes erroneously referred to as "bent plywood," but plywood cannot be bent once it is manufac-

tured. Curved forms are made by making molds of the desired shape, stacking layers of veneer with wet glue between the layers, and pressing the stacks between the shaped molds while the glue sets. The resulting piece retains the form of the mold. In production, molds may use steam or high-frequency radiation (as in a microwave oven) to heat the adhesive to produce rapid curing. Although the veneer layers curve quite readily in one direction, efforts to make forms with multiple (two-directional) curvature are limited by the inability of the veneer to stretch, making it impossible to mold deep, bowl-like shapes. Slight multiple curvature is possible and even helpful in such elements as chair seats of organic form.

Many products have made use of molded plywood, including aircraft parts, boat hulls, and such small objects as wooden plates, but the most visible uses of molded parts have been in furniture. The Finnish architect Alvar AALTO was a pioneer in the design of furniture of molded plywood in the 1930s, and the post–World War II furniture of Charles and Ray EAMES makes frequent and striking use of the technique.

MOLYNEUX, EDWARD (1891–1974)

London-born Irish fashion designer whose career was based in Paris where he catered to an elegant society of celebrities of the social and theatrical worlds. Molyneux was an art student in London when his fashion sketches were seen by Lady Duff Gordon (Lucile in her fashion role) who hired him as an artist and then as a designer for her Paris shop. After service in World War I, he opened his Paris house in 1919, beginning a long career supplying simple elegance to such figures as Gertude Lawrence, whose Molyneux costumes in *Private Lives* made his work widely known and admired. He closed his firm in 1950 in the face of declining health, but, after a period of retirement in Jamaica, he was sufficiently recovered to introduce a 1965 ready-to-wear line mass-produced under the name *Studio Molyneux*. His fame rests mainly on his simple, elegant designs of the 1930s.

MONDRIAN, PIET (1872–1944)

Dutch artist who pushed the concept of geometric abstraction to an extreme form, becoming a strong influence on 20th-century design practice. Mondrian was trained at the Amsterdam Academy and painted naturalistic landscapes of a fairly conventional sort until about 1908 when his paintings took on a strong, individualistic quality. In 1911 he moved to Paris and became involved with the cubist direction of that time. His work gradually became more abstract until, by 1919, he was painting purely geometric grid patterns. From 1915 until 1925 he was associated with the DE STIJL movement, moving toward a vocabulary of narrow black bands dividing his canvases into square and rectangular blocks that he painted white or filled with primary colors. His compositions of the 1930s in this style are usually thought of as Mondrian's major achievement. In 1940 Mondrian moved to New York and revised his style toward a more complex patterning of narrow bands made up of many small blocks of bright, primary colors arranged on a white background in strictly right-angled order. *Broadway Boogie-Woogie* (1942–43) is a late work in this style honoring the music toward which he was strongly drawn.

Of all abstractionists, Mondrian is probably best known and most influential. Although his work moved to an extreme of abstraction, it remained complex, involving, and also decorative. In architecture, interior design, the design of furniture and similar products, and graphic design, Mondrian's work remains a strong influence. The patterns of black bands and rectangles of white and color are almost too easy to translate into a page layout, a design for a cabinet, a store-front, or a building. The work of architects of the INTERNATIONAL STYLE school (such as Ludwig MIES VAN DER ROHE) often seems Mondrian-like in its simple geometry of structural lines and in-fill panels. The conjunction of Mondrian's painting and International Style architecture may be viewed as the basis for the MODERNISM of the 1950–1970 era. At worst this vocabulary lapses into cliché; at best it has been the strongest expression of 20th-century design thinking.

MONOCOQUE

Technical construction term in which an outer shell or skin is the primary structural element carrying all major stresses. It is distinguished from the more common framed structural systems in which a separate frame provides structural strength while the external surface exists only to provide enclosure. Monocoque construction was used for some airplane design elements such as the LOCKHEED Vega and Sirius fuselage structures that were tapered tubes of

MOLDED PLYWOOD. The modern unitized construction for automobiles in which there is no separate frame is a partial monocoque structure, with the entire body shell providing the structure as a unit.

MONTAGE

Image made by combining a number of separate images, often torn and overlapped in the manner of COLLAGE. The technique has been used in MODERN art and graphic design since its early use in the DADA movement by such artists as Kurt SCHWITTERS and John HEARTFIELD. Probably the most used form of montage is the PHOTOMONTAGE in which photographic images are cut up and combined to form a new composition. Montage is often used in advertisements and posters in combination with type so that words and images form a compact, imaginative relationship. The term "montage" is also used in motion picture production to describe editing in which very brief cuts are combined in rapid sequence to suggest events or a train of thought through rapid interaction.

MORRIS, WILLIAM (1834–1896)

Founder and leader of the 19th-century English ARTS AND CRAFTS movement whose ideas led to many concepts of MODERNISM in the 20th century. The Arts and Crafts direction was in turn a vital aspect of the more general AESTHETIC MOVEMENT that dominated art and design thinking in Victorian England. Morris studied divinity at Oxford, but his interests turned to art (through a friendship with the painter Sir Edward Burne-Jones) and then to architecture after an 1854 visit to three French cathedrals. In 1856 he went to work in the architectural office of George E. Street in London and there met Philip WEBB. Morris commissioned Webb to design a house for him shortly after his marriage, the famous Red House at Bexleyheath on the edge of London (1859–60). Although Webb was the architect, the house embodied Morris's ideas about a return to the honesty of handcraft techniques (in contrast to the growing industrialization of production in Victorian England). The house is of red brick with a red tile roof; its planning is informal and functional; its exterior unornamented; and so, in a sense, it is MODERN, although it contains a rural, VERNACULAR character that suggests medievalism. While completing the interiors of the Red House, Morris developed his interest in furniture, textiles, wallpapers, and related household wares. In

1861 he formed a cooperative firm, Morris, Marshall, Faulkner & Co., to take on interior decorating assignments and produce many of the required products, including wallpapers and textiles of Morris's design and stained glass designed by Burne-Jones.

In Morris's own designs and in his prolific writing, he aimed to turn away from the decorative excesses of mass-produced household objects and turn back to craft techniques, while using the aesthetic abilities of fine artists. Around 1888, Morris added an interest in printing and book design to his other concerns, tried his hand at manuscript illumination, and, in 1891, established the Kelmscott Press to print books of his own design. Morris was also an enthusiastic poet and, in 1883, became an active politician, promoting the cause of socialism.

Morris's own work as a designer is mostly limited to decorative materials generally using naturalistic plant motifs and to graphic artwork, including the design of several typefaces. However, his influence, through the growth of the Arts and Crafts movement, was profound. He was an effective speaker, writer, and propagandist for his ideas, and his followers, including Webb, Norman Shaw, C.F.A. VOYSEY, and many other artists, craftsmen, and architects, spread his ideas widely. In Germany, Hermann MUTHESIUS introduced Arts and Crafts concepts in the DEUTSCHER WERKBUND movement, while the CRAFTSMAN movement in the United States is a direct outgrowth of Morris's thinking. His opposition to mechanization led to a dislike of urbanism and a preference for rural life, thus feeding the concepts of "garden suburbs" that have come to dominate residential developments ever since.

The development of modernism in the 20th century has tended to turn away from Morris's emphasis on handcrafts and to accept, and even glorify, industrial production and the concept of "the machine." However, it has retained his ideas about sound uses of materials, honesty in their visual expression, and the need for a functional basis for design rather than formalistic concepts or historic references. Virtually every history of the modern movement begins with a discussion of Morris, his ideas, and his contribution to subsequent developments. Nikolaus PEVSNER, for example, titled one of his most important books *Pioneers of the Modern Movement from William Morris to Walter Gropius.* This book alone has guaranteed the key role of Morris in the history of modernism. It is curi-

Bluebell, a William Morris design of 1876 for printed chintz.

ous that Morris's name is probably best known to the public in connection with the Morris chair, not designed or invented by Morris, but by Philip Webb. It was first produced by Morris & Co. in the 1860s so the name is not totally without justification.

MORRISON, ANDREW (b. 1941)

American industrial designer best known for furniture developed for KNOLL INTERNATIONAL. Morrison is a graduate of PRATT INSTITUTE in industrial design and first became known for a seating system using aluminum frames to suspend upholstered seats and backs. Designed in partnership with Bruce HANNAH, the seating system was based on a proposal that won an Aluminum Corporation of America award. That system of 1970 was followed by office chairs in 1973. Since the dissolution of the partnership, Morrison's most important work has been a modular office system, also produced by Knoll.

MOROZZI, MASSIMO

See ARCHIZOOM ASSOCIATI.

MOSER, KOLOMAN (KOLO) (1868–1918)

Viennese artist, graphic and furniture designer associated with the Vienna SECESSION movement. Moser had studied painting before becoming acquainted with Josef HOFFMANN, Gustav Klimt, and Josef OLBRICH. He was a founding member of the Secession and, in 1898, the designer of a stained-glass window for Olbrich's Secession Gallery. In 1899 Moser began to teach at the Vienna School of Applied Arts, a post he continued to hold until his death. During his career he designed furniture, often using decorative inlays, jewelry, toys, and bookbindings, stained-glass for Otto WAGNER's Vienna Kirche am Steinhof (1904), posters, and other graphic items, including an Austrian postage stamp of 1908. He was, with Josef Hoffmann, a founder of the WIENER

WERKSTÄTTE. In his later years, Moser was chiefly active as a painter.

MOURGUE, OLIVIER (b. 1939)

French designer of furniture, toys, and textiles known for his playful, usually biomorphic forms and bright colors. Mourgue was trained as an interior designer in Paris and first attracted attention with the 1965 Djinn upholstery group for the firm of Airborne. Each unit is a curving slab of plastic foam supported by a hidden steel tube frame, the whole covered with stretch fabric upholstery. The 1973 Bouloum lounge is a similar design except that it has no semblance of leg support and appears to be simply tossed on the floor. Mourgue has received American Institute of Designers (AID) and Eurodomus awards, and one of his lounge units is in the design collection of the MUSEUM OF MODERN ART in New York. Mourgue has also developed various environmental designs, including a wheeled, mobile studio for himself, and has worked on interior design and color for Renault automobiles. He is also a teacher of design at the École d'Art at Brest.

MOURON, ADOLPHE JEAN-MARIE (1901–1968)

French graphic designer who adopted the pseudonym A.M. CASSANDRE for his professional work.

MUCHA, ALPHONSE (1860–1939)

Moravian-born artist and designer of posters and other graphic materials with a strong ART NOUVEAU stylistic character. Mucha worked as a theatrical scene painter and as a decorator in Vienna from 1879 to 1884 when he turned to formal study of painting in Munich and Paris where, around 1888, he began his career as a graphic and decorative designer and book illustrator. His 1894 Art Nouveau poster for Sarah Bernhardt established his reputation, and by 1897, an exhibition of 107 of his posters was held in Paris. The exhibit traveled to Brussels, London, and New York, insuring a flow of work that included calendars, decorative wall plaques, menus, packages (biscuits, soap), and postcards. The 1900 Paris Exhibition included carpets, jewelry, textiles and a complete exhibit pavilion for Bosnia-Herzegovina of Mucha's design. The Paris jewelry shop of Georges FOUQUET was designed by Mucha in every detail. In 1910 he settled in Czechoslovakia, traveling occasionally to France and America on various commissions. His style was focused on certain themes—usually female figures with long hair in typically curvilinear Art Nouveau shapes, along with plant and flower forms in delicate, pastel colors. A 1963 retrospective exhibit of his work at the VICTORIA AND ALBERT MUSEUM in London was a survey of his work, including the posters and postcards that remain popular in current reproduction.

MÜLLER-MUNK, PETER (1904–1967)

German-born American industrial designer, much of whose work was done for corporations based in Pittsburgh, Pennsylvania, where he maintained his office. Müller-Munk came to America in 1926 and worked for a time as a silversmith for the TIFFANY jewelry firm. He became well-known for his role in establishing the industrial design training courses in 1936 at Carnegie Institute of Technology (now CARNEGIE-MELLON UNIVERSITY) in Pittsburgh. He established his office in 1945. Müller-Munk clients have included Texaco, U.S. Steel, and Westinghouse. The timeless 1930s design for the Waring blender is probably Müller-Munk's best-known work.

MUMFORD, LEWIS (1895–1990)

American writer and critic whose views on architecture and planning are widely respected, although their influence has, in practice, been limited. Lewis Mumford's interest in urban planning stemmed from his study of the writings of the British urban and regional planning theorist Patrick Geddes. His book *Story of Utopias* (1922) was the first of a long succession that included works on architecture such as *Sticks and Stones* (1924) and on city planning (*The Culture of Cities* of 1938 and *The City in History* of 1961) and books that reach across boundaries between the fields of architecture, planning, and social and political history such as *The Brown Decades* (1931) and *Technics and Civilization* (1961). He was also the author of many magazine articles and wrote a regular column for *The New Yorker* magazine called "The Skyline." In all his writings, Mumford was a strong champion of modern architecture and of rational town and urban planning. His views were strongly humanistic and diverged from some modernist planning theory that encouraged mechanistic approaches to housing with emphasis on large, high-rise buildings in vast "projects." In his later writings, Mumford focused on issues relating to the growing dom-

inance of militarism in modern nations at the expense of individual human values and environmental concerns. He was a founding member of the Regional Planning Association of America, an organization founded in 1923 to encourage quality urban planning. It was instrumental in encouraging the pioneering "garden city" development of Sunnyside Gardens in Queens, New York, designed by Clarence STEIN and Henry Wright. Mumford lived there from its construction in 1924 until 1936. Mumford was a 1972 recipient of The National Medal of Literature.

MUNARI, BRUNO (b. 1907)

Italian artist and designer whose career has extended from the Futurist era of the 1920s and 1930s to the MODERNISM of the present day. After World War II, Munari became an abstract painter and was a co-founder with Joe COLOMBO and Gillo DORFLES of the *Movimento Arte Concreta* in 1948. He was the designer of various sculptural, nonfunctional machines and an active participant in "happenings" and other avant-garde activities. In the 1960s he turned to more design-oriented interests, developing the X-hour clock in 1963, and lamps and various accessories for Danese in the 1970s. He has also been active in graphic design and in the design of a number of toys and objects of an abstract nature that are hard to classify. He taught a design course at Harvard in 1967, has won various honors including 1950, 1954, and 1955 COMPASSO D'ORO awards, and has produced more than forty books as author, designer, or both. His work has been widely exhibited and the book *Design as Art*, by Aldo Tanchis (1955; English edition 1987), provides a good summary of his work.

MUNSELL, ALBERT (1858–1918)

American painter and scientific COLOR theorist who, in 1915, developed a systematic organization of color on the basis of the three descriptors hue, value, and CHROMA. Any color can be described by letters and numbers. Thus OY6/5 designates a hue of orange-yellow with a value (position between levels of black and white) of 6 and a chroma (intensity or purity) of 5. Arrangement of all colors in (1) a color wheel for hue, (2) a vertical stack for value, and (3) horizontal position outward from a central axis for chroma creates a "color solid" showing all SUBTRACTIVE COLOR relationships in a logical geometric arrangement. The Munsell system is widely studied and used in commercial art and design to specify the color of dyes and pigments in paints and other colorants. It is the color system most often studied and used by designers and artists.

MUSEUM OF MODERN ART (NEW YORK)

Leading American institution devoted to the collection and display of MODERN art and design. The museum was conceived by three wealthy collectors who felt a special interest in MODERNISM in the arts and who regretted the neglect of modern work by existing institutions. In 1928 conversations among Lillie P. Bliss, Mrs. John D. (Abby Aldrich) Rockefeller, Jr., and Mrs. Cornelius J. Sullivan led to the opening of the museum in 1929 with Alfred H. Barr, Jr. as its director. From the beginning, it was the policy of the museum to deal with architecture, design, photography, and film along with the arts of painting and sculpture. In 1939 the museum opened its own new building, itself a distinguished work of modern architecture by Philip L. Goodwin and Edward D. STONE. The building has been expanded and renovated in a number of steps over the years, but survives as the nucleus of the present extensive building cluster. In addition to its major role in collecting, exhibiting, and publishing modern art, the museum has been a vital force in encouraging modern architecture and design through many exhibitions and publications and through the leadership of a number of department heads and curators including Arthur DREXLER, Philip JOHNSON, and Eliot NOYES. Although a number of other museums now collect and display 20th-century design, the Museum of Modern Art remains a leader, an arbiter of taste, and a major force in shaping the direction of design development in America and around the world. The publications of the museum form a library of outstanding documentation of the whole course of modernism. The 1984 publication, *The Museum of Modern Art, New York: The History and the Collection*, is an excellent one-volume compendium of the work of the museum from its founding to the opening of its reconstructed building in that year.

MUTHESIUS, HERMANN (1861–1927)

German design theorist, writer, and spokesman for design causes of the early MODERN movement. Muthesius studied philosophy before becoming trained as an architect at the

Berlin technical college. He worked for several architects before becoming an official architect for the Prussian government in 1893. In 1896 he was sent to the German Embassy in London to study and report on English design developments of the time. In articles published in Germany, Muthesius reported on the ideas and work of William MORRIS and the ARTS AND CRAFTS movement, on C.R. ASHBEE, and on Charles Rennie MACKINTOSH. Back in Germany in 1904–05, he published the three-volume *Das Englishe Haus*, which made British domestic architecture and design familiar in Germany. Muthesius was an important figure in the formation of the DEUTSCHER WERKBUND in 1907 and continued to encourage design quality through various roles in that organization. He exerted significant influence on the development of design and taste in Germany through the development of MODERNISM in the 1920s and on the character of German work since World War II.

NADER, RALPH (b. 1934)

American lawyer who has become a leader in advocating consumer interests through legislation and litigation. Nader first came to notice for his book *Unsafe at Any Speed* (1965), an exposé of the notorious dangers of the rear-engined Chevrolet Corvair automobile. His successes involved his efforts to publicize the dangers associated with many industrially produced products sold to consumers and, to a lesser extent, with the unfavorable economic impact of many design features of consumer products introduced to encourage premature obsolescence. He is credited with creating the pressures which led to many pieces of legislation that require improved standards of safety and with creating a public awareness of a wide range of issues, including air quality standards, safety standards for atomic facilities, and improved crash resistance and occupant protec-

tion in automobiles. The concept of "consumerism," in which the public is organized as a force that advances its own interests, has also led to a dramatic increase in product liability litigation in which individuals who have suffered as a result of product failures take legal action against manufacturers. Nader remains an important leader in advancing concern over such matters.

NAEF, KURT

See KURT NAEF SPIELZEUG.

NAKASHIMA, GEORGE (1905–1990)

American craftsman-designer of wood furniture of modern character, often with a suggestion of traditional forms. Nakashima is an MIT graduate who worked for a time with architect Antonin Raymond. After World War II, he established his own shop at New Hope, Pennsylvania, where he still works. Nakashima's work is generally thought of as related to the craft movement, although he uses power tools and often makes short production runs of a particular design. In many of his designs, some natural forms of the wood as cut from the tree—its grain, shape, even bark—may be retained in the finished object. There is also a hint of traditional Japanese craft values and forms, combined with awareness of American Colonial and Shaker designs. For a time Nakashima experimented with handcraft development of designs that would then be translated into factory production. Nakashima tables and chairs were part of the KNOLL product line for a short time in the 1940s.

NASH, PAUL (1889–1946)

British artist, graphic designer, photographer, and designer of glassware, textiles, and interiors who is strongly associated with MODERNISM. Nash was trained as a painter, studied at the Slade School, and began to work in graphics and textiles around 1914 in a somewhat modernized version of ARTS AND CRAFT traditions. He was an official war artist for the British government during both world wars. As an interior designer, he is best known for a 1932 bathroom for Tilly Losch that incorporated mirrors, colored glass, tube lighting, and a floor of pink rubber. He was active in the 1935 British Art in Industry exhibit presented by the Royal Academy. His later work is largely in abstract and surrealist painting, but he continued to be viewed as a spokesman for all modernist causes in England.

NATIONAL MUSEUM OF DESIGN
See COOPER-HEWITT MUSEUM.

NECCHI
Italian manufacturer of CLASSIC sewing machines based in Milan. The 1956 Mirella model was a design commissioned from Marcello NIZZOLI; it is an early example of the elegantly sculptural vocabulary that emerged in post–World War II Italian design. The 1982 Necchi Logica is the work of Giorgio GIUGIARO of ITALDESIGN. Crisply geometric in form, it is in striking contrast to the Nizzoli classic.

NELSON, GEORGE (1908–1986)
American architect and industrial designer, a leader in the post–World War II development of the design profession. Nelson took his architectural degree at Yale in 1931 and was the winner of a Rome Prize thereafter. He became aware of MODERNIST trends in Europe and, after returning to the United States in 1933, became an editor of *Architectural Forum* magazine where he played a strong role in promoting modernism in its pages. In 1941 he designed the Sherman Fairchild townhouse in New York in partnership with William Hamby, a design unusual for its louvered facade, ramps, and internal courtyard. Nelson found an ideal client for his own work in HERMAN MILLER and in 1947 established his own office in order to develop an entirely new line of furniture for that firm. His office gradually acquired other clients, including the HOWARD MILLER CLOCK COMPANY and General Electric, and did exhibit design for the Chrysler Corporation and the United States Information Agency. Nelson operated his office on a studio or atelier system, making it both a training ground and a forum for many American designers who were actually responsible for its output. Among the designers who were employed there were Irving HARPER, director of design and designer of the Ball clock, Prolon plastic dinnerware, Marshmallow sofa, and many exhibits; Ernest Farmer, responsible for many furniture designs for Herman Miller including the EOG office system; Gordon Chadwick, an architectural partner; John Pile, designer of Steelframe storage and seating systems, among other Herman Miller products; William Renwick, designer of the Bubble lamp and GE kitchen systems; John Svezia, designer

Interior of La Potagerie, a New York restaurant designed by George Nelson and Company (Judith Stockman, designer in charge).
Photo by Norman McGrath, courtesy of George Nelson and Company, Inc.

of the Sling Sofa now in the design collection of New York's MUSEUM OF MODERN ART; graphic designers Don Ervin and George TSCHERNY; and many others. Nelson continued to write, lecture, and act as a spokesman for design causes less commercial in orientation than those of industrial designers of the 1930s. His books include *Tomorrow's House* (1945), *Problems of Design* (1957), and *How to See* (1977).

NELSON, PAUL (b. 1895)

Expatriate American architect whose career in the INTERNATIONAL STYLE was based in France. Nelson was born in Chicago, educated at Princeton University, and moved to Paris shortly before World War I. He worked for a time for August PERRET and then became, in the 1930s, chief hospital architect at Lille. He developed, designed, and built as a model a futuristic project that he named a "Suspended House" in which living spaces were suspended within an enclosing structure. The project was widely exhibited and published in 1937 and 1938. His best-known built project is the hospital at Saint-Lô in Normandy built shortly after World War II. A fine example of International Style design, it is highly regarded for its model planning and for such unusual features as an entrance hall

with a Fernand Léger mural and six egg-shaped operating rooms with ingeniously planned superior lighting.

NERVI, PIER LUIGI (b. 1891)

Italian engineer known for the striking forms of his structures, usually of REINFORCED CONCRETE. Nervi graduated from the University of Bologna in 1912, served in the Italian army from 1915 to 1918, and established his own firm as a building contractor with partners in 1920. His first famous structure was a 35,000-seat stadium in Florence of 1930–32, which has a dramatically cantilevered roof and striking exterior spiral stairs. In 1948 his Turin exhibition hall had a 240-foot span vault built of prefabricated cast concrete V-section elements. Nervi was a collaborator with Marcel BREUER and Bernard H. Zehrfuss in the design of the UNESCO building in Paris (1953–57) and with Gio PONTI in the design of the Pirelli Building in Milan of 1955–59. His three structures for the Rome Olympic Games of 1960 are striking for their elegantly detailed concrete lattice roof structures. In Turin an exhibition hall of 1961 uses sixteen giant concrete piers to support the 520-foot square steel roof structure. Nervi was a member of the architectural faculty of Rome

Pier Luigi Nervi design for an exhibition hall in Turin, Italy, shown in a scale model.

Interior perspective drawing by Richard Neutra showing his design for the Grelling house in Ascona, California. Courtesy of Richard J. Neutra, Architect & Consultant.

University from 1947 until 1961. The aesthetic successes of so many of Nervi's strictly structural works have had a major influence in encouraging similar approaches by other architects and engineers.

NESSEN, VON, GRETA (c. 1900–c. 1978)
See NESSEN, WALTER VON and NESSEN STUDIO

NESSEN, WALTER VON (d. 1942)
Designer of lamps trained in BAUHAUS design concepts in Germany. Von Nessen founded Nessen Studio in New York in 1927 to produce various MODERN lamps, including the widely used double swing-arm design that is a Nessen CLASSIC. Versions for floor and table use, with

Double swing-arm table lamp, the most famous design of Walter von Nessen. Photo by G. Barrows, courtesy of George Nelson and Company, Inc.

various shades and in varied sizes and finishes, have been offered over the years. After her husband's death, Greta von Nessen continued to operate the firm, introducing some designs by other designers and some new designs of her own. Her simple Anywhere table lamp of 1952 was selected for the GOOD DESIGN exhibit at New York's MUSEUM OF MODERN ART in that year. It remains in production as do many variations of the original Nessen design.

NESSEN STUDIO
Lighting firm founded in New York by Walter von NESSEN in 1927, carried on by his widow Greta, and still in business producing many lamps and lighting devices of superior design.

NEUTRA, RICHARD JOSEF (1892–1970)
Austrian-born American architect, a pioneer in introducing MODERN architecture and design in the United States. Neutra was trained in Vienna, studying there with Adolf LOOS. From 1921 to 1922 he worked with Erich MENDELSOHN before coming to the United States in 1923, where he was able to meet Louis SULLIVAN and to work briefly for Frank Lloyd WRIGHT. In 1926 he moved to California where he established a successful practice designing houses in the INTERNATIONAL STYLE vocabulary of MODERNISM when such work was otherwise virtually unknown in America. His Lovell ("Health") house of 1927–29, with its white walls and bands of windows, established his style. It was included in New York's MUSEUM OF MODERN ART 1932 exhibition entitled *The International Style*. The desert house near Los Angeles for the film director Josef Von Stern-

berg, with walls of gleaming steel and large windows looking into a courtyard with a pool and curving walls (1936), is a striking example of the work that made him famous. Later work included schools and housing projects, such as the Channel Heights housing of 1946 at San Diego and the house of the same year for Edgar Kaufmann, Sr. near Palm Springs, California. The massive Los Angeles County Hall of Records (1958), with automatically adjusting louvers for sun control, is an example of his later, large-scale work. His philosophy and design theories are set forth in his 1954 book, *Survival through Design*.

NIKON

Leading Japanese manufacturer of cameras and optical equipment. The Nikon brand name is synonymous with top-quality cameras that have become a near-universal standard in professional photography and, as a result, the favorite equipment of serious amateurs. Early Nikon cameras were range-finder models closely modeled on the German Contax, but superior Nikon lens quality soon moved the Nikon out of the category of cheap imitation. With the introduction of the single-lens reflex model F, Nikon established its domination of the quality camera field. Many improvements have been introduced in the F series, leading to the highly sophisticated model F-3. At the same time the less elaborate Nikkormat and simple automatic cameras for the casual amateur user have been introduced. Nikon cameras have stayed close to traditional instrument-style design, but in 1982, the F-3 was specially styled by Giorgio GIUGIARO of ITALDESIGN. Nikon continues to produce laboratory microscopes and other optical instruments of high quality.

NITSCHE, ERIK (b. 1908)

Swiss-born graphic designer and art director who was influential in introducing Swiss graphic concepts into American practice from the 1930s onward. Nitsche was trained in Lausanne, Switzerland, in Munich, and in Paris before going to work for the Paris printing house of Maximilian Vox in 1929. He then worked for various European clients before relocating in New York in 1934, where he developed a career producing advertisements (Ohrbach's department store), magazine covers, record jackets (Decca), and corporate design programs for such firms as General Dynamics, where he became art director in

1955. By 1960, his focus had turned to book design, and he produced such works as the monumental and elegantly designed *Dynamic America*, a history of the General Dynamics Corporation (1960). Later work has included the design of postage stamps for the West German postal system. Nitsche's work combines the creative use of type in orderly arrangement with visual images, all organized with geometric discipline.

NIZZOLI, MARCELLO (1887–1969)

One of the best known and most outstanding of Italian industrial designers, a key figure in bringing modern Italian design to world leadership. Nizzoli studied at the Parma School of Fine Arts and took up painting and then graphic and exhibition design. In 1938 he joined OLIVETTI as an advertising designer, but from that base moved into product design as the originator of the CLASSIC typewriters, the Lexicon 80 of 1948 and the portable Lettera 22 of 1950, and the Divisumma 24 adding machine of 1956. Nizzoli was also the designer of NECCHI's Mirella sewing machine, another classic of its time (1956). Nizzoli maintained an interest in graphic and advertising design and often created advertisements that presented his own product designs with outstanding success. All Nizzoli design was characterized by a superb balance between a sculptural, biomorphic direction and recognition of the mechanistic basis for the products in question.

NOGUCHI, ISAMU (1904–1988)

Important American abstract sculptor who has also designed furniture and lighting products from time to time. Noguchi was born in Amer-

Olivetti Lettera 22 portable typewriter, designed by Marcello Nizzoli in 1950. Photo by John Pile.

ica but lived in Japan as a child, returning to the United States in 1918 to study art in New York and then with Constantin BRANCUSI in Paris. He has had many major commissions for sculpture and gardens including sculptural elements, which are often associated with architecture, for example the plaza garden at the New York Chase Manhattan headquarters building in lower Manhattan. As a designer, he was recruited by George NELSON to design a few tables for HERMAN MILLER. His 1947 glass-topped coffee table with a sculptural free-form base became a popular modern CLASSIC that threatened to become a 1950s cliché. It is still in current production. His 1954 rocking stool was produced by KNOLL. His interest in lighting stemmed from such internally illuminated sculptural work as the relief executed for the liner *Argentina* when it was reconditioned after World War II—an early example of serious modern art finding shipboard acceptance. He was a frequent collaborator with Martha Graham in the design of staging for her dance productions. His 1948 simple three-legged cylinder lamp for Knoll led to later paper sphere lights made in Japan, widely known as AKARI LAMPS. In the 1980s Noguchi continued to work in sculpture at his Long Island City studio where he also maintained a gallery devoted to his own work.

NOORDA, BOB (b. 1927)
Designer born in Holland, but a resident of Milan since 1952, where he founded the UNIMARK international design consultancy in 1965. Graphic design and signage for the Milan subway system are a distinguished example of Noorda's work. Noorda was responsible for some graphic design for Pirelli in the 1950s and became that firm's art director in 1961.

Sculptural coffee table, a 1947 design of Isamu Noguchi, still in production by Herman Miller. Photo courtesy of Herman Miller, Inc.

NORELL, NORMAN (1900–1972)
American fashion designer who was instrumental in raising the standards of fashion design in the United States to a level rivaling Paris traditions. Norell was born in Indiana and came to New York to study painting, but shifted to study costume design at PRATT INSTITUTE, graduating in 1921. He began his career as a costume designer in the film industry and then, in 1924, became a designer for Charles Armour, a dress manufacturer. In 1928 he moved to the firm of Hattie Carnegie, remaining there until 1940 when he joined the firm of Traina, where his name was added to the Traina-Norell label. Norell's designs were typically simple, handsome, and luxurious. His use of sequins became a theme, along with the use of sportswear elements in evening clothes. In 1972, the Metropolitan Museum in New York staged a retrospective exhibit devoted to his work. He was the recipient of many awards and honors including a 1942 Neiman-Marcus Award and a Parson's Medal in the same year. He was a founder of the Council of Fashion Designers of America, an organization dedicated to the furtherance of high standards of both the art and the ethics of the field.

NORMAL CURVE
Graphic representation of a statistical concept in which percentages of the total number of measurements taken are found to follow a common pattern: the average value appears in large numbers while values above and below that occur in gradually lessening quantities. A graph of this pattern forms a bell-like shape with a high point at its center and a symmetrically falling curve on each side. Many natural phenomena are found to follow a normal curve pattern. Measurements, for example, of human dimensions show that a large number of individuals are close to average while gradually fewer are far above or below the average. The fields of ANTHROPOMETRICS and ERGONOMICS find the normal curve occurring in research and therefore of use in developing designs that relate to human proportions and movement.

NORMANDIE
French ocean liner designed to be the largest, fastest, and most beautiful passenger ship in the world of the 1930s. The *Normandie*'s maiden voyage in 1935 established a trans-Atlantic speed record but created even more interest through its extraordinary design, both techni-

cal and visual, external and internal. The *Normandie* incorporated innovations in turbo-electric propulsion machinery and hull design developed by the Russian-born architect and engineer Vladimir YOURKEVITCH. It presented an unusual and striking visual appearance with streamlined forms for portions of its superstructure and its three giant funnels. It was widely viewed as outstandingly beautiful externally.

Internally, the passenger accommodations were a lavish showcase of French ART DECO design of the 1930s. Jean Dupas, René LALIQUE, Émile-Jacques RUHLMANN, Raymond Subes, and Louis SÜE were among the distinguished artists and designers whose work was represented on the *Normandie*, although many others with lesser-known names also had major roles. Although larger and faster ships were built after the *Normandie*, she captured the imagination of the public in a way that has made her the ultimate example of the ocean liner, a legend surviving to the present. Possibly her legend is enhanced by the unfortunate fire in New York harbor in 1942 that effectively destroyed the ship.

NOTCHBACK

Term coined by automotive designers and stylists to describe an auto body form in which the passenger space ends with a nearly vertical rear window while the trunk extends to the rear below the window line, thus creating a "notch." A FASTBACK, in contrast, has a smooth top line that extends the roof downward, with a slanting rear window and tapered trunk continuing the same form. The 1947 STUDEBAKER design by Raymond LOEWY is a CLASSIC of notchback design, a type that has been widely adopted by automobile designers since the 1950s. Currently, both types are in popular use, each claiming certain advantages: better AERODYNAMICS for the fastback and better rear vision and trunk and passenger space for the notchback.

NOYES, ELIOT (1910–1977)

American architect and industrial designer known for his role in developing an outstanding CORPORATE IDENTITY program for IBM. Noyes was trained as an architect at Harvard. He worked for a time in the Cambridge, Massachusetts, office of Marcel BREUER and Walter GROPIUS, but then became the first director of the industrial design department of the MUSEUM OF MODERN ART in New York. The competition and resulting exhibition *Organic Design in Home Furnishings* of 1940 was organized under his direction. After World War II, Noyes became design director in the office of Norman BEL GEDDES where he began work on a new IBM typewriter. In 1947 he opened his own office and there completed design of the 1948 electric typewriter known at IBM as Model A, which, along with the 1954 Model B, remained an industry standard for many years. The 1961 Selectric IBM typewriter was an even more distinguished design aesthetically and remains Noyes's best-known achievement. His work for IBM included overall design responsibility, including the selection and direction of such designers as Paul RAND for graphic design. Noyes's office served a number of other major clients including Mobil, Pan American Airways, Westinghouse, and Xerox, developing identity programs for each. Among the most visible of his works are the Mobil gasoline stations with disk-shaped canopies and consistent graphics that appear worldwide. Although Mobil has gradually changed the standard design, many stations based on the Noyes prototype remain in use. Noyes's own house at New Canaan, Connecticut, winner of a 1954 *Progressive Architecture* magazine design award, is his best-known architectural project (1955). From 1965 to 1970, Noyes was president of the INTERNATIONAL DESIGN CONFERENCE at Aspen, Colorado. Noyes set a high standard for the industrial design profession, placing aesthetic and ethical values above strictly commercial concerns.

NUMMI, YKI (b. 1925)

Finnish designer, born in China, best known as a designer of lighting equipment and as a color consultant. Nummi was trained in both physics and painting, but turned to the design of lighting fixtures for the Stockmann store in Helsinki in 1950. His designs use simple forms, strong colors in plastic, glass, and metals in innovative ways. He was the winner of gold medals at the 1954 and 1957 TRIENNALE exhibitions. In 1958 Nummi became a color planning advisor for a major paint manufacturer and developed color plans for a number of large, important structures including the Helsinki cathedral. He was awarded a 1971 Pro-Finlandia medal for his design contributions.

NURMESNIEMI, ANTIL (b. 1927)

Finnish interior and industrial designer known for a variety of furniture, textile, wallpaper, and

lighting designs, including the Finel enameled coffeepot made by Wärtsilä. Nurmesniemi was trained at the Taideteollinen Oppilaitos in Helsinki and worked for the architect Viljo Revell before establishing his own office in 1956. He has been the interior designer for a number of offices and public spaces in Finland, including the Palace Hotel of 1952 in Helsinki. His sauna stool of 1964 won a TRIENNALE silver medal that year. Nurmesniemi was the winner of a Lunning prize in 1959 and is currently president of the Finnish design organization Ornamo. He often collaborates with his wife Vuokko Eskolin, a chief designer for MARIMEKKO.

OBRIST, HERMANN (1863–1927)
Swiss-born German designer of textiles, ceramics, metalwork, and furniture of JUGENDSTIL character. Obrist studied at Karlsruhe, Weimar, and Paris before establishing an embroidery studio in Florence, which he relocated to Munich in 1894. Obrist had a significant influence on the work of August ENDELL, and his chairs were included in a 1900 Paris exhibition room designed by Richard RIEMERSCHMIDT. He ran a design school in Munich from 1902 to 1904 and was thereafter known as a spokesman for the cause of better design.

OFFICE LANDSCAPING
Term literally translated from the German "BÜROLANDSCHAFT," a system of office planning in which there are no private offices or other partitions and work stations are placed in free formations determined by patterns of communication as revealed by survey techniques. The term "open planning" has come into use in the United States since 1965 to describe modified forms of office landscape that have been favored in many modern office projects and that have encouraged development of office systems furniture suited to open offices. Developed by the QUICKBORNER TEAM, a consulting firm headed by the SCHNELLE brothers, office landscaping was introduced in Germany in the early 1960s.

OLBRICH, JOSEF (1867–1908)
Austrian architect and designer known as a key figure in the development of the Vienna SECES-

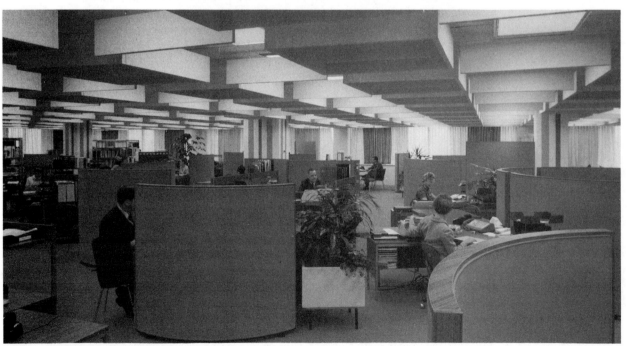

Office landscape (open plan) interior, in an early use of this concept for the DuPont Corporation, Wilmington, Delaware. Photo courtesy of DuPont Corporation.

1898 drawing by Josef Olbrich of his design for a Vienna Secessionist interior.

SION movement. Olbrich was trained in architecture in Vienna and won a Rome Prize in 1893. He worked for Otto WAGNER and was involved with Josef HOFFMANN and Koloman MOSER in the establishment of the Secession, a break with the conservative Künstlerhaus that took place in 1897. He contributed to *VER SACRUM*, the Secessionist journal, and was the architect of the Secession Gallery in Vienna in 1898. In 1899 Olbrich moved to Darmstadt to become a designer for and member of the art colony founded there by Grand Duke Ernst Ludwig of Hesse. He designed a number of houses and other buildings for the colony, as well as furniture and other decorative objects for use there and as part of various exhibitions, including one in Turin in 1902 and one in St. Louis in 1904, winning a gold medal in the St. Louis exhibit. The large Tietz department store in Dusseldorf is a major example of his work. The exterior has survived largely unchanged, although the original spectacular interiors have been totally altered. His work suggests JUGENDSTIL design, with a degree of restraint and geometric emphasis typical of the Vienna design of the time, but with frequent overtones of the fantastic or bizarre as well. The Ian Latham book *Josef Olbrich* of 1980 provides a good summary of his work.

OLIVETTI

Italian manufacturer of typewriters and business machines known for its enthusiastic sup-

port of high quality and advanced design in its products, advertising, showrooms, and buildings. Olivetti is one of the small number of major corporations of international status that has been a consistent patron of top design work. The firm was founded in 1908 by Camillo Olivetti, but came to major importance under the leadership of Adriano Olivetti. The MP1 typewriter, whose exterior form was developed by Aldo and Alberto Magnelli, is one of the first Italian industrial products to be designed for appealing appearance as well as functional practicality. The Studio 42 typewriter of 1935 was designed by the painter Xanti SCHAWINSKY and the architects Figini and Pollini. After World War II, Olivetti's assignment of design projects to such leading designers as Mario BELLINI, Marcello NIZZOLI (the Lexicon 80 of 1948 and the Lettera 22 of 1950), and Ettore SOTTSASS made the firm a leader of Italian design, which was gaining worldwide primacy. Graphic materials, showrooms, and every other aspect of the Olivetti organization were incorporated in an overall design philosophy with an outstanding commitment to excellence. After 1978, a new era in Olivetti history began with the chairmanship of Carlo De Benedetti leading to a role for Olivetti in modern computer technology, in office work station furniture, and in equipment needed for modern office automation.

OLMSTED, FREDERICK LAW (1822–1903)

American landscape architect who was a key figure in setting high standards in urban and park planning in the United States. Olmsted studied engineering and agriculture (the latter at Yale) and intended to become a farmer. His ideas became known through his writing for a New York newspaper, leading to his 1857 prize-winning plan for New York's Central

Olivetti ET 116 modular electronic typewriter.
Photo courtesy of Olivetti Office Products Division.

Park, developed in collaboration with Calvert Vaux (1824–1892). The plan created an extraordinarily varied and beautiful landscape and incorporated such advanced concepts as the separation of vehicular and pedestrian traffic in a way that remains remarkably effective even now. Olmsted and Vaux were responsible for the similarly excellent planning of Brooklyn's Prospect Park (1866–67) and for park plans for a number of American cities thereafter. Later work included plans for college campus layouts (the University of Maine, for example) and for such planned communities as Riverside, Illinois. The partnership with Vaux ended in 1872, but Olmsted continued work as a planner and as a spokesman for conservation and national park establishment. In fact, he was the planner of the Chicago World's Columbian Exhibition in 1893. Olmsted can be viewed as a pioneer in developing the profession of landscape architecture.

OMEGA WORKSHOPS
British effort dating from 1913 to 1921 to recreate some of the design-craft philosophy of the ARTS AND CRAFTS movement in a 20th-century context. Roger FRY was its leading spirit, and he drew into it such personalities as Vanessa Bell, Duncan GRANT, and Wyndham Lewis. The workshops produced various items of furniture, pottery, textiles, stained-glass, and a few complete interiors, but the effort appears to have been handicapped by an amateurish, dilettante level of performance that kept its productions decorative and trivial. Dissension among its participants led to its collapse in the 1920s.

OP ART
Development in MODERN art, particularly in painting and graphics, in the 1960s that exploited various optical (visual) effects such as those of moiré patterns, optical illusions, and COLOR effects such as the vibration produced when strong, complementary colors are juxtaposed. Op art often overlaps, and is closely related to, other developments of the modern movement such as MINIMALISM, color-field painting, and other types of geometric abstraction. Leaders among op artists were Richard Anuszkiewicz (b. 1930), Bridget Riley (b. 1931), and Victor Vasarely (b. 1908). Representing divergent directions in the painting of the 1960s, the term "op" formed a verbal contrast with the parallel POP art, making the two styles compet-

itors. Op had a strong influence in graphic and interior design, since its abstract, visual effects were easily applied in advertising design and in interior decorative treatments such as the large, colorful wall paintings that became known as "SUPERGRAPHICS." Although op art and graphics have a continuing place in modern art fields, interest has waned almost as rapidly as it developed, making the op art style now seem an event of recent history.

ORDERS OF ARCHITECTURE
Classical systems of architectural detail and ornament for columns developed in ancient Greece and Rome. Each order establishes a typical design for a column and the entablature that it supports. The entablature is a horizontal band consisting of, from bottom to top, an architrave, a frieze, and a cornice. The most-used orders are Doric, with a simple, unornamented capital; Ionic, with spiral volutes ornamenting the capital; and Corinthian, with a capital surrounded by a cluster of carved acanthus leaves. Each order makes use of a modular system of proportions that controls the relationship of its parts. The design of Greek and Roman temples was largely based on the use of an order, and the concept has characterized architectural design at various periods of history, including the Renaissance, the Neo-Classic and Revivalist era, and the early 19th-century period of ECLECTICISM. The orders have also influenced the design of many nonarchitectural items, including furniture, clocks, and many smaller decorative objects. A new interest in architectural orders has developed in response to the HISTORICISM that surfaced as part of the POST-MODERN movement.

O'RORKE, BRIAN (1901–1974)
English designer known for his work on the interiors of ships and airplanes. Trained in engineering and architecture, O'Rorke established his own design firm in London in 1929. His most distinguished work was the interior design of the Orient Line passenger ships *Orion* and *Orcades* of the 1930s. These ships were remarkable for their sensibly functional, handsome interiors at a time when the more excessive expression of ART DECO was the norm of ship interior design. O'Rorke also worked on railroad and airplane interiors, providing straightforward and appropriate design for a number of transport projects, including the interior of the Vickers Viking airplane of 1946.

ORREFORS

Swedish manufacturer of glassware that has established a high standard for design quality in its products. The firm was founded in 1898 at Kalmar, Sweden. Simon GATE and Edward HALD were the significant personalities who determined the design orientation of the firm in their roles as artistic directors and designers. Both had studied painting before turning to the design of decorative glass in an idiom that balances craft work with industrial production and the logical simplicity of FUNCTIONALISM with a freer and sometimes playful artistic creativity. The tradition has been carried forward in the work of Ingeborg Lundin (beginning in 1947), Gunnar Cyrén since 1959, and still more recently, Edvin Öhrström and Eric Olson, whose work is more abstract and technically experimental in character.

ORTHOGRAPHIC PROJECTION

Most widely used system for representing three-dimensional objects on flat paper in a way so that measurements can be taken from any part of the resulting drawing. Three views are projected onto imaginary planes of reference: one horizontal plane and two vertical planes at right angles to one another. The resulting views are a PLAN (or top view) on the horizontal plane and two ELEVATIONS (front and side view) or one elevation and a SECTION of each of the two vertical planes. When drawn to scale or occasionally at full size, such drawings make up the plans used for the design and construction of almost any object. Standard architectural and engineering drafting practice is based on orthographic projection, with the basic three views often augmented by such additional views as plans for each floor of a building or many sectional views that show internal parts of buildings or mechanical objects. The ability to read (understand) and to make orthographic drawings is basic to the training of all design professionals.

ÖSTBERG, RAGNAR (1866–1945)

Swedish architect, a leading proponent of Nordic (or Scandinavian) Romanticism. Östberg

Thousand Windows glass bowl, designed by Simon Gate and produced by Orrefors. Photo courtesy of Orrefors Sweden.

designed furniture, graphic materials, and metalwork in a style suggestive of JUGENDSTIL, but his reputation rests almost entirely on his design for the Stockholm City Hall (1911–23), a building that attracted much admiration for its balance of originality and a cautious MODERNISM with a strong sense of traditional forms and craft techniques. The interiors, including the Golden Chamber and Blue Hall, are richly decorated and striking in scale and detail. Östberg designed a number of other major buildings, including a marine museum in Stockholm (1934) and the Crematorium at Halsingborg (1935). He was a teacher of design at the Stockholm College of Art from 1922 to 1932.

OSTWALD, WILHELM (1853–1932)

German chemist and scientific COLOR theorist who developed the Ostwald System for organizing and studying color in a systematic way. The Ostwald system arranges colors in a circular spectrum (rainbow) or color-wheel order, with the strongest intensity or "saturation" at the outer rim of the circle and less saturated colors arranged inward, reaching a neutral at the center point. Then values are arranged to match the scale from black to white used as the vertical, central axis of the resulting color solid. The Ostwald system is somewhat similar to the MUNSELL system, but differs from it in that opposite positions in the circle are taken by red and green and by blue and yellow. Both value and saturation are described in terms of adding black and white to pure, chromatic color. Letters are used to indicate levels of black and white, following hue designation by name. The color solid generated by the Ostwald system is a double cone with a smooth external surface resulting from an equal number of steps of gradation for each hue. The Ostwald system is mostly used in the study and specification of ink colors for printing and in other applications in the graphic arts.

OTTAGANO

Italian design magazine founded in 1966 in Milan and still regularly published under the sponsorship of eight Italian manufacturers of products of outstanding design: Arflex, ARTEMIDE, Bernini, Boffi, CASSINA, Flos, ICF de Padova, and Techno. *Ottagano* features the designs of these manufacturers, but also carries articles of general design and historical design interest.

OTTO, FREI (b. 1925)

German architect, inventor, and designer of suspended and inflated structures using stretched cables and flexible membranes in place of traditional structural elements. Otto served as a pilot during World War II and took his degree at Berlin Technical University after the war. While visiting the United States in the early 1950s, he worked with Matthew Nowicki, Eero SAARINEN, and the engineer Fred Severud on several projects that used tensile roof structures. In 1955 he began to design such structures in Germany and became well known with his design for the German Pavilion at the Montreal Expo 67 WORLD'S FAIR. This project was a vast tent of stretched cable support roofing held up by a number of steel masts. His Munich Olympic Stadium of 1972 was an even larger and more dramatic exploration of the same structural approach. He has continued to develop inflated and hydraulic containment structures and has acted as a consultant for a variety of projects using suspended structures. His work was the subject of an exhibition at the MUSEUM OF MODERN ART in New York in 1972 (which included a suspended structure in the museum garden). The book *The Work of Frei Otto* by Ludwig Glaeser is a survey of his work up to its publication in 1972.

OUD, JACOBUS JOHANNES PIETER (1890–1963)

Dutch modernist architect associated with the DE STIJL movement. Trained at Amsterdam and Delft, Oud worked briefly in Germany and returned to practice in Leyden, Holland. He met Theo van DOESBURG and Gerrit RIETVELD in 1915 and joined with them in developing the De Stijl orientation. He designed a housing group of strict INTERNATIONAL STYLE character for the Weissenhof housing exhibition of 1927 at Stuttgart. Oud became Rotterdam City Architect in 1918 and designed a number of severely cubistic housing projects in that role. The houses at the Hook of Holland (1926–27) and the Kiefhoeck project at Rotterdam are the best-known examples of his work.

OUTERBRIDGE, PAUL, JR. (1891–1959)

American photographer whose work ranged from rather sentimentalized commercial images to still lifes with an abstract and documentary quality and powerful design impact. Outerbridge became involved in photography during his military service in World War I. In

1921 he entered the school operated by Clarence H. White in New York to learn pictorial and commercial photography. Produced on his first commercial assignment in 1922, his *Collar* is a still life showing a man's collar resting on a checkerboard background in a way that makes the image abstract and elegant while still totally realistic. Other work included city scenes, details of mechanical parts, and such common objects as a wine glass or tin box, beautifully contact-printed on platinum paper, making each image an expressive design. His role in the history of MODERN photography points toward the work of Berenice ABBOTT and Walker EVANS, whose work gave documentary photography a place in both design and art.

OZENFANT, AMÉDÉE (1886–1966)

French artist and theorist who played an important role in the development of MODERNISM in the 1920s. He worked with LE CORBUSIER in the development of a school of painting called Purism and in the publication of the magazine *L'ESPRIT NOUVEAU*. He commissioned a modern house in Paris by Le Corbusier, one of his earliest fully MODERN works, which was widely published. Ozenfant's influence survives through his influential book, *Foundations of Modern Art* (1931), which deals with the role of the design of utilitarian and mechanistic objects in relation to art.

PAHLMANN, WILLIAM C. (1900–1987)

American interior designer whose work was of period, ECLECTIC character except for a few efforts at MODERNISM toward the end of his career. Pahlmann's training began with a correspondence course in interior decorating, followed by study at the PARSONS SCHOOL OF DESIGN in New York and Paris. In 1931, Pahlmann established his own business in New York City with Mrs. William Paley as his first residential client. Her recommendations soon brought him a flow of work. He was put in charge of the decorating studios of Lord & Taylor's department store in 1936 where he put on exhibits that helped build the store's business and his own reputation. His model rooms were in varied styles, but always lush and elaborate, cluttered and colorful. He used schemes such as "pistachio, grape, and white" or "avocado, lime, plum, tan, orange, and white" as described in his 1955 book, *The Pahlmann Book of Interior Decorating*. After World War II, Pahlmann's work included restaurants and hotel and store interiors, among them a number of Bonwit Teller stores. His firm grew to include several associates who worked with him on such projects as the New York restaurant, The Forum of the Twelve Caesars. He took his most important step into modernism as a consultant to Philip JOHNSON in the design of the Four Seasons Restaurant in the 1959 Seagram Building in New York. From 1948 to 1950 he was president of the New York chapter of the AID (American Institute of Decorators) and won its Elsie de Wolfe Award in 1964.

PAILLARD S.A.

Swiss manufacturing firm known for its Hermes typewriters and BOLEX cameras and projectors, which was descended from the business founded by Moise Paillard, an early 19th-century maker of music boxes and watches. In 1875 a factory was built and the firm of E. Paillard and Company began to make phonographs and, later, record changers and radios. In 1922 production of typewriters was begun, and a portable model named Hermes 2000 was introduced a few years later. Designer G. Prezioso continued to work toward a lightweight portable of minimum size but full function. The Hermes Baby (later renamed Hermes Rocket) introduced in 1935 was the first truly miniature portable and remained the only such typewriter available until the introduction of the OLIVETTI Lettera 22 in 1950. The Hermes portable was a great commercial success, dominating its market for many years. In 1930 Paillard introduced the first Bolex 16mm moving picture camera, followed by successive models incorporating various improvements, projectors, and 8mm cameras and projectors of outstanding technical and design quality.

PAJAMIES, ESKO

Finnish furniture designer known for his simple, functional designs that often offer special

features such as knockdown construction or stackability. Pajamies' TU-520 stacking chair of 1961, made by Metalliteos Oy, uses a simple triangular steel base to support a fiberglass shell. The 1962 Finnsafari folding chair has a molded plywood frame supporting seating surfaces of leather. A 1965 design uses a demountable metal frame to support a canvas sling seat, while a 1971 design, Juju, uses simple tubular frames to support cushioned seating elements.

PALAIS STOCLET

Luxurious house designed by Josef HOFFMANN, built in Brussels (1905–11). The Palais Stoclet is usually regarded as Hoffmann's architectural masterpiece, with interiors that he designed in complete detail, including furniture, incorporating major art works, such as two impressive mosaics by Gustav Klimt. The form of the house is geometric and asymmetrical with smooth wall surfaces, but rich decorative and sculptural detail, lending it a unique character among Vienna SECESSION works.

PALMQUIST, SVEN (b. 1906)

Swedish designer trained in glass engraving at the ORREFORS factory and then as a sculptor in Stockholm and Paris. After returning to Sweden, Palmquist was active as a designer for Orrefors from 1936 to 1972, introducing many modern decorative and sculptural designs. He has also been active in the design of tableware, lighting, and architectural decorative elements.

PANKOK, BERNHARD (1872–1943)

German designer of JUGENDSTIL furniture and other decorative elements. Pankok studied painting at Dusseldorf and Berlin before settling in Munich where he became involved in the WERKSTÄTTE movement. His work was exhibited in Munich in 1898–99 and at the 1900 Paris Exhibition. His design was generally elaborate and heavy, with complex curving forms and many rich inlays of fantastic character. Pankok was an active figure in the DEUTSCHER WERKBUND movement after 1908. In 1913 he became director of the School of Applied Art in Stuttgart where he remained until 1937.

PANTON, VERNER (b. 1926)

Danish designer, now based in Switzerland, best known for his innovative and adventurous furniture using new materials and technologies. Panton was trained as a designer and architect in Copenhagen and worked for Arne JACOBSEN from 1950 to 1952 before establishing his own office in 1955 in Bissingen, Switzerland. He has designed for a number of manufacturers including THONET and HERMAN MILLER, most often working in steel wire, molded plywood, and plastic. His one-piece FIBERGLASS chair of 1960 (distributed by Herman Miller from 1967 to 1975) is probably his best-known work. Panton has also designed textiles, rugs, and exhibitions.

PAPANEK, VICTOR (b. 1925)

American designer, born in Vienna, best known for his teaching, writing, and criticism attacking the follies and commercialism of much consumer-oriented design. Educated in England before coming to America, Papanek continued his studies at COOPER UNION and MIT. He has taught and lectured widely in many countries and served as Dean of the School of Art and Design at the California School of the Arts and as a professor of design at the University of Kansas. Expressing special interest in design for underdeveloped countries, he has been something of a gadfly to design professionals in the United States and other developed countries by attacking their fixation on wasteful consumer products of questionable utility. With Jim Hennessey as collaborator, he is the author of *Nomadic Furniture* and *Nomadic Furniture 2* and *How Things Don't Work*. His most influential work is *Design for the Real World* (1971), which sets forth his views in some detail and which attracted wide notice at a time when a new public interest in ecological values was developing. His *Design for Human Scale* (1983) further develops his views and includes many examples of the design directions that he advocates.

PARAMETERS

Term from the fields of mathematics and science that has come into wide use in design fields to describe the values or objectives that are chosen to influence or control the development of a particular design. Defining parameters and CONSTRAINTS before actually beginning a design process is often considered an important part of establishing a PROGRAM. Use of this word in preference to more commonplace words such as "factors" or "goals" may sometimes reflect a desire to surround design with a mystique intended to impress rather than to explain and to assume the more prestigious mantle of science.

PARIS EXHIBITIONS

Exhibitions devoted to the decorative arts and related fields with a history dating back to 1798 when the first *Exhibition de l'Industrie* was held. By 1849, the eleventh exhibition included 4,494 exhibitors, and by 1867, the figure reached 42,217 exhibitors, attracting about 7 million visitors. The 1878 exhibition was the first to include work by designers destined to make an impact in the 20th century; among them were Walter CRANE and Louis Comfort TIFFANY. The 1889 exhibition was the site of the EIFFEL TOWER and a showcase for early ART NOUVEAU work. In 1900 the peak of the Art Nouveau era was reached with work by Émile GALLÉ, Louis MAJORELLE, and Alphonse MUCHA. The exhibit of 1925, entitled *Exposition des Arts Décoratifs et Industriels*, presented what has come to be known as ART DECO, with the work of Pierre CHAREAU, René LALIQUE, and Émile-Jacques RUHLMANN, along with the strictly modern Pavilion de *L'ESPRIT NOUVEAU* by LE CORBUSIER. The 1937 Exposition, really a WORLD'S FAIR, was the last Paris Exhibition with a major focus on design.

PARISH, MRS. HENRY ("SISTER") II (b. 1910)

Leading American interior decorator best known for the development of an informal or casual style in large and often elaborate residential projects. Parish (widely known by the familiar "Sister," as she was called by her family) began practice in 1933 without formal training, taking on projects for friends and, as her reputation grew, for many wealthy and well-known clients. Her style was ECLECTIC, her rooms comfortably cluttered with a profusion of antiques and accessories. During the 1960s she took on the redecoration of the White House for the Kennedys, working toward historic RESTORATION with the use of appropriate antiques and decorative elements. Mrs. Parish has continued in practice, since 1962 with Albert Hadley as a partner in the firm of Parish-Hadley Associates, Inc. The office employs a staff numbering some 25 designers. Its work now includes offices, clubs, and institutional interiors along with its continuing emphasis on residential design.

PARKER 51

Fountain pen that became a CLASSIC, known for its advanced design and streamlined form. Fountain pens were first developed in the 19th

century and became, in the early 20th century, an almost universally accepted writing instrument. Many manufacturers produced various versions that took on a typically chunky, cylindrical appearance with only minor stylistic variations. In the 1930s, Kenneth Parker was determined to introduce a new pen that would use a special fast-drying ink, new materials to cope with the ink's characteristics, and a new form to dramatize its innovations visually. Parker worked with industrial designers Marlin Baker and Joseph Platt to arrive at the pen's sleek form. Introduced in 1941 at a price, then viewed as very high, of $12.50, the pen was a great success technically. Its form was comfortable to use and distinctive in a way that made it a status symbol as well as a popular functional item. Only the coming of ink cartridges, ball points, and felt tips has pushed it out of leadership in its field.

PARSONS SCHOOL OF DESIGN

New York design school, traditionally known for its emphasis on fashion design, but now offering a wide range of art and design programs. Parsons was founded in 1896 by William Merritt Chase as the Chase School. In 1909 it became the New York School of Fine and Applied Arts. In 1910, Frank Alvah Parsons became its president; he was honored in 1940 by the change to the Parsons name. After 1940 under the presidency of Van Day Truex, Par-

Parker 51 pen as it appeared in a 1946 magazine advertisement. Photo courtesy of Parker Pen USA Ltd.

sons became the leading school of tradition-oriented interior decoration, training many of the best-known American decorators. In 1970, after a period of internal struggle over issues of stylistic emphasis, the school became a division of the New School for Social Research, developing a full range of programs in fine arts and in design fields including the crafts, fashion, illustration, interior design, and photography. In 1978 the Otis Art Institute in Los Angeles merged with Parsons, becoming its West Coast affiliate. Programs are now regularly offered in Paris, giving the school three major geographical bases.

PATTERN

Term most often used in design contexts to describe a repetitious, decorative surface design; a more technical meaning is used in connection with CASTING or molding. In order to make a casting, it is necessary to first produce a full- size model or pattern, usually in wood. The pattern is the exact shape of the object to be cast but is made slightly larger to allow for shrinkage of the cast piece as it cools. In SAND CASTING, the wood pattern is imbedded in fine sand held in a box. It is then lifted out, leaving its form imprinted as a hollow space in the packed sand. Molten metal is then poured into the hollow and allowed to cool before being pulled or knocked out of the sand. Many parts can be cast in this way, each duplicating the pattern. A similar wood pattern is usually required as a first step in making permanent molds of harder materials for large quantity production. The term "pattern maker" refers to the trade of expert wood workers who produce such patterns.

PAUL, BRUNO (1874–1968)

German designer of graphic materials, furniture, and interiors associated with the DEUTSCHER WERKBUND and WIENER WERKSTÄTTE movements of the early 20th century. His style was a somewhat geometric variant of JUGENDSTIL, though later in his career his work moved toward ART DECO. Paul was trained in applied art in Dresden and was at the Munich Academy until 1907. His work was displayed at the Glaspalast Exhibition at Munich in 1897, at Paris in 1900, and Turin in 1901, often alongside works by Bernhard PANKOK and Richard RIEMERSCHMIDT. After 1907 Paul became a teacher at the Berlin Kunstgewerbemuseum while continuing to develop furniture and work in interior design. Ludwig

MIES VAN DER ROHE worked in Paul's studio as an apprentice from 1905 to 1907. From 1924 to 1932 Paul headed the state art schools in Berlin where he lived until his death.

PAULIN, PIERRE (b. 1927)

French industrial designer known for his furniture of free, sculptural form. THONET manufactured some Paulin designs in the 1950s, which were widely used in Europe. In 1959 he became known for chairs using laminated wood seats and back units, fully covered with padding and supported by metal base frames. The relation of linear base members and biomorphically curved seat and back elements recalls the early designs of Charles EAMES. His 1964 designs have foldable metal cage bases, supporting canvas or leather sling seating elements. A 1967 chair consists of a single unit of FIBERGLASS, supporting a thin upholstery pad, while other designs of that year introduce metal tubular frames entirely concealed within upholstery padding that provides seating surfaces. Later designs often use several separate upholstered units that are assembled into a complete chair from shaped "chunks" with a hidden metal or plastic support structure. The Ribbon chair of 1966 (a flowing band of upholstery supported on a wood base) won an AID design award in 1969. The Dutch firm of Artifort has manufactured most of Paulin's designs. Paulin operates his own office in Paris and has worked on interiors, packaging, and designing telephones as well as furniture.

PEARSON, MAX (b. 1933)

American industrial designer who graduated from the University of Michigan in 1953 and the School of American Crafts in Rochester, New York, in 1958. He worked with the KNOLL INTERNATIONAL design development department at the Knoll factory at East Greenville, Pennsylvania, from 1959 to 1970. His most important works were a group of office chairs (1966) incorporating a swivel tilt mechanism developed by Robert Helms in 1960. The Pearson 1800 chair group of 1968 includes a full range of types and sizes, with and without casters, ranging from a secretarial posture chair through several armless and arm models as well as a large executive armchair. The larger chairs use a ring or hoop of structural material to support seat and back cushions in a way that is based on the concept of the more famous Saarinen lounge chair of 1948.

PENN, IRVING (b. 1917)

American photographer known for his work in fashion, but also for distinguished portrait and still life photography. Penn studied at the Philadelphia Museum School where he was influenced by the teaching of Alexey BRODOVITCH, for whom he worked summers at *Harper's Bazaar*. From 1940 to 1941 he worked as an advertising designer in New York and went to Mexico on a painting trip in 1942 before taking up photography for *Vogue* magazine in 1943. By the 1950s Penn had become well-known for his creative fashion and portrait work. His 1960 book, *Moments Preserved*, shows off the simplicity and documentary quality of his photographs of famous fashion designers' work and of famous people. His work has been included in many exhibitions, and he has had one-man shows in New York at both the MUSEUM OF MODERN ART and the Metropolitan Museum of Art. His techniques are generally simple: he uses natural light, a ROLLEIFLEX camera, and Kodak film. Unlike many modern photographers who leave darkroom work to technicians, Penn is involved in making his fine quality prints, often using obsolescent techniques such as the generally forgotten platinum process. His work has been published in *Worlds in a Small Room* (1974), *Inventive Paris Clothes* (1977), and *Flowers* (1980) and is included in many anthologies of modern photography. John Szarkowski's 1984 book, *Irving Penn*, published by the Museum of Modern Art is a fine presentation of Penn's best work.

PENTAGRAM

British and American design firm involved in a wide range of activities, including architectural, interior, industrial, and graphic design. The firm was founded in 1971 in London as an outgrowth of the earlier partnerships of Colin Forbes, Alan Fletcher, and Bob Gill, followed by the 1962 departure of Gill and arrival of architect Theo CROSBY in 1965. In 1972 Kenneth Grange, an architect and industrial designer, and Mervyn Kurlansky, a graphic designer, and in 1974 John McConnell became partners in the firm. The variety of skills among the partners and supporting staff make the firm particularly well able to deal with projects that cross boundaries between design fields. Work for the Cunard Line, providing interior design, graphic materials, and industrial design for the liner *Queen Elizabeth II*, is an example of such versatility. Other major clients have included

Trademark symbol designed by Pentagram for Tactics, a brand of toiletries for men produced by Shiseido of Japan. Courtesy of Pentagram Design Services Inc.

British Petroleum (BP), Kodak, Ronson, and Xerox. Work has included graphic and package design, products, exhibition and interior design in combinations dictated by clients' needs. The firm's style is based in the MODERNISM of Swiss graphics and BAUHAUS industrial design, but there is an element of lightness and a certain "English accent" that gives Pentagram design a special character. There are now offices in New York and Zurich as well as in London.

PERCENTILE

Number based on a scale of 100 percent that indicates the percentage of distribution that is at or below it. For example, in a set of measurements, a percentile value of 85 indicates that 85 percent of the measurements are at or below that level. In ERGONOMIC design, it is often practical to establish dimensions relating to a particular percentile value in a scale of ANTHROPOMETRIC data. With data on human bodily dimensions, for example, it is possible to set a door height to provide clearance for a known percentage of the total population. A height set at the 95th percentile would give clearance for 95 percent of the population.

PERMANENTE

See DEN PERMANENTE.

PERRET, AUGUSTE (1874–1954)

French architect and engineer whose work moved French architecture toward MODERNISM early in the 20th century. Perret was born in Brussels and joined his father and brothers in the family construction firm. He was a student at the École des BEAUX-ARTS in Paris and first

Apartment house at 25 bis, rue Franklin, Paris, a 1903 design of Auguste Perret. Photo by John Pile.

became known for his 1903 apartment house at 25 bis, rue Franklin in Paris, a building that expresses its REINFORCED CONCRETE frame externally, while incorporating decorative tile ornament of ART NOUVEAU character. The Théâtre des Champs Elysées of 1911–13 (begun by Henri VAN DE VELDE) was completed by Perret with visible concrete framing. The emphasis on structure in these works places them in a historical line that leads directly to modernism. The church of Notre Dame du Raincy (1922–23) uses concrete framing with walls largely filled by modern stained glass—a striking and much imitated approach to a modern form of ecclesiastical architecture. His plans for the post-war rebuilding of Le Havre (1949–56) were among his last works. Perret's strong influence was extended by his role as a teacher in several atelier and school situations, including, in 1940, the École des Beaux-Arts.

PERRIAND, CHARLOTTE (b. 1903)

French interior and furniture designer best known for her work with LE CORBUSIER. Perriand was trained in decorative design at the École de l'Union des Arts Décoratifs, but be-

came a convert to INTERNATIONAL STYLE modernism with her association with Le Corbusier in 1927. The chaise longue and upholstery often credited to Le Corbusier are now generally considered to be Perriand's designs. Her later independent work has turned toward a simple rural VERNACULAR style that retains a MODERN, functionalist spirit while using traditional materials and handcraft techniques.

PERSPECTIVE

General term for techniques used in drawing and painting to create illusions of three-dimensionality and distance. Artists of the Renaissance discovered and developed the ability to suggest real space on a two-dimensional surface through application of *aerial* perspective, in which distant objects are shown in softened color and line to suggest the effects of haze, and *linear* perspective, in which distant objects are reduced in size in comparison with the same objects seen close up. Lines moving into the distance are made to converge toward one or more vanishing points. Geometric techniques of linear perspective have been developed in a way that makes possible great precision in creating illusions of distance which correspond very accurately to human perception of real space. A camera renders the objects it photographs in perspective just as the lens of the human eye projects images onto the retina. The study of perspective drawing is an important part of the training of designers who need to know how to make convincing visual images of objects and spaces not yet actually made or built. In recent years, computer programs have been developed that make it possible to generate perspective views from ORTHOGRAPHIC drawings quickly and easily and to modify views by changing the imagined location of a viewer and the position of the objects being viewed. Realistic paintings, photographs, and accurate drawings of designs all share a convincing sense of perspective representation.

PERSSON, SIGURD (b. 1914)

Swedish designer and silversmith known for his craftmade jewelry, flat and hollow silverware, and the design of industrially produced products for household use. Persson was trained as a silversmith by his father and then studied design and craft in Munich and Stockholm. He opened his own studio in Stockholm in 1942, producing handcrafted jewelry and silver. In 1953 he designed stainless STEEL flat-

wate for the Swedish Cooperative Society and in 1959 was the winner of a competition for flatware to be used by Scandinavian Airlines (SAS). The latter won a 1960 Milan TRIENNALE medal. Persson's recent work has ranged from sculpture to cooking pots, a dustpan and brush set, Kosta glassware, and Swedish coinage. His work uses elegantly simple forms with a sculptural sense that is typical of the best of Swedish MODERN work.

PESCE, GAETANO (b. 1939)

Italian industrial and furniture designer known for radical and startling design of an experimental and adventurous character. Pesce was born in La Spezia, studied at the university in Venice, and worked at the HOCHSCHULE FÜR GESTALTUNG at Ulm in 1961. His 1969 Serie UP chairs are his best-known works. They use an innovative technique in which a plastic foam structure is placed inside plastic sheet packaging material and the air within the package is evacuated by a vacuum pump, causing the chair within to collapse into a flat form. When the package is cut open, after shipping, air flows into the foam and expands it to its original shape. Stretch fabric covering permits the cover to expand along with the foam inside. The simple, bulbous curved forms of the UP chairs are unusual and often humorous. C & B Italia was the manufacturer. Pesce's 1975 CASSINA Sit Down chair also uses a plastic foam internal structure with soft, bulging, quilted Dacron padding that forms a slipcover-like visible surface.

PEVSNER, (SIR) NIKOLAUS (1902–1983)

Influential British architectural and design historian and critic whose many books have formed contemporary understanding of the development of MODERNISM. Pevsner had a career in Germany where he was trained as an art historian at the universities of Berlin, Frankfurt, Leipzig, and Munich. He worked as a curator at the Dresden Gallery (1924–28) and as a lecturer at the University of Gottingen before moving to England in 1933. His 1936 book, *Pioneers of the Modern Movement from William Morris to Walter Gropius*, established his reputation as an exponent of the historical view that traces development from the ARTS AND CRAFTS movement through ART NOUVEAU to the BAUHAUS. The book was reissued by the MUSEUM OF MODERN ART in 1949 and was followed by *The Sources of Modern Architecture and Design*

(1968). *An Outline of European Architecture* appeared in 1943 and has remained an outstanding, concise survey of the subject. Pevsner was a writer for, and then editor of, the influential British *Architectural Review* in the 1940s; was a Professor at Cambridge University (1940–1955); and was knighted in 1969. He was an active and vocal spokesman for the cause of good design, particularly the design of the INTERNATIONAL STYLE, the Bauhaus, and its design followers. His views, along with those of Sigfried GIEDION, have become the widely accepted assessment of MODERN design history, still valid even when his critical judgment is called into question by some revisionist historians whose POST-MODERN perspective has taken a divergent direction.

PEWTER

Metallic alloy, with tin as its major component, used for metal containers and utensils since ancient times and continuing in modern use, primarily for hollowware serving containers such as pitchers, coffeepots, and bowls.

PFEIFFER, NORMAN

See HARDY HOLZMAN PFEIFFER ASSOCIATES.

PFISTER, CHARLES (b. 1940)

American interior and furniture designer known for his work in the CONTRACT interior field and for his reserved MODERN designs for KNOLL and several other manufacturers. Pfister's career began in 1965 with a position in the interior design department of SKIDMORE, OWINGS & MERRILL (SOM) in San Francisco. He was placed in charge of interior work for the Weyerhaeuser corporate headquarters project in Tacoma, Washington, and, in the course of that project, worked with Bill STEPHENS on the Knoll Stephens office system and designed an upholstered seating system that became a part of the Knoll product line. The interior of the Grand Hotel in Washington, D.C., was one of his last projects while at SOM. In 1981 he opened his own office in San Francisco to take on such projects as the Knoll Paris Showroom (1981) and the Deutsche Bank in Frankfurt, Germany (1982). The Pfister style may be described as rich and luxurious, but with a certain aesthetic discipline: his own phrase is "opulent without waste." Other work in furniture and lighting has include a table, desk, and credenza system for Knoll of classic simplicity, using rounded corners as a unifying theme; other

Settee and sofa from an upholstered seating system designed by Charles Pfister for Knoll. Photo courtesy of Knoll International, Inc.

seating for De Sede; and lighting for Casella and Boyd. Pfister was chosen as "Designer of the Year" by *INTERIORS* magazine in 1986.

PHILADELPHIA COLLEGE OF ART AND DESIGN (UNIVERSITY OF THE ARTS)

Major American art and design school known for its inclusion of a craft-oriented design program. The school was founded in 1876, along with the Philadelphia Museum of Art, as its educational branch. In 1964 it became a totally independent institution housed in a fine Greek Revival building, which was originally built as a mental hospital. In 1987 it merged with the Philadelphia College of Performing Arts, taking the new name of University of the Arts. There are now about 2,000 students with both undergraduate and graduate programs. Design programs are offered in the areas of crafts, design (including architectural studies, graphic design, illustration, and industrial design), and fine arts with programs in photography and film in addition to the traditional arts.

PHILADELPHIA EXHIBITION

See CENTENNIAL EXHIBITION.

PHOTOGRAM

Photographic print made without a camera by placing objects directly on sensitized paper and exposing it to light. Silhouetted images are formed by solid objects, while translucent objects create gray tones or patterns. The technique seems to have been invented around 1922 by Man RAY who called his prints Rayographs. László MOHOLY-NAGY probably came upon the technique independently at about the same time and gave the more usual name of "photogram" to his prints. The technique produced abstract images of objects that parallel cubist painting of the 1920s, its combination of photomechanical technique with abstract imagery forming a bridge between photography and painting. Many BAUHAUS students made photograms, and Moholy-Nagy continued to use and teach the technique as a characteristically MODERN form of expression in his classes at the New Bauhaus and the INSTITUTE OF DESIGN in Chicago. Photograms have often been used in modern advertising and graphic design by such practitioners as Lester BEALL and Paul RAND.

PHOTOMONTAGE

Form of MONTAGE treatment used in MODERN art and graphic design using photographic images cut or torn into fragments that are reassembled to form a new composition. This technique was developed by the DADA movement, with the work of John HEARTFIELD demonstrating its effectiveness in propagandistic materials attacking the growing Nazi movement in Germany of the late 1920s and early 1930s.

PHOTO-SECESSION

See STIEGLITZ, ALFRED.

PIANO & ROGERS

British architectural partnership formed in 1970 by Renzo Piano (b. 1937 in Genoa, Italy) and Richard ROGERS. The best-known work of the partnership is the Centre Pompidou in Paris (1971–77), a vast art museum and center with externally exposed structural and mechanical elements. Selected in an international design competition it is now a popular and striking example of the design direction called HIGH-TECH. Piano has been a lecturer at various architectural schools in Europe and in the United States and is a co-author with Richard Rogers of *The Building of Beaubourg* (1978), a detailed history of the Centre Pompidou project.

PICK, FRANK (1878–1941)

Managing Director of the London Transport system, responsible for the outstanding design quality standards developed under his direction and a strong influence in elevating standards in British design throughout his career. Pick had been trained as a lawyer, but joined London Transport in 1906 in a junior position. By 1928 he had risen to a post of authority in which he could demonstrate his concern for quality design in every aspect of London Transport activity. Under his direction, a CORPORATE IDENTITY program was established long before that term or concept was generally known. In 1914 Edward Johnston, a distinguished typographer, was asked to develop a new SANS SERIF type style that became a standard for all sign lettering, posters, and printed materials for the system. McKnight KAUFFER was assigned the graphic design of many posters while the architect Charles Holden was retained for the design of many station buildings as well as the 1928 multistoried head office building. The design of underground rail cars, buses, and the many details of platform benches and lighting were all dealt with in a coordinated way using a somewhat restrained version of MODERNISM admirably suited to their utilitarian functions. Pick was one of the founders of the DIA (DESIGN AND INDUSTRIES ASSOCIATION).

PININFARINA

Name of the Italian automobile body shop, founded in 1930 by the Turin-born Battista FARINA (1893–1966). The shop became known for the design of streamlined auto bodies in a style that established the leadership of Italian car design. The Cisitalias built around 1946–48 represent a high point in modern automobile de-

sign; an example is included in the design collection of the New York MUSEUM OF MODERN ART. In 1959, the firm was taken over by Battista's son Sergio (b. 1926). Body designs for Alfa Romeo, Austin, Ferrari, and Lancia continued the standards and style of Farina design. The sedate but elegant Peugeot 504 of 1968 is a Farina design of surprisingly conservative character.

PIRETTI, GIANCARLO (b. 1940)

Italian furniture designer whose best-known work is the Plia folding chair of 1969. Piretti was trained at the Bologna Art Institute and became design director for Castelli in Milan. The Plia chair has a seat and back of transparent plastic set into a simple metal frame. His collaboration with Emilio AMBASZ produced the Vertebra office chair of 1977 and the Osiris lighting unit for Erco.

PLAN

Drawing showing a horizontal SECTION of a building or other object. The three ORTHOGRAPHIC PROJECTION views most common in architectural and engineering drawings are ELEVATION, section, and plan. Because of the importance of plans, often called, in architecture, ground plans or floor plans, the word "plan" has come to have a general meaning describing all drafted drawings. In design drawings of objects, plan views are often designated horizontal sections or may be simply titled "section."

PLASTICS

Synthetic materials that pass through a soft, moldable phase during manufacture permitting them to be shaped into a desired form. Plastics have only come into wide use since the 1930s and so are often thought of as characteristically MODERN materials. Since each plastic results from a particular chemical formulation, a wide variety of qualities is possible among plastics, including transparency, translucency or opacity, flexibility or stiffness, hardness or softness, and a wide range in strength, color, and texture. Plastics can be divided into two main types: THERMOPLASTICS and THERMOSETTING (or thermoset) PLASTICS. Objects or parts of plastic must be formed from the raw material by some manufacturing process, which transforms the material into sheets, rods, tubes, or other linear form strips or into special forms that become useful objects or parts of objects.

Trimline telephone, designed in plastic by Henry Dreyfuss Associates for Bell Laboratories. Photo courtesy of Henry Dreyfuss Associates.

Common processing techniques include CAST-ING, COMPRESSION and INJECTION MOLDING, EX-TRUSION, foaming, LAMINATION, thermoforming, and VACUUM FORMING. Combining a plastic resin with GLASS fibers produces FIBERGLASS, a hybrid plastic material with high strength. Although used at first as substitutes for other materials (such as wood or metal), plastics are now in wide use as preferred materials for many products including appliances, boat hulls, furniture, housewares, office and industrial equipment, toys, utensils, and as parts for automobiles, air-craft, and any number of other modern objects.

The ease with which plastics can be formu-lated to provide desired qualities and the pos-sibilities for forming them into desired shapes with minimal labor have encouraged increas-ing use of plastics in modern designs. Eco-nomic advantages generally result from the fact that complex shapes can be created without hand labor through such processes as molding. The cost of molds can be high, but if used for quantity production, the cost of end products can be kept very low. In general, use of plastics for one-of-a-kind or short-run production tends to be costly, as does production of larger objects, because of the need for large molds and large quantities of raw materials. Plastics are, in general, at their best as materials for small ob-jects produced in large quantity. Plastic glasses, cups, knives, forks, spoons, handles for tools

and utensils, housings for small appliances, hose and pipe, gaskets and moldings, foam for cushions, and yarns for woven materials are typical examples of appropriate uses for plas-tics.

Industrial designers have been enthusiastic advocates for the use of plastics because, in addition to functional and economic advan-tages, plastics are viewed as "new" materials and so appropriate to modern design. The pio-neer industrial designers of the 1930s fre-quently used plastics in the course of developing products that would be stream-lined or otherwise different from earlier objects of comparable function. Telephones by Henry DREYFUSS, some cameras by Walter Dorwin TEAGUE, radio cabinets by Wells COATES, and kitchen containers by Earl TUPPER are typical early uses of plastic in professionally designed objects. Many modern design CLASSICS, such as the fiberglass chairs by Charles EAMES and Eero SAARINEN, tableware by Russel WRIGHT, and BRAUN products by Dieter RAMS, use plastic in important and appropriate ways. Sylvia Katz's 1944 book, *Plastics: Common Objects, Classic De-signs*, is an excellent survey of the role of plas-tics in design development.

PLATNER, WARREN (b. 1919)

American architect, interior and furniture de-signer known for sculptural wire furniture and

Executive office interior designed by Warren Platner (using Platner furniture) for MGIC Plaza, Milwaukee, Wisconsin.
Photo copyright © Ezra Stoller (ESTO), courtesy of Warren Platner.

various other designs produced by KNOLL. Platner graduated from the School of Architecture at Cornell University in 1941 and worked in several architectural and design offices thereafter. While working with Eero SAARINEN, he participated in furniture design projects and, after Saarinen's death, worked with the successor firm of Kevin Roche and John Dinkeloo. Platner was responsible for the interiors of that firm's Ford Foundation Building in New York (1967) and designed special furniture for that project which was subsequently distributed by the Lehigh Furniture Company. From 1953 until 1967 he worked on a group of chairs and tables under a Graham Foundation grant. The resulting designs all use a structure of wire cage made up of hundreds of curving wires welded to form units of great elegance. Office furniture that he designed for the MGIC building in Milwaukee, Wisconsin, has also been produced by

Knoll. His continuing practice in architecture and interior design includes residences, offices, clubs, and a number of restaurants. The Windows on the World restaurant on the 110th floor of the World Trade Center in New York (1976) is a fine example of his recent work.

PLUMB, WILLIAM LANSING (b. 1932)
American industrial designer whose Plumb Design Group has produced a wide variety of product designs that maintain high-quality standards, leading to frequent publication and various awards. Plumb graduated from Cornell and served as a naval officer before moving to Milan to work with Gio PONTI and Gianfranco FRATTINI. He returned to the United States in 1959 to work in the office of Eliot NOYES on various projects including the IBM Selectric typewriter. In 1963 he left Noyes to open his own office. Typical projects include

Volks chair designed by William Lansing Plumb.
Photo courtesy of Plumb Design Group, Inc.

the neat and functional process control panels for the Thermo Electric Company, the Savin 840 office copying machine, and the humorous plastic Volks chair, a 1970 exercise in parody POP design, which was included in the WHITNEY MUSEUM OF AMERICAN ART *High Styles* exhibition of 1985.

PLYWOOD
Material made up of a number of laminations of wood veneer, usually with the direction of the grain of each lamination at right angles to those above and below. Fir is a widely used wood for utility grades of plywood. Plywood panels are also made with face veneers of wood of good appearance such as birch or walnut. Plywood can also be made in curved shapes by molding, that is, pressing the layers of ply together between molds of a desired curved shape. The term "bent plywood" is often used for MOLDED PLYWOOD, but it is misleading in that it suggests a flat sheet has been bent. In general, molded plywood is only practical with curvature in one direction. Multiple curvatures (bowl or dishlike shapes) tend to split or crumple the layers of veneer and are therefore only possible to a very limited degree. Alvar AALTO pioneered in the development of furniture using molded plywood parts. The chairs designed in the 1940s by Charles EAMES make striking use of molded plywood seats and back.

POIRET, PAUL (1879–1944)
French fashion designer credited with freeing women from stiff corsets through the introduction of the brassiere, which was required for his early, simple, straight-falling dresses. An extremely gifted man, Poiret rose from an umbrellamaker's apprentice to great influence as a flamboyant couturier. After a visit to Russia in 1911, he developed a preference for the Orient, introducing opulent fabrics and brilliant colors in his designs. A man of wide interests, he wrote, painted, and designed for the theater and for interiors. He designed the famous costume that Sarah Bernhardt wore for her role in *L'Aiglon*. After a visit to the WIENER WERKSTÄTTE, he founded an art school in Paris for girls where they were encouraged to paint freely. He used their designs in fabrics. An associate of the Paris avant-garde, Poiret purchased Picasso's *Demoiselles d'Avignon* and hired Raoul Dufy to design prints for his fabrics. His career faded after World War I as a new generation of fashion designers came to prominence.

POLLOCK, CHARLES (b. 1930)
American industrial designer known for several chair designs that have had wide acceptance. Pollock was trained in industrial design at PRATT INSTITUTE and worked for several years in the office of George NELSON and Company in New York, developing FIBERGLASS chairs, tables, and a desk, all with tapering metal tube legs. In 1958, Pollock became an independent designer, working on a sling chair that used leather for the seat and back sup-

Original sketch for the Penelope chair designed by Charles Pollock for Castelli. Photo courtesy of Castelli Furniture, Inc.

ported by a steel frame, which was introduced by KNOLL INTERNATIONAL in 1960. His most successful design has been a desk chair that swivels, introduced by Knoll in 1965. It uses a plastic seat and back shell to hold an upholstered pad, with edging of EXTRUDED ALUMINUM holding the parts together. The chair has become a favorite in modern executive offices. More recent designs have included chairs for THONET and the Penelope stacking chair made for Castelli. It uses metal mesh for seat and back surfaces supported in a cage of steel rod. Pollock's designs are characterized by flowing curved forms and a sense of generous scale and mass.

PONTI, GIO (1891–1979)

Italian architect and designer who was a leading figure in the emergence of post–World War II Italian design. Ponti was born in Milan and trained there as an architect. He was, in 1928, a founder and first editor of *DOMUS* magazine, a publication that has had a strong influence in forming and spreading the ideas of MODERNISM in Italy. His work has included stage design, design of furniture and products along with an active practice in architecture, and he was a spokesman for design in Italy. The espresso coffee machine for La Pavoni of 1949, the interiors of the liners *Conte Grande* and *Andrea Doria* of 1950, the bathroom fixtures for Ideal Standard of 1954, and the famous Superleggera chair of 1955 for CASSINA suggest the variety of Ponti's work. Other furniture and product designs were produced by Altamira, Arflex, Arredoluce, and Nordiska Kompaniet. His most important architectural project is the Pirelli office building tower in Milan (1956) designed in collaboration with Pier Luigi NERVI. Throughout Ponti's works, from small objects to major buildings, there is a stylistic theme of angular straight lines and planes that sets them apart from the more flowing, sculptural curvature typical of most modern Italian design.

Ponti played an important role in the development of the Milan TRIENNALE exhibitions and in the establishment of the COMPASSO D'ORO award program. He exerted a direct influence on younger Italian designers as a teacher of architecture at the Milan Polytechnic.

POP (ART AND DESIGN)

Widely used, somewhat informal art-historical and critical term for work which developed in the 1950s and 1960s and drew its inspiration from popular or commercial art expression including packaging, the art of the comic strip, the vocabulary of film animation, and advertising art. The work of such artists as Jim Dine (b. 1936), Jasper Johns (b. 1930), Roy Lichtenstein (b. 1923), Robert Rauschenberg (b. 1925), Larry Rivers (b. 1923), James Rosenquist (b. 1933), Tom Wesselmann (b. 1931) and, most strikingly, that of Andy Warhol (1930–1987), with their realistic images of film stars, enlarged comic strip blocks, and versions of soup and beer cans, became a school of art contemporary with, but in contrast to, the OP art of the same period. Design was significantly influenced by pop art in such products as the Serie UP chairs of Gaetano PESCE, the inflated furniture of the 1960s and 1970s, and the MEMPHIS designs of the 1980s. Its influence is also traceable to POST-MODERN architecture with its eccentric forms and semicomic references. Although now often dismissed as a short-lived fad, pop art and design opened up avenues of expression that had previously been regarded as too frivolous to have any role in architecture and design.

PORSCHE, FERDINAND (1875–1951)

Automotive engineer, designer, and manufacturer known for his development of the original VOLKSWAGEN and the sequence of sports cars that carry the Porsche name. Porsche was responsible for many automotive designs of the 1920s when he was employed by Daimler-Benz. He established his own firm with his son Ferdinand ("Ferry") Porsche II (b. 1909) in Stuttgart where he worked on the Volkswagen design in the 1930s. The first Porsche car was produced in 1949 by a factory in Austria, with a body designed by Erwin KOMENDA using elements of the regular Volkswagen. It was marketed in 1952 as the Porsche 356 and quickly became a CLASSIC, although its bulbous, AERODYNAMIC design was sometimes criticized as clumsy. The Type 911 was introduced in 1964 with a somewhat modified body design. Successive designs for Type 912, the Targa, and the midengined 914 built the reputation of the Porsche as a prestigious status symbol as well as a sports car of outstanding performance. More recent Porsche automobiles, in the opinion of some, have been less distinguished in design character. The Porsche Design Group now also provides design (or STYLING) for various other products including sunglasses and wrist watches.

1989 Porsche 911 Carrera coupe. Photo courtesy of Porsche Cars North America, Inc.

POST-MODERNISM

Term that has come into general use in architectural history and criticism to describe stylistic developments that depart from the norms of MODERNISM. A developing impatience and dissatisfaction with modern architecture was given a theoretical base in Robert VENTURI's 1966 book, *Complexity and Contradiction in Architecture.* In it, Venturi questions the validity of the emphasis of modernists on logic, simplicity, and order, suggesting that ambiguity and contradiction may also have a valid place. In Venturi's own work and in that of an increasing number of followers, design directions introducing color, ornament, references to historic styles, and elements that sometimes appear eccentric or disturbing have come into increasing use. The architecture of Michael GRAVES and the design of the MEMPHIS group in furniture and smaller objects display post-modern characteristics, while many older, established architects have turned in this direction, as in the case of Philip JOHNSON's AT&T headquarters building in New York (1984). Debate continues as to whether the post-modernist direction is destined to become the main line of future development or no more than a fashionable trend, soon to be forgotten. Heinrich Klotz's 1985 book, *Postmodern Visions,* offers a good overview of this design direction.

PRAIRIE SCHOOL

Group of architects who developed an early form of MODERNISM in the American Midwest in the years between 1890 and 1914. The early works of Frank Lloyd WRIGHT (who called his residential designs "Prairie Houses") are the best-known examples of the style, but it also includes the designs of Louis SULLIVAN and a number of associates and followers of Sullivan and Wright—a body of work with its own distinctive character, quite different from European modernism. Like modernism, the Prairie School is nontraditional and strives for an organic union of strong, simple forms. It continues to hold to the ARTS AND CRAFTS principle of honesty of expression in workmanship and materials. But unlike orthodox modernism, it makes considerable use of ornament, often based on naturalistic forms suggestive of ART NOUVEAU and earlier, Victorian styles. In many Prairie School buildings, the emphasis on long horizontal lines may justify the identification with the flat prairie landscape. Other examples, however, are geometric and blocky, or even vertical in emphasis, and have no connection with the prairie except for the stylistic orientation of their designers. The best-known Prairie School figures (aside from Sullivan and Wright) are George G. ELMSLIE (1871–1952) of the firm of Purcell and Elmslie, George W. Maher (1864–1926), Walter Burley Griffin (1876–1937), and Marion Mahoney (1871–1926), who was the wife of Griffin.

PRATT INSTITUTE

Leading American school of art, design, and engineering located in Brooklyn, New York. Pratt Institute was founded in 1897 by Charles Pratt, a wealthy philanthropist whose fortune came from his oil company, which eventually became Standard Oil. The institute was founded to offer an education to needy and talented young people in fields that would have immediate practical value. Courses ranged from art and engineering subjects to "domestic science," library science, and even as specialized a field as leather tanning. Over the

Gordon Wu Hall at Princeton University, Princeton, New Jersey, exemplifies post-modern architecture. It was designed by the firm of Venturi, Rauch and Scott Brown. Photo by Tom Bernard, courtesy of Venturi, Scott Brown, and Associates.

years the course offerings became more varied and professional, with architecture, engineering, fashion design, and interior and industrial design being added at increasingly advanced levels. Pratt became a degree-granting institution in 1937 and now offers a wide range of programs in art, design, and technical fields. Distinguished graduates include Joseph Paul D'URSO, Charles POLLOCK, Paul RAND, and Robert WILSON, among many other leaders in design-related fields.

PREFABRICATION

Technique for building construction using factory-made parts that can be assembled on site to minimize costly hand labor and take advantage of the efficiencies of MASS PRODUCTION. Prefabrication has been viewed as a means of bringing the cost-effective techniques of industrial production to the generally inefficient building trades. The famous CRYSTAL PALACE of 1851 was an early example of the merits of prefabricated construction, but the technique has never come into common use. Many efforts to develop a system for building low-cost prefabricated houses were undertaken during the first half of the 20th century, often involving leading architects and designers (such as Buck-

minster FULLER, Walter GROPIUS, and Konrad WACHSMANN) but, in spite of a number of critical successes, none achieved general acceptance. Many parts of buildings—such as windows, doors, structural elements and exterior "skin" panels—are now regularly factory-made, but complete buildings made of prefabricated elements remain rare. The popular "mobile" and "modular homes" in current production are factory-made, but are shipped as assembled products and so are not truly prefabricated in the sense of parts assembled on site. That approach has the theoretical advantage of offering great variety, while using a small number of parts that can be produced and shipped efficiently. The concept of prefabrication continues to invite future exploration and development.

PRESERVATION, HISTORIC

Term used to describe efforts to repair, maintain, and generally sustain buildings that are significant in architectural history, political or cultural history, or some combination of these roles. Preservation is distinct from the processes of "restoration," which attempt to return a historic structure to its original condition. Restoration sometimes attempts to rehabilitate

structures, even districts that have been destroyed, and so many create all new structures that would more accurately be called "reproductions." Recent awareness that economic forces have brought about destruction or drastic renovation of many historical buildings has fueled the growth of the preservation movement. Through legal efforts and plans for ADAPTIVE REUSE that make preserved structures functional and often economically viable as well, the movement has brought about preservation of such structures as older office buildings, railroad stations, theaters, and private houses that would otherwise have been demolished. The present condition of George Washington's home in Mount Vernon, of the Greek Revival old Federal Court House (now Federal Hall) in New York, or the Academy of Fine Arts Building in Philadelphia are good examples of historic preservation efforts. Historic preservation has become a specialized professional field within the practice of architecture, and specialized training in its techniques is now available at a number of architectural schools.

PRESTINI, JAMES (b. 1908)

American designer-craftsman known for his work in wood. After training as a mechanical engineer at Yale, Prestini was an apprentice in furniture design with the Swedish designer Carl MALMSTEN in the 1930s. In 1948 he was one of an Armour Research Foundation team that developed a one-piece plastic chair for a MUSEUM OF MODERN ART-sponsored competition. His best-known work is in lathe-turned wood, a medium in which he has produced a wide variety of bowls of great elegance and simplicity beginning in the 1940s. He has taught design at ILLINOIS INSTITUTE OF DESIGN and, since 1956, at the University of California at Berkeley. From 1953 to 1956 Prestini went to Italy to study sculpture, the art in which he continues to work.

PRITZKER ARCHITECTURE PRIZE

Annual American award given for outstanding achievement in architecture as an art, established in 1979 by the Pritzker family, owners of the Hyatt Hotel Corporation. The award carries a stipend of $100,000, but is primarily significant for the international recognition it provides. The winners of the prize have been:

1979 Philip JOHNSON (United States)
1980 Luis BARRAGÁN (Mexico)
1981 James Sterling (England)
1982 Kevin Roche (United States)
1983 I.M. Pei (United States)
1984 Richard MEIER (United States)
1985 Hans Hollein (Austria)
1986 Gottfried Bohn (W. Germany)
1987 Kenzo Tange (Japan)
1988 Gordon BUNSHAFT
 (United States) and Oscar Niemeyer
 (Brazil)
1989 Frank GEHRY (United States)
1990 Aldo ROSSI (Italy)

PROCOPÉ, ULLA (1921–1968)

Award-winning Finnish designer of ceramics of simple modern design produced by the firm of ARABIA. Procopé was trained at the Helsinki Institute of Industrial Arts and began work for Arabia in 1948 after graduation. For a time she worked under the direction of Kaj FRANCK. Her own designs for tableware include the Liekki pattern of 1957 and the popular Ruska of 1960 whose rich brown glaze suggests craft design directions. She received an award at the 1957 Milan TRIENNALE and various other awards and medals at exhibitions of ceramics in the United States and in Holland.

PRODUCT DESIGN

Term often used for the design field, though it is more often referred to as INDUSTRIAL DESIGN. The latter suggests that only products for quantity, industrial production are included, while there is often confusion in the general public that "industrial design" refers to the design of factories. Product design can include craft products or one-of-a-kind industrial products, such as ships or power plants. It does not so readily include graphic, exhibition, or interior design—fields in which many designers practice while designing products, industrial or otherwise. No one term seems to have emerged that identifies the actual scope of modern design practice.

PROGRAM

Term most used to describe a verbal outline of the requirements and goals of a particular design project. Programming (sometimes a specialized function within the design process) involves identifying the specifics that a designer must address: the

nature of the problem that a projected design is intended to solve. It is generally recognized that clear definition of a problem is an important first step toward a solution—it is even often said that a problem well stated is close to a solution. Complex design projects (an airport, a hospital, a new type of ship) may require extensive research and the development of a complex problem statement (called in Britain a "brief"). Even seemingly simple projects (the design of a chair, a lamp, a flatware service) are now seen as aided and advanced by the development of a program that outlines goals, PARAMETERS, and CONSTRAINTS that can guide design, limit wasted motion, and direct efforts toward end results that serve genuine needs with optimal effectiveness.

PROPST, ROBERT (b. 1921)

American researcher, inventor, and designer responsible for office and health-care furniture systems developed by HERMAN MILLER, INC. Though Propst was trained as a chemical engineer at the University of Denver and took a master's degree at the University of Colorado, his interest turned to sculpture and he headed art departments in Texas and Colorado colleges. Eventually, research and invention became his primary focus, and he headed his own company for a time, developing various projects dealing with basic materials such as concrete and wood. During the 1950s he took on work for Herman Miller that led to the furniture product systems Action Office and Co-Struc. The former is a system of office furniture in which work and storage components are hung from movable panels. It was one of the first and by far the most successful of the systems developed for use in "open" or OFFICE LANDSCAPE planning. Co-Struc is a system of carts and containers to aid the service functions of hospitals and other health-care facilities. In 1960 Herman Miller set up an independent research corporation based in Ann Arbor, Michigan, with Propst becoming its president in 1968. In addition to his furniture-related work, Propst is known for the development of a timber harvesting machine (1970) and various other mechanical inventions.

PROTOTYPE

In INDUSTRIAL DESIGN, a full-size working model of a proposed product. A prototype is usually made largely by hand, but because it matches characteristics of the proposed product, it allows designers to test, evaluate, and improve that product before moving on to tooling and MASS PRODUCTION. A prototype differs from a MOCK-UP, which is cheaply made of convenient materials and serves only to evaluate shape, layout, and dimension, and from a model (even a full-size model), which simulates appearance but is not functionally operable.

PROXEMICS

Coined term for the systematic study of the psychological impact of space and interpersonal physical distances. Robert Sommer and Edward T. HALL have been influential through their studies and writing in bringing the term and the concerns it represents to the attention of architects, interior and environmental designers in the study of ENVIRONMENTAL PSYCHOLOGY.

PSFS BUILDING

Headquarters of the Philadelphia Savings Fund Society, built in 1932, generally regarded as the first truly modern skyscraper office building and among the first few large buildings in the INTERNATIONAL STYLE to be built in the United States. It was designed by William LESCAZE and George HOWE and is remarkable for the consistency and excellence of its overall concept and details. The black granite base contains an austerely geometric banking room with a windowed, rounded corner. Above is a 28-story tower office block with columns exposed along the sides and front CANTILEVERED forward. It has been a highly successful building and remains in fine condition and in regular use for its intended purposes.

PUCCI, EMILIO (b. 1914)

Italian fashion designer known for his stylish sportswear and use of striking printed silks. Pucci was educated in Italy and America, was an Olympic skier, and served as an Italian Air Force officer during World War II. His involvement in skiing led to a focus on ski clothing and then to a full range of sportswear. His chemise designs in silk jersey of the 1960s became a popular, daring fashion of their day. His design work has included accessories, airline uniforms, linens, porcelains, and rugs, as well as a line of perfumes.

Philadelphia Savings Fund Society (PSFS) building in Philadelphia designed by the firm of Howe & Lescaze. Photo by courtesy of Meritor Corporate Archives.

PULGRAM, WILLIAM
See ASSOCIATED SPACE DESIGN.

PULOS, ARTHUR J. (b. 1917)
American industrial designer and design educator known for his advocacy of responsible attitudes toward the role of professional design in its impact on society. Pulos was trained at Carnegie Institute of Technology and became chairman of the design department at Syracuse University in 1955, remaining there until his retirement in 1982. He also established his own firm, Pulos Design Associates, in 1958, remaining in active practice until 1987. The work of the firm ranged from Dictaphone dictating machines, Rockwell power tools (the Green Line, so-called for its unusual exterior color), and table flatware to medical and surgical equipment such as the Welch Allyn Otoscope Ophthalmoscope, a patented device now included in the design collection of the MUSEUM OF MODERN ART in New York. Pulos is the author of a two-volume history of American industrial design—the first volume *The American Design Ethic*, appeared in 1983, the second volume, *The American Design Adventure*, in 1988. Pulos has been active in the INDUSTRIAL DESIGNERS SOCIETY OF AMERICA, serving as its president in 1983–84.

PUSH PIN STUDIO
American graphic design firm (now named The Pushpin Group) known for work that moves away from the austerity of early MODERNISM toward a freer approach, often incorporating the art of illustration and a somewhat whimsical tone. The firm was formed in 1954 by Seymour CHWAST, Milton GLASER, and Ed Sorel. Early work concentrated on illustration for advertising, book jackets, and similar appli-

Packaging for Artone Studio India Ink designed by The Pushpin Group. Photo courtesy of The Pushpin Group.

cations, but the firm gradually moved toward a fuller involvement in all areas of graphic design. In 1975 Ed Sorel withdrew from the firm to concentrate on illustration, and Milton Glaser has also left to establish an independent firm, but the Pushpin style survives. It has been much imitated, widely exhibited, and has won many awards.

PUTMAN, ANDRÉE (b. 1925)

French interior designer and founder of the Paris ÉCART INTERNATIONAL design firm. Putman studied music with Francis Poulenc, but in the 1960s began selecting objects of high design quality for manufacture and distribution in France. She was largely responsible for the rediscovery of Eileen GRAY and arranged to have a number of her designs produced for distribution in reproduction form. This led to the founding of her firm, Écart International, in 1978 to make available many CLASSIC designs by such designers of early MODERNISM as Antonio GAUDÍ, Jacques Henri Lartigue, and Robert MALLET-STEVENS. The interior design work she did for her own home and for friends attracted attention and led to Ecart's also becoming active in that field. Putman has designed interiors for a number of couturiers, including boutiques for Yves SAINT LAURENT, a shop and showroom for Karl LAGERFELD, and work for Cristobal BALENCIAGA. In 1984, in cooperation with the Japanese architect Arata ISOZAKI, she designed the Palladium nightclub, a conversion of an old theater in New York. Other projects include interiors for hotels in Cologne and New York, where Ecart was responsible for the 1984 Morgan Hotel interiors. Putnam's style is subtle and highly personal, usually reserved in color, but occasionally surprising. She retains an interest in early MODERN classic work (she was responsible for new interior design for the 1916 house at La Chaux de Fonds, Switzerland, by LE CORBUSIER). Her work often suggests the influence of modernism of the 1920s.

QUANT, MARY (b. 1934)

British fashion designer and retailer, a key figure in the rise of British fashion in the 1950s and 1960s. Quant studied art at Goldsmith's College in London, where she met Alexander Greene, who became her partner in 1955. (They were married two years later.) The first Quant shop, *Bazaar*, which opened in London in 1955 on the King's Road, introduced a modern youth-oriented concept in display and marketing as well as in the actual garments offered for sale. Quant helped Britain rise to a position of leadership in the fashion world with the introduction of the mini-skirt in 1964.

QUICKBORNER TEAM

German management consulting firm known for its development of BÜROLANDSCHAFT ("office landscaping"), the system of modern office planning that omits all fixed partitioning in general work spaces. The organization was formed in the mid-1950s at the Hamburg suburb of Quickborn in Germany by the brothers Wolfgang and Eberhardt SCHNELLE. In the early 1960s, work in management organization led to the conviction that conventional (partitioned) office planning had a negative impact on office work efficiency. In 1961, offices for the firm Buch und Ton at Guttersloh, Germany, were laid out without partitions and with work areas placed entirely in free-form "scramble" patterns based on the results of communication studies. Other projects in Germany followed, and the concept was introduced in England in a 1964 magazine article by Francis Duffy. In 1967 a DuPont office planned with members of the Quickborner Team introduced the concept in the United States. A Quickborner office was established in America to offer open office planning to a number of American corporations, including Corning Glass, Eastman Kodak, and Uniroyal. The office landscape concept has gradually been absorbed into office planning practice and is now frequently used in combination with more conventional planning. Specially designed furniture systems are used that offer a range of work station types from totally open through various methods of privacy screening to full enclosure.

QUISTGAARD, JENS (b. 1919)

Danish designer of objects for household use in metals, wood, ceramics, and glass, best known as the founder of and principal designer for DANSK International. Trained as a silversmith with Georg JENSEN, Quistgaard opened his own design studio in Copenhagen after World War II. He was the winner of the Lunning Prize and

Designs by Jens Quistgaard for the Northwoods Collection by Dansk. Photo courtesy of Dansk International Designs, Ltd.

of two medals at the Milan TRIENNALE in 1954 with designs for enameled cookware and table silver. Also in 1954, Quistgaard founded the firm of Dansk International Designs in partnership with Ted Nierenberg, an American. His designs are essentially modern with a hint of craft origins typical of the style generally referred to as DANISH MODERN.

RABBET

Term used in wood joinery and cabinetmaking to identify a groove or channel cut into a board or panel, usually at its edge, so that rabbets at the edges of two boards fit together to form a rabbet joint. In distinction, the term DADO is usually reserved for a U-shaped groove or channel, generally running across the grain of a board.

RACE, ERNEST (1913–1963)

English textile and furniture designer best known for his Antelope chair and settee of bent steel rod construction designed for the 1951 Festival of Britain. Race was a student of interior design at the Bartlett School of Architecture from 1932 to 1935. In 1937 he made a trip to India and designed textiles to be hand-woven there. On his return to England, he briefly operated a shop selling the textiles of his own design. In 1946 he founded his own firm, Race Furniture, to make his own designs in metal. The firm gradually expanded to produce a complete line of CONTRACT furniture of Race's design. He was designated a Royal Designer for Industry in England in 1953, the year in which he designed the folding, stackable laminated-wood deck chair Orient Neptune, a modern version of the traditional ocean liner chair, re-

worked with flowing contours. His cast aluminum B.A.3 chair won a gold metal at the 1954 Milan TRIENNALE. During the last year of his life, Race worked as an independent design consultant.

RACKING

Term for undesirable movement in a piece of furniture, usually in the legs or base, when weak joints or insufficient bracing permits sidesway. When legs are set parallel (without SPLAY) or when the basic structure of an object is square or rectangular, the resulting geometric form may become distorted into a parallelogram when side thrust or movement is applied. Such racking can lead to an unpleasant sense of instability or, in extreme cases, to breakage or collapse. Bracing with stretchers or panels or reinforcing joints, along with adequately stiff parts, is the usual means of preventing racking. The term is also used, particularly in description of antique furniture, to indicate warpage or twisting that has developed as a permanent distortion in wood parts. An object with such problems may be said to be "racked."

RADIO CITY MUSIC HALL

Theater forming part of New York's ROCKEFELLER CENTER, which is regarded as one of the major masterpieces of the ART DECO style. The original architects were Reinhard & Hofmeister; Corbett, Harrison & MacMurray; HOOD & Fouilhoux, with the last team responsible for the overall original design of Rockefeller Center (1931–33). The Music Hall is discreetly imbedded within the RKO Building in such a way that it has no clear external identity except for its corner entrance and marquee, but the interiors, designed with Donald DESKEY in charge of decoration, are a finely preserved showcase of 1930s design. The main auditorium is a vast space seating 6,250, with stage and orchestra pit elaborately equipped with elevators, turntables, and other mechanical devices. The lobbies, grand stairway, and many lounges and smoking rooms are all distinguished examples of Art Deco idiom. The Music Hall has been a popular success and tourist attraction since its opening, as much for its design as for the films and stage shows offered there.

RAKE

Tilt or slope away from the vertical, usually in a rearward direction as customary for the masts and funnels of ships. A raked ship's bow slopes toward the front rather than toward the rear. It is not clear whether rake has any functional value (although it is sometimes said to be an aid in carrying smoke and fumes away from ships' funnels), but it has a strong visual impact suggestive of motion in a forward direction and of speed. Extreme rake is often typical of elements of high-speed boats and vehicles. In some situations it is related to STREAMLINING (as in the sloping windshields of modern automobiles), but it is often used in strictly decorative elements to suggest rapid movement by avoiding the sense of fixed stability implied by strictly vertical forms. The raking lines of modern automobiles, for example, imply speed in contrast to the upright forms of early "horseless carriages."

RAMS, DIETER (b. 1932)

German industrial designer known for an austere and puristic modern style typified by his designs for the electrical appliance firm of BRAUN. Rams was first apprentice-trained in wood joinery and then in architecture and design at Wiesbaden. He worked in the architectural office of Otto Apel before going to work as a designer for Braun in Frankfurt in 1955. Along with Hans GUGELOT, Rams led Braun design into the stylistic and theoretical directions of the HOCHSCHULE FÜR GESTALTUNG at Ulm. His SK4 record player of 1956 and KM 321 kitchen machine of 1957 are typical examples of the minimalist, abstract, geometric style he helped develop for Braun. Rams also applied a related approach to the design of seating, office, and storage furniture developed in the 1950s and 1960s for the German firm of Vitsoe+Zapf. Rams's design, although not aimed at popular consumer taste, has had a strong influence in the professional design world where the elegance and perfectionism of his approach are widely admired.

RAND, PAUL (b. 1914)

Leading American graphic designer best known for his role in developing the IBM identity program. A graduate of PRATT INSTITUTE in New York, Rand also studied at the PARSONS SCHOOL OF DESIGN there. He became art director of *Esquire-Coronet* and *Apparel Arts* magazines and then opened his own design office in 1939. His covers for *Direction* magazine (a journal for advertising art directors) quickly became known for their original character—making

Packaging incorporating the IBM logotype. Design by Paul Rand. Photo courtesy of Paul Rand, Inc.

abstract use of images suggestive of modern painting. Advertising and packaging design of similarly imaginative quality built Rand's reputation and eventually brought him a number of major corporate clients. In addition to his work for IBM, his clients included the American Broadcasting Company, Cummings Engine Company, and Westinghouse. His TRADEMARK designs for these firms have set a standard widely accepted in the modern corporate world. Rand has received many awards and honorary degrees, and his work has been widely exhibited. His book *Thoughts on Design* (1947) has become a basic text in the graphic design field. *Paul Rand: A Designer's Art* (1985) illustrates many fine examples of Rand's work, and the text gives a good summary of his thinking and design approach.

RAPSON, RALPH (b. 1914)

American architect responsible for several modern furniture designs of the 1930s and 1940s including a wood-framed rocking chair with a woven seat that was submitted to the New York MUSEUM OF MODERN ART furniture competition of 1940–41 and subsequently produced by KNOLL INTERNATIONAL. Rapson was trained at CRANBROOK ACADEMY and worked there in close association with Charles EAMES, Florence KNOLL, and Eero SAARINEN. He was a winner (with Robert Tague) of a competition for the Legislative Palace for Quito, Ecuador, in 1944, which was never built. He has been in active practice as an architect and has taught in several schools including the INSTITUTE OF DESIGN at ILLINOIS INSTITUTE OF TECHNOLOGY and MIT. Since 1954 he has headed the Department of Architecture at the University of Minnesota, Minneapolis.

RASSMUSSEN, JØRGEN (b. 1931)

Danish architect and industrial designer best known for developing the Kevi caster. Rassmussen graduated in architecture in 1955 from the Academy of Art in Copenhagen. In 1957 he opened his office with his twin brother Ib as a partner. His 1967 designs for office secretarial and arm chairs (known by KNOLL catalog numbers 1904 and 1908) were introduced in the United States by Knoll in 1968 with the Kevi name. They used plastic seats and backs supported on a cast ALUMINUM base of flowing shape, as well as the newly developed caster, with its wide, plain disk wheel of neat and simple appearance which minimized carpet wear. This caster became a widely accepted standard, produced by many manufacturers, often in unauthorized imitations of the original. Rassmussen has won a number of awards, including a 1959 gold medal and a 1969 industrial design prize from the academy in Copenhagen.

RATIA, ARMI (1912–1979)

Finnish designer and entrepreneur who became a key figure in the worldwide recognition of Finnish design as the founder and head of the MARIMEKKO chain of shops. The first Marimekko shop, opened in Helsinki in the 1950s, offered fabrics in colorful prints with abstract designs based on the peasant craft designs of the Karalian region of Finland. Ratia's designs set the unique stylistic tone for the shop, which retained its special character as other designers' work was introduced and the shop's range of wares was expanded to include a variety of household products, eventually encompassing toys, furniture, glassware, and craft objects. The chain continues in business with good success.

RATIONALIZATION OF PRODUCTION

Term for the highly organized approach to manufacturing essential to efficient MASS PRODUCTION. Each step in making an object is analyzed and isolated so that machinery and other equipment can be planned to make the individual step maximally efficient, using a minimum of hand work and so minimizing work time. Production steps are arranged in a logical order with the number of work stations provided in proportion to need so that both workers and equipment can operate at near-maximum capacity. The resulting "assembly line" has made possible the economical production of often

highly complex modern products. The classic assembly line production of such giant plants as those in the automobile industry is a key element in what is generally referred to as the "machine age." Recent steps toward computer control and the resulting automation of production are now making some aspects of assembly line production obsolete. Automated production is highly rationalized, but the ease with which automated equipment can be made to vary tasks reduces the emphasis on repetitious operations.

RAVESTEYN, SYBOLD VAN (b. 1889)

Dutch member of the DE STIJL movement of the 1920s whose furniture and lighting devices make use of the simple lines and planes and strong primary colors in geometric arrangements characteristic of the movement's style. His work is currently less known than that of Gerrit RIETVELD, whose work is similar in character. An asymmetrical wood chair of 1925 and some lamps of metal tubing and wood are currently in production by ÉCART INTERNATIONAL in France.

RAY, MAN (1890–1976)

American photographer who lived in Paris and became a part of the MODERNIST art movements of the 1920s. Man Ray was born in Philadelphia and studied architecture in New York before becoming a painter and sculptor. He moved to Paris in 1921 where he associated with the DADA and surrealist artists while turning toward photography as his primary medium. He developed a technique he named the "rayograph," a type of PHOTOGRAM in which objects are placed on sensitized paper and exposed to light to create a shadowlike image without the use of a camera. While the technique is simple, the choice of objects and their placement involve artistic judgment similar to that of collage. His 1922 portfolio of rayographs titled *Les Champs Delicieux* established his reputation in the surrealist art circles of Paris. He continued to work in photography of a more conventional sort (portraits and fashion) while also painting, producing other experimental photo work (often using solarization—a partial fogging of prints with light), and experimental films. Man Ray's photo work is represented in many museums, including New York's Metropolitan Museum and the MUSEUM OF MODERN ART. The latter museum also owns a major abstract painting, *The Rope Dancer Accompanies Herself with Her Shadows* (1916).

READ, (SIR) HERBERT (1893–1968)

English art and design critic and writer responsible for some of the first serious commentary on the theoretical basis of modern design. Read studied at Leeds University and then worked at the VICTORIA AND ALBERT MUSEUM in London, where he began writing studies on objects in the museum's collections. In 1931 he was made a professor of fine arts at Edinburgh University, but it was his 1936 book *Art and Industry* that made him a key figure in the design world. For many years it stood almost alone as a serious book dealing with industrial design and stating the modern point of view as it was developed at the BAUHAUS and in later thinking based on Bauhaus theory.

RECYCLING

Term describing any process in which reuse occurs. The term has been recently adopted in design and architectural fields to characterize the recycling of older buildings for new purposes in order to increase the economic feasibility of historic PRESERVATION. ADAPTIVE REUSE is a term used to describe the processes of change and revision that are often necessary in the recycling of older buildings so that they can be preserved and kept in current use.

REED, ROWENA (KOSTELLOW) (1901–1988)

Sculptor and design educator best known for her leading role in the Department of Industrial Design at PRATT INSTITUTE. As a student at the University of Missouri in Kansas City, Reed became interested in art while studying for her degree in journalism. After graduation, she turned to the study of sculpture at the Kansas City Art Institute where she met her future husband, Alexander KOSTELLOW, who was then a teaching assistant there. She studied for a time with the sculptor Alexander Archipenko and with Josef HOFFMANN before joining Kostellow at Carnegie Institute of Technology (now CARNEGIE-MELLON UNIVERSITY) in Pittsburgh, Pennsylvania, where Kostellow was establishing the first industrial design curriculum in America. In 1938 she relocated to Brooklyn, New York, to join Kostellow at Pratt Institute. In 1962, Reed became Industrial Design Chairman at Pratt, remaining in that role until her retirement in 1966. She continued to teach at Pratt until the year before her death. Reed exerted a strong influence on her students and on the program at Pratt through her insistence on the artistic and AESTHETIC side of design, based on

her continuing work as a sculptor. While accepting the importance of functional considerations, Reed opposed design education that focused on engineering concepts to the exclusion of artistic values.

REICH, LILLY (1885–1947)
German textile, interior, and furniture designer best known for her work in collaboration with MIES VAN DER ROHE in the 1920s and 1930s. Reich was an apprentice with the WIENER WERKSTÄTTE where in 1908 she worked with Josef HOFFMANN. Reich acted as director for WERKBUND exhibitions at Frankfurt from 1924 until 1927 and became acquainted with Mies during this period. She was the designer of various window displays and exhibit designs, including displays at Barcelona in 1929 and Berlin in 1931. She collaborated with Mies in a 1927 Berlin exhibit design known as the "Velvet and Silk Cafe" where textiles were shown together with steel tubular furniture of Mies's design and in the WEISSENHOF housing exhibit of the same year in Vienna. She became an active participant in many of Mies's projects and was, for example, influential in the interiors of the BARCELONA PAVILION and in furniture design, although the exact extent of her role remains uncertain since she seems to have offered her views and criticism in conversation rather than in drawings. Although there is a lack of documentation, Reich's influence on Mies is generally believed to have been extensive, particularly in the design of furniture and interiors. Mies also participated in some of Reich's own projects, such as a chair design shown in the 1927 Berlin exhibit. She maintained her own office but also taught weaving and interior design at the BAUHAUS under Mies. Reich was active in Mies's office, continuing to act as a business manager after he left for the United States in 1938.

REILLY, (SIR) PAUL (b. 1912)
British spokesman for design causes as a writer and as information officer for the Council of Industrial Design, where he became director in 1960. He was effective in moving British design away from the 19th-century influence of the ARTS AND CRAFTS movement and into the mainstream of MODERNISM. He was knighted for his role in design leadership in 1967.

REINECKE, JEAN OTIS (b. 1909)
American industrial designer based in Chicago best known for his commercially successful design of 1938 for the model IB12 Toastmaster electric toaster. The 1930 Toastmaster was the first automatic pop-up toaster, a somewhat boxlike, louvered chromium unit with a strongly ART DECO flavor. Succeeding models introduced various improvements, but Reinecke's design of 1938 was the first to offer bulging curved sides that exploited the glitter of chromium-plated surfaces. Sales grew dramatically when the new design was introduced, and it was widely copied by competitors until, in the 1950s and 1960s, a more rectilinear or "architectonic" design style began to make such flamboyantly glittering forms seem outdated.

REINFORCED CONCRETE
Structural building material widely used in modern architectural and engineering construction. Concrete was known to the ancient Romans, was forgotten, and then was reinvented in the 19th century. A mixture of cement, sand, and small stones (called "aggregate") is combined with water and poured into forms where it hardens into an artificial stone. Concrete has excellent compressive strength, but poor tensile strength, making it impractical for use in such structural elements as beams and columns. In France in the 1890s a technique was developed by engineers François Hennebique and François Coignet for imbedding STEEL rods within concrete in positions carefully planned to accept tensile stresses where they occur in beams and other structural elements. This permits the combination of the economy of concrete with the high-tensile strength of the more costly steel. Since concrete is cast in forms, structural elements can be made in any desired shape, including arches and other curved configurations, and structural parts can be large, monolithic, and continuous in ways that are particularly suited to long spans.

Many of the innovative shapes developed in MODERN architecture and engineering have resulted from the exploitation of reinforced concrete structures. The works of Eugène FREYSSINET, Robert MAILLART, Pier Luigi NERVI, and Auguste PERRET are outstanding because of their creative use of this material. It is important in the structural design of many modern buildings by such architects as Alvar AALTO, Marcel BREUER, LE CORBUSIER, and Eero SAARINEN. The TWA terminal at New York's Kennedy Airport is a striking example of the design possibilities

of reinforced concrete. Reinforced concrete is widely used in the construction of warehouses, garages, apartment buildings, and bridges. Since its use is more labor-intensive than construction using steel as its primary structural material, it is used less extensively in the United States than in Europe and other locations where the cost of steel is higher and the cost of labor lower. The engineering design of reinforced concrete structures is complex and has been recently aided by the introduction of computer techniques that analyze the stresses involved.

RENNER, PAUL (1878–1956)

German type designer best known for his design of the TYPEFACE called FUTURA (1927). Renner's original design for Futura was entirely geometric—composed of straight lines and parts of circles. It was eventually modified before production by the Bauer Type Foundry, but it remains a largely geometric SANS SERIF face. It gained great popularity in modern TYPOGRAPHY from the time it appeared until World War II. It is still frequently used, although other sans serif faces such as HELVETICA have supplanted it to some degree.

RESTORATION, HISTORIC

Term that has taken on an exact meaning in architectural and historic PRESERVATION activities to describe attempts to repair historic structures and rebuild them as necessary to return them to their original condition, or that of some particular past time. Preservation involves only maintaining an old structure's existing status, possibly in combination with finding new uses for it through ADAPTIVE REUSE. Restoration, in contrast, seeks precise information about its early status and attempts to recreate that condition as exactly as possible. Where detailed information about an earlier condition is not available, restorers must often guess or improvise design elements to approach the "correct" form. Restoration may include work of questionable authenticity or even totally new design misleadingly described as "restored." The work of such 19th-century restorers as Viollet-le-Duc at Carcassone or the Chateau of Pierrefonds in France, as well as the work in the 1930s on Colonial Williamsburg in Virginia, is now regarded as questionable because, although it was done in the appropriate historic style, there was no specific historic documentation for it. Recent work in the field of historic preservation has become more rigorous in its insistence that genuine old work must be distinguished from new restoration and that restoration itself must be based on firm data supporting its accuracy and authenticity.

REVEAL

Technical term used in design, architecture, and cabinetmaking to describe a groove or slot separating two elements. It has been used traditionally to indicate the surface at the side of a window or door that represents the difference between the thickness of the wall and that of the door or window frame. In modern usage it is applied to a recess between elements that creates a shadow line emphasizing the meeting point. The modern aversion to the use of moldings, regarded as reminiscent of traditional architecture, has encouraged the use of a reveal in place of a molding as a device to emphasize a line, while, at the same time, easing the construction difficulties of creating and finishing a perfect butt line. A reveal is often introduced where a wall and a ceiling meet, at the edge of a door frame where it meets a wall, or where panels meet in walls or in furniture. The shadow line it creates makes the joint crisp and emphatic without requiring an applied strip of molding or trim.

RHODE ISLAND SCHOOL OF DESIGN

Leading American school of art and design located on College Hill in Providence, Rhode Island. RISD (pronounced phonetically, as the Rhode Island School of Design is usually known) was founded in 1877 and became a degree-granting institution in 1937. Its programs include architectural studies (with majors in architecture, interior architecture, industrial and landscape design), fine arts (including ceramics, glass, jewelry and light metals, and textile design), graphic and apparel design, illustration, and photographic studies. The school was developed to support the design needs of the textile and light manufacturing industries in the Providence area, but has developed into an institution of national scope. An outstanding museum of art is part of the school.

RICCI, NINA (1883–1970)

Italian-born Paris fashion designer known for elegant expression rather than for innovation. Ricci was trained as an apprentice dressmaker and soon became a head designer. In 1932 she

opened her own shop in partnership with her husband, Louis Ricci, who was a successful jeweler. Her son Robert joined the firm and became its business manager and director. Ricci designed by working directly with fabric on a mannequin, aiming for a light and feminine quality that made the firm's work immensely successful. In 1954 design was taken over by a Belgian designer, Jules-François Crahay, who was succeeded in 1963 by Gerard Pipart, both of whom have carried forward the stylistic directions of the founder. The firm has remained under the management of Robert Ricci, who has also been responsible for the continuing success of Ricci perfumes, including the popular L'Air du Temps, which was introduced in a LALIQUE bottle with a glass bird-topped stopper.

RICHARDSON, DEANE W. (b. 1930)

American industrial designer, co-founder with David B. Smith of the firm of RICHARD-SONSMITH, now renamed Fitch Richardson Smith in recognition of its acquisition in 1988 by the British design firm of Fitch & Company PLC. Richardson was trained as an industrial designer at PRATT INSTITUTE and did post-graduate study at the University of Michigan. He founded the partnership with Smith in 1960. He is a fellow of the INDUSTRIAL DESIGNERS SOCIETY OF AMERICA (IDSA) and has been a frequent lecturer on industrial design in many countries.

RICHARDSONSMITH

American industrial design firm founded in 1960 by Deane RICHARDSON and David B. SMITH, both graduates of PRATT INSTITUTE. The firm has grown to be one of the largest design organizations in America with headquarters at Columbus, Ohio, offices in Boston, Massachusetts, and San Diego, California, and an affiliate in Tokyo. In 1988, the firm became a wholly-owned subsidiary of the British design firm of Fitch & Company PLC, an organization based in London best known for its work in the planning of retail shops. It was founded in 1971 by Rodney Fitch, an architect who began his career working with Terence CONRAN. The combined firms, with the American offices now known as Fitch RichardsonSmith, Inc., have become one of the world's largest industrial design organizations employing nearly 500 people in three American and five British offices. Clients of the firm have included dozens of major American and international companies including Corning Glass, Exxon, General Electric, Kodak, Raytheon, Sperry, 3M, Towle, Volkswagen/Audi, and Xerox. In addition to product design, the firm is active in marketing, graphics, and retail planning and design.

RIEMERSCHMIDT, RICHARD (1868–1957)

Early MODERNIST designer of furniture and other products closely associated with the German WERKSTÄTTE movement. Riemerschmidt

Office desk organizer made up from the Design-a-Space system developed by Fitch RichardsonSmith for Rubbermaid.
Photo courtesy of Fitch RichardsonSmith.

was born in Munich and studied painting at the Academy there. In an 1897 exhibition in Munich, he exhibited stained glass, a wall hanging, and a buffet that attracted favorable attention. The next year he designed furniture for the Munich Werkstätte. His 1900 room at the Paris Exhibition included lighting fixtures, furniture, carpet, wallpaper, and decorative details of his own design. His furniture was, for its day, remarkable in its simplicity. His wood chair using a diagonal side support brace is his best-known work—it has become a CLASSIC often imitated by later designers. He designed furniture for quantity production that was first shown in Dresden in 1905. He was a founding member of the DEUTSCHER WERKBUND in 1907,

and in 1908, he exhibited glass, porcelain, and flatware at a Berlin gallery.

From 1902 to 1905 Riemerschmidt taught in Nuremberg. From 1912 until 1924 he was the director of the Munich school of applied arts. From 1926 to 1931 he headed the industrial art school in Cologne. Riemerschmidt's work often incorporates some of the florid and flowing forms typical of JUGENDSTIL work, but at its best, in his architectural interior detailing and in furniture, it moves toward a simplicity presaging the direction of later modernism.

RIETVELD, GERRIT T. (1888–1964)

Dutch architect and designer, a leading figure in the DE STIJL movement who was trained as

Red and Blue chair, a 1918 design of Gerrit Rietveld and a landmark of De Stijl design. Photo courtesy of Atelier International, Inc.

an apprentice in cabinetmaking in his father's workshop. He worked as a designer for Casrel Begeer, a goldsmith, from 1906 until 1911. He then began architectural study with P.J.C. Klaarhamer in Utrecht. In 1918 Rietveld became involved with the de Stijl movement. His 1918 Red and Blue chair, now a well-known CLASSIC, uses color planes for the seat and back set in a black frame, all of wood, in a way suggestive of constructivist sculpture, such as that of Theo van DOESBURG. Rietveld's best-known architectural work is the 1924 Schröder house in Utrecht, a geometric sculptural essay in the de Stijl vocabulary of overlapping planes using only black, white, gray, and primary colors in a way that implies the painting of MONDRIAN. In 1928, Rietveld was one of the founding members of CIAM.

During the 1930s Rietveld was active as an architect, interior designer, and designer of furniture and other objects, including lamps. The Z or Zig-Zag chair of 1934, made of four simple slabs of wood, has become as well-known as the Red and Blue chair. Both are often cited as being more abstract compositions than usable furniture, but both are, in fact, quite practical and have been put into recent production. Other designs, such as the sideboard of 1919 (now in the Stedelijk Museum in Amsterdam) and the small table lamp of 1924, reflect the geometric and abstractly sculptural quality of all Rietveld design. After World War II, Rietveld was "rediscovered," and he then received a number of architectural comissions, including that for the Soonsbeek sculpture pavilion completed in 1954 at Arnheim and then reconstructed at Otterlo as part of the Kröller-Müller State Museum.

Rietveld is regarded as a key figure in the development of MODERNISM in spite of the modest extent of his work. His treatment of the practical structures of furniture and buildings as sculpture of a strongly abstract nature became one of the dominant themes in the development of the MODERN movement.

LA RINASCENTE
Italian department store chain that became a powerful influence in Italy's emergence as a prime source of modern design of high quality after World War II. The products sold, the display design, and the actual architecture of Rinascente stores represent Italian design at its best. The flagship store in Rome, designed by Franco ALBINI and Franca Helg in 1957–1961,

serves as a fine setting for MODERNISM in both artistic and commercial terms. La Rinascente established the COMPASSO D'ORO awards in 1954, a program that has continued to assert Italian strength in design matters.

RISOM, JENS (b. 1916)
Danish-American designer and furniture manufacturer who played an important role in introducing the style known as DANISH MODERN in the United States. Risom was trained at the School for Industrial Art and Design in Copenhagen and worked for a time in a cabinet shop and for the Danish architect Ernst Kuehn before coming to America. Beginning in 1939, he worked with interior designer Dan COOPER in New York designing textiles and custom furniture. In 1941 he began work with Hans KNOLL, developing a group of simple wood-framed chairs using woven canvas webbing as seat and back surfaces and some related storage pieces. The first Knoll catalog of 1942 is filled with Risom designs. Risom went into the United States Army in 1943, while many of his Knoll designs could be found in army officers' quarters and USO lounges. In 1946 Risom established his own furniture business and asked that Knoll not advertise his name in connection with his designs that remained in the Knoll line, since his own firm was developing a line in direct competition with Knoll. The Risom firm produced only Risom designs—most in simple wood with occasional metal parts—all in the modern style that is thought of as typically Danish. Forms are generally soft and "comfortable," modern without being forbidding. Risom added a range of office furniture to his original residential group and became increasingly successful as the CONTRACT DESIGN field expanded in the 1950s and 1960s. He acted as both business and design chief of his firm. He has continued to design modern furniture since his retirement from his own firm for a number of other American manufacturers.

ROBIE HOUSE
One of the most important and most famous works of early modern architecture designed by Frank Lloyd WRIGHT in 1909 for F.C. Robie. Built in Chicago, the Robie House is generally viewed as the masterpiece of Wright's early career. It is of the type that Wright called "Prairie houses," with long, low, horizontal lines, low-hipped roofs, and continuous bands of windows. Externally, the house has little orna-

ment, but the interiors are full of ornamental detail in Wright's characteristic geometric style. Built-in and free-standing furniture (the latter now disbursed) in Wright's geometric but complex vocabulary was developed for the house. The house became famous in Europe through publication there before it was known and admired in America.

The house is located on what is now part of the campus of the University of Chicago. It was threatened with destruction in 1957 to make room for a college building, but was rescued through a publicity campaign that finally attracted funds for its repair and preservation. It now serves university office and conference functions and remains a focus of attention for students and scholars of the history of modern architecture.

ROBSJOHN-GIBBINGS, TERRANCE HAROLD (1909–1973)

British-American interior decorator and furniture designer who promoted a style combining the simplicity of MODERNISM with a spirit of traditional classicism in luxurious interiors developed for wealthy clients. Robsjohn-Gibbings was born in England, studied architecture at the University of Liverpool, and worked as a designer and film art director in London. In 1936 he moved to New York and opened his own showroom. His famous showroom room setting display combined simple white walls with casts and mosaics based on ancient Greek motifs and his own Klismos chair, closely modeled on the Greek design that appears in many ancient vase paintings. Many fashionable people became his clients. His interiors were usually simple, using pale colors, with strong accent colors in the upholstery of furniture of his own design, usually incorporating light (often bleached) woods. In 1946 the Widdicomb Furniture Company introduced a group of his designs as limited production items. His armchair, with a slim, pale wood frame supporting leather straps, which, in turn, carried upholstered cushions, became a well-known example of his work and approach.

Robsjohn-Gibbings was a witty and sharp-tongued conversationalist and writer. His first book *Goodbye, Mr. Chippendale* (1944) and *Homes of the Brave* (1954) were popular and amusing attacks on both traditional ECLECTIC decorating and on the extremes of modernism. His 1947 *Mona Lisa's Mustache* is a somewhat intemperate attack on modern art. His later work became increasingly opulent, including elaborate screens, false arch elements, and huge, overscaled coffee tables and cabinets. A dining room designed in collaboration with architect Edward Durell STONE for a Dallas, Texas, residence, includes a table and seating placed on a circular island in a large pool. Throughout his career he managed a unique blend of the simplicity of modernism, the opulence of the decorating trade, and a continuing devotion to the classicism of ancient Greek precedents.

ROCHAS, MARCEL (1902–1954)

French fashion designer whose graphically strong and often dramatic designs sometimes were precursors for fashion directions that other designers developed more fully. Rochas had begun a career in law, but turned to fashion to clothe his young wife in a style that he regarded as appropriate. By 1930 his Paris couture house had become successful and his reputation was enhanced by a much-discussed scandal when eight stylish women all appeared at a party in identical Rochas dresses, each supposing hers was unique. Rochas used exotic details such as fabric flowers or birds along with bright colors—as many as ten together in one costume. His designs of the 1940s anticipated the military styles of Elsa Schiaparelli and the "New Look." His perfumes, including Femme, introduced in a LALIQUE bottle with black lace trim, and Madame Rochas, remain popular. His 1951 book, *Twenty-Five Years of Parisian Elegance*, is a survey of his work and of the fashion world of 1925 to 1950.

ROCKEFELLER CENTER

New York complex of skyscraper office buildings admired both as a popular tourist attraction and as an early example of a coherently planned, urban, high-rise grouping. Beginning during the Depression in 1931, Rockefeller interests acquired three entire city blocks in the heart of midtown Manhattan where few large buildings existed. A coordinated design for a group of thirteen large buildings was developed with a team of architects who planned a midblock private street (Rockefeller Plaza), a central garden walk leading to an open sunken plaza, and individual skyscraper buildings that make up the original complex. The architects were Reinhard & Hofmeister; Corbett, Harrison & MacMurray; HOOD & Fouilhoux; and, after World War II, Carson & Lundin. The

buildings are of varying height, with the 850-foot RCA building at the center. All have similar external materials, detailing, and slablike forms with setbacks typical of the skyscraper design of the ART DECO era. The project included underground pedestrian shopping areas and truck delivery access. The original intention to include an opera house was abandoned, but there were two large movie theaters (only one, the RADIO CITY MUSIC HALL, survives), the radio studios of NBC, many shops and restaurants, and some 10 million square feet of office space. Many works of art, sculpture, bas-reliefs, and murals are incorporated, including work by a number of leading artists of the 1930s. Although the architecture of the individual buildings may now seem undistinguished, the coordinated planning of the project and the massing of the group have been greatly admired. Sigfried GIEDION, in his *Space, Time and Architecture* (1941), devotes a number of pages to analysis and praise of this project.

Since 1960, Rockefeller Center has been extended, with additional buildings adjacent to it on the north and west (across Sixth Avenue), but the newer buildings are of indifferent design quality, though well-related to the concept of the original project. This complex remains a major attraction for visitors to New York and is a continuing example of the value of coordinated architectural planning in contrast to the more usual chaotic development of major urban real estate development.

ROERICHT, NICK (b. 1932)

German designer best known for his system of stackable china tableware of 1963. The system is produced by the Thomas Division of the ROSENTHAL China Corporation, and a grouping of this system is included in the design collection of the MUSEUM OF MODERN ART in New York. The design was developed while Roericht was a student at the HOCHSCHULE FÜR GESTALTUNG at Ulm in 1959. He taught at Ohio State University at Columbus (1966–1967) before opening his office in Ulm in 1967. He has worked for Lufthansa on color, graphics, and other elements of CORPORATE IDENTITY. Since 1977 he has also been a teacher at the Hochschule der Künste in Berlin.

ROGERS, RICHARD (b. 1933)

British architect (born in Florence, Italy) known for his MODERN work, most often with a HIGH-TECH character, such as that of the now famous Centre Pompidou in Paris (1971–77) designed in collaboration with Renzo Piano (b. 1937). Rogers was trained at the Architectural Association in London and Yale University at New Haven, Connecticut. Rogers worked with Norman Foster in England before forming a partnership with Piano in 1970. The partnership won a competition for the design of Centre Pompidou and has worked on many other projects, including the research laboratories for Patcentre at Cambridge, England (1974–75). Since establishing a separate practice in 1977 (Richard Rogers and Partners, Ltd.), his firm has produced a number of projects, the most visible being the new London headquarters for Lloyd's of London. The PA Technology Facility at Princeton, New Jersey (1985), is a major project in the United States, with a cable-suspended roof structure and exposed utilities in typically high-tech fashion. Rogers has won many awards, including a 1985 RIBA (Royal Institute of British Architects) gold medal.

ROHDE, GILBERT (1894–1944)

Pioneering American industrial designer whose career in the 1930s was an important factor in introducing MODERNISM to the United States. Rohde became familiar with cabinet-making in his father's shop. He worked as a furniture illustrator for several New York stores before making a trip in 1927 to Paris, where he became familiar with the MODERNE styles of the 1920s. In 1929 he opened his own design office, working on interiors and producing modern furniture designs at a time when modernism was largely unknown in America. In 1930 he established a relationship with HERMAN MILLER, INC. that was central to both his career and that furniture company's growth. His designs were clearly modern, although they incorporated decorative elements that now seem to imply ART DECO directions, with much use of exotic wood veneers, glass, mirrors, and chrome details. He developed the concepts of modular and sectional furniture and applied the modular idea to office furniture in his Executive Office Group (EOG).

Rohde had a number of other furniture design clients, including the Kroehler Manufacturing Company, Valentine Seaver, the Troy Sunshade Company, and Heywood-Wakefield. His clocks for the HOWARD MILLER CLOCK COMPANY are fine examples of Art Deco or-

Furniture design by Gilbert Rohde, including the Paldao group of 1941 for Herman Miller. Photo by Louis Werner, courtesy of Herman Miller, Inc., Archives.

namentalism with their abstract, geometric forms and glittering materials. Rohde developed various exhibit designs for the 1939 New York WORLD'S FAIR. A living room of his design suggesting the modernism of the 1950s was included in the Metropolitan Museum of Art's *Contemporary American Industrial Design* exhibition (1940) in New York. He was briefly the director of the short-lived Design Laboratory School, a project sponsored by the WPA from 1935 until 1938. He was the head of the industrial design program at the New York University School of Architecture from 1939 until 1943. Rohde's influence is most strongly felt through his success in convincing the Herman Miller management of the viability of modern furniture design, thus building a foundation for that firm's continued support of many important post–World War II designers.

ROHDE, JOHAN (1856–1935)

Danish early MODERNIST designer of furniture and silverware. Although trained as a painter, Rohde became a designer for the famous Danish silversmith Georg JENSEN. As early as 1897 he designed a wood cabinet for his own use of simple, unornamented form that suggested the directions in which MODERNISM would develop. For Jensen, he designed hollowware in 1906 and flatware in silver in 1908, using the simple but delicately curved forms typical of the style now called DANISH MODERN. Rohde's design thinking had a strong influence on Jensen, helping to form the direction of his own work and of the style of well-designed Danish products sold by the Georg Jensen firm.

ROLLEIFLEX

Brand name of a popular German camera made by the firm of Franke and Heidecke of

Braunschweig (Brunswick), Germany. In the 1920s, this firm introduced small cameras for stereoscopic photography that, in addition to the two photo-taking lenses, provided a third lens for reflex viewing and focusing. As the popularity of stereo photography waned, the firm developed a twin-lens reflex camera for taking single pictures on roll film in a 2¼-inch square format. This first Rolleiflex was introduced in 1928. It became popular at first with serious amateurs, and then, as word of its reliability and high quality spread, it was taken up by professionals as a convenient alternative to larger cameras because of its ground-glass viewing and fine image quality. A number of models introduced over the years added various improvements, such as a crank-wind film advance and wheels to control shutter speed and aperature. The CLASSIC "Rollei" (as it is usually called) was the Automat model introduced in 1937, which continued in production until 1959. The appearance of the Rolleiflex does not fit any clear stylistic category. It is MODERN, but its black and CHROMIUM trim and prominent LOGOTYPE, together with the pattern formed by the twin lenses and twin control wheels, make it unique. Many imitations were produced, but none achieved the quality, popularity, and status of the original, which became the favorite camera of fashion photographers and many other professionals.

With the development of single-lens reflex cameras of high quality such as the Hasselblad, which uses the same film size as the Rollei, and quality 35mm reflexes such as the NIKON, the popularity of the Rolleiflex declined. The firm developed a number of subsequent products including 35mm cameras without achieving the dominance that the older Rollei had sustained for so many years. Recent Rolleiflex designs in production include a roll film single-lens reflex (6000 series) and an unusual 35mm single-lens reflex (3000 series) of modular design with integral motor drive, separable film magazines, and battery case. These expensive cameras of high quality and original design intended for professional use maintain the prestige of the Rolleiflex brand name.

ROMAN (LETTERING)

Term describing letter and typeforms based on ancient Roman inscriptions that used all capital letters with thick and thin strokes ending in SERIFS. Many popular typefaces in modern use such as Baskerville, Bodoni, Caslon, Century, and Garamond are Roman type styles.

Chapel of Notre Dame du Haut at Ronchamp (1950–55) designed by Le Corbusier. Photo by John Pile.

RONCHAMP

Location of and therefore the usual informal name for one of LE CORBUSIER's most important works, the chapel of Notre Dame du Haut near Belfort in the French Vosges, which is generally regarded as a key masterpiece of modern architecture. This building of 1950–55, built to replace a structure destroyed during World War II, marks the architect's abandonment of the strictly geometric forms of his earlier INTERNATIONAL STYLE work in favor of a strongly sculptural, organic, even expressionistic direction. It is a concrete structure, with curving walls and a curved, overhanging hollow concrete roof, suggesting the shape of an airplane wing or, some say, the form of a traditional nun's hat. The internal space is small, but dramatically lit by stained glass windows of Le Corbusier's own design. There is an outdoor chancel for open-air services held for pilgrimage congregations. The site also includes a small hostel to accommodate visitors in simple and austere style.

ROOKWOOD POTTERY

Widely influential American pottery founded in Cincinnati, Ohio, in 1880 by Maria Longworth Nichols, a leader in the American effort to produce art pottery. Rookwood, functioning as a kind of workshop, was eventually influenced by both the ARTS AND CRAFTS movement and ART NOUVEAU. Mary Louise McLaughlin, a rival of Mrs. Nichols, was credited by her with the discovery of what came to be called "Cincinnati faience." International recognition came to Rookwood in 1889 when it was awarded a gold medal at the Paris Exposition Universelle. Helped by a Japanese designer, Kataro Shirayamadani, and by Karl Lagenbeck, the first glaze chemist in America, Rookwood's experimenters discovered decora-

Iris vase of 1907 by Sarah Elizabeth Coyne for the Rookwood Pottery. Photo by John White, courtesy of Garth Clark Gallery.

rated with painted landscapes, was a popular Rookwood item. Production was discontinued after the pottery was sold in 1956.

ROSENTHAL

German manufacturer of porcelain and other tableware and related products, known for its active design program. The firm of Rosenthal Porzellan AG was founded by Philip Rosenthal in 1880 at the town of Selb in Bavaria. The current head of the company, also a Philip Rosenthal, is the grandson of the founder. Early products were white porcelain dishes with elaborate painted decoration. Around the turn of the century the firm specialized in variations on ART NOUVEAU themes. In 1954 a separate division was established to produce the "Studio-Linie"—a variety of products designed by well-known modern designers—distributed in special showrooms called "Studio Houses" after 1960. Probably the most important group produced for the Studio-Linie were the restrained and functional, all-white TAC 1 and TAC 2 tea sets of 1969 designed by Walter GROPIUS (with the Architects Collaborative). Form 2000 by Raymond LOEWY and Richard LATHAM was introduced in 1954, and Drop by Luigi COLANI in 1972. One of the most productive of Rosenthal designers has been Tapio WIRKKALA, the Finnish designer of cutlery, glassware, tableware services, and various

tive techniques and glazes that were widely admired and imitated. Between 1904 and 1940, Rookwood's Vellum glaze ware, often deco-

Thomas TC-100 stacking china dinnerware designed by Nicholas Roerich for Rosenthal Studio-Linie.
Photo courtesy of Rosenthal USA Limited.

small "gift" objects. Other Rosenthal products are the work of Timo SARPENEVA, Wilhelm WAGENFELD, and Bjorn WIINBLAD. Sculptural and decorative designs have been commissioned from designers and artists including Herbert BAYER, Salvador Dali, Henry Moore, Victor Vasarely, and Tom Wesselmann. The Rosenthal factory at Selb (1964–65) and the glassworks at Amberg (1968–69) were both designed by Walter Gropius.

ROSSBACH, EDMUND (b. 1914)

American weaver and textile designer, a pioneer in the development of modern fabrics of colorful, simple pattern. Rossbach studied art education at Columbia University in New York before spending World War II in military service. After the war, he studied at CRANBROOK ACADEMY where he did distinguished work in both ceramics and textiles. He then turned to teaching design and weaving at the University of Washington until 1950 and then at the University of California, Berkeley, until his retirement in 1979. While at the University of Washington, he was influential in leading Jack Lenor LARSEN into his career in weaving and textile design.

Rossbach's work has won many awards and has been exhibited widely in America and Europe. Examples of his work are included in the collections of the Museum of Contemporary Crafts and the MUSEUM OF MODERN ART in New York as well as in museums in Holland and Norway. He is also the author of books on basketmaking and marionettes in addition to *The Art of Paisley* (1980).

ROSSI, ALDO (b. 1931)

Leading Italian modernist architect and theorist whose works combine POST-MODERNIST ideas with a surrealistic abstract quality. Rossi was trained at the Milan Polytechnic Institute. After his graduation in 1959, he established a practice in Milan. He has won many competitions, and his designs, often unbuilt, have been widely published, establishing his reputation. His designs use unornamented abstract, geometric forms, such as cubes or cylinders, in formal compositions that suggest the projects of the 18th-century neoclassicist Étienne-Louis Boullée recast in a way reminiscent of the paintings of Giorgio de Chirico. His project for a vast Cemetery for Modena (a competition winner of 1971) proposed a monumental "city of the dead." Among his built works, the circular li-

Drawing of Aldo Rossi's Teatro del Mondo, a 1979 theater built on a barge for the canals of Venice.

brary for a school at Fagnano Olona, Italy, of 1972–76 and his Teatro del Mondo for Venice of 1979 are particularly well-known. The latter is a tall, octagonal, peak-roofed, boxlike structure of wood on a barge that can be moved along the Venetian canals. With its bright orange and blue colors, it forms a strange contrast with the classic architecture of older Venetian buildings.

With Luca Meda he has designed a metal-framed upholstered seating system and a houselike wooden storage unit, both produced in Italy by Molteni & Co. Rossi is the author of various books including *L'Architettura della Città* of 1966. He has held teaching posts in Milan and is the editor of *Casabella* magazine.

ROWLAND, DAVID (b. 1924)

American industrial designer best known for his 40/4 stacking chair of 1964. Rowland stud-

GF 40/4 stacking chairs designed by David Rowland.
Photo courtesy of GF Furniture Systems, Inc.

ied with László MOHOLY-NAGY in 1940 at Mills College in California and at CRANBROOK ACADEMY (1950–51). He worked in the office of Norman BEL GEDDES in New York before establishing his own design practice there in 1955. His very successful stacking chair of 1964 for GF Industries uses a frame of thin steel wire to support stamped steel seat and back elements. Its name comes from the fact that it permits exceptionally compact stacking—forty chairs make a stack only four feet high. Its simple and elegant appearance has made it a CLASSIC design, widely imitated. Rowland's Sof-Tech chair of 1979 for THONET is remarkable for its use of exposed sinuous steel springs (plastic-coated) as seat and back. Also a stacking chair, its name refers to its industrial, HIGH-TECH appearance.

ROYCROFT SHOPS

Workshops and related community established by Elbert HUBBARD in East Aurora, New York (near Buffalo), beginning around 1893. Hubbard was strongly influenced by the ideas of William MORRIS and the ARTS AND CRAFTS movement. He first established the Roycroft Press to produce a magazine and art-oriented books of Morris-like design. A leather shop was opened and then, in 1901, a furniture shop, producing simple oak furniture in the crafts tradition that was favored by Gustav STICKLEY and his CRAFTSMAN movement at about the same time. A metalwork shop was added, which produced objects in hammered copper. A community grew up around the shops, including the Roycroft Inn of 1903, when some 175 people were employed in the shops. The Roycroft Shops continued in operation until 1938.

RUBBER

Familiar elastic material largely replaced in modern practice by a number of synthetics whose longer-lasting qualities can be exploited in a wide variety of applications. Made from the juice, or "latex," produced by any one of several tropical plants, known as rubber plants, natural rubber has been in use for many years as a material in which springiness, elasticity, or bounce is important. It is commonly used for pencil erasers (the source of the name as they are used to "rub out" errors), for elastic bands ("rubber bands"), and for balls used in sports. Because natural rubbers tend to age poorly, lose elasticity, and eventually crack and disin-

tegrate, a number of modern synthetics are now made from hydrocarbons, usually in the family of butadienes. These are actually PLASTICS, although that term is not usually applied to synthetic rubbers, also known as elastomers or neoprenes, produced under many different trade names. The process of vulcanization (using heat) converts the liquid rubber latex into a useful, stiffened form in a range of hardness, extending to "hard rubber," which is non-elastic. Rubbers are commonly molded into various forms or EXTRUDED into continuous bands useful as straps, hoses, and gaskets. Various types of rubber are in wide general use for such products as automobile tires, insulating and waterproofing products including many forms of washers and gaskets. Rubber webbing straps are used in upholstery construction and in some types of beds to provide softness and bounce. Foam rubber is made by beating in air or by a chemical reaction that creates a spongelike soft mass filled with small air bubbles. Such foam is widely used in furniture cushions and mattresses as well as a material for insulation and sound deadening. The terms "gutta percha," for a material similar to rubber, and "ebonite" and "vulcanite," for hard rubber, were used to identify materials similar to modern plastics that were developed in the 19th century on the basis of a process invented in 1838 by Charles Goodyear.

RUDOFSKY, BERNARD (b. 1905)

Austrian-born American critic, writer, and designer known for exhibits and books exploring varied, sometimes-neglected areas of design. Rudofsky graduated from the Polytechnic Academy of Vienna and then traveled and lived for a number of years on Greek and Italian islands, practiced architecture in Italy, worked in film and stage design, and then, from 1938 to 1941, practiced in Brazil. In 1941 he came to New York as an award winner in the furniture design competition sponsored by the MUSEUM OF MODERN ART. He became a licensed architect in New York, where he continues to live and work. He directed the Museum of Modern Art exhibitions *Are Clothes Modern?* in 1944, *Textiles U.S.A.* in 1956, and *Architecture Without Architects* in 1964. His books, *Are Clothes Modern?* (1947) and *Architecture Without Architects* (1964), grew from the related exhibitions and have been followed by *Streets for People* (1969) and *Now I Lay Me Down to Eat* (1980), the last an outgrowth of an exhibit with the same title at

the COOPER-HEWITT MUSEUM in New York. Rudofsky was an editorial and art director for *INTERIORS* magazine from 1946 to 1949. He has held teaching posts at MIT and Yale and in Tokyo and Copenhagen and has won many awards, including Ford Foundation, Fulbright, and Guggenheim grants. Rudofsky's special role has been to explore, document, and exhibit important aspects of MODERN design reality that have been otherwise ignored and neglected. His writing has been widely translated and published, making him an internationally known and respected critic and thinker.

RUHLMANN, ÉMILE-JACQUES (1869–1933)

French interior and furniture designer, a leader in the design directions of the 1920s now known as ART DECO. Born in Paris, Ruhlmann did not attract notice until the *Salon d'Automne* of 1910. There he first exhibited furniture in his personal style, elegant and formal, suggestive of 18th-century traditional design, but with simplified detail, often using rich materials such as ivory inlaid in ebony or other fine woods. He was a co-founder of the post–World War I firm of Ruhlmann et Laurent, a manufacturer of limited-quantity production versions of typically costly, luxurious Ruhlmann furniture designs. In the 1925 Paris exhibition, his rooms were among the most striking examples of Art Deco work. His Grand Salon in the *Pavillon d'un Collectionneur* was filled with furniture, lighting fixtures, and art work in an almost Victorian profusion, but the designs for each item, including a fantastically abstract painted ceiling, pointed toward a MODERNIST direction. A portfolio of his work, *Croquis de Ruhlmann*, published in the 1920s helped make his style widely known and imitated. His later work in the 1930s takes a simpler direction, relating the ideas of STREAMLINING that were developing in the MODERNE style, while maintaining the emphasis on fine materials and craftsmanship characteristic of his earlier work. His desk for the Maharajah of Indore uses Macassar ebony with CHROMIUM trimming in a symmetrical design, with a huge semicircular top supported on two slim drawer pedestals in a way that presages the concepts of recent modern office furniture. Ruhlmann was the designer of one luxury stateroom on the famous French liner NORMANDIE. His style, however, was dominant in many of its interiors through the work of many of his friends and followers who executed interiors for the ship after Ruhlmann's death.

RUMPLER, EDMUND (1872–1940)

German designer and builder of early aircraft and automobiles. Rumpler began his career as a maker of aircraft, notably his Taube (dove). After World War I, when Germany was prohibited from developing powered aircraft, Rumpler turned to the design of automobiles. His 1921 design for a streamlined car was named the Tropfenwagen (teardrop car). In side view it had a simple, rectangular box form, but in plan it was of typically streamlined shape with a rounded front and a rear tapered to a thin edge. Solid disk wheels were used with smoothly shaped fenders, and the radiator was enclosed, both drag-reducing features. The car's AERODYNAMIC qualities were studied at EIFFEL's laboratory at Auteil, France. While advanced for its day, the use of streamlined form only in the horizontal plane suggests that Rumpler did not fully grasp the possibilities of three-dimensional, sculptural aerodynamic form.

RUSSELL, (SIR) GORDON (1892–1980)

English furniture designer known both for his creative work and for his role as a publicist for MODERNISM in design. Russell grew up in the Cotswold district of England and was educated at Chipping Campden while Charles ASHBEE's Guild of Handicraft was based there. After service in World War I, he became interested in handmade furniture production in the ARTS AND CRAFTS tradition. An exhibition of his work at Cheltenham in 1922 was well-received and led to the establishment in 1926 of Gordon Russell Ltd. for industrialized production of his designs, which were generally simple and unornamented, but more conservative than modern in character. In 1930 he began to design radio cabinets for Murphy Ltd. with his brother, Richard D. Russell, which, with their curving, molded plywood forms, suggested directions appropriate to mass production.

In 1947 Gordon Russell became the director of the Council of Industrial Design and, in that capacity, became an official spokesman for the cause of quality design in England. As a member of the Board of Trade's committee on furniture during World War II, he was influential in the development of simple, unornamented, wood "utility" furniture. The British Design Centre was opened under his direction of the Design Council. He received many honors and awards and was knighted in 1955.

RYBICKI, IRVIN W. (b. 1924)

American automotive designer and design executive who has, in his positions at GENERAL MOTORS (GM), exerted a major influence on the STYLING of American automobiles since 1945. Rybicki has spent his entire career at General Motors, moving up through the organization to become a manager in the 1960s with responsibility for Buick, Cadillac, and Oldsmobile styling. After the retirement of Bill MITCHELL, Rybicki became vice president in charge of design in 1977. Under his direction, design at General Motors has moved away from the excesses of chrome and tail-fin styling of the 1950s and 1960s and has led GM toward design directions that might be characterized as middle of the road, somewhere between flashy and conservative. Rybicki is known as a skilled manager (he is a 1977 graduate of an Advanced Management Training Program at Harvard) and a diplomatic and responsible executive whose achievements have been more in the direction of avoidance of blatant error than in striking design leadership.

RYKIEL, SONIA (b. 1930)

French fashion designer known for her sweaters and sweaterlike costumes. Rykiel's interest in costume began when she designed her own maternity clothing, leading to professional work with the firm of Laura, which was owned by her husband. In 1968 she opened her own Paris boutique in the Galeries Lafayette department store and then her own Left Bank shop. She now operates shops in her own name, three in Paris, one in London, and one in New York. Her closely fitted, elegantly detailed ready-to-wear sweaters and sweater dresses have remained her speciality. She has also offered leather goods, a perfume, and a licensed collec-

tion of lower-priced knitwears. Her designs are known for their easy informality and ready combination, forming varied outfits related through color and the knit theme that is her signature. In 1986 she won a Fashion Group Award.

SAAB

Swedish industrial manufacturing company, whose full name is Svenska Aeroplan Aktiebolaget (Swedish Aircraft Company), known for the design excellence of its products, particularly the automobiles that bear the Saab name. The firm was established by Marcus Wallenberg to produce military aircraft. After World War II, the firm turned to the production of automobiles and introduced the Saab 92 in 1949, with engineering design directed by Gunnar Ljungstrom and body design by technical illustrator Sixten SASON. Related designs through Saab 96 continued in production until Sason's retirement in 1980. Design was then taken over by Bjørn ENVALL whose 900 series Saabs offer excellent technical and ergonomic qualities, along with a visual aesthetic unique to Saab production.

SAARINEN, EERO (1910–1961)

Finnish-born American architect whose varied and imaginative work in both furniture design and architecture were a significant part of the design scene in the 1950s. The son of the famous Finnish architect Eliel SAARINEN who relocated in the United States in 1923, Eero Saarinen grew up at CRANBROOK ACADEMY where his father was a principal teacher. He planned to become a sculptor and studied in Paris from 1930 to 1931, but returned to study architecture at Yale. He graduated in 1934 and worked briefly for Norman BEL GEDDES before returning to Cranbrook. He worked there with Charles EAMES and won two first prizes with him in the 1940 Organic Design in Home Furnishing competition organized by the MUSEUM OF MODERN

Original Saab 92 sedan of 1949. Photo courtesy of Saab-Scania of America, Inc.

Lounge ("Womb") chair designed by Eero Saarinen in 1946. Photo courtesy of Knoll International, Inc.

ART in New York. The winning designs were never placed in production, but they led to continued design development that finally produced the KNOLL lounge chair of 1948 (familiarly known as the Womb chair for its comfortably curved plastic shell) and the ped-

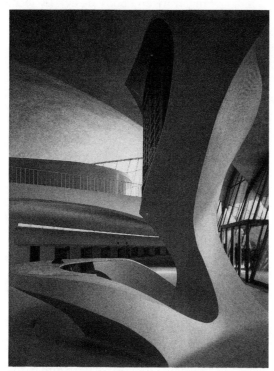

Interior of TWA terminal at New York's Kennedy airport. Eero Saarinen, architect. Photo by Ezra Stoller Associates, courtesy of Trans World Airlines.

estal-based Knoll tables and chairs of 1957 using FIBERGLASS shells on ALUMINUM bases.

As an architect, Saarinen began in partnership with his father in 1936, and often worked with Robert F. Swanson as associate or partner (from 1944 to 1947). That firm (Saarinen, Swanson, and Saarinen) won a national competition for a Smithsonian Gallery of Art for Washington, D.C., in 1939, which was never built. A number of distinguished schools, a 1942 church in Columbus, Indiana, and the music shed at Tanglewood, Massachusetts, were among the projects completed before the death of the elder Saarinen. Thereafter, Saarinen carried on his practice in his name alone, with Joseph Lacy, John Dinkeloo, and Kevin Roche as partners.

The General Motors Technical Center (1948–56) at Warren, Michigan, is designed in a severe, Miesian INTERNATIONAL STYLE. In later work, Saarinen took pride in developing a unique design direction for each project, never adapting a personal style to be applied to every project. Nevertheless, all his buildings share a quality that might be described as sincerity, a directness and simplicity along with a certain poetic sensibility. Important works in a sculptural vocabulary include MIT's Kresge auditorium (a huge spherical triangle touching the ground at only three points) and cylindrical, brick chapel (1953–55) in Cambridge, Massachusetts, as well as the Yale Hockey Rink (1953–59) in New Haven and the TWA passenger terminal (1956–62) at Kennedy airport in New York. In a more restrained vocabulary are the CBS tower (1965) in New York and the John Deere office building (1965) in Moline, Illinois, which were both completed after Saarinen's death. One of his last designs, the main building of Dulles International Airport (completed 1963) outside Washington, D.C., combines the restrained and the sculptural directions in his work with a vast, curving, cable-suspended roof hanging between sloping concrete supports. His partners Roche and Dinkeloo completed on-going projects and carried on the firm's practice in a successor firm in their own names.

SAARINEN, ELIEL (1873–1950)

Leading architect of the national Romantic movement in Finland, who built a second career in a more MODERNIST direction after relocating in the United States in 1923. Born in Rantasalmi, Finland, Saarinen was trained at the Helsinki Polytechnic. His early work was

done in partnership with Herman GESSELIUS and Armas LINDGREN, themselves leaders in Finnish architecture of the early 20th century. Their offices and houses in Hvittrask are a fine example of the Romantic style at its best. Saarinen alone was responsible for the executed design of the Helsinki Railway Station (1910–14), a building that brought him international fame. His second-prize design in the 1922 competition for the Chicago Tribune Building received critical acclaim and led to his coming to the United States. He became associated with CRANBROOK ACADEMY in 1925, designed its buildings, and taught architecture there, eventually becoming its president (1932–46). Frequently, he designed interiors, furniture, lighting fixtures, and other decorative elements for his buildings, working in a vocabulary that combined MODERNISM, a craft orientation, and a decorative style relating to the ART DECO work of the 1930s. He practiced alone and then in partnership with his son EERO, producing a number of distinguished buildings, such as a 1942 church in Columbus, Indiana, and the shed at Tanglewood, in Massachusetts, which combined the rigors of INTERNATIONAL STYLE modernism with a delicacy and charm that stemmed from the Scandanavian Romantic movement of his early career.

SAARINEN, LOUISE (LOJA) GESSELLIUS (1879–1968)

Finnish weaver and textile designer, who exerted a strong influence on the quality design aspects of modern textile production. The sister of the distinguished Finnish architect Herman Gessellius, Louise studied art at various schools in Finland and in Paris before returning to Finland and marrying her brother's partner, Eliel SAARINEN. She relocated in the United States with her husband in 1923 and became part of the creative community at CRANBROOK ACADEMY. In 1928 she established her own textile studio under the name Loja Saarinen. In 1930 she took over direction of the weaving shops at Cranbrook, continuing as department head until retirement in 1942. Her designs for carpets and textiles were widely exhibited and won many awards. Many of her designs were developed in cooperation with her husband for use in his buildings. Her style combined the restraint of MODERNIST work with the decorative patterns of Scandinavian traditional weaving and the geometric sense of ART DECO work of the 1920s and 1930s. She was the teacher of

many distinguished textile designers and craft weavers whose influence continues in present work.

SACCO, BRUNO (b. 1934)

Italian industrial designer who has directed the design program of MERCEDES-BENZ since 1975. After receiving his design training in Turin, Italy, Sacco began work with Mercedes-Benz at the Stuttgart factory in 1958. His most visible work has been the body and interior design for the 190 and 190E models of 1982, the first effort of Mercedes-Benz to produce a relatively small car. In accordance with Mercedes custom, the design is restrained and conservative, emphasizing continuity with earlier design over innovation. Respect for tradition and for expression of quality are dominant in a way that makes Sacco's work very different from the more flamboyant qualities usually associated with modern Italian design.

SAINT LAURENT, YVES (b. 1936)

French fashion designer sometimes regarded as the "king of fashion" for his enormous success based on design which is practical, charming, or pretty while still expressing the high style of haute couture. Saint Laurent was an art student in Paris when, at the age of seventeen, he won a fashion sketch contest staged by the International Wool Secretariat. At nineteen he was employed by Christian DIOR, becoming head designer for that house on Dior's death in 1958. With the support of an American financial backer, he opened his own firm in 1962, established his ready-to-wear line, Rive Gauche, in 1966, and added men's wear design in 1974. His work is known for its practical qualities, along with a certain glamour and occasional exotic touches based on oriental art, and gypsy and African motifs. His name and YSL initials have become a brand name identification, licensed to cosmetics, linens, perfumes (including the popular Opium and Y), sweaters, and other products with vast commercial success. He was honored with a retrospective exhibit of his work in 1983 at the Costume Institute of the Metropolitan Museum of Art in New York.

SAKIER, GEORGE (1893–1965)

American designer known for his work in the 1930s as a staff designer for the U.S. Radiator and Standard Sanitary Corp. Sakier was trained as an engineer, but studied art in Paris

before returning to the United States in the 1920s to become an illustrator and art director on *Harper's Bazaar* magazine. In the late 1920s he became the head of the Bureau of Design set up by U.S. Radiator. His most famous design was the Arco Panel lavatory, in which a prefabricated mirror, cabinet, and lighting unit formed a floor-to-ceiling backing for a wash basin. The unit was included in the New York MUSEUM OF MODERN ART 1934 *Machine Art* exhibition. Sakier also worked for other manufacturers, including the Fostoria Glass Company, for whom he designed simple ribbed glass bowls and vases (c. 1929).

SALADINO, JOHN (b. 1939)

American interior designer known for his modern work, which incorporates a sense of color and tradition that gives it a somewhat romantic quality. Saladino studied art history at Notre Dame University and painting at Yale, where he studied with Josef ALBERS. He worked for a time for an architect in Rome and for the office design firms of Saphier, Lerner, Schindler, and JFN in New York before starting his own practice in 1972. He has designed a number of residential and office interiors, including corporate offices for the Almay cosmetics firm in New York (1979). His work has a basis in the MODERN or LATE MODERN traditions, but is softened by an artistic color sensibility and a use of materials and textures that suggests more traditional design. In addition to interiors, Saladino has developed furniture designs, first, for the Indiana firm of Dunbar and, more recently, for distribution through his own showroom.

SAMPLE

Term used in the design fields for a single example of a product or other designed object. Although sample is often used interchangeably with PROTOTYPE, more exact usage distinguishes between the two terms. The more experimental prototype is a single object made by hand, while design is still in a development stage, to test ideas that may be revised as development continues. The sample is a single unit made of a final design, usually using final production techniques, but set aside as a "showcase" item for display, photography, and exhibition before regular production. The term is most often used in fashion design, is not unusual with such home furnishings products as furniture and lamps, and is less used for heavy industrial products such as automobiles or machinery.

SAND CASTING

Production technique for making parts of metals such as aluminum or alloys of lead, zinc, and tin. A mold is made, usually of wood, having the exact form of the object to be cast (with some dimensional allowance for shrinkage of the cast part), which is called a "PATTERN." That is pressed into a bed of damp, fine sand packed in a box. The pattern is lifted out, leaving a hollow in the sand that is the shape of the desired casting. When melted metal is poured into the hollow space, it takes the form of the pattern and, after cooling, can be removed, leaving the sand to be reused as the process is repeated to make a number of castings from the single pattern. A part to be cast in this way must be formed with tapered surfaces and without undercut elements so the pattern can be pulled out of the sand without disturbing the impression into which the casting metal is to be poured. Sand castings create a slightly granular surface, reflecting the texture of the sand, which must be polished or covered with a finished coating for a smooth appearance. The process is relatively slow and requires hand-labor for each casting, so it is best-suited for limited production runs and for making PROTOTYPE parts in small quantities. For larger quantity production, DIE CASTING is usually preferred.

SANS SERIF (TYPE)

Term for any letterform or typeface that omits SERIFs, the short strokes that begin and end the main strokes in ROMAN letterforms. The term "gothic" is also used to identify sans serif faces, somewhat confusingly since "black letter" type is also called "gothic." Sans serif type is regarded as MODERN in feeling and is much used in advertising and display typography. Such typefaces as FUTURA, GILL Sans, and HELVETICA are much-used examples of sans serif type.

SANT'ELIA, ANTONIO

See FUTURISM.

SAPPER, RICHARD (b. 1932)

German-born Italian industrial designer known for products that are both ingenious in technique and elegant in form. Sapper was trained in mechanical engineering and worked, in 1956, for Daimler-Benz in Stuttgart. He moved to Milan in 1958 to work for Gio PONTI and then, until 1977, in collaboration with Marco ZANUSO. This partnership has been re-

sponsible for a number of outstanding Italian product designs having a strongly HIGH-TECH character. Among them are a number of electronic devices designed for the firm of BRIONVEGA, including several hinged portable radios such as the TS502 (1965), the Doney 14 (1962) and Black 12 (1969) television sets, and an Italtel Grillo telephone (1965). The Black 12

Tizio desk lamp designed by Richard Sapper, 1972. Photo courtesy of Artemide Inc.

television set is a particularly striking example of MINIMALIST design: A simple cube of black plastic, its controls are unobtrusively grouped on top, and the screen is invisible except when the set is turned on. The sculptural Grillo telephone was the winner of a 1967 COMPASSO D'ORO award. The team also designed a number of elegant kitchen and bathroom scales for the Italian manufacturer TERAILLON. Working alone in 1972, Sapper designed the Tizio lamp for ARTEMIDE. A spectacularly popular bestseller of contemporary design, its spidery, double-cantilever, adjustable support structure carries power (at low voltage) through its metal parts, making exposed wires unnecessary. His elegant Bollitore kettle for Alessi (1983) uses a triple-whistle spout, the only ornament on a sternly minimalist form. Since 1980, Sapper has been a design consultant to IBM in Italy.

SARFATTI, GINO
See ARTELUCE.

SARPENEVA, TIMO (b. 1926)
Finnish designer of glassware, ceramics, and textiles whose work combines simplicity with a varied sense of color and texture typical of the best of Finnish MODERN design. Sarpeneva was trained in graphic design at the Helsinki School of Applied Art. Beginning in 1950, he became a designer for the Karhhula-Iittala glassworks, where he worked closely with Tapio WIRKKALA and was responsible for many utilitarian and sculptural pieces. In 1962 he established his

China dinnerware designed by Timo Sarpeneva for Rosenthal Studio-Linie. Photo courtesy of Rosenthal USA Limited.

own design firm and has, since then, worked in various mediums.

Many of Sarpeneva's designs introduce textures and color tones, some the result of a technique of his own invention: Glass is blown into a wood mold that contributes a color tone during the process. His designs have won many prizes, including a gold medal at the 1960 TRIENNALE in Milan. Sarpeneva has also designed printed fabrics, iron cooking utensils, and china, including the ROSENTHAL Suomi line of 1976.

SASON, SIXTEN (1912–1969)
Swedish industrial designer, primarily associated with SAAB automobile design, whose work was characterized by an emphasis on strictly practical FUNCTIONALISM, modified by an aesthetic sense that is distinctively Swedish. Trained as a silversmith, Sason became a technical illustrator for the Saab aircraft firm in the 1940s and was asked to contribute to the design of the firm's first automobile, the Saab 92 of 1950. The later model 96 was his most important achievement. Its success led to work with Electrolux and then to his work with Victor Hasselblad in the design of the famous reflex camera of that name which first appeared in 1949.

SCALE
Term used in design fields with two, only loosely related meanings. In its literal sense, scale describes the ratio of reduction of dimensions in drawing or model-making that makes it possible to illustrate a large object with a small image. When working in scale, a small dimensional unit consistently represents a large unit. For example, at a scale of 1" = 1'0", each foot of a real object is represented by 1 inch "at scale." This makes the scale representation ¹⁄₁₂ full size, so this scale can also be indicated by the ratio 1:12. Architects and designers working with objects closely related to architecture, such as furniture, commonly use scales of ⅛" = 1'0", ¼" = 1'0", ½", ¾", 1", 1 ½", and 3" respectively equaling 1 foot. Half-size and full-size drawings are also made, although the latter is not, technically, a scale.

The second, broader meaning for "scale" refers to the relation of actual size to apparent size in any design. The designer's aim is thought to be making an object seem to be the size that it actually is. An object that is really bigger or smaller than it seems is said to have "poor scale." This meaning has been further extended to cover the choice of appropriate sizes for objects or elements in a design so that all parts will seem well-proportioned. It is in this sense that one may say of furniture that seems too large in the space where it is placed that it seems "out of scale" or "over-scaled." "Good scale" also implies sizes and dimensions that relate well to human proportions. The ability to think in terms of scale while designing on paper or in models is an important skill that designers need to learn through training and experience. It is a key factor, although not an obvious one, in the success of design at its best.

SCARPA, CARLO (1906–1978)
Italian architect and interior designer influential as a teacher and through such work as his wood-framed, leather-cushioned Bastiano upholstery system distributed by KNOLL. Scarpa was born in Venice and was trained in architecture at the Accademia della Bella Arte. He opened his own office in 1931 working on minor projects but became known as a designer of glassware for VENINI from 1933 until 1977. He also designed silver for the Vicenza firm of Rossi & Arcandi. He was the designer of a number of exhibitions in Italy including the 1952 Venice Biennale (1952) and a Milan exhibition devoted to the work of Frank Lloyd WRIGHT in 1960; showroom interiors of great simplicity and elegance for OLIVETTI in Venice; and some furniture of restrained, simple rectilinear form inspired by his admiration of Wright. He taught at the Venice Art and Industry Institute from 1945–47 and at the Institute of Architecture at the University of Venice, serving as its director from 1972–78.

SCARPA, TOBIA (b. 1935)
Italian designer of furniture, glassware, and lighting of solid, dignified character within the Italian vocabulary of its time. The son of Carlo Scarpa, Tobia Scarpa was trained in Venice as a designer and worked for the VENINI glass works from 1957–61. His work there includes a number of designs that were exhibited at the Milan TRIENNALE in 1960. That same year, he opened an office together with his wife Afra (b. 1937) where they design furniture and lighting for B & B, CASSINA, Flos, and GAVINA. In his recent work he often uses rich woods with inlays and leathers of luxurious quality in simple, geometric forms modified by simple curves.

SCHAIBLE, MICHAEL (b. 1940)

American interior designer who has been in practice since 1969 with partner Robert BRAY in the firm of BRAY-SCHAIBLE, Inc., in New York. A graduate of the University of Colorado, Schaible also studied interior design at the PARSONS SCHOOL OF DESIGN in New York and worked for the firms of Ford & Earl and Saphier, Lerner, Schindler before opening his own office with Bray.

SCHAWINSKY, XANTI (ALEXANDER) (b. 1904)

Swiss designer and artist who had a brief role in the development of the OLIVETTI graphic and product design style. Xanti (as he prefers to be known) was born in Basel and studied at the BAUHAUS from 1924 to 1929, working closely with Oskar SCHLEMMER in stage design and developing a special interest in designing posters. Until 1933 he worked in Magdeburg, Germany, but then relocated in Italy to work for Olivetti. He was the designer of a famous poster advertising the Olivetti MPI typewriter and worked with Figini and Pollini on the design of the Studio 42 Olivetti typewriter. In 1936 he moved to the United States and taught for a time at Black Mountain College in North Carolina. Since 1938 he has worked only as a painter, except for occasional graphic design assignments. For a time in the 1960s, he developed a remarkable technique in which the artist rolls his body in paint and then onto the canvas.

SCHINDLER, RUDOLPH M. (1887–1953)

Austrian-born American architect who developed a distinctive style in his California work of the 1920s and 1930s. Schindler was a native of Vienna and studied architecture there before coming to America in 1913. He worked for a time for Frank Lloyd WRIGHT carrying on Wright's practice in the Los Angeles area while Wright was in Japan (1916–20). He was the designer of furniture for Wright's Freeman house (1927), in a strongly "Wrightian" vein—rather to Wright's annoyance. Wright eventually broke off all relations with Schindler in 1931. In 1921, Schindler began construction of an unusual house in West Hollywood, California, which was a joint communal residence for the Schindlers and another couple. It consisted of studios opening on garden courtyards, rooftop sleeping areas, and a communal kitchen. It combines elements of INTERNATIONAL STYLE modernism, the constructivist qualities of the work of such Dutch architects as Gerrit RIETVELD and J.J.P. OUD, and aspects of Wright's work of the 1920s. The house was shared for a time with the Richard NEUTRAs while Neutra and Schindler, working first as partners and then separately, were having a parallel impact on the development of MODERNISM in the Los Angeles area. The Schindler house was recently restored to its original condition and is open to visitors as an example of his finest early work. Of Schindler's other houses, the best-known and most-striking is the 1925–26 Lovell beach house in Newport Beach, California, with its strongly expressed concrete structural frame.

SCHLEMMER, OSKAR (1888–1943)

German artist, sculptor, stage and costume designer best known for his work and teaching at the BAUHAUS from 1920 to 1929. Schlemmer was born in Stuttgart and studied art there and in Berlin before becoming a master at the Bauhaus. He developed and taught the course *Man*, a remarkable synthesis of life drawing and the study of ANTHROPOMETRICS, philosophy, psychology, and history. His notes and outlines for this course make up the book *Man*, published in 1969 (in English in 1971). He was a key figure in the stage design program at the Bauhaus, developing an approach to scenery and costume for modern drama and dance in which the human figure was given an abstract, somewhat mechanistic quality relating to concepts of cubism in painting and to INTERNATIONAL STYLE modernism in architecture and interior design.

After leaving the Bauhaus, Schlemmer continued teaching in Breslau and Berlin until abstract art was suppressed by the Nazi regime. From 1940 until his death in 1943 he worked with an enamel factory at Wuppertal. As a painter, Schlemmer focused on the human figure rendered in robotlike, mechanistic terms within spaces that have a surrealistic, abstract, geometric quality. His *Bauhaus Stairway*, a painting of 1932 now in the MUSEUM OF MODERN ART in New York, is a fine example of his work.

SCHLUMBOHM, PETER (1896–1962)

German-born American chemist, and from time to time an inventor of objects that became, in a few cases, CLASSICS of MODERN design. Schlumbohm earned a doctorate in chemistry from the University of Berlin before coming to America in 1935. In 1938 he developed a coffeemaker for his own use from a laboratory

Classic Chemex coffeemaker designed by Peter Schlumbohm. Photo courtesy of Chemex International Housewares Corporation.

flask, funnel, and paper filter, which he patented. In 1941 he began to market his invention under the name Chemex. An instant, popular success, it became a prototype for any number of filter coffeemakers now in production. Schlumbohm developed a number of other products of fine design, including a cork-insulated ice bucket, a cocktail shaker, and an electric fan that required no guard since its blades were soft loops of fabric. Although of handsome appearance and popular for a time, none of Schlumbohm's other designs achieved the lasting success of the famous Chemex.

SCHMIDT, JOOST (1893–1948)

German sculptor and typographer known for his role as an instructor at the BAUHAUS. Schmidt studied at the Weimar academy and then at the Bauhaus before becoming a master there. He was, for a time, in charge of the sculpture workshop, then taught calligraphy, and became director of the classes in advertising graphics from 1928 to 1932. Schmidt was the designer of a number of Bauhaus publications, including the well-known poster of 1923, and of advertisements and exhibitions for various manufacturing firms. After leaving the Bauhaus, he continued in private practice in Berlin and became a teacher there from 1945 until his death.

SCHNELLE, WOLFGANG, AND, EBERHARDT

German management consultants, partners in QUICKBORNER TEAM, a consulting firm named for the Hamburg, Germany, suburb where it is located. The Schnelles and their firm had a significant impact on the practice of office design worldwide in the 1960s, when they developed the concept called BÜROLANDSCHAFT, known in English as OFFICE LANDSCAPE. The influence of this idea has gradually been assimilated into office design practice so that it no longer seems revolutionary.

SCHULTZ, RICHARD (b. 1926)

American furniture designer, whose work is produced by KNOLL and several other manufacturers. A graduate of Iowa State University and the ILLINOIS INSTITUTE OF TECHNOLOGY, Schultz joined Knoll in 1951, working with Harry BERTOIA on that designer's 1952 group of wire furniture. On his own, Schultz designed a small "petal" table, whose top has eight individual panels; a steel and wire chaise; the 1966 Leisure Collection of outdoor furniture whose plastic mesh seating surface is supported in an aluminum frame; and lounge furniture of 1981, all for Knoll. The Leisure Collection was the 1967 AID International Design Award winner. Schultz continues to work in furniture design for several different manufacturers. His Colonnade tables, using large tubular legs with simple slab tops, are part of a recent collection developed for the firm of Conde House.

SCHWITTERS, KURT (1887–1948)

German artist best-known for his work in COLLAGE, a technique he developed into an important MODERN abstract art form. Schwitters was trained in conventional painting at the Dresden Academy and began his career painting traditional portraits. His inclinations toward the DADA movement were set back when he was refused membership in the 1918 Club Dada in Berlin. He developed his own similar direction with the name *Merz* and began to create his *Merzbilder*, "trash pictures," made by pasting together bits of paper and other miscellaneous items, often picked up from the street. He also constructed *Merzbau*, abstract constructions of scrap materials that reached room size, anticipating the "environments" created by some conceptual artists of the 1980s. With the rise of Nazism in the 1930s, Schwitters was forced to relocate first in Norway and then in England. His work has had a continuing influence in the

development of modern art and design, with particularly strong impact on graphic design where collage techniques have been used in such commercial work as advertising layout.

SECESSION

Austrian art movement centered in Vienna (thus also known as Wiener, or Vienna, Sezession) and founded in 1897 when a group of modernists left ("seceded from") the Vienna Academy in protest against its conservative standards. Although the painter Gustav Klimt was one of its leaders, the movement came to be known for its achievements in architecture and design, where it can be regarded as a variant of the JUGENDSTIL or ART NOUVEAU movements. The Secession Gallery in Vienna, designed by Josef OLBRICH in 1897, served as a base for the movement. In addition to Olbrich, important individuals associated with the secession movement are Josef HOFFMANN, Kolo MOSER, and Otto WAGNER, all architects, interior designers, furniture designers, and frequently designers of glassware, jewelry, textiles, and other decorative objects. Their decorative works were often produced by shops that were members of the related WIENER WERKSTÄTTE group. Secessionist design is MODERN in its rejection of historic precedents, and related to Art Nouveau in its use of nature-related and curving forms, but generally more restrained and more geometric in character than related work in Belgium and France. Secessionist design is also described as "rectilinear Art Nouveau."

SECTION

Term frequently used in architecture and design to describe an ORTHOGRAPHIC drawing, in which a building or other object is shown as if cut through (therefore also called a "cross section") to show internal forms and materials. The most usual three views drawn to define the design of an object are PLAN, section, and ELEVATION. Two sections are often developed at right angles to one another: that taken of the long dimension is known as a longitudinal section; that taken across the object is a transverse section. The section is particularly revealing of form and structural detail.

SEMIOTICS

Systematic study of signs or signals that are alternate means of conveying meaning as opposed to words in languages. The term comes from the fields of linguistics and anthropology where the French writer and philosopher Roland Barthes (1915–1980) was influential in relating this somewhat abstruse field to the concerns of designers. Semiotics studies the ways in which the invented forms of art works and forms given to utilitarian objects by designers carry significant thought concepts from the artist or designer to the viewer through visual signs that can be understood as an alternative parallel to verbal communication.

SERIAL PRODUCTION

Alternate term for MASS PRODUCTION, which refers to the repetitious manufacture of identical objects on an assembly line.

SERIF

Term describing the short line or "foot" at the beginning and end of the main lines of letterforms in the ROMAN alphabet. A lettering form

Section view of the Volkswagen Beetle sedan. Courtesy of Volkswagenwerk AG.

or typeface using serifs is called "Roman," as distinguished from SANS SERIF types, which omit all serifs and so suggest the more rapid hand lettering of manuscript writing. Serifs are thought to have been developed as an aid to the ancient Roman stonecutters who carved lettered inscriptions. The serif provided a sharp cutoff line that helped make the carved or incised letter easy to cut with precision. Serif types are considered to be traditional in feeling, but are thought to be easier to read than sans serif faces and so are still widely used in modern typography.

SHAKER DESIGN

Style of 19th-century furniture and other objects, representing a forecast of the direction MODERNISM was to take, produced by the American religious sect known as Shakers (because of the dancelike movements that were part of their religious services). The first Shakers arrived in America from England in 1774. They built their own residential communities and produced their own furniture, stoves, tools, and other utilitarian objects. They designed these things in accordance with their devotion to simplicity and practicality and their desire to avoid ostentation and to conserve time and energy for religious pursuits. These goals led to designs of great simplicity and elegance. Developed during the 19th-century, Shaker design stood in striking contrast to the dominant Victorian taste. Shaker objects, particularly chairs and boxes, were produced for sale to outsiders and became popular for their practicality and simple appearance. Shaker design remains greatly admired, valued by collectors, and much-reproduced. Exhibits of Shaker work, such as that at the WHITNEY MUSEUM OF AMERICAN ART in 1986, keep this style in view and make it a continuing source of inspiration to contemporary designers.

SHARP, GEORGE G. (1874–1960)

English-born American naval architect, the founder of the still-active firm of George G. Sharp, Inc., which has been responsible for the design of more than 1,500 successful ships, including a number of outstandingly innovative designs. Sharp was educated in Scotland and came to the United States in 1902. He worked for a number of shipbuilding organizations in positions of increasing importance until 1916, when he was appointed chief surveyor of the American Bureau of Shipping. In 1920 he founded his own firm in New York. The 1939 Panama Line passenger ships *Ancon, Cristobal,* and *Panama* were notable for their innovative design, for their striking appearance, and for their interiors (with decorative design by the office of Raymond LOEWY), which used only fireproof materials throughout. The Sharp firm was also responsible for many wartime designs. In the 1950s and 1960s, Sharp developed the first cellular containerships and the first roll-on/roll-off (RO/RO) ships, which greatly improved the efficiency of cargo loading and unloading operations, both types now in general use worldwide. The first nuclear-powered merchant ship, the *N.S. Savannah,* a vessel of handsomely streamlined form, which was eventually converted to an ocean research vessel, was designed by the Sharp firm. The firm continues to be a leading designer of merchant and naval ships for both American and foreign clients.

SHEELER, CHARLES (1883–1965)

American artist and photographer whose sharply realistic paintings of architectural, industrial, and mechanical subjects helped focus attention on the AESTHETIC possibilities of such materials. Sheeler began his career in 1912 as an architectural photographer. Under the influence of Alfred STIEGLITZ, his photographic work gradually became more abstract, while his painting took on the realistic qualities of photographs. His 1939 painting, *Rolling Power,* is an almost literal translation into color of his black-and-white photograph, *Drive Wheels,* a documentary view of the wheels of a modern steam locomotive. Sheeler's rendition of subjects that are not inherently mechanistic still has a clarity and precision of FORM that suggests a relationship to the art of cubism. In his photography and in his painting, Sheeler demonstrated the connections between art and design in a way that was significant for both fields.

SHEER

Technical term in naval architecture for the slight front-to-back curvature of a ship's deck, now also used for similar curvature in other objects. Sheer seems to have been introduced in the design of ships to raise the front or bow as an aid in throwing off waves; it also acts to drain off any water that might have been taken aboard. The curvature from side to side known as CAMBER, together with sheer, makes a vessel self-draining to some degree. Sheer is often

omitted in the design of modern ships as being costly in construction and no longer necessary for practical reasons. However, the aesthetic effect of well-laid-out sheer is still regarded as important in explaining the attractive appearance of so many boats and ships.

SHELDON, ROY
See ARENS, EGMONT.

SIEGEL, ROBERT
See GWATHMEY, CHARLES.

SIKORSKY, IGOR (1889–1972)
Russian-American inventor, aeronautical engineer, and designer of a wide variety of aircraft. Sikorsky was born in Kiev and as a boy began to build airplane models of wood and paper after learning of the work of the WRIGHT BROTHERS and of Count von ZEPPELIN. A graduate of the Naval College at Petrograd, he studied engineering in Paris and graduated from the Petrograd Polytechnic in 1907. He returned to Paris in 1909 and came to know many of the pioneers in French aviation. Back in Russia, he began to design and build experimental, though unsuccessful, helicopters and successful airplanes, one of which won a 1912 award at a Moscow aviation exhibit. By 1913 he had designed and built the giant Le Grand, a four-engined airplane with a 91-foot wingspan, an enclosed passenger cabin of considerable luxury, and even an outdoor observation platform! After the 1917 Revolution, Sikorsky

Igor Sikorsky lifting off in the original Sikorsky helicopter. Photo courtesy of Sikorsky Aircraft.

relocated to France and then, in 1919, to the United States. By 1923 he was heading his own firm and developing a twin-engined transport as well as the S-38 amphibian, the first of a series of amphibians and flying boats that became the primary equipment of the developing Pan American Airways.

In 1938, Sikorsky returned to the design of helicopters and in 1939 demonstrated his VS-300, the first practical single-main-rotor design. With military sponsorship before and during World War II, a series of Sikorsky helicopters were developed, including the highly successful S-55 and S-58. Turbine, multi-engined, and amphibious helicopters followed, as did a series of Skycrane designs capable of lifting and transporting heavy loads. Sikorsky was the recipient of many hon-

Sikorsky S-42 four-engine flying boat of 1935, illustrated in a contemporary postcard.

ors and awards. The Sikorsky firm continues to be a major producer of helicopters of many types. All are based on Sikorsky's original concept of using a large, main lifting rotor with a small antitorque rotor at the rear of the aircraft.

SINCLAIR, CLIVE (b. 1940)

English electronic engineer, inventor, and designer whose miniaturized products are remarkable for their design quality. Founded in 1962, his firm, Sinclair Radionics, developed the first truly pocketable calculator, the Executive of 1972. The winner of a 1973 British Design Council award, it is singular in its simple design in black plastic, developed in collaboration with Sinclair's brother, Iain. The 1976 miniature television set, Microvision, and the compact personal computer (1980) distributed by Sinclair Research have followed a similar pattern of design excellence in simple, minimalist, functional terms. The computer, ZX81, won a 1982 Design Council award. However, Sinclair's successes have suffered, in part, from the fact that his products, each somewhat ahead of their time, have been quickly confronted with competition from larger manufacturers who produce similar products of lesser design quality but with superior distribution, tending to push Sinclair out of mass markets anywhere but England.

SITE (SITE PROJECTS, INC.)

New York firm dealing with environmental and architectural projects in an unusual, experimental, and often irreverent fashion. The organization was founded in 1970 by James WINES with Alison Sky, Emilio Sousa, and Michelle Stone. Although Wines's background is in sculpture, most SITE projects deal with architecture in terms that the group calls "de-architecture" in which the realities of a building are altered in ways that are sometimes startling, playful, and even humorous. The best-known SITE projects are a number of retail showrooms for Best Products Company, including the Peeling Project in Richmond, Virginia (1971–1972), the Notch Project, Sacramento, California (1976–77), and the Tilt Showroom at Towson, Maryland (1976–78). The names describe the curious exterior treatments: a facade appearing to peel away from its building, a facade notched by a broken-away corner that provides the building's main entrance, and a facade tilted up in relation to the building that it fronts. An unbuilt highway rest stop intended for Interstate I-80 in Nebraska included oddly corrugated road surfaces that would make a routine facility into an outdoor work of environmental art. SITE's projects have been widely published in periodicals and are documented in *SITE: Architecture as Art* (1980) and *De-architecture* (1988). In a way parallel to POST-MODERNISM,

"Indeterminate Facade Showroom" for Best Products Company, Houston, Texas, a 1975 project of SITE Projects, Inc. Photo courtesy of SITE Projects, Inc., ©1975.

SITE's de-architecture poses a challenge and offers alternatives to the norms of MODERNISM.

SITTERLE, HAROLD AND TRUDI (b. 1910) and (b. c. 1920)

American ceramicist-designer couple who built a considerable success with a limited line of products that they both designed and produced in their own workshop. Harold Sitterle was a graphic designer who gave up his job to enter into partnership with his wife, Trudi who was a ceramicist. Beginning in 1949, the Sitterles introduced various objects in porcelain, pitchers, candlesticks, and serving tools. Their 1949 salt dish and pepper mill were exhibited in New York's MUSEUM OF MODERN ART 1950 GOOD DESIGN show and became a best-seller, as well as a modern design CLASSIC. The Sitterle success is often cited as an outstanding example of the way in which independent designers can avoid difficulties in working with major manufacturers by setting up their own production facilities and selling their products directly to the public through normal retail channels.

SKIDMORE, OWINGS & MERRILL

Large American architectural firm known for the high quality of its output, generally characterized by the austerity of INTERNATIONAL STYLE along with the use of fine materials and careful detailing. The firm was founded in 1935 in Chicago by Louis Skidmore (1897–1962) and Nathaniel Owings (b. 1903, now retired); after 1939, engineer John O. Merrill (1896–1976) became part of the firm. The firm now has offices in New York and Seattle as well as Chicago and has taken in many partners, replacing the original founders with a constantly renewed direction. Although inclined to avoid development of individual "star" partners, SOM (as it is informally known in the profession) produced much of its best work under the direction of Gordon BUNSHAFT. Lever House (1951–52), the first glass-sheathed New York skyscraper of outstanding design, made Bunshaft a leader in the direction American architecture was to take for many years. The U.S. Air Force Academy at Colorado Springs (1959), the Beinecke Rare Book Library at Yale (1963), the Chase Manhattan Bank Office Building (1961) in New York, and the John Hancock Tower (1970) in Chicago are well-known examples from the list of hundreds of building that SOM has produced. Although SOM work has sometimes been

Lever House (1951–52), a New York office building designed by Skidmore, Owings & Merrill (Gordon Bunshaft, designer in charge). Photo courtesy of Skidmore, Owings & Merrill.

criticized as cold or overly mechanistic, it has set a standard of quality that is universally recognized. Recent work has tended to be less doctrinaire in design orientation, suggesting the influence of post-modernist thinking in American architectural practice.

SMALL, NEAL (b. 1937)

American designer and sculptor, a specialist in the design of simply formed objects made in transparent acrylic PLASTICS. Small set up his own firm, Neal Small Designs, in the 1960s to manufacture furniture, lamps, and other products of Plexiglas, formed by minimal bending into useful forms of great elegance and restraint. He also provided designs to other manufacturers, including NESSEN Lamps, Inc., for whom he developed the 1970 Miri lamp, a white hemisphere of translucent plastic supported by a frame of slim CHROMIUM-plated steel tube. From 1973 to 1978, Small gave up manufacturing to concentrate on design in his own country studio. Since 1978, his firm, Squire and Small, has developed sculptural projects as

well as product designs for various manufacturers.

SMITH, DAVID B. (b. 1932)

American industrial designer; with Deane RICHARDSON, a co-founder in 1960 of RICHARDSONSMITH (now Fitch Richardson Smith), a Columbus, Ohio, based design firm, one of the largest currently in practice. David Smith received his training in industrial design at PRATT INSTITUTE. He worked for several design offices in Detroit, Michigan, and in Frankfurt, West Germany, before joining in the establishment of his own firm. His work has included many award-winning projects for Crown Controls, a maker of power-driven freight-handling equipment and one of RichardsonSmith's original clients.

SONY

Japanese manufacturer of consumer electronic products known for its high standards of both technical quality and design. The firm was founded immediately after World War II as TTK (an abbreviation for its Japanese name meaning Tokyo Telecommunications Engineering) by Masaru Ibuka and Akio Morita. In 1955 the firm marketed the first transistor radio, the TR-55 under the Sony brand name, beginning a flow of miniaturized electronic products. The 1959 portable TV set TV5-303 made television compact and convenient. The Trinitron color TV tube of 1968 introduced a new level of color picture quality and began a sequence of TV products of good design quality

Sony miniature 8mm videocassette recorder and color monitor combination, designed by Sony staff.
Photo courtesy of Sony Corporation of America.

that have become internationally known and popular. The 1979 Walkman cassette recorder introduced the pocketable hi-fi music system. Although Sony designers remain anonymous, the quality of Sony design has been a major factor in the success of the firm's products.

SOTTSASS, ETTORE, JR. (b. 1917)

Austrian-born Italian industrial designer, a key figure in the recent history of Italian design. Sottsass was trained in architecture at the Turin Polytechnic, graduating in 1939. He founded his own firm in Milan in 1947, working on interior and exhibition design as well as the design of products. His work for OLIVETTI has included the 1959 Elea computer system and a number of office machines, including the 1963 Praxis 48 electric typewriter of unusually rectilinear form and the playful Valentine of 1969 designed with British designer Perry KING. He was the winner of COMPASSO D'ORO awards in 1959 and 1970. His work has included furniture for KNOLL and Poltronova, lamps for Arredolouce, and metal products for Alessi. His recent work has turned away from the logical vocabulary of MODERNISM toward a more personal, even eccentric style associated with STUDIO ALCHYMIA and the MEMPHIS group. The Nefertiti desk of 1969 is a massive, boxy, post-and-lintel construction of architectonic form, while the 1981 Casablanca storage unit is of oddly hyperactive form and color. Since 1980, Sottsass's firm, Sottsass Associati, has included Aldo Cibic, Matteo Thun, and Marco ZANINI. The firm and Sottsass himself continue to be strongly influential in current directions in industrial design.

SPACE DESIGN GROUP

New York interior design firm specializing in office design and space planning. The firm was founded in 1958 by Marvin B. AFFRIME, who continues as its leader with Frank R. Fialla as partner in charge of design. The firm's work is in the traditions of MODERNISM, with lively use of form and color in projects that include many large corporate headquarters and offices for major advertising agencies. The New York offices of Benton & Bowles (1969), BBDO Worldwide (1969), the International Paper Corporation (1983), and National Westminster Bank (1984), and the headquarters of the Johns Manville Corp. (1977) in Denver, Colorado, are among the projects for which Space Design Group is well-known.

Eastside Collection seating and table designed by Ettore Sottsass for Knoll, 1983. Photo courtesy of Knoll International, Inc.

SPARKMAN & STEPHENS

American firm of naval architects noted for the design of sailing yachts. The firm was established in New York in 1928 by Olin and Roderick STEPHENS and Drake Sparkman. With Olin Stephens as its leading designer until his retirement in 1979, the firm designed many cruising and racing yachts, including a series of America's Cup winners. *Freedom*, a 135-foot luxury yacht built in Italy in 1986 with an all-ALUMINUM hull, is a fine example of recent work of the firm. Sparkman & Stephens designs have set a high standard in both performance and AESTHETICS for modern sailing craft.

1938 sailing yacht, the yawl Edlu, *designed by Sparkman & Stephens.*

SPILMAN, RAYMOND (b. 1911)

American industrial designer whose career forms a cross-section of American product design from the 1930s to the present. Spilman was educated in art and design at Kansas State University and worked in design for GENERAL MOTORS (1935–40), for Walter Dorwin TEAGUE (1940–42), and for Johnson-Cushing Nevell before forming his own firm in 1946. His clients have included the American Optical Company, American Sterilizer (hospital equipment), Cosco Household Products, and Underwood typewriters (Model 18 of 1960). Spilman has been a lecturer and critic at Columbia University, RHODE ISLAND SCHOOL OF DESIGN, and MIT. He has shown a special interest in issues relating to the use of color in design and, since 1978, has been at work on a comprehensive history of the industrial design profession.

SPLAY

Term for an outward slope or spread, often used in describing furniture designs in which legs or feet are angled outward from top to bottom. Splay is commonly used for improving stability and discouraging the RACKING that can occur if joints weaken or leg material is too flexible in parallel legs.

STABILITY

Quality in an object that encourages equilibrium and discourages unwanted movement such as, for example, overturning of furniture. Although the term is often used loosely as synonymous with "strength," its more exact meaning in design refers specifically to the development of a form that resists any tendency exerted by the force of gravity to unbalance it. In order to stand securely, an object must be designed so that its center of gravity is located above the area defined by the outside limits of its base support. Such an object should maintain stable equilibrium when any anticipated loads are applied during use. An unstable chair, for example, may overturn if a user sits on a front edge or an arm, or if it tips back beyond a certain point where the center of gravity of the chair and occupant together moves outside the volume of space directly above the outside limits of the base. CANTILEVER forms are particularly subject to stability problems and require careful study to ensure that overturning will not occur as weight is placed on overhanging portions.

Stability is also an important issue in the design of mobile objects such as vehicles and boats where dynamic forces are involved in addition to the force of gravity. An automobile is expected to resist overturning in all normal and probable emergency maneuvers. The stability of a ship is the quality which ensures that it will not capsize when rolling in response to wave action.

STAM, MART (b. 1899)

Dutch architect and designer, best known as a pioneer in the development of tubular steel furniture, particularly the CANTILEVER chair, which became a favorite concept among various designers of MODERN furniture. Stam worked in several architectural offices in Rotterdam, including the office of Brinkmann and Van der Vlugt where he had a role in the design of the 1928–29 Van Nelle factory in Rotterdam. From 1928 to 1929 he was a visiting instructor at the BAUHAUS. Stam designed his cantilever chair in 1927 for exhibition in the WEISSENHOF exhibition at Stuttgart. His first PROTOTYPE used sections of straight tubing connected by elbow joints. Chairs using a similar concept were then designed at the Bauhaus by Marcel BREUER and Ludwig MIES VAN DER ROHE. Breuer's design was put in production in 1928 by THONET, but businessman Anton Lorenz, who had purchased rights to Stam's design, brought a successful suit against Thonet, establishing rights to the concept and forcing Thonet to credit Stam as the designer of some designs that were actually Breuer's work. The resulting imbroglio of credits has continued to confuse the history of tubular metal furniture. It seems clear that Stam was the first to actually make a cantilever tubular chair, while Breuer's designs, whether based on Stam's or independently arrived at, have become far more successful and better known.

From 1930 to 1934 Stam worked as an architect in Russia. He then returned to Holland to work in Amsterdam and to become, in 1939, director of the Institute for Industrial Art Instruction there. He was thereafter director of art academies in Dresden and Berlin-Weissensee, returning to Amsterdam in 1953. He retired from professional work in 1966.

STARCK, PHILIPPE (b. 1940)

French architectural and interior designer known for his "New Wave" MODERN furniture and interior design. Starck is one of a handful of French designers who have begun to reverse the lethargy of French design since the 1960s. His career began when he was eighteen years old with the development of inflatable house structures. He then went to work for Pierre CARDIN, designing a line of furniture. Two years later, he struck out on his own, designing two Paris night clubs, Les Bains Douches and La Main Bleue, whose interiors mingle the directions now called HIGH-TECH and POST-MODERN. His Paris Café Costes is dominated by a giant graphic clock (marked, confusingly, with eight hour markers instead of the usual twelve) at the head of a tapering central stair. Three-legged chairs are a favorite theme of his furniture design, including the Ed Archer, Miss Dorn, and Prattfall chairs of 1981. The Starck Club in Dallas, Texas, is his best-known project in the United States. It combines sternly technological elements, draped fabric, and a neutral color scheme in a way that suggests both MINI-

MALISM and current fashion. Other Starck work includes a Paris boutique, Creeks (1986), bathroom towels, clocks, pens, tableware, a Vittel mineral water bottle, and watches. Starck's approach attempts to bring together the usually divergent directions of architecture, technology, and fashion. He has become something of a celebrity in international style and fashion worlds.

STEEL

Metal most widely used in MODERN practice for engineering and building structures and in the production of a wide range of products made entirely or in part of metal. The character of modern architecture and of much modern design has been strongly influenced by dependence on steel as a primary material. Steel is made from iron by adding a small amount of carbon in a conversion process that greatly increases its strength and malleability. While steel was produced in small quantities in ancient times for specialized uses, for example, blades for weapons and plate for medieval armor, its production in quantity did not begin until the early 19th century when improved techniques for production joined with demand for a strong, inexpensive metal for use in making machinery parts and railroad rails. The use of steel in building construction and in bridge building has been a key factor in the development of tall buildings and engineering structures. Steel cable is used in the construction of suspension bridges, and steel rods as the tensile members in REINFORCED CONCRETE. Steel's high strength and low cost has brought it into use as the primary material for such products as automobiles, trucks, military vehicles, ships and for many household products including stoves, refrigerators, and some types of furniture. Steel tools, utensils, and table flatware are commonplace.

Steel is produced in flat sheets and in various forms of bars, tubing, and structural shapes (called "sections") such as I-beams, angles, channels, and Z-bars. The most serious problem presented by steel in general use is its tendency to rust, causing unsightly and eventually destructive damage. Steel must be kept painted or be plated with some other metal (most often CHROMIUM) to prevent contact with moisture in the air and resulting rust. A special form of steel called "stainless" is made by the addition of chromium, nickel, and manganese to create an alloy that is rust-proof. It is widely used for knife blades, for utensils and tableware, and often, for the construction of railroad cars and for parts of objects that will be exposed to weather. Making steel stainless also increases its strength, rendering it difficult to cut and machine, so that its use is restricted to applications where rust presents a special threat.

Steel is a heavy metal (about 490 pounds per cubic foot) so that other, lighter metals, particularly ALUMINUM, are often preferred where weight is disadvantageous, as in the construction of aircraft. Excessive weight in products made of steel can be avoided to some degree by design which uses steel in thin sheets (as in much office furniture and in appliances) and in such shapes as tubes or angles that offer adequate stiffness with a minimum of mass.

STEICHEN, EDWARD JEAN (1879–1973)

American photographer known both for his pioneering work in photography and for his role as director of the Photography Department at the MUSEUM OF MODERN ART in New York. Steichen began photographic work when he was only 16 years old. Then, as an apprentice to a lithography firm in Milwaukee, Wisconsin, he began his professional work, introducing photographs as elements in advertising posters. His own experiments in "artistic" photography were accepted in several exhibits, and in 1900 he decided to go to Europe to study and exhibit. On his way, he met Alfred STIEGLITZ in New York and sold him three prints. He visited London where his work was exhibited and Paris where he made portrait photographs of a number of known artists including Rodin. In 1902 he returned to New York and established a studio as a portrait photographer and had his work shown and published in the magazine *Camera Work*, as a member of Stieglitz's Photo-Secession group. He returned to Paris in 1906 and continued creative work in photography, including some early experiments in color. After work in early aerial photography for the U.S. Army in World War I, Steichen became director of photography for the Condé Nast publishing firm from 1923 to 1938. His own work often appeared in *Vogue* and *Vanity Fair* magazines. Steichen was put in charge of photography for the U.S. Navy in World War II. In 1947 he became director of the Museum of Modern Art's Photography Department and organized exhibitions of the work of many famous photographers including Henri CARTIER-

BRESSON, Walker EVANS, and Edward WESTON. His large exhibit titled *The Family of Man* and the related book were a major popular success.

With work that ranged from the soft effects of early art photography to commercial and abstract MODERN work with a documentary quality, Steichen achieved recognition in almost every aspect of contemporary photographic activity. He was the recipient of many awards and honors; his work is in the collections of many museums and has been widely published.

STEIN, CLARENCE (1883–1975)

American town planner known for his pioneering concepts for suburban developments laid out to accommodate automobile access. Stein studied architecture at Columbia University in New York and the École des BEAUX-ARTS in Paris and then returned to New York to work in the office of Bertram G. GOODHUE from 1908 until 1919. His awareness of the ideas of such urban planning pioneers as Ebenezer Howard, Frederick Law OLMSTED, Patrick Geddes, and Raymond Unwin had a profound influence on his thinking. Stein's most important work was done in cooperation with Henry Wright. The Sunnyside Gardens development in Queens, New York, of 1924–28 retains a preexisting city street grid pattern, but arranges row houses to face into interior garden spaces. The better-known project (1928) of Radburn, New Jersey, is a more complete planned community. It is made up of "super blocks," areas much larger than a normal city block, bounded by major streets. The houses do not face on the perimeter streets, but on cul-de-sac (dead end) streets that extend into the block to provide automobile access. The center of the block is park land, accessible by pedestrian walks from all houses. A pedestrian underpass connects the blocks, making it possible to walk from one house to any other or to schools and other community facilities without crossing any traffic street. Only two such blocks were built at Radburn, but the Radburn concept has become basic to town planning worldwide. In the United States there are few developments that take advantage of these ideas. Stein's 1957 book, *Toward New Towns for America*, is an important reference in the field of urban planning.

STEPHENS, OLIN J. (b. 1908)

American naval architect best-known for the design of sailing yachts, including a number of highly successful racing craft. Stephens de-signed his first 6-meter racing yacht, *Thalia*, in 1926 after only one term at MIT. In 1928 he established the firm of SPARKMAN & STEPHENS with his brother Roderick and Drake Sparkman as partners. *Dorade*, a yawl of 1930, established a new standard for sailing yachts, with successes in a Bermuda race and a trans-Atlantic race shortly after she was built. In 1937, Harold S. Vanderbilt asked Stephens to work with Starling BURGESS on the design of the America's Cup yacht, *Ranger*, built with a steel hull. A succession of winning America's Cup racers followed, including *Columbia*; *Constellation*; *Courageous*; *Freedom*, a 1980 winner; and *Intrepid* (often viewed as Stephens's greatest design). *Finisterre* of 1955, a 39-foot centerboard design, established a modern standard for yachts designed for equal success in racing and extended cruising. Stephens retired in 1979, but the firm remains in active practice.

STEPHENS, RODERICK S., JR.

See SPARKMAN & STEPHENS.

STEPHENS, WILLIAM (b. 1932)

American furniture designer who has developed a number of influential designs for KNOLL. Stephens was trained at the PHILADELPHIA COLLEGE OF ART and accepted a job building PROTOTYPES at the Knoll factory in East Greenville, Pennsylvania, shortly after graduation. He worked for a time on experiments in wood technology that eventually led to his chair group of 1967, in which he used laminated wood in slip strips to make a frame suggestive of the BENTWOOD technique. When the architectural firm of SKIDMORE, OWINGS & MERRILL was developing designs for the Weyerhaeuser corporate headquarters in Tacoma, Washington, the firm approached Knoll for an office furniture system suitable for the building. Stephens was put in charge of this project, leading to the 1973 introduction of the Stephens System, work station groupings of simple, geometric form with modular panels, suitable for use in OPEN PLAN offices. With the addition of desk and table top panels and acoustical screen panels, the system has become widely used and is the basis for many other systems of related design.

Stephens has continued work with Knoll, developing various products. A most recent office seating system uses cushion pads that fold over and wrap around the metal structure of a full range of adjustable swivel chairs.

STERN, ROBERT A.M. (b. 1939)

American architect known for his work of POST-MODERN character and for his role as a spokesman for recent architectural directions through exhibits, publications, and television appearances. Stern is a graduate of Columbia and Yale universities and was for a time a designer in the office of Richard MEIER before forming a partnership with John S. Hagmann in 1969. He has been in independent practice since 1977. Many of his projects have been houses and apartment renovations in which he has introduced historical references that give rise to the post-modern stylistic identification. Other projects include the Jerome Greene Hall for the Columbia University Law School (1975–77) and a number of exhibits for the Architectural League in New York. His headquarters building for Mexx International BV at Voorschoten, Holland, was completed in 1987, while an office building for the New England Life Insurance Company in Boston is currently under construction. His 1969 book, *New Directions in American Architecture*, is a useful compact summary of developments to that date. Since 1970, Stern has taught at Columbia University, lectured widely, and developed the series of television programs, *Pride of Place: Building the American Dream* (1986), which led to a related book with the same title. His work is documented in two volumes, *Robert A.M. Stern: Buildings and Projects 1965–1980* and *1981–1986*.

STEUBEN GLASS

American manufacturer of decorative "art glass" in varied designs ranging from heavily ornamented to simple modernist forms. The firm was founded by Frederick Carder in 1903 in the town of Corning in Steuben County, New York, taking its name from its location. It is now a division of the Corning Glass Works, a major industrial producer of glass and glass products. Older Steuben products were often colorful and in styles relating to ART NOUVEAU. When Arthur A. Houghton, Jr., became its president, Steuben production was limited to the use of clear lead crystal and to the making of objects requiring skilled handwork in blowing, hand forming, and cutting glass. Many designs also use engraving (done entirely by hand) to introduce surface patterns. Steuben designs are, with rare exceptions, the work of staff designers who work in various styles, developing objects that are sometimes functional (bowls, candlesticks, vases) and sometimes purely sculptural and decorative. Forms are often representational (birds are a favorite) and surface decoration may approach the pictorial. In spite of the masterly craftsmanship involved, some Steuben glass suggests KITSCH design. Its appeal to a large, affluent public has ensured its commercial success. Recently, both sculptural and functional designs of superior aesthetic quality have been offered and individual designers (such as David Hills and the architect

Equinox bowl designed by Neil Cohen for Steuben Glass. Photo courtesy of Steuben Glass.

Michael GRAVES, known for his POST-MODERN work) are now credited in some cases. Steuben maintains a shop in New York City, along with special showrooms in a number of department stores in other major American cities.

STICKLEY, GUSTAV (1857–1942)

American designer and maker of furniture in the tradition of the ARTS AND CRAFTS movement. Stickley was trained as a stonemason but began his career in furniture working on conventional revival style pieces in his uncle's workshop in Pennsylvania. In 1898 he made a trip to Europe, where he became acquainted with the English Arts and Crafts movement and met the architect and designer C.F.A. VOYSEY. On his return to America he established his own firm in Eastwood, New York, to produce his own designs. These were generally simple in form, of solid oak (or other hardwood) construction with hand-crafted joints, often exposed and accentuated for restrained decorative effect. In 1901 he reorganized his firm under the name United Crafts, a kind of craft guild that produced Stickley's designs with considerable success. His work became known as "MISSION STYLE" (after the furniture of the California missions, which had a similar simple craft quality) or as "golden oak" for the brown oak finish Stickley favored. Products in metal and glass were also introduced. A number of imitators sprang up to take advantage of the popularity of the designs that Stickley marketed (largely through catalogs) under the name *Craftsman* designs. These imitators included Stickley's three brothers. L. and G. Stickley, who founded in 1902 the Onandaga Workshops in Fayetteville, New York, produced craft-based designs similar to those of the original Craftsman shop until the 1920s. Another brother, Albert Stickley, took up factory production of similar furniture in Grand Rapids, Michigan.

In 1901 Stickley began publishing THE CRAFTSMAN magazine, which was devoted to popularizing his furniture and related work in crafts, architecture, and interior design of an Art and Crafts–inspired character. The magazine also promoted social goals in education and government of a generally progressive nature for their time. Stickley's firm went into bankruptcy in 1915 and the magazine ceased publication at that time.

The Stickley name became associated with the ideas of William MORRIS and John Ruskin

Armchair designed by Gustav Stickley in the Craftsman style. Photo courtesy of Cathers & Dembrosky, Beth Cathers American Arts and Crafts.

and had considerable influence on the early 20th-century work of various American architects and designers including GREENE & GREENE and Frank Lloyd WRIGHT. Although the popularity of the style declined after World War I, since the 1970's there has been a revival of interest in it, and surviving examples have increasing value with collectors.

STIEGLITZ, ALFRED (1864–1946)

American photographer and advocate of MODERN art in the early 20th century. Stieglitz went to Germany in 1881 to study mechanical engineering, but he became fascinated with photography, producing highly realistic images that told a story in the manner of the popular painting of the time. After returning to New York in 1890 his work moved away from the pictorial toward a more straightforward use of the medium—a direction that he continued to promote throughout his career. In 1887 he became the editor of *Camera Notes* and used that position and exhibitions that he organized to further his views of photography as an art. In New York in 1902 he formed, with Edward STEICHEN, Photo-Secession, an informally organized group dedicated to the development of alternatives to the hazy pictorialism of earlier art photography. Frank Eugene, Joseph T. Keiley, and Clarence H. White were among the founding members. In 1903, he began publication of the quarterly journal *Camera Work*, de-

voted to a creative approach to photography as an aspect of modern art.

In 1905 Stieglitz opened his first gallery, "291," exhibiting photography and art by such American pioneer modernists as John Marin and Georgia O'Keeffe, along with the first American showings of the work of Cézanne, Matisse, and Picasso. In his own work, Stieglitz progressed from pictorial documentation in such photographs as his famous 1911 image, *The Steerage*, to increasingly abstract images as in the portraits of Georgia O'Keeffe (who became his wife) to the images of clouds that he called "equivalents." In addition to his own work, Stieglitz was an important influence in the development of modern art and modern photography as advisor, propagandist, and gallery owner. His An American Place gallery was, from 1929 until 1946, a New York center for the exhibition and promotion of modern art and photography when it was almost unknown and unappreciated in the United States. While his influence on the world of design may be regarded as indirect, his recognition of the abstract visual qualities to be found in clouds, in images of city life, in ships, locomotives, and skyscrapers helped to make such things significant in modern designers' thinking.

Stieglitz's work is now in the collections of many museums and has been widely exhibited and published. There is an extensive literature devoted to his work; *Alfred Stieglitz: Photographs and Writings* (1983) by Sarah Greenough and Juan Hamilton is an excellent reference.

STILE INDUSTRIA

Italian industrial design magazine founded in 1953 on the model of *DOMUS*. Edited by Alberto Rosselli, it was for a time an important vehicle for the ideas of post–World War II MODERNISM in Italy, featuring the latest in modern Italian furniture and other product design. Publication was discontinued in 1962.

STONE, EDWARD DURELL (b. 1902)

American architect whose career has extended from the beginnings of MODERNISM in America in the 1930s to an ornamented modernism since the 1950s that has made him a favorite source of a more popular and more commercially successful style. Trained at Harvard and at MIT, Stone has always taken some pride in the fact that he never received a degree at either school. He received a Rotch Traveling Scholarship award in 1927. After returning to New York, he worked in several offices before designing the Mandel house on his own at Mount Kisco, New York, in 1935—one of the first INTERNATIONAL STYLE houses built in the United States. With Philip Goodwin, he designed the distinguished original building for the MUSEUM OF MODERN ART in New York in 1937. This is a strongly influential work both for its design excellence and for its association with the powerful organization that it houses. After World War II, Stone turned away from the austerity of the International Style, attracting much negative criticism within the architectural profession, but gaining popularity and commissions with a new style first demonstrated at his own New York townhouse, whose facade was entirely made up of a decorative grille screen. His U.S. Pavilion at the Brussels World's Fair of 1958, his 1954 U.S. Embassy at New Delhi, India, and the 1964 Huntington Hartford Gallery of Art in New York adopt this ornamentalism in large-scale projects. More recent projects have been on increasingly large scale, including the John F. Kennedy Center for the Performing Arts in Washington, D.C., the General Motors corporate headquarters building in New York, and the many buildings that make up the State University and governmental campus in Albany, New York. In spite of the magnitude of his recent success, Stone's reputation rests primarily in his International Style works of the 1930s.

STONIS, RICHARD

See ASSOCIATED SPACE DESIGN.

STOUT, WILLIAM B. (1880–1956)

American airplane, train, and automotive designer responsible for the development of all-metal aircraft in the 1920s. Stout's engineering education was gained at the Mechanical Arts High School in St. Paul, Minnesota, and at the University of Minnesota. He developed motorcycles and a car before World War I and worked on aircraft for Packard in 1916. In 1922 he designed the first all-metal airplane on an assignment from the U.S. Navy. The Stout Metal Airplane Company was bought by Henry FORD in 1925, bringing to Ford Stout's design for an "Air Pullman." This was eventually developed into an all-metal trimotor. Ford dismissed Stout after some disappointing trials and turned the project over to Harold Hicks, an engineer under whom the Ford Trimotor (affectionately known as the Tin Goose) was successfully com-

pleted. It became the standby of early air transport companies, served Admiral Byrd in his first flight over the South Pole (1929), and remained in use for many years on short routes where its ability to use small airfields and its excellent safety record made it desirable. Stout's Skycar (1931), an automobile-airplane hybrid, and his 1932 Scarab STREAMLINED automobile never achieved commercial success, but his work on the streamlined Union Pacific train M-10,000 of 1934 helped make it an impressive demonstration of MODERN design's applicability to rail transport. In retrospect, Stout has come to be known as a pioneer whose ideas were too often ahead of the ability of industry and the public to absorb them.

STRAND, PAUL (1890–1976)

American photographer who pioneered in making photographs that were abstract patterns created by selective arrangement of common objects. Strand's early work was in the soft-focus pictorial style that was regarded as "artistic" in early 20th-century photography, but he came under the influence of the documentary photography of Lewis HINE at the same time that he saw cubist paintings. In some way these two sources of stimulation fused,

leading to his work of 1917, exhibited at Alfred STIEGLITZ's gallery 291 and featured in the last two issues of his magazine, *Camera Work*. Along with abstract images, Strand photographed human figures, city street scenes, and buildings, often in combinations that are ambiguous or disturbing. During his long career he traveled widely, photographing nature subjects, towns, and people with points of view that were frequently unusual and in ways that make them different from snapshots they may resemble. His work is now generally recognized as a major contribution to the development of photography as an aspect of 20th-century art.

STREAMLINING

Widely used term for design work in which concepts of AERODYNAMICS are applied to generate forms based on those first developed for aircraft. For example, a bulletlike nose and a tapering tail were found to improve the flight characteristics of dirigibles and were later introduced in the design of airplanes. As these forms became visible in the 1930s, many industrial designers began to use them for strictly visual appeal. At first, streamlining was most often applied to moving vehicles, such as loco-

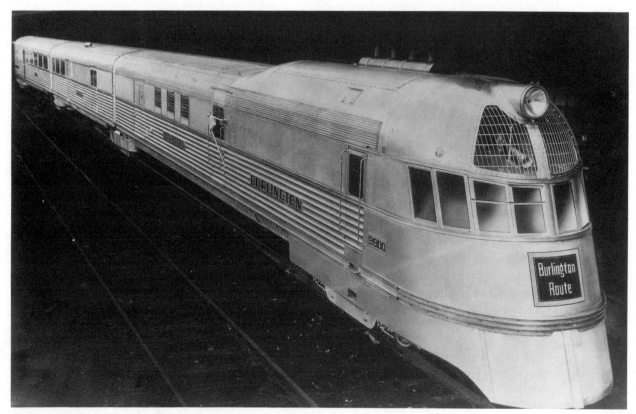

Burlington Zephyr, a pioneer streamlined railroad train of 1932.

motives, whole trains, automobiles, and ships. As streamlined forms became equated with newness and functional excellence, they were adopted for less logical objects—furniture, office machines, toasters, and even, in a famous design by the firm of Raymond LOEWY, a pencil sharpener. As a design theme of the 1930s and early 1940s, streamlining has acquired a certain quality of nostalgia, bringing it recent popularity even (or perhaps especially) in its more absurd applications—clocks, toasters, and radios now regarded as collectable.

STRENGELL, MARIANNE (b. 1909)

Finnish-born American textile designer credited with introducing the design quality of handwoven craft work into commercial production textiles for a number of American producers. Strengell was trained at the Institute of Industrial Arts in Helsinki, working thereafter (1930–36) in Copenhagen as a designer of rugs, fabrics, furniture, and interiors. She moved to America in 1936 to teach at the CRANBROOK ACADEMY in Michigan where she became the head of the weaving and textile design department. Beginning around 1940, Strengell developed designs for various manufacturers, among them 1947 designs for KNOLL and fabrics for automobile upholstery produced by Chatham. She has also designed custom fabrics for various architectural projects, such as Eero SAARINEN's General Motors Technical Center at Warren, Michigan, near Detroit (1948–56) and the Owens Corning Building in New York. She has made frequent use of synthetics, including such materials as FIBERGLASS in combination with natural fibers in designs that are restrained but richly textured. She continues work as a weaver, designer, and consultant on an independent basis.

STUDEBAKER MOTOR COMPANY

American manufacturer of automobiles known for its innovative design in the late 1940s and early 1950s. The Studebaker brothers, Clement and Henry, set up business in 1852 as blacksmiths and, as a sideline, built several wagons. By 1868 they had established a sizable wagon factory in South Bend, Indiana. By 1876 their wagon works was said to be the largest in the world, producing vehicles at a rate of one every seven minutes. By 1902 they were producing a few electric automobiles (Thomas EDISON owned their second prototype), and by 1904 their gasoline-powered cars were being built.

The brand established a stable niche in American automobile production, but Studebaker leadership in design only emerged in 1938 when independent design consultant Raymond LOEWY was retained. The pre-war Loewy designs were handsome, but not strikingly different from the norm of their time. In 1947, Studebaker introduced their first post-war model, often regarded as the masterwork of the Loewy office—which was largely the work of staff designer Virgil EXNER. Its passenger space was centered between the front and back wheels, permitting a large trunk at the rear, roughly equal in size to the motor compartment in front. Glass areas were unusually large, and the whole car had an elegantly STREAMLINED form, with a minimum of decorative trim. The design met with popular success, and Loewy produced revised models year after year including the 1953 design, which was more strongly based on European sport car practice and led to the Avanti of 1961. It became increasingly difficult for Studebaker to maintain its market position in competition with the three larger American automobile makers. In spite of its design leadership, it was eventually forced to merge with the Packard Motor Company, disappearing as an independent brand name in the late 1950s.

STUDIO ALCHYMIA

Avant-garde Italian design studio, which was originally a gallery where designers introduced new and experimental work in industrial design and architecture. It was founded in 1979 by Alessandro Guerriero and led by Alessandro Mendini, who has also been the editor of DOMUS magazine since 1979. Until 1981, Studio Alchymia's work, mostly that of Mendini and Ettore SOTTSASS, tended toward radical, eccentric, and strange decorative productions. In 1981, Sottsass left Alchymia (he would later become a leader of the MEMPHIS design group). Since then, Alchymia's direction has been toward a concern with performance arts and with political activity.

STUDIO PER

Group design practice based in Barcelona, founded in the 1960s to work in architecture, furniture design, and industrial design in the idiom of MODERNISM. The Belvedere Georgina house in Gerona, Spain, is probably its best-known work. Design work has included outdoor furniture, a metal-framed table and chair,

a shelf system, and various hardware items, including door hardware, a system of mail boxes, bathroom hardware, and a kitchen vent hood. All are produced by the Barcelona firm of B.D. Ediciones. Studio PER is notable as the leading design group currently practicing in Spain.

STUMPF, WILLIAM (BILL) (b. 1936)

American industrial designer responsible for innovative office furniture manufactured by HERMAN MILLER. Stumpf was trained in industrial design at the University of Illinois and in environmental design at the University of Wisconsin, graduating in 1968. In 1970 he joined Herman Miller as director of research and in 1973 established his own consulting practice, Stumpf Associates, in Winona, Minnesota. His 1976 Ergon chair was among the first examples of office seating to take full account of the ERGONOMIC issues involved in producing seating for office workers who spend considerable time in a particular chair. The chair received an ASID award in 1976. In 1977, Stumpf joined with Don CHADWICK to form Chadwick Stumpf and Associates. The Equa seating system (1984) is a further development of office seating that offers adjustment to body positions with minimal mechanical complexity. The Ethospace office system, also a 1984 development for Herman Miller, has similarities to many other systems with movable panels. But it has panels with open frames of varied height that accept small panel units called "tiles," which may be solid, transparent, translucent, or open. These units can be stacked and combined in varied ways to give any desired degree of privacy between total openness and solid partitioning. Stumpf's designs have received a number of awards. He continues design work with a strong orientation toward research.

STYLING

Term used to describe design, particularly industrial or product, that is concerned with appearance alone, often with the goal of making an object appear new or fashionable. The term is widely used in the American automobile industry as synonymous with "design," reflecting the view that it is separate from and unrelated to engineering. The resulting appearance of American automobiles is often characterized by such obtrusive details as excessive CHROMIUM trim, tail fins, and similar elements introduced to suggest newness and aid sales through forced obsolescence. As a result, outside of the automobile industry, styling has become a pejorative term, suggesting meaningless form variation developed only for supposed commercial advantage. Many designers emphasize the contrast between "design," meaning functional, structural, and form considerations considered in combination as the basis for innovation, and "styling" as surface decorative design unrelated to utilitarian and practical values.

SUBTRACTIVE COLOR

COLOR achieved by the use of pigments, dyes, or other colorants that absorb light of most frequencies and reflect only light of a particular frequency. Most color work using paint or dye behaves according to the physical rules of subtractive color. As colored pigments are mixed, the various frequencies they absorb are subtracted from any incident light, so that, for example, when red and blue are mixed, each absorbs its complementary secondary color (green and orange, respectively), reflecting only violet light. When all three subtractive primary colors (red, yellow, and blue) are mixed, only a nonchromatic neutral gray or dull brown remains. Such color effects are quite different from those of additive color in light, in which various colors are mixed to create resultant colors of light. The additive primaries are red, green, and blue, with red and green, when added together, producing yellow.

SÜE, LOUIS (1875–1968)

French architect and designer, a prominent figure in the ART DECO design of the 1920s and 1930s. Süe was trained as a painter in Paris and also became active as an architect after 1905. He visited Austria in 1910, becoming aware of SECESSION design of the period. In 1912 he set up his own studio in Paris, designing textiles, furniture, and ceramics. In 1919 he was a partner (with André Mare) in establishing the Compagnie des Arts Français, devoted to the production of design somewhat based on neoclassical origins in opposition to the emerging MODERNISM of the time. The firm exhibited at the 1925 Paris Exhibition and designed various Paris shops before achieving special note with its interiors of the French liner *Ile-de-France* in 1928. Süe was also the designer of the Deauville suite on the liner *NORMANDIE* of 1935. His interior design was featured in the 1937 Paris Exhibition pavilion of the Société des Artistes-

SULLIVAN, LOUIS H.

Décorateurs. His 1938 interiors for the Paris house of Helena Rubinstein mixed Art Deco modernism with African art and antiques in a lavish fashion that was somewhat surrealistic in effect. Süe retired in 1953.

SULLIVAN, LOUIS H. (1856–1924)

Pioneering MODERNIST American architect whose work spanned a transition from ART NOUVEAU ornamentalism to the FUNCTIONALISM of the 20th century. Sullivan is often considered to be the first architectural modernist in America, perhaps the world. He was an architectural student for a short time at MIT in Boston and for a year at the École des BEAUX-ARTS in Paris. In 1879 he settled in Chicago and went to work in the office of Dankmar Adler where he became a partner in 1881. His role in the design, particularly the interior design, of the Chicago Auditorium (1886–90) was his first major achievement. Externally, the building shows the influence of H.H. Richardson, with its heavy, Romanesque revival stone facing, hiding the modern iron structure within. In the interiors of the auditorium room and in the public spaces of the auditorium hotel, Sullivan's nature-related, Art Nouveau style is strongly in evidence. His designs for early skyscrapers, the Wainwright Building of 1890 in St. Louis, the Guaranty Building of 1894 in Buffalo, and the 1899–1904 Schlesinger-Meyer department store (now Carson Pirie & Scott) in Chicago, define the direction that functionalist modern architecture was ultimately to take, although each of these buildings retains elements of decorative ornament in Sullivan's highly personal, florid style. His design of 1893 for the transportation building at the Chicago Columbia WORLD'S FAIR exhibition was in contrast to the generally ECLECTIC classicism of most of the buildings there. Its rejection by the public began a turn in Sullivan's career, which left him with only a few small bank buildings to complete before a long period of decline during which he produced a number of essays and books, including *Kindergarten Chats* of 1901 and an autobiography (*The Autobiography of an Idea*) of 1924.

Frank Lloyd WRIGHT was employed briefly in Sullivan's office and regarded him as his only significant teacher. Wright's continuing admiration of Sullivan was a significant factor in the recognition of his importance in the history of modernism in architecture. The phrase "form follows function," which he often used was not, in fact, original with Sullivan, but rather a quo

Schiller Building (originally the German Opera House, now demolished) in Chicago, a design of Louis Sullivan.

tation from the earlier 19th-century sculptor and writer-critic Horatio GREENOUGH. The phrase has, nevertheless, come to characterize the original contribution of Sullivan's work.

SUMMERS, GERALD (b. 1902)

English furniture designer known for his early designs for molded plywood furniture (ca. 1934), including a chair formed from a single sheet of plywood. His work seems to have been influenced by INTERNATIONAL STYLE developments at the BAUHAUS and by the work of Alvar AALTO in Finland. His designs were produced briefly by a London firm named, appropriately, Simple Furniture Ltd.

SUPERGRAPHICS

Term used to describe a form of architectural and interior ornament in vogue as an aspect of

MODERNISM in the 1970s. As dissatisfaction began to surface with the austere and un-ornamented character of most modern design, some designers turned toward the vocabulary of printed graphic design as a source of inspiration. Abstract geometric forms and the shapes of type and lettering, enlarged to giant ("super") size, were introduced as wall decoration both indoors and, occasionally, on building exteriors. Although hailed for a time as a significant trend, the supergraphic fad has been absorbed into the mainstream of design development, merging with established practice in the use of artwork and the new acceptance of ornamentalism in much POST-MODERN design.

SUPERMANNERISM
Term used in recent design criticism to identify the group of design directions that represent challenges to the concepts of MODERNISM and the INTERNATIONAL STYLE. The term "mannerism" as used in art history describes the tendency to break away from the norms of classicism as they developed in the latter part of the Renaissance. "Supermannerism" is viewed as a comparable development in the 20th century in which the formerly unacceptable elements of ornamentalism, HISTORICISM, the more vulgar aspects of commercial VERNACULAR design, and concepts of contradiction, ambiguity, and complexity are accepted and even sought after. The ideas of Robert VENTURI and Charles Moore in America, and of Ettore SOTTSASS, the MEMPHIS group, and Mirio BOTTA in Europe all converge toward a direction that, having no accepted name, invites new terminology. C. Ray Smith has favored the term "supermannerism" and uses it as a heading for a section discussing these trends in his book, *Interior Design in the 20th Century* (1986).

SUTNAR, LADISLAV (1897–1976)
Graphic designer born in Czechoslovakia whose career in the United States was largely devoted to the design of technical catalogs and brochures. Sutnar came to the United States to work on the Czech Pavilion at the 1939 New York WORLD'S FAIR and remained after the Nazi invasion of Czechoslovakia. In 1941 he became art director for Sweet's Catalog Services, a firm that produced an annual compendium of catalogs of many manufacturers assembled for use by engineers and architects. Sutnar remained in that post until 1960, providing direction and actual design of catalogs included in the

Sweet's File when manufacturers wanted or needed such services. His work followed a BAUHAUS-based theoretical system of geometric logic, in which all materials were organized on a grid and rules and solid color blocks were used in the manner of a MONDRIAN painting as a basis for organizing page layout. Theories of eye movement guided his layout in an effort to aid the reader in understanding complex material through graphic aids. Sutnar also worked from time to time on magazine and book design and was the author of several influential books, including *Visual Design in Action: Principles, Purposes* (1961).

SWAGING
Manufacturing technique in which metal is formed by pounding with a forming tool called a swage. Although the term was originally used for handwork, it is now more commonly used to describe a machine technique in which a metal part, such as a tube, is pushed into a machine in which a powered swage pounds the tube so as to taper it to a reduced diameter. Swaged tubing is often used for furniture legs, as in the group of tables and chairs designed by Charles POLLOCK for George NELSON and Company in 1956 that was produced briefly by the HERMAN MILLER Furniture Company under the name "Swaged-leg Group."

SWANSON, EVA LISA (PIPSAN) SAARINEN (1905–1979)
Finnish-American interior, glassware, and textile designer closely associated with the design directions of CRANBROOK ACADEMY. Swanson was born in Finland and was educated in Helsinki, studying weaving and other crafts there. She moved to the United States in 1923 and to Cranbrook in 1925. She taught at Cranbrook until 1935 and then joined her husband's (Robert Swanson) architectural office to head its interior design department. Her work included furniture, textile, glassware design and color consultancies to various companies including Barwick Mills, Goodall Fabrics, and the Pittsburgh Plate Glass Company. Generally in the tradition of Scandanavian MODERNISM that merged craft elements with modern simplicity, her designs were exhibited and won many awards for excellence.

SYMMETRY
BALANCE achieved by opposing placement of identical elements on either side of an axis. In

bilateral symmetry, the most common form, two matching elements are arranged on either side of a center line. This organization is common in natural forms (including that of the human body) and in many aspects of design throughout history. In radial symmetry more than two elements are evenly placed about several axes as, in nature, in the five arms of a starfish. Symmetry has traditionally been regarded as an important element in aesthetic success so that its avoidance, asymmetry, has become a somewhat daring innovation in much MODERN design.

SYSTEMS DESIGN

Approach to design that focuses on processes of manufacture or construction and functional performance rather than on the creation of static, individual objects. The concept of a system assumes that any design must bring together many parts that may have been developed separately in order to establish a relationship that may not be fixed but that will serve various functions, which may be subject to change. Many modern artifacts can be viewed as elements in a system. An automobile is a complex unit, but it is a part of a system that must include manufacture, delivery, fuel supply, maintenance, repair, and a suitable system of streets, roads, highways, bridges, and so forth to make the vehicle usable in a wide variety of functions. Radios, television sets, cameras, or computers are examples of modern product types that depend on systems for power supplies, programs, materials (film, tape, disks, and so on) and "software" to make them useful in a range of functions that are variable and subject to change.

The application of this concept in architecture suggests that the view of a building as a completed, fixed, isolated object is obsolescent and unrealistic. Buildings are largely assembled from manufactured parts, can be used flexibly and are subject to constant change over their useful lives. Many of the problems presented to industrial designers have a similar quality. The issue is not, for example, to produce an aesthetic treatment for an office desk, but rather to examine the nature of office work and develop a range of elements that will facilitate that work as it is currently done and as it will be done in the future. While many "office systems" are currently produced, most are still limited to the provision of furniture. A full systems design approach to the office would deal with environmental factors (light, air quality, acoustics), equipment (typewriters, computers, telephones, copying machines), materials (paper, files, data storage media), as well as provision for all necessary power and communications wiring, privacy, security, safety, and ERGONOMIC issues, and accomplish all this in a unified way that would integrate all these elements into a single, inclusive system. Any such system would have to be totally flexible and readily adaptable to any changes in any of its parts.

Although many systems exist and operate in current practice (for example, an airline, a postal service, automated manufacturing processes, medical care facilities), most have evolved through combinations of preexisting elements as needs have developed. It is believed that recognition of the importance of systems by designers would favor the development of efficient and effective systems and reduce the variety of problems and disappointments that develop when objects are designed in isolation with little or no concern for their system roles. Systems design is discussed in such studies as A.B. Handler's *Systems Approach to Architecture* (1970) and *The Building Systems Integration Handbook* (1986) by Richard D. Rush.

TAC

See THOMPSON, BENJAMIN.

TAKAHAMA, KAZUHIDE (b. 1930)

Japanese architect and designer, now working in Italy, known for furniture designs produced by Gavina and KNOLL INTERNATIONAL. Trained as an architect at the Tokyo Institute of Technology, Takahama then taught architecture at the Kumanoto University of Technology from 1958 to 1963. In 1963, he was in Milan directing the installation of a Japanese exhibit at the TRIENNALE of that year and met Dino GAVINA,

the furniture manufacturer. His work turned toward furniture of simple, geometric form. The Marcel upholstery system of 1965 uses massive blocks of plastic foam held by ALUMINUM frame members. The Suzanne chair and sofa of the same year use similar blocks of foam with a half-round front or top profile. These designs were added to the Knoll line when Gavina merged into the Knoll organization in 1968. The simple, blocky forms of Takahama furniture can be thought of as MINIMALIST in character.

TALLON, ROGER (b. 1929)

French product designer, known as a phenomenon in a country where professional industrial design is a rarity. Tallon became known as the director of research in 1960 for the Paris firm of Technes, a design studio founded by Jacques Viennot in 1953. His designs for watches and for a coffee grinder for Peugeot (1958), a Japy typewriter of 1960 (winner of a 1960 Milan TRIENNALE medal), and watches for Lipp (1960s and early 1970s) were among the works that brought him to international notice. From 1957 to 1964 he was a design consultant for Frigidaire refrigerators and, later, the designer of lighting fixtures for Erco (1977). His furniture for Lacloche uses lumpy poly-foam cushioning in a striking way. He is best known in France for his consultant design work for SNCF, the French national railway system.

TAPIOVAARA, ILMARI (b. 1914)

Finnish architect and industrial designer best-known for his design of simple and practical MODERN furniture. Tapiovaara was trained at the School of Applied Art in Helsinki and worked for a time in the factory where Alvar AALTO's furniture was being manufactured. He worked for LE CORBUSIER in Paris in 1937 and spent 1952–53 in Chicago working for Ludwig MIES VAN DER ROHE. His best-known work is the Domus chair of 1947 designed for a dormitory in Helsinki. Many of his designs make use of knockdown (KD) construction to aid in maintaining modest manufacturing and shipping costs. Tapiovaara's work won medals in Milan TRIENNALE exhibitions in 1951, 1954, 1957, and 1960. His more recent work has included flatware for Hackman, hi-fi equipment for Centrum, aircraft interiors for Finnair, and various office, theater, and hotel interiors. Tapiovaara's work is of generally unpretentious and simple FUNCTIONALIST character typical of the best modern Finnish design work.

TATLIN, VLADIMIR (1885–1953)

Russian artist and designer, the founder and leading practitioner of the constructivist movement. Tatlin visited Berlin and Paris in 1913 and was influenced by Picasso's work of that period. After returning to Russia, he began to produce sculptures made by a construction process where he assembled pieces of material and wire to be suspended in space. He was an enthusiastic supporter of the Russian Revolution and turned to the design of monumental sculptures, such as the 1919–20 model for a monument to the Third International, planned as a hugh spiral, open-metal-cage structure intended to be more than 1,000 feet tall. It was never built, but became a well-known proposal in the realm of fantasy architecture and design. After 1920, as official Soviet art turned away from MODERNISM, Tatlin devoted his energies to more utilitarian projects including clothing and furniture. His steel tube CANTILEVER chair of 1927 is his most successful furniture project. It has been made available in reproduction by the Italian firm of Nikol Internatzionale. Interest in the development of DECONSTRUCTIVISM in architecture has encouraged a revival of interest in Tatlin's work, since it can be understood as a precursor of this stylistic direction.

Vladimir Tatlin's 1920 proposal for a monument to the Third International.

TEAGUE, WALTER DORWIN, JR. (b. 1910)

American industrial designer, a member of his father's firm who has maintained its reputation for responsible and businesslike design. Teague joined the established Teague firm in 1928, working on designs for Marmon and Ford. From 1942 until 1952, he worked for the Bendix Corporation, serving as head of that firm's research engineering department. He returned to the Teague office as a senior partner, working on U.S. exhibitions at Vienna and Zagreb. In 1966 he reorganized the firm in his own name as Walter Dorwin Teague Associates, serving a number of major American corporations.

TEAGUE, WALTER DORWIN, SR. (1883–1960)

American industrial designer, one of the leaders in the development of the profession in the 1920s and 1930s. Teague was a student at the Art Students League of New York before starting work as a professional illustrator. In 1927 his name was given to an Eastman KODAK representative as a possible source of some sketches for a new camera. Teague insisted on a far more thorough study of the project, leading to a long-standing relationship with Kodak

and the launching of his own design firm. Teague built an organization employing a number of designers and concentrated on maintaining excellent relationships with clients, emphasizing a businesslike approach to all design, along with an AESTHETIC direction based on an appreciation of the art of classical antiquity. In his 1940 book, *Design This Day*, he outlined his philosophy relating traditional aesthetic theory to the concepts of MODERNISM as he had encountered it in Europe on a 1926 visit. In fact, early work of the Teague office often combined a touch of ART DECO decorative form with straightforward FUNCTIONALISM. Teague's 1931 Kodak shop in New York emphasized geometric forms with Deco-style bands of CHROMIUM trim, while the 1932 Marmon automobile was a model of restraint and dignity. The famous Kodak Baby Brownie camera of 1935 was a simple molded box of black PLASTIC (then a new material), but its rounded corners and parallel ribbing made it modernistic, to the delight of purchasers who made it an immense commercial success. Later designs for Kodak included the tiny Bantam Special (1936), a gleaming, streamlined miniature camera in black and polished ALUMINUM, and the 620 Spe-

Vacuum cleaner of 1939 designed by the firm of Walter Dorwin Teague for Montgomery Ward.
Photo courtesy of Walter Dorwin Teague Associates.

cial, a larger roll film camera incorporating both a coupled range finder and a coupled exposure meter, a remarkable innovation in 1939. Work for other clients eventually included A.B. Dick showrooms, New Haven Railroad passenger cars, WORLD'S FAIR exhibits for Ford and U.S. Steel, and a very visible standard service station design for Texaco. Teague came to be regarded as one of the four leaders of the INDUSTRIAL DESIGN profession along with Norman BEL GEDDES, Henry DREYFUSS, and Raymond LOEWY. In 1944 he became the first president of the Society of Industrial Designers. His firm remains in active practice under the direction of his son, Walter Dorwin TEAGUE, Jr.

TECTON
See MARS.

TELNACK, JOHN J. ("JACK") (b. 1937)
American automobile designer who, in his role at the FORD Motor Company, has been responsible for the most recent directions in AERODYNAMIC design. Telnack was trained at the ART CENTER COLLEGE OF DESIGN in Pasadena, California. He joined Ford in 1958, working in various roles until 1966 when he was made chief designer for Ford of Australia. In 1969 he returned to the United States to work on Mustang and Pinto STYLING. In 1973 he was assigned to Ford of Europe, becoming a vice president for design there. In 1976 he returned to the United States, becoming chief of design for passenger cars in 1980. The 1986 and 1987 Ford Taurus and Mercury Sable models embody the new direction that Telnack has promoted, called "Aero" by Ford and "Jellybean" by detractors. The body forms of these cars are smooth and bulging, with rounded forms developed to minimize air resistance as studied in wind tunnel tests. The popular success of these models has exerted influence on a number of other manufacturers who are turning to similar body design.

TEMPLATE
Thin pattern or tracing guide used to transfer a shape to a drawing or from a drawing to a material. A print of a full-size drawing may be adhered to a thin sheet of plastic, metal, or wood and cut to a shape that can then be readily traced onto a final material (metal or plywood, for example). The term is widely used for the popular drafting guides of thin, transparent plastic with cutout openings in such frequently used shapes as circles or ellipses. Templates are also available with cutouts in the shape of furniture, kitchen appliances, bathroom fixtures, and similar items at various scales so that drawing these shapes on architectural or interior design plans is quick, easy, and uniform.

TENNESSEE VALLEY AUTHORITY
See TVA.

TENSEGRITY
Word coined by Buckminster FULLER combining the words "tension" and "integrity" to describe a quality of many structures he devised in which the tensile strength of material is exploited to an unusual degree. STEEL cable of small diameter is capable of withstanding extremely high tensile stresses and is a far more efficient structural element than steel (or any other material) used in compression. Fuller's goal is to use material in tension to the maximum possible degree so as to minimize mass, weight, and corresponding costs. Various masts and towers have been built to demonstrate the effectiveness of the tensegrity concept, and many versions of Fuller's GEODESIC domes are also highly efficient tensegrity structures. The sculptor Kenneth Snelson has exploited the tensegrity principle in his strikingly beautiful sculptural works.

TERAILLON
Italian manufacturer of kitchen and bathroom scales and other widely distributed household products with a reputation for fine design quality. The 1970s designs of Richard SAPPER and Marco ZANUSO, many still in production, have been the primary basis for the critical and commercial success of Teraillon products.

TESTA, ANGELO (b. 1921)
American textile designer who produced some of the first and most popular fabric prints of the post–World War II era. Testa was the first graduate of the Chicago INSTITUTE OF DESIGN in 1945. His use of abstract forms, most often lines and blobs, seemingly borrowed from MODERN art made his prints acceptable in the 1940s and 1950s interiors designed by modern architects and interior designers. For a time Testa operated his own production facility, but he also designed fabrics for Cohn-Hall-Marx, Greeff, and KNOLL. He remains active as a painter and sculptor.

THERMOPLASTIC

Any PLASTIC material that can be softened by heating into a semiliquid (literally "plastic") form so that it can be molded into a shape that it will retain on cooling. Thermoplastics are widely used for small, often inexpensive objects such as toys, novelties, and disposable tablewares that are molded of styrene, polyethylene, vinyl, or acrylics. The last are transparent resins often made into sheets that can then be formed by applying heat. All thermoplastics can be resoftened by heating and will reharden on cooling—an advantage in many manufacturing techniques such as VACUUM FORMING and EXTRUSION, but a limitation in any application where exposure to high temperatures is anticipated. Various thermoplastics can be "foamed" to create materials of varied stiffness made light through trapped air bubbles. Foamed thermoplastic in softer forms is often used for upholstery. Harder foam (called "structural") can be used to make lightweight panels or other forms for use in various furniture applications. A number of thermoplastics, including nylon and acrylics, are often extruded into thin strands that can then be spun into yarns suitable for knitting or weaving into fabrics. Thermoplastics must be distinguished from similar sounding but quite different THERMOSETTING PLASTICS.

THERMOSETTING PLASTICS

Type of PLASTICS that are made through the combination of a liquid (or semiliquid) resin and a catalyst, a chemical that, when the two are heated, brings about setting in solid form. Phenolics, melamines, and polyesters are thermosetting plastics and are therefore suitable for many kitchen applications, for dishes, and in LAMINATES for use as countertops and damage-resistant furniture surfaces. FIBERGLASS uses thermosetting polyester as its plastic base, which is then reinforced with glass fibers. COMPRESSION MOLDING, in which the plastic is pressed into shape in a hollow mold, is the most usual technique for manufacturing objects of thermosetting plastic.

THOMPSON, BENJAMIN (b. 1918)

American architect, a founding member of The Architects Collaborative (TAC) in 1946 and, in that context, a major figure in the promulgation of MODERN design in the post–World War II era. TAC was formed with Walter GROPIUS and a number of his colleagues at Harvard University as a Boston office devoted to production of modern work of a very high caliber. As a co-equal partner in TAC, Thompson's work is not clearly identifiable, but when he became chairman of the Department of Architecture at Harvard in 1963, he reduced his involvement with TAC in order to found his own office, Thompson Associates. His subsequent work shows a basis in the INTERNATIONAL STYLE, but introduces a degree of lightness and delicacy that makes it less forbidding than earlier, more doctrinaire work. Thompson's work has included many school, college, and university buildings, including groups at Williams College (Williamstown, Massachusetts), Brandeis University (Waltham, Massachusetts) and Phillips Academy (Andover, Massachusetts), all of the 1960s.

In 1953, Thompson added to his activities the founding of a retail shop in Cambridge, DESIGN RESEARCH (D/R), devoted to the sale of furniture and other household and office products of consistently high design quality. The success of the shop led to the opening of branches in other American cities (including New York and San Francisco) in the 1960s. Thompson eventually withdrew from D/R because he found it too demanding of his time and attention, and the chain subsequently closed. While it was in operation, it brought Thompson's judgment and taste to a wide public audience. Thompson continues to carry on an extensive architectural practice with projects in Africa and the Middle East as well as in the United States, where such urban revival projects as those at Faneuil Hall in Boston and the South Street Seaport in New York are visible and popular examples of his work.

THOMPSON, BRADBURY (b. 1911)

American graphic designer known for his role in the development of MODERN book design and TYPOGRAPHY. Thompson became involved in graphic design as the editor of his college yearbook at Washburn College in Topeka, Kansas. In 1938 he began work in New York and became editor and designer for *Westvaco Inspirations for Printers*, a promotional magazine produced by the West Virginia Pulp and Paper Company, which was widely influential within the professional graphic design community. Its style was, for its day, clearly modern and its use of varied images in combination with type was original and imaginative, while maintaining a certain restraint and conservatism. He de-

signed a number of publications and guidebooks for the New York WORLD'S FAIR of 1939–40. He has taught design at Yale University since 1937 and has been the format designer for a number of magazines including *Art News*, *Mademoiselle*, and *Smithsonian*. Among his more unusual works are a number of postage stamps designed for the United States Postal Service. In 1975 he won the annual Gold Medal award of the AMERICAN INSTITUTE OF GRAPHIC ARTS (AIGA).

THOMPSON, D'ARCY WENTWORTH (1860–1948)

English scientist and scholar whose 1917 book, *On Growth and Form*, has become required reading for MODERN designers. Thompson was a biologist, but also a classicist and philosopher. In his book, he explains in language accessible to nonscientists, the ways in which form in living things relates to and grows out of structural and functional considerations. The idea that form produced by human designers can and should parallel the developmental patterns of plant and animal form is a common basis for modern design teaching and theory. Thompson's book, with its many examples and illustrations, is a particularly fine reference for study of this concept.

An enlarged edition of *On Growth and Form* appeared in 1942. An abridged edition of 1961 edited by J.T. Bonner presents the most significant part of the original work in a compact form particularly convenient for designers and design students.

THONET

Furniture manufacturing company that has had, in several contexts, an important role in development and production of MODERN furniture, including designs by a number of famous designers. The German firm of Gebruder Thonet (Thonet Brothers) was founded in 1853 by five sons of Michael THONET to produce furniture using the patented techniques of wood bending developed by their father. Some examples of Thonet's BENTWOOD furniture had been exhibited at the CRYSTAL PALACE exhibition in 1851, and the new firm turned to quantity production of similar designs. In 1859 a catalog was issued showing twenty-six designs for chairs, tables, and benches all using the bentwood technique. Some of the designs, such as the simple No. 14 "café chair" and the florid rocking chair (introduced in 1860), quickly be-

came popular and are now regarded as CLASSICs of premodern design. In the era of the Vienna SECESSION at the end of the 19th century, Thonet introduced a number of designs by famous architects including Josef HOFFMANN, Adolf LOOS, and Otto WAGNER.

In the 1920s, Thonet began production of chairs and other items using tubular STEEL construction, including a number of designs by BAUHAUS personalities and their contemporaries including Marcel BREUER, Ludwig MIES VAN DER ROHE, and Mart STAM. LE CORBUSIER made frequent use of early Thonet bentwood products in his projects and contributed a number of original designs to the Thonet product line. Thonet began furniture production in the United States in 1938, manufacturing some anonymous designs by its own staff, some of the classic designs, and new works by various designers including Peter DANKO, Pierre PAULIN, and David ROWLAND. The firm remains active in production of modern furniture, placing special emphasis on products for institutional use in schools, hospitals, and homes for the elderly, while also continuing to offer many

Classic Thonet bentwood armchair, a favorite of Le Corbusier and so now named after him. Photo courtesy of Thonet ®, a division of Shelby Williams Industries, Inc.

of the famous designs on which its reputation is based.

THONET, MICHAEL (1796–1871)

German craftsman and inventor who is generally credited with the development of BENTWOOD furniture. His early work was in traditional styles, but around 1830 he began experiments with parts made from bent veneer (early forms of MOLDED PLYWOOD). It was his methods of bending solid beech that became the technical foundation for the designs which made him famous. He moved to Vienna in 1842 and was granted various patents that served as the basis for the furniture production of the firm Gebruder THONET founded by his sons in 1853. The Thonet name remains important in the history of modern furniture, with many of the early models still in production.

THUNDERBIRD

Name given to a semi-sports car model introduced by the Ford Motor Company in 1955. At the time, interest in European sports cars was increasing, and the absence of any American products in the field had attracted considerable comment. When GENERAL MOTORS introduced the Corvette in 1953, Ford was under competitive pressure to produce an equal. The original model approached the concept of European competition with a streamlined body, variously credited to Ford designers Frank HERSHEY, William F. BOYER and/or William (Bill) BURNETT. A porthole-like rear quarter "opera window" and a "continental" spare tire displayed at the rear cluttered the design with STYLING elements that detracted from its simplicity. In 1958 a four-seat model was introduced, not really a sports car in concept, but still popular with American car buyers. Earlier models, virtual symbols of the popular taste of the 1950s, are now collected and referred to affectionately as "T-Birds." The name is still applied to certain Ford models that are, in the view of many, of no special design distinction.

TIFFANY, LOUIS COMFORT (1848–1933)

American designer/craftsman best known for his work in glass and metals with a strong ART NOUVEAU character. Tiffany traveled in Europe in 1865 and returned to America to study painting with George Inness. Tiffany's ideas were strongly influenced by the ARTS AND CRAFTS thinking of William MORRIS, but his work moved toward the florid, curvilinear forms of

Table lamp with stained-glass shade by Louis Comfort Tiffany.

French Art Nouveau when he set up his own studios in 1879 as Louis C. Tiffany & Associated Artists. The artists included such late 19th-century figures as John La Farge and Lockwood de Forest. The firm undertook interior decorating projects (including several rooms for the White House in Washington) and provided wallpapers, lamps, furniture, and stained glass of original design. The Tiffany Glass Company, established in 1886, produced vases, various decorative objects, and the famous Tiffany lamps that are the most widely known of Tiffany products. Tiffany Favrile glass was soon sold by Samuel BING's shop in Paris. In contrast, Tiffany furniture was generally of an unimaginative, typically late-Victorian, heavy character. Tiffany inherited the famous silver and jewelry shop founded by his father. It remains a successful New York firm, whose products have no connection with Louis Tiffany's creative achievements.

TIFFANY & COMPANY

New York silver and jewelry firm established by Charles Louis Tiffany (1812–1902), the father of the famous designer/craftsman, Louis Comfort TIFFANY. The prestigious store has had a long-standing reputation for fine quality silver

and jewelry of high price. Under the presidency of Walter Hoving, Tiffany's expressed a strong interest in quality American design in the post–World War II years, although it has preferred to concentrate on designs appealing to its wealthy clientele.

LA TOURETTE

Convent (monastery) (1957–60) at Eveux near Lyons in France designed by LE CORBUSIER, one of his most distinguished works in the post–World War II style often called New BRUTAL-ISM. Forming a hollow square, the building is made up of a church on one side and a U-shaped group of monastic buildings around a central courtyard. Le Corbusier is said to have studied the medieval Cistercian monastery of Le Thoronet, making it a basis for the utter simplicity and austerity of his design, which relies entirely on the geometry of its propor-tions (based on Le Corbusier's MODULOR sys-tem) to achieve a sense of extraordinary beauty and serenity in a structure of rough concrete ("*beton brut*"). The monks of the monastery have now relocated in accord with changing ideas of their religious duties, and the building has become a study and research center.

TRADEMARK

Emblematic graphic form developed as an identifying symbol for products and other vis-ible manifestations of a business. Trademarks may be entirely abstract, may incorporate a letter, group of letters, or monogram, or be a name or image that symbolizes the name or the work of a particular organization. The concept of the trademark probably has its origins in medieval heraldry where a family's coat of arms served as identification to a public gener-ally unable to read. The modern trademark is often the centerpiece of a CORPORATE IDENTITY program that attempts to introduce a visual consistency or theme in all the often diverse activities of a modern corporation. Many early trademarks were standardized pictures, such as the shell of Shell Oil, the listening dog of "His Master's Voice" of the Victor Talking Machine Company (HMV in England), or the flying red horse of Mobil Oil. More modern trademarks tend to use more abstract forms, sometimes in some way symbolic of product or service (as with the British Overseas Airways "Speedbird"), sometimes a conventionalized letter or letter (the IBM LOGOTYPE for example), or sometimes entirely abstract and arbitrary (as

Paul Rand's 1965 design for the American Broadcasting Company trademark.

the Chase Manhattan Bank symbol designed by CHERMAYEFF & GEISMAR). Modernization or redesign of an existing trademark is often un-dertaken where a mark has come to appear dated and old-fashioned. The goal is to retain established recognition while promoting a MODERN or progressive image.

Modern graphic and industrial designers view trademark design as an important part of their work, and considerable research, testing, and design effort often go into development of a mark that is expected to express an organization's quality, goals, and production over a long period of time. Trademarks de-signed by Saul BASS, Lester BEALL, Herbert MAT-TER, and Paul RAND, among others, have been greatly admired for their aesthetic quality as well as for their commercial effectiveness.

TRIANGULATION

Introduction of three-sided polygonal forms into a structure, a primary means of achieving rigidity. Engineers, architects, and industrial designers make constant use of triangulation in almost every structural design, and triangula-tion is often present in a less obvious form where solid plates, panels, or other sheets of material function as an infinite number of tri-angles bracing the frame to which they are attached. This is based on the geometric reality that the angles of a triangle's apexes cannot be changed without there being a corresponding change in the length of one or more sides. No other geometric figure (square, rectangle, hexa-

gon, for example) has this characteristic. By making a triangle with sides of fixed length a part of a structural frame, the shape of the frame becomes locked by its unvarying angles. Triangular bracing is used in the design of bridges, electrical and radio towers, and many building structures in a strongly visible way. Corner braces, gussets, and solid panels often introduce triangulation in a less obvious way, preventing distortion of rectangular forms into parallelograms—a step that can lead to possible collapse.

TRIENNALE

Design exhibition held every three years at Milan, Italy. The first Milan Triennale was held in 1933, showing the work of many of Europe's pioneer MODERN designers, including Walter GROPIUS, LE CORBUSIER, Adolf LOOS, and Ludwig MIES VAN DER ROHE. The sequence of exhibitions was interrupted during World War II, but resumed in 1947 and continues as a showcase of modern, mostly Italian, design achievements.

TSCHERNY, GEORGE (b. 1924)

Hungarian-born American graphic designer known for MODERN work with a degree of clas-sic restraint. Tscherny came to the United States with his family in 1941 after having lived for a time in Berlin. After service in World War II, he studied graphic design at PRATT INSTITUTE and then accepted his first job with Donald DESKEY's New York office working on packaging and other graphic assignments. In 1952 he joined the office of George NELSON and was soon placed in charge of graphic work. In 1955 he opened his own design office and has since worked for many major clients designing annual reports, posters, advertisements and developing trademarks and identity programs. Clients have included Burlington Industries, the Ford Foundation, W.R. Grace Company, IBM, and RCA. His work is always orderly and organized, using type, free lettering, and images so that they together emphasize a dominant point or theme in each design. He was the recipient of the Medal of the AMERICAN INSTITUTE OF GRAPHIC ARTS (AIGA) in 1988.

TSCHICHOLD, JAN (1902–1974)

German/Swiss typographer and graphic designer, a key figure in the development of MODERN design of books and other graphic materials. Tschichold was born in Leipzig and

1976 United States commemorative postage stamp (honoring Alexander Graham Bell's invention of the telephone) designed by George Tscherny.

was trained there to be a drawing teacher. From 1919 to 1920 he studied TYPOGRAPHY at the Leipzig Academy. He visited the BAUHAUS exhibition of 1923 and was strongly influenced in the direction of MODERNISM. He established his own practice in Berlin in 1926 and then relocated in Munich to teach and practice. His 1928 book, *Die Neue Typographie*, quickly became a classic text in the field of modern graphic design. In 1933 Tschichold relocated in Basel, Switzerland, where he published his 1935 book, *Typographische Gestaltung*, available in English as *Asymmetric Typography* (1967). In 1946 he took over design of the English Penguin Books and lived in London until 1949. Thereafter he was in active practice in Basel designing many books as well as graphic materials for the pharmaceutical firm of Hoffmann-Laroche. He received many honors for his role in the development of modern typography and graphic design.

TUGENDHAT HOUSE
Major early work of Ludwig MIES VAN DER ROHE built in Brno, Czechoslovakia, in 1930. In it, the space concepts first demonstrated in the BARCELONA PAVILION, are introduced in a large and luxurious residence. The main living space of the house is an open area, not divided into conventional rooms, but partially divided by screen walls of rich materials. The outside walls are of floor-to-ceiling glass, arranged to retract into the basement so as to leave the house entirely open to the out-of-doors. Structural support is provided by slim STEEL columns encased in CHROMIUM. Bedrooms and service spaces are of more conventional design. A number of special furniture designs were developed for the house, some of them once more in production. The Tugendhat house, widely known through publication, became an influential CLASSIC of the INTERNATIONAL STYLE. It still exists, although somewhat altered for nonresidential use. Chairs designed for the house are in current production (distributed by KNOLL INTERNATIONAL).

TUMBLEHOME
Term from boat and ship building that has been adopted by industrial design, particularly automobile design, to describe surfaces that slope inward in their upper portion. Many modern

Plan of the Tugendhat house in Brno, Czechoslovakia, by Ludwig Mies van der Rohe.

streamlined automobiles narrow sharply from their widest point just below the window line, using inward-sloping glass windows to introduce tumblehome. As a result, the roof is much narrower than the car's maximum width dimension.

TUNGSTEN

Heavy metal with a very high melting point, which, along with its good conductivity, has made it the basic material for the filament of the incandescent electric light invented by Thomas EDISON. When electric current is passed through the tungsten filament, its electrical resistance causes it to become intensely hot, emitting a bright glow. When encased in a vacuum bulb of glass, the filament gives light, but does not burn out for many hundreds of hours. Tungsten can be combined with a HALOGEN, usually the element fluorine, to form a halide used in some modern electric light sources that combine some of the characteristics of incandescent and fluorescent lamps. Such lamps, or bulbs, are called tungsten-halogen or halide lamps. The term HID (for "high intensity discharge") is often applied to such lamps that are efficient in consumption of electric current and capable of high light output from very small lamp units.

TUPPER, EARL (b. 1908)

Inventor-designer of a system of household products, mostly food storage refrigerator containers, made from polyethylene PLASTIC. This plastic, which is naturally translucent white, has a rubbery flexibility that makes it unbreakable and soft enough so that snap-on lids make an airtight fit but are still easy to remove. In 1942, Earl Tupper developed the manufacturing technique for making a line of containers of his design. The name Tupperware was coined for the product and the Tupperware Plastics Company that produced it. Tupper's designs were generally extremely simple and functional and quickly became widely popular. Tupper was also the developer of a unique system of marketing that avoided normal retail channels by recruiting housewives as amateur sales agents who organized "Tupperware parties" where friends and neighbors were invited for a social occasion during which samples of the plastic products were shown and orders taken for later delivery. Recently Tupperware has been offered through more conventional mail-order sales. Many imitations of Tupper's products, usually of inferior design, have become widely available.

TVA (TENNESSEE VALLEY AUTHORITY)

Agency of the U.S. government set up in 1933 to deal with flood control problems in the Tennessee Valley area and to provide inexpensive electric power from hydroelectric generating plants built in association with the dams required for flood control. The dams and power plants were of a very distinguished design quality and have become an exceptional example of design merit in government-sponsored work. Design was developed by TVA's own engineering offices in Knoxville, Tennessee, where the Swiss-born architect Roland A. Wank was in charge of architectural aspects of construction projects from 1933 to 1945. Norris Dam, near Knoxville (1933–36), Hiwassee Dam (1936–40), and Fontana Dam (1942–45) are some of the most distinguished projects, with powerhouses that in both external and internal design set a high standard in a field where visual design is often given little consideration.

TYPE DESIGN

Highly specialized field concerned with the development of TYPEFACES, alphabets for use in printed materials. Early printing was generally

Interior of the powerhouse at the Fontana Dam in Tennessee. The 1942–45 TVA project's design was under the direction of Roland A. Wank. Photo courtesy of Tennessee Valley Authority.

done with lettering and illustrations hand cut in wood blocks. With the invention of movable type around 1450 by Johannes Gutenberg (c. 1397–1468), it became necessary to produce complete alphabets from cast metal with each letter separate and sufficiently standardized in form to permit interchangeability and reuse. A typeface is a complete set of type, with alphabets in both capitals and lowercase, plus numerals, punctuation marks, and italics making up a "font" so that any text may be set in a consistent style. In modern practice, a typeface is also often made in a range of sizes and in such variations as boldface (extra heavy), condensed, and extended. Early typefaces (such as that produced by Gutenberg) were based on hand-lettered manuscript styles, leading to letterforms now usually classified as "blackletter" or "Gothic," which were used in German printing until modern times.

Each early printer designed his own type so many faces were produced. For instance, printers in Italy developed typefaces based on lettering on ancient Roman inscriptions. Nicolas Jenson (1420–1480), a Frenchman, was the designer of the first fully successful ROMAN typeface using capital and lowercase letters. The characteristic features of Roman typefaces include both use of SERIFS at the ends of letter strokes and the use of thick and thin strokes imitating the weight of pen or brush strokes they are based on (vertical down strokes are thick, horizontal upstrokes are thin). As printing came into wide use, a great variety of typefaces were designed, including a number that have remained in use until the present such as Caslon (designed by William Caslon around 1725), Baskerville (designed by John Baskerville around 1755), and the Bodoni family of types (based on the designs of Giambattista Bodoni, 1740–1813). The presence of serifs and use of thick and thin strokes in Roman typefaces contributes to their legibility and so makes these faces generally preferred for text (body) type.

In the 19th century, types without serifs, at first called Egyptian, Gothic (not to be confused with black-letter Gothic), or Grotesque began to appear. Since then, SANS SERIF types have come into wide modern use. In addition, display types in larger sizes and with strong and varied character came into use for advertising, package labels, and similar uses. The slow and painstaking process of hand typesetting became obsolescent with the development of Lin-

otype and Monotype machines that mechanized the setting of text type. Makers of these machines offered a great variety of typefaces including many of recent design. Sans serif faces such as FUTURA (1927) by Paul RENNER, Gill Sans (1929) designed by Eric GILL, and HELVETICA by Max Miedinger (1957) have come into wide use, in part under the influence of the BAUHAUS where such avant-garde faces as Herbert BAYER's universal alphabet (1927) with only lowercase letters were developed. The replacement of metal type with phototypesetting beginning around 1950 and taking over the field by the early 1970s has made it increasingly easy to produce and use a vast variety of typefaces. The use of computers for typesetting and all other phases of graphic design has also been a stimulus to the design of new faces and the recreation of many older faces so that they have been fully adaptable to modern graphic arts production techniques.

TYPEFACE

Complete alphabets or sets of alphabets designed in a unified and related way, usually in a range of sizes, with numerals and other incidental characters, often with variations in weight and form. Typefaces are the end products of TYPE DESIGN. Those in current use include many faces with a long history (dating back to the Renaissance) and many modern faces developed in the 19th and 20th centuries. All typefaces belong to certain categories or families such as ROMAN (with SERIFs) and SANS SERIF, or text types (used for large bodies of text), display types (used for headings or alone in larger sizes), and decorative types (often heavily ornamented or varied at the expense of legibility). The design of a typeface is a complex and demanding project. Certain faces with proven serviceability are widely used, while hundreds of other faces are available for occasional use in special contexts. Examples of 20th-century typefaces are GILL Sans, HELVETICA, and ZAPF Book.

TYPEMETAL

Alloy of lead, tin, and antimony used for making movable metal printing type and for the "slugs" of multiple letters produced by the Linotype typesetting machine now made largely obsolete by modern, computer-generated type. Typemetal is an alloy suitable for DIE CASTING and is often used for making metal products produced by that process.

TYPOGRAPHY

Specialized field of graphic design concerned with the selection, specification, and layout of printed type. When printing became the primary technique for producing readable materials through Johannes Gutenberg's introduction of movable type (c. 1450), the arrangement of type became an important design activity, taking the place of the medieval art of manuscript text writing and illumination, all done by hand. Typography is concerned with the selection of TYPEFACEs (from among thousands of available designs), the spacing of set type, and the organization of type into lines, columns, or blocks that become elements in the graphic design of book pages and other printed materials.

Typographers may be designers of such graphic materials as advertisements, posters, or brochures; they may be book designers, designers of typefaces, or specialists who aid other graphic designers in their use of type. In addition to selecting typefaces, typographers make decisions about size, spacing, margins, alignment and placement of type, and use of rules and ornaments. Easy legibility and AESTHETIC issues are both vital in successful typographic design.

Traditional typography is based on classic principles of proportion and symmetry, largely developed in the early days of printing. It uses historic letterforms, including roman, italic, and black-letter (gothic) styles, usually organized in columns or blocks with type "justified," that is, spaced to produce a straight margin on the right as well as on the left side. In the 20th century, MODERNISM influenced typography in the development of freer, more daring uses of type, such as asymmetrical typography. It uses both traditional and modern typefaces, the latter often of SANS SERIF design, that is, lacking the serif ("feet") typical of ROMAN letterforms. In addition, it often uses unjustified lines of varied lengths, producing an irregular ("rag") right margin, and treats lines and blocks of type as abstract elements that can be arranged in free and unconventional ways.

Typography has been an integral part of a number of movements in the world of art and design including the ARTS AND CRAFTS movement, ART NOUVEAU, CONSTRUCTIVISM, DE STIJL, and the INTERNATIONAL STYLE based on BAUHAUS thinking. Leaders in the development of MODERN typography include such Bauhaus designers as Herbert BAYER, László MOHOLY-NAGY, and Joost SCHMIDT and others working independently including Herbert LUBALIN, Herbert MATTER, and Jan TSCHICHOLD. Twentieth-century graphic design is in large part identified with the use of modern typographic concepts.

ULM

German city where the HOCHSCHULE FÜR GESTALTUNG was located. Ulm was the post–World War II school, closed in 1968, often regarded as an effort to continue the BAUHAUS. In design circles, it is customary to refer to the school simply as "Ulm."

UNGARO, EMANUEL (b. 1933)

French fashion designer whose finely tailored suits and coats brought him initial success. Emanuel Ungaro was born in Aix-en-Provence, the son of Italian immigrants. His first training in his father's tailoring business was followed by work in Paris, including six years as an apprentice to Cristobal BALENCIAGA, whom he credits with having taught him everything. His more recent clothing designs are soft, richly colored and use mixed prints, as well as shirring, pleating, and draping.

UNIMARK

Design firm founded in 1965 which brought together the main trends of MODERNISM in graphic and industrial design in Italy and the United States. The founders of the firm were Jay DOBLIN, Bob NOORDA, and Massimo VIGNELLI. The original Milan office was followed by a 1966 New York office. Clients included Gillette, KNOLL, OLIVETTI, and various other major corporations. The firm disbanded when the designers elected to move in differing directions in the 1970s.

UNITÉ D'HABITATION

Name of the innovative Marseilles apartment building using REINFORCED CONCRETED con-

struction, designed by LE CORBUSIER and completed in 1952. The design was proposed as a prototype residential structure for the utopian *Radiant City* conceived by the architect in 1921–22. This first built demonstration of the concept was intended as part of a group of related buildings that were never constructed. Similar buildings by Le Corbusier at Berlin, Briey, Firminy, and Nantes are also referred to by the term *Unité*. Each is conceived of as a neighborhood made up of many apartments of varied size, a shopping street, school, restaurant, and even a small hotel. Most of the apartments are duplex units, running all the way through the building from front to back, reached by elevators and ingeniously interlocked along a corridor that occurs only on every third floor level. The concept of the shopping street, placed halfway up the eighteen-story building, failed to work as a practical matter and is now used for other purposes. Considerable controversy has focused on the concept of the Unité, with many critics denouncing its high-rise form—most apartments are remote from ground level. Given the realities of modern urban life, defenders suggest that this one-building "village" is more humane and truly habitable than the majority of apartment buildings designed before or since.

UNITY

Concept often discussed in design criticism concerned with the idea that the parts of any designed object should "hold together" and make up a single, comprehensible whole. A lack of unity leads to a confusion of unrelated elements, hard to understand or hold in memory, with a resultant failure of aesthetic intention. Efforts to achieve unity may include the use of related forms, consistency of detail, and colors and finishes that establish strong relationships. Complexity is not necessarily inimical to unity. In fact, it makes the achievement of some form of unity particularly important if the complex whole is to avoid disintegration into visual chaos. The confusion of the typical suburban sprawl shopping strip is an obvious example of the way in which a lack of unity creates ugliness. Unity is characteristic of outstanding designs throughout history from Greek temples to the tightly organized design of a modern Porsche or BMW automobile.

UNIVERSITY OF THE ARTS

See PHILADELPHIA COLLEGE OF ART AND DESIGN.

URBAN, JOSEPH (1872–1933)

Austrian-born American designer of theater stage scenery, theaters, and various other architectural projects in a style balancing the ART DECO themes of the 1920s and 1930s with the MODERNISM of the INTERNATIONAL STYLE. Urban's career began in Vienna in the last days of the SECESSION and WIENER WERKSTÄTTE movements. He moved to the United States in 1911 and became known as an interior and theatrical designer. He briefly ran a New York retail shop selling Werkstätte products from 1922 to 1924. From 1918 to 1933 he was in charge of stage design for the Metropolitan Opera in New York and also directed and designed a number of films and Broadway productions. As an architect, his best-known surviving work is the building of the New School for Social Research (1930) in New York. He developed a number of fine designs for a new Metropolitan Opera House (unbuilt) and designed the distinguished New York Ziegfeld Theater, unfortunately plagued with bad acoustics and now demolished. His furniture was typical of Art Deco work, with geometric forms, bands of black or silver linear ornament, and, often, inlays of rich decorative materials.

UTZON, JØRN (b. 1918)

Danish architect and designer best known for his competition-winning design for the Sydney, Australia, opera house (1956). Utzon studied at the Royal Academy in Copenhagen, worked for Gunnar ASPLUND and Alvar AALTO in 1945 and was for a short time with Frank Lloyd WRIGHT at Taliesin in 1949. His first works were modest homes and a group of houses at Elsinore in the gentle idiom of Scandinavian MODERNISM. His winning design for the Sydney opera house brought him international fame, with its huge sail-like roof forms, all derived from a geometric exercise in cutting surfaces from a hemisphere. Realization of the project was beset with difficulties, both technical and political, leaving Utzon with a reputation for being brilliant but "difficult." Sigfried GIEDION praised Utzon in the fifth edition of *Space, Time and Architecture*, suggesting that he was destined to be recognized as the next great master of modern architecture, a turn of events that has not been realized.

All of Utzon's work is based on repeated three-dimensional forms organized into complex compositions. This is true of a number of published projects, such as his Silkeborg mu-

seum project of 1963 and Zurich theater design of 1964. A similar concept is the basis for the Utsep Mobler seating system, with its varied modules suitable for assembly in curved or straight groupings.

VACUUM FORMING

Manufacturing technique in which plastic sheet material is shaped over a mold with the aid of heat and vacuum. The material used for vacuum forming is thin THERMOPLASTIC, such as styrene. It is clamped at the edges to a mold of wood or other convenient material, which is penetrated by small vent holes connected to a vacuum pump. The plastic sheet is heated from above until it is somewhat softened. Vacuum is then applied, permitting normal air pressure to push the plastic sheet into contact with the mold, taking its shape in the process. The depth of the mold must be limited and sharp corners avoided so that the plastic can flow into the intended shape without becoming too thin at any point. Tooling for vacuum forming is relatively inexpensive so that it is a favored technique for making parts in modest quantities. Vacuum-formed trays, liners for refrigerator doors, or automobile interior parts are typical items made by this process.

VALENTINO, MARIO

See ARMANI, GIORGIO.

VALLIN, EUGÈNE (1856–1922)

French designer of furniture and interiors in the ART NOUVEAU style. Vallin was trained as an apprentice in the French city of Nancy. His early work was in the Neo-Gothic style, but around 1895 he became part of the Nancy school of Art Nouveau designers. A dining room of his design (1903), restored in the Musée de l'École de Nancy, uses his own work along with products by other Art Nouveau figures in a characteristically florid, curvilinear, and somewhat overwhelming style. Vallin's late work of the 1920s becomes more restrained and suggests movement toward MODERNISM.

VAN DE VELDE, HENRI (1863–1957)

Belgian architect and designer, a major figure in the development of the ART NOUVEAU movement. Van de Velde was known as a painter before turning to design in 1893. In 1896 he designed four rooms for the Paris shop L'Art Nouveau operated by Samuel BING, and in 1897 his work was exhibited in Dresden. He relocated in Germany in 1899, and in 1906, he became head of the Weimar School of Applied Art, the institution that was later, after his 1914 resignation, to metamorphose into the BAUHAUS. In fact, the Bauhaus began its existence in a building of Van de Velde's design.

His work included graphic design, textile embroideries, silver, and furniture, all characterized by the flowing, undulating curves typical of the Art Nouveau aesthetic. As an architect, Van de Velde's works were the WERKBUND theater of 1914 at Cologne and the Kröller-Müller Museum at Otterlo in Holland. In his later work, he moved away from the florid style of Art Nouveau toward a more geometric MODERN style, as in his interiors for the ship *Prince Baudouin* (1933–34). Van de Velde exerted considerable influence through his writings in French and German, as well as through his teaching.

VAN DOREN, HAROLD (1895–1957)

American industrial designer, one of the pioneers of the 1930s who introduced professional design to industry in the United States. Van Doren studied painting and often supported himself as a ghost writer before opening his design office in the late 1920s. In partnership with John Gordon Rideout (d. 1951), Van Doren produced designs that used the current vogues of STREAMLINING and ART DECO forms to aid the sales of various industrial products. For the Toledo Scale Company, he styled a 1932 "penny-in-the-slot" public weighing scale in a skyscraper-like setback form that was so successful that it was claimed to have increased sales by 900 percent! His Air King table model radio of 1930–33 made early use of a plastic housing in a similarly styled MODERNE form. Other clients included Goodyear, Maytag (washing machines), and Philco. Van Doren's streamlined tricycles for American National Company introduced children to 1930s design.

His book, *Industrial Design* (1940), is a detailed text that spells out the step-by-step methods widely used by the first generation of industrial designers.

VAN KEPPEL–GREEN

Los Angeles–based furniture design and distributing firm founded in 1938 by Hendrick Van Keppel and Taylor Green (both b. 1914). The firm specialized in simple MODERN designs suitable for casual and outdoor "California style" living. The best-known designs used metal frames in simple forms and bright colors supporting seating surfaces of stretched white cord. Related tables had glass or wood plank tops. The designs were admired and included in various museum exhibits and GOOD DESIGN shows organized to promote the best work of the early post–World War II years.

VENINI

Italian manufacturer of fine-quality glass objects based in Venice. The firm was founded by Paolo Venini (1895–1959) and has been carried on by his son-in-law, Ludovico de Santillana (b. 1931), since Venini's death. Originally a maker of traditional, ornamental glass objects, the firm began to show MODERN designs in a Biennale at Monza in 1923 and at the TRIENNALE of 1933 in Milan using strong colors and inventive textures. Thin lines of white or color are often imbedded in clear glass to create remarkable visual effects. Designs were commissioned from Franco ALBINI, Gio PONTI, Carlo SCARPA, and Massimo VIGNELLI, among others. Since the 1950s, designs have included both anonymous work of staff designers and craftsmen and designs of well-known professionals including Pierre CARDIN, Tobia SCARPA, and Tapio WIRKKALA. Venini glass continues to be known for its fine quality and beautiful color, often in abstract, spectacular forms.

VENTURI, ROBERT (b. 1925)

American architect who has made a major contribution to the theoretical bases of POST-MODERNISM through his writing and who has also been active as a practicing architect and as a designer of furniture, textiles, and various other objects. Venturi was trained as an architect at Princeton University and worked for several distinguished architects including Louis I. KAHN and Eero SAARINEN before establishing his own office in partnership with John Rauch (b. 1930) in 1964. In 1989 the name of the firm was changed to Venturi, Scott Brown and Associates, Inc. Parners include Venturi's wife, Denise Scott Brown (b. 1931), Steven Izenour, and David Vaughan.

Venturi attracted wide attention within the architectural profession with his 1966 book, *Complexity and Contradiction in Architecture*, published by the MUSEUM OF MODERN ART in New York. It was the first serious and thoughtful challenge to the theories of MODERNISM as they had developed since the 1920s. Venturi suggested that the goals of simplicity and logic sought by the pioneer modernists were not always productive. He suggested a new acceptance of complication, ambiguity, contradiction, decorative elements, and historic references that violated the tenets of accepted modernism. Although disclaiming post-modern intentions in his own work, Venturi's theories have been the basis for the development of post-modernism.

In his own work and that of his firm, ambiguity and complication abound as in his Vanna Venturi house of 1962 outside Philadelphia; in Guild House, a residence for the elderly in Philadelphia (1960–63); and many other houses, larger buildings, and planning proposals. His designs for furniture and textiles for KNOLL included molded plywood chairs in cut-

Queen Anne Chair of molded plywood with painted decorative surface pattern. Designed by Robert Venturi for Knoll. Photo courtesy of Knoll International, Inc.

Guild House in Philadelphia, a 1960–63 design by Robert Venturi. Photo courtesy of Venturi, Scott Brown and Associates, Inc.

out forms suggesting traditional references, an oversized sofa, and small-scale textile print designs suggesting Victorian patterns. His 1983 silver for Alessi makes similarly whimsical references to traditional styles. Current work includes showroom and exhibitions in addition to increasingly large-scale projects, such as the addition to the National Gallery in London.

VERNACULAR DESIGN

Term used to describe anonymous design developed through craft tradition, often of local origin. Vernacular architecture includes primitive dwellings, peasant cottages and farm buildings, industrial building and warehouses, and similar structures built without architects or other trained professionals. Similarly, vernacular objects include many simple tools and implements, baskets and weavings of traditional sort, and objects such as small boats, wagons and carts, boxes and bottles in common use of unknown design origins. Vernacular design is often striking in its excellence and has come to be viewed as presenting a significant set of object lessons in what design can be when self-conscious efforts toward commercial STYLING are absent. Rather, a natural evolution as craft and user experience are allowed to shape objects in a direct and effective way.

VER SACRUM

Magazine published in Vienna from 1898 until 1903 as the primary vehicle for the ideas and work of the Vienna SECESSION movement. The work of such leaders of the movement as Josef HOFFMANN, Koloman MOSER, and Joseph OLBRICH was extensively illustrated and chronicled.

VERSEN, KURT (b. 1901)

Swedish-born American designer and manufacturer of lamps and lighting fixtures of simple, MODERN design. Versen studied in Germany and came to the United States in 1930. Versen supplied lighting fixtures for the PSFS BUILDING in Philadelphia (1931) and for various installations at the 1939 New York WORLD'S FAIR. His post–World War II firm was a primary source for well-designed modern lamps in the 1940s and 1950s, which often included gooseneck elements and swivel joints to permit adjustability. Later production included architectural lighting fixtures of more standard form. Although no longer produced, many of the Versen designs of the 1940s have a CLASSIC quality of functional excellence.

VERTEBRA CHAIR

See AMBASZ, EMILIO.

VICTORIA AND ALBERT MUSEUM

London museum of decorative art and design, given its present name by Queen Victoria in 1899. It grew out of a series of institutions dating back to 1852 when a Museum of Manufactures was established in Marlborough House

with the purpose of "improvement of public taste in Design." Buildings on the present site in South Kensington were constructed in several phases, the last of 1899–1909 designed by Sir Aston Webb (1849–1930). The museum holds a vast collection of utilitarian and decorative objects assembled before 1908. A new, ongoing effort to collect contemporary design was begun after 1946. The BOILERHOUSE PROJECT (named for its location in the old heating system of the museum) under the direction of Stephen BAYLEY has established a fresh program of innovative exhibitions focusing on particular phases of contemporary design such as the *Taste* exhibit of 1983. An accompanying booklet with the same title contains an excellent anthology of writing on that difficult subject.

VIENNA SECESSION
See SECESSION.

VIGANO, VITTORIO
See ARTELUCE.

VIGNELLI ASSOCIATES
American design firm based in New York working in a wide range of design fields with a strong, simple MODERN style that runs with a certain consistency throughout varied assignments. The firm is headed by Massimo (b. 1931) and Lella Vignelli with David B. Law (b. 1937) senior vice president. Massimo Vignelli was born in Milan, Italy, and studied art and architecture at the University of Venice. Lella Vignelli was similarly trained there as well. Massimo Vignelli was in Chicago in 1957 on a fellowship at the INSTITUTE OF DESIGN. He returned to Milan and established an office there, but returned to the United States in 1965 to establish the international design firm of UNIMARK with partners Jay DOBLIN and Bob NOORDA. Commissions included graphic design for KNOLL INTERNATIONAL and signs and maps for subway systems in New York and Washington, D. C.

In 1971, the Vignellis established their New York office and began work in the varied fields of graphics, including book design, product and furniture design, and architectural interiors. In addition to graphics and furniture for Knoll, Vignelli designs have included furniture for Sunar Hauserman, plastic dinnerware for Heller, glassware, silver, jewelry, exhibits, and showrooms for a wide variety of clients. An unusual project was interior design for St.

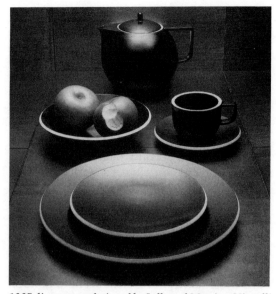

1985 dinnerware designed by Lella and Massimo Vignelli with David Law for Sasaki Crystal. Photo by Luca Vignelli, courtesy of Vignelli Associates.

Peter's Church in New York, a modern building in the shadow of the giant Citicorp skyscraper. Their work was all-inclusive, down to such details as altar vestments and fittings. Vignelli work follows the mainstream of INTERNATIONAL STYLE modernism, but does so with lively qualities of color and scale that make it seem both typically Italian and typically American in spirit. The Vignelli firm probably comes closer than any other American design office to maintaining a practice equally active and equally successful in every area of design. The firm has grown to include a staff of about 25, but it still maintains a quality of personal style that is all its own. Vignelli work has been widely exhibited and published and has won many awards including a 1964 COMPASSO D'ORO, the 1983 medal of the AMERICAN INSTITUTE OF GRAPHIC ARTS (AIGA), and a joint honorary doctorate from the PARSONS SCHOOL OF DESIGN in New York in 1983.

VILLA SAVOYE
Most famous of the early works (1931) of LE CORBUSIER, a weekend house 38 kilometers from Paris. Its main body is an almost square white box, elevated on tubular columns to the second floor level. Tucked underneath at ground level are a garage, entrance, and service spaces. Within the main living level (reached by a ramp) are a large living-dining area, an adjacent open deck, kitchen, sleeping areas, and a ramp that continues outdoors to roof

level where there is additional open living space. The house stands in an open meadow, and its austere, cubistic, INTERNATIONAL STYLE geometric form places it in sharp contrast with its natural setting. The interior spaces use strong color and are rich in complex spatial relationships. Although threatened with destruction at one time, the house is now government property and is preserved and open to visitors. It may be regarded as a primary masterpiece among the architect's works.

VIONNET, MADELEINE (1876–1975)

Swiss-born French fashion designer often regarded as the greatest couturiere of the modern era. Vionnet was apprentice-trained and by the age of sixteen was working professionally for a Paris dressmaker. In 1896 she went to London where she spent five years, working first for a tailor and then for the firm of Callot Soeurs. After working for that firm in Paris until 1907 and for Jacques Doucet until 1912, she opened her own firm, remaining in business until 1940. Her work was always forward- looking. She turned away from corsets, she claimed, before Paul POIRET and developed the bias-cut, cutting and fitting directly on a jointed wooded mannequin figure so that full-size patterns could then be prepared for cutting the final material. She was known for a subtle color sense, favoring tones of rose, pink, and other pale colors, except when she turned to black. Geometric shapes, often triangles, were favorite elements, always worked to take account of the three-dimensional figure of the wearer. Her clients included many wealthy and prominent personalities who were willing to take an individualistic approach to costume.

VISUAL PERCEPTION

Field of study that investigates the ways in which the human eyes and brain see, interpret, and understand observed reality. The field overlaps various areas of scientific study, including the physics of optics, the physiology of eye and brain, and areas of experimental psychology that study the ways in which the brain interprets and remembers what is seen. The field has important significance to artists and designers whose works are known primarily through vision. In spite of its familiarity in everyday life experience, the processes of vision are quite complex and the ways in which objects become known and understood through simple inspection are matters for con-

tinuing study. The image cast by the lens of the eye on the retina is inverted, only sharp at its center, and presents objects in perspective and in varied size according to distance. The two eyes see slightly different views, while eye, head, and body movements send constantly changing images to the retina. All of these stimuli make it possible for the brain to create three-dimensional models of reality, more or less complete according to the completeness of observation, that can be remembered and understood.

Artists and designers are aware that their works are objects that will stimulate these processes in the minds of viewers and that understanding of visual perception may be helpful in creative work. Studies such as those of Rudolf ARNHEIM in his *Art and Visual Perception* are frequently used as an aid to understanding the complications involved in these seemingly simple processes.

VOLKSWAGEN

German automobile manufacturer whose products have set worldwide standards for small, economical cars suited to mass acceptance. The term "Volkswagen" means in German "people's car," a name given to an automobile design proposal of Ferdinand PORSCHE in 1933. The rising Hitler regime encouraged the project, leading to actual production beginning in 1936. The body design for the rear-engined car was developed by Erwin KOMENDA. It became in time widely popular and was sold in vast numbers worldwide after World War II. The design is variously regarded as ugly or as a model of simple FUNCTIONALISM. In English the name "beetle" or "bug" has come to describe its rounded, streamlined shape. In 1961 the Italian designer GHIA was asked to produce an alternate body in both closed and convertible versions for a smaller production, more luxurious, and sporty model that has become known as the Karmann Ghia, now approaching the status of a design CLASSIC.

As increasing prosperity made the original VW seem too spartan in quality and as concerns developed about its safety record, Volkswagen turned to development of a replacement design with front wheel drive and more comfortable accommodation. The resulting car, variously named Golf, Polo, and Rabbit in various versions and different markets, has largely taken the place of the original VW. Its body design by Giorgio GIUGIARO of ITALDESIGN has set a new

Volkswagen Golf two-door sedan of 1988. Photo courtesy of Volkswagen of America, Inc.

standard for small cars and has met with pop-ularity almost matching that of the original Beetle. Volkswagen has gradually added a number of alternate body styles and models of varied size, price, and design, making up a line competitive with many other manufacturers' products.

VOLVO
Swedish manufacturer of cars and trucks founded in 1924, whose products have devel-oped a reputation for high quality, long life, and a good safety record; design has generally been conservative. As head of Volvo design, Jan Wilsgaard has articulated a policy of avoid-ing any fashion-oriented intentions, although Volvo design often seems to follow trends de-veloped by other, larger manufacturers. At its manufacturing plants, Volvo has been innova-tive in exploring ways to avoid the monotony of assembly line MASS PRODUCTION work by developing new approaches in which teams are involved in the total production of com-plete cars, rather than individuals working alone in repetitiously boring routine. Improved quality is said to result, along with improved worker satisfaction and loyalty.

VOYSEY, C.F.A. (CHARLES FREDERICK ANNESLEY) (1857–1941)
Architect and designer who carried forward the ARTS AND CRAFTS movement in England on the basis of ideas developed by William MOR-RIS. Voysey was trained through work in sev-eral London architectural offices in the late 19th century and began his own practice in 1882. He was encouraged to develop wallpaper designs by A.H. MACKMURDO and participated in an Arts and Crafts exhibition in 1888 with textile and paper designs. In the same year, his first house was built, a large cottage at Bishop's Itchington in a simple, traditional, VERNACU-LAR style. He continued in practice until 1920, designing many houses including Broadleys on Lake Windermere (1898) and the Orchard at Chorley Wood (1900), usually viewed as his most important works. He was also a designer of lighting, silver, furniture, and other items of daily use, which, along with his designs for wallpaper and textile prints, carried forward the Arts and Crafts tradition, while also taking account of English rural traditional design and the directions of ART NOUVEAU. His work was widely published and admired and had exten-sive influence, including an impact on the CRAFTSMAN movement in the United States.

V'SOSKE, STANISLAV (1900–1983)
Russian-born American designer and manu-facturer of carpets and rugs. V'Soske led a fam-ily business that experimented with new colors and textures, developing designs for fine-qual-ity rugs and carpeting that offered patterns which were strikingly MODERN. V'Soske rugs

became a popular element in luxury interiors of the post–World War II (1940s and 1950s) era in America. Designs were sometimes commissioned from well-known artists and designers, ranging from the painter Stuart Davis to architect-designer Michael GRAVES.

WACHSMANN, KONRAD (1901–1980)

German architect and designer-inventor whose reputation is primarily based on his efforts to develop an industrially produced house in America beginning in 1942. Wachsmann was trained as a cabinetmaker and then studied architecture in Berlin and Dresden. He established his own practice in Berlin in 1929. In the 1930s, he worked in Spain, Italy, and France. In 1941 he relocated in the United States and joined in an effort with Walter GROPIUS to develop a practical system for prefabricated house construction. Wachsmann was particularly concerned with the detailed development of panel connection systems of great ingenuity. The General Panel Corporation was established in New York in 1942 to produce wartime housing using the Wachsmann-Gropius designs—a dream that was never realized in spite of its great promise, as conventional construction resumed after the war. With the ending of

General Panel in 1949–50, Wachsmann became a professor at the INSTITUTE OF DESIGN in Chicago where he remained until 1965. He then accepted a teaching appointment at the University of Southern California where he headed a graduate program in architectural industrialization. Gilbert Herbert's book, *The Dream of the Factory Made House* (1984), gives an excellent overview of Wachsmann's career and contribution.

WAGENFELD, WILHELM (b. 1900)

German designer of glass and tableware whose career and style of work is associated with the BAUHAUS. Trained as a goldsmith, Wagenfeld studied drawing briefly at Hanau before becoming a Bauhaus student in 1923. He developed lamps and various metalwork products, some of which were in production in Germany between 1926 and 1930. Beginning in 1926, Wagenfeld taught at the Bauhaus while concentrating on the design of glass products in his own work. In 1930 the Jenaer Glasswerke began production of some of his designs, including a version of his clear glass Jena teapot and related tea service. Like most of his designs, it is a simple, unornamented example of the FUNCTIONALIST ideals of Bauhaus teaching. Wagenfeld has continued to design in the Bauhaus tradition, producing glass, china for ROSENTHAL, a meal service system in plastic for Lufthansa, and flatware and light fixtures for other manufacturers. He is the designer of the unusual 1938 Zig-zag Pelikan ink bottle still in production. Since 1954, he has worked out of his own office in Stuttgart.

WAGNER, OTTO (1841–1918)

Austrian designer, architect, and city planner, a major figure in the Vienna SECESSION move-

Interior of the Postal Savings Bank of 1904–12 in Vienna, a major work of Otto Wagner. Photo by John Pile.

ment. Otto Wagner was trained as an architect at the Vienna Polytechnic and at the Bauakademie in Berlin. His early work was in the florid 19th- century style current in Vienna at the time, and in 1894 he became the leading professor at the Vienna Academy. In 1895 he signaled a break with traditional design by moving toward a form of early MODERNISM. His work for the Vienna urban transit system (1894–1901), including many station structures, made extensive use of iron construction often richly decorated in the JUGENSTIL-related Secessionist style. Wagner was influential in encouraging Secession design as a teacher and through his employment in the offices of such leaders as Josef OLBRICH and Josef HOFFMANN. His Postal Savings Bank in Vienna (1904–12) is usually considered his most important work, particularly the steel- and glass-roofed main banking room and various other interiors. The spectacularly decorated Vienna church, Am Steinhof (1905–07), though more heavily decorated, is also a pioneering work of modernism. Wagner designed furniture for the Postal Savings Bank and for production by THONET, all in a functional vocabulary that suggested the directions that the modernism of the 1920s and 1930s would follow.

WALKER, GEORGE (b. 1908)

American automobile designer and stylist known for his important role in STYLING for the FORD Motor Company. George Walker's training began at the Otis Institute in Los Angeles in 1916 and continued at the Cleveland School of Art. He became a successful industrial designer, heading his own Detroit office in the 1930s, with such clients as the Nash automobile firm (from 1937 to 1945), International Harvester Company, and Westclox. His role at Ford began in 1945 as an independent consultant, and he was often at odds with Ford staff designers such as Robert (Bob) GREGORIE. The very successful 1949 Ford (the first post–World War II model) was largely the result of Walker's art-oriented influence. In 1956 Walker became a Ford employee, eventually becoming a vice-president with responsibility for Ford styling until his retirement in 1962. Walker's exact role in the designs credited to him remains unclear. Actual design was probably largely the work of assistants and model-makers, but Walker was clearly responsible for promoting and defending directions that drew on his art background rather the car-hobby orientation of most Detroit designers of the day.

WALLANCE, DON (b. 1909)

American designer of MODERN metalwork products and furniture, best-known for his stainless flatware designs, such as Design 1 of 1954 for Lauffer, whose smoothly curving sculptural forms suggestive of handcraft or Scandinavian design include an S-curved knife. His Design 10 of 1979 makes unusual use of plastic for a quality flatware service. Wallance was the designer of the special auditorium set developed for New York's Avery Fisher Hall (1964). Wallance's book, *Shaping America's Products* (1956), is a collection of case studies of design projects of its time.

WALTON, GEORGE (1867–1933)

Scotch-English interior designer and designer of glass and textiles who was, for a time, closely associated with Charles Rennie MACKINTOSH. Walton studied at the Glasgow School of Art and in 1888 opened his own business as a decorator in Glasgow. He designed several tearooms for Miss Cranston's Glasgow chain and worked closely with Mackintosh on several of these projects. In 1897 he relocated in London and until 1901 was active in designing a number of KODAK showrooms in various European cities. Later, he had only minor commissions, including the design of textiles for Morton Sundour from 1926 until 1931. Walton's work car-

Magnum, stainless steel tableware designed by Don Wallance for the Towle Manufacturing Company.
Photo courtesy of Don Wallance.

ried forward qualities of the ARTS AND CRAFTS aesthetic along with original decorative elements suggestive of ART NOUVEAU.

WANK, ROLAND A. (1898–1970)
Hungarian-American architect and designer known for his leadership in the design programs of the TVA (Tennessee Valley Authority) in the 1930s and 1940s. Wank came to America in 1924 and worked for a time for the firm of Fellheimer & Wagner in New York where he was the primary designer of the Cincinnati Union Terminal (1929–33), a major work with strong ART DECO characteristics. From 1933 to 1943 Wank was principal architect for TVA, leading a project team based in Knoxville, Tennessee, responsible for the many dams and power houses built by the agency. Wank's work, generally simple and reserved, showed a blend of monumentality and streamlined or Art Deco aesthetic that was at once impressive and attractive. In addition to control of strictly architectural elements, Wank directed design of power house interiors, including even the design of the electrical generating machinery. Simple forms and strong colors made this industrial equipment into something of abstract beauty, which became greatly admired as an outstanding expression of modern technology.

WANKEL, FELIX (1902–1988)
German engineer and inventor best known for his development of the Wankel rotary engine, intended to be more compact and more efficient than the conventional piston engine now in general use. In the Wankel engine the usual cylinders and pistons of internal combustion engines are replaced by a single triangular rotor that revolves in an elliptical combustion chamber. With only two moving parts, the engine is intended to reduce friction and complexity, resulting in improved performance. Wankel started work on his concept in 1926, but worked on other projects for MERCEDES-BENZ and BMW. The Wankel engine was finally put in production by the Japanese automobile firm of Mazda in 1971. Although theoretically a greatly improved engine, difficult wear and maintenance problems developed that have delayed its wide acceptance. Wankel engines are still used in RX-7 Mazda sports cars.

WANSCHER, OLE (b. 1903)
Danish designer and teacher of furniture design, a strong influence in the development of the DANISH MODERN style. Wanscher's furniture uses traditional woodworking craftsmanship in graceful and simple modern forms whose softness is typical of Danish design of the 1940s and 1950s. He was trained as an architect and has been, since 1955, a professor at the Royal Academy of Fine Arts in Copenhagen. His book *The Art of Furniture* (1966) is an outstanding study of furniture history from ancient times to its date of publication. It is illustrated with photographs and many fine measured drawings, some of them by Wanscher himself.

WASMUTH EDITION
Usual designation for the first important publication of the work of Frank Lloyd WRIGHT. German publisher Ernst Wasmuth produced two portfolios of Wright's work in 1910 and 1911 in Berlin, including full illustration of his work up to that time. It was this publication that made Wright's work known in Europe and that gives some basis for his frequent claim of having been the originator of all MODERNISM in architecture, since European pioneers may have been aware of and possibly influenced by the material illustrated in these portfolios.

WASSILY CHAIR
Name given to the 1925 metal-framed chair designed by Marcel BREUER at the BAUHAUS in response to requests of the painter Wassily (or Vassily) Kandinsky, also a Bauhaus teacher. The frame is of tubular steel with stretched surfaces of canvas or leather for the seat, back, and arm surfaces. The chair was first produced by THONET. Widely copied, it has become a CLASSIC of MODERNISM and is now produced by a number of manufacturers in more or less faithful versions of the original design.

WEBB, PHILIP (1831–1915)
English architect, a friend of William MORRIS and a significant figure in the ARTS AND CRAFTS movement. Webb received apprentice training in an architectural office before going to work for Edmund Street in 1854. In 1856 he met Morris and in 1858 designed for him the famous Red House at Bexley Heath, a functionally planned, nonhistorically imitative building of natural red brick and red tile. Webb became a member of the firm Morris founded in 1861 and designed furniture, stained glass, jewelry, and silver for the firm. He also designed many houses, often including furniture and fittings of

his own design in the Arts and Crafts vocabulary. He retired from active practice in 1900.

WEGNER, HANS (b. 1914)

Leading Danish furniture designer whose work has set the highest quality standards in design of the DANISH MODERN idiom. Wegner was trained as a cabinetmaker but also studied at the School of Arts and Crafts in Copenhagen. He worked in the office of Arne JACOBSEN until setting up his own office in 1943. Many of his designs have been produced by the Danish furniture firm of Johannes Hansen, and many have had worldwide distribution. His simple wooden armchair of 1949, using delicately tapered, carved shapes in teak with a woven seat, has come to be regarded as a high point in Danish MODERNISM. Other designs have been based on the traditional Windsor chair, have used steel structures, and have included folding and stacking models. Wegner designs have been distributed in the United States by KNOLL. Twenty-two museums throughout the world are said to hold Wegner chairs in their collections.

WEISSENHOF SIEDLUNG

Exhibition of MODERN housing designs organized in 1927 by the DEUTSCHER WERKBUND and built outside Stuttgart, which served as a showcase for the work of most of the major figures of European modern architecture of the 1920s. Ludwig MIES VAN DER ROHE was the overall planner and designer of a model apartment block, the largest building of the group. Individual houses were designed by Peter BEHRENS, Walter GROPIUS, LE CORBUSIER, J.J.P. OUD, and Mart STAM among others. All the buildings were of uncompromising INTERNATIONAL STYLE austerity with white walls, flat roofs, and large glass areas. The grouping has survived in generally good condition and remains a remarkable display of the ideas of early MODERNISM.

WELCH, ROBERT (b. 1929)

English silversmith and designer who has bridged the gulf between craft and industrial design in metalwork, glass, and pottery. Trained as a silversmith at the Birmingham School of Art, Welch then studied at the Royal College of Art in London. He traveled and studied current design practice in the Scandinavian countries before setting up practice in England at Chipping Campden in the Cotswolds in 1955. He has worked with David MELLOR in development of stainless STEEL flatware as well as objects in iron, including kettles and candlesticks. He was commissioned to design bathroom fixtures for British Railways and tableware for the Orient Lines ship *Oriana*. Welch continues to accept assignments for making custom silver objects, along with such industrial projects as Westclox clocks and lamps for Lumitron. His style incorporates some of the sculptural elegance of Scandinavian design with the solidity of the English traditional VERNACULAR.

WELDING

Metalworking process in which metal parts are joined by melting and fusing together, often with the addition of weldmetal. Cold welding is sometimes achieved by pounding parts together until fusion takes place, but most welding is dependent on heat that melts some portion of the parts to be joined until they fuse together and remain welded after cooling. The most common methods of welding are gas welding, in which high heat is generated by a flame from a torch that burns suitable gases, usually oxygen and aceteline. Arc welding uses electric current arcing at the point to be welded to produce necessary heat. Welds may be continuous ribbons or FILLETS, smaller fused areas, or individual points called "spot welding"; the last usually uses an electric arc to produce the small area of weld.

Welding is widely used in the production of modern products made of STEEL, such as automobile bodies, railway cars, appliances, and furniture of steel construction, and to a more limited extent, in steel structural framing. ALUMINUM welding is also possible and is used in making aluminum door and window frames, railings, and similar architectural products. As compared to the use of rivets or other mechanical joining techniques, welding has the advantage of producing more continuous joints and avoiding the weight and appearance of rivet or bolt heads. Assuring the strength of welds presents some difficulty, so that its acceptance in highly stressed structures has tended to be somewhat limited.

WENDINGEN

Design group based in Amsterdam dedicated to a handcraft-related approach to MODERNISM and the magazine of the same name produced by the group from 1918 to 1931. The

Wendingen group had its roots in the early pre-MODERN work of Hendrikus Petrus BERLAGE and took a strong interest in the work of Frank Lloyd WRIGHT as well. In fact, the special 1925 issue of *Wendingen* was an important link in introducing Wright's work in Europe. Under the editorship of H.Th. Wijdeveld, the magazine exerted a considerable influence through its content, by presenting DE STIJL and other modern work in architecture and design as well as through its TYPOGRAPHY.

WERKBUND

One of a number of organizations organized during the 1900–1930 period to promote excellence in design in German-speaking countries. The DEUTSCHER WERKBUND became the model for similar organizations in Switzerland (Schweitzer Werkbund), and Austria (Ostereichischer Werkbund) as well as in various cities. All Werkbund organizations were related in a loose affiliation, and all shared the common goal of encouraging the development of design in the direction now recognized as MODERN.

WERKSTÄTTE

Loosely affiliated organization of craftsmen dedicated to design excellence. The best-known group is the WIENER WERKSTÄTTE, organized in Vienna in 1903. But the Werkstätte movement also developed in other European cities at about the same time.

WESTON, EDWARD (1886–1958)

American photographer known for his crystal-clear images of rocks, driftwood, nudes, and varied objects, often viewed close-up in fragments or details. Weston can be called a "designers' photographer" in that his subjects, of whatever nature, become abstract design in his photographs while remaining totally recognizable and realistic. His influence on the development of MODERN photography as an aspect of modern art has been profound. Weston settled in California in 1906 and made it his lifetime base of photographic activity. His early work was in the sentimental, pictorial style of early 20th-century photographers, but by 1920 he had begun to move to a more documentary, abstract style. In 1922 he visited New York and met Charles SHEELER, Alfred STIEGLITZ, and Paul STRAND. From 1923 to 1925 Weston was in Mexico, and after returning to California, he produced the major work of his career: images of shells, green peppers, artichokes, sand dunes, human figures, even, in 1930, an enameled bedpan isolated on a black background. He generally worked with an 8 x 10 view camera and made contact prints from the large negatives. His photographs are always sharp and realistic, of superb technical quality, but also abstract in their visual impact. Weston's work has been widely published and exhibited and is represented in the collections of many major museums. His son, Cole Weston (b. 1919), is also a photographer and has, since his father's death, continued to make prints from Edward Weston negatives following exactly the instructions left by his father.

WHEELER, CANDICE (1827–1923)

American designer of textiles and wallpapers linked in style with ARTS AND CRAFTS directions. Wheeler developed an amateur interest in art and in 1877 founded the Society of Decorative Art to encourage design of superior quality. She became friendly with Louis Comfort TIFFANY and eventually became a member of his firm, designing embroideries, wallpapers, and textiles for use in the firm's interior decoration projects. From 1883 to 1907 Wheeler managed the Tiffany firm. Her work made use of floral motifs and showed the influence of Japanese art and design. She was the author of the 1903 book, *Principles of Home Decoration*, an influential book in its time.

WHITE, STANFORD (1853–1906)

American architect, a partner in the firm of McKim, Mead & White and a leading figure in the peak period of ECLECTIC architecture at the turn of the century. White had no formal training in architecture, but worked in the office of H.H. Richardson (1838–1886) in Boston where he met Charles Follen McKim (1847–1909). In 1879 McKim and White entered into a partnership with William R. Mead (1846–1928), forming one of America's most successful architectural firms. Although the work of the three partners was the result of close cooperation, White's contribution was generally of an ornate and decorative character and included a particular interest in interior work. Madison Square Garden (1887–91, now demolished) is an example of White's florid style in a major public building. In residential work, White was significant in developing the country house style now called Queen Anne through his work on such projects as the Watts Sherman house (1874) at Newport, Rhode Island, designed in the

Richardson office, and in many houses by McKim, Mead & White, particularly those in the informal idiom that has come to be called the "shingle style." The Newcomb house at Elberon, New Jersey (1880–81), and the Low house at Briston, Rhode Island (1887), are outstanding examples of this stylistic direction. White was responsible for involving Elsie DE WOLFE in many of his projects as an interior decorator and can be viewed as influential in creating the role of the interior decorator in America.

WHITNEY MUSEUM OF AMERICAN ART
New York museum founded in 1930 by Gertrude Vanderbilt Whitney as a showcase for the work of American artists with particular emphasis on MODERN work. The original Whitney Museum occupied a group of converted townhouses on New York's Eighth Street in Greenwich Village, but in 1966 the institution relocated in a new and striking building designed by Marcel BREUER on Madison Avenue at 75th Street. The Whitney has generally been more adventurous than other New York museums in showing work that is avantgarde and experimental, and it has recently indicated an increasing interest in design as an aspect of American art. Such shows as the 1985 *High Styles* exhibit devoted to 20th-century design and the *Shaker Design* exhibit of 1986, with related publications, have made the Whitney Museum a significant force in presenting design to the American public as an important aspect of art.

Exhibition gallery in the Whitney Museum of American Art in New York, a 1963–66 design by Marcel Breuer and Hamilton Smith, architects. Photo copyright © Ezra Stoller (ESTO), courtesy of Marcel Breuer & Associates.

WIENER WERKSTÄTTE

Organization of craft workers established in Vienna in 1903 to promote and distribute work of high design quality in the stylistic direction established by the SECESSION movement of a few years earlier. Its 1905 brochure showed the organization employing more than 100 craftsmen who produced designs by Josef HOFFMANN and Koloman MOSER. A number of others contributed designs thereafter, making the Werkstätte the primary source of objects in the Secession style. The organization survived until 1932 when it closed as a result of financial difficulties. Werkstätte products included leatherwork, jewelry, metal objects, and furniture in the JUGENDSTIL-related vocabulary typical of Secession design. The success of the Vienna group led to the spread of the Werkstätte to other European cities.

WIINBLAD, BJØRN (b. 1919)

Danish artist and designer known for his work in varied design fields, including stage and costume design, furniture, interiors, and for the ceramics, glassware, and cutlery he designed for the ROSENTHAL Studio-Linie. Wiinblad now lives in Lausanne, Switzerland, but maintains studios in Kongens-Lyngby and in nearby Copenhagen, Denmark, where he directs a staff of craft potters and maintains a retail shop, Blaa Hus, where his craft products are sold. Wiinblad's work combines MODERNISM with a personal style based in the crafts that is typical of DANISH MODERN design.

WILSON, ROBERT (b. 1931)

American originator and director of theatrical productions, plays, operas, and hard-to-classify works that combine drama and pageantry in productions that last, in some cases, for many hours. Trained as an interior designer at PRATT INSTITUTE, Wilson always had a strong interest in theater that he was able to develop as a graduate student at Yale where he studied before beginning an independent career in the theater. He has sustained a strong interest in design, giving unusual attention to the visual aspects of his theatrical productions and often

China tableware designed by Bjørn Wiinblad for Rosenthal Studio-Linie. Photo courtesy of Rosenthal USA Limited.

using objects of his own design as stage props. His special interest in chairs and other objects of furniture has led to some of his designs being recognized as unique art objects. His forms often use exaggeration, distortion, or unlikely combinations that transform banal materials and shapes into mysterious, ambiguous assemblies. A 1982 side chair uses plumbing pipe and plywood in a somewhat crude relationship to support a suede cushion, while one side of the chair is supported by a galvanized metal triangle from which a gilded claw-foot emerges. His 1977 Stalin chairs designed for the play *The Life and Times of Joseph Stalin* have a surface of sheet lead draped over a FIBERGLASS support structure. They and a plumbing pipe Witness chair used in the opera *Einstein on the Beach* (1977) were both included in the WHITNEY MUSEUM OF AMERICAN ART 1985 *High Styles* exhibit in New York.

WINES, JAMES (b. 1932)

American sculptor and designer, a founding partner and conceptual leader of SITE (Site Projects, Inc.), a New York architectural and environmental design firm known for its unusual and iconoclastic approach to design. James Wines was educated at Syracuse University in art history and sculpture, graduating in 1955. From then until 1967, he lived in Rome and worked as a sculptor. He was awarded fellowships by the American Academy in Rome, the Ford Foundation, and the Guggenheim Foundation and exhibited with the Marlborough Gallery in New York and London. Wines founded SITE (Sculpture in the Environment) with three partners in 1970 to develop innovative approaches to environmental design that combined sculptural, architectural, and adventurously innovative concepts. The catalog showrooms of the Best Products Company, with such descriptive names as "Notch" and "Tilt," are among the best-known of SITE's many projects. Wines is the Chairman of the Department of Environmental Design at PARSONS SCHOOL OF DESIGN in New York and the author of the 1988 book, *De-Architecture*, which presents his theoretical views.

WIRKKALA, TAPIO (1915–1985)

Finnish craftsman and designer of ceramics, glass, metal, and wooden objects as well as an industrial designer who worked on furniture, lighting appliances, and exhibitions. Trained at the Helsinki Institute of Industrial Arts,

Century New Wave china designed by Tapio Wirkkala (with decoration by Dorothy Hafner) for Rosenthal Studio-Linie. Photo courtesy of Rosenthal USA Limited.

Wirkkala began designing for the IITTALA glass works in 1947. His Kanttarelli glassware of 1947 uses blown forms with ribbed textures—an example is in the collection of the Metropolitan Museum of Art in New York. Wirkkala has produced cutlery designs and ceramics for ROSENTHAL (1963), glass for VENINI, woodenware for Soinne using laminated construction, and he has established a record as the winner of seven grand prizes in Milan TRIENNALE exhibitions. His work balances the austerity of FUNCTIONALISM with a decorative delicacy that is characteristically Finnish.

WOOD

One of the most used, basic, naturally produced materials, familiar in historic design, but also in wide use in modern products and structures. Wood in current use comes from two families of trees: evergreen (coniferous) trees that produce softwoods and deciduous trees that produce hardwoods. Softwoods are widely used in carpentry because they are easily worked and relatively inexpensive. The most-used softwoods are pine, fir, spruce, cedar, and redwood. Hardwoods come from the slower growing trees, including familiar fruit and nut varieties. Common hardwoods include birch, maple, oak, walnut, mahogany,

teak, cherry, poplar, and various more exotic woods such as rosewood, ebony, satinwood, pear, and ash.

Wood is cut from the trunks of trees in various dimensions for use in solid form. It can also be sliced into thin sheets known as "veneer," which may be used to surface other solid wood for a veneer panel. Many layers of veneer may be laminated together to form PLYWOOD. In modern practice, panels are often made up of sawdust and waste wood clips bound together with a resin adhesive and pressed into sheets known as "particle board." In addition to making cores for veneer panels, particle board is used in utility applications in carpentry and furniture production where the material is used in hidden locations or is finished with paint or other surface material.

Wood presents a number of problems to designers, including the lengthwise form created by its growth and the resulting grain structure. Tendency to shrink, swell, and warp with varying humidity is also a characteristic that must be dealt with through appropriate design. Plywood and particle board reduce or eliminate some of these problems. In addition, wood is inflammable unless specially treated and subject to rot and insect damage. Its cost constantly rises as its availability declines since consumption outruns replacement through new growth. However, in comparison with such alternate materials as metals and PLASTICS, wood remains economical in many applications, while its appearance and warm, tactile qualities are advantageous for use in many products, including furniture and many small utilitarian and decorative objects.

WORLD'S FAIRS

Public exhibits of brief duration, often to commemorate some historic event, organized repeatedly in the 19th and 20th centuries as important showcases for advanced design in products, architecture, and planning. The Great Exhibition of 1851 held in London (often known as the CRYSTAL PALACE exhibition after its main building) is usually thought of as the first world's fair. All nations were invited to exhibit their best works in industry and the arts so that visitors had the opportunity to review this cross-section of world achievement at one time and place. World's fairs of particular interest in terms of design have included the Paris Exhibitions of 1867, 1878, 1889 (including the EIFFEL Tower), 1900, 1925, and 1937; the CEN-TENNIAL Exhibition of 1876 in Philadelphia; Columbian (1893) and CENTURY OF PROGRESS Exhibitions (1932–33) in Chicago. More recent world's fairs with important design content were the New York Fairs of 1939 and 1964 as well as the Expo 67 exhibit in Montreal.

The temporary nature of fairs has encouraged the use of innovative architecture, ranging from the Crystal Palace through the vast exhibition halls of Paris fairs of the late 19th century to Louis SULLIVAN's transport building of 1893 in Chicago and FULLER's 1967 GEODESIC dome and the Habitat housing structure of Moishe Safdie at Expo 67 in Montreal. In product and artistic design, the fairs have often served to focus the development of movements or concepts such as the ART NOUVEAU emphasis at Paris in 1900, the ART DECO of Paris in 1925, or the STREAMLINING featured at Chicago in 1932. Attempts to produce world's fairs on a too-frequent basis have tended to reduce the importance of the many fairs staged in the post–World War II era.

WORMLEY, EDWARD (b. 1907)

American designer of MODERN furniture known for its restrained and somewhat conservative character. Wormley studied at the Art Institute of Chicago in the 1920s before specializing in furniture design in the 1930s when he began a long- lasting relationship with the Dunbar Furniture Company of Berne, Indiana. After World War II, Wormley set up a private practice in interior and furniture design with Dunbar as his primary client. Early in his career, Wormley designed both traditional and modern furniture, but his reputation is primarily based on modern design with a conservative flavor. Wormley used wood and upholstery in a way that seemed comfortable to an audience not totally ready for the austerity of INTERNATIONAL STYLE design. Wormley often called his designs "transitional," and he did not hesitate to use forms such as those of the ancient Greek *klismos* chair. Wormley's Dunbar furniture was included in a number of GOOD DESIGN exhibitions at the MUSEUM OF MODERN ART in New York.

WRIGHT BROTHERS

Designers and builders of the first successful airplane. Wilbur Wright (1867–1912) and Orville Wright (1871–1948) operated a bicycle shop in Dayton, Ohio, where, in their spare time, they worked on kites and gliders that

aided them in the development of a powered airplane. Their first flight at Kill Devil Hill, North Carolina, in 1903, though brief, demonstrated the practicality of powered flight in a decisive way. By 1905, a 35-mile flight was successfully completed. The Wrights eventually demonstrated their design convincingly in France, England, and the United States to skeptical U.S. Army representatives. Quite unlike most later airplanes, Wrights' designs were biplanes with control surfaces at both front and rear. Two propellers were driven by a single engine, while the pilot took a prone position on the lower wing in flight. The Wrights' airplanes nevertheless provided the foundation on which all later European and American designs were based.

WRIGHT, FRANK LLOYD (1867–1959)

American architect generally regarded as the most important pioneer of MODERNISM and the most famous of American architects, as well as an important designer of furniture and other elements related to architectural projects. Wright studied engineering briefly at the Wisconsin State University at Madison, but received most of his training as a draftsman in the office of Adler & Sullivan in Chicago beginning in 1887. Wright regarded Louis SULLIVAN as his only significant teacher and referred to him as "Lieber Meister" throughout his career. In 1893 he opened his own office in Oak Park, outside Chicago, and began to produce residential designs in significant quantity. The Winslow house of 1893 and the Roberts house of 1904 (both in the Chicago suburb of River Forest) are major works that define his developing concept of the "Prairie House"—a low-hipped roof with strongly projecting horizontal lines, without any historical references, but with Wright's own geometric ornamental detail. He designed furniture, stained glass windows, and many other details for his architectural projects.

The Larkin office building in Buffalo, New York (1904), was a monumental structure with open office spaces arranged around an open central court. Its forms were massive blocks and slabs with a strongly abstract character. Wright designed special metal furniture of simple, functional style for use in the building. The ROBIE HOUSE in Chicago (1909) is widely regarded as one of the great masterpieces of early modern architecture. By 1911, Wright had produced a major body of work that became known in Europe through the publication of what has come to be called the WASMUTH EDITION.

As a result of various misfortunes, Wright left the United States for several years and went to Japan where he designed and directed construction of the Imperial Hotel in Tokyo (1915–22). That the building survived an earthquake in 1923, which destroyed a large part of the older Tokyo was a major factor in shaping Wright's fame.

After his return to the United States, Wright built a new career with the design of such famous works as FALLINGWATER (1936) and the S.C. Johnson office building in Racine, Wisconsin (1936–39). After World War II, Wright had a flow of major commissions, including such works as his GUGGENHEIM MUSEUM of 1959 in New York.

Wright designed interiors, furniture, decorative elements, and even, in some cases, textiles and china as part of many of his architectural projects. His work had a strong influence in the developing modernism of Europe in the 1920s and 1930s, but it stood outside the mainstream of American architecture and remains an admired, but isolated, contribution to the development of design in the United States. At his own estate at Taliesin (near Spring Green, Wisconsin), Wright built a vast grouping of buildings, including the quarters of the Taliesin Fellowship, a loosely organized effort at apprentice teaching in which younger men came to work and study with Wright.

There exists an extensive literature by and about Wright, including Henry-Russell Hitchcock's *In the Nature of Materials* (1942), a survey of Wright's work up to its publication; Wright's autobiography of 1943; and such recent works as Brendan Gill's *Many Masks* (1987).

Wright's highly personal style, his combative personality, and resulting isolation from the architectural and design professions of his time make his work a special phenomenon, an expression of undoubted genius, but not strongly integrated into the development of 20th-century design. Wright's use of ornament, an ornament based in Sullivan's ART NOUVEAU vocabulary, but with a more geometric quality suggesting ART DECO, sets his work apart from the austerity of INTERNATIONAL STYLE modernism. He regularly spoke in bitter opposition to the work of the pioneer European modernists, and although his work sometimes seemed to show their influence, he remained an independent, with no clear ties to any movements of his time.

Interior of the Solomon R. Guggenheim Museum in New York designed by Frank Lloyd Wright. Photo courtesy of the Solomon R. Guggenheim Museum.

WRIGHT, RUSSEL (1904–1976)

American industrial designer best-known for the design of very popular ceramic dinnerware of the 1930s and 1940s. Wright studied sculpture at the Art Students League of New York and was a law student at Princeton but became involved in stage design at the beginning of his working career. In 1927 he married Mary Small Einstein who became an active influence and partner in his career. Her advice led him away from the theater and into design, at first, of novelty caricature and decorative objects. In the early 1930s he began to design practical metalware objects, tableware in spun ALUMINUM, bunwarmers, ice buckets, and similar items intended as practical aids to informal entertaining. This work, with its adoption of a MODERNISM that was practical, informal, and appealing to average householders, established the theme of much of his work as an industrial designer. At the same time he designed a wood-framed arm chair with sculpturally carved arms, almost suggesting ART NOUVEAU directions, that was used for the boardroom of the 1932 MUSEUM OF MODERN ART in New York.

Beginning in 1935, in partnership with Irving Richards, Wright began to design a variety of products carrying the name American Way. Metalware and furniture designs were followed in 1937 by Wright's greatest success, the earthenware china called American Modern manufactured by the Stubenville Pottery Company in Ohio from 1939 until 1959. The shapes were simple and unornamented with flowing forms and somewhat exaggerated spouts for teapots and pitchers. The glaze colors were soft, greyed pastels. Although it took some time for the design to achieve popularity, it eventually became a phenomenal success, a favorite of every "young modern" American household.

Wright designed glassware, linens, and placemats in related colors as his name became a well-known selling feature for household products. Other manufacturers produced his designs for restaurant china, a sturdy ovenware china for home use, plastic dinnerware, cutlery, lamps, small appliances, and textiles. His later work included a school furniture line (for Samsonite, 1955), color and design consultation in the United States and Japan, and consultant work for the National Parks Service. Among the American industrial designers of the 1930s, Wright was particularly successful in arriving at designs that had a strong popular appeal for home use, while retaining aesthetic qualities that lifted them above the level of pure commercialism.

YAMAMOTO, KANSAI (b. 1944)

Japanese fashion designer known for his theatrical showings in Tokyo, Paris, and New York. Yamamoto was trained in engineering and worked for Hisashi Hosono Studio before setting up his own firm in 1971. That year he had a showing in London conducted in an extravagant manner, and his spectacular Tokyo show in 1972 drew an audience of 5,000! His first Paris show was in 1975, and his New York showing of 1979 was a disco event that attracted wide attention. His designs are sharply at odds with the traditions of French fashion because he uses forms, colors, and textures in casual, almost chaotic combinations representing new directions that Japanese fashion has brought to Europe and America. His work now includes menswear, bags, linens, and even stationery design.

YAMAMOTO, YOHJI (b. 1943)

Japanese fashion designer, now based in Paris. Yamamoto is a graduate of Keio University and studied fashion design at the Bunka College of Fashion in Tokyo, where he studied with Chie Koike, was was in turn a student of Yves SAINT LAURENT. He established his own firm in Tokyo in 1972 and had a first major showing there in 1976. In 1981 he set up his firm in Paris, opened a boutique there, and now shows regularly during the annual Paris fashion week. Yamamoto designs are generally functional, strong in pattern and color, with no attempt to show off the figure within their oversize, asymmetrical, and deliberately careless form. They often incorporate whimsically placed buttons, pockets, and even torn edges. Yamamoto design is representative of a Japanese school, clearly in contrast with the norms of Paris fashion.

YOURKEVITCH, VLADIMIR (1885–1964)

Russian-born naval architect known for his development of a unique hull form used for the French liner NORMANDIE. Yourkevitch had been trained as a naval architect and worked at the Baltic Shipyard in St. Petersburg designing submarines and warships there from 1910 until the Russian Revolution in 1917. He had designed hulls for four battle cruisers with a new form: a flared bow with a hollowed-out contour at the waterline and a bulblike shape at the foot (bottom), which, when tested out in model test tanks, to the amazement of skeptics, proved to be superior to all more conventional designs. However, these ships were never completed, and Yourkevitch left Russia, eventually finding his way to Paris by 1922 where he went to work as an assembly-line worker in an automobile factory. In 1929, having heard of the plan to build a new French liner, Yourkevitch offered his services to the Penhoet shipyard and eventually, again through tank testing, persuaded decision makers of the superiority of his hull design. The *Normandie* was built with a Yourkevitch hull, which achieved exceptional efficiency in terms of speed in relation to power. For example, the rival *Queen Mary* required 208,000 horsepower to reach the speed that the *Normandie* achieved at about 160,000 horsepower. Yourkevitch set up a New York office in 1937 while continuing an active consulting practice in Europe until the start of World War II. He was in New York at the time of the *Normandie's* fire in 1942 and provided consultation on possible salvage and reconstruction, which, in the end, was never attempted. As a consultant naval architect in New York, he proposed designs for a number of larger liners, but none was accepted. Most modern ships are now built with hulls based on Yourkevitch concepts.

YUKI (Born MIYAZAKI-KEN) (b. 1940)

Japanese fashion designer, now working from a London base, whose work includes both ready-to-wear and elegant couture design, usually of flowing, sculptural form. Yuki was trained in Japan as a textile engineer and then worked in film animation in Tokyo before moving to London. From 1962 to 1964 he studied architecture and interior design at the Art Institute of Chicago, and then, from 1964 to 1966, he was a student at the London College of Fashion. He worked briefly for Harnell in London and in 1969 went to Paris to work for Pierre CARDIN. He introduced his own first collection in Paris in 1972. Yuki also designs jewelry and leather goods and has designed for theater and television. In 1978, the VICTORIA AND ALBERT MUSEUM presented a retrospective of his work.

ZANINI, MARCO (b. 1954)

Italian industrial designer best known for his work for the MEMPHIS product group. Zanini studied architecture at the University of Florence and traveled in the United States before becoming a partner in the office of Ettore SOTTSASS in 1977. His work was included in the 1981 and 1982 Memphis exhibitions in Milan. His Dublin sofa of 1981 uses four foam cushions covered in bright colors placed on top of a tablelike slab base. Zanini's work in glassware has included tumblers and vases of elaborate, abstract form, such as his 1982 Alpha Centuri vase for Toso—a tower of blown glass shapes in various colors rising from a funnel-like base.

ZANUSO, MARCO (b. 1916)

Italian industrial designer known for his work for BRIONVEGA and OLIVETTI done between 1958 and 1977 in collaboration with Richard SAPPER. Trained as an architect at the Milan Polytechnic, Zanuso was the designer of the Milan TRIENNALE in 1947 and from 1951 to 1955 and an editor of *Casabella* magazine during the same period. He won a COMPASSO D'ORO award at Milan for his Borletti sewing machine in 1956 and for his 1962 BrionVega television set. He has designed a range of BrionVega products with Sapper, including the Black 13 television set of 1969, pens for Aurora, and scales for TERAILLON. Most of these designs use simple geometric forms, strongly rounded corners, vivid colors, and a lively arrangement of details typical of the best of Italian MODERNISM. Zanuso has also designed industrial plants and offices for Olivetti. His furniture has developed from massive curved slabs of 1951 for Arflex through modular units of 1967 for B&B Italia to colorful plastic children's chairs of 1964 for Kartell (designed with Sapper).

ZAPF, HERMANN (b. 1918)

German type designer known for a number of widely used MODERN but conservative TYPE-FACES designed in the 1950s. The best known are Palatino and Melior, both elegant ROMAN typefaces, and Optima, a face with thick and thin strokes, but without SERIFS.

ITC Zapf·Book® Medium

abcdefghijklmnopqrstuvwxyz
ABCDEFGHIJKLMNOPQRSTUVWXYZ
1234567890 .,;:"&!?$

Zapf Book, a typeface designed by Hermann Zapf.

ZAPF, OTTO (b. 1931)

German designer of furniture and lighting best known for the open office system developed in 1973 for KNOLL. The Knoll Zapf system was designed as a lighter, less costly version of the STEPHENS system originally developed at the request of SKIDMORE, OWINGS & MERRILL. The Zapf system uses fabric-covered panels, with half-round vertical edges, that form screens and enclosures having a soft feeling. They support a range of work surfaces, and storage and lighting units. Zapf has also designed a seating system, chairs, and a lighting unit that have been included in the Knoll product line at one time or another.

ZEISEL, EVA (b. 1906)

Hungarian-American designer best known for her work in modern ceramic dinnerware. Trained as an artist at the Royal Academy in Budapest, Zeisel then worked as a designer for a Budapest manufacturer of earthenware and for various ceramic manufacturers in Germany and in the USSR. Her 1929 tea service for Schramberg uses geometric forms with a strong MACHINE ART flavor. In 1937 she came to the United States and taught at PRATT INSTITUTE in New York (1939–53) and at the RHODE IS-LAND SCHOOL OF DESIGN (1959–60). In 1946, the MUSEUM OF MODERN ART in New York introduced the line of china that she had designed for the Castleton China firm with sponsorship by the Museum. Named "Museum Shape," its simple, but elegant sculptural curving forms were produced only in white. Zeisel also designed a demountable metal-framed chair (1964), various wooden objects, and another china service, Hallcraft (1952), produced by Hall China. A major exhibit of her work was mounted in 1984 at the Musée des Arts Décoratifs in Montreal.

ZEISS

German optical and precision instrument firm founded in 1846 by Carl Zeiss (1816–1888), a mechanical engineer, and Ernst Abbe (1840–1905), a physicist. The microscopes made by the firm using Zeiss's mechanical skills and Abbe's knowledge of optics were of the highest standards in performance and helped create the vocabulary of design associated with precision instruments. The quality of Zeiss lenses made them well-known in photographic applications, and Zeiss took up the manufacture of cameras for amateur and professional use. The Contax cameras of the 1930s (models I, II, and III) joined the LEICA cameras in making 35mm

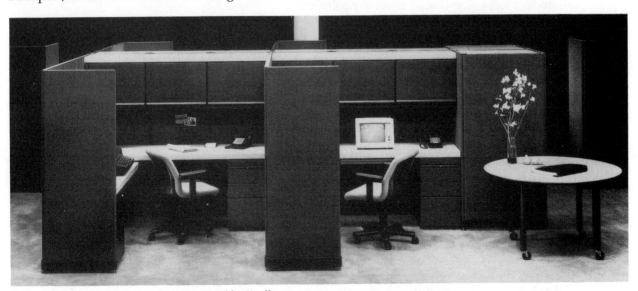

Office furniture system designed by Otto Zapf for Knoll. Photo courtesy of Knoll International, Inc.

photography practical and popular. Zeiss also made folding, reflex, and motion picture cameras, all with appearance design by anonymous factory personnel; their crisp, functional quality set them apart from other brands. After World War II, Zeiss returned to making cameras for a time, yet eventually abandoned all such consumer-oriented products with the rising popularity of Japanese photographic equipment. Zeiss lenses, microscopes, and laboratory and technical instruments continue to set a high standard in performance and design quality.

ZEPPELIN

Popular name for the rigid airship, or dirigible, of the type developed by Count Ferdinand von ZEPPELIN around 1900 in Germany. Zeppelins built after World War I were usually given streamlined shape, with a bulletlike nose and tapered tail. The gigantic size of the last zeppelins (such as the *Graf Zeppelin* and the *Hindenburg*), their extraordinary long voyages, and unfortunately dramatic accidents kept them in public view, while the belief that they represented the travel mode of the future gave them symbolic significance. The zeppelin form became a design theme of the 1930s that was understood to suggest speed, power, and optimism about a constantly improving technological future. The most famous zeppelins were the British *R-100* and *R-101*, the German airships mentioned above, and the U.S. naval craft *Akron*, *Macon*, and *Shenandoah*. All met with unfortunate ends except the *R-100* and the *Graf Zeppelin*. Enthusiasts continue to suggest that modern technology could make zeppelin aircraft safe, practical, and economically productive in present-day use.

ZEPPELIN, GRAF (COUNT) FERDINAND VON (1838–1917)

German aircraft designer, builder, and navigator, famous for the type of rigid airship usually called by his name. Count Ferdinand von Zeppelin had had a military career, had visited the United States (where he had a conversation with President Lincoln), and had become a skilled engineer before turning his attention to aviation around 1890. Zeppelin's contribution was to put together the concept of the balloon, a rigid frame that created a shaped envelope, and the newly developed internal combustion engine. His first design, the dirigible LZ-1, was 420 feet long. In 1900 it flew a distance of 3½

miles, reaching a speed of 18 mph. A series of improved versions and frequent mishaps followed, but by 1911 the LZ-10, named *Schwaben*, was able to carry 24 passengers at 44 mph. It made 218 flights, carrying 1,553 passengers on regular trips. Dirigibles were able to provide far larger and better passenger accommodations than the primitive airplanes of that day. The *Hansa* carried a total of 6,217 passengers and, in 1912, set a distance record with a 450-mile trip from Hamburg to Copenhagen. With the coming of the World War, the German military began using zeppelins for the infamous bombing raids on London. After the war and Zeppelin's death, civilian airships were developed on the basis of wartime experience, some of them capable of successful long flights. The characteristic streamlined form of the ZEPPELIN entered into designers' thinking as a symbol of modernity and speed, which has survived in spite of the eventual abandonment of the dirigible in favor of the more practical airplane.

ZINC

Metallic element often used as a rust-preventative coating on iron and STEEL, applied by a hot dip or an electrolytic process called "galvanizing" (named for its inventor, Luigi Galvani [1737–1798]). Galvanized metal is often used for metal roofing or siding and for buckets and other containers. Zinc is also an element much used in the production of various alloys such as BRASS, DIE-CASTING metal, and *Zamac*; in the last alloy zinc is combined with ALUMINUM and magnesium to achieve strength as well as qualities favoring casting.

ZOGRAPHOS, NICOS (b. 1931)

American designer (born in Greece) known for furniture of his own design manufactured and distributed by his firm, Zographos Designs Limited of New York. Zographos is a fine arts graduate of the University of Iowa. From 1957 to 1962 he was a designer with the New York architectural office of SKIDMORE, OWINGS & MERRILL. In 1964 he founded his own firm to produce his own designs. His best-known works use simple metal frames of INTERNATIONAL STYLE simplicity, as in the glass-topped table TA.35G and the tubular-framed chair CH.66 in the collection of the MUSEUM OF MODERN ART in New York. The Zographos firm now produces an extensive line of furniture in metal, wood, and upholstery of consistently simple but elegant form.

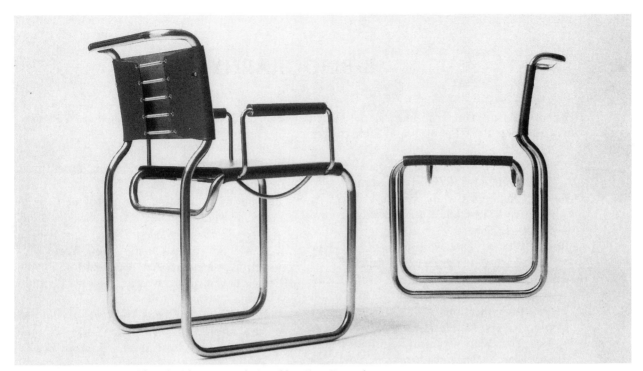

CH.66 chair in versions with and without arms, designed by Nicos Zographos. Photo courtesy of Zographos Designs Limited.

ZWART, PIET (1885–1977)

Dutch graphic designer and typographer whose work is associated with the DE STIJL movement. Zwart was trained as an assistant in an architectural office and worked in furniture design before becoming connected with the De Stijl movement and contributing to the magazine of that name. His work makes use of type and abstract forms in patterns that combine de Stijl geometry with a suggestion of DADA freedom.

BIBLIOGRAPHY

Armi, C. Edson. *The Art of American Car Design.* University Park: Pennsylvania State University, 1988.

Arnason, H.H. *History of Modern Art.* New York: Prentice-Hall/Harry N. Abrams, 1986.

Bayley, Stephen. *Conran Directory of Design.* New York/London: Villard Books/Conran Octopus, 1985.

Boyce, Charles. *Dictionary of Furniture.* New York: Facts On File/Henry Holt, 1985.

Craig, James, and Barton, Bruce. *Thirty Centuries of Graphic Design.* New York: Watson-Guptill Publications, 1987.

Doblin, Jay. *One Hundred Great Product Designs.* New York: Van Nostrand Reinhold, 1970.

Emery, Marc. *Furniture by Architects.* New York: Harry N. Abrams, 1983.

Ferebee, Ann. *A History of Design from the Victorian Era to the Present.* New York: Van Nostrand Reinhold, 1970.

Garner, Philippe. *Contemporary Decorative Arts.* New York: Facts On File, 1980.

———. *Twentieth-Century Furniture.* New York: Van Nostrand Reinhold, 1980.

Heskett, John. *Industrial Design.* New York: Oxford University Press, 1980.

Heyer, Paul. *Architects on Architecture.* New York: Walker & Co., 1966.

Hiesinger, Kathryn B., and Marcus, George H., eds. *Design Since 1945.* Philadelphia: Philadelphia Museum of Art, 1983.

Jenks, Charles, and Chaitkin, William. *Architecture Today.* New York: Harry N. Abrams, 1982.

Jervis, Simon. *Dictionary of Design and Designers.* Harmondsworth, England: Penguin Books, 1984.

Larrabee, Eric, and Vignelli, Massimo. *Knoll Design.* New York: Harry N. Abrams, 1981.

Mang, Karl. *History of Modern Furniture.* New York: Harry N. Abrams, 1979.

McDowell, Colin. *McDowell's Dictionary of Twentieth Century Fashion.* London: Frederic Muller, 1984.

Milbank, Caroline Rennolds. *Couture.* New York: Stewart, Tabori & Chang, 1985.

Morgan, Ann Lee, ed. *Contemporary Designers.* Detroit: Gale Research Co., 1984.

——— and Naylor, Colin, eds. *Contemporary Architects.* Chicago/London: St. James Press, 1987.

Pevsner, Nikolaus. *The Sources of Modern Architecture and Design.* New York: Praeger, 1968.

———. *Pioneers of Modern Design from William Morris to Walter Gropius.* New York: Museum of Modern Art, 1936; 2nd ed., 1949. Rev. ed. Harmondsworth, England: Penguin Books, 1960.

Phillips, Lisa, et al. *High Styles: Twentieth Century American Design.* New York: Whitney Museum of American Art/Summit Books, 1985.

Placzek, Adolf K., ed. *Macmillan Encyclopedia of Architects.* New York: Free Press, 1982.

Pulos, Arthur. *American Design Ethic.* Cambridge, Mass.: MIT Press, 1983.

———. *American Design Adventure.* Cambridge, Mass.: MIT Press, 1988.

Richards, J.M. *Who's Who in Architecture from 1400 to the Present.* New York: Holt, Rinehart & Winston, 1977.

Russell, Frank; Garner, Philippe; and Read, John. *A Century of Chair Design.* New York: Rizzoli International, 1980.

Sembach, Klaus-Jurgen. *Contemporary Furniture.* New York: Architectural Book Publishing Co., 1982.

Stegemeyer, Anne. *Who's Who in Fashion.* New York: Fairchild Publications, 1988.

Tate, Allen, and Smith, C. Ray. *Interior Design in the 20th Century.* New York: Harper & Row, 1986.

Wilkes, Joseph A., ed. *Encyclopedia of Architectural Design, Engineering and Construction.* New York: John Wiley & Sons, 1988-89.

Wilson, Richard Guy; Pilgrim, Dianne H.; and Tashjian, Dickran. *The Machine Age in America 1918–1941.* New York: Harry N. Abrams, 1986.

Wingler, Hans. *The Bauhaus.* Cambridge, Mass.: MIT Press, 1969.

INDEX

Bold face numbers indicate main headings. Italic numbers indicate illustrations.